Rodin: The Shape of Genius

Ruth Butler

Yale University Press New Haven and London

The Shape of Genius

Published with assistance from the Iris and B. Gerald Cantor Foundation.

Designed by Sonia L. Scanlon
Set in Bembo type by The Composing Room of Michigan, Grand Rapids, Michigan
Printed in the United States of America by Thomson-Shore, Inc., Dexter, Michigan

Butler, Ruth, 1931–
Rodin: the shape of genius / Ruth Butler.

p. cm.

Includes bibliographical references and index.

ISBN 0-300-05400-0

1. Rodin, Auguste, 1840–1917. 2. Sculptors—France—
Biography.

I. Title.

NB553.R7B88 1993

730'.92—dc20

[B] 92-43552

CIP

A catalogue record for this book is available from the British Library.

The paper in this book meets the guidelines for permanence and durability of
the Committee on Production Guidelines for Book Longevity of
the Council on Library Resources.

10 9 8 7 6 5 4 3 2 1

For Gillie and Stani

Contents

Foreword

A life rarely unfolds in linear fashion. Rodin's was no exception. Still, it is necessary to follow the road he traveled from his first works to those in his triumphant retrospective at the Exposition Universelle of 1900, when Rodin assumed his position as the most widely known and respected sculptor in Europe.

We want especially to know about the 1880s, when Rodin encountered Camille Claudel, with whom he discovered such a vivid passion in a period that coincided with his most intense years of creativity. It was then that Rodin developed the repertory of subjects and forms that we find in his doors for the Musée des Arts Décoratifs (*The Gates of Hell*). This masterpiece was a true catalyst, the crucible of the totality of his work. The subjects and groups destined for the doors, though integrated into the relief, were perfectly capable of escaping and recreating themselves as autonomous sculptures, thus reclaiming the third dimension lost when placed in the original matrix.

In 1891 the Société des Gens de Lettres gave Rodin the commission for a monument to Balzac. He did his preparatory studies in a spirit of profound searching for the inner nature of the great novelist, a search that took years to complete. The plaster monument was finally shown in the Salon of 1898. Shocked by the audacity of the statue, the Société refused to accept the work. This refusal was particularly distressing for the sculptor because in the same year his separation from Claudel became definitive.

Beginning in 1899, with the great retrospectives of Rodin's work in Belgium and in Holland, the artist's fame continued to assert itself in a series of exhibitions: in 1900 in Paris, in 1902 in Prague, in 1903 in New York, and in 1904 in Germany. Then, in 1906, *The Thinker,* purchased through public subscription, was placed before the Panthéon, making clear Rodin's unique place among modern French sculptors.

Thanks to Rainer Maria Rilke and to his wife, Clara Westhoff, Rodin discovered the Hôtel Biron, soon installing himself in a suite of rooms on the south side. He had embarked upon the last great enterprise of his life, the creation of his own museum.

France accepted Rodin's donation of his work in December 1916. Seventy-seven years ago, Rodin's sculpture still offended. It was only due to the obstinate devotion of politicians such as Clemenceau and Clémentel that the administrative process had a positive outcome. This colossal gift magnified the image of the artist. Rodin gave the French state everything he owned: sculptures in marble and bronze, his immense collection of plasters, more than seven thousand drawings and five thousand photographs, his personal art collection, his furniture, his home in Meudon—and the totality of his personal archives. This last was the basis for Ruth Butler's work.

Although Rodin was a passionate seeker after official honors, a dream most fully realized in 1910 when he was made a Grand Officier of the Légion d'Honneur, his

personal life hardly fit the norms of bourgeois respectability. Faithful Rose Beuret, his adoring companion from his early years, had to put up with her partner's numerous liaisons. At the last moment, however, Rodin made their bond legitimate. He married her on January 29, 1917, sixteen days before Rose Beuret's death, but he never did recognize their son, Auguste-Eugène Beuret, who was born in 1866. I believe the pain of Rodin's youth explains his relative loyalty. The periods of happiness that he shared with Rose Beuret would seem to explain the paradoxical nature of his fidelity. Rodin was always a man of two women (the one and the other, the other not always being the same), and that was the primary reason for his rupture with Claudel.

In the early eighties, after the commission for the doors for the Musée des Arts Décoratifs, Rodin began systematically to keep everything: the letters he received, drafts of his own letters, telegrams, bills, whatever came across his door. It was in this period that he subscribed to *Argus de la presse* and then to *Je lis tout,* which furnished him with all the press clippings in which his name was mentioned.

This aspect of the Rodin donation, beyond its immediate revelation of his considerable ego, shows Rodin's will to go beyond the simple framework of a gift and to offer to future generations the necessary means to study his personality and all the elements needed to make a just assessment of his life and work. The study of the history of art—as represented by Charles Blanc and the *Gazette des beaux-arts*—was at its apogee at just this time, and the status of the artist as we understand it today was being born.

For twenty years Ruth Butler has worked regularly in the archives of the Musée Rodin; she has looked into its furthest corners to read everything, and in the process she has acquired a unique understanding of Rodin as a person, of his milieu and creative environment, and of the friendships that gathered around him.

The admirers of the master of Meudon have waited impatiently for *Rodin: The Shape of Genius.* Ruth Butler has not let them down. She offers us a vast biography, precise, clear, sparkling with unpublished anecdotes. It gives a new sense of Rodin's life by replacing myths with an actuality afforded by the archives that the sculptor himself hoped would show the way into his life.

Rodin loved women and they returned his feelings. We must imagine how happy he would be to know that after Judith Cladel, his first biographer, Ruth Butler has arrived in full possession of the love, the patience, and the obstinate will to accomplish this book. After years of work, her biography is finished. It remains only for us to plunge into this vast river where we can immerse ourselves in the multiple facets of the life, the personality, and the work of a titan.

Jacques Vilain
Director, Musée Rodin
Conservateur en Chef du Patrimoine

Preface

In the middle of the First World War, Auguste Rodin signed a deed of gift donating all his possessions—his sculptures, paintings, and drawings; his art collection, ancient and modern; his writings, published and unpublished; and all his papers—to France. As a graduate student in the 1950s, when I took up the then unfashionable subject of nineteenth-century French sculpture, concentrating on Rodin, I noticed that little use had been made of the documents Rodin had given to the public, even in Albert E. Elsen's noteworthy doctoral dissertation on *The Gates of Hell* (Columbia University, 1958).

When I went to Paris on a Fulbright fellowship to work on my own dissertation, I learned to my dismay that I would not be able to see any of the archival materials. The curator of the Musée Rodin at that time was not inclined to show them to anyone. Only in a chance conversation with a secretary in the museum did I learn that Rodin had made a lifelong practice of keeping everything the press published about him or his work. I hoped at least to read in this collection of published materials, but that too was off limits.

All this changed in 1973, when Monique Laurent became the chief curator at the Musée Rodin. She immediately arranged to organize the archives and make them available to scholars. The first thing I wanted to read was the clipping file to which I had been denied access. It became the basis for *Rodin in Perspective* (1980), an anthology of writings about Rodin. Next I did research for the Salon section of *Rodin Rediscovered,* the exhibition held in 1981 at the National Gallery of Art in Washington. At that time I began reading the correspondence. Once I began to delve into this rich archive, curiosity consumed me: the present book had begun.

I felt I already knew the people in Rodin's life, but to become acquainted with them as personalities was extraordinary. I was able to call out the dossiers of Gustave Geffroy, Emile Zola, Claude Monet, Jules Dalou, George Bernard Shaw, not to mention Rodin's son, Auguste Beuret, and his lover, Camille Claudel. It was so satisfying to find out when Rodin met various people, how soon they were on a first-name basis, what presents Rodin gave them, and how they felt about him. At times I felt I would not be satisfied until I had read every dossier in the Musée Rodin. Since there are over five thousand dossiers, some containing hundreds or even thousands of letters, had I attempted such a comprehensive survey, this book would not have been completed for years, perhaps not in this century.

The dossiers I did read contained only letters *to* Rodin. Those *from* him were not available, as the archivist Alain Beausire and the staff of the Musée Rodin were putting together a four-volume publication of Rodin's letters. Since Rodin's handwriting is quite difficult to read, I was just as happy to work with typed or published copies of letters rather than with the originals. The first volume of Rodin's collected letters appeared in 1985, the last in 1992.

Letters are the heart of this book. I have loved their gentility, their frequent warmth and openness, sometimes their silliness—and, of course, who can resist secrets? To know some of the things I know about people who lived in another century and another country, who wrote in a language different from my own, feels very special. Through the letters, I have tried to capture the voices and personalities of Rodin and his contemporaries. More often than not, I have refrained from expressing my own opinions about the personalities revealed in the letters (whether they emerge as self-centered, sexist, boasting, compassionate, cruel, pushy, mushy, manipulative, and so on), thinking it more interesting for readers to make up their own minds. Most of the manuscript material from which I have quoted is in the Musée Rodin. To save the book from being peppered with note numbers, I decided not to provide endnotes for the Musée Rodin material, but manuscripts located in other archives have been carefully acknowledged in the endnotes. The content and organization of the book have been greatly affected by the amount of unpublished material available to me. I have devoted space to evoking incidents in Rodin's life that might seem minor, while neglecting others that are clearly major, simply because some events are documented only in manuscript sources and others have been told in dozens of books.

Having worked on Rodin for many years as an art historian, I was keenly aware of the questions a biographical treatment might answer. I wanted to know what role Rodin's totally nonartistic family played in his choice to be an artist. Though much has been written about *The Gates of Hell,* there has been insufficient explanation of how the commission came about in the first place and why the *Gates* never found a home in Rodin's lifetime. I wanted to understand his internal dialogue as he came to realize that he was leading an attempt to rout the nineteenth-century craving for adulatory monuments, narrative history, and historically accurate portrayals in sculpture.

I have been writing through the years in which we have all gotten to know something of Camille Claudel, beginning with Anne Delbée's *Une Femme* (1982) and Bruno Gaudichon's show of Claudel's work at the Musée Rodin in 1984. What really happened? Was Rodin as bad for women as women said in 1984? Only in assembling the material for *Rodin in Perspective* did I realize that Rodin was clearly seen as the most famous artist in the world at the turn of the century. I wanted to understand better how that came to be and what effect it had on him and his work. I wanted to know why, with the exceptions of the portraits, he created so few sculptures in the twentieth century. His work is probably the most widely collected in the history of sculpture. During his lifetime, in so distant a country as Japan, critics were writing about his influence on local sculptors. The whole question of how Rodin's work affected people outside of France and whether their perspectives differed from the way French people viewed it interested me. I restricted this aspect of my research to England and America. Germany's reception of Rodin is an important and fascinating topic, but to have treated it more thoroughly would have made a long book longer. Since Claude Keisch has illuminated the subject so well, I direct my readers to his "Rodin im Wilhelminischen Deutschland."[1]

Some readers will be disappointed to find so little about Rodin's companion of fifty-three years, Rose Beuret. She is the only major personage in the book who could barely write—thus she has no "voice" here. That she is reflected only in the words of others is a profound loss. Clearly, Beuret was important to Rodin, but a biographer cannot supply what her subject chose not to commit to writing. A further difficulty is that, with the exception of Judith Cladel and Rainer Maria Rilke, Beuret had a remarkably bad press among those who described her.

I did not anticipate when I began this book that Rodin's first biographer would turn out to be its mystery personality. All of us know Rodin through Judith Cladel, even those who have never heard her name. Her major work, *Rodin: Sa Vie glorieuse, sa vie inconnue,* was published in 1936. It is packed with information; all Rodin scholars have made heavy use of it, disseminating both the information it contains and Cladel's views of Rodin. I remember as a graduate student disliking the book for its heavy drama, its adulatory flavor, and the central place of the author. I now know that I was reacting to something very real, that Cladel was moving the parts around to make her particular story work, and that the story she tells is often not quite accurate. Nevertheless, I have tremendous respect for Cladel and for the way she fought for the existence of the Musée Rodin. She surely did more for Rodin's reputation than any other person, so it was a considerable shock to read the correspondence and discover that Rodin treated her badly, perhaps worse than anyone else. In a recent book on Jeanne Bardey, Hubert Thiolier, who has read the same correspondence I have, has come to the conclusion that Cladel had it coming, that she was an aggressive, self-interested person.[2] I do not share this view, but I find Thiolier's book intelligent and I admire his attempt to break the stranglehold Cladel has had on the Rodin story.

Finally, a word about "The Shape of Genius." I believe that is what Rodin was about. Another recent biographer of Rodin states that he will refrain "from dwelling on that interminable topic, the aesthetics of his 'genius.'"[3] Even though I find his point well taken, I have felt it imperative to draw attention to Rodin's *own* idea of genius. In every way, Rodin imbibed the nineteenth-century commitment to the creative man as a unique and elemental force. When still a young man, he and his friend Léon Fourquet strolled for hours in the Jardin du Luxembourg discussing the subject of genius and how it related to their own lives. Rodin understood the role suffering played in the life of the creative genius. One of the few Salon statues he ever mentioned by name was *Mercury* by Jean-Louis Brian. In 1864 Brian's dead body was found frozen beside the clay statue, which had been wrapped in his only blanket. Such images were uppermost in Rodin's mind as he initiated his career; out of them grew his central goal: to fashion the nineteenth century's monument to Genius, a totality in sculpture that would have a status not unlike Balzac's *Comédie humaine*. This is surely how we must read *The Gates of Hell* and the Victor Hugo and Balzac monuments. Thus, if we are to view Rodin in the context of his time, we must attend with particular curiosity to "the shape of genius."

Acknowledgments

Anyone allowed free range in the precinct of another culture's "sacred monster" must, of necessity, feel considerable gratitude. Every time I slipped the braided cord on the second floor of the Musée Rodin off its hook, in order to move into an area where the public has no access, I felt grateful—first to Monique Laurent, conservateur en chef, who opened the Rodin archive to scholars in 1973; then to her successor, Jacques Vilain, who has done so much to support Rodin scholarship; to the curators, Nicole Barbier and Claudie Judrin, for their careful attention to the organization of their collections; to the smooth and gracious host of the salle de travail, François Cizek; and to the archivists, Alain Beausire and Hélène Pinet, from whom I have learned much and with whom I have shared many ideas over the years.

While working in the archive, I have met other scholars whose writings and ideas I value, especially Joy Newton, Helena Staub, Penelope Curtis, Claude Keisch, and Claudine Mitchell. During the years of researching the Rodin biography, I watched the great Musée d'Orsay come into being. The women who put the sculpture collection into place, Anne Pingeot, conservateur en chef, with Antoinette le Normand-Romain and Laure de Margerie, have made my work better and easier at every turn, from the beginning to the end of the book. Others in Paris who have shared valued ideas, bibliography, photos, archival records, recollections, and friendship include Catherine Krahmer, Catherine Mathon, Jean Savant, Dominique Rolin, Marc de Montalembert, Anne Martin du Nord, the late Mme Roland de Margerie, Alexandra Parigoris Stone-Richards, Sr. Jeanne d'Arc de Massia, Reine-Marie Paris, Anne Rivière, Nan Guy, and Cécile Faure. Stanislas and Gillie Faure participated in every aspect of this project—locating documents, illustrations, and books, helping with problems in translation, interpretation, French history and customs—not to mention offering hospitality that made it possible for me to survive the worst research snafus.

The book demanded extended trips to Brussels, times that were full of pleasure due to the kindness and help of Jacqueline de Groote, Douglas Silar, Eva Heidelberg, Mlle Soligné, Léon Zylbergeld, Baroness Van Ypersele, the prince de Ligne, and Sura Levine.

People in other parts of the world who knew or possessed things they have generously shared and which have entered beneficially into this book are: Sabina Quitslund, John Attebury, Joan Vita Miller, Dorothy Stevens Cimino, Campbell Cimino, Virginia Veenswijk, Ferdinand Coudert, Ornella Francisci-Osti, and Robert E. Elborne.

Closer to home, my thanks to University of Massachusetts colleagues and students—especially Paul Tucker, Nancy Stieber, Marilyn Sorensen, Melissa Burns, Fuad Safwat, and Richard Freeland—and friends, some of whom were with the book early on, others in the middle or in its final stages: Celia Gilbert, William Kelly, William

Rawn, Jill Weber, Francis Bator, and Carl Kaysen. My appreciative thanks to the staff of the library at the University of Massachusetts in Boston and that of the Boston Athanaeum.

Through the years of writing, work was frequently made easier by invitations to connect my word processor in some very special places: at the Rockefeller Study and Conference Center in Bellagio, the Tyrone Guthrie Centre at Annaghmakerrig, the Artists Foundation's Writers' Room of Boston, and the Duxbury Writers' Colony supported by my own writers' group: Paula Bonnell, Judith Cohen, Christopher Corkery, Alice Hoffman, Alexandra Marshall, Susan Quinn, Pamela Painter, Sue Standing, Margery Waters. I have been aided in a number of important ways by experts on Rodin and sculpture who have responded to my questions: Jacques de Caso, Daniel Rosenfeld, J. Kirk T. Varnedoe, Jane Roos, Rosalyn Frankel Jamison, John Hunisak, and most especially Albert E. Elsen. The first readers of a manuscript are critical to an author's ability to rethink and refine. My first readers have been outstanding: to Paula Bonnell, Sandra M. Siler, June Hargrove, Josephine Withers, Jane Van Nimmen, and Al Elsen I am deeply grateful for their time, their incisive criticism, and their rich array of suggestions.

Several presses would have been glad to publish the biography of Rodin. I have always considered myself fortunate to have had the wisdom to listen to John Nicoll and to choose Yale University Press. Working with Judy Metro has been a pleasure, and Harry Haskell has been an ideal editor in the final stages of manuscript preparation.

Writing a biography is long and expensive. This one would not have been possible without the generous support of a number of foundations and institutions: the Florence J. Gould Foundation, the John Simon Guggenheim Memorial Foundation, the National Endowment for the Humanities, the University of Massachusetts Summer Research Grant Program, and the B. G. Cantor Rodin Research Fund. Bernie and Iris Cantor, the major private collectors of Rodin's work, have been angels over and over again in the interest of making Rodin's work known and understood in the world. They have been real patrons for this book, and I hope that they will be proud to add it to their list of accomplishments in the interest of Rodin's reputation.

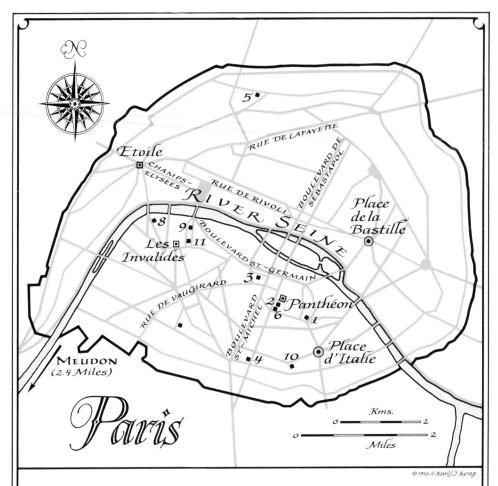

Paris

KEY

1. 7 rue de l'Arbalète, residence of Rodin family, 1837 to December 1840

2. 6 rue Fossés-Saint-Jacques, residence of Rodin family, 1857–1862

3. Petite Ecole, rue de l'Ecole-de-Medecine, the art school Rodin attended from 1854 to 1857

4. 91 rue de la Tombe-Issoire, residence to which the Rodin family moved in 1862

5. 175 rue Marcadet, residence of Rodin, Rose Beuret, and Auguste Beuret, 1865–1871

6. 268 rue Saint-Jacques, residence of Rodin, his father, and Rose and Auguste Beuret, 1877–1882

7. 36 rue des Fourneaux (today rue Falguière), Rodin's studio with Léon Fourquet, 1877–1886

8. 182 rue de l'Université, Rodin's primary studio, 1880–1917

9. 71 rue de Bourgogne, residence of Rodin and Rose and Auguste Beuret, 1884 to 1889 or 1890

10. 68 boulevard d'Italie (today Auguste-Blanqui), "La Folie Payen," Rodin's studio with Camille Claudel

11. 77 rue de Varenne, Rodin's studio 1908–1917, now the Musée Rodin

Chapter 1
A Parisian Family in 1860

Auguste Rodin was thoroughly Parisian—everyday, poor Parisian. He would always carry with him something of the place in which he was born—on the back slopes of the Panthéon, where students mingle with ordinary people who work with their hands.

The first known sculpture from the hand of Auguste Rodin—as well as his earliest extant letter—date from 1860, when he was almost twenty years old. The letter was occasioned by a trip that had been put into motion by Rodin's older sister, Maria. She wanted to see the homeland of her mother, Marie Cheffer Rodin, in Lorraine and to meet her cousins. The two Rodin men had jobs that made it impossible for them to leave the city. Jean-Baptiste was a minor official in the central administration of the Paris police department, and his son worked in the atelier of a decorative sculptor, making "scrolls and palmettes."[1] The wonder and excitement of the trip stimulated brother and sister into epistolary fervor; their letters during the six-week period lay the foundation for understanding the tenor of life in the Rodin family.

The journey began late on a Friday in August. The evening was cool when the four Rodins stepped out the door of their home at 6 rue des Fossés-Saint-Jacques, around the corner from the Panthéon. They made their way to the Jardin du Luxembourg to wait for a horse-drawn omnibus that would take them north across the river and the Ile de la Cité, up the boulevard de Sébastopol, beyond the old city gates of Saint Denis and Saint Martin.[2] Their route traversed the major north-south axis of Paris, the old Roman way recently made straight and wide according to the vision of Emperor Louis-Napoléon's Prefect of the Seine, Georges-Eugène Haussmann. From a distance the travelers could see their destination: the majestic Gare de l'Est, with its giant fan-shaped window of iron and glass. Not yet a decade old, it was regarded by many as the best-designed railroad station in the world.

The family alighted from the carriage, crossed the place de Strasbourg, and entered the great iron-vaulted foyer. The station was crowded and noisy as they made their way to the platform. Jean-Baptiste and Auguste waited to make sure Mme Rodin and Maria found seats on the east-bound train. Then the two men, as Auguste wrote his mother the next day, walked "the length and the breadth of the hall. We wanted to stay until nine to hear the whistle of the locomotive that took you away, vain hope! There were so many people chattering and chirping that we weren't able to have even this tiny consolation."[3]

Marie Cheffer Rodin was going home, probably for the first time since she had come to Paris in the 1830s. This was an experience she shared with an increasing number of Parisians of her age and class. The majority had left their families as young people at a

time when the separation seemed frighteningly permanent. The cost of the trip back to the provinces put it out of reach of poor people, except in emergencies. But by the late 1850s, with the completion of the first network of rail lines, it became possible for most French people to travel. By 1860 France had more than five thousand miles of operating railways. Now no major provincial city was more than sixteen hours from the capital.

Marie's family was not poor, but she grew up in modest circumstances. She was born on January 3, 1799, the eldest of five daughters.[4] Her father, Claude, had been a lieutenant in the Armies of the Republic before he married Catherine Chéry. The couple settled in Gorze, on the western bank of the Moselle. Cheffer supported his family as a weaver, working at home; most likely in the spring and fall he took part in planting and harvesting along with the other workers of the town. Sometime before 1825, Claude and Catherine Cheffer moved their family to the town of Etain.

Life was not easy in Lorraine following the end of the Napoleonic wars in 1814; agricultural productivity dropped and population declined. A slight revival during the Bourbon Restoration (1814–30) was cut short by another downturn during the reign of Louis-Philippe (1830–48). Even though France as a whole showed a steady pattern of growth in the second and third quarters of the century (except for the crisis years in the late 1840s), Lorraine, together with Champagne, lagged behind and many of its inhabitants were forced to emigrate.

In 1825 the second Cheffer daughter, Françoise, married a restaurant owner from Metz, Jean-Claude Butin. Then Henriette, the third daughter, married a hairdresser, M. Cordonnier. They too settled in Metz. Evidently the three remaining Cheffer girls were unable to find suitable husbands. They had little choice but to join the migration to the capital in search of employment: Annette as a housekeeper for the popular operatic composer François Auber, and Thérèse as a cleaning woman in the home of the noted Ecole des Beaux-Arts professor Michel-Martin Drolling. We do not know how Marie made her living, only that she was thirty-seven in 1836, when she married the widower Jean-Baptiste Rodin. Her youngest sister, Thérèse, did not find a husband until she was forty-five. A hatmaker named Eugène Dubois married her even though he was not the father of any of her three sons. Annette married Paul Hildiger in 1842. The Hildigers soon left Paris for Lorraine and purchased a small farm in the village of Avril, where they raised two children.

The Hildiger home was the first stop for Mme Rodin and her twenty-three-year-old daughter. Maria was excited; she had never met her cousins, Paul and Louise, and she had a special feeling for her Aunt Annette, who was her godmother.

As the sun set on August 10, the Rodin women speeded east at thirty-five miles an hour, while the men headed back to the Left Bank. Auguste was concerned that the train would make his sister unwell, "what with those hard seats, the drafts, that two-hour wait in the night air at Châlons, all this put together with the general anxiety of the trip." But these fears were Auguste's, not Maria's. She yearned to know her family better, to see what amounted to another country, and to experience the adventure of travel.

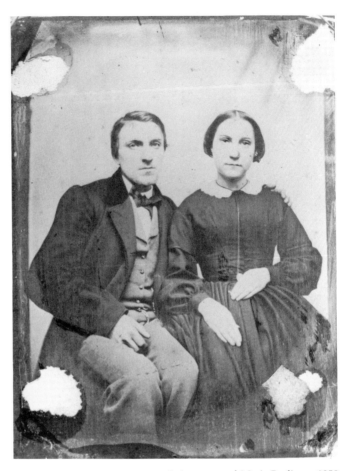

1) Auguste and Maria Rodin, c. 1859

Maria and Auguste were unusually close. Perhaps it was because they had lost their baby sister, Anna Olympie, when Maria was eleven and Auguste eight.[5] And they resembled each other, both having the straight Rodin mouth and nose. This is recorded in a photograph taken in 1859 or 1860. Maria had her mother's perfect oval face and, like Mme Rodin, she parted her hair primly in the middle. This hair style made her look older than her twenty-two years. Auguste's face was longer than Maria's, and he had their father's strong chin. He was not exactly handsome, but his thick auburn hair and soft blue eyes made him interesting to look at. His gaze had the searching quality frequently found in myopic people. He was short, standing a little over five feet three inches, and in general looked young, boyish in fact.[6] To emphasize his manhood, he had begun to cultivate a beard and moustache.

We have a photograph of Mme Rodin, as well.[7] Her outfit is conservative, a white lace collar being the only decoration on her dark dress. Her hair is parted in the middle,

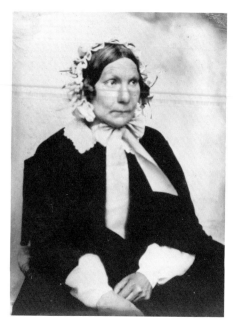

2) Marie Cheffer Rodin

symmetrically coiled over the ears, and covered with a bonnet held in place by broad ties. Like her children, Marie Cheffer Rodin has a steady, unsmiling mien, and her sunken lower lip may suggest she has lost some of her teeth.

Family photographs and railway journeys were signs of Europe's expanding bourgeois culture in the second half of the nineteenth century. Nowhere was this new enfranchisement more apparent than in Paris, and clearly the Rodins were eager participants. Letters were part of the revolution, too. The French first stuck stamps onto envelopes in 1849, thus making it possible to mail letters without going to the post office. In 1854, a subsidy significantly lowered the cost of postage. Auguste lightheartedly insisted that Maria "make sure the post office earns its 4 sous; your letter should be crammed full, put together like a bundle, because stuffed or not the price is always 20 centimes."

Rodin's letter of August 11 begins: "My dear mother"[8] In fact, however, it was intended for Maria. Because Mme Rodin did not know how to write, Auguste urged his sister to "act as mama's secretary, taking down her thoughts and remembrances (what she remembered at Etaim [sic], for example) and then put all this in a letter and send it promptly." He closed with the good news that he was now earning five francs a day at his job—reason enough, in his mind, for forgoing the trip to Lorraine. On that same day he wrote to his Aunt Annette: "I so regret not being able to see you, but my work does not leave much latitude; when one is born a beggar, one had better get busy

and pick up the beggar's pouch. . . . Ask uncle if he remembers fourteen years ago when he was working in the rue de la Glacière . . . building a little house. There was a field of carrots and we used to eat them, I more than anyone. Tell my uncle that little boy of long ago now has a profession like his in that we both work in plaster and we both go around with our shirts white and dirty from wet plaster."

The correspondence between Auguste and Maria gives us a valuable view of their relationship and of the strong contrast in their personalities. Maria's letters are forthright and precise. Her brother had asked her to describe everything; she complied with gusto, giving details about the Hildigers' house, their cousin Louise ("as big as I am, but with brown hair and stronger"), the sleeping arrangements in Avril, the vegetables they picked for dinner, the kinds of pigs, sheep, horses, and chickens found on the farm. Their days were filled with "running around Etain like fat cows," visiting and eating with all Mme Rodin's childhood friends. On August 15, the Feast of the Assumption, the great traditional summer holiday, Maria started the day at Mass, danced away the afternoon in the village square, broke for dinner, and went on dancing until 2:30 in the morning. The next two days were much the same, prompting Auguste to describe the celebration as "an exhausting pleasure, bordering on work."

Maria also did sewing for her aunt, and even found an opportunity to make some money. In Paris she worked in the shop of Jean-Stanislas Coltat, her uncle by marriage. He manufactured holy medals and religious objects suitable for pilgrimages and expeditions in foreign lands. It occurred to Maria that she could find some customers in Lorraine. One day she and her mother visited the widow Roos, who had a shop in her home where she sold, among other things, medals and crosses. Maria asked what she paid for her merchandise. "Then," she wrote to Auguste, "I got her to listen to the difference it could make if she bought from us with our discount. She is sorry she has just bought so many of those things. Next time she will buy ours. For my part I promised that once she starts to buy from us I shall include samples in her order with an explanation of which are the best objects. She has promised to give our address to her agent so that he too can buy our merchandise." Maria talked with the nuns of Avril, as well as with the village priest, who received her warmly and told her which convents in Metz would be likely customers.

Maria's letters also show her instinct to organize her younger brother's life. Dispensing counsel freely, she sounds more like a solicitous parent than a sibling. "You must distract our father. The two of you should take walks together. Eat well. Don't get bored. Tell all our news to my uncle, my aunt, my good Marie, Félicité, my cousins, to M. and Mme Moine, my aunt Thérèse, to Méline. Tell me about my starling, is he all right? Does he still talk? Auguste, if you want to go to Cherbourg to have some fun, go, but be prudent. We are pleased that you are earning 5 francs a day. Water my roses."

Auguste played the role of go-between for his sister and their Paris relatives (whom she seemed to think were uniquely hers). What unasked-for news he gave was brief and to the point. He didn't even mention the Feast of the Assumption, although on this

particular August 15 the Rodins' neighborhood was thronged with visitors who had come to see Emperor Louis-Napoléon dedicate the fountain of Saint Michael in the beautiful new place du Pont-Saint-Michael at the entrance to the Latin Quarter. Auguste's letters reveal a state of extreme emotional agitation in his sister's absence. In the tone of a forlorn lover, he told Maria that the "weather is nothing but sad since your departure." He was "encompassed by solitude." "I water your flowers which are so beautiful it is as if they bloom just to replace you in your absence."

The apartment from which Auguste wrote was on the fifth floor of a simple eighteenth-century structure. The Rodins had three rooms, two of them with fireplaces. From the front windows they could see over the houses across the street to the cupola of the Panthéon.[9] For this apartment, the nicest home the Rodin family had ever had, Jean-Baptiste paid an annual rent of 320 francs.[10]

Like his wife, Jean-Baptiste Rodin was first-generation Parisian. His father was born in Troyes, in Champagne, and his mother was Norman. All seven Rodin children were born in the Norman town of Yvetot.[11] Jean-Claude was a cloth merchant, but when he was in his early fifties, probably for reasons of health, he retired and took his family to Paris, where he died in 1823. At that time Jean-Baptiste was twenty and he continued to live with his mother and his younger brother and sister at 2 rue Soufflot, in the shadow of the Panthéon. Jean-Baptiste had many addresses in the years to come, almost all of them among the narrow streets and tortuous impasses on the slopes of the Montagne Sainte-Geneviève, where the largest percentage of Parisian poor found their homes. It was here that he lived with his first wife, Gabrielle Catenau, after their marriage in 1829. The couple had one child, Marie-Clotilde, of whom we know nothing save that she lived to adulthood and that the family considered her to be a "fallen woman."

Gabrielle probably died in 1836. Soon thereafter Jean-Baptiste met Marie Cheffer and asked her to become his second wife. The Rodins were married in September 1836 and rented an apartment just off the rue Mouffetard on the back side of the Montagne Sainte-Geneviève. Although they could walk to the Ile de la Cité in less than half an hour, residents of the rue Mouffetard had little daily contact with the central activities of the July Monarchy: the Palais de Justice and the counting houses and the newly fashionable cafés of the Right Bank were a world apart from the quarter where tanners and curriers, dyers and leather finishers lived and worked. The Rodin neighborhood was where Victor Hugo set Jean Valjean's flight through streets—"fast asleep as if under a medieval discipline and the yoke of the curfew." Balzac, in Le Père Goriot, evoked the silence of the rue Mouffetard, where "the absence of wheeled traffic . . . deepens the stillness of these streets cramped between the domes of the Val-de-Grâce and the Panthéon, two buildings that overshadow them and darken the air with the leaden hue of their dull cupolas. In this district the pavements are dry, the gutters have neither mud nor water, and the grass grows along the walls."

Marie Rodin's first children were born in the rue de l'Arbalète: Anna-Marie (Maria) on July 28, 1837, and François-Auguste-René on November 12, 1840. By the time

Marie and Jean-Baptiste's third child, Anna Olympie, arrived in 1844, the family was living in the rue des Bourguinons behind the great seventeenth-century monastery of Val-de-Grâce, which had been transformed into a hospital during the Revolution. This was still their home when Olympie died four years later. And it was the neighborhood of Auguste's primary school. He attended the classes offered by the Frères de la Doctrine Chrétienne in the rue du Val-de-Grâce until he was nine years old.

The Rodins probably moved from the Val-de-Grâce quarter to the rue des Fossés-Saint-Jacques in the early 1850s. The family already knew the street well: Jean-Baptiste's brother Alexandre, a professor of Latin, lived at number 12. Another brother, Hippolyte, directed his own school in Beauvais. Even though by 1860 Jean-Baptiste enjoyed the illustrious title of *inspecteur* in the police department, his work was clerical and it is obvious that he was less ambitious than his brothers.

The photographs of the Rodins, and their concern for the children's education, attest to their bourgeois aspirations. But to live a bourgeois life in Paris during the Second Empire, it has been estimated that a family of four needed an annual income of at least five thousand francs. [12] Jean-Baptiste's salary in 1860 was only fourteen hundred francs, which put the family on the verge of poverty. [13] It is all the more admirable, therefore, that he and Marie provided their children with at least the aura of a richer life.

Auguste's letters to his sister in 1860 offer only two brief glimpses of the weeks he spent with his father. "This morning, Saturday, papa made the coffee, swept the apartment whistling all the time, then we left" (Aug. 11), and "Thursday evening, a joyous papa opened the door for me with your letter in his hand; he barely ate in order to get home early, knowing there might be news (once or twice it's happened that we have not had dinner together)" (after Aug. 16). Nevertheless, being alone together, perhaps for the first time, must have been an important event for the two men. It seems likely that they discussed Auguste's career, as it was a genuine concern for the family: Auguste had chosen, outside of any tradition among either the Rodins or the Cheffers, to become a sculptor.

The first written evidence of Auguste's intention to pursue a career in sculpture dates from 1854, when he returned home after a three-year period as a boarder in his uncle's school in Beauvais. He had done poorly in the academic subjects and did not want to continue. When school opened the next fall, one of his classmates, D. Holen, wrote to describe how it was going in Auguste's absence. He speculated that Auguste had by now "entered a profession, that of sculptor or another" (Nov. 3).

At age thirteen, Auguste had shown interest in and talent for one thing alone—drawing. In the fall of 1854, he switched from a classical curriculum to art and enrolled at a government school, the Ecole Spéciale de Dessin et de Mathématiques. It was called the "Petite Ecole" to distinguish it from the Ecole des Beaux-Arts, which, as the training ground for the great artists of France since the seventeenth century, was known as the "Grande Ecole." The Petite Ecole had been founded in 1766 with a special mission to train the industrial workers of France. The young men who followed its

three-pronged curriculum of "geometry and architecture," "figures and animals," and "flowers and ornament" emerged with the proper preparation to be woodworkers, stucco workers, textile designers, clock makers, and goldsmiths for the nation.

The Petite Ecole was in the rue de l'Ecole-de-Médecine, an easy walk from the Rodin home. When Auguste began to study there, the school was enjoying a particularly fruitful period, having been recently reorganized under the strong direction of Hilaire Belloc. The nine professors on the faculty taught mathematics, drawing, sculpture, and composition. But the highest priority for both faculty and students was drawing. It was the linchpin of the whole system; when a student came out of the Petite Ecole, he knew how to draw.

One professor of drawing was particularly renowned. Horace Lecoq de Boisbaudran put his mark on French nineteenth-century art because of the students he taught.[14] Lecoq's teaching encompassed two revolutionary ideas: he encouraged his students to rely on memory, showing them how to observe an object closely and then draw it once it was out of view; and he prescribed freedom in the way models posed. Believing it was the goal of art "to show man acting freely and spontaneously," Lecoq called on art schools to do away with academic poses.[15] In advanced classes, he combined his two methods in a manner that pushed his students in the direction of naturalism. He often held classes in the country, where the models could walk freely in a rural setting and the students would draw from memory what they had seen. Only a small number of students participated in these classes, however; for the most part, work with nude models was not part of the Petite Ecole curriculum.

At the end of his first year, Auguste won a second prize for "Dessin de Mémoire," and in 1856 he took a first in drawing.[16] The Petite Ecole approach to drawing stayed with Rodin all his life. In 1913, when L.-D. Luard brought out an edition of Lecoq's writings, Rodin wrote a foreword for the text. He recalled that he and the other boys in his class "did not truly understand how great was our luck to have fallen into the hands of such a professor. I do now and most of what I learned from him is still with me."

Another notable presence at the Petite Ecole in 1854 was a young teaching assistant, Jean-Baptiste Carpeaux, the future creator of the most famous sculpture of the Second Empire—the *Dance* on the facade of the Paris Opéra. In his mature years, Rodin remembered Carpeaux as another master whose measure he did not quite grasp while he was a student. Nevertheless, he said, "our admiration went out to him instinctively; it may have been that we had some presentiment of his greatness; the wildest among us were full of respect for him."[17]

Auguste was enrolled at the Petite Ecole from 1854 to 1857. Beside working hard at his studies, he earned money by cleaning canvases for a painter friend of his father's. At other times he could often be found at the Louvre drawing from Greek and Roman statues, or at the Bibliothèque Impériale studying the large tomes from which he learned how to draw classical drapery. He liked to spend his evenings drawing at the Gobelins factory, the state studio for the production of tapestries in the rue Mouffetard,

which offered drawing classes with models willing to hold poses for long intervals. But Auguste's most wonderful discovery in his student years was sculpture. Later, recalling the first day he entered the modeling room at the Petite Ecole, he said it was as if he had "mounted unto the heavens."

Although the school's stated purpose was to train boys for careers in the decorative arts (article 18 in the 1843 statutes stipulated that "the sole object of instruction is the application of the fine arts to industry"), many of the students had no intention of becoming artisans. They planned to go to the Ecole des Beaux-Arts and become artists. This is what the best-known sculptors who graduated from the Petite Ecole did: Carpeaux, Dalou, Carrier-Belleuse, Chapu, Barrias, Saint-Marceaux, to name only a few. In spite of the statutes, the administrators of the school openly applauded their success.

Attendance at the Ecole des Beaux-Arts was a prerequisite to success for an artist in nineteenth-century France. Only its students were qualified to compete for the Prix de Rome, the greatest prize an aspiring artist could hope for and one that assured a prominent career. Study at the Ecole des Beaux-Arts provided an entrée to the ateliers of the most prestigious professors, the men best equipped to endorse the work of their protégés when the time came for them to submit their work to the Salon. Without such support, acceptance was difficult, and without showing in the Salon, an artist had no career. The system was simple and everyone knew the rules.

After his third year at the Petite Ecole, Auguste Rodin, like many of his classmates, applied for admittance to the Ecole des Beaux-Arts. In 1857 he entered the drawing competition and was successful. Next came the sculpture competition, which he failed. He tried again in 1858 with the same result. He competed for the last time in the spring of 1859, when he was nineteen. Again the verdict was negative.

No sculpture remains from Rodin's hand in the 1850s, so it is difficult to account for this phenomenal lack of success. Almost no other sculptor of reputation in the nineteenth century shared Rodin's fate. A hypothesis might be extrapolated from the drawings he made in the 1850s. A fair number have survived, and they show his natural feeling for the crude, the out-of-place, and the awkward. The early drawings portray necks that are too thick and thighs that are too long. In retrospect, we can see that such distortions were at the core of Rodin's powerful vision, but at the beginning of his career no one yet knew how to look at such work. In the 1850s Rodin's interest in the gauche, the unbalanced, the haphazard, in all the ways the body could reveal its vulnerability, would probably have seemed an insult to nature, particularly the controlled nature that was known to the faculty of the Ecole des Beaux-Arts.[18]

The rejections devastated Rodin. About the time of the third, his father began to write him letters of encouragement and advice. Frequently he underlined his ideas or fashioned big, bold characters to attract attention to the importance of his words:

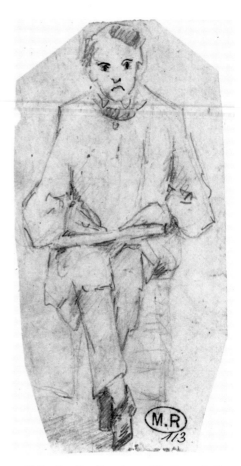

3) Rodin, *Boy Drawing on His Knees*. Before 1870. Lead pencil, pen, and ink. Musée Rodin.

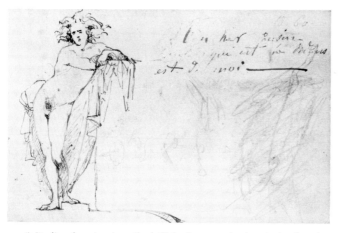

4) Rodin, drawing inscribed: "My dear cousin, here's the drawing that is by me." Before 1865. Lead pencil. Sketchbook owned by Mrs. Jefferson Dickson. On loan to the Philadelphia Museum of Art.

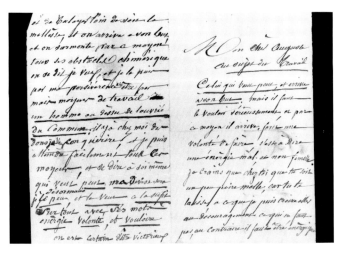

5) Letter from Jean-Baptiste Rodin to Auguste Rodin, c. 1860.
Musée Rodin.

MY DEAR AUGUSTE
ON THE SUBJECT OF WORK

The person who wants to succeed will attain his goal In this way he will achieve the will to do it, that is to say, a kind of male energy, not female. What I fear in your case is that you are becoming something of a pushover, because you let yourself become discouraged, and that you must never do; on the contrary, it is necessary to be energetic, to sweep away all signs of slackness or effeminacy. . . . One says to oneself, I want it and by my perseverance I can have it, and by my own way of working I can be a man above ordinary workers; I have gifts and I want to conquer. . . . Think about words such as: energy—will—determination. Then you will be victorious.[19]

We have only four letters from Jean-Baptiste to Auguste, but they amply demonstrate his commitment to his son's career. He was worried about Auguste's passivity and his frequent bouts with depression, states he associated with women's problems. Clearly Jean-Baptiste abhorred anything he considered effeminate. He was afraid his son would not stand up for himself and fight for his art and his future. He wondered if he would ever understand about money. It was probably after Auguste's final rejection at the Ecole des Beaux-Arts that Jean-Baptiste arranged for him to meet the son of a friend , who was earning six francs a day at the Sèvres porcelain factory. He was willing to take Auguste on a tour of the studios. In Jean-Baptiste's eyes, if an apprenticeship of this sort could be worked out, it would be perfect.

During this period, when Jean-Baptiste was searching to understand his son, Auguste created two portraits of his father, one in oil, the other in clay. The painting shows Jean-Baptiste in profile, dressed in a dark suit that sets off his gray beard. Shadows on

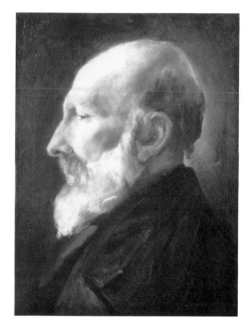

6) Rodin, *Jean-Baptiste Rodin*. 1860s. Oil on canvas. Musée Rodin.

his cheeks give his bone structure a sharp edge. He is bald on top, while darker hair rings the back of his head at the nape of his neck. The pose has restraint and the eyes gaze quietly; together they suggest Jean-Baptiste's steadfastness and modesty.

The second portrait is far more remarkable. Here, in clay, Auguste rendered his father's face without its beard and moustache; he cropped the hair close to the head and enlarged the frontal bones over Jean-Baptiste's eyes. He made no use of clothing, but portrayed his father's chest naked in the manner of a republican of Roman times. This image is full of a power not portrayed in the quieter painted portrait.

The two portraits together demonstrate some of what Auguste had learned during his years of study. He could create in different styles and he had more than one medium at his disposal. His "Roman" bust gives evidence of the many hours he had spent in the Louvre studying ancient sculpture. He put his bust into plaster and gave it to his father. It must have been a powerful presence in the tiny Rodin apartment. In the last year of his life, Rodin held the plaster bust in his hands and remembered that his father "was annoyed because I refused to put in his whiskers, mutton-chop ones like a magistrate. He could not see that, treating the bust as an antique, I was bound to leave them out."[20]

As Jean-Baptiste witnessed these creations, his respect for his son's talent grew. It seems natural to believe that the most beautiful of his letters was written after Auguste had given him the portraits which reveal so clearly a sense of deep filial homage. Jean-Baptiste's statement reads as an unqualified response to these noble gifts and to talent that had unexpectedly sprung from his loins. His great desire now was that it grow and

flourish: "You must not construct your future on sand so that the smallest storm will bring it down. Build on a solid, durable foundation One must work for the future so that there will be something left for posterity. The day will come when one can say of you as of truly great men—the artist Auguste RODIN is dead, but he lives for posterity, for the future. It is in this way that after death one continues to live. . . . Courage, courage . . . posterity will give its testimony back to you. Auguste RODIN is no longer but he lives in our hearts, he is not dead. Long live the artist." Jean-Baptiste may have wanted his son to take a job at Sèvres in order to have day-to-day security, but it is clear that it was not his intention to hamper his son's ambition. His dreams for his only son were remarkably free of ambiguity.

The truth about Auguste Rodin was that failure depressed and confused him immeasurably; he was in great need of powerful doses of encouragement in the face of rejection. It also appears that his father, although he had no apparent background in or direct connection to the arts, understood the quality in his son's work as well as the fact that he badly needed a vote of confidence.

Another person on whom Rodin could rely for support was his best friend, a young artist named Léon Fourquet. Léon threw himself into the cause of helping Auguste continue to see himself as an artist, even though he was not going to receive the training of the elite who dominated the art circles of Paris. Auguste and Léon became friends at the Petite Ecole. In the summer of 1858, when Auguste was seventeen and Léon

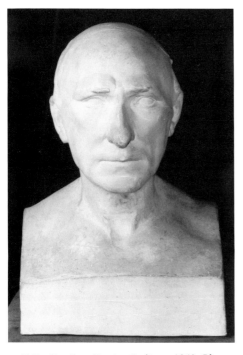

7) Rodin, *Jean-Baptiste Rodin*. c. 1860. Plaster.
Rouen, Musée des Beaux-Arts.

sixteen, the Fourquets moved to Marseille. Léon's father was a sculptor, and when Napoléon III decided to make the southern port into the empire's second city with a new stock exchange, a new police headquarters, a palace of justice, and an imperial palace, the elder Fourquet recognized the opportunities that lay there. He took his son with him so that he could teach him the art of sculpture as they worked side by side.

Through letters the boys remained close. Auguste's side of the correspondence is lost, but Léon's letters reveal a rich questing after experience and understanding. He loved travel and was a passionate observer of events around him. When France and Italy went to war against Austria in 1859 and the troops departing for Italy left from Marseille, Léon was there to report on the spectacle. Often he would describe what he saw in terms the boys knew best—through references to art. Watching the troop ships being loaded, he told Auguste, "They lift their frightened horses onto boats—it could be a scene out of Géricault."

Léon began examining the sculpture of Marseille. He was disappointed that "the museum does not have a single original by Puget," but delighted in the bas reliefs on the Arc de Triomphe showing scenes from the heroic days of the First Republic and Napoléon's glorious victories. They were by Ramey and David d'Angers. The latter was Léon's favorite modern sculptor.

Even though Léon was lonely in Marseille, he came to love the city by the sea, "the same sea where once the argonauts of Ulysses sailed." He frequently passed days at the water's edge, carrying a book or a writing tablet for his letters to Auguste. Léon was a great reader, and much of the correspondence is focused on books. We know through these letters how much Rodin read as a teenager. In the spring of 1859 the two were reading Hugo's *Notre-Dame de Paris* and the picaresque romance by Lesage, *Gil Blas*. Léon did not own the second volume of the latter and wrote urgently: "When will you write me the rest of the story?" Léon devoured Chateaubriand's *Les Martyrs*, Lamartine's *La Nouvelle Méditation*, and Hugo's *Les Orientales*. He liked Hugo better than Lamartine—"more energy." In 1860 he discovered Chateaubriand's *De Bonaparte et des Bourbons*. In it he learned for the first time that Napoléon had plotted the murder of the duc d'Enghien. He also discovered the details of the French occupation of Spain, as well as how Napoléon dealt with the Pope and how he used propaganda: "Now if I reread one of my other authors who praise his acts in a beautiful style, I shall have some other facts and some doubts."

For the two boys, one author towered above all the rest: Victor Hugo. When Léon began a letter by posing the question to which he always returned—Why has man been put upon this earth?—he invariably ended with a quotation from the god of modern literature: "I love Victor Hugo more and more—he is a man who takes life and art seriously and his thoughts are elevated and true . . . like those of David d'Angers. These great men are like high mountains."

The concerns of the two young men were not frivolous, but sometimes we glimpse a lighter side, as when Léon expressed his anxiousness about Auguste's hanging around

"with troubadours." At another point Léon teased Auguste by implying that he did not need to read as much poetry as Léon did because "you have those beautiful eyes looking at yours with a sweet and gracious smile that can inspire poetic ideas." Even this apparent reference to a girlfriend in Auguste's life caused Léon to come back to a more serious idea: that he was always going to need "a text," whereas Auguste was the kind of person who went straight to life for inspiration. "You were born for art, while I was born to cut in marble what is germinating in your head—that's why we shall always be together."

The Fourquet letters offer lively testimony of a rich friendship shared by two young men with abundant dreams and anxieties to match. Léon was truly present for Auguste in the winter of 1858, when he was preparing for his final attempt at the entrance competition for the Ecole des Beaux-Arts. "I know that you wish it were spring so that you could know what is going to happen—as you always say, 'I want to know what I will be when I am twenty.' But everyone has his destiny and you have already put away your broom in order to take up the chisel. Your decision took courage, and it is clear that if you don't succeed in figure sculpture, at least you will do so in ornamental work. I also wish for you some gaiety in your life during these days in which worries beset you, and I want you to continue to cover your sketch book with those lively drawings you make as no one else can do." No one understood better than Léon how enormous the stakes were; he faced the same uncertainties himself. The competition was the crossroads that would determine the direction of their careers: it would lead either to an artisan's life, decorating the magnificent buildings of Second Empire Paris, completing the works of better known sculptors; or to a sculptor's life, the immortality Jean-Baptiste Rodin so wanted for his son.

When the worst happened, Léon took special care with his New Year's letter at the beginning of 1860. He wanted to put the experience of the past year into a context and to give his friend hope.

Dear friend

Do you remember a few years ago when, on those delicious evenings, we walked under the trees of the Luxembourg, how you, always with a stern look on your brow, and I, a little more careless, would talk about our glorious future?

We were sixteen and without care, you were already covered with laurels in school and we spoke about art with an enthusiasm that transported me. Michelangelo and Raphael—the great names. In our delusion we were able to approach them, we saw the way open up and crowns tumble to our feet.

Thus suspended, you wanted to break through the obscure darkness of four years in order to read what destiny reserved for you at age twenty.

Then each year brought new phantoms and now we must look life in the face with fewer illusions. Maybe we can ask again that question which you used to ask me: Which would you rather have—twenty years of happiness or ten years of glory?

I think in those days we both chose happiness rather than glory if it was to be accompanied by pain.

Sometimes, even now, when I am working, dreams come to me, dreams in which glory, happiness, and misfortune are all mingled.

I also dream that I have a sweet companion, and that together we have a happy, peaceful existence.

It used to be that when I heard people talk of great honors, other passions would appear in fresh supply. I would think: I am an artist and I have my chisel and, like David d'Angers, I will bring great men to life and people will talk about me. It is the vestige of those old illusions of glory.

Then simpler ideas come to me. I dream of an existence in which gentle intimacy is mingled with all the rest, so that it can help sustain the dream. This is no longer a sentiment of glory, nor even of infinite happiness; it's simply about a life conducive to work and to having someone who loves you to whom you can confide everything you think. When these ideas come to me, I am happy.

And you—I often see you in your atelier with clay between your hands, following the inspiration of your genius.

Me—I make copies.

But each of us is assured of a future. There is nothing more solid than our dreams.

We are entering 1860. A long interval still separates us before we shall see each other again, but until that happy moment, we must try to worry as little as possible. If one doesn't proceed in this way, one is bound to be unhappy.

I've been reading Walter Scott, whom I like very much—beautiful style. Also the history of the American Indians by Cooper—such picturesque scenes in those vast forests of America.

> your friend,
> Léon

My greetings and happy new year to your parents.

The dreams remained, but the truth of 1860 was that Auguste was doing decorative work. He was not on a path to become a figure sculptor and he would never prepare for a Prix de Rome competition. But at least he was able to joke with his aunt about the situation: "When one is born a beggar, one had better get busy and pick up the beggar's pouch."

Such were Auguste's thoughts during the six weeks his mother and sister were away from Paris. Finally it was September. With great relief, he wrote to Maria:

Wednesday I was a happy man. I got two letters at the same time—yours and one from our friend in Marseille. Of course you have no doubt about which I opened first.

Maria, you must find this as strange as I do—carrying on this remote conversation, one which must be renewed with voices and embraces in a few days, but we

enjoy saying, over 70 leagues of distance, something that we know so well, that we cherish each other—me and you and mama and you and me. If you were here, I would embrace you and tell you all that you mean to me, but from a distance I am obliged to expand on my feelings for both in order to show you that I am always your Auguste. Not being able to embrace you, I write more tenderly than I could if you were right next to me and I were speaking to you. . . . While we wait for the 11th, we shall visit Aunt Marie as you ordered me to do.

Mme Rodin and Maria did not return home until September 13. Maria wrote that Auguste should be at the station early, in case the train arrived ahead of time. Léon was also coming home. He had written from Marseille: "Each day brings me closer to you. When that thought comes to me, I work with intensity; I work faster because it is in your presence that I find the beautiful thoughts, or the germ of an idea that I almost had. I am the poor outcast that you spoke of in your letter—I am in need of being cultivated." When he arrived, he brought his dearest friend a gift—a hat made of Italian straw.

The events of September—a beloved sister returned home, a best friend back in Paris—made Auguste feel positive enough, in spite of the failure of the previous year, to participate in a cooperative atelier with other young sculptors where he could work in the evenings and on Sundays.[21]

Maria went back to work. Each morning she walked to her Uncle Jean's shop in the

8) From the Coltat stationery, an engraving of
their religious medal factory

rue d'Enfer. But she remained focused on the trip to Lorraine and the meaning it held for her. In the end, what had made the most profound impression was not the night-long dancing but her talks with the priest of Avril. She wrote to him that he had brought her to a "new understanding" and that the Feast of the Assumption in Avril had meant everything to her. Recalling the "great serenity" of those days, Maria ordered a diadem to be placed on the Blessed Virgin Mary in the church of Avril on the Feast of the Immaculate Conception.[22] When it arrived, the priest wrote immediately to let Maria know how pleased Mary would be to be "crowned by a demoiselle who is pious, shy, reserved, in fact, possessed of every virtue of her sex, as well as of an unusually fine education."

The two young Rodins who resembled each other physically and were so affectionate with each other were, in fact, quite dissimilar. In every way Maria was the older sibling, with her foresightedness, a will of iron, a confidence in establishing the goals of her life. Even her gift to the Virgin Mary was part of a plan taking shape in her mind about the next step she would take.

In contrast, her younger brother was unsure and frequently depressed. Although he knew what he wanted, he did not know how to accomplish it. His father considered him a pushover. So did Maria, and when she needed to, she took advantage of Auguste's docile temperament. As we shall see, she was the power base of the family; she felt it only too natural that she should organize her brother's life. She was not only older, she was better educated and more determined. Far from resenting Maria, Auguste was in awe of her. There was an excitement about her that riveted him; he felt graced in her company. Thus the relief and pleasure he experienced upon her return from Lorraine made those September days a golden time.

Chapter 2
Maria's Vow

In 1861, Auguste Rodin was twenty, the age when Frenchmen were obliged to partici-
pate in the national lottery that determined who would be taken for the imperial army.
If a man drew a number in the "first series," he was obligated to give seven years of
service, unless, of course, his family was rich enough to purchase him a "good" num-
ber. The Rodins were hardly in a position to buy such a privilege.

Months before the drawing date, we get a glimpse of Auguste's anxiety in a letter
from Léon Fourquet: "At the end of your letter there is a sentence that makes me
tremble—you say: 'It's possible that we shall hardly be reunited before we shall be
separated if I am to be conscripted.'" Léon went on to describe what life would be like
for Auguste if he ended up "with a foot soldier's coat" on his back: "They will send you
away and you will lose your life in a cause that makes no sense and for which you have no
sympathy, or, what is more likely, one that you don't even know what it is. Tell me
exactly when this lottery will be on which seven years of your life depend. Let us keep
faith—there is luck and we must hope for the best."

March 1, 1861, was the date for the men of the Fifth Arrondissement to assemble at
the Hôtel de Ville for the drawing. There were 661 eligible candidates. Anyone who
needed to send someone in his place to pick his number was allowed to do so. Auguste
went himself and at noon heard the announcement: men drawing numbers between 1
and 388 were to be placed in the first series. He drew his number: 590. He was saved.[1]

Now that Auguste did not have to sacrifice seven years, or even his life, "in a cause
that makes no sense," the two friends could celebrate. What did they do to vent their
pent-up anxiety and to express their joy over Auguste's escape? Since they were to-
gether, and hence had no need to write, we do not know. We can, however, imagine
their mutual pleasure at seeing and talking about the artistic events of the capital. Surely
they went together to see the celebrated new sculptural work that had just arrived from
Rome.

Carpeaux, Prix de Rome in 1854, a young sculptor so admired when Auguste was at
the Petite Ecole, had sent his plaster of *Ugolino,* the culminating work from his six years
in Rome, to Paris. Its very scale—a freestanding, five-figure group, more than life-
size—made it one of the most impressive sculptures of the nineteenth century. The
combination of its sources was equally breathtaking: the main figure, Ugolino, was
inspired by Michelangelo's Medici princes and the subject came from one of the most
dramatic and terrible moments in Dante's *Inferno.* Using a subject drawn not from the
Bible, nor from mythology or ancient history, as the basis for a monumental work
caused a great scandal at the Académie Française in Rome. Paris was waiting to see this

daring departure in modern sculpture. When it was put on view in the chapel of the Ecole des Beaux-Arts in March 1861, most of the young sculptors in Paris probably went to see it.

Even more vivid was the other March event: Richard Wagner's *Tannhäuser* opened at the Opéra. In all likelihood two not-very-solvent young men would not have been able to penetrate this world. Nevertheless, they must have been aware of the climate of anticipation. "Le tout Paris" waited breathlessly for the first performance of the new opera. Rehearsals had been taking place throughout the spring, fourteen of them with full orchestra. By opening night, the public arrived eager to laugh at music that had no familiar melodic forms and ready to shout catcalls when the moment came for the ballet—the high point of any French opera—that did not take place.

The evening ended in a riot. Charles Baudelaire rushed home to write about the combination of opera and uproar. He searched for the essence of *Tannhäuser,* locating it in the human heart, that battleground where the war between the spirit and the flesh remains forever at issue. He explained why French people were so vigorously opposed to the work. The problem, he said, was that it was *serious* art. No one understood better than Baudelaire—the most notorious victim of the lightheartedness of "la fête impériale"—the depth of the hostility with which his compatriots leveled their attack at the new German opera.

There can be little doubt that Auguste and Léon would have been riveted by the hullabaloo that greeted *Tannhäuser* in the journals.[2] It was Rodin's first experience of the press's unquenchable appetite for tearing at the very fabric of a work of art that departed from established conventions. The day would come when he, too, would be the victim of that vitriolic press and would be wounded to the quick by its destructive force. Little could Auguste have dreamt in 1861 that before the century was over his very Frenchness would be brought into question because he had confronted the public with forms that were too new and too challenging.[3]

Saved from the military, Auguste could now get on with his life. His thoughts turned to ways of establishing himself as an independent man. No document tells us this directly, but a long letter from Maria leaves no doubt as to his intentions. "*Mon frère,*" she began "what a sudden change in a few days, just when I was coming to believe that we were going to be happy." She proceeded to tell Auguste that she had played a critical role in his getting a good number in the lottery, or at least that is how she saw it.

> I got everyone I knew whom I believed could fashion a prayer that would be granted, I joined my prayers to theirs, I asked God to refuse me every earthly happiness, I said I would give up years of my life . . . but he must not refuse me this favor. Yes, I went to bed late in the night in order to pray for you, I made novenas and—don't think that I enjoy telling you this or that I want your gratitude— never—I did this only to satisfy the desire of my heart. For nine days Masses were said for your intention and at each of these masses a candle was lit at the altar of the Blessed Virgin. A candle burned on the day of the lottery from 7:30 in the morning

until 5 in the evening in order to represent our collective desire that your hand would make the lucky move. I promised the Blessed Virgin Mary to honor this day in order to bear witness to the gratitude I feel. I offered to make an altar cloth.

Maria described how happy she was after the lottery because she knew that "if one day circumstances no longer permit me to stay with my parents, at least you will be there to see them, to cheer them up, to make their last days on earth happy ones." Instead, Auguste was preparing to leave home, a plan that did not suit Maria at all. She continued:

> Your heart has changed, you have said good-bye to all the fine feelings that once animated it. You no longer have respect or love for those who have given you so much, those who have made you what you are and who could have expected everything in return from you. If you consider the evil that children can do to their parents before they have reached our age—the anxiety, the worry, the sleeplessness, the pain—oh! If you understood these things your conduct would be different . . . you would console our parents in whatever way possible. . . . But you have shattered their happiness, you have created a lament that should never have been . . . especially for mama . . . you have dug her tomb. Do not appeal to God, as you have in the past . . . do not even come to me if I am still alive. No one will respond to you. One thing alone will be your executioner and that will be your own conscience. . . . You will never be pardoned by those who have loved you and whom you have not understood. Papa has sacrificed his life to make Mama happy and you have destroyed it in a moment. . . . You will regret this all your life. . . . If you want to leave your parents, if you want this liberty, you could have had it in another way. . . . You laugh at everything. That's the fruit of all your reading; you should return to religion; religion alone will bring you happiness. You have fled, separated yourself from the Faith. Think about my letter and do not think that I exaggerate. You will understand later but it will be too late. . . .
>
> Your sister who loves you always
> Maria Rodin

With astonishing strength, Maria flexed her muscles in the manner of a powerful, guilt-producing parent. Just as this "soft pear" of a brother was beginning to acquire the confidence to step away from the family, his sister dealt a blow to his budding assertiveness, pulling him back into the fold. She did so in a way that made her force a factor in his life until the end of his days. We also learn from this letter that Auguste had once been a religious person who appealed to God in times of need, but that he no longer was so inclined. This only increased Maria's anger at her brother who was about to cross her.

What Maria did not say in the letter was that *she* was on the threshold of making a fundamental change in her life. A girl in Maria's situation had three options. She could marry, but there is no evidence that Maria ever had a suitor.[4] She could continue to live

at home and work for her uncle, perhaps eventually opening her own jewelry business. But she spelled out her lack of enchantment with this life in no uncertain terms in a letter to a new friend made during the vacation in Lorraine: "I go to bed late and rise early to get all the provisions before I leave for the boutique. On Sundays I spend the whole day in the kitchen and I do the cleaning. . . . My life is without variation—every day at the boutique, every evening in the house, every morning it starts again—*voilà*, that's my life."

There was a third possibility: Maria could enter a religious community. Her letters to the priest of Avril and the intensity of her religious activities to "save" her brother reveal how caught up Maria was in the religious life. In 1861 one of her best friends took the veil in Nantes. She was too sick to make the trip for the ceremony, which distressed her immeasurably.

That summer, in fact, everyone in the Rodin household was ill, and Jean-Baptiste's condition was serious. In a letter to Aunt Annette on July 27, Maria called her father "deranged" and indicated that he no longer went to the office. She knew her aunt would understand what that meant: "You know how he has always been a slave to work. . . . The doctors call it a melancholy monomania because such people have only black thoughts." They were recommending a mental institution. The Rodins talked to other doctors who were against the idea, which was a relief to Maria: "If they send him away, Mama will be too sad." Maria spoke of the "terrible" baths and showers given to people in mental institutions, adding, "Here he takes baths but not showers and at least it is in our own home. The doctor has ordered bleeding and purgatives."

To make matters worse, that summer the Rodins moved to another apartment in the same building on the rue des Fossés-Saint-Jacques. The move tormented the sick man; the women had to get him out of the house in order to carry out the plan. Jean-Baptiste was convinced that they would simply have to move again. He believed, Maria wrote, that "we cannot afford to pay the new landlord and that he will throw us out and keep our furniture. . . . Papa says he can no longer do anything, that he will never return to work, that it's finished, that we won't have anything to eat." By August 1 it was official: for reasons of health, at age fifty-seven, Jean-Baptiste would take early retirement. Although he would receive a pension, henceforth the Rodins would be on a very restricted budget.

In spite of all these domestic problems, that fall Maria announced that she planned to enter a convent. She explained her decision in a letter to her aunt and uncle in Metz: "For some time now I have wanted to become a nun, but I kept this idea buried in my heart, wanting it, but fearing that circumstances would keep me from having this happiness. It was always the thought that my brother would get a bad number which would have had such terrible consequences for me. I put everything in God's hands, thinking that it might be according to his will. . . . If it had turned out otherwise, it would not have been my vocation. Oh! how much I thought about that lottery, which had such happy results for my brother and at the same time was so desired by me."

Maria told the Butins that when she had organized the trip the previous year, she

thought it might be her last opportunity to see her mother's homeland and to get to know the family. She also told them that she believed her family would have preferred her to stay home and go into business: "My brother promised me three years of his earnings without exception so that my boutique would work." Nevertheless, they were behind her in this decision: "My brother remains the same, ever obliging in my regard. Since I cannot give the dowry to the convent, he has made a commitment to give each year whatever he can." This letter reveals that Maria and Auguste had regained their old footing, apparently at the cost of Auguste's having renounced his plans for an independent life. At the end of her letter, Maria mentions her desire that her aunt and uncle contribute to her trousseau. Clearly, Maria was so convinced that she was doing "God's will" that she expected everyone to support her plans, no matter what it cost them in energy and funds.

As Maria prepared to leave home, once again she felt it necessary to express her parental instincts toward her younger brother. She wrote the important points out for him in a letter: that he should never cause their parents pain, that he should attend Mass on Sundays and say his prayers before going to bed, and that he should "never, never speak ill of priests." She wanted his solemn promise to do all these things, for "they will make me happy; I count on your word and on the love that you have always borne me."

On December 19 Maria packed her trousseau, went down the narrow staircase at 6 rue Fossés-Saint-Jacques, through the warren of busy streets near the Panthéon, across the Jardin du Luxembourg, up the rue de Vaugirard with its vast gardens hidden behind high walls, and turned right into the rue Saint-Maur (today the rue Abbé-Grégoire), stopping at number 8. There she entered the spacious seventeenth-century residence of the Community of Saint-Enfant-Jésus.[5] It was less than a half-hour's walk from her family's apartment; nonetheless, worlds away.

Maria surely knew this route. For it must have been the "Dames de Saint-Maur" who had given her the "unusually fine education" that so impressed the priest of Avril.

In the seventeenth century, Nicolas Barre had founded the Sisters of Saint-Enfant-Jésus as a teaching order for the daughters of the poor. Early in the eighteenth century they bought the building in which Maria was a postulant. Later they purchased another large house on the adjacent rue de Sèvres, with a garden joining it to their original courtyard. This they made into a school. Not long after, however, the revolutionaries seized and sold the school as national property. In 1853 the Sisters of the Community of Saint-Enfant-Jésus repurchased the property from the Prunelet family and made it into a school again. Maria would have been a student there during this transition, and it would have been in this house on the rue de Sèvres that she polished the French so elegantly displayed in her letters, and learned the history and geography lessons she carefully wrote out in notebooks which her brother kept until the end of his life.[6]

Soon after Maria arrived in the rue Saint-Maur, she wrote home. It was impossible, she said, to explain the full dimension of "the feelings that lie within my heart." Yet she could not bear it if her family had no notion of the fact that "for the first time in my life I am truly present in our beloved epoch." Maria's sense of that epoch is crucial to our

understanding of the context in which she made her choice to enter a convent. She began her novitiate at the very best time in the nineteenth century for such a commitment to be made. Throughout the late eighteenth century and the first half of the nineteenth, France had been undergoing a process of de-Christianization. It began with the questioning of Catholic doctrine on the part of the philosophes, followed by the revolutionaries' destruction of church organization and the loosening of ties with Rome. In 1801 Bonaparte negotiated a concordat with the Pope by which Catholicism became "the religion of the majority of the French people." (Not until 1905 were the French church and state formally separated.)

With the restoration of the Bourbon monarchs in 1814 and 1815, Royalist and Catholic passions mingled in a particularly extreme form, one that ultimately did not serve the Catholic cause well. During the July Monarchy there were strong, even brilliant, representatives on both sides—secular-revolutionary forces and Catholic-legitimist figures. The existence of the latter explains why the Revolution of 1848 was the first French revolution that was not expressly anti-Catholic. The revolution gave birth to the Second Republic, which lasted three years. One of the most significant decisions of this government was the *loi Falloux,* which gave the church a great deal of power over the education of the young. The coup d'état of 1851 brought in the Second Empire; thereafter, motivated by expediency and cynicism, Napoléon III supported the church. Between 1852 and 1862, 982 new religious congregations were approved, the majority of them for women.

During the years of steady decline in religious observance in France, French women frequently showed themselves to be of a different mind on the question of religion from their men. By 1861, for the first time in French history more women than men were in religious orders. Their number had tripled since 1824, to more than ninety thousand.[7] A strong process of feminization was taking place within Catholicism during the second half of the nineteenth century.

Another aspect of Maria's faith that was confirmed in contemporary Catholic practice was her devotion to Mary. It was the Feast of the Immaculate Conception that drew forth her most fervent expression of homage—to the point that she purchased her own crown for the Madonna. And it was to the Virgin that she directed the prayer campaign in the interests of getting her brother a favorable lottery number. Catholics of the Second Empire were more enthusiastic about Mary than their ancestors had been since the Middle Ages. An early manifestation was Mary's appearance to Catherine Labouré in November 1830 in a chapel on the rue de Bac in Paris. She gave Catherine a prayer: "O Mary conceived without sin, pray for us who have recourse to thee." These words, in combination with the apocalyptic image of Mary crowned with stars and trampling a serpent beneath her feet, became a major item among the medals manufactured by Jean Coltat's firm. It was this medal that Maria had so enthusiastically sold to the widow Roos in Etain.

Maria must have been a student in the community at the time when the dogma of the

Immaculate Conception was defined. At the General Vatican Council of December 8, 1854, the belief that Mary alone had been conceived without sin was pronounced as dogma, at the same time that the primacy of the Roman Pontiff was strengthened. The Pope as supreme teacher was now considered infallible, thus making the Immaculate Conception unassailable truth. As Cardinal Pie, bishop of Poitiers, remembered: "None of those who were men or even adolescents in the year of grace 1854 has forgotten the immense and profound emotion which seized the entire Church, when Pius IX, using his prerogative and fulfilling his ministry as supreme and universal doctor, proclaimed the doctrine of the Immaculate Conception. . . . Most of us remember that great hopes accompanied the joy. . . . This new glorification of the Mother must thus be the sign and prelude of a new glorification of the Son: that is, of a manifest expansion of his reign, or a more abundant harvest of saints, of greater liberty for the Church."[8]

Belief in the new dogma was reinforced by an extraordinary event that took place in a small town in southern France on March 25, 1858. A girl called Bernadette told the world how Mary had appeared to her in a grotto in Lourdes, saying, "I am the Immaculate Conception." The fact that the miracle took place in France was significant. It told French Catholics that they remained a privileged people of Mary. Now they could hope with renewed fervor that there would be a triumphal reunion of church and state. These were Maria Rodin's beliefs; it was only after she passed through the convent gate that she was able to take stock of it all and to write to her family that, finally, she was "truly present in our beloved epoch."

The loss of Maria's income, and the reduction in Jean-Baptiste's once he retired, made it necessary for the Rodins to move again. They went to 9 rue de la Tombe-Issoire in the new Fourteenth Arrondissement, a street that until 1860 had been in the village of Montrouge. Moving from near the center of the city to an outlying area must have been particularly hard on Jean-Baptiste, who had lived almost forty years in the same neighborhood. It was all the more devastating for a man who was sick, losing his eyesight, and in unstable mental condition.

The early months of 1862 were extremely difficult for Auguste. This is reflected in one of Léon Fourquet's letters, in which he complained to his friend: "It really gets me down when I hear you curse your lot, when you surrender to unhappiness." He believed that Auguste's "torment and anxiety" resulted from his inability to find steady work. Auguste had been coping with this problem for years, however. What is surely more to the point is his discouragement over the combination of his father's health, the move, and, more than anything else, the loss of his sister.

Even Léon's support was less comforting than it had once been, for he had succeeded in passing the entrance examination at the Ecole des Beaux-Arts, which must have affected Auguste deeply. Léon was now a student of Jouffroy, who was considered the best sculpture professor of the Second Empire. As for Maria, she was not only absent, she was resoundingly happy. Her letters sang with the pleasure of bouquet making for

the altar and the anticipation of winning a prize in the needlepoint contest. Nor did she spare her family her advice on all matters of health and household organization.

As fall drew near, so did the important day when Maria would take a new name and put on the habit of the Sisters of Saint-Enfant-Jésus. Characteristically, she organized the whole event, determining who should be there and who should not. Apparently fearing that her father's mental state might make him a burden, she wrote to Auguste with singular lack of charity: "Tell Papa to go to Metz." The ceremony took place on Sunday afternoon, September 21. Eight postulants took the gray habits of the order. Auguste was there to embrace his sister and, for the first time, to address her as "Sister Euphemia."

Maria, however, had only two months to live the life for which she had planned and struggled so keenly. In December she came home again, having contracted smallpox. Her confessor, Father Raphael, wrote to Jean-Baptiste that the sisters were relieved it was not typhoid. Maria was not to worry: "The worthy women of this community have no interest in beauty, we have sisters who are very marked from the disease and it does not keep them from doing good. Tell her that I forbid her to fret, that she should accept this trial with gratitude." He looked forward to visiting as soon as Maria was well.

Father Raphael must have felt smallpox less of a mortal threat than typhoid, since vaccine was available and fewer people died from smallpox. But vaccination was not well understood in France and the need for revaccination was not taken seriously.[9] In fact, Father Raphael never visited, for on the Feast of the Immaculate Conception, December 8, 1862, Maria Rodin died.

Mother Delphine, the first assistant to the Superior General and the woman who had organized the September ceremony, wrote a letter of condolence to Jean-Baptiste and Marie Rodin. She believed that Maria was a "fruit ripe for heaven" and that she would now be able to "pray for us and for you." She hoped the Rodins would come and see her when they were able so that they could "talk a little about this poor child."

Auguste idealized his sister, and his feelings were not without erotic overtones. To complicate matters, her death came soon after the period in which she had manipulated him into staying at home when he had wanted to leave, a desire she circumscribed with guilt. She had moved away, and now she was gone forever. The culture of the nineteenth century did not allow Rodin to understand the combination of rage and sorrow that must have dominated his feelings after Maria's death. He was never reported to have spoken a harsh word about his sister. These suppressed emotions affected Rodin's subsequent relationships with women in the profoundest way. Maria had been a total commitment, and in a sense no one could ever replace her. The worst of it was, Rodin never understood why he could not find a real companion for his life as other men did.

A picture taken by a friend of Rodin's, the photographer Charles Aubry, shows him seated and dressed in a sculptor's smock. His face, forehead, eyes, mouth, and especially his shoulders are pulled down. He looks like a man mute with pain, one who has

9) Auguste Rodin in a sculptor's smock, 1862 or 1863. Photograph by Charles Aubry.

given up. The photograph is not dated, but traditionally it has been associated with the time of Maria's death. It is tempting to see this image, so different from the conventional portraits of the period, as a record of the grief that tore Rodin apart. If that is the case, we are led to believe that he was willing to have the experience of his greatest loss documented for all time.

Rodin's grief was so overwhelming, his desperation to remain with Maria so intense, that he decided to carry on her life. Within thirteen days of her death, he entered a Catholic order—something Maria's letter of only a year earlier had suggested was the farthest thing from his mind.[10]

Chapter 3
Brother Auguste

Upon hearing of Maria's death, Léon Fourquet wrote Auguste a long letter, apparently assuming his friend still lived at home. Although Léon did not have a sister, he understood how enormous the loss of those "sweet moments" shared by brother and sister must be. He paid tribute to the "great work" that was Maria's destiny and for which she had sacrificed parents, brother, friends, a future husband and children. He confessed that he knew nothing about convents, "either for men or for women, but who cannot respect these sisters of charity one sees on the street, holy women dressed with such noble simplicity?" He wanted Auguste to know that he appreciated the pride he had taken in his sister's life, which made the loss he must now face so great.

Léon, playing his accustomed role of sensible supporter trying to calm the dark emotions he knew to be buried in his friend's heart, searched for ways to give positive help. He had been reading about the new science of spiritism. Did Auguste know that the living could converse with the souls of the dead? He explained the system of Allan Kardec, the leading spiritualist in France, who had just published his *Livre des médiums*. It is clear from Léon's letter that he had delved into this study, for he was extremely knowledgeable about how Kardec viewed the stabilization of souls in death according to the degree of purity they obtained in life.

For the first time in years, the caring friendship of Léon could not do its healing work. The content of the letter is familiar: Léon's thinking about the problem, the books he has read, the enthusiasm for a new idea. But he had no conception of the intensity of Auguste's suffering, or of his terrible needs in the wake of this death—emotions that were big enough to derail years of planning and study to become a sculptor.

The two old friends were out of step. Clearly, religion had never been part of their discussions as they walked the streets of Paris talking through the critical questions of life and art. We might suspect the Fourquets were Republicans; certainly we feel it in Léon's high regard for the ideas of Victor Hugo and the greatest of Republican sculptors, David d'Angers. Most lower-middle-class city dwellers in nineteenth-century France viewed the Catholic church as the enemy of liberalism, of the workers, and of freedom of conscience. The Fourquets and Rodins could not have seen eye to eye on religion, and thus the two friends probably found it convenient not to discuss the subject. If they had talked about religion frankly, Léon never would have summarized Kardec in order to help Auguste focus on something positive in his hour of need.

There are no more letters from Léon in 1863. We do not know if there was a break in the relationship because of Auguste's choice to enter a religious order, but we can imagine Léon's pain when he learned what had taken place in his best friend's life.

Maria had not been in her grave three weeks when Rodin moved in with the Fathers of the Blessed Sacrament, a small group of priests and brothers who had a house a ten-minute walk from the Rodin home. The community was led by Pierre-Julien Eymard, a fifty-one-year-old priest with a self-styled mission to foster devotion to the Holy Eucharist. Born south of Grenoble in La Mure, Eymard had served as a Marist priest in Lyon for ten years before moving to Paris in 1856. He first visited the capital in January 1849, shortly after Louis-Napoléon's election to the presidency of the Second Republic. Eymard revealed his particular sense of French history and political loyalties on January 21, the anniversary of the death of Louis XVI, by going to the place de la Concorde to stand where the guillotine had fallen. He then went to Versailles in order visit the site of the "September massacre," where hundreds of priests as well as some bishops had been put to death in 1792. He took time to look for traces of the martyrs' blood that he might rub his fingers across the surface of the stones on which they died.

The visit provided Father Eymard with the nascent ideas that would become the driving force of his life. He discovered a new practice carried on by a few devout women in the capital. They called it the "forty-hours' devotion" because it was a continuous period of prayer before the Blessed Sacrament, the consecrated host—Christ's body—being the focal point of all Catholic devotion. The prayer lasted for the same amount of time that Jesus spent in the tomb between his death and resurrection. Eymard also got to know two recent converts, a pianist named Herman Cohen and a captain in the navy, Count Raymond de Cuers, both of whom were interested in "nocturnal adoration," periods of prayer carried on through the night in front of the Blessed Sacrament. These experiences fermented in Eymard's mind and heart, and he became increasingly aware that it was his mission to found a Eucharistic congregation.

Eymard's decision was highly personal. It grew out of his own devotional practices and the visions he had experienced. But the desire to know Jesus Christ in the most intimate way possible was a theme that echoed through mid-century French Catholicism. It was not so much an issue for the political leaders of the church, who were particularly engaged in fighting the battles of Catholic education, but it was part of a new surge of popular piety. This display of devotion was most evident in increased interest in daily communion, perpetual adoration, and more vigorous participation in the liturgy of the Mass. Eymard had sympathetic exchanges with Dom Guéranger of the Benedictine abbey at Solesmes and the curé of Ars, who had a similar understanding of the efficacy of liturgy.

Eymard saw his mission as reparation to an outraged Christ for the sins of modern times. When he established himself definitively in Paris, the first thing he needed was the archbishop's consent to create a new community. Thus, he found himself at the door of Auguste Sibour, the highly respected liberal bishop of Paris. Sibour listened to Eymard's request, but rejected the concept as "too contemplative." He saw the real problems of the church in Paris as too few parish priests serving too many alienated workers in poor neighborhoods packed with adolescents who had never had any

religious instruction at all. The two men reached an agreement about a mission to adults, especially to that floating population of poor immigrants from the provinces that continued to crowd into the poorest districts of Paris. If Eymard could include these indigents in his goals, he could have his community.

Thus, in 1856, the Society of the Blessed Sacrament was born. It had two members: Eymard and Raymond de Cuers, who had been ordained the previous year. The archbishop allowed them a portion of the Villa Chateaubriand, so called because it had once belonged to the writer. The address was 114 rue d'Enfer, two doors from the Coltat residence at number 110.

In their first year as Fathers of the Blessed Sacrament, Eymard and Cuers spent the greater part of their days visiting workshops and factories in the poorer areas of the neighborhood, especially around the rue Mouffetard, where the Rodins lived. They particularly tried to appeal to young men, encouraging them to come to their house for religious instruction. Stories circulated through the neighborhood about the priest who invited children to his house and bid them kneel and pray with him. Half the time, confronted by such strange behavior, the children would burst into laughter before they could make it through an "Our Father." Eymard tried other approaches—lotteries, gifts of books and clothing, anything he could think of that would bring the boys and men of the neighborhood into the Christian orbit.

10) Fathers Pierre-Julien Eymard (right) and
Raymond de Cuers, founder and first member,
respectively, of the Society of the Blessed
Sacrament. After 1856.

Sibour had become a staunch defender of the new society by the time he was murdered by a suspended, deranged priest on January 3, 1857, in the church of Saint-Etienne-du-Mont. Eymard lost not only a friend and supporter, but his house as well, for Sibour's successor cast his eye upon the villa. For the second time in two years, Eymard had to look for new quarters, and eventually located a run-down place at 68 rue du Faubourg-Saint-Jacques. Although there were few clergy in the community when Rodin entered, the number of people in the house would swell when laymen came in shifts to take their places before the tabernacle for the nocturnal adoration.

Father Eymard's missionary zeal was particularly successful in drawing lay people into the work. His approach to the society was of the utmost simplicity—simple enough that someone as unprepared as a twenty-two-year-old sculptor was able to become a novice in the community. The kind of dialogue that took place between Eymard and a prospective member has been recorded. Eymard would ask the newcomer: "Do you wish to serve?" If the answer was affirmative, he replied, "Come. Of a servant we ask nothing; rather we give him something. The only security required of him is that he should take to heart the interest of the Master whom he wishes to serve." The newcomer was not asked if he was a holy person or if he could account for good works. Only "Who sent you?" to which the answer was, "Jesus Christ," and "To whom do you come?" "To Jesus Christ." "On what conditions?" for which the reply was, "On none whatsoever."[1] By this simple formula Rodin would have been greeted in the winter of 1862. He had entered the "Cenacle"; that is, he was in the supper room of Christ. This was the name used by Eymard for all the houses that he founded.

We can imagine that Eymard would have been delighted to find a sculptor at his door. Might he not have found it providential—a sign of the next step he should take as he considered the dilapidated quarters he had purchased? According to his plan, creative genius must play a role in preparing the house of prayer. He believed that a true recreation of the setting for the Lord's Supper was only possible in the presence of refined taste and good art: "The gospel tells us . . . that Jesus chose a 'large furnished room.' What an astonishing thing! Jesus always sought out poor houses and here we find a kind of sumptuousness. For the Eucharist nothing is too beautiful."[2]

Rodin donned the white surplice of a novice and entered a house where everyone's daily goal was the perpetual adoration of Jesus Christ in the presence of the Holy Eucharist. This meant hours in private and communal prayer, kneeling in silence, thinking upon the mysteries of suffering, sacrifice, loss, sin, guilt, and death. For Rodin, immersed in his personal crisis, these practices must have made a great deal of sense and not been devoid of their capacity to heal. We also know that some of his days included visits from his "pious and saintly mother," as she was referred to years later in a letter from a priest.[3]

When Rodin was not participating in devotions, he may have put his talents as a decorator to work in a house that badly needed improvement. Judith Cladel has suggested that he concentrated his work in the monastery garden. Moreover, Father

Eymard was sufficiently impressed by the neophyte's other vocation to give him permission and space to work as a sculptor. As the two men got to know each other, it was agreed that Brother Auguste would make a bust of the founder of the Society of the Blessed Sacrament.

When did these sittings take place? It is generally believed that Rodin spent Christmas 1862 with the Fathers of the Blessed Sacrament. On December 26 Father Eymard left for Angers, where he was in the process of establishing a third community, the second having been founded in Marseille in 1859. He returned to Paris late in January, having decided to seek papal approval for the congregation, now that it had three houses. Throughout February he prepared papers and reports for the Pope. This is the only month when the two men were both in residence at Faubourg-Saint-Jacques; therefore, we can be certain that the initial modeling of Father Eymard's portrait took place in February 1863.

There was much excitement in the community about Eymard's impending trip to Rome. For many, Eymard, a man of exceptional charisma, was already a saint. Rodin must have welcomed this opportunity. It was his first chance to take clay in his hands and make the image of a great man. As he approached the problem, he turned to the style of the sculptor who had been more successful than anyone else in the nineteenth century in rendering the features of the great and noteworthy in marble and bronze: David d'Angers.

David d'Angers—the faithful Republican who sought exile after Louis-Napoléon's coup d'état of 1851, returning to Paris in 1853, three years before his death—continued to be an exemplar for young sculptors. Fourquet never tired of bringing this to Auguste's attention. David was everything right—a great sculptor, an idealist, a creator in possession of that concentrated male energy which Jean-Baptiste Rodin wanted so much for his son. And David had understood, as few other modern artists had, exactly how to satisfy the nineteenth-century desire to possess images of its great men.

In the style of David, Rodin created a sharp-edged herm, the bust's outer edge assuming the traditional abstract shape of ancient origin, while the interior articulation of the bust is a carefully modeled description of the priest's clothing—his soutane, cape, and clerical collar. Rodin introduced a scroll into Eymard's vestments in the same fashion, just as the medieval cathedral carvers had done when they wanted to explain the most characteristic thought of a saint. Inscribed on the scroll are words from Eymard's own prayer: "Laudes ac gratiae sint omni momento sanctissimo ac divinissimo sacramento" (Give praise and thanks in every moment to the most sacred and divine sacrament).

The bust of Father Eymard displays greater assurance in Rodin's approach to portraiture than the bust of his father. This is clear in the new resolution of scale, profile, and proportions. Rodin created shadows by digging out pockets in the clay surface—under the cheek bones, in the temple area, between the lower lip and the chin. The frontal bones above the eyebrows emerge in strong relief. The priest's hair is richly modeled so

that the profile has a fantastic look, especially in the front view, which reveals its exaggerated asymmetry. The planes are mobile, ever changing and altering the character of the surface. The American sculptor Truman Bartlett was the first to mention this bust in print; he believed that Eymard was not totally happy with Rodin's image: "The masses of hair on the sides and top of his bust suggested to him the 'horns of the devil.'"[4] When we compare photographs of Eymard to the bust, it is easy to see what bothered him. He normally kept his hair cut or combed close to his head. Rodin made an expressive departure when he enlivened the profile of his bust by twisting masses of clay into place on either side of the central part in the priest's hair.

We have no way of knowing how far along Rodin was with the bust when Eymard departed for Rome. He sailed from Marseille on March 9 and was then kept waiting in

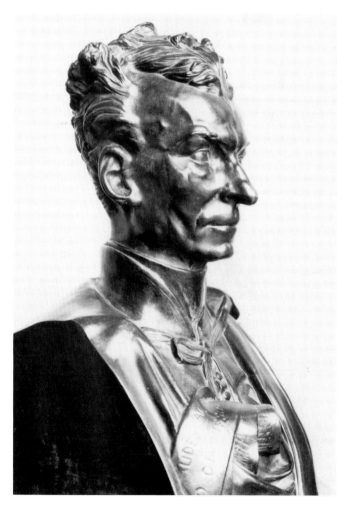

11) Rodin, *Pierre-Julien Eymard*. 1863. Bronze. Musée Rodin.

Rome for months before he received an answer to his petition. Through this long period he kept in regular contact with Paris, and in a letter of late May he mentioned in passing how sorry he was "about Brother Auguste, it seems that in this case there is a *tentation de famille,*" indicating a recognition that Rodin now wished to live a secular life.[5] We have always known that Rodin did not remain long with the Fathers of the Blessed Sacrament, but we have never known when or why he left. This one sentence is the only reference to his departure. Nevertheless, he remained close to the community, frequently returning to see his model and friend.[6]

When Rodin left the priests of Faubourg-Saint-Jacques, they still had no news of the disposition of Pius IX toward the community. It came in June: "The society is approved, I have the Decree of Approbation in hand," wrote Eymard. By August he was back in Paris; he gathered the priests and brothers around him to renew their vows and then settled down to focus on writing a constitution for the society.

Another of Eymard's concerns in this period was for the women associated with the Fathers of the Blessed Sacrament. He wanted to help them achieve the dignity of belonging to a real religious society, and he decided that Angers would be a good site for a new convent. In December he bought them a house and by May 1864 twenty sisters had taken up residence in the community. They became known as the Servants of the Blessed Sacrament.

It was not until after Rodin's departure from Faubourg-Saint-Jacques that he finished his bust of Father Eymard. Once he had the clay cast in plaster, Charles Aubry came to document the event. In Aubry's photograph we see Rodin standing before his bust on a modeling stand, his right hand cupped over the top of the head and holding a scraper to rework the plaster.

The only contemporary reference we have to the bust is in a letter from Marguerite Guillot, superior of the Servants of the Blessed Sacrament. Rodin, perhaps with Maria in mind, had sent them a cast of Eymard's portrait. On June 21 Father Eymard wrote to Mother Marguerite: "You can send your thank-you letter for this worthy fellow, Brother Auguste, to me—it's a poor gift which he has given you."[7] Mother Marguerite noted this last remark in her journal, interpreting it as a sign of Eymard's humility: "That's a saint for you," she wrote. Of course, it may also have been an expression of Eymard's equivocal feelings about the bust. Mother Marguerite went on to mention that "the good brother, who is no longer with the Fathers, made several of these casts."[8]

Pierre-Julien Eymard died in La Mure on August 1, 1868. For the next nine years, La Mure and Paris struggled over who should get the body. Paris won. The former Brother Auguste was faithful to the end, attending the funeral in the Chapel of Corpus Christi on the avenue de Friedland on July 3, 1877.

The movement to canonize Father Eymard was initiated in 1899. On April 5, 1900, Félicité Coltat, a member of the Community of the Blind Sisters of Saint Paul, wrote her cousin Auguste to ask if he had any letters or papers to contribute to the cause. She thought he might, for she knew how much he loved "*le bon père,* and especially what

12) Rodin working on Father Eymard's bust, 1863. Photograph
by Charles Aubry.

keen affection he had for you." Apparently, Rodin had no letters, but Sister Félicité's
request confirms the continuing place in Rodin's consciousness of the man who had
provided a sanctuary where the wounds inflicted by love and sorrow could be soothed,
as well as showing faith in the talent he saw before his eyes.

Eymard was canonized on the Feast of the Immaculate Conception 1962—the hun-
dredth anniversary of Maria Rodin's death.

Chapter 4
Independent Man

It took Rodin four months to feel sufficiently healed from the trauma of Maria's death to reenter the world. The fellowship of the house of prayer surely contributed to his ability to resume his life, for it was in the company of the Fathers of the Blessed Sacrament that Rodin created his second serious work, thus reaffirming his vocation as sculptor.

With no support from the fine arts establishment and little from his family, Rodin was very much on his own when he decided to take on the responsibilities of his career. Besides an income, he needed a place to work. Charles Aubry appears to have helped him take this first step. Aubry had a studio in a large building at 20 rue de la Reine-Blanche in the faubourg Saint-Marcel. It was here that Rodin set himself up in the stable off the court.[1] The roof was not tight, so the stable was cold in winter, and a well in the corner made it damp. An ornament maker in the same building by the name of Jean-Joseph Bièze took Rodin on as a worker. Soon Rodin found a more established shop, Fannière Frères, to which he could sell the ornaments he designed for their vases, tankards, and clocks. They were among the most important silversmiths of the Second Empire.

Understanding that work in the decorative arts required skill in rendering animal forms, Rodin signed up for classes with Antoine-Louis Barye, the best animal sculptor of modern times. During the July Monarchy, Barye had been an outcast, frequently unable even to place his work in the Salon. Now he was working on allegorical figures for the decoration of the new Louvre and on an equestrian figure of Napoléon I. Some modern critics went so far as to compare him to Phidias and Michelangelo.

When Rodin enrolled in Barye's classes at the Museum of Natural History, he worked side by side with his own cousin, Emile Cheffer, and one of Barye's sons. The three young men drew animal skeletons in the basement, and occasionally the great old *animalier* would come down to have a look at what they were doing. All Rodin could remember of this experience was that Barye "talked very little." By the following spring Rodin was beyond the bones in the basement, having received a permit to draw live carnivores in the menagerie of the Jardin des Plantes.[2]

Once he was working again, Rodin settled into a routine that was both disciplined and vigorous. He was drawing the animals in the zoo and at the nearby horse market; he studied human anatomy at the Ecole de Médecine and drew in the streets. Nor did he neglect the ancient-sculpture galleries of the Louvre. Rodin had now accepted the fact that the next phase of his training was to be his own responsibility.

Rodin began to think about where he could exhibit his work. This led him to get in touch with Louis Martinet, director of the Société Nationale des Beaux-Arts, an orga-

nization created to provide exhibition possibilities for contemporary artists. When his application was accepted, he sent off the necessary sixty-franc fee, which was equivalent to several weeks' earnings for him.

Martinet was an innovative presence in the Paris art world, having founded a successful commercial gallery on the boulevard des Italiens as well as a newspaper, the *Courrier artistique*. Enrolled in the society were such artists as Delacroix, Millet, Ingres, Courbet, Manet, and Préault. They held their first show in June 1862. An opening for a private members' exhibition was usually accompanied by a banquet. Many years later Rodin reminisced about the celebrities at these occasions, "mostly men of letters. I attended one of them in 1864, I think, and among those present were Théophile Gautier and Alexandre Dumas."[3] To that particular banquet Rodin had brought his bust of Father Eymard. He explained to Truman Bartlett, the American sculptor with whom he shared so many early memories, that he considered it "his right to sit down with the mighty men into whose presence he was now to enter. . . . To his great comfort it was much admired, and he felt, for the first time in his life that there was a ray of light not unwilling to fall upon his head."[4]

Léon Fourquet, who was again living in Marseille, returned to Paris in the spring of 1864. The friendship between the two young men resumed. Aubry documented this

13) Léon Fourquet (left) and Auguste Rodin, 1864. Photograph by Charles Aubry.

time in an unusually fresh and informal photograph that he took outside of his studio showing Rodin leaning affectionately on Fourquet's shoulder.[5] The top of his head comes only to Fourquet's eyes. This is one of the rare photographs in which we can really take stock of just how short Rodin was. His gaze is direct, he is not particularly handsome, and he certainly looks a little awkward. Rodin has managed to maintain his smile through the long minutes when Aubry held the shutter open. It is the last smile we shall see on his face. Henceforth, his look in photographs was always serious, an aspect reinforced by the heavy beard and mustache he cultivated in middle age.

Aubry was not a portrait photographer; these photographs were inspired by friendship.[6] His specialty was still life. He was searching to establish the intimate realities of nature in a fashion that could provide models for the new industrial arts. In 1863 and 1864, when Aubry was photographing Rodin, he was in the midst of preparing an exhibition of flower and leaf photographs as well as establishing a method for producing plaster casts of plants and flowers with an industrial use in view.[7] Rodin would have been able to give him considerable practical advice in carrying out this latter project.

In the spring of 1864, the most important thing in Rodin's life was a clay head on which he had been working over the past year and which he planned to enter in the next Salon. The Salon, which held sway over the visual arts in France in the nineteenth century, took its name from the Salon d'Apollon, where the eighteenth-century Académie Royale had held its exhibitions. Those were small shows that took place twice a year. Under Napoléon I they became biennial, and with each passing decade the size of the spectacle grew until it included thousands of works and excluded thousands more. The exclusions became a problem. Louis-Philippe tried to respond to the pressure created by the great numbers of artists who wanted to exhibit by making the Salon an annual event. That helped, but the real problem was the jury that chose the work, for it was composed primarily of conservative members of the academy and of professors from the Ecole des Beaux-Arts. They met in secret each April, examined every work, disposed of those they considered truly bad without a vote, and admitted some because of personal commitments or "arrangements" with other jurors. Their decisions were absolute and extended to designating where works would be placed and which would receive prizes. Since the jury's taste was conservative, artists working in a new way had little room in which to maneuver.

The situation was particularly desperate for sculptors. A critic looking at the last exposition of Louis-Philippe's reign—the Salon of 1847—concluded that "sculpture has never been held in less esteem than now. Sculptors suffer far more than painters from the autocracy of the jury. A group in plaster, a statue in marble, where can one show these? To whom can they be sold? . . . Not only does the jury kill poetic impulse, it is ruining our poor French artists. On its conscience there rests a large number of hopeless, miserable people, premature deaths and suicides!"[8]

During the Second Empire a more democratic method of selecting the jury was put in place, but it did not help. The power of the administration became increasingly

pronounced. By 1863 exclusions rose to over four thousand works; the system was at the breaking point. Napoléon III, who understood that the visual arts were of critical importance to his regime, then stepped in. The *Moniteur* for April 24 told the story: "Numerous complaints have come to the emperor concerning the works of art refused by the jury of the exposition. His Majesty, wishing to allow the public to judge the basis of these complaints, has decided that the works of art which were refused will be exhibited in another part of the Palais de l'Industrie." The critic Jules-Antoine Castagnary compared this event to the Edict of Milan, which gave Christianity legal status in the fourth century "after centuries of proscription and martyrdom," and to the Edict of Nantes, "which after forty years of butchery and massacre, restored liberty to the Huguenots." He said, "When this note [the statement in the *Moniteur*] was made known to the Parisian public, there was universal relief and joy in the studios. They laughed, they cried, they hugged each other."9

So it was that when Rodin left the monastery in May 1863, the most dramatic Salon of the century was awaiting him. For the Salon of 1863 included the Salon des Refusés, which was a sure sign that the winds of change had begun to blow. It must have been a significant factor in Rodin's confident decision to begin preparing a work for the Salon.

It was primarily the *idea* of the Refusés that would have captured Rodin's imagination. For it happened that the *juried* show in sculpture was far more important in 1863. Critics pointed out that in this show sculpture was better than painting, surely a "first" in Salon assessment, and a far cry from 1846, when, after seeing the Salon, Baudelaire wrote his famous essay "Why Is Sculpture Boring?"10

The sculptors to whom people gave particular attention in 1863 were Albert Carrier-Belleuse, outstanding alumnus of the Petite Ecole; Paul Dubois, recently returned from Rome; Auguste Préault, a particularly radical sculptor of the Romantic generation; and Jean-Baptiste Carpeaux, who brought his *Ugolino* from Rome.

For Carrier-Belleuse, the Salon of 1863 made it clear that he had succeeded in making the transition from decorative artist to serious sculptor. The state purchased his *Bacchante* directly from the floor of the Salon. Everyone was enthusiastic about this voluptuous beauty, whose raised arms allowed full exposure of her beautiful nude body. Dubois submitted two plasters, one pagan and one Christian: *Narcissus* and *Saint John the Baptist*. Each was a handsome nude, and the state paid the thirty-four-year-old artist six thousand francs apiece for them.

The most difficult work in the Salon was that of Préault. Along with Barye, he was one of the few surviving members of the generation of the 1830s. Then he had been considered impossible. Now he was accepted—he even received public commissions—but his works remained so strange and terrible that hardly anyone understood them. In the present Salon he showed *The Murder of Ibycus, Fate,* and *Hecuba.* Paul Mantz told the readers of the *Gazette des beaux-arts* that the exaggerated proportions, the deep holes dug into the surfaces, and the odd lengthening and shortening of the limbs were incomprehensible: "What he has done is to treat the human form like . . . a thing, not a

14) Jean-Baptiste Carpeaux, *Ugolino*. 1860–63. Bronze. Paris,
Musée d'Orsay.

person." Mantz was convinced that his contemporaries would never be able to comprehend such unbridled passion in sculpture.

The star of the Salon, however, was Carpeaux. He showed three works: *Neapolitan Fisherboy,* a vigorous nude adolescent; a portrait of the emperor's cousin, Princess Mathilde; and the extraordinary five-figure group *Ugolino,* which Rodin had seen in plaster at the Ecole des Beaux-Arts. Now the bronze claimed a first-class medal. Carpeaux had selected canto 33 of the *Inferno,* in which Dante dealt with political traitors, and the vivid passage describing how Count Ugolino, the Ghibelline tyrant of Pisa, had been incarcerated with his sons in a tower, there to starve to death. Nineteenth-century critics interpreted Dante's line "I bit into both my hands for grief"—so vividly depicted by Carpeaux—as the moment before Ugolino's hunger

overcame him and he turned to the flesh of his sons. No one had ever before seen a large sculpture based on the idea of cannibalism at the Salon. And no one could remember seeing such a monumental and complex display of human anatomy there.

Rodin certainly attended the exhibition, although his thoughts about it are not recorded. From both the Salon and the talk that surrounded it, several things would have been clear to him, especially the fact that sculpture was considered a more promising art than it had been a few years earlier. He also would have noticed that the most daring experimentation was being done by masters who worked with male figures focusing on anatomy and gesture. Would Rodin have liked the sculptures that we now consider to be the best of 1863—in particular, Carpeaux's *Ugolino* and Préault's extravagant experiments? Probably not. In the 1880s, Rodin remembered how he had laughed at François Rude's *Marshal Ney,* a statue done in the mid-century that was rich in expressive gesture and movement. He confessed to Bartlett that when he first came in contact with Barye, he "saw nothing in him." He preferred Pradier and Ingres. They seemed like "veritable gods," a taste he shared with Fourquet, who spoke enthusiastically about the rather conservative Pradier in a letter of the sixties. Rodin described to Bartlett how he "went to the *Salon* and admired the works of Jean-Joseph Perraud and other leading sculptors, and thought, as ever, that they were great masters, though in their sketches I saw they were not strong."[11] Perraud, an artist with high academic credentials, won a Medal of Honor at the Salon of 1863 for *Childhood of Bacchus,* a group that displayed two well-formed, squarely planted, and smooth male bodies.

The only work exhibited at any of the Salons that Rodin ever singled out for praise was Jean-Louis Brian's *Mercury.* This statue won a Medal of Honor at the Salon of 1864. Rodin called it "one of the finest things in the world. . . . Such force and beauty!"[12] The figure is a simple male nude at rest, in a conservative classical mode. Part of Rodin's enthusiasm was an empathetic response to the story known by almost everyone in Paris: Brian had frozen to death in his unheated studio, having wrapped *Mercury* with the blankets from his bed so that it would not freeze and break apart. In the winter of 1864, Rodin understood this dire situation, as he himself was working with a lump of clay that he cherished in his own unheated studio. Years later he repeated to Bartlett the whole story of the sculptor who had "deprived his starved body of its own protection."

To be in love with Pradier, Perraud, and Brian while harboring reservations about Rude and Barye was to be in the classicist camp. As Rodin was getting ready to enter the professional arena, he thought of himself as anything but revolutionary.

In the fall of 1863, Rodin was at work on the sculpture he planned to use for his debut. For the first time he hired a model—not a professional, but a workman who swept artists' studios in the faubourg Saint-Marcel. His name was Bibi, and the most marked aspect of his physiognomy was his broken nose. Rodin felt he "had a fine head; belonged to a fine race—in form—no matter if he was brutalized."[13] The "fine race" that Rodin associated with Bibi's face was Greek. It is an odd association, for Greeks did not seek to represent imperfect faces; on the other hand, a large portion of the ancient

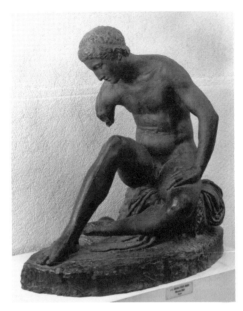

15) Jean-Louis Brian, *Mercury*. 1863. Bronze.
Paris, Musée du Louvre. Photo R.M.N.

marble heads that Rodin studied in the Louvre literally had their noses broken off. As
Rodin worked on his head, it took on something of the emotional atmosphere of a
Hellenistic "Blind Homer," although the finished work is actually closer to a portrait of
the third-century B.C. philosopher Chrysippus in the Louvre. The eyes are blank in the
classical manner, and Rodin caught Bibi's hair into a thin fillet circling the back of the
head. Not only did this device reinforce the classical reference, but it added the sugges-
tion of immortality that the fillet signified for the Greeks. The "brutalized" part of
Bibi's face was the more modern and naturalistic aspect of the study. It allowed Rodin
to go beyond classical allusion and to portray the suffering of a living man. Rodin
frequently worked with Bibi for as long as six hours a day. It was his first realization of
what became a veritable artistic dictum for him: that great work depends on a "close
collaboration between an artist and a model, that . . . they must have a mutual sense of
the expressive gesture."[14]

Probably Rodin intended to submit his head to the Salon of 1864, but it was not ready
until the spring of 1865.[15] From later accounts we can imagine the year and a half he
spent on the clay head. He lavished considerable attention on every surface area: the
neck, the short curly beard, the hair thinning on top and the matted locks behind, the
cheeks, broken nose, ears, eyes, and especially the forehead, which appears as the center
of thought and concentration. In this head Rodin initiated his method of studying
profiles. He moved around the three-dimensional work so that, with the slightest
change in view, a new and coherent profile came into being. There can be no doubt that
the head is a likeness of Bibi, but it is more as well. For the first time Rodin modeled a

surface that sent forth waves of emotion from an image that was not simply a likeness. The miracle of this head is its existence both as a portrait and as a portrait type known from the classical tradition. Rodin had enlarged his vision and captured more than the man before his eyes. In so doing, he went well beyond what he had done with his father's portrait and with Father Eymard's.

The head that Rodin cast in plaster for the Salon of 1865 was not a bust like his previous portraits. Rather, it was a mask with the neck extending only to the sternum and with no back beyond the line described by the fillet. From behind, the head was a hole; you could look into it. Rodin explained this unconventional submission: "The winter that year was especially rude, and I couldn't have a fire at night. 'The Man with the Broken Nose' froze. The back of the head split off and fell."[16] Rodin should have known that a mask would not have as good a chance of being accepted as a bust. But he had arrived at something he regarded as right, perhaps even more so in its fragmentary state, so he sent it as it was. The jury, however, was not open to the experiment. It rejected the work.

The Salon of 1865 went down in contemporary annals as a "triumph of vulgarity." People lined up to jeer and hoot at Manet's *Olympia*. One critic mentioned that Manet had found his model in the neighborhood of the rue Mouffetard, which seemed to reinforce his view of it being a "low-class" painting. In a similar vein, Courbet's

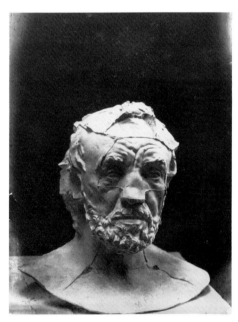

16) Rodin, *The Man with the Broken Nose.*
1863–64. Plaster. Photograph
by Eugène Druet.

portrait of Proudhon and his daughters was described as a work in which "the energy is gone and only the vulgarity remains."[17] Critics hoped that sculpture would not plunge to the depths of painting. Dubois got the Medal of Honor for *Florentine Singer,* a historically dressed Renaissance youth delicately accompanying his own song on a lute: "a studied and reasonable work." It seems hard to believe that this statue brought recognition to Dubois as "one of the best hopes of modern sculpture," but it did.

Rodin expected neither medals nor reviews, and he certainly wanted no part of the jeers aimed at Manet. He simply wanted to be recognized as a sculptor. But the head on which he had been working for eighteen months was not to make that happen. One of the problems was that it was a mask. Even before the judges walked around it to discover it had no back, they could see that the head terminated at the bottom of the neck and had to be screwed to a base. It would not have held its own in the long line of busts that was a standard feature of every Salon: one third of the sculptures were portraits standing shoulder to shoulder on either side of the main exhibition space. Rodin's portrait was atypical in other ways as well. The combination of so many features reminiscent of the ancient Greek manner of representing philosophers—the rendering of the hair and beard, the perplexed emotions, the fillet, the blank eyes—was uncharacteristic of contemporary portraiture. Nothing like it can be found in the work of Carpeaux or Carrier-Belleuse, who were the best portrait sculptors of the Second Empire. They put their sitters in their own clothing and modeled their eyes fully, indicating the direction of a glance so that the sitter's personality could shine forth.

When modern sculptors made portraits of men, they occasionally did away with contemporary clothing if the sitter was very famous—like the emperor, in which case the classical allusion of a nude bust was appropriate—or when there was a special relationship between sculptor and sitter and the lack of clothing was a sign of intimacy and friendship. Carpeaux was a master of the latter, as we see in his late portraits of the painters Jean-Léon Gérôme and Bruno Chérier. Another aspect of Rodin's mask that the jury must have found difficult was the exaggerated asymmetry and fluid modeling. It looked flashy and aggressive by contemporary standards. Even Carpeaux, the greatest modeler of the Second Empire, never treated a forehead the way Rodin did in this mask or emphasized the flab of cheeks and the pockets under the eyes in such a manner. In short, the unusual work demanded that the judges broaden their categories about what was acceptable in sculpture, and when such a demand came from a totally unfamiliar source, it was usually not honored. In 1865 no one had heard of Auguste Rodin.

Rodin showed his mask to Bièze, hoping for some appreciation from his employer, but, Bartlett says, "even with 'The Broken Nose' before his eyes, he could not see anything in his workman but a willful maker of strange ornaments."[18] Rodin hoped to show it with the Société Nationale des Beaux-Arts, but the organization had just disbanded.[19] Despite these disappointments, Rodin did not lose his conviction that the head was truly fine; in fact, he came to consider it "the first good piece of modelling I ever did. . . . I have kept that mask before my mind in everything I have done."[20] *The*

Man with the Broken Nose is the first work with which Rodin identified in a deeply personal way. The face—lined by suffering and pain, one that has known loss and poverty—*was* Rodin's. It would show up again and again in his work, almost as a signature. It was how Rodin saw himself at twenty-three.

At some distance from the 1865 rejection, an old and famous Rodin described his next step: "I wasn't discouraged; I took another, slightly better studio, and I began a figure. My model didn't have the grace of city women, but all the physical vigor and firm flesh of a peasant's daughter, and that lively, frank, definite, masculine charm which augments the beauty of a woman's body." He was talking about his own *Bacchante,* the first large figure he ever made:

> Near my bacchante, I forgot all I had suffered. What discouragement when it wouldn't come right! What joy when at last I found a contour I had long sought!
>
> I waited impatiently for the moment when I would have enough money to have her cast
>
> She was finished; I was happy, for I knew I had put into her all that was in myself.
>
> But one day—I still can't think of it without my heart breaking, . . . it will always be painful for me—I had to change studios. At the end of the day, when we were all extremely tired, without any warning, my two movers took hold of the figure, one by the feet, they took a few steps; the armature swayed, twisted; the clay fell off at once. Hearing the crash, I bounded forward. My poor bacchante was dead."[21]

We have no idea what the *Bacchante* looked like, but the work is important because of the identity of the model. It was Marie-Rose Beuret, who would live with Rodin for more than fifty years. Apparently they met in 1864, and when Rodin remembered the "suffering," the "joy," and the experience of putting "into her all that was in myself," he was describing not only the creation of his first important figure, but the beginnings of love. That Rodin neglected to mention Rose's name when he talked about *Bacchante* in the twentieth century is not surprising, for it reflects his lifelong ambivalence about their relationship.

Rose Beuret was eighteen when she met Rodin. She had come to Paris from Champagne. Her parents, Etienne and Scholastique Beuret, owned a vineyard in Vecqueville. The Beurets had two sons and six daughters.[22] Rose was the eldest and no more than a girl when she left for Paris to find work. For women, honest work in the 1860s usually meant the textile industry, which engaged 62 percent of working women in Second Empire Paris, even though few could count on earning more than three and a half francs a day—barely a living wage. The hours were long and the work was boring, so when Rose Beuret met a young sculptor who recognized her "physical vigor and firm flesh," it is hardly surprising that she leapt at the opportunity for additional work as well as potential friendship.

Rose sewed clothes for Mme Paul, whose shop was in the Gobelins district. In that

period Rodin was working on decorative sculpture for the Théâtre des Gobelins.[23] Rose lived in a room in the rue Thiers, a newly developed street just beyond the place d'Italie, only a ten-minute walk from Rodin's studio. Many years after the fact, Rodin described his meeting with Rose: "She attached herself to me like an animal."[24] It is a forceful statement and reflects the way Rodin—so awkward and shy as a young man—experienced this fiery, determined woman who did, in fact, attach herself quite well. Their relationship would last all their lives.

Judith Cladel, who became Rose's friend at the end of the century, pieced together various descriptions of young Rose and merged them with her own impression of the fifty-year-old woman she met in the 1890s: "At age twenty Marie-Rose Beuret was more than just a pretty woman. Her traits were a bit boyish, she had brown eyes that blazed at the least sign of feeling. Her abundant mass of brown hair was curled and coiffed with splendid originality, and, as simple as she was, she liked to complete her costume with a large hat that she knew how to wear with considerable élan, composing herself in a manner which one would call 'un type.'"[25]

Rodin made one sculpture that shows us this girl with blazing eyes and masses of brown hair curling round her face. She looks up quickly, mouth open; Rodin has emphasized her high cheekbones and deep-set eyes. His girl is energetic, strong, and sensuous. Nothing superficial or decorative diminishes the force of the portrayal. The life comes solely from structure, expression, movement, and modeling. We know the work as *Mignon*. Was this a pet name Rodin gave to Rose? Since the portrait was not shown during Rodin's lifetime and there are no allusions to its title in print, we have no way of knowing.

In the spring of 1865, within weeks of the return of the mask to Rodin's studio, Rose Beuret discovered she was pregnant. Her son was born on January 23, 1866. For his name she chose that of her lover, Auguste. After delivering Rose of her baby, a midwife by the name of Adèle Alliot went to the town hall of the Fourteenth Arrondissement to declare the birth, a task she performed for several other neighborhood women on the same day. She gave Rose's address in the rue Thiers, which leads us to believe the couple did not have a joint household when their baby was born. In the blank space after the word "Father," Madame Alliot wrote, "unknown."[26] Of the eighteen babies born in the Fourteenth Arrondissement on January 23, 1866, six, besides Auguste Beuret, were "natural" children. In 1875, one baby out of every fourteen born in Paris was illegitimate. This statistical gap is dependent upon many factors, but the two that stand out are money and class.[27] The Fourteenth Arrondissement had a poor and transient population, and this in turn affected the social mores of family life in the district.

For an artist to choose not to marry in nineteenth-century Paris was not unusual. In fact, some considered marriage detrimental to an artistic career. The model Dubosc remembered hearing Delacroix berate a young painter who was about to marry, saying, "And if you love her and if she's pretty, that's the worst of all. . . . Your art is dead!"[28] Théophile Silvestre, in his *Histoire des artistes vivants,* described Courbet's attitude to-

17) Rodin, *Mignon*. c. 1865–68. Plaster. Musée Rodin.

ward women: "She is a bird in passage who stops for a certain time in your place. Love is born to run through the world and not to install itself in households, like an old domestic; and the artist who gets married isn't an artist; he's a sort of jealous proprietor, always ready to be irritated when you visit his home."[29] Edmond and Jules de Goncourt finished one of their last novels, *Manette Salomon,* in 1866, the same year in which Auguste Beuret was born. They built their tale around the trials of Coriolis, a painter who had a brilliant future—until he met Manette. She was his model, then his mistress. She bore him a son and led him to a justice of the peace, thus ruining his chances to become a great artist. The novel by the bachelor brothers is a polemic against the kind of woman who "wangles" her way into the life of a creative man and who, once estab- lished, enforces a domesticity which destroys his art.

Among artists in Paris in the second half of the nineteenth century, the comforts of a bourgeois marriage were neither valued nor particularly sought after. It was just thirty

years since Jean-Baptiste Rodin had found his small-town girl from the East and had written to her father to ask for her hand. Rose Beuret followed in the footsteps of Marie Cheffer and many like her who came to Paris with few skills, unschooled in reading and writing, hoping for work—and looking for husbands. Rose Beuret was not as fortunate as Marie Cheffer. The man she fell in love with never would write her father to ask for her hand, nor fight to establish a good bourgeois family life. Rodin's unstable psychological state in the wake of his sister's death, his professional ambition, and the generally accepted view that an artist should not marry made it possible for him to avoid taking the step that Rose Beuret surely hoped for.

Rodin's decision not to marry the mother of his child must have offended Marie Rodin's desire that he live a good Catholic life and Jean-Baptiste's hope that the family have a bourgeois image. Rodin could not have been insensitive to his parents' wishes. Nevertheless, Jean-Baptiste and Marie did accept both their grandson and his mother. We have no idea when the Beurets learned of their grandson's existence, for there is only one letter from Rose's father. Writing when Auguste Beuret was thirteen (February 1879), addressing himself to "mes chers enfants," he did what a father with a vineyard might be expected to do: he arranged for a shipment of wine.

The sole description of the young ménage emerges from a memory that Rose shared with a secretary employed by Rodin during the last years of his life: "When he came into the world he was a beautiful baby, but very naughty. He cried all the time. M. Rodin used to get in a rage!—the crying disturbed him when he was working. . . . One day when Auguste had smiled at his father M. Rodin said to me, 'Rose, I'm very glad it's a boy.' 'If only he hasn't your nasty character!' I answered. 'I don't mind if he has my character,' M. Rodin said, 'if only he's an artist and works like me!'"[30] Rose also reported that Rodin was "always making clay studies of a mother and child." Some small terra cotta groups and drawings in the Musée Rodin give us an idea of the work Rodin did with Rose and little Auguste serving as models. On one of the sketches he scribbled possible titles: "Bouquet of Life," "Young Mother," "The Action of Grace," and "Deliverance." Clearly he was thinking of developing them along the sentimental lines so favored in the Second Empire art market.

Between 1863 and 1885, first children—all of them sons—were also born to Pissarro, Monet, Cézanne, and Renoir. None of these men was married to the woman who bore his child, yet all gave their family names to their sons. When Cézanne finally married Hortense Fiquet in 1886, he no longer loved her; they lived apart most of the time, but his wish to make his son Paul his legitimate heir was reason enough for the marriage.

Rodin was not so inclined, and in any case Auguste Beuret was quite the opposite of his father's pride. Rodin's few brief references to him in letters are punctuated with adjectives such as "lazy" and "irresponsible." In her biography, Judith Cladel tells about a "serious accident" that befell Auguste Beuret while Rodin and Rose were living in Brussels, that is, between his sixth and eleventh years. They had left Auguste in the care of Rodin's Aunt Thérèse. On the day of the accident, Auguste supposedly lunged at a

balloon escaping through an open window in Thérèse's third-floor apartment. When he fell out the window, he hit his head on the awning of the bakery below. "This caused permanent brain damage," reports Cladel.[31] The account—to which Cladel devotes only a few lines—has been repeated in every book on Rodin's life. But it is suspect, for we have letters from Thérèse and her children in which they discuss the problems Auguste Beuret was causing in their household (see chapter 7 below), but do not mention any fall or worry about brain damage. Cladel's story has the earmarks of a convenient explanation for Rodin's cruel treatment of the boy and his unwillingness to

18) Rodin, *Mother and Child*. c. 1865. Terra cotta. Musée Rodin.

19) Rodin, *Mother and Child.* c. 1865. Bronze.
Musée Rodin.

recognize him. Rodin's attitude seems so incomprehensible that some have questioned whether Auguste Beuret was in fact his son. But a comparison of adult photographs of the two men leaves no doubt that he was.

Rodin never made a direct statement against marriage in the manner of Delacroix and Courbet, but then, they never set up households with women who became their lifelong companions. Pissarro, Monet, Renoir, and Cézanne eventually married the mothers of their children. Even Manet, who did not recognize the son born to Suzanne Leenhoff in 1852, married her in 1863, when his father, who would have objected to the union, died. Rodin did eventually marry Rose Beuret in 1917, shortly before they both died, but the wedding was planned by others who wanted to insure Rodin's legacy to France. The marriage made Rose into Rodin's legal heir as protection against any hidden wills in favor of other women.

Rodin's lifelong resolve not to marry raises a number of interesting psychological questions. To what extent does it suggest oedipal feelings toward his sister, who behaved so like a parent? Had Maria lived so that he could have continued to engage and ultimately to disengage from her, would he have been able to include another woman in his life in a more solid fashion? Was his resistance to a committed adult family life a form of loyalty to Maria? Failing to legitimize one's own child and neglecting the respon-

sibilities of fatherhood show a deep ambivalence about taking the step into adult life. Something in Rodin did not choose the maturity that comes with being a true head of household. The independence of the studio—with its infinite possibility for freedom, achievement, and delight—was far more attractive. At age twenty-five, Rodin was willing to give Rose and her child financial support and to offer Rose his loving companionship, but he never committed his whole being to anything save his art. He would reaffirm that decision in the years to come, and he would agonize over it in old age. In 1866, the issue could not have been clearer: Rodin's child was unexpected and unwanted, and he had no desire to marry the woman who had borne his son.[32]

Chapter 5
A Sculptor's Assistant

Paris in the Second Empire, especially in the late 1860s, was an artist's dream: it was fifth-century Athens, it was fifteenth-century Florence, it was a time and a place when the creative individual believed the life he had chosen was particularly grand. He was born to participate in the magisterial richness of the imagination. Writers, musicians, and artists moved with ease from their studios to theaters and cafés. Their activity was especially visible in newly popular gathering places on the Right Bank, in Batignolles and Montmartre. The names of the Brasserie des Martyrs and the Café Guerbois conjure up glittering conversations carried on within a brilliant society of men.

Rodin moved to this part of the city in 1865. There is nothing to suggest, however, that he ever participated in the sparkling café world of a Courbet or a Manet. He and Rose Beuret moved in together for the first time at 175 rue Marcadet, just beyond the northern edge of the Cemetery of Montmartre. The reason for the move was to gain proximity to Carrier-Belleuse's atelier in the rue de la Tour-d'Auvergne, where Rodin was now a full-time employee. Establishing a home for himself and Beuret and their baby was a big emotional change in Rodin's life. For the first time he was more than fifteen minutes from his parents' home.

Rodin's period with Carrier is barely documented, so we have to consult others for a sense of the energy that was in the air of Montmartre and the master's studio. A collector who spent a day there wrote:

> I went along with a light heart to visit the sculptor, Carrier-Belleuse . . . ; what wonders I found in his studios! what life! what animation! The master himself would sketch a work in clay or draw upon the surface of a marble block. I saw fifty "praticiens" in the studio, artists of every sort who worked under the master's direction. One would be chipping away on a block of marble, another putting wax on to plasters, a third covering completed clay groups with wet cloths But where Carrier-Belleuse surpasses himself is when he lets go with one of his smiling apparitions—well, even when the apparition is sad he knows how to grasp and to fix expression, to animate cold clay. He does it with the spark of Prometheus.[1]

Carrier as Prometheus bringing life to cold clay: the vigorous image recalls Daumier's caricature of the sculptor as a conductor on a podium with arms outstretched, an enormous head of curls flying in all directions as he simultaneously models busts and directs dozens of other busts as if they were his orchestra. Carrier's hands were his "baton," and through them he exerted power. Clay was the medium for his ideas. Once he had developed the idea—the model—he handed it over to an assis-

20) Honoré Daumier, *A. Carrier-Belleuse*.
Lithograph published in *Le Boulevard,* May 24,
1863. Paris, Cabinet des Estampes.

tant. Which assistant depended on the material and on whether the work was headed for
the Salon or was being readied for an edition of copies in bronze, plaster, or terra cotta.
Carrier was probably the first sculptor to maintain a separate atelier for the sole purpose
of producing multiple copies of his works.[2]

Carrier also employed numerous artisans to make plaster molds. A plaster cast taken
from a clay model was the basis of every work that came out of his studio, whether the
final form was to be in marble, bronze, or terra cotta. Whenever Carrier sketched out a
composition that was particularly fine, more often than not he would order a full
treatment, which consisted in having it realized in marble and in bronze and then having
the work reduced in size so that it could be sold in an edition.

Carrier hired assistants as modelers, mold makers, and marble carvers. Rodin did
only modeling, for, like Carrier and the majority of the best sculptors in the nineteenth
century, his instinctive way of working was as a modeler, that is, a manipulater of clay.
He seldom carved marble and we assume he never made molds if he could help it.
Carrier would turn over clay groups, bas reliefs, or heads to Rodin, and it was his job to
take the rough clays and finish the details before they were sent to the mold makers.
About his employer, Rodin recalled that he "had good ideas of arrangement, a pretty
correct eye, and composed well. . . . He could make a sketch that no one could finish as
well as myself."[3] But Rodin was resentful because he felt Carrier did not understand

how good he was. Jules Desbois, a sculptor whom Rodin met in the atelier in Mont-martre and who became a life-long friend, remembered Carrier saying of Rodin: "I could never get him to compose as I do. He is a strange fellow." Adrien Gaudez, also a member of the atelier, told Bartlett in the late 1880s that "no one who knew Rodin at Carrier-Belleuse's had the least idea that he would succeed or that he had anything in him."[4]

If Rodin did not receive the proper academic education, he did get a first-rate appren-ticeship in entrepreneurial skills. His father introduced Rodin to the work ethic, but Carrier was his model as to how to run an atelier. In his employ Rodin learned every facet of making and selling sculpture. The lessons he absorbed there were fundamental to his eventual development as a supremely successful artist.

When Rodin changed from part-time to full-time status in the Carrier atelier, the older sculptor had good reason to want more hours from an able worker. Not only was he aggressively showing and selling his work all over the country, he was now receiving major commissions. They came mainly from the state. Napoléon III, eager to establish his claim to fit into the tradition of great French rulers, lavished money on architectural projects. The most impressive works that went up under his sponsorship were the new Louvre and the Opéra. At the Louvre, Carrier decorated one of the semicircular lunettes at the roof line on the river side with *Abundance,* and he worked on the interior of the Lesdiguières Pavilion, a project for which he called on Rodin's talents.[5] At the Opéra, his most famous figures are the caryatids and the candelabra of the Grand Foyer.

Among private commissions, Carrier's most stunning work was for the residence of the marquise de Païva on the Champs-Elysées. Of all Second Empire courtesans, La Païva (born Esther Lachmann in a Russian ghetto and married to a Portuguese noble-man) was the most exalted. Hers was the most celebrated "salon," where the talk was brilliant and one might hope to encounter *le tout Paris*. But to receive her distinguished company, La Païva needed the right setting, so she hired the architect Pierre Mauguin to create her dream palace. With the help of an array of Renaissance models and a young sculptor named Eugène Legrain, who was placed in charge of interior decoration, Mauguin proceeded to do just that. Legrain, recently out of the Petite Ecole, brought in a team of artisans to work with him in realizing a decor that could support the fantastic life style of La Païva. One of them was Jules Dalou, a sculptor Legrain had known at the Petite Ecole. La Païva herself hired Carrier, whose team included Rodin. It was proba-bly at the Hôtel Païva that Rodin and Dalou met for the first time. By century's end, they would compete for the distinction of being the most important sculptor in France with a new voice.

At the Hôtel Païva (today the Travelers' Club), Carrier's interior chimney ornaments in silvered bronze are still in place. They are female figures in a pseudo-sixteenth-century style. The poses are artful, the drapery and jewels intricate and rich, and the details are worked out with a delicate sensibility toward the appropriate nature of the marquise's bedroom setting. But Carrier's strongest contribution to the sumptuous

Hôtel Païva was in the dining room, where his *surtout*—an elaborate silver center-piece—was placed upon the table. While eating, guests could gaze upon a sensuous Ariadne reclining upon her panther, as Nereids and Tritons lifted silver bowls above their heads.

The work has disappeared, but old photographs survive. We also know the impression it made the night diners first sat at eye level with this silver wonder. The Goncourt brothers were invited to the unveiling on May 31, 1867. Jules, with characteristic acerbity, tells us about the marquise and the sculpture, and about how the sculptor was viewed by the assembled guests that spring evening on the Champs-Elysées:

> We move to the dining room and sit down. Now it is time to show off the *surtout* which was the basis for which this bourgeois invitation was given in the first place—such poor taste, without shame. We are forced to admire it and then to admire it again. No one mentions the price; but somehow it is said that such-and-such a work coming from this particular maker would cost in the neighborhood of 80,000 francs. At this point it is necessary that everyone put his hand to his throat and exclaim admiration and compliments.
>
> The compliment, no matter how big, is never big enough. Saint-Victor goes on and on; he is inexhaustible in his praise of this trite sculptor, Carrier-Belleuse, this shoddy trader in eighteenth-century style. Saint-Victor prides himself on his having obtained the sculpture medal for him this year, and he is shocked that they have not yet decorated the modeler of this object before which we must now dine.[6]

Carrier brought out the Goncourt brothers' snobbishness. What annoyed them most was his eclecticism. His work at the Hôtel Païva was based on sixteenth-century models, but more often he leaned toward the eighteenth century. In fact, he was one of the earliest sculptors to absorb eighteenth-century style into his work. This probably made the Goncourts particularly angry, for here Carrier was treading on their own territory. They had become authorities on eighteenth-century style, surrounding themselves with objets d'art of the period, and in doing so had identified their lives with that of the former nobility they so liked to emulate. Thus Carrier—a parvenu—brought them to a point of pique.

The Goncourts' remarks about Paul de Saint-Victor are telling. Saint-Victor was a conservative critic who never lost an opportunity to attack Manet and friends, and he was one of the most influential writers on art in the Second Empire. He publicly took credit for Carrier's medal at the Salon of 1867 and, as we have seen, he expressed annoyance that "his" sculptor had not yet been decorated by the Légion d'Honneur, the ultimate sign of recognition in the eyes of the French establishment.

It is doubtful that much of this had direct bearing on Rodin while he was working at the Hôtel Païva. It was his first job in an establishment of luxury; probably he never saw the client herself. His name is on no document, and we do not know exactly what he did while he was there. Nor do we know what he did at the Louvre, or if he ever worked at

the Opéra at all. For Rodin, the apprenticeship at Carrier's atelier was a time to watch and listen. He learned how sculptors got commissions and how they succeeded with clients and bureaucrats. He discovered how powerfully a critic could alter the course of a man's career. He saw how teams of artisans were assembled, how assignments were given and prices established. He learned all the practical matters that a successful sculptor needed to know.

It seems that Rodin did not participate much on Carrier's big commissions. His boss preferred to give him genre groups and "fantasy" busts. They were decorative heads, women with coquettish smiles and flowers in their hair, which were called *Memory, Regret,* or *Bacchante with Roses.* Carrier sold them at auction or sent them to exhibitions in the provinces, producing a steady source of income.

In the evening Rodin would go off to a studio of his own that he now rented in the rue Hermel. Rodin felt he survived this apprenticeship without doing permanent harm to his work only by rigorously maintaining his habit of working from life. He believed that his own work was superior to what he did for Carrier because the sculptor's main objective "was to please the uncultivated, often vulgar, fancy of the commercial world. To accomplish this, the living model was dispensed with, haste took the place of thought and observation, a bad style of modelling was practiced, and a manner of finishing equally reprehensible."[7]

Rodin's intense desire to work from nature paralleled the approach of many young contemporary painters. In 1863 Monet recoiled in shock when he realized that his teacher, Charles Gleyre, placed "style" above nature. He said: "I saw it all. Truth, life, nature, all that which moved me . . . did not exist for this man." Renoir's encounter with an older painter—Narcisse-Virgile Diaz—was more positive, for he told Renoir that "no self-respecting painter should ever touch a brush if he had no model under his eyes." The difference between Rodin and the young painters was that they had a host of predecessors in their struggle to locate nature at the center of their work: Courbet, Manet, Jongkind, and Boudin, as well as the Barbizon painters. Rodin was virtually without a model near at hand for his own pursuit of nature.

Another factor that separated sculptors from painters in this period was the eclecticism of a studio system that obliged sculptors to learn various styles in order to meet the practical realities of the marketplace. Do we imagine Monet working in other people's styles for fifteen years? Yet that is what Rodin did. Only at night was he able to continue his search for his own way. As he described it, he worked "slowly, thinking much, observing clearly and trying to reproduce his model with exactness in all its outlines, interior and exterior. It was the only . . . way of getting happiness—endeavoring to make good sculpture."[8]

One event, the Exposition Universelle of 1867, made a particularly forceful impression on all these artists in their twenties. At this time, Haussmann's Paris finally showed herself off as she was intended to be—the perfect setting for a giant show. Visitors from the world over poured into the city to gawk, eat, and dance. The biggest show of all was

the procession of sovereigns parading through the fabulous environment: the prince of Wales, the pasha of Egypt, the sultan of Turkey, and the kings of Greece, Denmark, Belgium, Sweden, and Spain, along with the brother of the mikado of Japan, the tsar and tsarina of Russia, and, not to be overlooked, the king of Prussia. There were balls by the hundreds. At the embassies they waltzed until dawn, while common folk watched the bewitching cancan of Mlle Fifine or swayed to the rhythms of bands playing through the night under three thousand gas lamps at the bal Mabille. Locals declared Paris "trop gai" (too gay) and hoped that this giant carnival would be the last.

According to the Goncourts, the exposition dealt a death blow to French culture, for in it industry dominated art. They proclaimed it the "Americanization" of France and thought it horrid. It was true that the French placed more emphasis on industry at the exposition of 1867. But they continued to recognize their eminence in the arts: "The most beautiful sculpture in the world is made in France," said Charles Blanc, "because sculpture is a formal art that takes its life from tradition and it can only flourish when it is well taught, as it is here."[9] Blanc was a conservative critic serving on the Fine Arts Jury for the exposition in 1867 when the conservative majority admitted no sculptor who had not previously won a Salon medal. As a result, there was little fresh or new to look at. This was true of the sculpture in both the Exposition Universelle and the Salon of 1867 that took place across the river. France put only her best-established practitioners on view in this gigantic cultural tournament.

Perraud received the Medal of Honor at the Exposition Universelle for his *Childhood of Bacchus,* which Rodin had admired in the Salon of 1863. Guillaume was cheered for his *Napoléon I,* and Carpeaux finally showed his *Ugolino* in marble, a project that had consumed him for years. Carrier-Belleuse's work looked strong in both exhibitions: his marble *Angelica* and four portrait busts were at the *Exposition Universelle; Between Two Loves* (a Venus and Cupid) and the *Messiah* (a Virgin and Child) were in the Salon. He considered these two large marbles to be complementary pagan and Christian views of maternal love. They won the hearts of the jury, who awarded him the Medal of Honor.

Rodin and his friends from the studio must have spent considerable time at both exhibitions, probably with mixed emotions. They would have been fascinated by their first real international exhibition—they had been too young in 1855 to take the measure of such a display—and curious about the placement of their employer's work. At the same time, they would have been aware of the difficulties their own generation was having placing works in such exhibitions. The admissions jury for the Salon of 1867 was particularly severe, rejecting two thousand out of the three thousand works submitted.[10]

The best way to walk from the Champ-de-Mars to the Salon, held as usual in the Palais de l'Industrie on the Right Bank, was by way of the Pont de l'Alma, a new bridge commemorating the Crimean War. It gave access to a splendid new square where three broad avenues converged. Here, in the place de l'Alma—which Courbet described as "the most beautiful site in Europe"—the visitor found two private exhibitions, one

21) *French Sculpture in the Exposition Universelle,* 1867. Paris, Cabinet des Estampes.

erected by Courbet, the other by Manet. Courbet, since Ingres' death the previous January, had become the lion of the French art world. He did not really need to mount a protest exhibition as he had in 1855, but he enjoyed his one-man exhibition with its anti-official tone. He wrote to a friend: "I will probably never again send anything to the expositions of a Government that has until now behaved so badly to me."[11] Manet, however, was motivated not so much by defiance as by desperation to exhibit, having been turned down regularly by the jury.

Rodin surely saw both shows, probably feeling more sympathy for Courbet's naturalism than for Manet's modernism. It is unlikely that in 1867 the modeler of light-hearted bacchantes for Carrier recognized a kindred spirit in Manet's loose compositions, arbitrarily placed figures, and strange disjunctions of scale. But when Rodin finally did take command of his own style in the 1880s, it had more than a little in common with the bold aesthetic departures of Manet.

Historians have frequently looked to the Exposition Universelle of 1867 as perfectly reflecting the tone set by the Second Empire. The show was a blatant hymn to prosperity and materialism, celebrating Paris as the world's supreme pleasure capital. Charles Hugo captures the spirit of the late 1860s in a letter to his brother, in which he tried to convince François-Victor to come out of exile and join him in Paris: "Paris is dazzling. The new Quarters are splendid. The houses now going up are quite charming, and built in many different styles. There is an increasing number of Squares, Gardens, Promenades, Fountains. The degree of luxury is *incredible*. The carriages, horses and pretty women are a feast for the eye at every moment of the day."[12]

Once the exhibition closed, the single most visible monument in Paris proclaiming

the extravagant spirit of the Empire was the Opéra. Rising rapidly in the new place de l'Opéra, it was the work of Charles Garnier, an architect who had virtually no reputation when he triumphed over hundreds of others to win the commission. He conceived of a building that would be rich and plastic; in order to achieve the full measure of its force, he relied on a host of sculptors to create works that would become an integral part of his design.

Four commissions were featured in the scheme: the large groups that would flank the entrances on the main facade. In 1865 the assignments were handed out: *Harmony* went to François Jouffroy, the popular professor of sculpture at the Ecole des Beaux-Arts (and Fourquet's professor), Eugène Guillaume got *Music,* Perraud, *Lyrical Drama,* and Carpeaux, *Dance.* All four men had been winners of the Prix de Rome. They were the same sculptors who stood out in contemporary exhibitions. When Charles Blanc wrote about the jury's decisions for the Exposition Universelle, he made it clear that "in the arts the state has a point of view as the artists know all too well. The state encourages men who are capable of working on the decoration of public buildings who are willing to devote themselves to a characteristic kind of statuary and the study of style."[13]

Carpeaux was something of an anomaly in the group, for he was under forty, and his work, though prize-worthy, was controversial and certainly not "characteristic." But Carpeaux, a skillful politician, had become a favorite in imperial circles. Nor did it hurt that he and Garnier had been good friends since they went to the Petite Ecole together.

In the late spring of 1869, the scaffolding that concealed the four large groups started to come down. The official unveiling took place on July 26. Rodin remembered:

> When the group "La Danse" was unveiled, I was working for Carrier-Belleuse; my comrade and I hurried to finish that day so that we could be on the steps of the Opéra to cry out our admiration for the masterpiece and for the artist; but from other throats, what rage, what shrieks, what real or false indignation! Rarely had the formulas of the academies had to sustain a ruder shock, all the more rude when one compared "La Danse" to the cold mortality of the three other groups exhibited in the same scheme. Carpeaux was held to be a bad sculptor; the head of one atelier dismissed a student who couldn't contain his enthusiasm for him.[14]

Although four groups were unveiled that day, Rodin remembered only *La Danse.* No one can seriously look at the groups on the Opéra facade without seeing what distinguishes Carpeaux's. Three of the groups center on a draped allegorical figure who stands with one arm raised, while the other holds a sensible symbol like a victory palm, a torch, or a lyre. Carpeaux's nude figure flies through the air in a joyous leap, both arms raised, one holding a tambourine—an unexpected object that is not a symbolic attribute but part of the action. This figure is not flanked by sedate secondary allegories, as are the groups by Jouffroy, Guillaume, and Perraud, but is surrounded by nude bacchantes beating out the rhythm with a kick and a leap and a shrug, glancing to the left and right as they move. A critic complained: "The women he has chosen as types are

22) Jean-Baptiste Carpeaux, *Dance*. 1866–69. Plaster. Paris, Musée d'Orsay.

neither goddesses nor even bacchantes as the poets have characterized them, and dance as he has expressed it has no name in any language; it addresses itself only to the lowest instincts of humanity." Carpeaux referred to his figures as "bacchantes," but Parisians *saw* street girls who "stink of vice and reek of wine." *La Danse* showed things that ought not to be seen in public. "If only these lost dancers were Greek women with their splendid bodily attitudes and form. But no, no, look at those hard faces which provoke the passerby."[15] One of the fascinating things about the tone of the criticism was the continual merging of aesthetic and moral issues.

La Danse had its supporters, though fewer in number. One was the maverick anti-imperialist writer who backed Manet, Emile Zola. Apparently an administrative decision was made to remove Carpeaux's group after it had been vandalized with a bottle of ink. Zola took it upon himself to explain why he thought the action had been taken: "It's very simple: Carpeaux's group is the Empire. It is a violent satire of contemporary dance, that furious ball of millions: women for sale and men who have sold out. It cries, 'Hey, friends, don't look like that—we're all drunk and you're just vulgar scum, still standing there on your dignity.' It sways its hips and swoons, it alone lives the life of the Empire beneath the great lie of the building."[16]

This episode must have exploded in Rodin's consciousness. *Sculpture* had never before been the center of these incendiary public scandals that the press compulsively fanned into forest-fire dimensions. One expected it in the theater: Hugo's *Hernani,* a drama on everyone's mind after its successful revival in 1867, was the prototype of a modern work powerful enough to polarize the public and the press. In the 1850s and 1860s the press indulged its penchant for censorious invective with gusto. It pitilessly knocked about the poems of *Les Fleurs du mal,* the hobnail-booted peasants of Courbet, and the painted prostitutes found in Manet's works. But for a major work of sculpture to cause such comment—that was new.

Rodin empathized. In a twentieth-century interview he reflected upon Carpeaux's situation: "His enemies never gave up. In his last days, affected by their attacks, tired out and yielding to physical pain, the great artist came to know the supreme pain: he sometimes doubted his work."[17]

The "supreme pain" that comes from doubting your work: Rodin knew something about that in 1869. Most of his contemporaries had experienced some success. Friends like Dalou, Gaudez, and Fourquet had all shown works in the Salons of the sixties. The same was true of Saint-Marceaux, Vasselot, Barrias, Jean Gautherin, Jules Chaplain, and Antonin Mercié, all in their late twenties or early thirties. Among sculptors who would eventually make a name for themselves, only Rodin was left out.

In 1870, when Rodin was about to turn thirty and must have been experiencing painful doubts about his future, a diversion came along. Carrier sent him to Brussels. After showing *Angelica* in the Exposition Universelle, Carrier placed it in the Brussels Salon, where it won a first-class medal. It helped him win a reputation in Belgium, whose capital was becoming known as "little Paris." Opportunities for sculptors abounded, and many Frenchmen were heading north to take advantage of the monu-

mental building projects in the rapidly developing urban capital.[18] At the Exposition Universelle of 1867, Léon Suys had presented his plans for the Bourse, or Stock Exchange, of Brussels. It would provide a focus for a new section of the nineteenth-century part of the city, just as Garnier's Opéra did for the Right Bank in Paris. Even more amazing was the structure rising up on "Gallows Hill": a gargantuan Palace of Justice designed by Joseph Poelaert. When complete, it would be the largest building in Europe.

We learn about Rodin's first visit to the Belgian capital in a letter from Edouard David, a sculptor who also worked for Carrier. On July 26 David wrote Rodin in Brussels about what had been going on in Paris since Napoléon III made his fateful decision to declare war on Prussia (July 19, 1870): "Things have changed; it's really sad now. . . . Paris is not calm at all at this moment." He told Rodin that Carrier had left that morning for London to organize a sale of terra cottas for the end of the year. We also learn in this letter that Rodin was traveling in the company of another member of the atelier, Antoine Van Rasbourgh (called Joseph), a Belgian-born sculptor who had been working in Paris for some time. David made no reference to the nature of Rodin's business, but he offered to attend to Rodin's affairs in Paris during his absence. Apparently, Rodin was not expected home soon.[19]

It was not an easy time for a Frenchman to be in the capital of Belgium. During the last week of July, the Prussian premier, Otto von Bismarck, staged a major propaganda coup by releasing a four-year-old dispatch written by France's ambassador to Berlin. The world—and especially the Belgians—now learned that Napoléon III had long been eyeing Belgium's territory, having drawn up a plan in 1866 by which France would absorb most of this relatively new country on its northern border. (Belgium had only gained its freedom from Holland in 1830.)

The implacable old enemy of the Second Empire, Victor Hugo, arrived in Brussels from Guernsey on August 18. Brussels papers were full of the amazing news that, at age sixty-eight, he would return to France and enlist. He did not get the chance; everything collapsed before he could leave Belgium. On September 1, Napoléon III surrendered to the Prussians at Sedan. It was not a turn of events that displeased the Belgians.

The news of Sedan stunned Paris, and the Second Empire withered away overnight. A new day—a new life—was proclaimed on September 4: for the third time France was a republic. Decisions for the entire nation were hastily made by Parisians. They chose the only general whose reputation was still intact, Louie Trochu, to head the government and continue the struggle against the Prussians. Paris would save itself by a *levée en masse* (a massive enrollment of soldiers). The Opéra became a military depot. Thousands of sheep and oxen were herded into the city to serve as food through the siege. They grazed peacefully in city squares and the Bois de Boulogne. Compulsory registration for the National Guard was established. Overnight it produced 350,000 able-bodied men. By the middle of September, Paris had been transformed into one of the most powerfully armed fortresses Europe had ever known.

On the eastern front, almost immediately after Napoléon III handed his sword to the

king of Prussia, the cry went up: *Nach Paris* (to Paris). On September 17 the Prussians began to encircle the city, a maneuver that took three days. Ten days later they severed the telegraph cable laid on the bed of the Seine. Paris was cut off from the rest of the world.

We do not know when Rodin returned to Paris, but on September 27, the day the cable was cut, he joined the 4th Company of the 158th Battalion of the National Guard. His recruitment came at the very end of a huge glut of inductions. Two friends from the Carrier atelier joined the 4th on the same day: Almire Huguet and Alphonse Germain.[20] The government issued uniforms to those who could not afford to buy them; the men lived at home and were permitted to do as they wished when not in training or on assignment. They were totally untrained; the only duty they could safely perform was to guard the ramparts. They did drill regularly, but the rest of the time they were bored. There was much drinking and passing of evenings in the left-wing "red" clubs.

Rodin was a corporal; he later told Judith Cladel that his neighbors called him the "caporal en sabots" because he could not keep his feet warm enough in military shoes and replaced them with peasant footwear. Guardsmen received one and a half francs a day and their wives got half-pay. Félix Pyat, a politician of the far left, demanded that "unmarried wives" should receive the same benefit, so the Rodins would have had an income of two and a quarter francs, or less than half of what Rodin had earned when he was twenty and single. Food prices rose steadily throughout the siege.

In early October the great radical socialist Auguste Blanqui published *La Patrie en danger,* predicting that "the good Germans will await phlegmatically the end of our cattle and our flour," which is exactly what happened. Fall turned into winter and the quest for food and fuel became the universal preoccupation. The men received rations. It was hardest on poor women and children.

The long days of the siege might have provided Rodin with time for his own work, but they were too troubled to make any kind of creative life possible. Bartlett specifically asked Rodin: "Did you work at all during the war and the siege?" The artist replied, "Though I had my studio at rue Hermel I didn't work much. Just 2 busts for 30 frs each for officers of my company."[21]

January brought a new terror: the bombardment. The king of Prussia gave the order on New Year's Eve, and on January 5 Herr Krupp's giant steel guns—which had been so proudly displayed at the Exposition Universelle of 1867—were wheeled into place in the southern villages of Issy and Vanves. Only the Left Bank was within their range. It was the Rodins' old neighborhood that received the heaviest impact—the rue d'Enfer, the Panthéon, and the Convent of the Sacred Heart were among the most heavily bombarded locations.

When the bombardment started, Rodin was no longer in the National Guard. Cladel tells us that "his poor eyesight made him unfit for service and it soon merited him a discharge."[22] There is something feeble about this explanation. Rodin's myopia had been a part of his military record since he was twenty. If he had wanted to use it as a reason not to serve, he could have done so in the first place. He even could have

remained in Brussels. Degas, whose eyes were inadequate for service in the infantry, asked for a transfer to another branch of the armed forces. A way could always be found to stay in service. Like the majority of French artists, Rodin chose to be part of France's struggle, but once it was clear that this was a war of waiting, he seems to have resurrected his deferment. The boredom, the inactivity, the separation from his work must have been extremely difficult for him.

The French made one last attempt to break out of Paris. On January 18 the National Guard started marching toward the west of Paris. Edmond de Goncourt called it a "grandiose, soul-stirring sight, that army marching toward the guns booming in the distance" to throw their might against the extraordinary military force.[23] The march ended in monstrous confusion and General Trochu resigned. Only the young mayor of Montmartre, Georges Clemenceau, wanted to continue. The civilian population was ready for any peace that was possible. The terms of the armistice were made public on January 28: France would relinquish all claim to Alsace and Lorraine and would pay an astronomical indemnity of five million francs.

The new Assemblée Nationale withdrew to Bordeaux to carry out a painful debate on the terms of the armistice. Until the indemnity was paid, France would be partially occupied. Though the German troops were still in Paris, Rodin got a passport; he was going back to Brussels.

Rodin described the day of his departure to Judith Cladel. He wanted to see his cousin, Henri Cheffer, who was stationed on the Avron plateau east of Paris in the Garde Mobile. Avron had been a strategic point in the defense of the city and had received the most brutal shelling of the entire bombardment. Rodin went out with Aunt Thérèse, part of the way in a cart, the rest on foot. After they found Henri, the three of them located a workers' tavern, the kind that Rodin always loved best for his daily meals. It was more or less abandoned and bread was all they could find, but down in the cellar they located a fine Bordeaux. Together with the radishes Thérèse had brought, it became a passable lunch. Rodin remembered that his mood changed and "he began to joke and to tell stories."[24]

As he ate, Rodin must have felt the strain and hardship of six months begin to fall away. Then he was gone. He headed north toward Brussels. Rose, Auguste, Marie, and Jean-Baptiste Rodin remained in Paris, not knowing when he would begin to earn the money he had promised to send them, or when they would see him again.

Rodin left Rose in charge of his sculpture in the atelier. Since most of this work was still in clay, it was an enormous responsibility. She had to keep all the sculpture damp so that the clay did not dry and crack. In letters from Brussels, Rodin mentioned only six by name: *Gladiator, Torso of Love, Father Eymard, Bibi (The Man with the Broken Nose)*, a little *Virgin*, and *The Alsatian*. Rodin told Bartlett in 1887 that he "made lots of things before going to Belgium, just as good as the *Age of Bronze*—for some of them I would gladly give many 1,000s of francs—but I had no friends and they all went to ruin. Oh! what patient work I did on those things."[25]

We can count barely a dozen sculptures from Rodin's hand that were executed during

the 1860s. Of these, only two—*The Man with the Broken Nose* and *Mignon*—permit a glimpse of the power of the future artist. This is a small sample from what must have been a considerable output. To a certain degree, the loss is compensated by some of the drawings of the 1860s. These show Rodin's personal vision, the vision he would share with the world once he stopped putting in his days on other artists' work and was able to devote himself to his own unique way of making sculpture.

Chapter 6
Brussels and a Partnership

By March 1, 1871, Rodin was in Brussels. For many French people in the nineteenth century, simply to mention the Belgian city was enough to suggest a haven. After the fall of Napoléon at Waterloo, they came in great numbers, Jacques-Louis David and François Rude among them. Many of the participants in the Revolution of 1848—men such as Edgar Quinet, François Raspail, Pierre Proudhon, and Victor Hugo—fled to Brussels. During the Second Empire the number of disaffected Frenchmen in Brussels grew large. And debtors, including Alexandre Dumas and Charles Baudelaire, found Brussels an accommodating refuge from insistent Parisian creditors. These flights were described endlessly in the Belgian press: where the exiles lived, the restaurants they patronized, the people they entertained, the lectures they gave at the Cercle Artistique et Littéraire.

In contrast, Rodin arrived quietly, an anonymous worker who could not earn a living at home. He probably shared some of the prejudices of his more famous compatriots who found the Belgians to be vulgar, obsessed with money, comfort, and cleanliness. But the people Rodin actually met were more like those described by Hippolyte Taine: Belgians were people with "natural" and "comfortable" lives, in comparison to the "artificial" and "uncomfortable" ways of the French. Taine must have known that his French readers would yawn at his apology for the Belgians, but for him "this civilization which seems coarse and vulgar to French people has a unique merit: it is healthy. The people who live here have a gift that we lack, which is wisdom. This bears with it a recompense that we no longer merit, and that is contentment."[1] Taine's Belgium was the one Rodin discovered. He would always look back on the years he and Rose Beuret, who would join him two years later, lived in Belgium as "the most beautiful days of our lives."

March was a good month. Carrier-Belleuse had preceded Rodin to Brussels and had already moved into an atelier in the rue Montoyer owned by Léon Suys, the architect of the new Bourse. Carrier had captured the major sculpture commission for Suys' gigantic project. Rodin felt at home when he arrived in the rue Montoyer, and he was pleased to work with Joseph Van Rasbourgh again. The studio was then concentrating on the frieze that was to run the length of three sides of the building. Rodin knew the project well, both from his previous visit to Brussels and from Carrier's atelier in Paris, where half the models had been prepared.[2]

Rodin found a room over a tavern in the rue du Pont Neuf from which he could walk to the Bourse. The bridge for which the street was named spanned the river Senne, which ran through the middle of the city. It had frequently overflowed its banks and

was blamed for the great cholera epidemic of 1866. Its enclosure, which was taking place when Rodin arrived, was at the very heart of the rebuilding of Brussels, so the location he selected would allow him to watch at close range the transformation of the Belgian capital into this new "little Paris."

Rodin took stock of his life, apparently he liked it. His only letter to Rose from this period bears a lightness of spirit seldom seen in him: "I was in the country and I grasped the pleasure of pure air and the beautiful day, but my spirit was with you—it seemed to me you were saying nice things and that you were content. The song that you always sing was going through my mind: 'Soldats qui m'écoutez / Ne le dites pas à ma mère'" He told Rose he was overcome by an "attack of tenderness," but he wanted her to know that he had no intention of being "tyrannized by sweet emotions." He enclosed sixty-five francs: thirty for his hired helper, Bernard, thirty for his parents, and the rest for Rose and little Auguste. He sent "hugs" to his parents and asked her to tell "Bernard to finish my marbles—I will send him money." As poor as he was, Rodin hired others to translate his plaster sculptures into marble.

Rodin had left Paris so quickly that his friends did not know what had become of him. In March, Saffrey, an engraver who served in the same battalion during the siege, wrote: "What's happened to you? No one knows. Even Huguet, with whom I had lunch on Sunday, doesn't know anything." Saffrey was most interested in "our busts— have they been fired?" Rodin had made a portrait of Saffrey before he left Paris. He had also done a pair of portraits for a brick and furnace maker named Garnier who worked for Carrier, as well as a portrait of Garnier's wife.

The four busts represented a new style for Rodin. They were in terra cotta, a medium that allowed him to develop every detail of dress and expression. He tooled and textured the hair and pricked the clay to create the pupils for the eyes. These busts are the sculptural equivalent of contemporary daguerreotypes that so effectively recorded the appearance of bourgeois sitters. Naturalistic and conservative, they were nevertheless reasonably up-to-date as examples of realism. It was a style that would serve Rodin well in the 1870s, when he fashioned portraits of his Belgian friends. Saffrey could not wait. "I burn with desire," he wrote, "to have mine, which will be the most beautiful ornament of my little salon, *hélas!* stripped bare by the Prussians."

The situation in Paris, however, suddenly became ominous. Trouble erupted between the National Guard of the city and the regular French army. The new chief executive, Adolphe Thiers, responded in a way that took almost everyone by surprise: he moved the government out of Paris to Versailles. At this point Parisians organized their own election, which was won by the far left. Then they set up a new city government called the "Commune," a name that evoked memories of the Jacobins and the Great Revolution. Paris was radicalized and stood against the government in Versailles.

On Palm Sunday the Versailles troops launched a canon attack on the west side of the city; Parisian forces retaliated. On April 4 the Communards arrested the archbishop of

Paris, Monseigneur Darboy, and began a wholesale roundup of priests. By April 8, Victor Hugo, who had returned to Brussels, publicly declared that both sides were mad. On the night of May 23, fires were set all over Paris. Edmond de Goncourt thought of the last days of Pompeii as he watched the burning of the Tuileries, the Palais-Royal, the Palais de Justice, the Préfecture de Police, the Légion d'Honneur, the Ministère des Finances, and the Hôtel de Ville.

Rodin followed the terrible sequence of events in the Belgian press. On May 26 *Indépendance belge* reported that the struggle raged on with no sign of letting up. The army of Versailles fired at random into the neighborhoods where the resisters were known to be seeking refuge, especially in Montmartre. There were fires in the center of the city, at the Palais-Royal, on the Ile de la Cité, at the Luxembourg. Only one-third of the galleries at the Louvre had been saved (the reported destruction of the Louvre turned out to be vastly exaggerated). The correspondent begged forbearance from his readers for the incoherence of his report; the constant noise of cannons obliterated his ability to think. Those who remembered 1848 said it had been nothing compared to what was happening in Paris that day.

On May 28 the Commune collapsed. For more than a week its leaders had been looking for ways to leave the country. One route they could not choose was the road to Brussels: the Belgian government had voted not to receive them. Hugo took up the cause of the fleeing Communards. His open letter to the Belgian government was published in *Indépendance belge* on the day the Commune ended. The journal was careful to disassociate itself from his position. Hugo began with a clear statement against the violence. The attack on the Louvre was a crime against civilization and the day on which they toppled the Vendôme Column one of the saddest in French history. But now, Hugo pointed out, the French Assemblée had vanquished the Commune. The men who fled—"les vaincus de Paris"—were political refugees with the right to asylum, so he was offering asylum at place des Barricades. It would be "le vaincu d'aujourd'hui" (the vanquished of today) in the home of "un proscrit d'hier" (yesterday's exile). England would receive the fugitives. Why not Belgium?

The Belgians did not care for Hugo's interference. On May 30 a mob gathered in front of his house, shouting, "A bas Victor Hugo! A bas Jean Valjean!" Strangely, the police who usually stood guard at 4 place des Barricades were absent that night. The following day the Belgian Parliament debated Hugo's actions and concluded that he should leave the country. By June 2 he was in Luxembourg.

Rodin did not write of these events, which certainly must have absorbed him. When he did write, on June 3, 1871, concern for his loved ones was uppermost in his mind: "Death is in my soul as I write. My poor Rose, where are you? Write immediately. I am also writing my parents. What has happened to them? Write me immediately about how you are. I had hoped that things would be better for me than they are, but I'm indifferent to all that now. Write quickly. I can send a little money. Oh! that I could press you to my heart. Rose, *tout à toi.*"

Beuret answered as quickly as she could to tell him they were safe. Although her letter has not survived, we know it was not long, for Rodin complained that she failed to answer all his questions. He wanted every "detail of what you have been doing in these mournful days." This would become one of Rodin's standard complaints over the years; he could never quite grasp how hard it was for Beuret, basically unlettered in writing, to answer his letters. Our only information about Beuret is from Judith Cladel, who tells us that she kept from starving by sewing shirts for soldiers for less than two francs a day.[3] Rodin devoted most of his letter to his sculpture: "Go to the atelier to make sure nothing is broken, and . . . tell me about M. Garnier and M. Bernard, to whom I shall send money soon." Reluctantly, he broached a difficult subject: he had had a fight with Carrier and had not been working for almost three months. "I don't have a sou," he wrote, asking Beuret to take his pants to the "mont-de-piété," the pawnshop—familiar words in Paris in 1871. She was to tell their landlord that he would send money as soon as he was able. But he warned Beuret that he did not think she could continue to live where she was and that "if I decide to stay . . . I will arrange for you to come, because I am unhappy without you."

Carrier and Rodin had quarreled about Rodin's independence and his eagerness to earn money on his own. Rodin wanted to make and sell sculpture under his own name, and when he put to use some of the contacts he had acquired as an employee in the Carrier atelier, his employer found it intolerable and fired him.[4] Rodin wrote his old friend Almire Huguet about what had happened. Huguet said he had already heard something of it among the men at the atelier. He also told Rodin there was no work in Paris, implying that he did not think it was a good idea for Rodin to return even if he was out of work in Brussels.

Rodin threw himself into making contacts in Belgium; he knocked on any door that might lead to a show or a sale. The secretary of the Cercle Artistique et Littéraire wrote to say they would show his work, even though the organization usually did not include sculpture: "too expensive and too much responsibility." Rodin placed two busts in the Salon de la Société Belge des Aquarellistes, which opened on June 11, and in the last week of June he sold three busts in Antwerp: *La Fille, Enfant d'Alsace,* and *Flora.* The sale allowed Rodin to send twenty francs to Beuret and thirty to his mother.

This was the last thing Rodin ever did for his mother. On August 23, 1871, Marie Cheffer Rodin died. We have no mention of her death in any surviving letter, and Rodin clearly did not go to Paris for her burial. How are we to interpret this fact? Perhaps Rodin's financial circumstances were simply too difficult to permit the trip. But when we think back to Maria's death, to Rodin's hasty departure from his grieving parents and the avoidance that action entailed, we can imagine that he did not want to return to his father at the time of his mother's death—his father was now alone, in unstable mental health, and going blind. Marcelle Martin, Rodin's employee and friend in the twentieth century, quotes Rodin as saying: "I am in such a state of distress beside a deathbed that I have a wild longing to say something cruel."[5] There was a pattern, and

when Rodin was asked to take responsibility for a difficult emotional situation, he held back.

In September Rodin sent money for the landlord along with instructions about how Beuret should organize the move out of his Paris studio. He told her which works to abandon and which to take. "Go to see papa and tell me how he is." More instructions followed on October 1: "Take care of the mold of *Bibi* [*The Man with the Broken Nose*] and of the clay sketch for the little *virgin* Be careful of the molds, wrap them in newspapers, handkerchiefs or anything especially the mold for *The Alsatian*."

Jean-Baptiste was now Rodin's biggest problem. The sculptor conferred with his cousin, Auguste Cheffer, who wrote back that he and Rose had both been to visit Jean-Baptiste. He concluded that Rodin's father had three options. He could enter a *maison de santé* (but probably Jean-Baptiste's pension would not cover it); or he could live with Beuret (but Cheffer suspected the idea of moving to Montmartre would be as repugnant to Jean-Baptiste as moving to Montrouge would be to Beuret). The third possibility seemed best suited to everyone's needs: "My uncle and the boy [Auguste Beuret] could live with my mother [Thérèse]," Cheffer wrote on November 20, 1871. "I don't have the impression that it would be disagreeable to her. [Jean-Baptiste] would never be alone and he would always be warm—two important things for him. In my mind, this is the best solution."

Rodin agreed, with what seems an astonishing lack of concern for his five-year-old son. He told Cheffer that things were going better in Brussels, that he had a new commission for a group in stone. With a touch of irony, he described it as "only 7 meters tall"; never before had Rodin had the opportunity to touch a piece of stone of this dimension.[6]

There was only one place where Rodin could have been working on a seven-meter-tall figure—at the Bourse. But he was not with Carrier. Not only had they not made up, Carrier had returned to Paris.[7] Rodin was working for Van Rasbourgh, who had now received his own commission at the Bourse. Van Rasbourgh's assignment was for allegorical groups of Asia and Africa to crown the lateral bays of the building, as well as for some interior work. He was to receive 14,500 francs for both, which made him the fourth-highest-paid sculptor at the Bourse. Carrier received 33,000 francs for his frieze and four over-life-size figures.[8]

Although Van Rasbourgh had won the commission, he did not have the ability to carry it out. He was not an especially able sculptor, and Rodin's presence in Brussels may even have been a factor in his seeking the commission. Toward the end of 1871, the two men became partners in the village of Ixelles, a picturesque suburb southeast of the city. When Van Rasbourgh and Rodin established their atelier at 111 rue Sans-Souci, Ixelles was well-known as a community in which artists felt at home. They liked its simplicity and its rural charm. Antoine Wiertz, Charles de Coster, and Camille Lemonnier, a writer and critic who later became a friend of Rodin's, all made their homes there.

23) Henri Rieek, apartment building in the boulevard Anspach,
Brussels. 1872. Photo taken in the early twentieth century, before
the building was destroyed in 1929. © A.C.L. Bruxelles.

The biggest work in their atelier in 1872 was the sculpture for the Bourse. But it was not the only thing Van Rasbourgh and Rodin were doing. The royal architect, Alphonse Bulat, was in the process of creating two new facades to unify the exterior of the Palais-Royal, as well as designing a vast *escalier d'honneur* and redecorating some of the major salons. By November 1872 the two sculptors had completed a relief of over-life-size seated female allegories as part of the decoration for the throne room.[9]

Their third undertaking developed out of a favorite project sponsored by the popular burgomaster Jules Anspach. Since the overflowing river Senne had been blamed for the cholera epidemic, Anspach became the leader in negotiating to have the river filled in, creating an enormous tract of new land for development. Planners envisioned boulevards and blocks of houses similar to those built in Paris during the Second Empire. The first properties went on sale early in 1872; by 1876 there were over seven hundred new buildings, the most prominent being on the boulevard Central (today the boulevard Anspach).

Rodin worked on at least two of the new buildings on the boulevard Central.[10] One was a property owned by the *patissier-confiseur* Charles Cornelis. Cornelis' architect was Henri Rieek, in whose drawing we find three figures in the central bay of the piano nobile supporting the balcony: the figure in the center is a female caryatid; this is flanked by two male atlantes, all with raised arms to create the effect that they carry the balcony.[11] This was the general idea of what Rodin was commissioned to carry out for the Cornelis building.

The boulevard Anspach has long since given way to new high-rise construction. Most of the nineteenth-century structures have come down, but fortunately five of Rodin's figures were saved. Two are original works in stone that were taken off a building at the time of demolition; the others are plaster casts taken from the figures of the Cornelis house when it was torn down in 1929.[12] These figures are the first examples of Rodin's figure style in monumental form. We immediately see his way of giving grandeur to the human body through the breadth of the torsos and the strength portrayed in rippling sequences of muscles in the torsos. It is basically a Michelangelesque figure type, and it was present in Rodin's work as soon as he got the opportunity to create monumental figures.

As 1872 drew to a close, Van Rasbourgh and Rodin could look with pride on the work of their atelier. Modern Brussels was in the making and they were very much a part of it. At this juncture they decided to formalize their relationship. They asked a lawyer to draw up a contract, which both men signed on February 12, 1873. The firm would be called Van Rasbourgh–Rodin, with headquarters at 111 rue Sans-Souci. The company's goal was to undertake all necessary transactions to execute artistic and industrial sculpture. The partners would share equally in profits and expenses and the contract would be in effect for twenty years, with the possibility of renewal. Until this point, it sounds like a standard partnership agreement. Clause 11, however, contains a surprise: "M. Van Rasbourgh, the director of sculpture, will have the prerogative of

24) The atlantes from the Rieek building in the boulevard Anspach. 1872. Plaster. Musée Rodin. © A.C.L. Bruxelles.

making the sketches and of signing the artistic work." Clause 12 balanced clause 11: "The previous article should be modified in the case of work done for France, which will be directed and signed by M. Rodin." It is doubtful that the partners had given much thought to work they might do in France. The contract raises several questions. The working relationship of Van Rasbourgh–Rodin was already established, and it was clear that Rodin was the primary creative force. Why would he have signed an agreement that would take him into his fifties in a subordinate position to a man who was clearly much less talented? On first examination it makes one wonder if, after a decade of failure, Rodin was simply not able to shake free of self-doubt. (There was probably another reason, however, which we shall examine in a moment.) Nevertheless, the partnership did represent a step forward for Rodin: for the first time in his life, he was not working for wages. He also had primary administrative responsibility for the company's day-to-day operation, an invaluable experience for his future career.

In the fall of 1873, Rodin and Van Rasbourgh were making every effort to get the sculptures into place at the Bourse. The inauguration was scheduled for Christmas week, and the politicians and people of Brussels intended to celebrate: there would be a ball in the main hall on December 27, followed by a concert in honor of the king and queen, and, for a finale, an immense banquet honoring the man most responsible for the whole project—Burgomaster Anspach.

Far more important than the social occasions—to which they were surely not invited—Van Rasbourgh and Rodin waited for the reaction in the press. The big review appeared on January 1 in the *Art universel,* written by Jean Rousseau, the country's leading critic. The importance of this essay stems from Rousseau's keen understanding of context. He considered design in a modern building in light of its purpose; furthermore, he examined what kind of sculpture was appropriate to a stock exchange, both functionally and aesthetically.

Rousseau's review is at once scathing and laudatory. He was pleased that the building was on such a grand scale, and he congratulated Suys for having given such importance to sculpture in his design. But his assessment of the sculpture itself was quite negative. He was particularly critical of what he viewed as a distorted use of the language of classical mythology and allegory. "Is this 1873? Are we in Belgium?" He reminded his readers that monuments like the Bourse were for the people and that the masses were not interested in things they could not understand. Recalling the cathedrals of the Middle Ages and the clarity of the language used by those sculptors when they spoke to ordinary people, he considered the Bourse a missed opportunity. The goal of modern art should be as it was in ancient times: to speak to the mass of people with power and directness.

Once Rousseau laid out his parameters, he proceeded to examine the work, sculpture by sculpture. He found it all wanting, until he came to Van Rasbourgh's work, which he liked because the subjects were "clear and recognizable." He felt *Asia* and *Africa* were "not without fault . . . but two things are entirely pleasing in this sculpture. First, there

25) Léon Suys, Bourse, Brussels. 1868–73. © A.C.L. Bruxelles.

is the choice of types and accessories that are appropriate to the subjects. We recognize *Asia* immediately from her slanting Chinese eyes, the silk drapery across her knees, and from the elegant Hindu kneeling to present her with perfumes; *Africa,* attended by a Negro figure, is a no less well described being of an Egyptian type, with the meaning further disclosed in the sheaf of wheat recalling the proverbial fertility of the Nile Valley. Finally, the work itself is supple and alive."

This was a triumph for Rodin and Van Rasbourgh. It also told them that they had made the right decision in choosing to identify their work by Van Rasbourgh's name alone. Rousseau indicated that the power of the style that so attracted him was clearly related to "the traditions of our good old Flemish school." If he had known *Asia* and *Africa* were Rodin's work, he would not have been able to say this with the same force, and nationalism was a leading motive in Rousseau's criticism.

Rousseau's article examined the entire project in terms of a rebirth of the "Flemish" tradition. Rousseau wished that Jacquet, the sculptor of the principal facade, would loosen up, let himself go, and become a "true Flemish sculptor." He was not at all taken with the female figures by Carrier-Belleuse because they were too complicated, too "Parisian." In fact, for Rousseau, the greatest problem of the Bourse was that the entire enterprise—architecture and sculpture—was in a style that was "far less Flemish than Parisian."

As the Belgians approached the celebration of the fiftieth anniversary of their nation in 1880, they had begun to speak out against the oppressive domination of Paris in the arts. They yearned for an art in which they could locate their own heritage; the people of

Brussels dreamed of the day when Brussels would be known as a center of art as influential as Bruges, Ghent, and Antwerp had once been.

Even as the festivities at the Bourse were taking place, the firm of Van Rasbourgh and Rodin was turning to new projects. They were invited to contribute to the decoration of the Conservatoire de Musique recently finished by the architect Jean-Pierre Cluysenaar in the rue de la Régence. He had designed a large square entrance court, creating three facades that needed decoration; Cluysenaar engaged eight sculptors to fashion the allegories of Composition, Elocution, Instrumentation, Poetry, and Music. Van Rasbourgh signed a contract on January 26, 1874, to execute two caryatids, two genies, and a bust of Beethoven for 4,400 francs.[13] Work went quickly and before the end of the year everything was in place. As at the Bourse, it was the atelier on the rue Sans-Souci that got the attention in the press. Camille Lemonnier said Van Rasbourgh's caryatids were "gracious in attitude" and "vigorously modeled," that here was a sculptor able to create a rich pictorial feeling with an unusually fine sense of relief.[14]

The second project for Van Rasbourgh–Rodin in 1874 was on the other side of the Palais-Royal at the Palais des Académies in the rue Ducale.[15] Their commission was for allegorical groups of Science and Art. Rodin imagined Science as a robust putto in the process of measuring the world with a giant compass, while standing on a pile of books and scientific tools scattered across the base. To represent Art he used a copy of the

26) Rodin, *Science*. 1874. Brussels, Palais des Académies. © A.C.L. Bruxelles.

27) Rodin, *Art*. 1874. Brussels, Palais des Académies. © A.C.L. Bruxelles.

Belvedere Torso (the Palais des Académies was to house the state collection of plaster casts of antique sculpture) surrounded by a musical score, a mandolin, a palette, and a sculptor's mallet—clustering them into a broad swathe of drapery playing across the thighs of the antique fragment.[16]

During these three years of active production in his partnership, Rodin also did small works on the side to enhance his income. He turned out little terra cotta groups and fancy heads of the kind he had learned to finish for Carrier-Belleuse, as well as portrait busts. But Rodin's pride was in the public works—the works that graced building facades and stood along the streets of Brussels and about which critics spoke so enthusiastically. These elicited Rodin's first reviews, and if they did not mention Rodin by name, nevertheless they were about *his* work. The energetic three-dimensional still-life groups in the rue Ducale remain today Rodin's most accessible sculptures in Brussels. When he was putting them into place in 1874, he thought Van Rasbourgh–Rodin was just coming into its own. He had no idea that this would be his last work on a public building in the Belgian capital.

Toward the end of 1873, the firm of Van Rasbourgh–Rodin received its first commission away from home, for a monument in Antwerp. Geographically, Brussels and Antwerp are close, but history, language, and civic consciousness sharply separate them. In the second half of the nineteenth century, they were pitted against each other as rivals for the dominant cultural position in modern Belgium. The problem was intensified when the government decided to focus its national defense strategy on Antwerp as a port city. Knowing that Belgium could not maintain an army large enough to defend her borders, the government decided that in the event of an invasion a way must remain open to Britain. To this end, Antwerp was girdled with a ring of forts, just as funds were being appropriated to adorn Brussels with an array of parks and monuments.

The man responsible for the new fortifications, François Loos, was considered the foremost burgomaster of modern Antwerp. In 1871 the city opened a subscription for a monument in his memory. It was to be placed in one of the junctures created by the newly laid-out streets at the city's edge, a bleak and unformed area badly in need of focal points to provide continuity between the raw new developments at the periphery and the wealth of fine monuments and buildings at the center.

It took the city fathers three years to organize the commission. When they were finally ready to give out the award, it was of the utmost importance that it go to a local artist. They selected Jules Pécher, a painter in his forties, who had studied in Paris under Thomas Couture. His special competence lay in religious painting, but in 1869 he had begun to experiment in sculpture, and by 1874 he had successfully shown his sculpture in various Belgian art exhibitions. Even so, he was not prepared to execute a large monument on his own. Thus he turned to Van Rasbourgh and Rodin, and together they designed a monument that was to include five over-life-size figures. Pécher reserved the central allegory of Antwerp and the bust of Loos for himself, giving the allegories for the base—Industry, Commerce, Navigation, and Art—to Rodin and Van Rasbourgh.

The sculptors did most of their work in the atelier in the rue Sans-Souci; nevertheless, the commission frequently took Rodin to Antwerp. Sometimes he stayed overnight at Pécher's house. From letters it is clear that "Jules" and "Auguste" had begun to enjoy a friendship. Rodin, who thought one of the worst aspects of living in Belgium was the wine, arranged for Rose's father to ship a supply of French wine to his new friend. When Pécher went to Paris to see the Salon of 1875, he wrote about the success of Rodin's marble bust, *The Man with the Broken Nose.* This eye-witness report about his

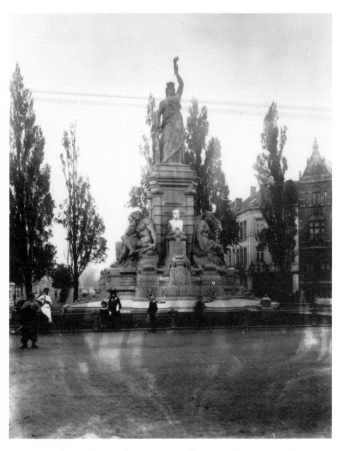

28) Jules Pécher and Auguste Rodin, *Loos Monument,* Antwerp.
1874–76. The monument has been disassembled; parts of it are
presently in a private garden in Antwerp.

first work to appear in a Paris Salon must have warmed Rodin's heart. Pécher returned
from France and Rodin willingly counseled him about his allegory of Antwerp, for
which Pécher was enormously grateful.

A decade later, memories of the incipient friendship had faded from Rodin's mind;
only feelings of bitterness remained. Rodin told Bartlett that the whole idea of making a
monument on such a grand scale had been his alone. He described his struggle with
Pécher about the style in which the figures were to be rendered: "He wanted them in the
Rubens style of sculpture, and he would come to the studio when I was absent—he did
not dare to come when I was there—and oblige Van Rasbourgh to alter them, to their
great injury. I left them hardy and vigorous, but Van Rasbourgh's changes, and the
wretched way that they were executed in stone, have made them round, heavy and
lifeless. I was so disgusted with this that I lost interest in the figures, and never went

near them while they were being cut."[1] Rodin also complained that the stone cutters on the job were better paid than he was.

With the Loos monument, Pécher gained a reputation as the standard-bearer in sculpture of the new "Flemish school." His busts in the Brussels Salon of 1875 were seen in that light; Jean Rousseau predicted that these stylistic traits would be fully revealed once Pécher put the final touches on the Loos monument: "a gigantic and complicated composition worthy of one of our great old masters."[2]

The Loos monument was inaugurated in August 1876. The *Fédération artistique* (Sept. 1) called it an important statement of "*l'art flamand* in every sense," and a writer for *L'Actualité* (Sept. 17) pointed out: "We are in Rubens country! M. Pécher was thinking about how Rubens showed flesh, that's for sure. Michelangelo may have made his figures big, but only Rubens was able to render stoutness as grandeur." Even before the

29) Rodin, Industry from the *Loos Monument*. Pécher has placed his signature beneath Rodin's work. © A.C.L. Bruxelles.

monument was completed, however, people began to say it was not Pécher's work. Rodin told Bartlett that this worried Pécher so much that he went to Van Rasbourgh and told him to get rid of Rodin. "But how can I do that?" Van Rasbourgh asked, to which Pécher replied, "It is simple, do not give him any more work."[3] It is hard to take this story at face value, since Van Rasbourgh and Rodin were partners. Perhaps this is why Bartlett decided not to publish it, but Rodin's account reflects the unhappy state of affairs that caused the dissolution of the firm.

The partnership had dominated Rodin's life for four years. Certainly, his artistic personality comes forth strongly in his work with Van Rasbourgh, and the rare works of Van Rasbourgh's to be seen in Brussels in the years following the end of the partnership have little resemblance to the figures of the Palais des Académies or the Loos monument. As important as the experience of creating monumental figure work was for Rodin, the chance to learn how to run an atelier, locate materials, arrange for transportation, deal with bureaucrats, hire workers, and see that the bills were paid was equally valuable. It was in Brussels that Rodin learned to be a boss. Something of that is reflected in his remark to Bartlett that Pécher "did not dare to come when I was there." It was not simply that Rodin was the more gifted of the two sculptors; he was also the more forceful and decisive.

The production of Van Rasbourgh–Rodin was by no means the full extent of Rodin's professional life in Brussels. Between 1871 and 1876 he showed approximately thirty works in at least fifteen exhibitions.[4] These works were either portrait busts of men or fantasy heads of women. He exhibited them in plaster, terra cotta, and marble. Not all the busts were made in Brussels. In Paris Rodin had five sculptors working for him: his old friend Fourquet, Bernard, Huguet, Tréhard, and Louis Demas. They copied his work in marble and worked on plasters made from his molds.

Rodin's big money-maker in Brussels was an old work, a little head called *The Alsatian Orphan* which he had modeled years earlier, perhaps in Strasbourg, after leaving the Fathers of the Blessed Sacrament. It was a tiny dreamlike head floating in a halo of drapery, and he showed it six times in Belgium between 1871 and 1876, in plaster, terra cotta, and marble. The combination of sentiment and delicacy in a beautiful little head that evoked Alsace, one of France's lost provinces, had considerable appeal for collectors of the 1870s. Even in the 1880s Rodin was able to sell three marbles of this head.

Sometime after arriving in Brussels, Rodin went back to his favorite work, *The Man with the Broken Nose*. He developed it as a bust, completing the back of the head, modeling the chest and shoulders, and placing it on a base. He exhibited it in plaster in the Brussels Salon in the fall of 1872, but it went totally unnoticed.

In the spring of 1874, Rodin returned to Paris for the first time since he had moved to Belgium. He had decided to enter *The Man with the Broken Nose* once again in the Paris Salon, this time as a marble bust. It was an important move and he seems to have consulted three of his practitioners—Bernard, Tréhard, and Fourquet—about it. In the

30) Rodin, *The Man with the Broken Nose.* Carved in marble by Léon
Fourquet. 1874. Musée Rodin.

end he entrusted the work to Fourquet, and by March 1875 it was ready to be taken to
the Palais de l'Industrie for judging. Fourquet wrote to ask how the label should read.
Rodin said to call the bust "Portrait de M. B . . . ," following a common Salon practice
of not revealing the sitter's name. Rodin also borrowed back his portrait of Garnier as a
second submission. When an artist submitted to the Paris Salon, he was expected to
give the name of his professor. Rodin instructed Fourquet to inscribe the names of
Barye and Carrier-Belleuse on the entrance forms. His works were accepted, but they
did little for his nonexistent reputation in France; not a single critic took any notice.

Rodin was not satisfied either. We know this from a letter Tréhard wrote to him after seeing *The Man with the Broken Nose* in the Salon. "It produced the same effect on me that it did on you—the execution is flabby and loose. You could start over" When Rodin did start over a few years later, it was on another tack: he went back to the mask and had it cast in bronze.

In 1874 Rodin began to exhibit some of his portraits of Belgian friends. Their direct and naturalistic style continued the approach he had taken in the busts of Garnier and Saffrey. The first works he showed had been inspired by gratitude—to Doctor Thiriar, a surgeon from Ixelles who had operated on the hernia he got from moving a heavy marble block, and to Van Berckelaere, a pharmacist who had saved his life more than once by lending him money. Rodin also showed his portrait of Jules Petit, a French singer who was his favorite traveling companion through the Belgian countryside.

It was in response to these simple, fresh, and direct portraits that Rodin received his first reviews under his own name. Even with his Flemish bias, Jean Rousseau was enthusiastic. He considered Rodin's "realistic" busts evidence that at least one artist was able to work freely and intelligently without belonging to any school.[5] The bust of Petit in the Brussels Salon of 1875 caused one reviewer to alert visitors to the expressive, compact modeling, which offered "an emotional intimacy that makes the man come to life."[6] Rodin was pleased that his name was beginning to appear in the press, but he must have noticed that it was with far less frequency than those of his Belgian contemporaries whose works were in the same exhibitions.

Rodin's major commitment in these years was to reach the largest possible audience. By 1875 he had shown in Brussels, Antwerp, Ghent, Paris, Vienna, and London, and he had sold works in the last two international exhibitions.[7] Next he tried Philadelphia. The Belgian government sent thirty sculptures across the Atlantic to represent the country in the celebration of the American centennial, which occasioned the first major international art show ever mounted in the United States. The organizers' lack of experience showed at every turn and exhibitors complained. One of the things to which the Belgians objected was the small number of awards given to their artists. The Americans managed to come up with some new medals so that five of the eight Belgian sculptors were recognized. Although eight of the thirty sculptures in the Belgian exhibit were by Rodin, he received nothing.[8] Philadelphia, like the Loos monument, represented a failure for Rodin. By 1876 it was becoming clear to him that no matter how hard he tried, recognition and success might forever elude him in Belgium.

Rodin must have regretted the prospect that his days in Belgium were numbered, for his day-to-day existence there was more comfortable and pleasurable than anything he had ever known. He and Beuret, who joined him in 1872, lived at 15 rue du Bourgmestre, not far from the Forêt de Soignes and only a twenty-minute walk from the studio in the rue Sans-Souci. Their greatest joy was their garden, with its enormous tree. Rodin told Bartlett how they sat under the tree, ate and drank French wine, watched flowers grow, and felt happy. Bartlett asked if he spent much time looking at

Belgian art, to which Rodin responded enthusiastically that he "saw everything, and walked no end of miles." In his notes, the interviewer quoted Rodin as saying, "I went everywhere in Belgium," but Bartlett later crossed out the "I" and inserted "we." In Belgium, Rodin and Rose Beuret were truly a couple, but they were not a family, for Auguste Beuret had been left in Paris with Thérèse Cheffer. It must have been easier that way, at least for Rodin's work, but again we recognize Rodin's total resistance to the responsibilities of fatherhood. And Rose, in moving to Brussels, clearly chose her man over her child.

Sometime in 1872 or 1873, Rodin memorialized his peasant wife—my "wild flower," as he called her—in a painting.[9] The girlish beauty of *Mignon* has been replaced by a seriousness and intensity. It shows in the eyes that dart quickly to the left and in the trembling lips. We recognize in a flash that quality of immediacy—of real presence. By all reports, whenever people met Beuret they were struck by the intensity of her nature, which showed itself most vividly in angry outbursts of jealousy.

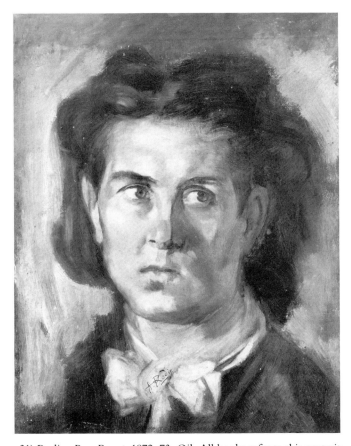

31) Rodin, *Rose Beuret*. 1872–73. Oil. All books refer to this portrait as Marie Cheffer Rodin. Clearly it is not Rodin's mother, but Rose Beuret. Musée Rodin.

Rodin painted Beuret's portrait with the same terra cotta and matte-red pigments he used for the houses and roofs of the cottages in the Brabant where they walked on Sundays. He described the experience of painting in Belgium to one of his secretaries in the twentieth century: "The light is wonderful in that country. The interplay of sun and rain is so delicate, so varied and evanescent that I tried in vain to capture it in my paintings. . . . But in Belgium it rains a great deal. Rose carried an umbrella. I carried only my box of paints. When I saw a landscape I wanted, or an effect of light that struck me as capable of being transferred to canvas, I would take my brushes, and while Rose protected me with her umbrella against the rain and the wind, I would quickly try to put this fairy tale sky on canvas."[10]

Rodin's letters offer glimpses of a man opening up to life: he describes walks in the forest, painting for the sheer pleasure of it, invitations to dinner, a week-end train ride in the country with a friend—"Let's sleep over," he wrote to Jules Petit (Feb. 3, 1875)— and the beginnings of a library. In the fall of 1874, the Librairie Alfred d'Hont presented him with a bill for a complete set of Shakespeare and five volumes of Plutarch, Seneca, Lucian, and Lucretius, as well as other classics.

This is not to say that Rodin was totally happy in Belgium; he still got depressed and suffered from the recurrent doubts that would haunt him for the rest of his life. Almire Huguet replaced Fourquet as confidant, a friend to whom he turned in his blackest moments. In October 1874 Huguet wrote, "You are just having a moment of discouragement. When you compare yourself to a worn-out old rag, you exaggerate." But, it must be emphasized, Belgium is where Rodin came closest to being happy. In 1916, the year before he died and in the aftermath of a stroke, he was frequently muddled in his mind about day-to-day events. Judith Cladel told an old friend that she thought he was finally "quite happy—full of serenity and sweetness. He thinks that he's in Belgium."[11]

In 1876 Rodin decided to return permanently to Paris. The timing was probably determined by his efforts to place a work in the Paris Salon, but the decision was as much personal as professional. Until this time, Rodin and Beuret had turned deaf ears to relatives whose letters made it all too clear how much Jean-Baptiste Rodin and Auguste Beuret suffered from their absence. Rodin's father and son had been living with Aunt Thérèse for four years. Initially the arrangement may have been attractive to Thérèse, whose husband, Eugène Dubois, had died more than a decade earlier and whose boys had grown up and moved away. It allowed her to reconstruct a family group around her, and Jean-Baptiste's pension, along with the money Rodin sent from Brussels, must have been a welcome addition to the small income of a hat maker's widow. But Thérèse surely did not anticipate how difficult the old man and little boy would be.

Everything we know about what transpired in the family during Rodin's absence comes from nine letters: five from Auguste Cheffer (eldest son of Thérèse and married to Rodin's cousin Anna Rodin), one from Thérèse, and three from members of Jean-Baptiste's sister's family, the Coltats. Auguste Cheffer wrote every year; his letters are a

sort of annual report from 1871 to 1876, and they tell the tale of two lives on a perilous downward track.

Ever since 1862, when Jean-Baptiste's breakdown had forced him to retire, the family had been worried about his mental stability. Auguste Cheffer wrote with considerable relief that on the day of Jean-Baptiste's move, he did not show a single sign of irrational behavior. He even engaged in an "amiable argument, laughing all the while, with my brother Emile." Nevertheless, Cheffer added that at times Jean-Baptiste believed they would put him in prison: "On these days he is less amusing." Jean-Baptiste's paranoia intensified, and in August 1873 Thérèse told Rodin that his father "constantly thinks someone is going to kill him." By 1874 Auguste Cheffer felt his mother was coping better; she had successfully learned to administer compresses that had a sedative effect. Nevertheless, Jean-Baptiste settled into a profound and lasting depression; Cheffer told his cousin that he just sat in his chair all day long without saying a word.

The problem of Auguste Beuret was even worse, though at first it did not appear to be. In 1872 Cheffer said that even though the boy was a "vrai diable" (real devil) and carried on like a "polichinelle" (clown), he was doing well in school and developing into a good reader. By the summer of 1873, things had disintegrated. Although Thérèse could barely write, she felt that she herself had to tell her nephew exactly what was going on: "I don't want to torment you, but your son has the same defects as Clotilde!" This is the only mention in the Rodin correspondence of the artist's half-sister, Clotilde, who was Jean-Baptiste's child by his first marriage. Thérèse recognized in Auguste "the same kind of double-dealing. He's just not honest." She urged Rodin to take a strong position: "Tell him you will put him in prison for stealing," she wrote—not an idle threat in nineteenth-century France, when children over six could be imprisoned if the family felt they were intractable.

Rodin did not come to Paris until the following spring, and we do not know how he intervened, but the report from the Cheffer household in 1874 was less urgent: "The child is all right; we just let him do whatever he wants to." By December 1875 things were difficult again; Auguste Cheffer said that the boy was too exasperating, that he caused too much trouble for his mother, and that Rodin had to do something: "I speak to you as the father of a family . . . the time has come to make a change." By the end of 1875, it was clear that Rodin and Rose Beuret had to face their responsibility toward their son.

The letters from the other side of the family corroborate the Cheffer letters, although the Coltats saw the situation in a different light. They did not approve of the Cheffers, feeling themselves to be socially superior. They had not wanted Jean-Baptiste to be lodged with Thérèse Cheffer. Marie Coltat wrote a long letter in June 1873 in which she suggested that Rodin change his father's situation: "He needs exercise, air, distractions," which she believed he was not getting. Perhaps Charenton (the famous psychiatric hospital) would be a good home for him, "not with the crazies, but in a separate section for ex-functionaries." As for her cousin's son, Marie Coltat felt that "he's all right, but he's going to be a real demon and his aunt does not know how to raise him."

A letter from Jean-Stanislas Coltat in 1876 offers a further insight into the family. His specific purpose was to ask Rodin to help a certain M. Ricard, a young Frenchman on his way to Brussels. He described Ricard as "an honest man and a Carlist refugee." In other words, Ricard was a legitimist, a man who favored the reestablishment of the French monarchy by putting the grandson of Charles X, the comte de Chambord, on the throne. After the spring elections of 1876, France was not an easy place for Carlists. Uncle Jean emphasized that Ricard was "in no way a Communard" and urged Rodin to "be useful to him and help him find work." The Rodin family, like many petit bourgeois Catholics of the time, entertained political views of the far right. Jean Coltat clearly believed that his clarification would be a recommendation in his nephew's eyes.

There would be many problems for Rodin to sort out when he returned to Paris. In addition to dealing with his wild ten-year-old son and his elderly father sliding into paranoia, depression, and blindness, he had to consider the new political realities that were so crucial to the life of an artist in France, and especially to a sculptor. All the time Rodin was in Belgium, the forces of the right, hoping that the Republic would be a brief interlude before the return of a monarchy, had fought the forces of the left, who were working to put a real and lasting republic into place. On January 30, 1875, the left had prevailed and the two chambers of France's legislature had accepted a constitution that defined the powers of the president, the Assemblée, and the Sénat, and the responsibilities of the various ministries.

The climate of art had also changed since Rodin's departure in 1871. The most extreme example was the challenge to the Salon in April 1874. A rebel group of artists, including Monet, Pissarro, Renoir, Sisley, Cézanne, and Degas, had mounted their own show in Félix Nadar's recently vacated studio in the boulevard des Capucines. The world of sculpture had changed in a different way, for the two most prominent modern masters, Carpeaux and Barye, had died while Rodin was in Brussels.

Bartlett asked Rodin what he thought of France as an art country before and after he went to Belgium. Rodin answered that until 1870, he had "lived in the old idea that sculpture was in progress in France. It was not true. We were running down hill and had no successors to Puget. Before 1871 I adored Perraud, now I don't care for him. I changed my ideas during my life in Belgium and when I came back my idols had fallen in the dust. I adored the Florentine Singer but now I can't bear it. I can't bear sculpture made after plaster casts, it has no life. I can make them better from life."[12]

This view, which Rodin formulated in the 1880s, broadbrushes the change in his thinking in the Belgian years. As a man of the Second Empire, Rodin had been intrigued by the superficial emulation of the past found in the work of sculptors like Perraud and the classical Beaux Arts masters. He also liked the more fashionable work of Paul Dubois, whose *Florentine Singer* so scintillatingly evoked the quattrocento. But the basic truth was that by the time Rodin returned to France, he had begun to put on the mantle of a new religion that he called "Nature." This is what he was talking about when he pronounced his own work better than that of others because it was "from life."

Chapter 8
Michelangelo

...ne summer of 1875, the city of Florence was getting ready to receive delegates from many nations for the celebration of the four hundredth anniversary of Michelangelo's birth. Louis Alvin was there from Belgium, and when he returned home he gave a well-publicized lecture saluting the magnificence of the celebration. He was impressed that the city fathers had renamed the great piazza above the city where the church of San Miniato stood "piazzale Michelangelo," and that they were sensitive enough to know that no modern sculptor was capable of memorializing the divine Michelangelo. Instead, they had ordered an assemblage of bronze casts after Michelangelo's *David* and the allegories of the Medici Chapel to be placed in the center of the piazza. Alvin felt Florence had handled the observance admirably, not only by dedicating the new piazza, but by transforming Michelangelo's house into a sanctuary where pilgrims could discover some of his lesser-known works in the context of his life. Alvin suggested that in the Casa Buonarotti one might even hope to encounter the ghost of Michelangelo.[1]

Rodin may have attended Alvin's lecture; even if he did not, we can surmise that he read the articles that appeared throughout the fall containing rhapsodic descriptions of discovering Michelangelo in Florence. *L'Art,* a new publication of 1875, chose Michelangelo's *Moses* for its masthead, and when one of its founders, Paul Leroi, set out to attend the celebration in Florence, he said it was a "holy pilgrimage." His rendezvous with Michelangelo would be nothing short of sacred.

Michelangelo worship hung in the air of the artistic circles most familiar to Rodin while he was finishing his allegories for the Loos monument. He fashioned broad, muscular, seated figures and worked hard to make the contrapposto play of their massive limbs visible to all. He told Bartlett: "It was while I was making the figure of the sailor (*Navigation*) that I was struck with its resemblance to the statues of Michelangelo, though I had not had him in my mind. The impression astonished me, and I wondered what should cause it. I had always admired Michelangelo, but I saw him at a great distance."[2]

During the difficult days when Rodin was struggling with Pécher and Van Rasbourgh over the style of his figures, as he gradually realized that his working arrangement was about to fall apart, he needed something or someone to help him take the next step. That someone became Michelangelo. As Rodin put it to Bartlett, "The studies of the past eighteen years were demanding some definite order and classification" and the "visions of the compositions of the Renaissance Colossus had a nearer and more forcible effect." It was in such a mood that Rodin "set out . . . to study the Florentine's masterpieces in their original surroundings."[3]

Rodin tried to convince Rose Beuret of the necessity of the trip, for she would again bear the burden of his search to locate himself in his career. He instructed her in all the details of caring for his studio and keeping the clays wet. Since he would be spending rather than earning, he told her she had to keep expenses down.

Rodin left for Italy sometime after the second week in February 1876.[4] He went by train, taking a southeasterly route that passed through Dinant, a citadel city nestled on the Meuse River. Then into France, where the first stop was Reims. Here he discovered the cathedral that would resonate in his mind and heart for the rest of his life. As much as he learned to love the Italian churches, Rodin never found anything equal to this masterpiece of French architecture. Pontarlier in the Jura meant the border was near; time to buy some French sausage. Rodin was convinced he would not be able to eat decently in Italy. The French customs officers and the train crew were replaced by Italians. "Then the train starts up again, hesitantly, knocking from right to left, finally finding its pace as it climbs a steep slope," Rodin wrote to Rose. "I lean out as I always do and discover why my train is frightened. We are at 1,200 meters! Hesitation, signals, moving on, stop, we enter a tunnel that looks like a mole hole going through the middle of Mont Cenis." Turin, where it rained and where all the modern sculpture looked ugly, including the work of the great local sculptor, Carlo Marochetti; Genoa, where "I eat artichokes and peas, and, where they have beautiful women, Rosette. . . . In Genoa [the sculptor] Puget is less Puget than usual"; then the trip down the coast, from Genoa to Pisa, through "more than a hundred tunnels."

Finally Florence: "Beautiful weather, truly a paradise on earth, with its mountains of green, violet, and blue." Although it turned cloudy and rained for six days, it hardly mattered: "Everything I ever saw in photographs or in plaster casts gave me no idea of what the sacristy at San Lorenzo would actually look like." This was the ultimate moment in the pilgrimage. Rodin had managed to hold off going to the Medici Chapel for five days, while he looked at other treasures, but once he found his way there, he exploded with a new kind of joy. He told Beuret he found the chapel and tombs so grand that at first he could "not even analyze it. Let me tell you, since the moment I got to Florence I've been studying Michelangelo—that won't surprise you, and I think the great magician is going to give me some of his secrets."

Rodin wrote only one letter, but it is packed with the excitement of a maiden trip into a foreign culture. Although he posted the letter in Rome, he said not a word about the art of the High Renaissance, nor of the Baroque masterpieces in the capital. For this part of Rodin's visit, we must rely on the few drawings he made: Michelangelo's *Moses* (to which he gave special attention), a sketch after Raphael's frescoes in the Vatican, another made from a single figure in Michelangelo's *Last Judgment,* a figure from the Cesi tomb in Santa Maria della Pace by Vicenzo di Rossi, and a couple of Roman tombs in the Vatican and Capitoline museums, upon one of which he made a notation: "Michelangelesque."

After visiting Naples, Rodin headed north again, passing through Florence, then to

Padua and Venice, where the sketches tell us it was the great Renaissance equestrians by Donatello and Verrocchio that held his attention above all else. A few summary lines indicate that he spent time looking at Donatello's reliefs on the altar of San Antonio in Padua, and there is a quick sketch of a particularly erotic Roman sculpture in San Marco, *Leda and the Swan*.[5]

There are fewer drawings than we might expect. Either some are lost, or Rodin was moving too fast to fill many sketchbooks. The latter seems more likely. Rodin's more fortunate contemporaries, winners of the Prix de Rome, had five years in Italy at government expense, but Rodin had to learn his Italian lessons in a month. It left little time for sketching, not to speak of copying, the standard way of learning from older masters practiced by the prizewinners installed in the Villa Medici. Rodin's way of memorizing the works of the past was to look deeply and attempt to grasp his predecessors' principles. He told Bartlett, "During my journey to Rome, Naples, Siena and Venice, I continued drawing, in the hope of discovering the principles upon which the compositions of Michaelangelo's figures were founded."[6] Among these little draw-

32) Rodin, drawings from the Italian trip of 1875. Lead pencil, pen, and brown ink on scraps of paper pasted onto cardboard and incorporated in an album assembled in 1930. Musée Rodin.

33) Michelangelo, *The Dying Slave*. Marble. Paris,
Musée du Louvre.

ings, which Rodin himself mounted montage fashion, we repeatedly find a reclining figure with a muscular buttock and a sharply bent knee, reminiscent of the Medici Chapel allegories. Rodin was fascinated by a male figure with his head falling heavily to one side and connected to a twisted, lifeless arm, similar to the Christ in Michelangelo's Florence *Pietà*. He liked figures with a contrapposto twist at the hip, a play of straight leg and bent leg, straight arm and bent arm, as in Michelangelo's *Victory* in the Palazzo Vecchio and the *Slaves* in the Louvre. We are witnessing Rodin's search to understand how Michelangelo realized dramatic effect through the structuring of the human body.

Rodin's infatuation with Michelangelo was far from unique. Michelangelo was a major hero in the 1860s and 1870s, not just for artists. An interesting case is that of Emile Ollivier, the minister of justice during the Franco-Prussian War who was exiled in Italy after 1870. One of his activities there was to write a little book about the Medici Chapel. The study of history did not save him from bitterness, for he discovered the same faults and unhappiness in the past that he knew so well in the present. Only one thing seemed to offer solace: his love for "divine works of art." This sentiment animates Ollivier's book on the chapel, which is cast as an imaginary dialogue between two young Florentines named Raoul and Flaminio. Their conversation focuses on Michelangelo's unhappiness after the fall of Florence and on how he relied upon Dante in those dark days, just as Ollivier was relying on Michelangelo. The young men then turn to the Medici Chapel itself. For Flaminio it is a sanctuary of suffering; in it he recognizes its creator crying out against his fate—banishment from Florence. Thus the Medici Chapel allowed Ollivier to examine his own fate, using Michelangelo as his guide and companion.[7]

When Ollivier linked Michelangelo to Dante, he was simply repeating an association made by every cultured nineteenth-century person with an interest in Italian art. It was common to view Michelangelo's *Last Judgment* as a visual parallel to Dante's *Divine Comedy*.[8] There was a chain of thought that had passed from Virgil to Dante to Michelangelo, which modern man needed to understand in order to become one with this pattern of conception and creation.

Michelangelo became an ideal and a model for modern men. When the historian Michelet visited Rome in 1830, he felt a profound contrast between Raphael—the great "Catholic painter"—and Michelangelo: "a man of the Old Testament or a pagan with something of Dante mixed in." Michelangelo had been able to extract the religious sentiment from traditional Christianity and to use its force within the context of a new secular humanism.[9]

The Goncourt brothers reported an interesting discussion about "models" in their *Journal* entry after a Christmas Eve party in 1866. Hippolyte Taine pronounced Shakespeare, Dante, Michelangelo, and Beethoven the "four caryatids of humanity." The critic Sainte-Beuve objected: "But that's all force; what about grace?" After 1870, however, no one in France was speaking in favor of grace; force would have its day, and Michelangelo was the supreme example. This split between force and grace was ob-

vious in the sculptors' work of the 1860s and the way they related to the experience of Italy in art. Sculptors outdid everyone in their continued loyalty to the trek to Italy for inspiration. When neoclassicism froze into academic rituals and modern painters ceased to find Italy necessary, the sculptors simply turned their attention to the Italian Renaissance and Baroque periods.

Carpeaux was the sculptor who, more than anyone else during the Second Empire, imbibed Michelangelo's force: "I feel a vivid sympathy in my imagination for that great man, and all my works are marked with his gigantic stamp."[10] He told a friend that he believed a "statue containing the ideas of the *Divine Comedy* and fashioned by the father of *Moses* would be the chef d'oeuvre of the human spirit."[11] And, of course, he set out to create that chef d'oeuvre when he sculpted *Ugolino*. When Carpeaux was called upon to depict "Imperial France as Protectress of Science and Agriculture" for the Pavilion of Flora at the new Louvre, he turned to the Medici Chapel for his primary inspiration.

Carpeaux was exceptional, though. Most of his contemporaries found their models, not in the High Renaissance, but in the quattrocento. Paul Dubois stunned Paris with his boyish *Saint John the Baptist* and *Florentine Singer* in the early sixties. Mercié, Falguière, Delaplanche, and Saint-Marceaux all followed his example and paid homage to Donatello and Verrocchio in their sculptures of the Second Empire.

After the war and the Commune, however, people wanted force, not grace, and the bigness and seriousness of Michelangelo's forms answered this desire. For the Salon of 1872, Ernest Barrias drew inspiration from Michelangelo's Christ in the Florence *Pietà* in creating the dead father in his *Oath of Spartacus*. The combination of Michelangelesque forms and stoical subject matter made it an instant success. Dubois' *Narcissus,* which owes so much to Michelangelo's *Dying Slave* in the Louvre, had the same reception in the Salon of 1873. Dubois' most important work, however, was his funeral monument to Gen. Louis-Christophe de Lamoricière in Nantes, for which he returned to the ideas he found in the Medici Chapel. Delaplanche and Saint-Marceaux, both dedicated Florentines, now renounced the quattrocento and joined in the search to enlarge the vocabulary of forms by relying on Michelangelo.[12]

Given this context, it is clear that Rodin's illumination as he worked on the Loos monument was anything but unique. Nevertheless, the result in his work was unique, for Rodin did not copy or create pastiches in the manner of Dubois or Barrias. As he confided to Rose, "The great magician is going to give me some of his secrets." He was not after a motif or instant inspiration for a single work, some point of reference in Michelangelo's work that would be instantly recognizable to Salon viewers. Rodin wanted a whole new system. We must remember that he was almost the only sculptor without a master. In 1875, at age thirty-five, Rodin took Michelangelo as his master. If he had died in his forties, we would remember him that way—as the nineteenth-century sculptor who was most profoundly indebted to Michelangelo. The secret he was searching for was how to breathe life into the human body, particularly the male body. He wanted to remove the formulaic quality from contemporary sculpture in order to give new life to the sculpted body.

34) Paul Dubois, *Narcissus*. 1862. Marble.
Paris, Musée d'Orsay. Photo Giraudon.

Throughout his life, Rodin was clear about what his journey to Italy had meant to him. In the late 1880s he still spoke of the Medici Chapel as the most impressive thing he had ever seen. Bartlett reported that "Rodin returned to Brussels and continued his investigations of the principles of composition upon which Michaelangelo's figures are founded. At last, he solved the problem, and the mystery became clear. With its solution also came the key of the principles inherent in his own nature, and by which he has been guided in all his subsequent works. He does not feel certain that he would have found them had he not first studied Michaelangelo."[13]

Rodin never stopped asserting this basic fact about his career and the illumination Michelangelo had given him. In an interview with an American in 1902, he said of Michelangelo: "He is my master and my idol."[14] Around 1905 he wrote to Bourdelle: "Michelangelo called me to Italy and there I received precious insights which I took into my spirit and into my work before I even understood what it was about."[15] Again to Bourdelle: "It was Michelangelo who liberated me from academicism."[16]

The writer Paul Gsell, who put so many of Rodin's ideas and reminiscences into literary form, reinforces the picture of a monumental upheaval in Rodin's life and art during a single month in 1876. He quotes Rodin as saying: "When I went to Italy myself, I was disconcerted before the works of Michelangelo since I had my mind full of the Greek models I had studied passionately at the Louvre. At every turn, Michelangelo's figures contradicted the truths I thought I had finally acquired. 'Well!' I said to myself, 'why this incurvation of the torso? Why this raised hip? Why this lowered shoulder?' I was quite confused."[17]

For an artist to discover his *master* at the very moment when he is on the verge of making his *masterwork* is unusual, but this is exactly what happened to Auguste Rodin in the spring of 1876.

Chapter 9
The Vanquished One

A single sentence in Rodin's letter to Rose Beuret from Italy alerts us that a new sculpture was in the works: "Now, about my figure, make sure it's not too damp. Better for it to be a little firm, and pay attention to that little numskull Paul [Frisch], that he doesn't touch it." For some months before Rodin went to Italy, he had been working on a life-size statue, and a major reason for making the journey was to see some of the great nude figures of the Renaissance and classical past. The presence of the life-size figure in his studio may even have provoked the trip, and he felt so intensely about the experience that he found it "confusing."

Nineteenth-century sculptors, like their predecessors, regarded the creation of a monumental statue of a nude male as a singularly important challenge. It was what academic training was all about. When a Prix de Rome sculptor returned home, the best thing he could bring back was a beautiful statue of a male figure as the mark of worthiness. Carpeaux returned with *Ugolino,* Dubois with *Narcissus,* Falguière with *The Winner of the Cockfight,* Mercié with *David,* and Barrias with *The Oath of Spartacus.*

David and *The Oath of Spartacus* were in the great postwar Salon of 1872, a show seen as a triumph for French sculpture because of the large number of works that were serious in scope and presentation. Critics contrasted this Salon with the frivolous exhibitions of the Empire; they considered the work of Mercié and Barrias major contributions to the change in the artistic climate. Mercié's *David,* a nude youth with a raised foot placed upon the face of Goliath, was hailed as a sublime combination of naturalism with obvious echoes of the Italian Renaissance. Nonetheless, one critic did wonder if it was not so naturalistic that it might have been cast from life![1]

This was the competition Rodin saw around him. It is not surprising that he felt he too needed to experience Italy. The confusion seems to have come when he actually saw a great number of figures by Michelangelo, forms that had a very different kind of force than the antiquities he knew so well in the Louvre, not to mention the neo-Renaissance figures displayed in the Salons.

Going to Italy was only one step in Rodin's carefully planned campaign to create a "big figure." Another was selecting the right model, something that would remain a critical issue in Rodin's way of working. This is the first time we are privy to the process by which he chose the model for a life-size figure. From Bartlett we know that Rodin did not usually work from models in Brussels.[2]

Convinced that a well-built young soldier would be right for his statue, Rodin spoke to his friend Captain Malevée, commander of the Sixth Ixelles Company of Telegraphists. Malevée came up with nine candidates, from which Rodin selected a Fleming,

Auguste Neyt, "a fine noble-hearted boy, full of fire and valor."[3] Neyt first came to the studio on the rue Sans-Souci on October 7, 1875. Many years later, he described the sessions in a newspaper interview: "I had to go through all kinds of poses every day in order to get the muscles right. Rodin did not want any of the muscles to be exaggerated, he wanted naturalness. I worked two, three, and even four hours a day and sometimes for an hour at a stretch. Rodin was very pleased and would encourage me, saying 'Just a little longer.'"[4]

The working relationship that developed between Rodin and Neyt was amiable. A morning's work frequently ended with Neyt having lunch with Rodin and Rose Beuret. As they came to know each other better, Rodin would discuss his ideas about the statue with his model. Neyt treasured the memory of Rodin as a man who was "ever calm and simple." The work was long and arduous. Rodin told Bartlett he "was in the deepest despair with that figure, and I worked so intensely on it, trying to get what I wanted, that there are at least four figures in it."[5] He wanted to understand the fundamental difference between volume, plane, and contour. He would move around the figure looking at what he called the "profiles," one after the other, making sure the clay contours matched the model in all the parts, each limb, every muscle. He even got up on a ladder in order to study the statue from above.

Since Rodin was determined to escape from standard studio poses, he had Neyt "go through all kinds of poses" in his search for the right one. Rodin found an untrained model valuable, for he did not automatically assume the poses known by trained models in the academies. Nor was Rodin interested in contemporary realism. He did not want his statue to look as if it was engaged in a specific action. Artist and model settled on a pose that placed Neyt's feet close together, right foot flexing at the toes so that the heel came away from the ground and the knee bent gently. Then Neyt placed his right hand on top of his head, taking his hair in a firm grasp. He raised his left hand to the level of his neck. In order to maintain this pose, he held onto a metal rod. The effect is a delicate contrapposto, with the body leaning slightly to the right. A feeling of hesitancy is coupled with the potential for forward movement.

This pose has little to do with a Michelangelesque figure. The closely placed feet bear no resemblance to Michelangelo's contrapposto, and Rodin's figure elicits less of the sense of working with a plumb line that we observe in Renaissance statues, which are so gracefully disposed to the right and left. Yet Rodin noticed a relationship between the stance of his model and that of an antique *Apollo* he had seen in Naples.[6] Another attempt to explore this relationship can perhaps be found in a drawing of a figure with feet and legs like those of the *Dying Slave* in the Louvre (though in reverse), and a long Michelangelesque torso with arms raised. Rodin labeled the drawing "Creation of Man," but in contradictory fashion he put wings on the ankles and the back of the figure. These studies are all we have to explain Rodin's feeling of confusion when he returned from Italy. He had been well along with his figure when he left on the trip; it seems he did not fundamentally change it when he returned. Nonetheless, he was

35) Auguste Neyt in the pose of Rodin's
statue, 1877. Photograph by Marconi?
Albumen print.

36) Rodin, *The Vanquished One*. 1875–77.
Plaster. Photograph by Marconi.
Musée Rodin.

trying to reconcile what he had seen with what he was doing, and it was a confusing process.

When the plaster statue was ready for exhibition, Rodin had the Brussels photographer Marconi take a picture of it. Later he asked someone, perhaps Marconi, to photograph Neyt in the same position so that people could compare the model and the sculpture.[7] One of the things we discover in this fascinating comparison is how accurate Rodin was in his treatment of the body. The only perceptible change is that Rodin's figure is slimmer, more elegant than Neyt's body really was. In the face the changes are more significant. Rodin emphasized a structure that was angular and bony, a face with thin lips, avoiding Neyt's rounded chin, with its cute dimple in the middle. He decided to close the eyes and open the mouth of his figure, thus introducing an emotional note. This expression, together with the raised arms and the hesitant forward movement, present the viewer with an enigmatic image of a man opening himself up to pain.

Rodin worked hard on his statue. He wanted to get every inch, every profile, perfect. He probably worked on it longer than he needed to; later he said he considered the statue overworked, but he had so much wanted to make it right that he could not take his hands off it. Finally, by the end of the year, he was ready to release it to a mold maker so that the plaster could be prepared.

Rodin tried his hand at many other new things in 1876. His aspirations grew. With an eye to Michelangelo and Carpeaux, he made an "Ugolino" group, but, dissatisfied, "destroyed all save the body of the principal figure."[8] A young admirer of Rodin saw the figure in his Paris studio and described it to Bartlett as "a bit like Michelangelo . . . so large, lifelike, and ample in the character of its planes and modelling."[9] Rodin also made a portrait of his friend, the sculptor Paul de Vigne, eliminating details as never before to create in a loose, naturalistic style a likeness that reveals the brooding seriousness written across the Belgian artist's face in a highly unified frontal presentation. Most ambitious of all, Rodin began a sketch for a monument to Lord Byron to enter in the international competition opened in London the previous year for a monument in Hyde Park. He prepared a maquette showing the poet standing with an allegorical figure on either side.

In 1876 Rodin was working primarily by himself. We do not know the source of his income, but the legal document ending the Van Rasbourgh–Rodin partnership was not drawn up until 1877. Bartlett once asked Rodin if he would have left Belgium had he "not been refused employment by Van Rasbourgh and Pécher." Rodin answered, "Perhaps not. I did not know that I had any talent. I knew I had skill, but never thought I was anything more than a workman. I did not sign my work and I was not known."[10]

During this period Rodin put out feelers about going back to work for Carrier-Belleuse in Paris. At the end of December Fourquet went around to the studio in the rue de la Tour-d'Auvergne to look into the possibility. Carrier complained that Rodin was extremely stubborn and made fun of him when he was not around. Nevertheless, he

37) Rodin, *Ugolino*. 1876. Plaster. Musée Rodin.

recognized Rodin as the most subtle of workers, one who understood absolutely everything Carrier said to him. Fourquet's advice was, "Don't worry, he'll have a place for you, but you must write him yourself. Let him know that he's the boss. Carrier needs you."[11]

Our picture of Rodin in his mid-thirties, then, is of an artist in a foreign country with no steady income, still somewhat unsure of his talent, but utterly certain that his skill was superior to that of his associates—which made him a difficult working partner. He was also exploding with new ideas and eager to try every route to success.

Rodin's début as a figure sculptor took place at the Cercle Artistique et Littéraire, one of the most important cultural institutions of Brussels, where men of art, science, and literature, both Belgian and foreign, came together for exhibitions, lectures, and literary occasions. Rodin was a member of the Cercle. It may even be where he became friends with Edmond Picard, the lawyer, with Doctor Thiriar, whose bust Rodin fashioned, and with the important critics Jean Rousseau and Charles Tardieu. It is possible that he even got to know Burgomaster Anspach, who was also a member of the Cercle in those years.

Exhibitions at the Cercle were small and only members could show there. In this intimate setting, Rodin's statue went on view in January 1877. Soon thereafter, an anonymous writer mentioned it in Belgium's leading political journal, the *Etoile belge*. He urged his readers to go and see the statue before it left for the Paris Salon, where "it will not go unnoticed . . . for if it initially attracts attention by its oddness, it holds it by a quality that is as rare as it is precious: life." The journalist went on to speculate about two things: the statue was so lifelike it forced him to wonder what "part casting from life has played in making this plaster"; further, he did not understand what the figure meant. He felt it must be about some sort of "physical and moral collapse," but "without having any indication other than the work itself, it seems to us that the artist wished to represent a man on the verge of suicide."[12]

Rodin was devastated. Here he was at thirty-six with the figure he considered to be his big chance, and someone was accusing him of using a dishonest studio practice. He sat down to write the editor a letter. Though he began in a measured tone—"Of course, I am proud of the praise you have give my work"—he could not keep the emotion out of his letter and ended on a strident note with an invitation to any connoisseur who wished to come to his studio to examine the model side by side with his statue. Anyone with eyes would see how far his work was from being a "servile copy." The editor published the letter. Now *he* was annoyed: "We find it strange that the sculptor is taking advantage of our account, written with so much good will, in order that he might respond to doubts that have been given voice at the Cercle."[13]

Rodin then got in touch with Rousseau, who was critic for the Brussels daily *L'Echo du parlement*. Rousseau was a seasoned journalist, having been the Paris correspondent for two Belgian papers in the fifties and with *Le Figaro* in Paris in the early sixties. Everyone knew him as an independent, eloquent writer and many artists owed their reputations to him. Rousseau had praised Rodin for the busts he showed in 1874 and 1875, and surely by this time he must have known that the statues he so admired as excellent examples of fine Flemish style at the Bourse were by Rodin.

Rodin and Rousseau got together to talk about the statue. The result of their meetings appeared in the *Echo du parlement* on April 11, even though Rodin's work was no longer in Brussels. After describing the statue, Rousseau explained that Rodin, "like every true artist," had been more concerned with style and execution than with the subject, so "naturally there are questions, even strong criticism: What is the meaning of the half-

closed eyes and the raised hand?" Nevertheless, Rousseau wrote, "everything is clearly and logically explained by the title: *Le Vaincu,* and it is sufficient to add that the raised hand was to have held two spears."

After talking with Rousseau, Rodin settled on the title *The Vanquished One.* Perhaps the critic even suggested it. Rodin hoped this would make his meaning clear and forestall future criticism. It was a good title. Most Frenchmen felt vanquished in one way or another during the 1870s: in 1871 Victor Hugo had been worried about the vanquished of the Commune, and Emile Ollivier was vanquished in his exile. In a sense, Rodin felt vanquished by his failure to make his living in Paris. Further, the single most popular sculpture of the decade was Mercié's group *Gloria Victis*—"glory to the vanquished ones"—which Rodin had admired in the Salon of 1874. Rousseau would have preferred Rodin to place a pair of spears in the figure's left hand to make the sense of the title even clearer. Rodin had considered this possibility, but in the end he left it out because he felt it ruined the profiles. In his review, Rousseau compared the figure to the best work of the Greek and Florentine sculptors. He believed Rodin had excelled in rendering broad planes, showing balance and firmness, and understanding human anatomy. Rousseau's highly favorable review was the perfect send-off to Paris.

After eighteen months of walking around and looking at Auguste Neyt's body, of working his fingers through the moist clay day after day, of destroying and starting over again, Rodin finally had a figure with which to make his official entry into public view. Anyone could see that *The Vanquished One* was out of the ordinary. But what most accounted for its extraordinariness was Rodin's refusal to define a subject. Academic tradition demanded that an artist draw his subject matter from the Bible, mythology, or history, or render an allegory, an animal, or a contemporary genre. Rodin had not drawn from any of these. As he explained to Bartlett, his "sole ambition" had been "to make a simple piece of sculpture without reference to subject." That was that, and forever after he would think about the year in Brussels when he had been able "to enjoy the pleasure of the soul as its emotion [was] passing out of the ends of [my] fingers into a piece of clay."[14]

The second thing that made Rodin's statue difficult was that it did not seem to be adequately indebted to a particular stylistic tradition, not even that of Michelangelo. No sculptor before Rodin had shaken himself so free of stylistic influence. In place of a subject defined by literature and a style defined by the past, Rodin committed himself to nature as his guide. Among sculptors working in Europe in the late 1870s, such a choice was nothing short of revolutionary.

During the months when Rodin was working on *The Vanquished One,* his younger helpers in the atelier on the rue Sans-Souci must have begun to wonder if he would ever finish his big figure.[1] He defended himself by asserting that if an artist could create just one good statue, he would establish his reputation.[2] So Rodin continued working and reworking.

One of the heroes of modern French sculpture was François Rude, the great Romantic artist who created *La Marseillaise* on the Arc de Triomphe in Paris. For many years Rude lived in Brussels, where he too made decorative sculpture. When he decided to return to Paris, he focused on the Salon as the way to establish his reputation in his homeland. For it he created a beautiful male nude that he called *Mercury,* the messenger of the gods. In 1827 he put his daring and elegant figure before a sophisticated Paris audience in the Salon. Rude's *Mercury* betrayed a movement that was totally at odds with the static neoclassical statues in the exhibition, but the work became widely acclaimed, and by Rodin's day it was one of the benchmarks used to measure the stages by which nineteenth-century sculptors freed themselves from the strictures of neo-classicism.

That had been fifty years ago. Rodin knew the story by heart. It was the perfect scenario, the way he wished his own career to evolve. Like Rude, Rodin would be returning to an art world that was surprisingly hospitable to sculpture. In fact, for the first time in the history of the Salon, sculpture was held in greater esteem than painting. Critics began to voice this opinion in 1872 after the opening of the first Salon of the Third Republic, and they continued in this vein throughout the decade:

> More than ever, and with great energy, sculptors preserve the honor of French art. The large number of works in the present exhibition constitute one of the most glorious ever assembled. One cannot remember having seen, side by side, four or five works by younger sculptors of such great worth and so full of promise. (Georges Lafenestre, "Salon de 1872," *Revue de France,* June 30, 1872)
>
> Sculpture attracts attention because it is at once the most elevated and the most popular of the arts. . . . A painting is entirely conventional, while sculpture draws near to nature herself. . . . Sculpture is truly a model of man, and, like him, she lives and palpitates. (Henry Jouin, *La Sculpture au salon de 1873,* Paris, 1894)
>
> Sculpture remains the solid, strong part of our national art. (J.-A. Castagnary, "Salon de 1873," *Salons,* vol. 2, Paris, 1892)

38) Antonin Mercié, *Gloria Victis*. 1872–75. Bronze. Paris,
Musée du Petit Palais.

Sculpture . . . holds together better . . . than painting at the salon because it is three-dimensional and because it is more compatible with the temperament of the French people. (Anatole de Montaiglon, "Salon de 1875," *Gazette des beaux-arts,* 1875)

Sculpture is clearly in better health than painting. It betrays less of that scattered, showy individuality. (M. F. Lagenevais, "Le Salon de 1875," *Revue des deux mondes,* June 15, 1875)[3]

Two things worked in favor of the sculptors. First, the most adventurous and talented painters had become *too* revolutionary and had begun to turn away from the

Salon. They called themselves "Independents," but critics referred to them derisively as "Intransigents" or "Impressionists." An even more important factor in sculpture's primacy was its ability to contribute positively to the national sense of identity. Sculptors could fashion patriotic images in an epoch that desperately needed them. After seeing Mercié's *Gloria Victis,* an American visitor to the Exposition Universelle of 1878 said: "No effort of French genius since Sedan—no poem, romance, oration, or work of art—has given so much solace to the defeated nation as this statue."[4] Sculptors aspired to such praise with much greater fervor than the painters. It was their true realm.

Léon Gambetta, a staunch Republican of the left, stated in a famous speech of 1872: "Now Republican politics begins; the Republican administration has everything to do anew." That included their policies toward art and artists. Under the Empire a superintendent of fine arts had been attached to the house of the emperor; now there would be a director of fine arts reporting to the minister of public instruction. Serious artists working in the Republic were expected to ennoble public imagination. They had an educational role to fulfill. Republicans believed in treating artists fairly and therefore giving them greater access to the Salons. This issue provoked tension, however, because, as a recently defeated nation, France had to prove that its artists were the best in the world; hence, selection should be rigorous. The last Salon of the Empire showed more than five thousand works; the Salon of 1872 included slightly more than two thousand. The state wanted to exhibit only the best that France had to offer. It was not long before cries of "tyranny" could be heard, just as in the past.

Rodin went to Paris in March, before the Salon opened. He did not understand the politics of the organization and soon lost much of his confidence, telling Rose that he was falling "back into discouragement. Today it seems to me that my figure is not as good as I thought it was." Nevertheless, he did everything he could to insure the success of his statue. He did not want to add a pair of spears to make *The Vanquished One* a convincing title, so he changed the name. In Paris it was known as *The Age of Bronze.* Rather than asking the viewer to enter into feelings of oppression and loss, the new title suggested man awakening to a new day. The change in emphasis was timely, for the notion of the "ages of man" was currently being redefined. People were coming to understand how ignorant they had been about the origins of humanity, and they now associated the Age of Bronze with a time when man first made tools and weapons, that is, with a richly creative period in human history. The *Revue des deux mondes* brought out an important article on the subject just after the Salon opened in 1877.[5]

The jury would be examining the submissions on April 5 and 6. Rodin's anxieties are reflected in the steady stream of letters he wrote to Belgium. He was continually telling Rose Beuret what she must do, what their assistant Paul must do, how to keep the clays wet, how to pack the works that he wanted sent to him, especially the big "Ugolino," and how to get the Byron maquette ready to go to London.

Rodin thought about the aspersions that had been cast on his statue in Brussels regarding the relationship of figure to model. Maybe he should have some sort of

document in hand to prove its originality. He sent a letter to Malevée: Would he be willing to write a certificate giving the dates on which Neyt had posed for Rodin in 1875 and 1876? Then he remembered that one of his neighbors in the rue Sans-Souci, a painter by the name of Modeste Carlier, was friendly with the well-known academic sculptor Gustave Crauk. Maybe a letter of introduction to someone on the inside would be useful in getting a decent position in the exhibition. Off went another letter to Brussels.

Rodin's figure was accepted. The circumstances, however, were not good. It was badly placed, "while sculptures by amateurs are shown in really good light," Rodin wrote to Gustave Biot. Even worse, the accusation that first appeared in the *Etoile belge* resurfaced: "moulée sur nature." Glumly, Rodin wrote to Beuret: "I am truly sad that Falguière says he finds my figure really beautiful, but others say it's cast from nature. I put all my hope in the power of truth. He [Falguière] thinks what they are saying is a compliment, but that makes me mistrustful."

Thoroughly wretched and indignant, Rodin felt he had no recourse but to write to the "President of the Jury of the Fine Arts Exposition."[6] The man who answered to that title was Charles-Philippe, marquis de Chennevières-Pointel. Rodin wrote:

> How surprised I am that the figure I submitted for the Salon has been called a cast from nature. By this doubt the jury has robbed me of the fruit of my work. Just suppose that, contrary to that opinion, I actually worked for a year and a half and that my model was constantly in my studio.
>
> Just suppose that I saved every sou I had to work on this figure in the hope that it would find in Paris, as in Belgium, a success because the modeling is good, and it is only the process that one impugns.
>
> What an unhappiness to see my figure, which was to help me find a future, a future that is starting late because I am 36 years old—what an unhappiness to see it thrust aside by this disgraceful suspicion.
>
> I want to tell you, M. le Président, the supposition is not true. I did not make it from a cast.

Rodin's letter is raw and full of moral indignation. He was too upset even to suggest how the administrator should redress the wrong he had suffered. He simply let out a cry from the heart. It is easy to imagine how readily Chennevières put the letter aside as just another complaint. The marquis had worked in arts administration for thirty years. He had been in charge of the imperial Salons through most of the 1860s. So, when President Adolphe Thiers was ousted in 1873 and the Republic moved to the right under Marshal MacMahon, Chennevières was the perfect choice to head the fine arts administration in the new "moral order" government. An experienced and able organizer, he looked back with pride at his many initiatives, including the redecoration of the Panthéon, travel grants for artists, and the awarding of a "grand prix de Salon" in addition to the medals that had always been given. As the new director of fine arts, he set about

to create a comprehensive inventory of the cultural riches of France (*Inventaire général des richesses de la France*). For Chennevières, this work was as fundamental to national rehabilitation as were the military and educational reforms being carried out in the postwar period. But on a par with the inventory was his passion to establish a Musée des Arts Décoratifs in France. He felt particularly strongly about this because so many invaluable decorative art objects had been lost in the fires of the Commune.

A few weeks after the exhibition opened, the state published a list of works it would buy from the current Salon. Rodin's figure was not on it. Once again he took up his pen: "I have the honor, M. le Marquis, to address to you a request that you might be able to buy the figure in plaster that I showed in the Salon under the name 'The Age of Bronze.'" Chennevières at least dignified this request with an answer: "I regret to inform you that the state does not have sufficient credit to respond favorably to your request."

Rodin felt very alone in these months in Paris: "I am literally bruised in body and in spirit. If you were here, I would sleep in your arms with so much pleasure," he wrote to Beuret. She passed along encouragement from Van Rasbourgh and Neyt. Other Belgian artists such as Bouré, Carlier, and Biot wrote letters for Rodin to show to the officials in Paris. Biot said: "I declare on my honor that your figure *Le Vaincu,* which is at this moment in the exhibition in Paris, has been entirely modeled after the living model and that I saw you both begin it and finish it." He wrote a second, more personal letter in which he let Rodin know that Jean Rousseau was writing Paul Dubois, and perhaps Falguière, in defense of his statue. They were both professors at the Ecole des Beaux-Arts and powerful voices in Paris. Biot said they had been trying to figure out what the problem was; Rousseau surmised that Rodin had shown nudity with too much directness. Rousseau, recently named director of fine arts by the Belgian government, sympathetically urged Rodin to stop worrying: "No obstructions can stop a talent like yours."

In a long letter to Biot about the Salon, Rodin reveals two aspects of his character that show up frequently during his lifetime: his insecurity—poor self-image, we would say—and his anger. He begins by thanking Biot for his friendship; how much it means to have someone willing to support a "sick dog" like himself. He apologizes for not being an equally good friend to Biot. He feels he should spend more time talking to Biot about Biot's own work. Suddenly, the letter explodes in an outburst of spleen as he describes the bad placement of his work and the preferential treatment meted out to amateurs at the Salon: "Until now I believed that here in France art was truly respected, but I see now that an artist has to be a Freemason and that the Romans [recipients of the Prix de Rome] are against me. They say that I used casts; now they are saying that my figure is no good." Nevertheless, Rodin reported that "some artists came to shake my hand."

Falguière and Gabriel-Jules Thomas told Rodin to forget the whole thing and to stop circulating photographs of Neyt and his statue in the same pose. They warned that he

was on the verge of annoying the jury, who were likely simply to dismiss his sculpture as inferior. Rodin closed his letter to Biot with an observation that shows a great deal of self-awareness: "I need a craftier brain than the one I've got." Rodin did have difficulty in grasping how the system worked. He frequently approached the official world in a manner that was both naive and suspicious. The results were often not what he wanted.

The Salon reviews that counted most were those in the monthly journals, for they would be bound and would last for all time. Critics reviewed the different parts of the Salon in a prescribed order. Painting came first, in May. Sculptors had to wait until July, sometimes even August, to know what, if anything, the critics would say about their work. Waiting for the major reviews was Rodin's last trial in 1877, after the rumors about a life-cast, the bad placement of his sculpture in the hall, and the state's refusal to purchase it.

Once again Parisian critics more or less agreed that sculpture was in better shape than painting. "Painting has taken it as her role to be amusing," said Charles Timbal of the *Gazette des beaux-arts,* while sculpture "provides noble thoughts." There were 642 sculptures in the Salon of 1877, and Timbal felt most of them were worth talking about. But he had four favorites: *Roman Marriage* by the director of the Ecole des Beaux-Arts,

39) Sculpture Section, Salon of 1877. Paris, Musée d'Orsay, Album Michelez.

Eugène Guillaume; *Genie of the Arts,* a decorative piece by Mercié for the exterior of the new Louvre; *Music* by Eugène Delaplanche; and *Thought* by Henri Chapu. Timbal discussed dozens of works. At the end of his review, he finally mentioned *The Age of Bronze.* He described it as a "sickly nude fellow," repeated the rumor about a life-cast, and said he found the title pretentious. The review could not have been more crushing.

The review in *L'Art* did not come out until August. It was written by one of the editors, Charles Tardieu, who was Belgian and a friend of Rousseau's. He went systematically through all the sculpture types: busts, Greek and Roman subjects, mythological works, allegorical subjects, animal sculpture, patriotic sculpture. At the very end he got to "realist sculpture." He said there was not much of it, just *Neapolitan Fisherboy* by Gemito—"positively and absolutely ugly"—and "this controversial work, *The Age of Bronze,* by Rodin." Tardieu did not think the title worked. He, too, mentioned the rumor that the sculpture was a cast from life, but he attributed it to the jealousy of other artists toward a man who was able to fashion such a realistic statue. Tardieu accepted it as an honest work; he even praised it for its quality of "life," but in the final analysis he found it only "a slavish likeness of a model with neither character nor beauty, an astonishingly exact copy of a most commonplace individual."

A few weeks before the Salon opened, the annual show of the independent painters got under way. It was the first year in which they chose to designate themselves "Impressionists." Clearly, a new school was in the making, and critics were struggling to define it. They focused on the paintings as direct, unfettered representations of reality. One of the group's leading defenders, Georges Rivière, explained that "to treat a subject for the colors and not for the subject itself is what distinguishes the Impressionists from other painters."[7]

It would have been possible to speak about Rodin in the same way, saying that he treated the figure in terms of the profiles rather than of the subject. But Rodin was not showing in the independent exhibition. He was in the official Salon, and he was alone. The critics' difficulties with his work clearly stemmed from their inability to recognize and describe a new style in which naturalism played a stronger role than the traditional narrative and symbolic propensities of sculpture. But Rodin could by no means put his situation into perspective. He was appalled by the criticism; Bartlett said "it cut him to the quick."[8] He felt accused of being dishonest both as a man and as an artist. The pain went even deeper because Rodin identified with his figure. Bartlett was the first to describe *The Age of Bronze* as an ideal self-portrait in which Rodin was "concealed in the figure of a young warrior waking from the half-sleep of unknown strength."[9] No one since has disagreed that through this work Rodin came to life as a sculptor.

In spite of Rodin's failure in the Salon, he did not reconsider his decision to return to Paris. In June he went back to Brussels to close his studio and collect Beuret. It was surely a difficult leave-taking for her. All the letters addressed to Rodin from Brussels in the years following their return to France include Beuret in the greeting with considerable warmth. Never again would their life together, their very real partnership, be so intense and so loving.

Rodin made the rounds of family members whom he had not seen in years. He was still in Paris on June 8 when his Aunt Rose, widow of Uncle Alexandre, died, and he must have attended the funeral. Her will named Jean-Baptiste as executor, indicating that he was still considered in some sense to be of sound judgment. June was also the month in which the ceremony to mark the removal of Father Eymard's body to Paris took place. Tradition has it that Rodin donned the white surplice of a novice in order to honor his old, and now celebrated, friend. In the fall Rodin rented an apartment at 268 rue Saint-Jacques in the Latin Quarter. It was his old neighborhood, conveniently close to Aunt Thérèse at 218 rue Saint-Jacques. Jean-Baptiste and Auguste Beuret moved down the street to live again with Rose and Rodin. Reunited with his family after a six-year separation, Rodin must have felt the burden of responsibility as he considered how he was going to support them both financially and emotionally.

As he had anticipated, Rodin negotiated a new arrangement with Carrier-Belleuse. In Rodin's absence Carrier had received an important assignment from the state to become the art director of the national porcelain manufacture at Sèvres. The manufacture's buildings, devastated during the war, opened in new accommodations in the Park of Saint Cloud in 1876. It was a beautiful setting. Carrier was more than content to move his family to a place where they were able to live in grand style.

By 1877 Rodin was once again working up finished models from Carrier's sketches.[10] He was not at all happy about the arrangement, and the only thing that made it possible was that Rodin also worked for himself in a studio he now shared with Fourquet at 36 rue des Fourneaux (today the rue Falguière). Rodin's resentment toward Carrier had not abated; he told Bartlett that he knew Carrier had no sympathy for him and kept him only because he was a good worker.

Bartlett described Rodin's work after the return from Brussels as being "for various decorative sculptors, as occasion or necessity required." Rodin was full of frustration, even bitterness. "Not one of these men treated me like a man," he complained.[11] Besides Carrier, Rodin worked for Eugène Legrain, the brilliant young alumnus of the Petite Ecole who had been in charge of decoration at the Hôtel Païva. Legrain had the good fortune to capture the commission for the decorative work on the Trocadéro Palace, an exotic hall in oriental style being built on the hill of Chaillot for the Exposition Universelle of 1878.[12] Shortly after hiring Rodin, Legrain wrote him on September 10, 1877: "Why haven't I seen you? I thought you would be here Monday. Now Tuesday has passed. We are overwhelmed with work. I'm counting on you." The only thing we know that Rodin produced for his impatient employer is a series of large grotesque heads—the *Mascarons*—which decorated the great fountain with its tiers that allowed water to cascade down into a giant basin on the river's edge (destroyed in 1937). Jules Desbois, a young sculptor with whom Rodin became friendly in 1878, told Bartlett that Legrain was always correcting and retouching Rodin's work, which is presumably what Rodin meant when he said he was not "treated like a man."[13]

When Rodin decided to return to Paris, construction work for the Exposition Universelle was already under way. Everyone knew it was to be an important event for

France. They hoped it would bring foreigners back to the capital. More than that, it was seen as critical to the restoration of France's battered self-esteem. France badly needed to show the world that she was strong and stable.

As little as Rodin cared for politics, he certainly took stock of the enormous changes wrought during his absence in Brussels. Until 1875 France had been poised between monarchy and republicanism. It faced a choice once again between becoming a dynastic and, to a certain degree, Catholic country, or living out its revolutionary inheritance as a free-thinking, secular society. The struggle that dominated the early 1870s was only settled in January 1875. A moderate deputy, Henri Wallon, made a simple proposal that "the president of the Republic be . . . elected by the Sénat and the Chambre [des Députés]." It was adopted by a majority of one vote. Thus France took on the governmental system of two chambers, with a president elected for a seven-year term. She could now securely call herself a republic.

Rodin's very Catholic family betray themselves in their correspondence as aligned with the traditions of the right. When Rodin told Biot, "I see now that an artist has to be a Freemason," he clearly recognized that power in France was now lodged in the left (men like Léon-Michel Gambetta, who was briefly prime minister in 1881–82, and Jules Ferry, minister of education and twice prime minister, were Freemasons) and that he was not one of them. If Rodin was not interested in politics, he would have to learn, for no sculptor could live long in France without understanding who held power and how to cultivate their favor.

The Exposition Universelle opened on May 1, 1878. After seven years of mourning and intense political struggles, the citizens of France finally celebrated. Rodin did not try to place a work in the art exhibition. Fourquet did, but then he had already received two Salon medals and stood a much better chance than his friend did. Rodin did get a work into the Salon that year: he had ordered a bronze cast made of *The Man with the Broken Nose* and he entered it as *Portrait of M ****.

One of the exhibits in the Italian pavilion was a private collection that included the *Portrait of Michelangelo* attributed to Daniele da Volterra (now in the Louvre). Critics picked up on the resemblance between Rodin's mask of "M" and the sixteenth-century head. Louis Ménard commented favorably that Rodin's work brought "to mind the head of Michelangelo" (*L'Art*, 1878), and Eugène Véron, seeing the same similarity, concluded that "there is thought and nobility in this beautiful head; it is not in vain that a person bears resemblance to great men."[14] It was not much, but Rodin could not have been displeased.

By 1878 Rodin was at work on his second big figure. He was living in "deep poverty," as he described it to Bartlett, and working so hard, usually late into the night, that he frequently was "unable to reach his lodgings without assistance after he had left his studio."[15] He called the figure *Saint John the Baptist Preaching,* though he had not started with a preconceived notion of creating a biblical figure. As with *The Age of Bronze,* the sculpture grew out of an inspired relationship between Rodin's powers of

40) Rodin, *The Man with the Broken Nose*. 1863–64. Bronze cast in the Salon of 1878. Photograph by J.-E. Bulloz. Paris, Musée Rodin.

41) Attributed to Danielle da Volterra, *Portrait of Michelangelo*. Mid-sixteenth century. Bronze. Exhibited at the Exposition Universelle of 1878. Paris, Musée du Louvre.

observation and the body of an untrained model whose movements he found forcefully suggestive.

When Rodin described his work on *Saint John* to Dujardin-Beaumetz in the twentieth century, he placed it in the larger context of explaining his life-long commitment to nature. Rodin had always wanted to incorporate *himself* into nature. "She leads me," he would say, and "the sight of human forms feeds and comforts me." Dujardin-Beaumetz pressed for examples of how a life-model could play such a strong role. It was then that Rodin told him the story of Pignatelli, the model for *Saint John*. He described meeting an Italian peasant fresh from the Abruzzi who was looking for work in Paris. Before him stood a "rough, hairy man, expressing violence in his bearing and his physical strength," but Rodin also recognized a "mystical character." It was this that made him think of Saint John, and it made him want to depict the Baptist as "a man of nature, a visionary, a believer, a forerunner who came to announce one greater than himself. . . . The peasant undressed, mounted the model stand as if he had never posed; he planted himself head up, torso straight, at the same time supported on his two legs, opened like a compass. The movement was so right, so determined, and so true that I cried: 'But it's a walking man!' I immediately resolved to make what I had seen."

Pignatelli was no Neyt. Rodin never asked him home for lunch nor discussed the

42) Pignatelli in the pose of *Saint John,* after 1878. Anonymous
photographer for the Ecole des Beaux-Arts.

progress of his figure with him. In fact, Rodin considered him "a dreadful creature,
capable of cruelty; he had the refined wickedness of a civilized being and the deceitful-
ness of a savage."[16] Nevertheless, Pignatelli's unkempt wiry body and haggard face
inspired the extraordinary movement and power of Rodin's figure striding forward,
pointing to the ground, and gesturing with his right hand as if to say, "Come follow
me."[17]

Rodin also worked on the figure when Pignatelli was not around. With *Saint John,* he
adopted an approach that became standard procedure for him and an integral part of his
creative process. He detached the limbs and other extremities in order to consider each
part separately: the body without the head (enlarged in the twentieth century to become
famous as *The Walking Man*); the torso by itself, which in isolation looked particularly

Michelangelesque; and the hands alone, so that he could consider how to achieve the right balance with the rhetorical gestures.

As a result of this strenuous effort, Rodin was able to go beyond what he had done in *The Age of Bronze*. He freed himself from the grace, finish, and slightly static feeling of that figure. His new sculpture was far more forceful and dynamic, though awkward and angular at the same time. In response to the charge that he had cast from life, he made it larger than life. By working on gesture and expression, he made it possible for people to read the subject, even though this Saint John had no hair shirt and was rendered with unusual naturalism.

The figure was not ready for the Salon of 1879, but Rodin was anxious to show it. So he submitted the head as a bust under the title *Saint John the Baptist Preaching*. Eugène

43) Rodin, *Saint John the Baptist*. 1878–79. Clay. Salt print by
Michelez. Musée Rodin.

Véron looked at the way he had tilted the head, and in it he recognized "the Precursor preaching strongly. His eyes are filled with faith and he dominates those who follow him, and with his open mouth he eloquently proclaims the coming of the Messiah."[18] If you could read the subject in the head alone, ambiguity in the subject was no longer a problem.

While Rodin worked on *Saint John the Baptist, The Age of Bronze* was never far from his mind. As long as Chennevières directed the fine arts administration, Rodin felt no hope for justice. Then Chennevières resigned, forced out, in his words, by the "tyrannical" behavior of the artists.[19] The man who succeeded him, although in a reorganized department and under a new title—undersecretary of state for fine arts—was Edmond Turquet, a big, blond deputy from the department of Aisne who rode in on the coattails of Jules Ferry. Turquet was a liberal. He voted consistently with the left. He was also rich and considered a man of taste. He had put together an art collection. The writer Emile Bergerat described Turquet at home in Neuilly, "surrounded by painters, sculptors, musicians, even poets . . . entertaining them with a hospitality to renew them much as once did the Medicis of Florence."[20] During his tenure as an elected deputy,

44) Pignatelli in the pose of *Saint John,* after 1878. Anonymous photographer for the Ecole des Beaux-Arts.

45) Rodin, *The Walking Man* (original scale). 1877–78.
Musée Rodin.

Turquet had always been attentive to the arts. Thus, his appointment was greeted with enthusiasm by both artists and critics. *L'Illustration* engraved his photograph on a cover in March 1879 so that its readers could get a good look at the forty-one-year-old administrator with his intense gaze, broad forehead, long nose, and double-forked curly beard. The reporter described him as a man of military bearing who had inherited the skills of a magistrate from his forebears, a man whose convictions led him to politics and whose passion inclined him to the arts. Another contemporary profile emphasized a quality of bravery and daring that all those who knew Turquet well were frequently privileged to witness, and reminded its readers that once he had jumped in the Seine to

save a woman from drowning. In fact, he was still president of the Sauveteurs de la Seine.[21] "This then is our new secretary," concluded the article, "a man of energetic countenance who inspires respect, a man of elegant bearing, yet not lacking in candor, all qualities that make one feel immensely drawn to him."

Rodin must have been pleased, especially since he was slightly acquainted with Turquet. At the time of the Salon of 1877, the deputy had sought him out to congratulate him on his figure. So at the earliest possible moment Rodin made an appointment with Turquet to ask him to reopen the inquiry for his *Age of Bronze*. He described how he had sent the members of the jury testimonial letters from artists as well as photographs comparing his model and his figure, and how his packet of evidence had been returned unopened. "I ask you to hold another inquiry, which will vindicate me in the eyes of artists and reinstate me after the blows I received in 1877." Rodin also asked that the state pay for a bronze cast, a much bolder request than the one he had addressed to Chennevières—simply the purchase of a plaster.

Turquet's responded positively, and in the first week of February 1880 a committee of administrators and critics went to Rodin's studio to examine the work. Although they said they did not believe the statue to be cast from life, their report was as devastating as if they did: "We do not think that there is any justification for having this work cast in bronze; the comparison with a terra cotta model of a Saint John the Baptist which we saw in the artist's studio confirm us in this opinion, that M. Rodin, without the assistance of the literal translation that direct casting from life permits, is not yet capable of modeling correctly the ensemble and the details of a figure."[22]

Two weeks later a second report, this one signed by six sculptors, appeared on Turquet's desk. These men—Dubois, Falguière, Carrier-Belleuse, Chaplain, Thomas, and Delaplanche—said they had looked at everything in Rodin's studio, especially *Saint John* and *The Age of Bronze*. They found the works to be "a testimony to an energy and a power of modeling that is rare and of great character. We express our unanimous and sincere appreciation in order to put an end to the accusations of the figure being a cast from life. This is absolutely in error."[23] A more distinguished group of sculptors could hardly be found. It was the first significant sign of professional acceptance in Rodin's life.[24]

Turquet chose to honor the second opinion. He put an order through for a bronze cast to be made by Thiébaut Frères. The state paid Rodin twenty-two hundred francs for his statue. It was the most money he had ever earned. (Bartlett referred to it as "the modest sum of three hundred dollars.")

Rodin was delighted that Turquet was head of the fine arts administration. By 1880 this view was not shared by most other artists in Paris. They were particularly angry about Turquet's handling of the Salon. A writer for the *Courrier du soir,* Numa Costa, said that "when Turquet came there were some souls who imagined we finally had a director of fine arts who did not believe he was the messiah with a heavenly mission, that he would not be so pretentious as to try to direct the imagination of artists. The

46) Rodin, *The Age of Bronze*. 1875–77. Bronze cast by Thiébaut
Frères, 1880. Placed in the Jardin du Luxembourg in 1884, where it
remained until 1901, when it entered the Musée du Luxembourg.
Paris, Musée d'Orsay.

illusion was short-lived" (Jan. 13, 1880). As far as Costa could see, the first thing Turquet did when he settled into the Fine Arts office in the rue de Valois was to pack it with people willing to leap forward and shout: "You are a great spirit and you must save art before it dies."

Turquet made sweeping personnel changes, both in his own office and at the Palais des Champs-Elysées. He replaced the longtime organizer of the Salons, Frédéric Buon, with Georges Lafenestre. Helpful and familiar staff to whom the artists had grown accustomed suddenly disappeared. Then Turquet gave no warning that he was having electric lights installed in the exhibition space, lights that affected the way the colors in the paintings looked. He admitted works that had not been seen by the jury; worst of all, he changed the rules. The artists particularly disliked his new way of grouping works for the purpose of installation. Instead of the old alphabetical order, he put them into "les groupes sympathiques." One such congenial group was that of the prize winners, whose works were exhibited in special rooms, thus establishing a new elite. As for the rest, the public had no idea how to locate the works they had come to see in the new installation. In protest to these changes, three jury members, including Bouguereau, president of the painting section, resigned. Quarrels and accusations rose up from every side about the manner of displaying 7,289 works of art, more than had ever been seen before, more than anyone could handle, or ever wanted to see.

Chennevières, Turquet's adversary and critic, described the chaos of the Salon of 1880 as a "tohu-bohu sans nom" (indescribable hubbub).[25] A cartoonist satirized Turquet by visualizing Prudhon's *Crime Pursued by Justice and Vengeance* with Turquet as the criminal, one foot in a bucket of paint, the other rupturing a canvas, while pursued by an artist and a critic who cover him with ink and varnish. A writer for *Le Grelot* composed a song in two parts: "Before the Opening of the Salon" and "After the Opening." The refrain of the first part was, "Turquet, responded Lafenestre, Blond Turquet, you are absolutely right." In the second part, it changed to, "Que *Turkey*, répondit Lafenestre, en anglais, veut dire dindon" (What *Turkey?* responded Lafenestre. In English, that means turkey).

With the Salon of 1880, the dissatisfaction of generations of artists reached a peak. They could no longer endure the state standing between them and their public. Such a situation did not exist for writers, musicians, or actors. Why did artists have to submit to administrative control? A meeting was called for December 13, 1880. Turquet, angry at the abuse heaped upon him, approached this delicate encounter in an unbending mood. Coldly, he rose to make an announcement: henceforth artists themselves could organize the Salons. When he said what he had come to say, Turquet stalked out of the chamber. Eugène Guillaume, the former director of the Ecole des Beaux-Arts, was the first to recover his voice: "Well, we've been thrown in the water, so let's swim." The upshot was the Société des Artistes Français, the statutes of which eventually were approved on June 15, 1882.

Rodin was probably one of the least dissatisfied artists who exhibited in the Salon of 1880. He proudly showed *The Age of Bronze* in bronze, now a purchase of the state,

47) "New and Happy Arrangements for the
Opening of the Salon: Crime Followed by
Vengeance." Cartoon satirizing the artists'
objections to Edmond Turquet's innovations
in the Salon of 1880.

along with *Saint John* in plaster. The daily press and the prestigious art magazines paid
attention, particularly to *Saint John,* using words like "strange," "mysterious," "origi-
nal," "primitive." One critic accused Rodin of being a slave to anatomical detail and
wondered where he had found the model for *Saint John,* "the worst-built man in the
world" (*Le Figaro,* May 5, 1880). But no one mentioned the word *cast* any more, and
one man, M. Gaïda, said that the figures made one dream of Dante and Michelangelo.

Rodin was surely pleased, even with his beautiful statues being badly placed—as they
were—in the worst Salon of the century. He could begin to look forward in a way he
had never been able to before—forward to his fortieth birthday, to the 1880s, and, most
important, to a growing friendship with the undersecretary of state for fine arts.

In 1907 Antoine Bourdelle said of *The Age of Bronze,* "It was him, Rodin, it was his
soul!"[26] Similarly, Bartlett believed *Saint John* had "little to do with any biblical pur-
pose," but was the sculptor as a "chieftain heralding the coming of a new force in art."[27]
Rodin made a brilliant choice when he decided on the subject of Saint John. It was
acceptable in the conventional terms of the Salon, while at the same time enabling him
to make a statement about himself as forerunner, innovator, outcast, and martyr. He
could only have known this dimly, but surely it was true. In 1880 Rodin came out of the
wilderness.

The Republic of France. When Rodin left in 1871, they were just words. When he returned in 1877, the Republic was a reality; France had become a nation with a constitution, a parliament, and a president. Were ordinary citizens pleased about their new system, or did they regard it simply as the form of government that would serve until the next monarch came along? Probably the majority tended to be "passive" Republicans rather than "true believers."

This attitude changed at the beginning of 1879, when the January elections put a Republican majority in the Sénat, prompting the royalist president, MacMahon, to resign. His successor, Jules Grévy, was a true Republican whose first act was to move from Versailles into the Elysée Palace in Paris. The legislature soon followed: deputies to the Chambre des Députés on the quai d'Orsay, senators back to the Palais du Luxembourg (displacing the city administration, which had been housed there since the burning of the Hôtel de Ville during the Commune). *La Marseillaise* became the national anthem and July 14, Bastille Day, the national holiday.

The creation of a republic called for some kind of visible commemoration. It is difficult in the twentieth century to comprehend the quasireligious need nineteenth-century people had for monuments to portray the meaningful events in their lives. Even in revolutionary circles, people wanted something more than the throwing off of past conventions. In an editorial in a Jacobin newspaper of 1870, we read: "We will not lay down our rifles until the beaten and battered Prussians have recrossed our frontiers, and until, returning victorious to our household hearths, we find there a statue of proud demeanor on a bronze plinth on which we shall read the words: To Paris, from a grateful France."[1]

The first three-dimensional sign of the Republic's existence was a temporary image by Auguste Clesinger for the Exposition Universelle of 1878. It showed the Republic holding out her arms to welcome visitors. Jules Castagnary read it as the "opportune moment to prove to foreigners drawn to Paris by the Exposition Universelle that the Republic, now definitively established, can display its image in public places." He could hardly believe that the Republic had endured for seven years without a statue to give shape and a sign to its existence.[2]

The initiative was taken the following year, not by the national government, but by the Conseil Municipal of Paris. In March it voted to open a competition for a "monument to the Republic" and published specifications for a traditional personification, which was to be colossal and standing. A twelve-member jury presided over by the prefect of the Seine expected to review the maquettes on October 6. The winner would

receive twenty-five thousand francs and the city would have the winning model enlarged and cast in bronze for the place du Château-d'Eau, which would be renamed the place de la République. There was a general sense that the project would foster an atmosphere of reconciliation. It was to be a peace offering from city to state, a sign that the wounds of the Commune had healed, that Paris and France were one.[3]

The council established a second project in April, one that was more specifically Parisian. It wanted to commemorate the courage of the city's residents in defense of Paris in 1870. The men of the Conseil Municipal interpreted the heroism of Parisians as laying the groundwork for the birth of the Third Republic. For them, the resistance of Paris was key to the awakening of a new France. The monument would be erected at the rond-point de Courbevoie in the western suburbs, where the defense of Paris had been mounted in 1870. There was another reason as well for the choice of the site. In 1870, Léon-Michel Gambetta, as minister of the interior in the Government of National Defense, had ordered the statue of Napoléon at Courbevoie taken down and dumped in the Seine, leaving an empty base. The council planned to replace it with an allegorical group to symbolize the "Defense." They asked for two figures and maquettes were due by November 5. The winner of the competition would receive fifteen thousand francs.

Even more than the Salon, public monuments were central to a sculptor's reputation in France. How can we imagine the great Rude without the *Marseillaise* or Carpeaux without his group at the Opéra or his figures on the Fontaine de l'Observatoire in the Jardin du Luxembourg? Even a runner-up in a major competition was assured of future commissions. Rodin was poised to take advantage of this opportunity. He had little help in his studio and could scarcely afford to work for no pay on a competition maquette. A Carrier-Belleuse could easily enter both competitions, but Rodin had to choose, and he decided on *La Défense.* It was slightly less prestigious than the monument to the Republic, but it offered more latitude for an imaginative interpretation.[4]

The seventy-eight submissions for the monument to the Republic were judged in October. Of the three finalists, the jury selected a maquette by Léopold and Charles Morice for a Republic crowned with laurel, raising her arm so that all could see the olive branch in her hand. Eugène Véron, shocked at its mediocrity, launched an attack on the jury system, which, as far as he could see, always resulted in compromise. The more talent an artist had, the more strongly he stated his artistic personality, the more likely it was that some jurors would oppose his work.[5] Many people agreed with Véron, for it hardly went unnoticed that the one sketch of true genius—that of Jules Dalou, a former Communard who still resided in exile in London—had received few votes.

Although less money and prestige were connected to *La Défense,* the competition attracted more entries and better artists. A hundred of them carried their models to the Ecole des Beaux-Arts in November; some even brought two. Most of the best sculptors living in France came forward, as well as a large number of unknown artists. Rodin, arriving with his sketch to exact specifications—two figures, each two and a half feet high—did not exactly fit into either category.

Until this time, a combination of insecurity and perfectionism had caused Rodin to

48) Rodin, head of the warrior from *La Défense*. 1879. Plaster.
Musée Rodin.

work slowly and carefully, but this maquette, by necessity, was done in a hurry. Like most of the other entries, it consisted of a female allegory juxtaposed with a male combatant. Rodin envisioned her as a fighting Genius of Liberty wearing a Phrygian cap and elevating her body in the air, much as Carpeaux had elevated his Genius of the Dance. The dying warrior leans against her lower body, his twisted left arm holding a broken sword. The force of the work depends on ever-changing rhythms and profiles that move back and forth, punctuated by sharp angles. Liberty emits a shattering cry, hurling two clenched fists into the air and furiously flapping her strong wings. Rodin's work is not pretty; the limbs of the figures are big and blunt, and the surfaces are more roughly modeled than anything he did before. He barely articulated the warrior's face. Deep holes containing circular knobs for eyes are punched on either side of a twisted

lump of clay that serves as a nose. The mouth is nothing more than a gash in the clay.[6] The face is pulled back, indicating that Rodin did not intend it to be seen.

When the jurors assembled on November 29, they noticed that thirty-one of the one hundred submissions violated the guidelines by including more than two figures. Rather than excluding these entries across the board, the jury adopted a flexible approach and allowed the multifigure groups to remain. The first cut in submissions reduced the contestants to twenty-six. Rodin and Fourquet, who had also submitted a sketch, were eliminated at this point. The next cut was to eleven. Finally, three names emerged: Ernest Barrias, Alexandre Lequien, and Mathurin Moreau. To make the final decision, the jury asked for larger models. In May, Barrias became sculptor of *La Défense*.

49) Louis-Ernest Barrias, *La Défense de Paris*. 1879–80. Plaster model. Paris, Dépôt des Oeuvres d'Art de la Ville.

Barrias' background was not unlike Rodin's. Born in 1841, he came from a family just as modest in its means as the Rodins. They, too, discovered their son had an extraordinary capacity for modeling clay. But the similarities end in 1858, when Barrias was accepted at the Ecole des Beaux-Arts. Seven years later he won the Prix de Rome, which exempted him from military service, so he did not have to experience Rodin's anxieties about the lottery. Nevertheless, when war broke out, Barrias, determined to fight the Prussians, returned home to join the *mobiles* (national guard) of the Marne and to fight in the siege of Paris.

50) Albert Carrier-Belleuse, *La Défense de Paris*. 1879–80. Plaster.
Paris, Hôtel Carnavalet.

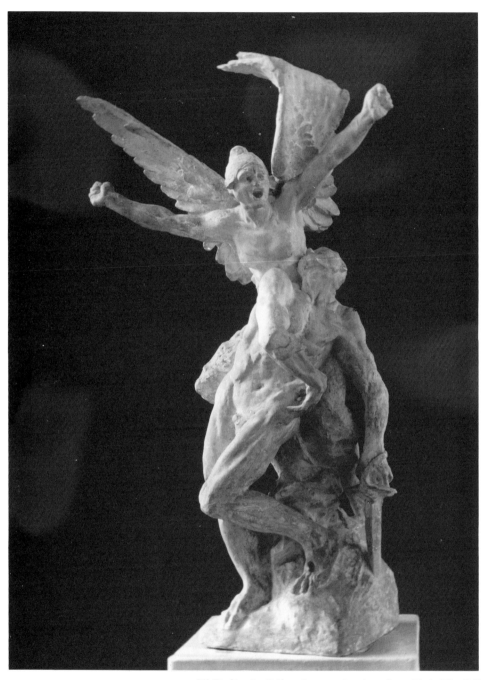

51) Rodin, *La Défense* (conventional modern title is *The Call to Arms*). 1879–80. Plaster. Musée Rodin.

Barrias won the prize with a sketch composed of an allegorical figure of the city of Paris wearing the uniform of the National Guard, holding the flag of the city, and leaning on a cannon. At her feet is a tattered mobile still holding his rifle. Huddled behind the two figures we find a shivering girl, symbol of the people of Paris in 1870. Although the group was conceived as an allegory, the details were realistic and contemporary. Barrias, Moreau, Lequien, and Carrier-Belleuse, as well as a number of others praised by the judges, focused on events in the outskirts of Paris in the winter of 1870. It was important to show the presence of the mobiles, for it was they, not the regular army, who had mounted the defense of Paris. Thus every button, hat, water canteen, and weapon had to be correct. The flag was especially critical, for who did not remember the men who gave their lives that the French flag not be defiled?[7]

To understand why Rodin's maquette was eliminated from consideration, we need to look more closely at its subject than at its style, although the latter certainly jarred with the contemporary sense of decorum. Rodin was not a bit interested in the actual

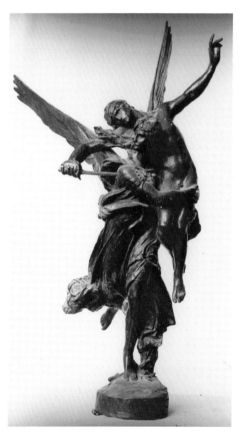

52) Antonin Mercié, sketch for *Gloria Victis*.
1872. Bronze by Barbedienne. Paris,
Musée d'Orsay. Photo R.M.N.

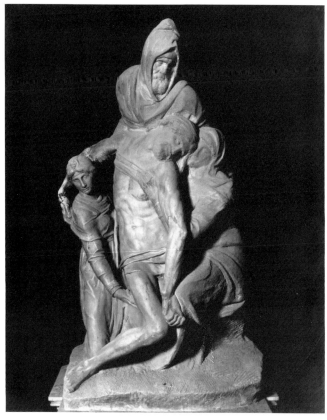

53) Michelangelo, *Pietà*. 1540s–1555. Marble. Florence, Duomo.

defense of Paris. He.had grander ideas about the universal idea of the death of the hero and the fury of a nation under siege. Rodin simply did not consider the political climate in which he was working. His priorities were artistic, and for this he paid a price—one that he would pay over and over again throughout his career.

In *La Défense* (its conventional modern title is *The Call to Arms*), Rodin was concerned with creating a dynamic work that would hold the viewer's attention through movement and expressive content. He also wanted to make his sources obvious, so that the public could know the context in which they were to consider him as an artist. Carpeaux had the same feeling when he put his *Ugolino* into the Salon. He wanted the public to think of the Hellenistic *Laocoön* and of Michelangelo. A winged allegory supporting a dead warrior with a broken sword immediately brought to mind the most spectacular sculptural group created thus far in the Third Republic, Mercié's *Gloria Victis*, which had been so prominent at the Exposition Universelle of 1878. Rodin consciously executed the same subject as Mercié, but he invested it with harsh pathos

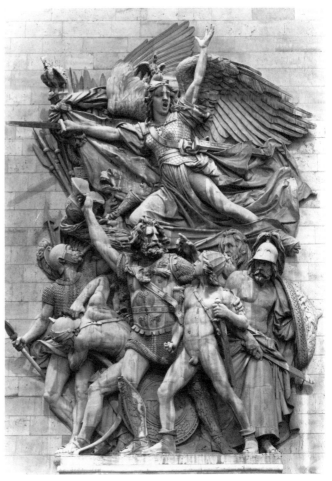

54) François Rude, *The Departure of the Volunteers of 1792*. 1833–36.
Stone. Paris, Arc de Triomphe at Etoile.

rather than the noble beauty of Mercié's classical allegory. For his dead soldier, Rodin
went to a glorious source: the Christ in the Florence *Pietà* that Michelangelo carved for
his own tomb. Rodin played with the figure and changed it a good deal, but the
reference to the work of his "master" is unmistakable. The principal spirit of the work
comes from Rude's great figure in *Marseillaise,* with her outstretched arms and stupen-
dous "call to arms." This relief on the Arc de Triomphe was the national image par
excellence. When Véron reviewed the sketches for the monument to the Republic, he
reminded people that "modern sculpture has found nothing to correspond to the inspi-
ration of the *Marseillaise.*" Rodin was glad to give it a try. As Sophie Frémiet Rude
modeled for her husband's Genius, Rodin's Rose Beuret posed for his. A story circu-
lated in the ateliers of Paris that whenever Sophie's pose went slack, Rude commanded,

"Yell louder." It is not hard to imagine Rodin giving Beuret the same order. And, of course, when he envisioned making the connection between his work and the great relief of the 1830s explicit, he was highly conscious of the relationship between the Arc de Triomphe and the rond-point de Courbevoie, for you could see one from the other.[8]

Such an iconographic conception, which today seems quite compelling, was not at all what the Conseil Municipal had in mind. For them the goal was to erect a monument in the rond-point de Courbevoie that spoke directly and clearly about the reality of the struggle through which Parisians had lived only recently.

The city government offered a cornucopia of commissions for sculptors in 1879. Another of their concerns was statuary for the *mairies*—the town halls—of the twenty arrondissements of Paris. Napoléon III had doubled the size of the city by incorporating towns on the periphery, each of which had a new municipal building that housed the police headquarters, administrative offices, and national guard. They also served as social centers and secular churches where marriages could take place. In the new republicanized state, every mairie would require an image of the Republic.

Rodin competed for the Thirteenth Arrondissement. Again Beuret modeled. Whereas in *La Défense* his focus had been anger and energy, here his vision required a brooding and unyielding image, so much so that Rodin's "Republic" was long ago baptized *Bellona*. There is a suggestion of epaulets across the female figure's shoulder, and a bit of drape covers her breasts and head. Instead of the Republic's Phrygian cap,

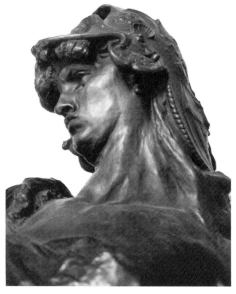

55) Rodin, *Bellona*. 1879. Bronze.
Musée Rodin.

Rodin gave her a rich Renaissance casque casting the deep-set eyes into permanent shadow. The elements seen in Rodin's head did not add up to the Republic as she was viewed in 1879, so it is not surprising that one critic remarked: "No, it is certainly not here that we find our amiable Republic."[9] Maurice Agulhon has pointed out that by this date what French people must wanted were images that furthered "the calming power of Reason rather than on the fervent call to permanent battle."[10] Rodin's choices were neither amiable nor calm. Whereas Barrias was ready and willing to work with the politics of sculpture, Rodin's choices were wholly artistic. In 1887, when Bartlett asked him about these competitions, Rodin said that he probably should never have entered them in the first place.[11]

The next prize in the hands of the municipal leaders was an enterprise that would involve hundreds of sculptors: the new Hôtel de Ville to replace the building that had burned to the ground during the Commune. It would be in the same Renaissance style as the original structure, and it was important that it "speak" the right civic language, the language of the Republic. The Conseil Municipal wanted thirty-one statues of female figures—allegories representing the major cities of France. Paris was to be seen in the context of the rest of the country, yet her primacy was never in question. Figures of 102 famous men and 6 famous women born in the capital were also to be included. No competition was held, even though that would have been the "republican" way of allocating the work; it was feared that competition would ruin the spirit of harmony. Sculptors were simply to petition for the privilege of submitting a model. Finally, Rodin had a chance.

A special commission was named on May 10, 1879.[12] Rodin quickly sent off a petition to the president, calling attention to his honorable mention in the Salon and saying that he would be happy to do a "bas relief, a decorative head, a *mascaron*, a statue, or any kind of accessory or ornamental motif."[13] In June Carrier-Belleuse wrote a letter in support of Rodin's petition, and the following February Rodin requested a letter of recommendation from M. Garnier, the furnace maker of whom he had made a bust in 1870. Finally, in the fall of that year, Rodin received a commission: he was assigned to sculpt the eighteenth-century mathematician and philosopher Jean le Rond d'Alembert. Fourquet got the nineteenth-century painter Delaroche. Each received four thousand francs, the standard payment for a statue at the Hôtel de Ville—almost double what Rodin had received for *The Age of Bronze*. Given Rodin's need for work and money, he must have been delighted, even though he was hardly interested in creating a figure wearing eighteenth-century costume.

Throughout 1879, before the purchase of *The Age of Bronze* and the Hôtel de Ville commission, Rodin was desperately poor. He was forced to seek his third engagement with Carrier and to pursue work outside of Paris. In August he went to Nice to work with Charles Cordier, a talented sculptor whose work was much in vogue during the Second Empire, on a decorative program for the Villa Neptune on the Promenade des Anglais. Next he went to Strasbourg to do more houses, more ornaments.

56) Auguste Rodin at about age forty (usually identified as
Jean-Baptiste Rodin). Photograph by J. F. Jouin. Musée Rodin.

Without these trips we would know little of Rodin, Beuret, and their life together
after they returned from Belgium. His letters home reveal a playful, affectionate side of
Rodin, a man alive to the pleasures of the eye: looking at the sea, the oleanders, the
indolent sailors strolling the quais, the beautiful women of the South ("I hope it doesn't
make you angry that I tell you," he apologized to Beuret), the funny way the Germans,
both men and women, wore their hair. Food and wine were lifelong pleasures for
Rodin, but he told Beuret he would have to be careful because the *vin du pays* went to his
head. In Marseille he recalled his visit with Léon Fourquet more than ten years earlier;

57) Rose Beuret in her late thirties. Photograph by E. Graffe and
A. Rouers. Musée Rodin.

he wanted Rose to tell Léon that he was thinking of him. He went swimming for the
first time in his life. Characteristically cautious, he kept his back to the waves and held
on tightly to a cord: "If I had the courage to go swimming every morning, I would
become strong. But it's a little cold when you are not used to it." Rodin had his usual
worries about money—"We are in a period when we both must save"—and he re-
minded Beuret to take care of his father. He sent a special message for Auguste Beuret:
what he wanted most from their thirteen-year-old son were notebooks filled with
drawings for him to look at when he returned.

The most important thing we learn from these letters is that the friendship between
Rodin and Rose Beuret was wondrously alive—and still sexually charged: "I don't
know what to do alone in the night, so I get up at 4 a.m. and work, . . . Ah, *petite* Rose, I
wish that a good fairy would pick you up in the air and bring you to me because I want
so much to . . . oh, but I was on the verge of saying silly things." Rodin's second letter
from Strasbourg makes it clear that he has heard from Beuret and that she was unhappy,

presumably because she missed him. He tried to get her to write more often and to tell him everything: "What you eat, drink, what time you go to sleep, tell me what you do with your money—now, don't get angry. I'll come back soon or I'll send some." There is an echo here of a letter he once wrote to Maria, expressing the same desire for moment-by-moment intimacy. But Rodin could not seem to grasp Beuret's difficulty with writing. He complained that she had written only once and had not even filled the whole sheet of paper: "Were you afraid to stay a little longer at the desk?" asked the hard taskmaster. Their relationship continued to be loving, if not totally comprehending.

By the end of the year Rodin was home. In December he paid a visit to Pierre Baragnon, a critic for the *Courrier du soir*. On December 14 Baragnon dropped him a note accepting Rodin's offer of "a little terra cotta in exchange for an article that can help you sell your beautiful marble of the 'Orpheline.'" In 1879 Rodin needed whatever help he could get. This exchange marked the beginning of his long and successful history of dealing with the press. As he became more experienced, he also became more subtle.

On January 11, 1880, Rodin visited the offices of the fine arts administration and reintroduced himself to Edmond Turquet. We already know of the successful outcome of that visit: the state's purchase of *The Age of Bronze*. But much more was to come from this fruitful encounter. Turquet would give Rodin a bigger opportunity than he could have ever dreamed possible.

58) Undated letter from Rose Beuret to
Auguste Rodin. Musée Rodin.

Chapter 12
Why Was Rodin Commissioned
to Make the Doors?

The Turquet-Rodin meeting produced one of the seminal works of relief sculpture in Western art: *The Gates of Hell,* originally commissioned for the entrance of the Musée des Arts Décoratifs. In his 1887 interviews with Truman Bartlett, Rodin provided the basis for posterity's view of the commission: "It was a valiant thing for Turquet to give Rodin the doors in face of opposition of the Institute" (the Institut de France, of which the Académie des Beaux-Arts is one of the five classes); "Every masterpiece is the result of a martyrdom"; and "Rodin says Turquet created him."[1] In the same year, Turquet told Bartlett: "I was sure . . . that I had discovered a great artist, one fully capable of executing any task confided to him. The result, as is now well-known, has amply confirmed my judgment."[2] In these accounts Turquet stands out as an administrator with unique taste, a penchant for risk, and the courage to stand up for an unknown artist in whom he believed—in other words, a heroic figure.

Strangely enough, the door was intended for a building that did not exist. In his excitement at being commissioned to do a bronze door—one of the most coveted assignments a sculptor could receive—Rodin apparently ignored the risk he ran in accepting it, for how could he be sure the building would materialize? As he told the story: "It is to M. Turquet that I owe this commission. . . . At that time it was a question of constructing a palace for the decorative arts on the place where the old Cour des Comptes once stood—what is the Gare d'Orléans today. They proposed for me to execute a monumental door that would be included in the project of the engineer, Berger. I accepted and, with the consent of M. Turquet, I decided to make *The Gates of Hell.*"[3] Rodin's wording was intentionally vague, for in fact when he accepted the commission, no one knew where or when the museum would be built. The intention to build the Musée des Arts Décoratifs on the site of the former Cour des Comptes was not made clear until 1882, two years after Rodin received the commission.[4] In the end it was never built. Why the undersecretary of fine arts wanted a potentially superfluous bronze door is a mystery. The answer, as is so often the case in France, has to do with politics and is embedded in the history of the decorative arts movement of the second half of the nineteenth century.

French recognition that a museum of decorative arts ought to exist dates from 1851 and the Universal Exhibition in London. On this occasion the decorative arts came to the fore as being central to competition among the Western nations. Charles-Ernest Clerget was a French delegate to the exhibition. When he returned to address the Comité Central des Artistes Industriels in Paris, his basic message was: "We need to

create a museum of industrial arts."[5] From the beginning this idea was couched in terms of international competition, particularly with Great Britain. The 1857 opening of the Museum of South Kensington (later renamed the Victoria and Albert) only intensified French desire for a museum of decorative arts.

The energy for the foundation of such an institution came from the Union Centrale des Beaux Arts Appliqués à l'Industrie (Central Union of the Fine Arts Applied to Industry), a group founded in 1864 by commercial artists, ornamental sculptors, metal workers, and designers. Its headquarters were in the place Royale (now the place des Vosges), in the quarter where many of the Parisian craftsmen had their studios. Rodin knew and admired at least one of these organizers, Jules Klagmann, a gifted ornamental sculptor who worked in a Romantic style. Rodin knew all about the union; he may even have participated in some of its activities.

The need for a decorative arts museum came into focus even more sharply after the war of 1870–71, when some of the finest woodwork, furniture, textiles, and ceramics of the ancien régime were destroyed. This immense loss prompted a new group to champion the cause. In contrast to the artists and artisans who had led the movement until then, they were aristocratic collectors, many of whom specialized in the decorative arts of the eighteenth century. Thus, what had started out as a producers' association was taken over by a wealthy group of amateurs who wished to preserve works of art and to educate the citizens of France in the elegant beauty through which they themselves defined the achievements of French genius.[6]

In 1876 the Union Centrale opened a national subscription for the creation of a museum of decorative arts. They placed full-page advertisements in *L'Art* which opened with the statement that twenty years earlier France's superiority in all the arts had been unquestioned. Today, however, "the Ministère de Commerce announces that our exports are dropping in comparison to those of our competitors, and especially in comparison to England, whose exports are on the rise." A museum of decorative arts had become not just a matter of artistic glory, but also of millions of francs every year. The question was, how could France regain its superiority? The answer was all too clear: "Do what England did—spread a feeling and a taste for the arts throughout the land by a process of intelligent education, by accumulating chefs d'oeuvre in a museum where everyone can see them, study them, and compare them to each other. England founded South Kensington; France will now found a museum of decorative arts."[7]

In 1877, the Society for the Musée des Arts Décoratifs was founded under the leadership of the duc d'Audiffred-Pasquier. As director of fine arts, the marquis de Chennevières recommended the government recognize the new society, which was looking for a suitable location for the museum. He himself favored the Jardin des Tuileries.[8] When Chennevières resigned in 1878, he became an energetic and outspoken member of the society's Committee of Directors. His first major effort was to mount an Exhibition of Old Master Drawings of Decoration and Ornament. He included examples from his own splendid collection, as well as from those of Edmond de

Goncourt, the duc d'Aumale, the comte de la Baudrière, and Alexandre Dumas. These wealthy collectors were determined to educate public taste. They mounted their show in the galleries of the Louvre and then moved it to the Palais de l'Industrie, where it ran concurrently with Turquet's notorious Salon of 1880. The two shows closed on exactly the same day—June 20. Clément de Ris, in the May *Gazette des beaux-arts*, called the drawing show "the *lion* of 1880." And all the credit went to Chennevières.

Not only had Chennevières and his aristocratic friends made off with what had once been an artisan's project and by rights should have become a project of the Republican left, but he stole Turquet's thunder in 1880. To add insult to injury, he was the instigator of the most offensive views of Turquet that appeared in the press that spring.

One area of French decorative arts that had come in for unusually strong criticism in the early years of the Third Republic critic was porcelain and ceramic ware. A French critic who traveled to Philadelphia in 1876 to review the Centennial Exhibition immediately recognized the work from Britain as much handsomer than anything in the French exhibit. "Particularly in ceramics their progress is noticeable, and it threatens our factories in a most unkind competition."[9]

Thus Republican politicians came to focus on Sèvres, which had been the national manufacture of porcelain since the eighteenth century. Actually, the very word *Sèvres* had become synonymous with bad taste; it conjured the image of graceless forms covered with bouquets of flowers that bore no relation to the shape on which they were painted. What happened at Sèvres is critical, however, to understanding Rodin's commission for the door of the Musée des Arts Décoratifs, for Sèvres was not only an important chapter in France's struggle to reestablish its decorative arts, it was also the place where Rodin was employed in this period and where he made the contacts that set him up for the commission.

The government, in its move to reorient the entire production at Sèvres, appointed Carrier-Belleuse artistic director in 1875. Shortly thereafter the factory moved to new buildings on the edge of the Parc de Saint-Cloud. Its inauguration in November 1876, in the presence of President MacMahon, Minister of Public Instruction William Waddington, and Léon-Michel Gambetta, president of the Budget Commission, was a major event.

At the Exposition Universelle of 1878, critics thought they saw some change in the porcelain, but they still complained about dead colors and transparencies (the superimposed colors) that did not work; many saw Sèvres as caught irreparably in a routine of producing undistinguished, lackluster porcelain. Again the government looked for new personnel and hired a chemist, Charles Lauth, to work with Carrier. Lauth reorganized the departments, changed the ways in which artists were paid, and initiated experiments with paste, color, and glaze. His most significant contribution was the discovery of a "new porcelain" (*pâte nouvelle*) that could be fired at lower temperatures, making available a wider range of colors.

Lauth told Carrier that they needed new artistic talent, and Carrier came back with

four names: Sevestre, Maugendre, Dubois, and Rodin. He called Rodin his own student and asked that he receive three francs an hour, whereas the others could be paid less. Further, Rodin would come in only two days a week, while the others would work four.[10] By 1879 Carrier seems to have forgotten the rancor of the Belgium days. When Lauth questioned the recommendation, Carrier responded with amazing generosity: "M. Rodin is an artist of considerable merit and unusually flexible talent. Because of this we must find the way to apply his talent to our new problems. At this moment he is learning to draw in the ceramic paste, and, since he draws to perfection, on the day he masters the technical side of things, a day that will come very quickly, we shall have discovered a new way of working, a way of engraving figures into the porcelain and that will be very interesting."[11]

Rodin quickly mastered the *pâte-sur-pâte* technique, which involved adding a specially prepared clay to the unfired pots. He attempted to refine it by engraving on the surface of the pots and drawing directly on the thick ceramic paste before the glaze was applied. He would then reinforce the design with paint to heighten the effects. Though only a few vases resulted from these experiments, Rodin's designs of putti at play,

59) Rodin, Sèvres porcelain. Musée Rodin.

couples with arms and legs twisting about each other's bodies, and mythological figures romping across the ceramic surfaces of Carrier's newly designated shapes, constitute a rich ensemble. Carrier must have felt well rewarded for the confidence he showed in his "student," even though Lauth continued to have doubts about giving Rodin special treatment.

One of the members of Carrier's new team of innovative artists was a modeler and decorator named Taxile Doat. In the early twentieth century, when Roger Marx was writing his book about Rodin's work at Sèvres, he contacted Doat, still working at Sèvres, to ask what he remembered of Rodin when he was at the factory. Doat's reminiscences give us a picture of Rodin in all his enthusiasm: how he would leave the rue Saint-Jacques at dawn, walk across the city to the southernmost loop of the Seine, then follow its bank to Sèvres, where he would arrive "drunk with the freshness of morning." Once he entered his atelier, he was in another world. He worked with such intensity that when the lunch bell rang and Doat came to get him, "Rodin would look surprised. Then slowly, very slowly, his eyes wide and still focused upon the object in his hands, he would detach himself from his work, as if he was sorry to be woken from the dream that filled his head." [12]

Rodin loved working at Sèvres. The facility was excellent and it allowed him to experiment in an area where, thanks to his education at the Petite Ecole and his years of apprenticeship during the Second Empire, he was superbly trained. Being at Sèvres even fulfilled a certain idea that his father had had for his career (see chapter 1). How much Rodin enjoyed being part of the Sèvres group became clear in 1885, when Lauth, noting that he had done no work in several years, tried to have his name taken off the list of part-time personnel. Rodin immediately went to the undersecretary of fine arts to have the decision reversed. He returned to Sèvres in 1888 and put in some time there every year until 1893. He was there again in the last three years of the century.[13]

Much more important for Rodin's future than the success of his work at Sèvres was a personal encounter with a family by the name of Haquette. The father was Théodore, the accountant for the factory; his wife was a professional actress and they had two sons, both in their twenties. Maurice started working at the factory as his father's assistant in March 1879, shortly before Rodin arrived in June. When Théodore retired in July, Maurice went to work for Lauth. The younger brother, Georges, taught painting in the factory's art school. Georges was the most critical contact for Rodin because he was married to the sister of Edmond Turquet's wife.

After Rodin's period at Sèvres, he saw little of the Haquettes; they did not remain close friends. But the family's role in helping him obtain the commission for the door of the Musée des Arts Décoratifs cannot be overemphasized. From time to time Rodin and Beuret went out socially with Georges and his wife. His relationship with Maurice was more complicated, based as much on need as on affection. Part of Maurice's job was to carry messages from Sèvres to the Ministère des Beaux-Arts in the rue de Valois. For Rodin, this became a valuable conduit of information. Maurice needed Rodin as well,

for he seems to have had few friends. At one point he spoke of having "encountered animosity from every side during the entire time I have worked at the factory."[14] Rodin did befriend him and even lent him money. The two men also had fun together, as a curious document in the archives of the Musée Rodin attests. On a stiff roll of paper, Maurice drew crossed papal keys in bold purple and at the bottom signed his name in a splash of red: *Mauritius princeps Haquettis*. In the document he refers to Rodin as "Rodin-din-dron" (rhododendron) and explains that he has been excommunicated, thus losing his privilege to eat either bread or salt and to keep company with his fellow men. Why such punishments? The document states mysteriously, "For six months he has wanted to wash a medal," and "Last Monday, November 29, he made us pose until one o'clock." The second reason at least is clear, for Rodin was making a portrait of Maurice Haquette.[15]

The Haquettes sang Rodin's praises to the most important arts administrator in the country, Turquet, who was already well disposed toward him. Turquet must have been in a fine frame of mind in the fall of 1880, in spite of his misfortunes of the previous spring. On September 25 President Jules Grévy selected Jules Ferry, who had been the minister of public instruction and thus Turquet's immediate superior, to take charge of the government and form a new cabinet. Turquet enthusiastically sent a report to Ferry describing the programs he wanted to push forward. He planned to commission decorative work for provincial buildings on a vast scale: city halls, theaters, schools and universities. He described his plans for the annual exhibitions in the Palais des Champs-Elysées for artists of every country and school. He knew it was important to strive to bring such a large number of ill-matched works into an orderly arrangement, and he would do it. He also intended to commission monumental works of art that would be of interest to the public and placed in important locales in Paris.[16]

Ferry already knew of this last intention. Only a few weeks earlier, when he was still at Instruction Publique, Turquet had put a commission for a "decorative door destined for the Musée des Arts Décoratifs" on his desk. It appears that Turquet had begun planning the commission in the spring, during the difficult period of the Salon when he was the focus of so much criticism. Almost no one knew about his idea—but the Haquettes knew, and they did everything in their power to keep the interests of their friend in view. By June, Turquet and Rodin had an agreement. Georges Haquette wrote a note for Rodin to take to Georges Hecq, the chief secretary at the Ministère des Beaux-Arts: it will "facilitate your access," he explained. On July 1 Hecq wrote directly to Rodin:

Monsieur

It is my pleasure to tell you that you are authorized to use atelier M with M. Osbach at the Dépôt des Marbres, 182 rue de l'Université, for the duration of time that you need to carry out the work.

Hecq

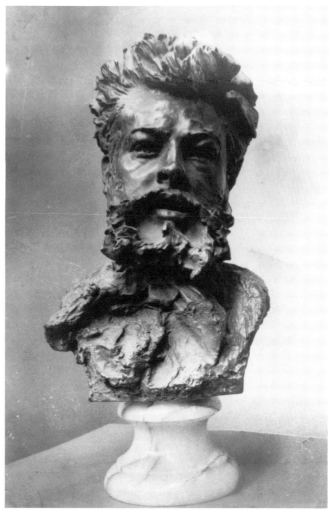

60) Rodin, *Maurice Haquette*. 1880 (previously dated 1883). Bronze.
Photograph by Eugène Druet. Musée Rodin.

When the final piece fell into place, again it was Georges Haquette who let Rodin know that everything had worked out as they had hoped: "You can sleep with peace of mind now. I just learned that your commission has been signed by the prime minister." On August 16 Ferry put his signature on the decree charging Rodin with the production of a model for a decorative door destined for the Musée des Arts Décoratifs. It would be a "bas relief representing *The Divine Comedy* of Dante." The artist was to receive eight thousand francs for the work.

The significant question is why Turquet launched his monumental arts program with a commission for a door for the unbuilt museum. The answer, I propose, lies in the adversarial relationship between Turquet and Chennevières. In commissioning the

door, Turquet was bound to make inroads into his rival's territory, but he preferred to keep his plan quiet, at least for the time being, and spoken of it to almost no one. We find no significant mention of it in the press in 1880.[17] Bartlett confirms the low-key nature of the commission: "No one outside of the little circle of Rodin's intimate friends had the slightest idea of the importance of the commission that M. Turquet had given him. At the time of receiving it he [Rodin] explained the plan he proposed to follow in its design, and that official [Turquet] expressed his entire confidence in the sculptor's ability to carry out any scheme he might undertake."[18]

There is no reason to doubt Turquet's sincerity and daring in offering the commission to Rodin. But it is also likely that few if any other candidates would have accepted a commission to decorate a building for which no plans yet existed. Falguière, Chapu, and Mercié were all turning away commissions in 1880. Nor would they have been willing to take on such a big project for 8,000 francs (the state had just paid Carrier 2,400 francs for a single bust!). Even Dalou, recently back in Paris after the declaration of amnesty for Communards, had just been voted 250,000 francs by the city of Paris so that he could erect his *Monument to the Republic* in the place du Trône. Rodin was the perfect choice for an administrator in need of a first-rate sculptor willing to undertake decorative work for an unbuilt museum. Under the circumstances, Rodin's lack of fame was a bonus; it would help to keep the project quiet until the time was right.

A man as intent as Turquet was on putting a Republican message into French art might have been expected to devise the program for such an important commission, but he seems to have put the matter entirely in Rodin's hands. The subject mentioned in the August decree—"a bas relief representing *The Divine Comedy* of Dante"—has always been considered Rodin's idea.[19] It does not come as a surprise. Rodin had been thinking about the subject for years; he had even embarked on an "Ugolino" group in Brussels. Dantesque subjects were found in every contemporary exhibition, and of course the most celebrated sculptural group of Rodin's youth, Carpeaux's *Ugolino,* had never left his mind. The entire generation of the 1870s had identified Dante and Michelangelo as a pair of geniuses to follow. Perhaps Rodin's choice was obvious, but it was also brilliant. He took the tradition of bronze doors, in which biblical stories were told at the entrances of religious buildings (in March 1880 *L'Art* ran a big illustrated article on Sansovino's bronze doors for the sacristy of Saint Mark's in Venice depicting the final period of Christ's life), and replaced it with Dante's more earthly narrative of the Christian search for salvation to use as the entrance of a secular museum.

Traditionally, sculptors longed to try their hand at two great commissions: an equestrian monument and a bronze door. By end of the summer of 1880, Rodin was no longer an unknown sculptor struggling to exhibit and sell his work; he was the only artist of his generation who had the commission for a bronze door. What did it matter if he did not know when or where the building would be located? He had a studio from the state, a purpose, and, finally, a future.

Turquet released information about the door only after it was clear that he was going

to have to leave his post. In November 1881 Jules Ferry was turned out of office in the wake of the debate on his Tunisian policy. On November 11, *L'Evénement* and the *Chronique de l'art* both announced that "M. Auguste Rodin has just received from M. Edmond Turquet, undersecretary of state for the fine arts, a commission for a monumental door in bronze which is destined for the Musée des Arts Décoratifs. M. Rodin will take his subject from *The Divine Comedy* of Dante." The words must have been taken directly from a press release, as they are identical in the two journals. The story that Turquet really wanted the public to have, however, was contained in an article by Maurice Vachon in *La France* on November 24. Describing the vigorous work being carried out by the Prussians to restore the arts in postwar Germany, Vachon wrote:

> And we in France have not even been able to create a national museum of decorative arts! For two years it has been on the verge of becoming a reality, but they fritter away their time in useless talk, fruitless struggles between ambitious men, and the laying out of impractical projects. The only thing that has been done in a positive way is the commission to M. Rodin for the door of the future museum! According to the undersecretary of state for fine arts, perhaps when the door is finished, they can decide at the inauguration how to put the walls around it. Evidently, this is the reason for the existence of this peculiar commission, which may very well become legendary.

So, during his last days as undersecretary of fine arts, Turquet was able to use the commission he had given Rodin as a powerful thrust in his ongoing battle with the marquis de Chennevières in the pages of the Parisian press. More important, he could leave office feeling satisfied that he had taken a major step toward recapturing the Musée des Arts Décoratifs for the Republicans of the left. With pride, he could pass on "his door" to the incoming administration, when the arts would be under the leadership of Antonin Proust.

All his life Rodin complained about a multitude of physical ailments. His periods of illness were particularly intense when the fate of his work was uncertain. The emotional energy he poured into his quest for success made him sick, so it stands to reason that June 1880 was a terrible month. His friend Gustave Biot wrote from Brussels: "Until recently you have complained only of headaches and a rotten stomach, but now you're talking of anemia. You've got to take care of yourself. Take iron, get more rest."

Georges Hecq's letter informing Rodin that he was to have a government studio presumably eased the tension, and probably helped restore his health. Rodin was now the proud possessor of an atelier in the Dépôt des Marbres, located between the Seine and the rue de l'Université on the Left Bank. There he would be in the company of other recognized artists with government commissions. Consider Rodin's pleasure at making his way to the dépôt for the first time—opening the large door, introducing himself to the concierge, walking through the courtyard where the government stored blocks of marble to be awarded to sculptors with public commissions. He stopped at Studio M, which would not be his alone, for he would share it with the younger sculptor Joseph Osbach. In the end, however, Rodin would take over three studios at 182 rue de l'Université, making the address as famous as that of Canova's studio at the beginning of the century, when guidebooks told tourists on the Grand Tour not to leave Rome without seeing it.

Studio M was Rodin's retreat through the fall and winter of 1880 and into the following spring. He wrote to hardly anyone and received few letters. Hecq and Jean Rousseau (who had recommended Rodin to Turquet) wrote to thank him for gifts. All his life Rodin would reward those who helped him with offerings of his work: a drawing, a terra cotta, a plaster, or—as in Rousseau's case—a marble head. "This beautiful arrival is really out of proportion with the small service I have done for you," the critic wrote. But he found it "ravishing" and was delighted to own something he believed could compete with the best of Greek sculpture.

Rodin received twenty-seven hundred of the eight thousand francs awarded by the state in October, just in time to pay a foundry bill. He hired a carpenter named Guichard; in the spring he took on a mold maker named Granet. He continued to work at Sèvres and on his statue of d'Alembert for the Hôtel de Ville. But mostly he was at the rue de l'Université, drawing, reading, occasionally working from a model, searching on paper and in clay for the direction he would take in the door for the Musée des Arts

Décoratifs. Soon after the October payment arrived, he wrote to Turquet that he would bring a number of drawings and sketches in clay around for his approval.[1]

The tremendous freedom, as well as the money and space, that the project gave Rodin were intoxicating. We get some sense of this from a third-person autobiographical sketch he wrote in 1883. Rodin hoped a journalist named Gaston Schéfer would make an article out of it. In about a thousand words, he encapsulated the drama of his life, here and there heightening it or smoothing the rough edges. Turquet, he wrote, "believed in the artist whom he had followed for so long, and so he gave a commission to Rodin, who was so happy to be able to create sculpture without restraint the way he had wanted to do all his life, so that now he works with the happiness of an artist of bygone days."[2] Rodin's happiness must have arisen from the security of patronage and the knowledge that he had an important project that he could carry to completion in an independent fashion. Finally, he could step back into his own studio and create freely.

By the end of 1880, Rodin also must have felt enhanced in the eyes of the better-known sculptors with whom he had been competing on such unequal terms for the past twenty years. The established sculptors of Paris were, in fact, quite busy in the winter of 1880–81 developing rules for organizing the Salon Libre, the new salon to be run by the artists rather than the state. As usual, the venture counted more for sculptors than for painters, since the painters' frustration with the Salon had been somewhat alleviated by the shows of the Indépendants. In January a steering committee was elected for the Salon Libre. Twenty-one sculptors were on it, including Dubois, Chapu, Mercié, Falguière, Frémiet, Barrias, Guillaume, and Rodin's friend Captier. Dalou, only recently returned from exile, was a runner-up in the election.

Rodin was never mentioned as a possibility for the committee. Nevertheless, people were beginning to know who he was. The journalist Emile Bergerat, writing in the early twentieth century, remembered the day he first saw Rodin. Bergerat was sitting in the antechamber to Turquet's office with Rodin's studio mate, Joseph Osbach. "Suddenly the door of the undersecretary's office opened. It framed a beard—because, in truth, it was only a beard pierced by two eyes and mounted on legs. Then it advanced like Birnum Wood in *Macbeth,* totally concealing the man. 'Rodin,' whispered Osbach in my ear. The name told me nothing about the furry one." But Bergerat, loath to appear ignorant, exclaimed: "'Rodin *chez* Turquet, what do you suppose he's doing here?' 'It's about *The Gates of Hell,'* replied the student of Carpeaux, and he left me considering this enigma." Bergerat's account is part fabrication, but it does give us a sense of aura.[3]

The earliest published account of Rodin's door was written by a man related to Rodin by marriage, Henri Thurat. (His cousin was married to Rodin's cousin, Hippolyte Coltat.) He published an essay in the *Art populaire* in April 1882, the first of many descriptions by visitors to the studio at 182 rue de l'Université. Rodin's space, Thurat wrote, was

poor, severe, but big. No refinements. You would think yourself in a monk's cell. This ascetic lair demands respect. It almost awakens a superstitious dread. There is an air of mystery here. Fantastic visions rise up to assault you. What are those veiled shadows standing along the wall? What masterpieces stand beneath the wet cloths? And this immense wooden cabinet that rises to the ceiling taking up so much space, what is that?

Rodin says quietly: "It's my door." Great men and women will pass under this triumphal arch. In spite of my promise to Rodin to be discreet about this work, I have to say—it is what I want to say to him alone—that this colossal conception will be the great secular monument of our age. When this bronze door, commissioned by Turquet, is placed upon the heights of Trocadéro at the entrance of the Musée des Arts Décoratifs, with its immortal scenes from Dante's poem, when we see the fantasy of the relief twisting about, suspended above our heads, then we will believe that we, too, have penetrated the circles of hell in the company of Virgil. The whole genius of Dante is there in this leaf from a sculptor's book, but we should not see it as a new translation; it is an evocation![4]

This account gives us a sense of how far Rodin had come in the first year and a half of work. By the beginning of 1882, he was well along, but he still felt tentative about it: "Be discreet," he cautioned Thurat.

Rodin's work of 1880–81 is found in sketches on paper and in clay. He also spent a lot of time reading *The Divine Comedy,* a copy of which he always carried in his pocket.[5] Rodin's friend and biographer Judith Cladel described how "he read and reread it, and made a sort of commentary in the form of innumerable sketches that he jotted down mornings and evenings at table, [or] while walking, stopping by the wayside to dash off attitudes and gestures on the pages of his notebook."[6]

There are hundreds of sketches. They show nude figures, often coupled: men and men, women and men, women and children, only rarely women and women. Men dominate. Sometimes their names are written in the margins: Dante and Virgil, Icarus and Phaeton, Dante and a Shade, Minos, Medea, Count Guido and Count Ugolino. There are embracing couples inspired by Paolo and Francesca. Even Frenchmen who had never read *The Divine Comedy* knew the sad story of the lovers who were confined to hell because their love was outside the marriage bond. And they knew Count Ugolino of Pisa, a Ghibelline who betrayed his city by currying favor with the Guelph enemy and was confined to a tower with his children, where they died of starvation.

These stories of transgression were common coin; painters and sculptors counted on audiences being bound by the spell of their pathos. At mid-century Ingres had been haunted by Paolo and Francesca, as had Ary Scheffer, who depicted Dante and Virgil watching the couple's shades floating before them. In sculpture, the big display of interest in Dante came in the 1870s. In the Salon of 1876, Aristide Croisy showed Paolo and Francesca reading their love poetry, and Jean-Baptiste Hugues placed their shades in the "hellish storm" for the Salon of 1879, near Aubé's life-size portrait of Dante

61a) Rodin, sketch related to the doors of the Musée des Arts Décoratifs. 1880 or 1881. Lead pencil, pen, and wash. Cambridge, Mass., Fogg Art Museum. Bequest of Grenville L. Winthrop.

looking down at the fragmented heads of damned souls at his feet.[7] Jules Blanchard continued the trend in the Salon of 1880 with another rendition of the lovers' shades in the Inferno. That sculptors should have been so enthralled by this tale made Eugène Véron throw up his hands in disgust: "What a subject for a sculptor!" he cried.[8] As for Ugolino, Fuseli, Blake, and Flaxman had all treated the subject, but no one had ever created such a forceful and heartrending image as Carpeaux's. He was the hero of Rodin's youth and surely the reason that Ugolino was the first literary subject to have challenged Rodin (see chapter 9).

61b) Rodin, sketch related to the doors of the Musée des Arts
Décoratifs. 1880 or 1881. Lead pencil, pen, and wash. Paris,
Cabinet des Estampes.

In his autobiographical sketch for Schéfer, Rodin described his joy at receiving the
commission for the door of the Musée des Arts Décoratifs. He also spoke of the pleasure
of having enough money "to pay the models whom he always had in his atelier,
allowing them to do whatever they wanted, but still observing their movements from
the corner of his eye and putting down their poses such as they are in nature." Rodin
requested that his models walk freely about the studio so that he could draw their

61c) Rodin, sketch related to the doors of the Musée des Arts
Décoratifs. 1880 or 1881. Lead pencil, pen, and wash. Paris,
Cabinet des Estampes.

unpremeditated poses. It was a precious lesson that he remembered from Lecoq de
Boisbaudran's classes. He used it from the beginning of work on the door. The draw-
ings that came out of this period were full of dark emotions, tremulous yearnings,
feelings of fear and loss. They are the emotions of "hell." We call them the "black"
drawings for the darkness of the medium and the intensity of their aspect, and we search
in vain for themes inspired by Dante's *Purgatory* and *Paradise*. The *Inferno* alone held
Rodin's interest.

The single-figure drawings, couples, and compositional scenes are Rodin's most
fascinating creations of 1880–81. But he needed a context for these ideas, and through-
out the year he was busy on architectural sketches as well. His challenge was one that
sculptors had faced since the eleventh century, when Bishop Bernward of Hildesheim
came home from Rome with a bronze door on his mind: to organize a narrative
sequence in three dimensions on a large, dark surface. Like other sculptors who had
tackled the problem, Rodin first thought of sculpting rectangular panels for scenes and
borders for decorative elements and single figures. He knew and respected the great
Italian tradition of Ghiberti and Sansovino, and he took some cues from the Old
Testament panels of Michelangelo's Sistine Chapel ceiling as well.

But when Rodin created his last clay maquette for the door, a forty-inch slab with
figures pressed onto its surface, the panels were gone. He had decided to divide the
composition into three major sections—a left- and a right-hand door topped by a
lintel—and three minor ones—lateral pilasters and a panel below. The maquette is
packed with figures, none of them very distinct, but three areas are more developed

62) Rodin, third and last maquette for the doors of the Musée des Arts Décoratifs. 1880. Plaster. Musée Rodin.

63) Rodin, *The Thinker* (called "Dante" in early 1880s), on a
scaffolding in Rodin's studio. Photograph by Pannelier, 1882.

than the rest: a seated figure in the lintel, which would have been Dante; an embracing
couple in the left door, Paolo and Francesca; and to the right a seated man with a child in
his arms, Ugolino. In giving up the framed reliefs for all-encompassing panels, Rodin
moved from shallow to deep space, and he now had a single figure presiding over all. In
the process, Rodin departed from the narrative tradition of paneled doors, so popular in
the Renaissance, to what we might call the "Judgment" tradition, with a single domi-
nant, centralized figure like those in Michelangelo's *Last Judgment* or French medieval
cathedrals.[9]

 This seated figure at the top became the focal point of Rodin's maquette. It was nude,
bending forward and incorporating a contrapposto gesture like that of Carpeaux's
Ugolino, with left elbow to right knee and the knees and feet close together. Rodin
quickly developed his nude into a more brooding figure, a man turned in upon himself,

the one we know as *The Thinker*. When visitors came to his studio in the early eighties, however, and looked up at the clay figure perched high upon a wooden scaffolding, they referred to it as "Dante."

Rodin made no reference to this figure in the early eighties, but later he spoke about his desire to move away from the images of Dante and of specific scenes from the *Inferno*. He told Bartlett that "although the door is generally understood and popularly called, for description's sake, an illustration of Dante's *Inferno*, it is only true to a limited degree."[10] To Serge Basset he said: "I lived a whole year with Dante—living only with him, and drawing the eight circles of his hell. . . . At the end of a year, I saw that while my drawings rendered my vision of Dante, they were not close enough to reality. And I began all over again, after nature. . . . I abandoned my drawings of Dante."[11] He said that he had once thought of placing a draped figure of the ascetic medieval poet on his door. Instead, he "conceived another thinker, a naked man, seated upon a rock, his feet drawn under him, his fist against his teeth; he dreams. The fertile thought slowly elaborates itself within his brain. He is no longer dreamer, he is creator."[12]

The figure Rodin made, the one who was not Dante but who came from "nature," was his third great male nude, and though from nature, it was Michelangelesque in the extreme. It remained the only constant element of the composition throughout the whole process. By 1881, Rodin had placed the seated giant on a crude shelf high up in his studio. Catherine Lampert has described it as "an alter-ego presiding imaginatively . . . over the construction."[13] Once again Rodin was identifying with one of his creations. In Belgium in the seventies, he had seen himself as the "vanquished one," and later, while preparing a second big figure for the Salon, as one who cried in the wilderness. Now, under the impetus of the new commission, Rodin could identify with a powerful creator firmly planted in the midst of a world that he himself was in the process of making.[14]

Earlier French artists had provided models for Rodin's innovations. An obvious one was Courbet's self-portrait in his *Painter's Studio: A Real Allegory Summing up Seven Years of My Artistic Life*. Rodin would have seen it when it was first exhibited in Courbet's show of 1855. He was able to see it again in the summer of 1881, for it was on display in the foyer of the Théâtre de la Gaité in preparation for the posthumous sale of Courbet's work. Rodin must have been struck by the way the leader of the realist school saw himself—so serene and Olympian—in the midst of the world he had created, and yet apart from it.

As Rodin's thoughts circled around the giant on the shelf, he surely also had recourse to the hero of his youth, Victor Hugo. A revisiting of Hugo's "Après une lecture de Dante" would have been a must, for in it the old Romantic explored the relationship between the poet and the world he creates: "Quand le poète peint l'enfer, il peint sa vie" (When the poet paints hell, he paints his life). In this poem "life" and the creative act are one, and Dante's descent into hell symbolizes the poet-genius disappearing into his own imaginative vision. Hugo had a strong sense of identification with Dante. In "A

64) Gustave Courbet, *The Painter's Studio*. 1855. Oil. Paris,
Musée d'Orsay. Photo R.M.N.

Olympio" (*Les Voix intérieures*), he showed how the man of superior genius struggles with his ability to see into the depths of life, which makes him both god and victim. We can imagine Rodin's feelings and thoughts as he encountered such images while he was searching for the right tack to take in the most important venture of his life.[15]

As Rodin built a composition shaped by images of transgression and judgment, he enlarged his vision to include Adam and Eve in the ensemble. He had already finished a figure of Adam and submitted it to the Salon of 1881 under the title *The Creation*. It continued his work with Michelangelesque figure types. In order to arrive at the power he wanted in this work, Rodin had engaged as his model a strongman from the circus, Caillou, known as "the man with the iron jaw." He got Caillou to twist his big limbs like a corkscrew, head down, touching his left shoulder as if he were a giant awakening to life. He showed a single finger of the right hand in isolation so that it quivered with significance, reminding us of the "touch of creation" bestowed upon Adam by Michelangelo's God in the Sistine ceiling.

Critics found Rodin's new figure difficult: "*The Creation of Man* is philosophically incomprehensible, in fact it is just plain bad," said the reviewer for *Le Figaro* (May 4, 1881). Few found it worthy of praise, but at least, as the critic for the *Revue littéraire* pointed out, "no one can accuse him of casting from nature this time" (June 1, 1881). Whether or not they liked the figure, all the critics talked about Rodin's debt to Michelangelo.

One critic, a certain M. Gaïda, did like *The Creation*. It prompted him to go to see Rodin in his studio. To his amazement, he found himself "standing before a powerful and complex personality, one who merits a thorough study." He felt he had found "an apostle of a new aesthetic," a man with a special ability to locate "expression in movement." It struck Gaïda that Rodin was doing something in sculpture that none of his contemporaries was doing. Rather than "eliminate the troublesome parts," Rodin acknowledged "every plastic element as a sign of life. He is continually nourished by the sight of living models and disdains nothing." Gaïda had seen the "sketches for the door for which 'the Adam' is destined." He was convinced that it would open "a new way in sculpture."[16] Thus, even before Turquet's press release, a few critics did know of the work in progress, even if the majority remained ignorant.

65) Rodin, *Adam (The Creation)*. 1880. Plaster. Photograph by
Jacques-Ernest Bulloz. Musée Rodin.

66) Rodin, *Eve*. 1881. Plaster. Photograph by Bulloz. Musée Rodin.

Rodin had been working on the figures of Adam and Eve before he received the commission for the doors. Perhaps the desire to combine the two old themes came when he abandoned the small bas-relief panel format of Italian inspiration and moved to a more French and cathedral-like conception, with the single large figure in the center. In this way *Adam* and *Eve* would play the role of jamb figures, standing like the Old Testament ancestors at Saint-Denis and Chartres on either side of the entrance: they would represent our ancestors—he and she—who made this hell into such a dark concern for all mankind.

As the scope of Rodin's conception grew, he was forced to grapple with what it might mean in contemporary terms. It made him think about ideas that were important

in modern France, a country at once so Catholic and so profane. In what context was the modern individual to confront the dualism of the human encounter with good and evil?[17] Standing near Rodin's *Creation* in the Salon of 1881 was Jean Gautherin's *Paradise Lost,* a group representing Adam and Eve in which Gautherin presented his concept of the first human encounter with guilt. Adam appears to comprehend, while Eve crouches behind him, unable to fathom what has befallen her. Many people thought the group merited a Medal of Honor for the seriousness of the subject alone. Rodin was working with the same idea of establishing contrast between the nature of man and the nature of woman. He created a powerful Adam, trembling, coming alive to his own creation, while Eve lowers her head, holds her pregnant body, and appears to experience the troubled ache of knowing that guilt will be her part of creation.

Rodin's determination to put the biblical figures into his scheme was evident by July 1881, when he asked for Turquet's permission to take his figure out of the Salon and return it to the rue de l'Université. He said he needed it to establish the proportional relationship between the door and the statues.[18] The next we hear of these figures is in an anxious letter from Rodin to Maurice Haquette: "I just heard from Osbach that Monsieur Turquet might resign at any moment. . . . Could you help me out and talk to Monsieur Turquet (either tonight or tomorrow, although he might be going to Senlis) about my two figures which are to stand on either side of my door and which have not been officially commissioned? . . . You have to understand this is a very serious matter for me and that you are the only person who can help me."[19]

This letter must have been written on November 10, the day when Ferry resigned and President Grévy entrusted the formation of a new government to the strongest man of the Third Republic, Léon-Michel Gambetta. That Gambetta would one day be prime minister of France had been in the minds of many for a long time. The ministry he created is always referred to as the "Great Ministry." He gave fine arts a ministry of its own, removing its affiliation with Instruction Publique. The new minister of fine arts was Antonin Proust, journalist and noted supporter of Edouard Manet. He was also a central figure in the movement to create a Musée des Arts Décoratifs. With Turquet out of office, Rodin was once again anxious. The fifteen months in 1880 and 1881 when Rodin launched his work on the great door were probably the most creative of his entire life. Rodin was loath to see this period of intense artistic freedom end.

Chapter 14
Genius in a Man's Face

The greatness of Parisian art collections, the authority bestowed by an exhibition in the capital, and the fellowship of other artists were the irresistible attractions of Paris, the mecca where artists discussed the latest theories in cafés, restaurants, and studios. When a man had a special need to lambaste the capricious judgments of the Salon jury, he knew where he could find a sympathetic ear. Painters got together at informal teaching studios such as Charles Gleyre's, where Monet, Bazille, Sisley, and Renoir met one another, or at the Académie Suisse, where, for a small fee, an artist could drop in to draw from models. It is here that Monet, Cézanne, and Pissarro became friends for the first time. Artists and writers met in private surroundings such as the rendezvous at Edmond de Goncourt's *grenier* (garret) in Auteuil and the dinners in Berthe Morisot and Eugène Manet's home in Passy.

Friends were artistic subjects as well as companions. They were forever lending each other their faces and figures. Fantin-Latour's *Studio in the Batignolles Quarter,* where Manet works in the midst of a coterie of painters and writers, and Bazille's *Artist's Studio, rue de la Condamine* are classic glimpses into this cohesive and enviable world of talented men.

Few women found their way into these chosen circles, and Rodin was not part of them either. Exclusion from the Ecole des Beaux-Arts, the long period in Brussels, and the virtual nonexistence of independent sculptors lessened his chances of finding a circle of creative companions with whom he could share a sense of enterprise and ambition. He had individual friends from school and work, of whom Fourquet had long been the best. In 1880 the two men still shared a studio, but their intimacy had diminished. Rodin felt closer to Biot, but Biot lived in Brussels. He was fond of Almire Huguet, but Huguet had left for Geneva in 1878. A new friend, the young sculptor Jules Desbois, had a wonderful sense of humor, but he too left Paris to work for several years in New York. Rodin then looked to the Haquettes. All these men recognized Rodin's superiority as an artist; he had no experience of friendship with a man whose gifts he believed to be equal to his own.

Rodin broke the pattern in the summer of 1880, when he went to see Jules Dalou. Since they had both attended the Petite Ecole and worked at the Hôtel Païva in the sixties, they knew each other slightly. Like Rodin, Dalou had spent most of the seventies out of France and had just received an important commission from the Conseil Municipal. Although he had lost the competition for the *Monument to the Republic* in 1879, his maquette was acknowledged to be the best. The council therefore ordered a second monument from Dalou and had just voted the funds when Rodin contacted

him. Being in the midst of changing ateliers, Dalou was not immediately available, but on June 15 he wrote: "Now I am at 95 rue de Vaugirard. You must come when you have a moment. You have no idea how much pleasure I get from being able to see you." Some years after Dalou's death in 1902, Rodin remembered him as "my first friend."[1] The two men were kindred spirits. Although Dalou had made the successful transition from the Petite Ecole to the Ecole des Beaux-Arts, he was not proud of it; he was known to have exclaimed: "That Rodin, he was the lucky one, he never attended the Ecole des Beaux-Arts!"

The first significant outgrowth of the friendship was Dalou's help in organizing Rodin's trip to London in the summer of 1881. He made contacts for Rodin with Constantine Ionidas, a banker and avid collector of modern French art, and with the painter and printmaker Alphonse Legros. Legros, convinced that Paris would not yield a decent living, had moved to London in 1863. Although he never learned English well, by 1881 he was a distinguished professor, occupying the chair Felix Slade had endowed at University College ten years earlier. A whole generation of English artists took pride in having studied with Legros.

67) Alphonse Legros, *Portrait of Rodin*. 1881–82. Oil. Musée Rodin.

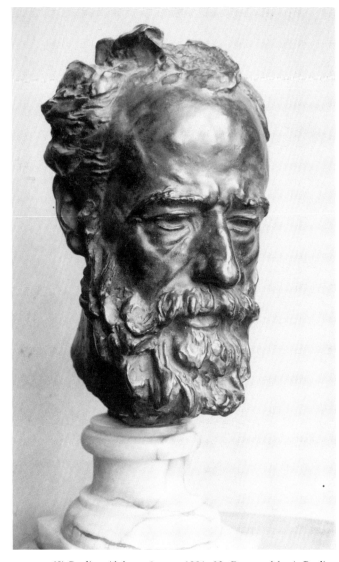

68) Rodin, *Alphonse Legros*. 1881–82. Bronze. Musée Rodin.

When Rodin left London in August, the two men had become good friends; their letters and visits continued into the twentieth century. Rodin and Legros learned from one another, for Rodin did his first etchings in Legros' studio and Legros took up sculpture in response to Rodin's encouragement. At the end of 1881 Legros went to Paris, where he and Rodin celebrated their friendship by executing portraits of each other. Legros' oil portrait is as fine an image as anyone ever made of Rodin. His chestnut locks fall loose and free from his forehead down to the nape of his neck. Legros chose a three-quarter view, emphasizing the structure and length of Rodin's nose and

his half-lowered eyelids under the brows and powerful frontal bones. Highlights strengthen the three-dimensionality and give Rodin the look of brooding complexity. Perhaps no artist ever captured as well Rodin's personality—the combination of vision and introversion, of power and self-doubt.

Rodin made a head, not a bust, of Legros. He concentrated everything in the face of the forty-three-year-old artist. He emphasized its length, the fullness of the hair surrounding the face (which in photographs looks thin and wispy). The eyebrows, nose, and moustache intersect at right angles and give clarity to the portrayal of a gentle, thoughtful, intelligent man. Rodin sent the head to London, where it was shown at the Grosvenor Gallery in the spring of 1882. Legros wrote: "I've seen the bust you made of me. It's wonderful! Really effective, everyone admires it."

Legros' friendship opened up England for Rodin. He became an enthusiastic Anglophile, despite his ignorance of English. In many ways, his natural shyness worked to his advantage in a country where everyone was forced to speak *his* language, and before long Rodin had more invitations to England than he could hope to accept. Among his many new English friends, the most significant for his future was William Ernest Henley, a writer who in 1881 was enduring the daily grind of journalism and drama criticism in order to support himself. That summer he complained of feeling like "dry rot" and wrote to a friend that he "must get away and get young again." So, in the company of his best friend, Robert Louis Stevenson, who immortalized Henley in the character of Long John Silver in *Treasure Island,* he went to Paris in September. It must have been during that visit that Henley got to know Rodin well enough to write him an intimate letter in which he discussed his drinking problem, his writing, and his new house, where he hoped Rodin would be a guest. We discover in this letter that Rodin has given him a gift: "the bust" (probably the *Bust of Saint John*). He couldn't stop looking at it and it constantly made him think of Rodin. The two men felt great sympathy and mutual admiration. Henley closed his letter by saying how deeply he understood the struggle of Rodin's life and "how great has been your pain. But now you must be happy! For you are working for future centuries and you know that what you are making is good, so be happy." In November Henley wrote again: "Since I saw you I have had the good fortune of being named editor in chief of the monthly review, the *Magazine of Art.* I want to place engravings of your works in the magazine. . . . I would especially like to engrave the bust of St. John, or even the entire statue. What do you want? It's entirely up to you."

This was Rodin's first solid relationship with a major writer. Henley played a substantial role in developing a taste for modern art in England in the 1880s, championing such unknown and controversial artists as Whistler and Rodin. The first engravings of Rodin's work in the *Magazine of Art* came out in early 1883; from then until Henley's resignation in August 1886, the magazine documented the evolution of Rodin's work in the most positive light. Henley helped Rodin get his work exhibited in London during the same period.

Rodin thought another gift was in order. Henley objected. Rodin owed him nothing, he said, but, "if you insist . . . one of these days you can make a little sketch of my big empty head and with that everything will have been said" (Oct. 15, 1883). Rodin decided to celebrate their friendship with more than a sketch. By the fall of 1884 Henley was in Paris sitting for his bust. When it arrived in London two years later, Henley said: "We find it very beautiful, very me. Perhaps too thin, too much the dreamer, and not as flamboyant nor as English as the poor model" (Oct. 28, 1886). Henley was known as the man who introduced Rodin to the public in England. After his death, when his monument was to be erected in Saint Paul's, his family chose Rodin's portrait as the only one that adequately served the memory of this very flamboyant "Long John Silver."

Legros was not the only artist with whom Rodin made a portrait exchange in 1881. The other was the esteemed history painter Jean-Paul Laurens, who frequently thrilled Salon audiences with his Christian martyrdoms, excommunications, inquisitions, and

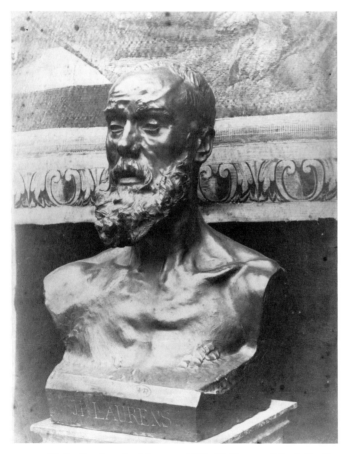

69) Rodin, *Jean-Paul Laurens*. 1881–82. Bronze. Musée Rodin.

political murders. It was such sanguinary images that won him the important commission to paint the death of Saint Geneviève for the Panthéon. So he, too, had a studio at 182 rue de l'Université, where he met Rodin. In his 1883 autobiographical sketch, Rodin wrote, "At that time the powerful artist J.-P. Laurens asked Rodin to make his bust."

Laurens had a noble and sensitive face, which Rodin exploited in all its drama, with its eyes wide and far-seeing under the agitated forehead. His mouth is open as if to speak, and the rich, flowing beard obscures his powerful neck. The right arm was once raised, until Rodin sliced it off at the shoulder, but the suggestion of movement remains to create a forceful asymmetry. Clearly Laurens liked the bust, for he ordered a lost-wax bronze cast from Gonon, the best founder in Paris. Laurens reciprocated by including Rodin's face among the Merovingian warriors in his huge Saint Geneviève mural.

In the early eighties, Rodin's growing reputation gave him access to a wider circle of friends. In the last months of 1881 he received a letter from the prominent realist painter Léon L'Hermitte. He, too, was a Petite Ecole graduate, although he attended after Rodin had graduated. He clearly did not know Rodin when he wrote to say how happy it would make him to meet the "author of Saint John." When Rodin complimented him on his widely heralded *Paye des moissonneurs,* which was in the Salon of 1882, L'Hermitte wrote back: "You are one of the very few whose appreciation is truly precious to me."

About this time Rodin developed a friendship with another alumnus of the Ecole, Jean-Charles Cazin, who had lived in England from 1871 to 1875. Although primarily a realist painter, he focused on the revitalization of the decorative arts when he returned to France. He set up a kiln at his primary residence in a village near Calais, but he spent much time in Paris, and in February 1882 he and Rodin had a show together in a gallery in the rue Volney. Cazin was enormously enthusiastic about everything Rodin had done and about their "good feelings for each other."

Cazin was probably behind a letter Rodin received in June 1882 from the writer and critic Louis de Fourcaud, noted defender of the Impressionists: "Many times our friends Cazin and L'Hermitte have wanted to bring us together. So let's do it now." The result of this meeting was an article in *Le Gaulois* (July 1) in which Fourcaud stated that "among all the young sculptors, [Rodin] is the one I would place in the highest rank."

Jules Bastien-Lepage, a young painter who came out of the same group at the Petite Ecole as L'Hermitte and Cazin, had similar feelings when he saw Rodin's work: "My visit to your studio was a great experience and has given me some of the most exceptional sensations I have had in all my years as an artist. I am truly grateful." He suggested that they get together soon to talk about a personal commission he intended to give Rodin.[2]

This, then, was the nucleus of Rodin's new group of friends: Dalou, L'Hermitte, Laurens, Legros, Cazin, Bastien-Lepage, the writers Fourcaud and Henley, plus another graduate of the Petite Ecole, Alfred Roll. They met regularly to eat at the Café Américain, calling themselves the "Pris de Rhum," mockingly raising their glasses to

the academics with whom they shared the walls of the Salon each spring. They thought of themselves as modern and forward-looking, but not as radical in the way the Impressionists were. Rodin felt most comfortable with this group. Though permanently at odds with the Ecole and the academic system, he did not believe that his work represented a break with the past. Rather, he saw himself as working within the great tradition of antiquity and the Renaissance. But he yearned for honors, as did everyone else in the Pris de Rhum. It was they who would become the core of the Société Nationale des Beaux-Arts, which, from 1890 on, provided an alternative to the official Salon. It would not be long before the society took on an official tone of its own.

A third portrait Rodin made in the winter of 1881–82 had nothing to do with his group of congenial new friends. During his last days of regular work at Sèvres, he made a bust of Carrier-Belleuse. We know nothing of the actual circumstances, but the bust was ready for the Salon in the spring.[3] Bartlett mentioned it, saying that he had gotten his information from "one of the ablest of the younger French sculptors. . . . After Belleuse saw that Rodin was making friends, he got him to work at Sèvres, and asked Rodin to make his bust, which Rodin did, and gave it to him. But even while doing that his way of working did not please Belleuse, and the latter used to exclaim in half-indignation, 'Sacred name of Rodin, he has worked for me for ten years, and I have not been able to print myself upon him. He will never be able to model as I want him to.'"[4] Even if Bartlett's source was another sculptor, the feelings are Rodin's and we recognize how unreconciled the two men remained. Although the older sculptor finally came to brag about his most gifted student, the accolade did not please Rodin. He entered his name in the Salon catalogues as a "student of Carrier-Belleuse," but that is not how he thought of himself.

Unlike Legros and Laurens, Carrier made no portrait of Rodin. Moreover, Rodin's bust exactly corresponds to the best-known contemporary photograph of Carrier, showing one curl from the sculptor's mass of hair falling on his forehead, the bushy moustache, and a velvet jacket. Even the loose cravat falls in an identical fashion in the photograph and in Rodin's bust. In all probability, Rodin's bust was done after the photograph. The style of the bust has a Second Empire quality; it would sit easily beside Carpeaux's portrait of Alexandre Dumas. Clearly, for Rodin, Carrier was the past.

Rodin's antipathy to Carrier aside, he considered the bust sufficiently fine to put it in the next Salon along with his head of Laurens. But *Laurens* outshone *Carrier-Belleuse* in everyone's eyes. One critic said that with the Laurens bust Rodin appeared equal to the Greeks and the masters of the Renaissance.[5] Even more important, he was finally equal to Mercié and Falguière. Many critics considered *Laurens* the best work of sculpture in the Salon. Daniel Bernard of the *Univers illustré* said he had never heard Rodin's name before, but "the only thing I know is that the man who modeled the portrait of Jean-Paul Laurens is a great artist" (June 24). Not a few were shocked at the way the naked torso was lengthened and manipulated to form a base, but they knew the conception was unlike anything they had ever seen before. Only Thurat, in his long review in the

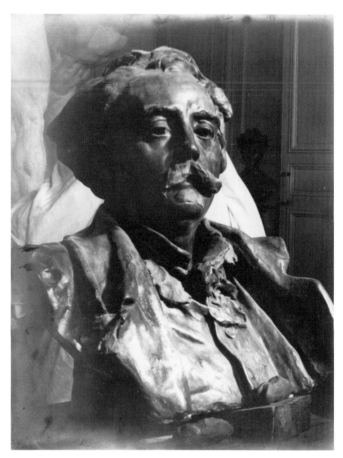

70) Rodin, *Albert-Ernest Carrier-Belleuse*. 1881–82. Bronze.
Photograph by Druet. Musée Rodin.

Art populaire, saw *Laurens* as related to *Saint John, The Man with the Broken Nose, The Age of Bronze,* and *The Creation of Man.* Finally, Paul Leroi brought Rodin into the prestigious pages of *L'Art.* Linking his achievement with that of L'Hermitte, he asked: "What if the Medal of Honor is the least serious thing in the whole world? As we approach the Salon, the question of art still weighs in the balance, and, this being true, there would be only two possible competitors for painting and sculpture: M. Léon L'Hermitte, the painter of *La Paye des moissonneurs,* and M. Auguste Rodin, the sculptor of the *Portrait of M. J.-P. Laurens,* a bust that gives glory to one of the greatest masters of all time. . . . Remember the name of Rodin, it will go far. I wait impatiently for the monumental portal he is doing . . . to embody the poem of Dante."[6]

The following year Rodin put his bust of Legros, which he had already shown in London and Antwerp, in the Salon. He paired it with the portrait of another professional friend, J. Danielli, inventor of a galvanic process of bronze plating that Rodin was

trying out. In the same year, Dalou, who had not shown since his return to France, placed two enormous multifigure reliefs into the Salon: *Estates General, Meeting of June 23, 1789* (a historical relief showing the comte de Mirabeau responding to the marquis de Dreux-Brézé, master of ceremonies to Louis XVI), and *Fraternity*. They were so successful that the Salon of 1883 was referred to as "Dalou's Salon." He received the Medal of Honor and was named to the Légion d'Honneur. Still critical of the award system, he wrote in embarrassment to Rodin in London: "Pity me! The fact of the matter is, I have the Medal of Honor, but that doesn't mean I've changed my ideas."

Rodin, however, regarded them as anything but empty honors, and, perhaps in celebration of his friend's success, embarked on a portrait of Dalou. He crowned a broad naked chest and a tense columnar neck with Dalou's proud face. Treating the naked chest in portraits of the men he most admired was a special mark of their elevated status for Rodin. Even though he was creating straightforward, naturalistic portraits, it

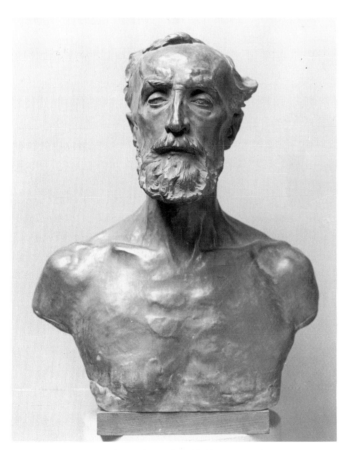

71) Rodin, *Jules Dalou*. 1883. Bronze. Boston, Museum
of Fine Arts. Gift by contribution.

gave stature to his subjects. Rodin's portrait is a work of extraordinary quality, and it came into existence in a climate of friendship and mutual respect, as Rodin and Dalou began their rise to fame in the Third Republic. Dalou never made a portrait of Rodin, however. Although it was not apparent to Rodin in 1883, Dalou's growing reserve toward him would be one of the sadnesses of his life.

In 1882, the year of Rodin's first critical success, he wrote to various critics who had praised his work. One letter went to Edmond Bazire, ex-Communard and ardent young Republican journalist on the staff of Henri Rochefort's radical *Intransigeant.* Bazire first mentioned Rodin in March, after seeing the bust of Carrier in a gallery in the rue Vivienne. He liked it, but when he saw *Laurens,* his enthusiasm exploded: "A thumb has done some rough work here. This battered, irregular, rough, ascetic, violent, contemplative image is stupendous. It is willful, it is stubborn, wild, without concessions. The sculptor shows the painter in whom there is nothing soft, who puts down brush strokes like blows from his fist. My thanks to the sculptor!" (June 17, 1882).

Rodin responded: "I would be happy, monsieur, to pay a visit to a critic who has received my work so favorably." Bazire was not in the offices of *L'Intransigeant* when Rodin came to call, but he asked to visit Rodin's atelier. He came first to the rue des Fourneaux, which he described as "a sort of branch store filled with studies, projects, and sketches, all quite powerful, with originality bursting forth out of the tiniest object. The artist, very sweetly, very modestly, showed me the various works . . . and when he felt that my congratulations were not simply conventional, he began to see me almost as a friend, to share confidences, all this as we walked along the tramway platform on our way to the rue de l'Université. He explained to me the deceptions and injustices that he had been subject to and all the hatred that he had stirred up." Rodin went over all the old ground with Bazire: the accusation that *The Age of Bronze* was cast from life, the committees, the investigations, the fact that many people still did not accept the truth. Bazire was filled with sympathy for Rodin and tried to think of ways to help: "You could make portraits of men who everyone would know were incapable of lending themselves to such an odious procedure. Victor Hugo, for example, or perhaps Rochefort. *He* would never let his face be cast," Bazire wrote soon after his visit.

Bazire's meeting Rodin in 1882 was a *coup de foudre*—love at first sight. It was clear to him that this "très doux, très modeste" artist had done courageous and imposing work for almost no recognition, a situation that appealed to Bazire's inclination to fight for the underdog. He was so swept off his feet that he even began writing sonnets about Rodin. One opened with the line: "Suddenly Michelangelo has passed this way." He wanted to pick Rodin up and catapult him into his own celebrated circle, the entourage of Victor Hugo.[7] In February 1883, he wrote Rodin: "If you are free Sunday, get out your evening dress, put on your white tie and meet me at nine in the avenue Victor-Hugo. You have been announced *chez le maître,* and I am so proud and happy that it is I who present you!" Together, the two men went to the Hôtel Continental on February

27 to eat *bouchées Agnès Sorel* and *escalopes de foies gras à la Montgolfier,* which they washed down with Mouton Rothschild 1870 to celebrate Hugo's eighty-first birthday.

Bazire never lost sight of his ambition that Rodin should sculpt Hugo. Unfortunately, Hugo had just finished posing for a lackluster sculptor, Victor Vilain, and was not eager to sit again for anyone. Undaunted, Bazire drafted a letter for Rodin to write. "*Cher et illustre Maître,*" it began, "I hope you can forgive my insistence. The ambition to be the man who has made the Victor Hugo of his generation is so natural that you can't reproach me. And then I have another desire, as I told you—that it be ready for Mlle Jeanne's [Hugo's granddaughter's] birthday. If I start now, I can do it. Please let me count on just a few moments with you from time to time. I shall not impose on your goodness in any way and the bust will come into being all by itself without you even perceiving that it is happening."[8] Hugo succumbed, with little enthusiasm. Bazire to Rodin: "I saw Victor Hugo last evening. Don't forget to come Sunday . . . for lunch. He will establish the conditions. . . . Accept them." The conditions were that Hugo would not actually pose, but that he would permit Rodin to be present in the house at mealtime to take notes and make sketches.

So Rodin, the outsider, suddenly found himself at the dinner table of the idol of his youth, not only in Hugo's company but with others who were near legendary. There was Hugo's mistress, Juliette Drouet, whose love for the poet was famous the world over. And there was his daughter-in-law, Alice Lockroy, with her children, Georges and Jeanne (her husband, Charles Hugo, had died in 1871).[9] Sometimes others were present: Henri Rochefort, Emile Bergerat, Paul Meurice, Auguste Vacquerie, Catulle Mendès and his wife, Judith Gautier (a former mistress of Hugo's), the Ménard-Dorians. Rodin got to know them all. Several left written accounts of the sculptor who had barely located his footing in the Paris art world sitting at the table of the man regarded by half of France as semidivine. Bergerat wrote:

One evening at Victor Hugo's table, avenue d'Eylau, in the last years of the poet's life, a thoughtful guest approached to sit down.

His beard was that of a sapper in the imperial guard, rusty-colored, undulating, magnificent, and he disappeared into it. His manner was soft.

Now this sapper was of an extreme timidity. Not only did he do no undermining at all, but he did not even carry a hatchet, his usual tool. He stayed in his place without moving, remained silent, did not eat, drank even less, and paid no attention to his neighbors. He just looked at Victor Hugo.

He didn't do anything but that, he looked at Victor Hugo. . . . Neither the Maître nor his family seemed bothered by this. Only the other guests were wondering what role he played in these marvelous dinners, which seemed to survive from a grander epoch.

Then they began to ask themselves with even more reason why the good sapper was slipping cigarette papers under his plate, which he would then open with his fingernail and on which he would draw plans, cross-sections and elevations of

Victor Hugo's head . . . and all the familiar attitudes and expressions of the great man.

The meal would finish and Victor Hugo would walk here and there, the sapper standing beneath a tiny light, still defining the gestures and the manner of moving that he observed in his majestic model.

When the gossamer album was filled, the harvest was done and the sapper slipped away, his tawny beard no longer shining forth from the shadows. Then Mme Drouet would say: "M. Auguste Rodin has left. The seance is finished."[10]

Rodin worked fast, making dozens of drawings; some were, in fact, on cigarette paper, although others were on larger sheets. They show Hugo from above, in profile, in three-quarter view, his gestures, his expressions. They are not detailed but indicate the large planes, the characteristic edges, the general shape of Hugo's head. At a certain point Rodin brought clay with him. Then he would stay in a corner of the porch, watching his subject at a distance. Later, Rodin recalled that he fell back on his Petite Ecole education as he drew from memory: "Being unable to follow my habitual procedure, I placed myself beside or behind him, following him with my eye, making quick sketches of him, drawing as many profiles as I could on little squares of paper; . . . I

72) Rodin, *Twelve Sketches of Victor Hugo's Head.* 1883. Black crayon heightened by gray wash. Musée Rodin.

then compared those contours with those of the bust; thus I managed to execute it, but with such difficulties. I extricated myself from them as best as I could."[11]

After working for three months, Rodin "was given to understand that the bust was finished." This is something of an understatement: it seems Rodin was unceremoniously thrown out by Hugo. Bazire was devastated. "*Cher ami,*" he wrote, "I just learned what happened Friday. I cannot hide the fact that I am ashamed and humiliated about it. Mme Lockroy feels the same way but the Maître is adamant. You must not return there. But come see me—we shall talk. I love you more than ever, my dear Rodin" (March 25, 1883). It is not surprising that Hugo grew irritable with a stranger. That March, Juliette Drouet was dying of cancer. In February they had celebrated the fiftieth anniversary of their liaison; Hugo gave her a photograph of himself inscribed: "50 years of love, that's more beautiful than a marriage." Drouet was so weak she could barely thank him, and on May 11 she died.

There is no doubt that Rodin's work at the Hugo home was fraught with difficulty. Given his timidity, it must have been extremely hard for him to insert himself into the company of such a complicated and exalted household. Some have implied that he was insensitive to the situation and overstayed his welcome. Years later, Rodin confessed to Anna de Noailles that he found Hugo almost insulting in his regard, and that he suffered greatly from the great man's disdain.[12] Nor was Rodin sure that Hugo liked his bust, and he certainly knew that some in Hugo's coterie had made deprecating remarks about it.[13] Thus, when he pointed out in his 1883 autobiographical sketch that Georges and Jeanne Hugo believed the bust closely resembled their grandfather, he was being defensive.

Whatever questions may have been raised about the bust, Rodin remained welcome in the Hugo entourage. He attended Madame Drouet's funeral and was invited to Hugo's eighty-second birthday the following February. *Le Matin* reported that "le tout Paris littéraire" was on hand for the occasion and that "in the salon, surrounded by flowers, the crowd admired a beautiful bust of Victor Hugo by M. Robin [sic]" (Feb. 27, 1884). In February 1885, when Hugo turned eighty-three, Rodin was again at the party, this time in the company of Dalou, whom he introduced to the Hugo household. Bartlett's notes give two versions of this episode: in one, Dalou asked Rodin for an introduction; in the other, Rodin suggested that Dalou come with him and Dalou accepted hesitantly because of feelings of "unworthiness."[14] Whichever version is correct, we must imagine that the shared visit to the "lion" of their lives—the "Hercules," the exalted one who "belonged to a great race," as Rodin described Hugo to Bartlett— was emotional and complicated. In part, the emotion resulted from the natural competitiveness between the two artists. This competitiveness would soon burst into the open and cause Rodin excruciating pain. After Hugo died in May 1885, his family gave Dalou, not Rodin, the honor of making sketches of the great man as he lay on his deathbed and of taking the death mask.

In 1884 Rodin could not foresee that his act of generosity would lead to the unraveling

73) Rodin, *Bust of Victor Hugo,* with Rodin in the background. 1883?
Photograph by Bodmer?

of his precious friendship with Dalou. He was preparing to celebrate his entrance into the Parisian art world with the paired busts of Hugo and Dalou for the next Salon. This show placed Rodin's career in a new realm; never again would his work be overlooked. Every major critic reviewed Rodin's pair of busts in 1884, and most did so in extremely positive terms. Louis de Fourcaud wrote: "Modernity in sculpture is life expressed with biting precision. . . . Every time I go to this year's Salon, I am captivated by two busts. Their gaze follows me and their speechless lips have a confidential way of talking to me. One is the bust of Victor Hugo, the other of Dalou, and both are by M. Rodin. There is nothing at the Palais de l'Industrie more modern than these, because there is nothing so resolutely true."[15] Fourcaud felt, like everyone else, that *Dalou* was superior to *Hugo*— not surprisingly, for Rodin had been able to risk more in creating the sublime nakedness of *Dalou*. Further, he had worked on it over a longer period of time, under far better circumstances than the awkward atmosphere of the Hugo household.

74) Rodin, *Bust of Victor Hugo,* with David d'Angers' *Bust of Victor Hugo* in the background

Late 1883 and early 1884 was a particularly intense period in Rodin's life. Just as he was beginning to feel his career was almost established, he had to face the loss of the man in whose countenance he had first tried to grasp the feeling of the greatness that lies in the face of a man: Jean-Baptiste Rodin died on October 27, 1883, and was buried in the Cemetery of Montrouge. Many friends attended the funeral. No one's presence meant more to Rodin than that of Dalou and his wife:

> Dear friends
>
> That you were with me all the way to the cemetery even though it was so far away touched me enormously. Madame Dalou has borne beautiful witness to the concern you have for me.
>
> Thank you and accept my expression of ardent friendship.
>
> <div align="right">A Rodin</div>

Bazire, unable to attend the funeral, wrote Rodin a compassionate letter, urging him to take strength in the affection that he inspired in everyone who knew him. It was true: when Jean-Baptiste Rodin—the man who had imagined so much about his son's future—died, Auguste Rodin was firmly established in the republic of accomplished men. He had become one of them.

Chapter 15
The Women in Rodin's Life

Rodin grew up with two female role models. His mother, an extremely pious woman, spent most of her time at home, was unable to write, and, according to the existing civil code, was denied participation in the full rights of citizenship. In other words, she was wholly dependent on her husband. Jules Michelet described the contrast between men and women during the period when Rodin was growing into maturity. He summed up man's experience by saying: "History goes forth, ever far-reaching, and continually crying to him: 'Forward!' A woman, on the contrary, follows the noble and serene epic that nature chants in her harmonious cycles, repeating herself with a touching grace of constancy and fidelity."[1]

Such words cast Marie Cheffer Rodin's life in a positive light. Nevertheless, it was not one that interested Rodin's second role model, his sister, Maria. She had no intention of becoming like her mother, and she was not eager to marry. Although she did consider opening her own business, her eventual decision to enter the convent was one frequently taken by intelligent women who lacked economic means to obtain higher education. A small number of French women were entering the university for the first time in the 1860s, but they were the privately educated daughters of well-to-do families. Had this been an option for Maria, she might well have taken it.

Rodin loved both his mother and his sister, and he chose to spend his life with a woman who in some ways reflected aspects of each. Like his mother, Rose Beuret was a country girl who came to Paris to make her living as best she could without an education or any special training. When she moved in with Rodin, her relationship to him was clearly subordinate: when he wished, she followed; when he did not, she stayed home. But, according to descriptions of Rose from people who knew her in the twentieth century, she, like Maria, was a woman of temperament. She did not accept everything Rodin handed to her, and she knew how to pick a good fight when necessary.

When Rodin won his first successes in the early 1880s, he and Rose had been together for over fifteen years. More than a faithful companion, she had been a willing studio assistant whenever Rodin needed one. We find dozens of traces of his instructing her—easy and affectionate, if somewhat paternalistic, notes, as in a letter from London in the spring of 1883: "My dear little Rose, On Sunday I want you to get dressed and go speak to M. Baton, the concierge at the rue de l'Université, and ask him to show you my *Ugolino*. Check and see if it's in good shape. I'll probably be back on Thursday." Rodin signed himself "ton ami," then gave a few more directives and another "au revoir ma petite Rose" as he fused endearments and instructions. Rose was Rodin's woman, and

until a more complex social world drew him out of their intimate partnership, it seems he had no other female friend.

The Rodin household changed as he attracted friends from different social circles. His Belgian friends always sent Rose their regards, whereas his English friends did not know her. Rose had been Rodin's companion with the Haquettes, the Alfred Bouchers, and the Dalous. Rodin did not take her, however, to the home of Mme Juliette Adam, the great hostess of the Third Republic in whose salon he met Gambetta in 1881, or to the home of the Ménard-Dorians, who constantly invited him in 1883, let alone to Victor Hugo's famous house on the avenue Eylau. Rose gradually faded into the background as the decade wore on. In 1887, Truman Bartlett dined with the couple at home. Bartlett described their rooms in the rue de Bourgogne as very humble, adding: "Normally they receive no one." When he mentioned the dinner to the sculptor Adrien Gaudez, "Gaudez was surprised because he never knew that Rodin was even married and had never been in Rodin's house."[2]

Contact with a larger social world gave Rodin new ideas about what a couple could be. Three wives of his new friends were accomplished artists: Marie Bracquemond was a painter, and Marie Cazin and Charlotte Besnard were sculptors. All three women showed in the Salons of the 1880s. Rodin had real friendships with the two sculptors and took pleasure in discussing their craft with them.

Rodin loved the active exchanges he was beginning to have in every direction. Many of his friends were engaged in teaching. As a self-taught artist and one who had never taught, Rodin felt younger people learned best on the apprenticeship model. He believed that beginning sculptors should learn to develop a master's sketches in the *practicien* mode, as he had done for Carrier-Belleuse. Nevertheless, in 1882, as a personal favor to Boucher, who had won the Prix de Rome, he agreed to supervise a small group of students, all of whom were young women. Every Friday Boucher stopped by their atelier at 117 rue Notre-Dame-des-Champs to look at their work and make corrections. When he left for Italy in 1882, Rodin began to come in his place.[3]

One of the students was seventeen-year-old Camille Claudel. Her family had recently moved from Nogent-sur-Seine to Paris, where they lived on the rue Notre-Dame-des-Champs, only a few doors from Camille's studio. Under Boucher's tutelage in Nogent, she had made a figurative group, *David and Goliath*. It showed such promise that when she arrived in Paris, Boucher took her to meet his own professor, Paul Dubois, director of the Ecole des Beaux-Arts. He, too, was from Nogent and was similarly impressed with her talent. Evidently, Dubois offered her enough critical advice that Camille saw fit to put his name on her roster of professors the first time she exhibited in the Salon.

Camille's fierce determination to become a sculptor had been a major factor in getting her bourgeois family out of Nogent so that she might study in Paris. This may seem extraordinary, but in fact more and more women were thinking of studying art in the last part of the nineteenth century, and at least some families heeded their daughters'

aspirations. The Claudels' decision recalls that of the Morisots, who rented a house at Ville d'Avray in 1861 because their daughters, who had taken up painting, wanted to be near the great Corot; or that of the Cassatts of Philadelphia, whose daughter, Mary, understood that she needed more education after she finished the program at the Pennsylvania Academy. The entire Cassatt family moved to Paris in the summer of 1866.

Since women were not admitted to the Ecole des Beaux-Arts, they had to find other ways to study art. An artistic girl could engage a private master, or she might join one of the "ateliers féminins," where women could draw from nude models. Each year Paris saw more of these ateliers opening. In 1873 Mme Léon Bertaux had begun a course in modeling and sculpture; most of the women sculptors who showed in the Salons of the 1880s were graduates of her classes. Even while teaching, she led the fight for the admission of women to the Ecole des Beaux-Arts. Equal opportunity for women at the Ecole was finally achieved in 1900; three years later, women were permitted for the first time to compete for the Prix de Rome.[4]

When Rodin met Camille Claudel, her best work was her portraits, one of her thirteen-year-old brother, Paul, the other of an elderly servant, Hélène. Rodin must have been impressed at such quality coming from the hands of a provincial girl. He would also have quickly recognized in her an unusual degree of willfulness and tenacity, not to mention her wild, untamed beauty. For her part, Camille must have considered herself fortunate to discover that her new teacher was the man who had recently made a sensation in the Salon with the portrait of Jean-Paul Laurens.

Under Rodin's tutelage, Camille completed the *Portrait of Madame B.* for the next Salon. This Salon was the second organized by the Société des Artistes Français, that is, by the artists themselves after the fine arts officials had bowed out of the annual exhibition business. There was much talk of "quality"; many members of the society believed that in order to maintain "standards," they should not let in too many for-eigners or women. So Rodin would have felt justifiably proud when two of the women from the Notre-Dame-des-Champs atelier had works accepted in the Salon of 1883: Camille's *Portrait of Madame B.* and two works by Thérèse Cailloux. The following year a Swedish girl who shared the atelier, Sigrid of Forselles, had a work accepted that she called *Penseur*. Catherine Bradford, an Englishwoman who exhibited at the Salon of 1885, gave her address in the catalogue as 182 rue de l'Université. She, too, must have been a student of Rodin's. Of the 1,047 sculptors who showed in the Salon of 1883, 101 were women, a figure that gives some indication of how many women wanted to be sculptors by this time.[5]

Once Rodin began accepting students, they began to pour in, especially women.[6] In January 1883, L'Hermitte wrote to ask Rodin if he would take Amélie Casini as a student. Rodin reserved a place for her, though in the end she did not study with him. Madeleine Jouvray, however, did come to work in Rodin's studio that year, as did Jessie Lipscomb, a twenty-two-year-old Englishwoman from Peterborough who had stud-

ied at South Kensington with Legros. When Lipscomb won the National Silver Medal in 1883, Legros, together with her sculpture professor, Edouard Lanteri—also a friend of Rodin's—advised her to pursue her studies in Paris. There was quite a rush on the part of English girls to study art in Paris, and several passed through Rodin's atelier. When Amy Singer, a friend of both Camille Claudel and Jessie Lipscomb, left Paris in 1885, her father wrote to thank Rodin for giving his daughter wonderful instruction, and also for *not* having accepted payment for the lessons. Rodin continued to think of himself not as a professor, but as a professional sculptor with a large studio in which younger artists could learn as his apprentices.

Alice Greene's article "The Girl Student in Paris," published in the *Magazine of Art* in 1883, describes the atmosphere these Englishwomen encountered in Paris: "The decorous, easy-going English schools scarcely prepare one for the rougher, more business-like, and slightly Bohemian 'Ecole pour Dames.' It is a startling plunge, but the effect is as refreshing and revivifying as that of a cold compared to a warm bath. Make the plunge, come up, shake yourself all over, and set to work, and all your artlife you will be thankful that you have done so." Greene reminisced about the atelier, about going to lunch with her fellow students and running into their models at every turn: "a respectful salutation from the old man whose white beard was going to give us so much trouble in the afternoon, or a familiar little nod from our last child-model, a fascinating imp who could not be still two minutes together." She described how the *maître* would arrive sometime after eleven, take "off his hat with a courteous '*Bonjour, Mesdames,*'" then take the place "of the student at the nearest easel and go carefully over the whole of her work, finding out with unerring eye all the faults of proportions in the first blocking out of the *ensemble*." Greene's maître had come every day, but she knew for a fact that in the ateliers of more famous artists, students could go "for weeks without seeing the master." The biggest difference between South Kensington and Paris, she said, was that English professors wanted you to "put in the very toe-nails of a cast, even when, with all your eyes, you could not see a trace of them," but in Paris the chorus was an everlasting "*Ne voyez pas ces petites choses*" (Do not look at these little things).[7]

Among the young women apprentices and students Jessie Lipscomb met in Rodin's studio, the one with whom she developed the most solid rapport was Camille Claudel. Lipscomb soon found a place not only in the atelier at 117 rue Notre-Dame-des-Champs, but in the Claudel household, where she lived. Each woman discovered a deep and lasting friend in the other, and together they explored the richness of Paris as they forged their identities as artists. They worked in the Louvre and the Luxembourg, at Versailles and Saint-Germain-en-Laye.[8] They studied anatomy in the Musée d'Histoire Naturelle.[9] Together they drew from the nude at Philippe Colarossi's academy in the rue de la Grande-Chaumière, which was just around the corner from their studio. And by 1884 they were both assistants to Rodin at 182 rue de l'Université.

The two women were not similar in every way, however. Rodin had fallen in love with only one—Camille Claudel. An 1883 letter from Auguste to Camille makes clear

75) Camille Claudel and Jessie Lipscomb in their studio at 117 rue
Notre-Dame-des-Champs, between 1883 and 1885

that they fell in love almost at first sight.[10] It is the letter of a man who has fallen in love in a way he did not know possible, and it was occasioned by a rupture between the two. Rodin addressed it to "ma féroce amie":

My poor head is all mixed up and I can no longer get up in the morning. This evening I ran around (for hours) to all our spots without finding you. Death would be sweeter! And how long is my agony. Why didn't you wait for me in the atelier, where are you going? to what agony have I been destined. . . . Camille, my beloved, in spite of everything, in spite of the madness which I feel approaching and which will be your doing if this continues, why won't you believe me? I abandon my Dalou, the sculpture, that is. If I could go any place, to some country where I could forget, but there is none. In a single instant I feel your terrible force. Have pity, mean girl. I can't go on. I can't go another day without seeing you. Atrocious madness, it's the end, I won't be able to work anymore. Malevolent goddess, and yet I love you furiously. . . .

You do not believe my suffering. I cry and you won't believe it. I have not laughed in so long. I no longer sing. Everything seems insipid and indifferent to me. I am already a dead man and I no longer understand all the trouble that I have gone to over things to which I am now indifferent. Let me see you every day, which would be a good idea and might make me better, for only you can save me with your generosity. Don't let this slow and hideous sickness overtake my intelligence, the ardent and pure love I have for you—in short, have pity, my beloved, and you will be rewarded

Rodin

He placed his signature upon the letter but could not stop. "I regret nothing," he continued, "not even the end, which seems like a funeral. My life will have fallen into an abyss. But my soul has had its time of flowering, late, alas. I had to have known you. Then nothing was the same, my dull existence broke into a fire of joy. Thank you, because it is you to whom I owe this, the part of heaven that came into my life." The "fire of joy" and the "hideous sickness" were to become part and parcel of Rodin's life, alternately fueling his creativity and ruining his days and nights.

Jessie Lipscomb was crucial to the progress of this romance. Slightly older than Camille, more serious, certainly more reliable, she became the go-between. Rodin would write her for news of Camille and counted on her to come and bring Camille: "You weren't able to come yesterday evening and you weren't able to bring our dear stubborn one [notre chère têtue], whom we love so much that I do believe it is she who runs us."[11] This is an understatement, for, in fact, Claudel tormented Rodin.

Lipscomb was engaged to be married; in 1886 her fiancé, William Elborne, came to Paris and photographed the women in the studio at 117 rue Notre-Dame-des-Champs. He showed them at work in their cluttered atelier and relaxing over a cup of coffee and a cigarette. Here we see Jessie, Camille, and Camille's sister Louise, not as the bourgeois

76) The Claudel family on the balcony of 31 boulevard de Port-Royal, 1887. Camille Claudel is in the center. Photograph by William Elborne.

they were, but as Bohemian artists participating in the rough-and-tumble Paris art world described by Alice Greene.

Elborne's camera also caught an intimate view of the Claudel family on the balcony of their new apartment at 31 boulevard de Port-Royal. As the most alert and alive member of the group, Camille dominates the center of the photograph. Beside her, Louis-Prosper Claudel leans against the wrought-iron railing. It must have been a weekend, for during the week he stayed and worked in Rambouillet. Paul Claudel described the head of the family as "a kind of nervous man of the mountains, fiery, quick-tempered, fantastic and excessively imaginative."[12] Seated in front of Camille is

Louise-Athanaise Cerveux Claudel. Her hair is severely pulled back, there is a cameo at her throat, and the set of her shoulders conveys a rigid uprightness that is always described as being fundamental to her character. All parties agree that she found it difficult to give support or to demonstrate love to her children. "She never embraced us," remembered Paul Claudel, who appears in this picture as the eighteen-year-old naïf standing behind Camille. He had recently taken his baccalaureate at the Lycée Louis-le-Grand, with prizes in rhetoric and philosophy. His sister helped to orient him toward modern literature; she even arranged for him to meet avant-garde writers whose energy seduced him just as their libertine lives scandalized him. The child with musical gifts, Louise Claudel, is at her mother's feet. She was the daughter who would marry, lead a stable bourgeois life, and win what Camille never felt she had—her mother's love. Louise's fiancé, Ferdinand de Massary, stands behind Camille, and Jessie is beside her.

In 1886 Jessie invited Camille to visit the Lipscombs in Peterborough. The young women left for Wooton House in late May. The Lipscomb home was a brand-new mansion that Sidney Lipscomb had built for his family in 1882 after making a fortune on the London Coal Exchange. Coincidentally, Rodin was planning a visit to London. In April, Gustave Natorp, a young German sculptor whom he had met through Legros and who lived in London, wrote to say he would come to Paris and bring Rodin back with him in late May. Rodin was Natorp's guest at 70 Ennismore Gardens for a fortnight. He had no particular business in London on this trip. If it had not been for Camille, he probably would not have been there. Claudel, displeased that Rodin had followed her, made no effort to see him in England. He continued to rely on Jessie Lipscomb as his ambassador and spokesperson. He wrote her shortly after his arrival, confessing that an "overwhelming sadness" had accompanied him from Paris.[13] Things looked brighter when he anticipated Jessie and Camille's impending visit to London and his own to Peterborough. Rodin thanked Jessie for her warm wishes "and those of Mademoiselle Claudel, but maybe that was an act of charity." As the weekend in Peterborough drew near, he wrote: "I count on your goodness, that you can anticipate any awkwardness that may arise. I am so happy at the moment that I am afraid of everything." And awkward moments there were. In the evening during Rodin's visit, Jessie sang ballads. From London he wrote: "At the very moment I discovered that you were a real musician and that I loved listening to you, our dear princess decided she would have no more of it." Claudel had broken up the evening; Rodin confessed to Lipscomb that he felt it was wrong, "but you can see what power she has over everyone."

The impossible eighteen-year-old student whose indifference had driven Rodin to despair had not become any easier at twenty-one. She still had the capacity to plunge him into fits of anxiety. By 1886 Claudel had been working as an assistant in Rodin's studio for about two years. Her passion for sculpture as a way of life was developing on a course parallel to his own. Like him, she believed in having a special relationship to models, and by this time she was working successfully with a male model by the name

of Giganty. She was independent and competitive, and she tyrannized Rodin just as she had tyrannized her family as a girl.

Several aspects of Camille's personality—notably, her willfulness and determination to achieve goals she set for herself—remind us of Rodin's sister. It is not surprising that he was swept away by this new Maria, whose vocation was not the religious life but sculpture. As for Rose, her place in Rodin's life was swiftly becoming that of a desexualized mother maintaining the hearth. While Rodin was in England, he wrote her twice. He had left her in charge of the clay sculptures, which were to be kept moist so as not to dry and crack: "I am serene with my work in your hands. . . . Don't put too much water on them and test them with your fingers." He assured her of his quick return, explaining that he was busy but not particularly enjoying himself. Rodin must have told Rose many an untruth in these years, but this is the first time we actually witness his withdrawal of candor and openness. For Rose, to whose pain we have no access, Rodin's crisis over Camille came at a moment of transition, for in the summer of 1886, Auguste Beuret was inducted into the army. He would not return until 1914, when "home" was a very different place.[14] Rodin was sufficiently concerned about Rose that he asked Paul Vivier, their physician and a close friend, to invite her to the Viviers' place in the country while he, Rodin, was in London.

Rodin was planning a second visit to Peterborough but suddenly canceled it, explaining to Mr. Lipscomb: "I have received a letter from Paris that forces me to leave immediately." What called Rodin back was a letter from the critic Octave Mirbeau. He was involved in organizing the fifth Exposition Internationale de Peinture et de Sculpture at the gallery of Georges Petit; they wanted Rodin's participation. Mirbeau had only a few days to write the catalogue for a show that would open in two weeks. He needed to know what works Rodin could show and what titles to give them—"Do you want *my frog* and what do you call it anyway?"[15] Mirbeau, worried that Rodin would not return from London, held out Renoir's name as enticement: "We have corralled Renoir into submitting some things and he is going to have a wonderful show."[16]

By the mid-1880s, Rodin's professional life was changing. He did not attempt to place his figures from the doors for the Musée des Arts Décoratifs in the Salon. Instead he showed them in galleries, first in the Exposition des Arts Libéraux in the rue Vivienne, then in the summer international exhibitions organized by Georges Petit in his gallery in the rue de Sèze. Petit's bright new luxury showroom was so seductive that he was luring artists away from Durand-Ruel, the longstanding champion of new art.

It was at Petit's that Rodin's work was singled out for attention by the brightest young critics, Gustave Geffroy and Octave Mirbeau among them. They followed close on the heels of Edmond Bazire; like him, they sympathized with Rodin as a persecuted artist, and, though younger than Rodin, they watched over him with compassion, recognizing the vulnerability that they regarded as an aspect of his genius. But their importance for Rodin lay in how well they understood what was new in his work and the uniqueness of his style.

One of the things Geffroy and Mirbeau recognized was the extraordinary life given to the female figures in Rodin's new sculpture. He had built his reputation through powerful male bodies and faces of unusual and creative men. The shift from an almost exclusive focus on male figures to a major focus on female figures began in the context of the work on the doors. Rodin conceived of the lateral panels as including single female figures, and in the central section he paired male and female figures as lovers or as antagonists. All the poses were from life, unself-consciously assumed by men and women who were not (or at least did not behave like) professional models. In his 1883 autobiographical sketch, Rodin had mentioned how much he needed money for "models that he had always in his atelier, allowing them to do whatever they wanted, but observing their movements from the corner of his eye." Rodin's method was at odds with the long-honored practice of a model taking and holding a particular pose in the established repertory.

Just as the character of Rodin's studio was changing with the presence of women students, female models were becoming ever more in evidence in his atelier. By the end of his career, Rodin had notebooks filled with names and addresses of models, most of them women. In the twentieth century, Rodin explained to Dujardin-Beaumetz how he worked and related to his models. He stressed that he could "only work from a model" and recalled his favorites from the period of the doors: "I can still see them: two Italian girls, one dark, the other blond. They were sisters, and both were the perfection of absolutely opposite natures. One was superb in her savage strength. The other had that sovereign beauty of which all poets have sung. The dark one had sunburned skin, warm, with the bronze reflections of the women of sunny lands; her movements were quick and feline, with the lissomeness and grace of a panther; all the strength and splendor of muscular beauty, and that perfect equilibrium, that simplicity of bearing which makes great gesture."[17] For Rodin, a model was as important as the clay in his hands; through the model came the form.

The two Italian girls Rodin mentioned to Dujardin-Beaumetz were Adèle (whose body we see in *Torso of Adèle, Eve, Fallen Caryatid Carrying Her Stone,* and *Crouching Woman*) and Anna Abruzzezzi. For years they were an integral part of his studio. Rodin was as generous in helping them to get through their pregnancies as he was in helping his assistants get their work into the Salon.[18] Rodin's collaboration with Adèle was at its peak in *Crouching Woman* (Mirbeau's "Frog"), an extraordinary work inspired by her ability to relax in a crude squat. The woman sits on her haunches in a way that is primitive and meditative at the same time, spreading her knees wide to reveal her sexual center. The work is impressive, not only for Rodin's willingness to depart from con-ventional poses, but for the model's ability to make her body available in a way hardly imaginable if artist and model had not had an exceptional rapport. Rodin recognized his models as artistic collaborators. As he said to Bartlett: "A model may suggest, or awaken and bring to a conclusion, by a movement or position, a composition that lies dormant in the mind of the artist. . . . A model is, therefore, more than a means

77) Octave Mirbeau in his salon. Mirbeau's "Frog" (*Crouching Woman*) is on the mantel. Photo by Dornac. Archives Larousse.

whereby the artist expresses a sentiment, thought or experience; it is a correlative inspiration to him. They work together as a productive force."[19] A twentieth-century commentator, considering Rodin's attraction to Adèle's body, suggested that he "siphoned" something off from her, which was possible because what they shared was so "intimate and untrammelled."[20]

The clay figures that grew in Rodin's hands as he watched nude models perambulating, crouching on the floor, or lying on a sofa were certainly not fit for the Salons of the 1880s. But the galleries took them, beginning with two works at the Cercle des Arts Libéraux in February and March 1883: a marble called *Age of Stone* (*Cariatide à la pierre*) and a bronze *Torso of a Contorted Nude Female Figure* (*Eve jeune aux pieds plats*).[21] It was the first showing of extracts from the door, and the first time Rodin exhibited a partial figure as a work on its own. Geffroy, writing for the radical *Justice,* responded with just three sentences: "M. Rodin has sculpted the female figure in tormented forms. People are saying wonderful things about these works, in which he seems haunted by the memory of Delacroix sketches. Let us wait until his path becomes clear and this kind of creation has truly asserted itself" (March 3, 1883).

Rodin did not reveal this aspect of his oeuvre again until June 1886, when, in response to Mirbeau's urging, he returned from England to select three groups and five female figures for the exhibition at the Georges Petit gallery. The show was a breakthrough. Nothing like it had been seen before; the most agile Parisian critics were quick to recognize that Rodin had extended the boundaries of modern sculpture. Dargenty, calling his readers' attention to these studies as part of the state commission for the doors, identified the doors themselves as "dynamite in a box, and when the box explodes, it will be incredible. The repercussions will be felt in the four corners of the earth."[22]

As would often be the case throughout Rodin's life, Geffroy's writing was the most pointed, the most knowing. He began his 1886 review by indicating the contrast between what could presently be viewed in the Salon of 1886 (in which Rodin showed nothing) and Rodin's work at Petit's. He described each work in Rodin's show, stressing details of anatomy: "a foot placed solidly upon the earth," "unyielding and twisted hair," "arms deformed by hard muscles," "a back curved and hollowed by a nervous shudder," "the passion of a kiss on the neck," "fingers piercing into flesh," "figures kneeling and virile in an exchange of torrid confidences."[23]

Other critics saw Rodin as *the* visual artist who was carrying on the search to discover the "modern soul" in the manner of Baudelaire, Hugo, and Flaubert.[24] One critic discovered a desperate figure, below which he read these lines:

Many a flower sorrowfully releases
its softly secret perfume
in profound loneliness.

78) Rodin, *Crouching Woman*. 1881–82. Bronze. Musée Rodin.

Is this Ariadne, weeping for her lost one? I rather think it is Sappho with Phaon, having won her over to sensuous love. This is but the threshold of the temple into which Monsieur Rodin leads us before the living idols of flesh crucified by desire.[25]

A modern ear attuned to the transformations taking place in French art during the Third Republic will quickly hear the language of change, one that is frequently dated to 1886. In that year the Impressionists showed together for the last time as a group, and the poet Jean Moréas convinced the editors of *Le Figaro* to publish his grandiose manifesto of the new style of writing that he called symbolism. Then Stéphane Mallarmé published his definition of poetry—"the expression of the sense of mystery in the aspects of existence"—in the new review *La Vogue,* which lasted from April to December 1886. In the same language used by the symbolist poets, critics hailed Rodin as the epitome of all that was new.

The character of these works cannot be separated from Rodin's love for Camille Claudel. Some commentators have suggested that Camille was part of the vision in an even more immediate way, as a model.[26] It is highly unlikely that Rodin so stretched the strictures of social and professional decorum to ask his young assistant, living with her bourgeois parents who had entertained him in their home, to take off her clothes and walk about in the studio as Adèle did. It was a matter of class. However, if Rodin was not actually working with her naked body before him, surely we can see suggestions of Camille in the great female figures of the mid-1880s, such as *Meditation, Danaïde,* and *The Martyr.*[27]

If we do not have the form of Camille's body before our eyes, Rodin certainly betrayed his terrible passion when he combined *Crouching Woman* and *Falling Man* in

79) Rodin, *Je suis belle*. 1882. Bronze. Photograph by E. Fiorillo.
Musée Rodin.

such a way that the woman eludes and repulses the grasping, amorous man. At the Georges Petit gallery, the world saw this pair with a verse from Baudelaire inscribed into the base:

> I am beautiful as a dream of stone, but not maternal; And my
> Breast, where men are slain, none for his learning,
> Is made to inspire in the Poet passions that, burning,
> Are mute and carnal as matter and as eternal.[28]

The coldness of the breast where a man experiences passion, inspiration, and ultimately death was the implacable force that Rodin spoke of over and over in his letters to Jessie Lipscomb, in which he expressed no hope of ever receiving an answer from the "dream of stone" herself.

Perhaps even more autobiographical is another work of this period: a bearded figure—half man, half goat—opens his ugly, brutish lips as he pulls a girl into his lap. Rigid, she recoils from his desire.[29] It is a lascivious and lusty reworking of the idyllic *Kiss,* which had emerged from the door as an independent group around 1884—the first of Rodin's seated lovers, when he was just beginning to grapple with the theme of illicit love through the Dantesque subject of Paolo and Francesca.

If Rodin did not give us a portrait of his beloved's body, he modeled her face many times. The first was a simple little head in clay. An intent face looks straight ahead. It grows out of the clay, with hair no more than a few strips of disorganized clay balls flattened out, as are the eyebrows and the thickened edges of the almond-shaped eyes. The cheekbones are high, the lips straight and unwavering. Youthful, not conventionally pretty, but fierce, proud, and determined. Late in life, Paul Claudel would look at this bust and say, "I can still see her, that lofty brow projecting above those magnificent eyes of dark blue so rare in Latin people, that nose which she jokingly claimed as inherited from the Virtues, her great mouth more proud than sensual, and that powerful sweep of auburn hair falling down her back."[30]

Rodin never showed a "Mademoiselle Claudel" in the Salon as he showed *Legros, Dalou,* and *Laurens*; rather, she was *Dawn,* she was *France,* or *Saint George.* But his most powerful evocation was *Thought,* a terrible, perfect, aloof beauty who was Rodin's vision of Camille in 1886.

Since Camille was so much a part of Rodin's exhibition at the Georges Petit gallery, we might imagine that he was saddened by her absence and inability to share in his triumph. But such a thought would have been beyond Rodin in June of 1886; he was too depressed, or, as he explained it to Jessie, "my poor soul is worn out and badly in need of encouragement." He confessed to her that he felt in great difficulty since his return from London and Peterborough: "I am so alone in my castles in the air that even divine nature, that charming reality of the countryside bathed in pure sunlight, this beautiful France . . . no longer says anything to me, for all my force has taken refuge in a corner. It is reduced to nothing, it vacillates; will it ever exist again?" Rodin enclosed articles

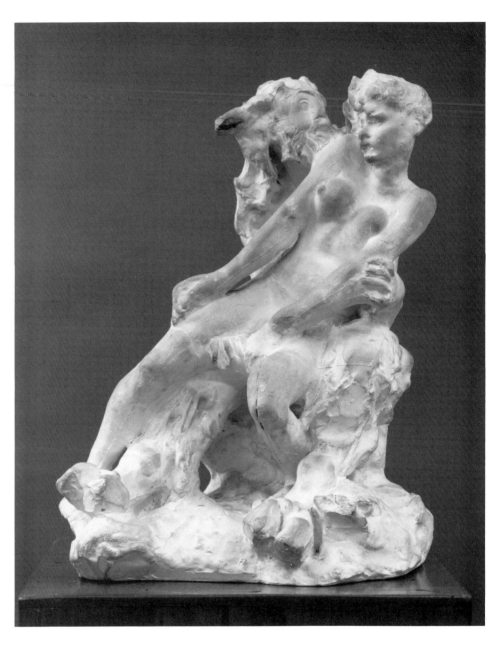

80) Rodin, *Minotaur*. c. 1886. Plaster. Los Angeles County
Museum of Art. Gift of Mrs. Leona Cantor.

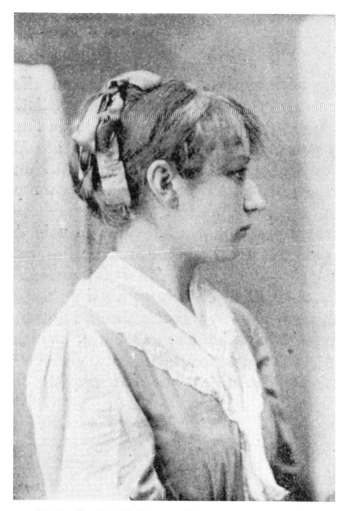

81) Camille Claudel. Photograph by Cesar. *Revue encyclopédique Larousse,* Nov. 28, 1892.

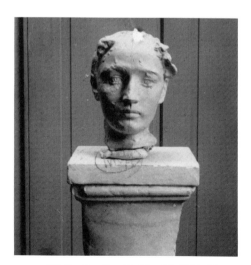

82) Rodin, *Camille Claudel*. 1884. Plaster.
Musée Rodin.

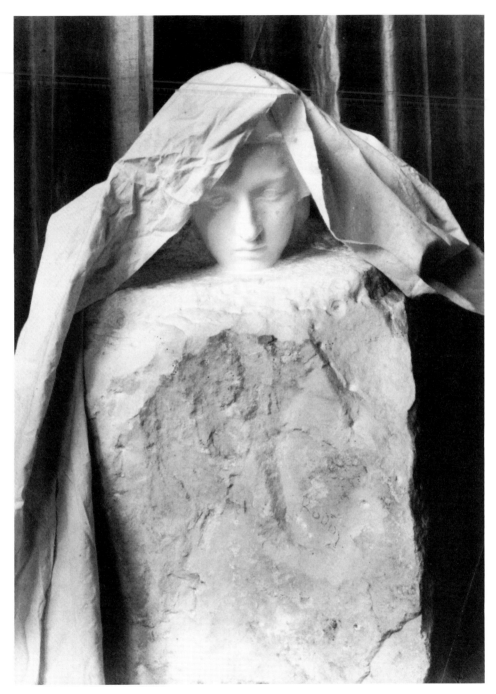

83) Rodin, *Thought*. 1893–95. Marble carved by Victor Peter.
Musée Rodin. Photo by Freuler?

about his recent show, but confessed that he was worried his students would think him vainglorious and laugh at him, when what he wanted was to win their "esteem and friendship." A man who was being compared to Phidias, Donatello, and Michelangelo was worried that his students would laugh at him for sending them clippings! Rodin's passion for Camille made him terribly insecure, and it expressed itself in a confused tempest of schoolboy ardor.

In August the Lipscombs took the two young women on holiday to the Isle of Wight. Paul Claudel joined them. Rodin hoped to be included, but Camille would not have it. Jessie told him of Camille's decision; Rodin wrote back that he was profoundly upset and that it took all his courage to say so. He added a single sentence in a postscript about the success of his summer exhibition; nevertheless, he summed up his state of mind as "desperate and worn out."

Finally, Camille wrote: "I am really angry to find out that you are still sick. I am sure that you have been eating too much at those stupid dinners with those wretched people whom I detest and who take up your time, ruin your health, and give you nothing in return. But what can I say? I know that I am powerless to save you from the harm I see." After thoroughly chastising him, Camille did inquire about how he was coming on the maquette without his model, perhaps referring to *Thought*. At the end of the letter, she confessed that she was not exactly feeling "très gaie," for she felt very far away from him ("si loin de vous!").[31]

On August 23 Rodin, knowing his students were about to return to France, wrote again. He said he felt a little better but did not dare think it would last. He wanted to meet them in Calais: "I know that all this depends on your arrangements and also on the caprice of Mlle Claudel."

How much Camille inhibited Rodin's self-esteem is blatantly clear. From another point of view, however, his love for her came at a time when he was developing more confidence and when he had new role models for the relationship between men and women. Not only was he close to three couples in which the women were artists and shared the world of their partners, but he had also witnessed the great liaison between Victor Hugo and Juliette Drouet. Hugo had fallen desperately in love with Drouet when she played Princess Negroni in his *Lucrèce Borgia* in 1833; she remained his mistress for over fifty years. Rodin told William Rothenstein that he once found Drouet "lying outside the poet's door."[32] For Rodin, as for many Frenchmen, the love between Hugo and Drouet was one of the great loves of all time. It must have been inspirational for Rodin as he wrestled with the deep passions opening up his own life.

Rodin's hopes to meet Camille and Jessie in Calais in the fall did not materialize. The letters from the summer of 1886 give us a view of a man in midlife, bewitched by a twenty-one-year-old woman, led into the vortex of a love he had scarcely dreamed possible. By contrast, Camille, young, ambitious, independent, had a multitude of reservations about the relationship. An extraordinary document that has recently come to light further focuses our view on the dynamics of the affair. Rodin wrote it; the terms appear to be Camille's:

In the future and beginning today, 12 October 1886, I will have no student other than Mlle Camille Claudel, and she alone will I protect with all the means I have at my disposition and with the help of my friends, who will also be her friends, especially my influential friends.

I will no longer accept other students, so that there will be no chance of rival talents being created, although I do not suppose that one will often meet an artist so naturally endowed.

At exhibitions I shall do everything possible for placement and journals.

Under no pretext will I go to the home of Madame . . . , to whom I shall no longer teach sculpture. After the exhibition in the month of May, we will leave for Italy and we will stay there for 6 months, living communally in an indissoluble liaison, after which Mademoiselle Camille will be my wife. I will be very happy to offer a figurine in marble to Mademoiselle Camille if she would like to accept it in 4 or 5 months.

From now until the month of May I will have no other woman, and if I do, all the conditions are dissolved.

If my commission for Chile works out, we will go there instead of to Italy.

I will take none of my feminine models whom I have known.

I will order a photograph from Carjat of Mademoiselle Claudel in the clothes she wore to the Academy [when she was] dressed for town, and perhaps one in an evening dress.

Mademoiselle Camille will stay in Paris until May.

Mademoiselle Camille commits herself to receive me in her atelier 4 times a month until the month of May.[33]

To this crude draft, Rodin affixed his signature. The terms of the agreement are so strange, in a sense so childish, that the reader is left speechless. One person has suggested that it might be a joke within a lovers' quarrel, but neither of the participants in this liaison ever revealed any levity about their mutual predicament. At least one fact is clarified by the document: there is no doubt the love affair was a consummated union. What are we to make of Camille's voice as reflected here? Was she so jealous and possessive that she would stake her claim in the middle of Rodin's most creative years? Or was Rodin's obsessive love, whipped to a peak of desire by her unobtainability in the summer of 1886, driving him to project onto her memories of his other stern taskmistress, Maria, the most unobtainable woman of all?

Chapter 16
The Burghers of Calais,
1884–89

In short, I am a sculptor who, like you, asks only to make
a masterpiece, if that be possible, and for whom the question
of art takes precedence over all others.
—**Rodin to the editor of** *Le Patriote*

With the Salon of 1884, Rodin achieved status among contemporary sculptors. But he still lacked the one thing that guaranteed a permanent place in the annals of nineteenth-century sculpture: success in a competition for a public monument. The Third Republic commissioned six times as many monuments as any previous regime.[1] It was a burgeoning field of creative expression, as a growing number of citizens came to believe that the liberal, secular climate of the French Revolution had finally taken root and that honor should be bestowed upon men and women, both humble and high-born.

It was not for lack of trying that Rodin had not executed such a commission. He had failed with his submission for the Byron monument in London in 1877, again in the 1879 competition for *La Défense,* and again in the competition to create the monument to the mathematician and military strategist of the Revolution, Lazare Carnot, in 1881. It was the same story with the monument to Diderot for the boulevard Saint-Germain and the monument to General Margueritte of Sedan fame, both of which he considered desirable projects.

In Rodin's mind, these failures were a continuation of his painful experience in being turned down by the Ecole des Beaux-Arts and the Salons. Once again he stood alone on the edge of the golden circle, looking in, but not being permitted to enter. In October 1884 a small opening appeared. A painter from the northern coastal city of Calais, Alphonse Isaac, a student of Rodin's friend Jean-Paul Laurens, mentioned that his hometown was planning to erect a monument to the most illustrious citizen of its medieval past, Eustache de Saint-Pierre. Laurens had brandished Rodin's name in glowing terms.

Calais had long wished to celebrate the hero of the Hundred Years' War who had given himself up as hostage to King Edward III of England in 1347. Eustache's bravery during the English siege inspired others to surrender, thus saving the citizens of Calais from starvation. Eustache was to Calais what Jeanne d'Arc was to Orléans. In 1845 the city had approached David d'Angers about a monument, but financial and political considerations got in the way, and the project had died with Louis-Napoléon's coup d'état in 1851. Now, Mayor Omer Dewavrin had raised the question again, this time in connection with a plan to join Calais to a large industrial suburb, Saint-Pierre. In the

process of reshaping the distinguished old city, the medieval walls would have to come down, and Dewavrin proposed to erect a memorial on the site. In the fall of 1884 he addressed the Conseil Municipal: "Today, at the moment when the last vestiges of the ramparts of our city are about to disappear and when our city will cease to be itself, we think that it is the duty of those of us who will be the last representatives of an independent Calais to perpetuate one of the most beautiful memories in our history with a monument."[2]

Normally, such a project would have been handled by a competition, but that would would have been costly and time-consuming. Instead, the officials of Calais inquired about likely candidates to execute the monument. On October 17 P. A. Isaac wrote Dewavrin: "Monsieur Jean-Paul Laurens and many other competent people have been unanimous in giving opinions about the choice of a sculptor. . . . We should speak to a man whose previous performance guarantees that we shall receive a real work of art. Monsieur A. Rodin, whose name you no doubt know, is the one whose powerful talent would be the most appropriate to treat this subject. This is my unbiased opinion; I give it on purely artistic grounds and advise putting his name before all others."[3]

Since Isaac's family had helped to put Dewavrin in office, he was easily able to get the mayor's attention. Before the month was out, Dewavrin had visited Rodin's atelier in Paris. For the first time in Rodin's life an elected official was in his own studio, talking about a monument that someone wanted—not somewhere, sometime, but right now.

About a week later, Rodin wrote to Dewavrin: "Since I had the honor of your visit, I have been busy on the monument. I've had the good fortune to come up with an idea that I really like. The execution would be original; I've not seen anything like it." Rodin said he wished to create a composition that was completely integrated with the subject. "It would be so much better than what one finds in all the other cities, which is always the same monument, give or take a few details. I'm going to make a clay sketch and have it photographed."[4]

Rodin had shown himself willing to do any kind of monument people might pay him to do: the eighteenth-century figures of d'Alembert and Diderot, Lazare Carnot of the Great Revolution, a contemporary figure in Margueritte, or an allegory depicting the defense of Paris. Now he rushed headlong into a medieval project. As Dante had been his guide while he worked on the doors for the Musée des Arts Décoratifs, now he took his cue from the fourteenth-century chronicler Jean Froissart and his account of the siege of Calais. The town was at King Edward's mercy. His vassals urged moderation, and in the end he agreed to take just six citizens. He ordered them to come out of the city "with their heads and their feet bare, halters round their necks and the keys of the town and castle in their hands. With these six I shall do as I please, and the rest I will spare." An emissary brought the message to Calais. There was weeping, then silence, until finally the richest man in town, Eustache de Saint-Pierre, stepped forward: "I will strip to my shirt . . . and deliver myself into the hands of the king of England." One by one, five others followed.

This is the story that Rodin wanted to tell in bronze. He formulated his idea almost immediately. Nothing like the monument he was planning existed in France, or for that matter anywhere else. Traditionally, monuments were based on a single or a dominant figure, and sculptors revealed ideas through their handling of movement and gesture, physiognomy and clothing. Rodin's monument would have six figures of equal importance, and their vitality would lie not only in their physiognomies and gestures, but in their relationships to one another—a problem similar to the one Rodin faced in the portal.

On November 20 Rodin sent Dewavrin a plaster sketch composed of six loosely clad figures, each just over a foot tall: moving, bending, turning, and bound to one another

84) Rodin, *The Burghers of Calais.* First maquette. November 1884.
Plaster. Musée Rodin.

by a rope encircling their necks. Standing on a rectangular pedestal upon which Rodin had drawn a triumphal arch design, the figures gesticulated in every direction. The mayor acknowledged the sketch on November 23: "You have rendered the idea in the most thrilling and heroic fashion. . . . Everyone who has seen the group is gripped by it." The Conseil Municipal was ready to open a subscription: Rodin must come to Calais to examine sites. By return post, Rodin reassured the mayor that he would not charge too high a fee, because "one does not often get such a beautiful opportunity to execute a work that inspires not only patriotism but sacrifice." On November 25, Rodin wrote that the monument would cost 34,000 francs, including 15,000 francs for the founder and 4,000 for the stone base. His own fee of 15,000 francs was perhaps based on the amount Barrias had been awarded for *La Défense*. But that had been a two-figure group, whereas for Calais Rodin had proposed six over-life-size figures. By contrast, Dalou had charged 250,000 francs for the *Monument to the Republic,* while the recently announced winner of the competition for a monument to Gambetta was to receive 350,000 francs. Rodin's modest bid was sure to lose him money, but money was rarely an issue in his mind. What he wanted was the commission, and he wanted it badly.[5]

A month went by with no word from Calais. Rodin knew that other artists had submitted maquettes. Nervous, he asked his friend Cazin, a native of Pas-de-Calais, to assess the situation. Cazin journeyed to Calais with Legros, who had come from London. Asking to see the "Burghers of Calais" projects, they showed their appreciation for each maquette "as seemed appropriate." Then they outlined the merits of Rodin's sketch to an attentive audience of officials, comparing it particularly to projects based only on a single figure of Eustache de Saint-Pierre. Cazin wrote to Rodin that he had emphasized "how much better your work has glorified the entire population. In conclusion, we did everything we could and in no way did it appear that our visit had been inspired by you."

Rodin was touched that an artist of Cazin's greatness would give so freely of his time. Perhaps the visit of Cazin and Legros did help; in any event, the commission promptly fell into place. On January 23 the Conseil Municipal voted: there were thirteen votes for Rodin's project and two against, with two abstentions. The report read: "He has presented us with such a seductive project that it has unified our endorsement; his is a new idea, one that has not been and could not be exploited by others. . . . His idea is a good answer to the spirit of defaming reputations which recently has seen the light of day in certain circles among those who do not believe in civic virtue and heroic actions like those of Eustache de Saint-Pierre."[6]

Only at this point did the officials began to negotiate with Rodin in earnest. He wanted the commission so much that he ended up making promises he could not keep—most specifically, the promise to deliver in a year. Dewavrin came to Paris in February to review the schedule at the foundry. For the time being, it was to be his last official action with regard to the monument; a few weeks later he was defeated in his bid to become mayor of the new city of Calais / Saint-Pierre, though he continued to serve

on the Conseil Municipal. Rodin, beset by insecurity and stress, fell sick. Nevertheless, he started the second maquette in May 1885. Working with models, he created nude figures and then draped them. Once the individuality of each figure was established, he sought to project the spirit of "patriotism and sacrifice" that he believed critical to the success of the monument. It would be a matter of interaction, burgher with burgher, the whole group with the viewer. This last step was his ultimate challenge.

On July 14 Rodin—who frequently wrote letters on holidays, when the studio was quiet—informed Dewavrin that the maquette was ready. It consisted of six figures slightly over two feet tall. Rodin cautioned Dewavrin that many details were not yet finished and that the drapery would be redone in the final work. In the maquette, he had focused on body types and gesture, rendering them in a way that he believed was unique. Rodin went to Calais to uncrate the figures himself. He remained for several days as the guest of Dewavrin and his wife, Léontine. A friendship began to grow. Rodin's meeting with this couple, people his own age who not only respected his work but were genuinely fond of him, was a great bonus of the commission.

At last Rodin felt graced by the opportunity to execute a large, important commission for which he had no real competitors and in which he had been allowed the freedom to do what he wanted. The fee, though not sumptuous, was more money than he had previously earned, and everyone seemed enthusiastic about his original conception of the monument. Nothing had gone wrong—nothing, that is, until the Calais *Patriote* appeared on the morning of August 2.

> The model of the planned monument to Eustache de Saint-Pierre has just arrived in Calais. We have been fortunate to be able to study the sculpture and will let our readers know how it impresses us. . . . Eustache de Saint-Pierre is seen in the foreground, standing with head down, the upper part of his body bent slightly forward, his arms hanging in front of his legs, the palm of a hand turned toward the knees. His appearance is heartbreaking; . . . His pain is such that his arms *literally sag* . . . another one of the six burghers is pulling out his hair and seems to abandon himself to fits of anger that are untimely. . . . We want to say, "If your sadness is so great . . . why didn't you stay at home?". . . The feelings emanating from the work, in general, are those of sorrow, despair, and endless depression.[7]

The article went on to say that Rodin's group did not represent the historical event as viewed by the citizens of Calais. First of all, he had chosen the wrong moment in the siege. Rather than depicting the burghers in bondage, Rodin should have focused on their decision to sacrifice themselves, for that was when they were most "beautiful, noble, great, and . . . also were dressed as bourgeois." The article addressed formal issues, too, especially the fact that Rodin had made all the figures the same height: "Instead of assuming the pyramid shape generally used for this type of monument, the group forms a cube, the effect of which is most graceless." The article was signed "A Passerby," but it closely reflected the thinking of the conservative members of the

Conseil Municipal. They made their objections known to Rodin a few weeks after the article appeared. The councilors were distressed that the gestures and facial expressions made the burghers' suffering painfully real. They wanted to see their ancestors walking toward death, "not as criminals . . . but as martyrs." Further, they objected to the "silhouette" of the monument, which was so lacking in elegance. They found no other option but to "insist" that Rodin change his work.[8]

For Rodin, the controversy must have been disturbingly reminiscent of the day eight years earlier when a critic had suggested that he had cast his *Age of Bronze* from life. But in 1885 Rodin was a stronger man, and he was better able to handle the situation. He immediately sent Dewavrin a point-by-point rebuttal of the councilors' criticism. He emphasized that they had misinterpreted the figure of Eustache. Far from humbling himself before the king of England, the burgher was "leaving the city to descend toward the camp. It is this that gives the group the feeling of march, of movement." As for the assertion that the composition should form a pyramid rather than a cube, Rodin objected that his work was being "castrated." His critics were regurgitating the laws set down by the Ecole des Beaux-Arts, and Rodin declared that he was *directly opposed to this principle,* which has dominated since the beginning of the century."

Rodin's next letter was to *Le Patriote*; it was a masterpiece of public relations. He began with a general explanation of a sculpture's evolution from maquette to finished work. He then moved to a subject on which he was certain they would agree: "I find the title of your paper *Le Patriote* so beautiful, and you must agree with me in thinking that our sculpture must be treated in the national taste, that of the sublime Gothic epoch . . . which places us so far above anything that can be seen in Italy But that renaissance . . . has nothing to compare with the loftiness (and that is the word) of the Gallic soul of our Gothic epoch. . . . It is for this reason, sir, that I have chosen to express my sculpture in the language of Froissart's time, if you prefer. It is for this reason that I reject the pyramid, which belongs to conventional art and locks everything in place. Also, curved lines are dull." Rodin ended his letter to the editor with one of the most eloquent statements he ever uttered in defense of his own vision: "One can make beautiful things differently than I have done, but you must allow me to work with my own mind and my own heart, otherwise you take away my energy, my teeth, and my nails, and I become but a workman. In short, I am a sculptor who, like you, asks only to make a masterpiece, if that be possible, and for whom the question of art takes precedence over all others."[9]

Rodin felt confident enough about his group to turn his back on the criticism and return to work. He wrote Dewavrin: "In Paris, in spite of the struggle I carry on against the antiquated mode of sculpture at the Ecole, in my door I am free." He intended to claim the same freedom in his monument for Calais.

Rodin needed a new studio to accommodate the monument. By the fall, all the work on *The Burghers of Calais* was being done in a studio at 117 boulevard de Vaugirard. The following spring Edmond de Goncourt visited Rodin there and described it as "filled

85) Rodin, *Head of Eustache de Saint-Pierre*.
Modeled after the head of Jean-Charles Cazin.
1885. Plaster. Musée Rodin.

with lifelike humanity," in contrast to the atelier at the Dépôt des Marbres, which was the "domicile of a poetic humanity."[10] With more space at his disposal, Rodin was ready to turn to the figures as monumental forms. He worked on the bodies, the hands, and the heads separately.[11] It was in the nude torsos with attached arms that he addressed the problem of movement. Heads were a special concern. He wrote Dewavrin: "I intend to study some expressive portrait heads in the countryside for the companions of Eustache de Saint-Pierre." Rodin's belief in the existence of regional types and his firm commitment to naturalism made him look for models from Calais. He considered Cazin ideal for the figure of Eustache de Saint-Pierre, and his friend greeted the idea with enthusiasm: "I'm ready to pose. . . . I'll be there, rope around my neck and barefoot. This excellent man who is in some way an ancestor of mine on my mother's side would surely approve of your choice, for I am in profound admiration of his grand action" (May 29, 1885).

Another Calaisian friend of Rodin's was of the same mind: Coquelin *cadet,* celebrated actor of the Comédie Française, wanted to know if Rodin might like him "to pose as a man of the people. . . . I was born in Boulogne, thus I am a real native of Pas-de-Calais and would be an absolute natural. Besides, it would give me so much pleasure to serve as model for the great sculptor Rodin." Coquelin *cadet* modeled for the figure we call Pierre de Wissant.[12]

Rodin had promised the monument for 1886. At the beginning of the year he reported that he had almost finished three figures and was well along with the others. He assured Dewavrin that he now worked on nothing but the Calais project and that he did so with great enthusiasm and passion. However, he needed more money—say, two thousand francs (Jan. 11, 1886). He was probably anxious because he had not heard from Dewavrin since October; usually they exchanged several letters a month. Finally, Léontine Dewavrin wrote that the banks of Calais were failing, including that of Maurice Sagot, treasurer of the monument committee, who had deposited the money for the commission in his own bank.[13] Rodin wrote immediately to commiserate with Sagot and Dewavrin. As for himself, he said: "Don't worry, I can wait." By February, bankruptcies were mounting. Even so, the Maison Sagot had been able to declare a first

86) Rodin, nude study for the figure of Pierre de Wissant. 1885–86. Plaster. Musée Rodin.

87) Rodin, nude study for the figure of Pierre de Wissant. 1885–86. Plaster. Musée Rodin.

88) Rodin, *Head of Pierre de Wissant*. Modeled after Coquelin *cadet*. 1886. Plaster. Musée Rodin.

89) Coquelin *cadet*. Anonymous photograph in the collection of the Comédie Française.

dividend of 7 percent. Mme Dewavrin hastened to send Rodin a check for seven hundred francs and promised send another as soon as she could.

By 1886 Calais was feeling the impact of the "Great Depression," the economic upheaval viewed by historians as among "the most serious depressions that has ever marked the history of an industrialized nation."[14] The Union Générale had crashed in Paris in 1882 and the banks of Calais were collapsing as the coal and textile industries fell apart. Rodin did not fully understand the seriousness of the crisis. Though he needed money, it apparently did not occur to him to cash the check until May. The truth of the matter was that, although Rodin had assured Dewavrin he was devoting all his time to *The Burghers of Calais,* he was actually busy on so many fronts that he could not keep them straight. In addition to the doors, he was either working on or trying to secure commissions for six other monuments in 1886. The nearest to his heart was a monument to his friend Jules Bastien-Lepage, who had died of cancer at age thirty-six in 1884. The plan was to erect the monument in Damvillers in Lorraine, the painter's birthplace. Rodin attended the first meeting of the organizational committee in 1885,

and soon thereafter the commission became his. In the summer of 1886, Jules' younger brother, Emile, assuming that Rodin was busy on the monument, suggested that he go to Damvillers to look at the site and talk to the workers there.

Another possibility came through a certain G. Saunois de Chevert, who was considering asking Rodin to create a monument to his forebear, Gen, François de Chevert, killed at the Battle of Hastenbeck (1757) during the Seven Years' War. Rodin put two well-placed friends, Roger Marx and Antonin Proust, on the case, hoping that their intervention would bring him the commission.[15] In a similar fashion, Rodin persuaded Turquet, once again undersecretary of state for fine arts, to approach the Chilean government on his behalf for two commissions that he knew about through the Chilean ambassador to France, Carlos Morla Vicuña. The Chileans were planning to erect a monument to the uncle of Vicuña's wife, General Lynch, and another to the statesman-writer Benjamin Vicuña-Mackenna. Rodin did maquettes for both; the sketch for the General Lynch monument was his first and only equestrian figure. Neither saw the light of day.

Another project on Rodin's mind was the competition being organized by the city of Nancy to honor the seventeenth-century landscape painter Claude Lorrain. Roger Marx, critic, collector, and arts administrator, had moved to Paris from Nancy in 1882 and formed a committee to work in tandem with one in Nancy. He and Rodin soon became friends, so we must assume that Rodin was kept informed of the fund being collected for the monument. In 1885 Rodin contributed a work to a benefit lottery, and by the following year an invitational competition was being planned. In June 1886 Léon Mougenot, the head of the Nancy committee, visited Rodin's atelier in Paris. Rodin won the award in 1889.

Rodin was also putting time and effort into planning a monument to Victor Hugo. Presumably it was to be placed in the Panthéon, which for the third time in less than a hundred years was secularized in order to receive Hugo's body. We know nothing of this project, but Rodin's early biographers give 1886 as the year in which he began work on it. A journalist noted Rodin's absence from the Salon that year, explaining that he was "preparing a project for the tomb of the poet who sleeps in the Panthéon."[16]

Of the many things that kept Rodin from finishing his monument for Calais, none was more debilitating than his failure to work out a satisfactory relationship with Camille Claudel. Whatever Rodin had hoped to achieve with the strange contract of October 1886, it had failed. By 1887 the lovers were estranged again. Jessie Lipscomb, now living in England, returned to Paris in March 1887 to see Rodin, but he refused to receive her. Perplexed and annoyed, she wrote: "I tell you frankly that we have come from England just to get your advice and you promised to give it to us. We do not intend to stay with Mlle Claudel, if that is what bothers you. The problems you are having with her have nothing to do with us."

The year 1887 was one of acute suffering for Rodin. With certain people he spoke openly about his pain, but never of its causes. To his new friend Robert Louis Stevenson

he wrote: "What bad years I have just gone through, and ironically it was during this time of despair that my reputation grew in Paris."[17] With other friends, such as Edmond Bazire, he kept silent. After seeing Rodin's 1887 show at the Georges Petit gallery, Bazire wrote: "Do you know how much pain you're causing me? I've been waiting for an eternity and I never see you. What are you doing? I almost had tears in my eyes as I looked at your three burghers, your faun, your Francesca, and your bust of a woman. I thought: he doesn't love me anymore!" Rodin wrote to Léontine Dewavrin, now a confidante, about the success of the exhibition, but said it meant little to him: "I'm too nervous. I'm interested in absolutely nothing; even the countryside—so adorable in springtime—leaves me cold. I'd like to get rid of my brain and just vegetate" (May 1887).

No one kept in closer touch with Rodin than Octave Mirbeau, the brilliant and combative writer whom he had met in 1885 and who became one of his most resolute supporters.[18] In 1887 Mirbeau took his bride, the beautiful former actress Alice Regnault, to Kerisper on the coast of Brittany. They insisted that Rodin be their first guest in a lovely house overlooking the river: "You will see, this country will enchant you" (June 1887). Rodin responded negatively, but Mirbeau would not be put off: "What, you are still sad! You complain that you cannot do what you want to do, you, the great creator! What an injustice toward yourself. You have the greatest artistic mind of our times. What else do you want?" (July 1887).

Finally, Rodin gave in. In August he took the train to Brittany, where he stayed with the Mirbeaus for slightly less than a month—the longest vacation he had taken in his life. Rodin was almost as fond of Regnault, now becoming a painter, as of her husband. The Mirbeaus found many diversions for their guest, such as a visit to Mont Saint-Michel. Mirbeau was fascinated to see Rodin at ease, far from the city, the worries, and the work. He wrote to a friend:

> Do you know what an admirable little guy that Rodin is? If he doesn't say a word in Paris, believe me, he sees everything. Very few things escape him. He is able to form judgments about things and people that are astonishing. To begin with, he knows everything. Could you imagine that he knows philosophy as well as Renan, anatomy as well as Claude Bernard, history as well as Michelet, and chemistry and physics and geology, and astronomy, *enfin tout?* More than that, he is a great poet. In the intimacy of a field, he is free of his usual shyness and lets loose with all that. You ask yourself, is this Rodin speaking? That's right, it's Rodin. I have passed such sweet hours with him, really delicious. He has even begun my portrait in charcoal. It's a real Rembrandt.[19]

Mirbeau, whose unerring taste brought him to defend Monet, Cézanne, Pissarro, Van Gogh, and Gauguin, put Rodin high up on a pinnacle by himself. He never withdrew his love for the man and his worship of the artist, even though he saw the world in very different terms than Rodin did. He once told Edmond de Goncourt that Rodin was

capable of anything, even "of a crime, if it was for a woman," and that he regarded Rodin as "the beast of a satyr that you see in his erotic groups."[20]

The August visit with the Mirbeaus restored Rodin's spirits. He was able to resume work once he returned to Paris, and for the moment the letters of complaint ceased. He wrote Gustave Geffroy, his other loyal and talented critic, to apologize for neglecting their friendship and to tell him how much he loved him. He mentioned that he had been to see Georges Hecq, still secretary at fine arts, and that there was "hope." The hope Rodin entertained was for the Légion d'Honneur: he was profoundly conscious of never having received this recognition. It was part of the quasimilitaristic system of "decorations" originated by Napoléon, which throughout the nineteenth century had given artists an entrée into bourgeois society. Refusing the honor could be an equally powerful statement: not accepting the ribbon of the Légion d'Honneur was a standard means for artists to declare their opposition to society, the government, or the Ecole. Daumier turned it down because he wanted no award from Louis-Napoléon's empire. Courbet feared it would inhibit his freedom. Degas refused the ribbon, and when his friend de Nittis accepted it in 1878, he chided him as too bourgeois. He felt the same about Manet, who was anxious to be decorated and only got the ribbon through the intervention of Antonin Proust during his short term as minister of art in 1881. Renoir was so worried about what Monet would think when he accepted his belated decoration in 1900 that he wrote to Monet: "I have let them give me a decoration. . . . Whether or not I have done something stupid, your friendship still means a lot to me."[21]

Unfortunately, Rodin went after the honor just as the traffic in Légion d'Honneur awards became a matter of public knowledge. The scandal of people buying the ribbon. reached the upper levels of government and was one of the reasons Maurice Rouvier's administration toppled in November 1887. So when Rodin got official word in December, he had mixed emotions. He told Bartlett, who was with him on the day the notice came, that "it's too late as an expression of appreciation. It simply informs the public that another artist has been noticed by the authorities, just as it knows that many others, without the least talent for art . . . have also been noticed."[22] Nevertheless, Rodin accepted. Dozens of friends wrote to tell him how happy they were that a grave injustice had finally been repaired. Besnard became "chevalier" at the same time, and friends gave them a joint banquet at the Lion d'Or on January 24, 1888. Geffroy could not come. "All that is very official, very Parisian, chic, and superficial," he wrote. "When I get back I'll invite just you, my dear sculptor, to a banquet in a wine merchant's place."[23]

Mirbeau, who adamantly opposed decorations, was not happy. A few days before the banquet he published "Le Chemin de la croix," an article about the "cross" of the Légion d'Honneur. In it he lamented an artist whom he loved and who had recently been decorated. "Imagine," he wrote, "one day you meet a woman equal to the vision of poets. You look at her and your heart anticipates, your imagination exalts . . . your dreams are illuminated by this sweet angel Then the next day you see her again in a

slum, drunk, her hair a mess, sitting on some lout's knee." This is how Mirbeau felt when his friend accepted the Légion d'Honneur. Then he named the friend: "Look, we have this magnificent artist: Auguste Rodin. . . . What does his genius have in common with the cross of the Légion d'Honneur?" Mirbeau thought it would have been more appropriate to have given this "honor" to some "sweet mediocrity" (*Le Figaro,* Jan. 16, 1888). Lest his criticism damage their friendship, Mirbeau wrote immediately to assure Rodin that the "cross" had changed nothing: "Today as yesterday you are the greatest artist, the best of men."

As 1887 drew to a close, Rodin put into writing a resolve that he must have been formulating throughout the fall. Having heard nothing concrete from Calais, he informed Léontine Dewavrin that he was going back to work on his door; when it was finished, he wrote, "I shall return to the burghers." His letter sparked an immediate reaction from Omer Dewavrin, who spent much of 1888 trying to get Rodin back on the job. Calais intended to celebrate 1889, the centennial of the Revolution, by inaugurating their new port and unveiling *The Burghers of Calais.* Subtly and persistently, Dewavrin managed to suggest that it was Rodin's fault the monument was not finished. Yet it is also clear that Calais did not have the funds necessary to cast the work. In temporarily withdrawing from the project, Rodin wrote diplomatically to Dewavrin that great works take much time and reflection, and that he considered it important for every part of the monument to be the work of his own hand. He thought it better not to hurry.

Rodin presented the completed plaster of *The Burghers of Calais* to the world at Georges Petit's gallery on June 21, 1889, as part of a two-man show with Monet. The *Burghers,* in which Rodin declared his freedom as an artist while making a bold nationalist statement, was the ideal work for him to offer at the time of the centennial. In a sense, the misfortunes of Calais served Rodin, for the city's inability to pay for the casting in 1886 and 1887 allowed him to complete the work at a bit more remove from the watchful eyes of the committee. He interpreted the subject and worked with the composition exactly as he wished, without having to make the compromises the committee might have demanded.

The commission for *The Burghers of Calais* gave Rodin the opportunity to reach deep into his past, to his boyhood love of Hugo's *Notre-Dame de Paris* and his passion for the French cathedrals. The year before Rodin began the *Burghers,* Hugo had published his "Vision de Dante," in which he presented a personal view of the medieval period and described how he identified with Dante.[24] Many people saw this collection of poems, in which Hugo conversed directly with God, as hopelessly out of date. Rodin, however, was equally eager to declare a personal vision of French history, of patriotism and sacrifice. He also wanted to explore his understanding of narrative. It is telling that in a letter to Robert Louis Stevenson, he referred to the *Burghers* as "my novel." After the plaster was exhibited, people frequently spoke of Rodin as "that Gothic." One critic wrote: "His real artistic family is in the Musée du Trocadéro [the Museum of Compara-

90) Rodin, *The Burghers of Calais*. 1889. Plaster. Exhibited for the first time at the Georges Petit Gallery in June 1889. Photograph taken by J. F. Limet in Rodin's studio in Meudon after 1901.

tive Sculpture, a museum of plaster casts of masterpieces of French architectural sculpture, opened in 1882], and we must jump back in a single bound, over several ages of our sculpture, to connect the sculptor of *The Burghers of Calais* to his true ancestors."[25] To modern eyes, a group of figures so dependent on naturalism and on subtle psychological characterization might suggest Donatello rather than the carvers of Chartres and Amiens. But Rodin's contemporaries, thrown off balance by his break with academic practices, strained to find a terminology to express the changes they saw. Rodin himself was not at all displeased to be identified with the sculptors of the cathedrals he loved so much.

The Burghers of Calais stood out as a uniquely fulfilling project for Rodin. To work on a public monument with great freedom, to bring it to completion in a relatively short space of time, to have it installed where he had envisioned it (although the unveiling did not take place until 1895), and to have a fair number of people understand it in the way he had intended—these were not everyday occurrences in Rodin's long career.

In the spring of 1887, Emile Bergerat wrote of the doors to the Musée des Arts Décoratifs: "We shall see them in the Salon in either two or three years" (*Reveil matin,* May 13). The following year the poet and critic Armand Silvestre wrote: "Rodin has promised us the *Gates of Hell of Dante* for the next Salon and no doubt for the Exposition Universelle as well" (*Revue de Paris,* July 15, 1888).

The Burghers of Calais and the other commissions Rodin was seeking remained secondary in his mind to the doors for the museum. But seven years after he had received the commission, the doors remained unfinished and the museum had not even been begun. The responsibility lay with the politicians of the Third Republic and the instabilities of the 1880s, including the economic catastrophes and aggravated social situation. These things, as much as the break with Camille Claudel, must have caused Rodin's depression in 1887, and we might interpret the letter he wrote to Léontine Dewavrin in December of that year, declaring his intention to return to work on the doors, as a step toward breaking though the impasse. It would have been logical for Rodin to want to see the doors exhibited, and the best place would have been in the exhibition that France planned to hold in 1889 to celebrate the centennial of the Revolution.

To understand Rodin's frustration and bitter disappointment, we must go back to 1881. Antonin Proust, minister of arts in Gambetta's "Great Ministry," envisioned the Musée des Arts Décoratifs as the crowning glory of his administration. It was Proust who picked the block-long, burned-out hulk of the Cour des Comptes, untouched since the Commune, to be the site of the museum. In February 1882, Proust lost his job and moved into a leadership position in the newly formed Union Centrale des Arts Décoratifs, which enabled him to continue to work on the museum. The union, a private organization, took over the initiative for building the museum from the government. Initially, it planned to fund the project through voluntary subscriptions. When this proved unrealistic, it requested state approval for a lottery. There were many such requests, so the competition was fierce and ticket sales slow. The museum lottery lasted thirty-four months and raised 3.5 million francs—not quite the sum the union had hoped for.[1]

Rodin, though eager to meet Proust, did not manage to do so until the end of 1883. A new friend, Henri Liouville, prominent Republican, deputy from the Meuse, and

LES RUINES
DE LA COUR DES COMPTES

Les trois principaux monuments de Paris
« flambés » par la Commune, l'Hôtel-de-
Ville, les Tuileries, la Cour des Comptes,
ont eu un sort différent.
Destinée dans l'esprit de ses reconstruc-
teurs à devenir un jour la demeure du maire
de Paris, le futur et vrai maître de la capi-
tale, la Maison-Commune a été rebâtie avec

Les ruines de la Cour des Comptes : Vue générale prise du quai des Tuileries.

91) The ruins of the Cour des Comptes, in the 1880s

insider in the Gambetta circle, was the link. Liouville and his socialite wife, Marie Charcot, were much taken with Rodin's talent, and by early 1883 they were frequently inviting him for lunches and dinners, sometimes in the company of Dalou. On December 1, Liouville wrote Rodin that Proust would like "to visit you in your atelier as soon as possible."

Proust was a strong presence in Gambetta's left-wing Union Républicaine party, and he was a friend and defender of avant-garde artists, particularly Manet. At the same time, due to his elegance and wealth, he seemed distant, even conservative. One writer described his presidency of the Union Centrale des Arts Décoratifs as expressive of "his social and cultural elitism."[2] In combining an elite sensibility and left-wing politics, Proust resembled Turquet, who was his natural rival, but Rodin never managed to establish a truly warm friendship with Proust. Nevertheless, he needed to cultivate him and went about it in the way he knew best—by doing Proust's portrait. It must have come up soon after their initial meeting, for between March and April 1884 Proust wrote Rodin six times about posing sessions, usually to cancel them.

Rodin was running short of funds. The plaster molds of the doors were being made by the Seiguillier firm in Montmartre. Their bill was seventy-one hundred francs, and to date Rodin had received less than ten thousand francs for his work.[3] By June 1884, Rodin was in contact with the highly respected founder Eugène Gonon to discuss the cost of a lost-wax bronze cast. Gonon asked for forty thousand francs, but if the state would pay for the metal, he was willing to reduce the price by eight thousand francs. In July Rodin went to a second founder, Bingen, who agreed to do the job for thirty-five thousand francs.

At this point, Rodin clearly anticipated completing the doors. While trying to influence Proust, he persuaded Dalou—who had impeccable credentials as a winner of the Medal of Honor in the Salon and a chevalier in the Légion d'Honneur—to approach the new minister of public instruction, Armand Fallières. Dalou told the minister that he was sure the doors would be "one of the most beautiful works of the century. . . . The sum allocated for the work, you know as well as I do, is really *quite low,* not only in view of the considerable expenses it entails, but also as regards the great artistic value of this beautiful sculpture."[4] Dalou's lobbying was successful, and in August the budget for the doors was raised to twenty-five thousand francs. This enabled Rodin to hire an architect, Nanier, to work on the structural part of the project—a further sign that he believed he was close to completion.[5] By November 1884 Cazin was so sure that Rodin was about to put the finishing touches on the doors that he urged him to take a real vacation. He invited Rodin to visit him and Marie in Pas-de-Calais, after which the three of them would go on to London.

Rodin communicated with the ministry in December about the importance of having the work cast according to the lost-wax method, because it was the only process that allowed a sculptor to work on the model during the casting procedure. He said that he would work hand in hand with the founder on each of the five sections—the two pilasters, the two panels, and the entablature above. "I am longing to finish this work. I am consecrating all my efforts and all my time to it," he wrote.[6] At the close of 1884 Rodin was anxious in the extreme; he knew that at any moment the project could fall apart. He wrote to Bazire: "For the moment what I want . . . is that no one speak of the commission for my bronze [he added 'of my door' between the lines] in the newspapers. I haven't received it [authorization to cast the doors] yet. I'm afraid of anything that might impede it, although the president of the council [Proust] has recommended it in the most exceptional way."[7]

Perhaps in hopes of clinching Proust's favor, Rodin placed his bust as his sole entry in the Salon of 1885. His obsessive attention to details comes out in a letter to Gauchez, editor of *L'Art,* in which he requested not only that the bust be mentioned in the magazine, but that the reviewer be instructed to speak of Proust "as one of [his] friends."[8] Gauchez did not comply. When Eugène Véron reviewed the Salon for *L'Art,* he simply mentioned Rodin's name in a list of sculptors who had made expressive portraits that year. Mirbeau commented that Rodin's lone offering was "not much, but in another sense it is enormous because of the evident mastery in the work" (*La France,* May 2, 1885). André Michel wrote the best line of all on the Proust portrait in the *Gazette des beaux-arts:* "a superb and vibrant translation of the world enclosed within the man himself" (July 1, 1885).

On February 19, 1885, the state and the Union Centrale reached a provisional agreement to install the national museum of decorative arts in the restored Palais d'Orsay.[9] In March, Jules Ferry reappointed Edmond Turquet as undersecretary of fine arts, under Minister of Public Instruction René Goblet. On July 20 Rodin wrote the minister that

would have been cast in time for the centennial had it not been for the financial crisis that culminated with the fall of Jules Ferry on March 30, 1885. This brought the ascendancy of the Third Republic's founders to an end, ushering in a period of "increasing ministerial instability" and "years of economic and social difficulties," in which the "liberal, parliamentary Republic disappointed the masses."[11]

Understanding how shaky his commission was, Rodin was not eager for the journals to discuss the doors before February 1885. But the provisional agreement on the museum prompted him to give journalists access to his studio, and he looked forward to reviews of the project. One week after the agreement was signed, Mirbeau published the first significant article on the doors, which he believed would become the "principal work of the century." He explained that Rodin had gone to Dante for his subject matter and related the work to both Gothic and Renaissance art. Mirbeau counted "more than 300 figures, each portraying a different attitude or feeling, each expressing in powerful synthesis a form of human passion, pain, and malediction." He described the central figure of "Dante" (*The Thinker*), the group of Ugolino and his sons, and that of Paolo and Francesca, each with a "different expression or attitude." In conclusion, Mirbeau remarked that although Rodin had been inspired by Dante, the most impressive aspect of the work was the "personal imagination" that had gone into it.[12]

Sometime in 1885, Rodin approached the critic Maurice Guillemot about writing a piece on the doors. Guillemot was not able to oblige at the time, but in June 1887 he apologized for having let so much time go by and said he was now free to come to Rodin's studio and write the article. Rodin answered that he would be happy to receive Guillemot at the rue de l'Université: "I am always there, especially afternoons. I should be happy to talk with you and to show you my work. But I do not want you to talk of *my door* nor of *my burghers,* which could be abandoned. We can talk about the way a sculptor sees nature or even about art in Paris, its hopes and its dreams."[13]

With both projects in limbo, Rodin belatedly tried to step back from the public eye. But too many critics had already been to his studio, and some of the figures for the doors had been exhibited at the Georges Petit gallery in 1886 and 1887. Rodin and his friends continued to refer to his work for the museum simply as "the doors," but as it came more and more into public view, critics began to speak about "The Gates of Hell." An aggressive young critic named Félicien Champsaur published a long review in 1886 entitled "The Man Who Returns from Hell" ("Celui qui revient de l'Enfer"). A luminous description of the doors, it included an eloquent plea for an additional appropriation so that they could be cast. Although Champsaur did not use the title "The Gates of Hell," his article reinforced the growing tendency to treat the doors as a work of art separate from the museum for which they had been commissioned.[14]

Among Rodin's friends, the general feeling was that he should show his doors in the exhibition of 1889. The sculptor François Captier wrote in February 1888: "I hope that your magnificent decorative portal is finished and that you will be able to put it in the Exposition Universelle." Government support for the project was still forthcoming;

94) Rodin, upper section of *The Gates of Hell*. 1887. Photograph by Lipscomb.

Rodin received an additional payment on March 31, 1888, but there was no talk of an appropriation to have the doors cast in bronze. This was not surprising: in the midst of a financial crisis, how could any government spend thirty-five thousand francs on a work of art for which it had no immediate use?

Claude Monet had a different idea about what Rodin should do for 1889. He suggested that he and Rodin show together at the time of the Exposition Universelle, not as Courbet and Manet had done, in their own pavilion, but at Georges Petit's gallery, where they had both already shown well. The two men had gotten to know each other mostly through Mirbeau and Geffroy, who were equally supportive of painter and sculptor. By 1886 Rodin and Monet were attending the monthly dinners of the Bons Cosaques, a group that included a number of the younger and more avant-garde artists brought together by Mirbeau. In 1887 Rodin was a regular visitor to Monet's home in Giverny, and by 1888 they had begun to toy with the idea of a joint exhibition. That spring, as a gesture of respect and affection, Rodin gave Monet a bronze sculpture.[15]

Rodin was conflicted. Faced with choosing between a gallery exhibition and unveiling his doors at the Exposition Universelle, he knew what his priority was. In the fall of 1888 a certain Monsieur Noirot asked Rodin to do his portrait. Rodin declined, writing: "As you know, I am working ardently on my *Door,* which I hope to show in '89. Since I believe I can do it, I work on nothing but my door. If, however, I lose ground and realize that I can't do it, I'll do your bust" (Oct. 7). In the same vein, he wrote to Geffroy about the exhibition with Monet: "My door is more and more my total occupation. I can only show a few things, almost nothing. I'll simply have my name with Monet's, and that's it."[16]

95) Rodin, lower section of *The Gates of Hell*. 1887. Photograph by Lipscomb.

The more Rodin dodged, the more intensely Monet set his heart on the joint exhibit at the time of the Exposition Universelle. In February 1889 Monet wrote that he was seeing Petit to make a final commitment. He assured Rodin that the show would include "*no one but you and me*. Are you still so disposed as you told me you were the last time we talked?" Finally, Rodin accepted. Although he was resigned to not seeing his doors at the 1889 exhibition, he was not an easy partner for Monet, who needed all his force to keep the foot-dragging sculptor on the team.

Monet had just discovered a spectacular new motif in the Valley of the Creuse in central France. He and Geffroy had stayed in an inn near the home of the poet Maurice Rollinat. Monet wanted to go back and paint through the spring, but Rodin's evasiveness held him up. "I have to know before I leave if Rodin is at my disposal as he said, or if it's a deception. I'm in a real funk because I can't leave and I want to paint that country in the worst way. . . . On the other hand, the silence of this damn Rodin keeps me from finishing anything. If he does not want to get involved in this exhibition, he should tell me. . . . Without him I'm not going to launch myself in an exhibition that would be interesting only if we were both there, but I really believe we can do something very good."[17] It was Monet who had to negotiate the dates and financial terms. "Opening will be between the 5th and the 10th of July, [and it will last] for 3 months," he informed Rodin. "Entrance fees [will be split] between Petit and us, 10% on each sale, and 8,000 francs worth of paintings and 8,000 francs worth of sculpture to give to M. Petit" (April 12, 1889). Monet renegotiated for an earlier date, but in exchange he was forced to relinquish part of his and Rodin's percentage.[18]

Rodin's ambivalence took him right up to the deadline. The day before the show

began, Monet telegraphed: "Absolutely urgent that you come *this instant* with the rest of your groups for the final installation. We open at 9 tomorrow morning" (June 20, 1889). According to a note in the Goncourts' *Journal,* the tension of that spring put Rodin into a foul state. "It seems the most terrible scenes have taken place, during which sweet Rodin suddenly became a Rodin none of his friends had ever seen before, screaming: 'I don't give a damn about Monet, I don't give a damn about anyone, I'm only interested in myself!'"[19]

We have almost no letters from Rodin in the spring of 1889, except for a few telling people of his unavailability: "Can't budge, not even for my dear friend [name illegible] and my dear friend Geffroy," he wrote to one correspondent. "I'm terrified and must work steadily. If I leave the atelier, ideas escape and like birds they are slow in returning. They can pass a whole day debauched by the promenade of one evening" (May 8).

Thoughts of evening promenades must have been quite vivid in Rodin's head, for by May 8 the Exposition Universelle had opened virtually on the doorstep of the Dépôt des Marbres. At night when Rodin stepped into the courtyard, his whole being would have been engulfed in powerful pulsations of red, white, and blue light coming from the electric beacons on the Tour Eiffel. Asians and Africans were clustered into the "History of Habitation" exhibit along the quais directly behind the dépôt. In this way the sounds and smells of a non-European world made their way into Rodin's ears and nostrils while he worked monomaniacally to finish his part of the show. (The day after the exhibition opened, Edmond de Goncourt wrote, "First sign: insupportable smell of musk")

Rodin did manage to get his work to the gallery on time, but not without causing Monet a final disappointment: "I came to the gallery this morning, and what did I find but my painting on the back wall, the very best of my show, absolutely lost since Rodin has put in his group. But the evil has been done . . . it's a total disaster for me. . . . If Rodin could have understood that as joint exhibitors we should have agreed on the placements . . . if he had thought about me and taken a little care with my works, it would not have been difficult to arrive at a beautiful arrangement without interfering with each other. . . . I left the gallery completely crushed."[20]

Monet recovered, particularly since with this exhibition—a true retrospective—he forcefully took the leadership position among French painters. He had put nearly 150 paintings before the public, from the first work he ever submitted to the Salon (*La Pointe de la Hève,* 1864) to his 17 most recent paintings done in the Creuse. Some were probably not yet dry.[21] Rodin had 36 works in the show: the definitive version of *The Burghers of Calais,* the plaster figure for his *Monument to Bastien-Lepage,* now ready to be installed at Damvillier, and three busts—*Bellona* in marble, *Saint George* in plaster, and *Mrs. Russell* in silvered bronze. Rodin was sensitive about this last head because it had been turned down for the Salon the previous year. The other 31 works were either from the door or had grown out of his exploratory work on the project.

The importance of the exhibition was enhanced by the catalogue essays: Geffroy's on

Rodin, Mirbeau's on Monet. Years later, Geffroy reflected: "For the two prefaces we mimicked each other, Mirbeau and I; it was a touching emulation. Today I think we made the catalogue too long. If no one had stopped us, we would have written a whole book, we were so excited."[22] Mirbeau wrote a panegyric to "the greatest living artist," stressing how truthful and discriminating Monet's art was and calling it "a unique combination of consciousness and imagination that captured the precise effects of light at particular moments of the day."[23]

Geffroy opened his essay on Rodin with a quotation from Stendhal's *History of Painting in Italy* (1817), in which the Romantic author posed the question: "If a Michelangelo were given to us today, what would he be?" When visitors walked out of this exhibition, Geffroy was sure they would know the answer. He spoke at length of the doors for the Musée des Arts Décoratifs, referring to the central figure from the tympanum not as "Dante," but as the "poète-penseur." He described the whole of Rodin's door, which the gallery viewers could hardly imagine, as an "assemblage of action, instinct, destiny, desire, desperation, everything that cries and groans in man." In these "bodies bending over, heavy backsides, desolate figures," Geffroy found more Baudelaire than Dante. He emphasized how important it was to understand that although much of Rodin's identity as an artist could be understood through the books he had read, viewers should be careful. He was not an illustrator of Dante, Baudelaire, or Flaubert, but a man "wrestling with the powers of nature." Only once in his essay did Geffroy use the words "The Gates of Hell," and then within quotation marks. But there can be no doubt that the 1889 exhibition was an important moment in the evolution of Rodin's relief from a work designated for a particular purpose to a singular, if peculiar, masterpiece capable of standing on its own.

The Petit show was the biggest success Rodin had ever known, but he remained ambivalent about it. To comprehend this, we might connect his reservations with a proposition made by the historian Joseph Reinach: "Tell me how you would celebrate the centennial and I will tell you who you are."[24] It was a matter of identity, and a gallery show was simply not Rodin's idea of who he was as an artist.

The idea to hold a universal exhibition for the centennial came out of Jules Ferry's first administration. The bureaucrats decided on it in 1880, the year Rodin received his commission for the portal for the Musée des Arts Décoratifs. The factors that made it so difficult to realize the doors were the same ones that undermined the efforts to mount an exhibition: changing governments, promises followed by inaction, the political struggle between the left and the right, and the lack of adequate funding. Many in the government did not want the exhibition at all, fearing the financial burden it would place upon the French people. It was the Ferry government in its second incarnation (February 1883–March 1885) that really put the exhibition in place. An advisory committee was appointed to select the site and to make recommendations about design and financing. Antonin Proust was its chair. He was making the critical decisions about the Exposition Universelle at the very moment he was posing for Rodin. Their conversa-

tions must have touched on the plans. How could Rodin not have dreamed that his doors might be part of the great scheme in the making?

The exhibition was mounted only with the greatest difficulty. Not until 1886, after two more governments had fallen, did someone have the presence of mind to inquire about the participation of the other European nations. In fact, they wanted no part of it; the monarchies of Europe were not inclined to celebrate the French Revolution and they did not show.[25] France went ahead. The Exposition Universelle of 1889 was a big gamble, but it had become a matter of national pride.

The rave reviews of the Monet-Rodin exhibition continued throughout the summer.[26] Many critics observed how the small figures from the portal showed Rodin's ability to evoke feelings, attitudes, and passions. "Figures born in pain from the block of material unfurl themselves, as from a veil, and then leap forward in anguish," wrote Félix Jeantet. He applauded Rodin as a "poet in three dimensions" and compared his power to express "doubt and desolation" to that of Chateaubriand, de Vigny, and Baudelaire.[27] Even more than in 1886, the language of symbolism abounds in these reviews. In Rodin's gesturing bodies convulsed with pleasure and his isolated heads standing alone as symbolic fragments, critics saw a world akin to that of Rimbaud, Verlaine, and Mallarmé.

In one sense, the Monet-Rodin exhibition, which included *The Burghers of Calais* and all of Monet's landscapes, can be seen as the triumph of naturalism in modern French art. But we need to remember that it took place in the period when a number of avant-garde artists were withdrawing from naturalism, which Huysmans dismissed as "that pigsty," in favor of esoteric symbols and the invisible world of the psyche. Rodin had a choice, though he would not have been able to articulate it as such. Rather than pursue his goal as a monument maker and public sculptor, he could have taken the figures and fragments from the doors and placed them in gallery exhibitions with artists of the emerging symbolist group. Given his obsession with physical love, contemporary artists who were pursuing ecstasy and *l'âme* under the banner of *la décadence* would have been all too happy to accept him.

But such an idea was not attractive to Rodin in 1889. This fin-de-siècle brand of unease was for more delicate sensibilities and for artists of more privileged classes than his. Rodin identified with a simpler part of French society, one in which hard work was constant, official accolades were good, devotion to French greatness was a constant, and belief in individual genius was an article of faith. Moreover, he wanted to participate in putting his ideas and forms before a large public.

In 1889 many people in France thought that no work of art was more necessary than a contemporary monument celebrating the French Revolution. The government was well aware of this, particularly the politicians of the left, who were anxious to establish specific ties between the Great Revolution and the Third Republic. The first person to draw up plans for such a monument was Turquet in 1881. He was succeeded by Proust, and Proust by someone else, and then governments began to fall in such rapid succession that no one could arrive at anything concrete.

As the exhibition date approached, the Conseil Municipal of Paris realized that there was no monument to adequately reflect the importance of the year 1889. So the councilors concentrated on one they had commissioned at the beginning of the decade: Dalou's *Monument to the Republic*. Unfortunately, it had not yet been cast in bronze, and Dalou was not eager to color the plaster to make it look like bronze. But Adolphe Alphand, the city's director of works, appealed to Dalou's Republican spirit. The council wanted the monument to be unveiled in a working-class neighborhood, in the Place de la Nation, on September 21, the anniversary of the proclamation of the First Republic in 1792. The theme of the day—on the eve of the most important general election since 1876—was unity: one republic, open and equal for all. The hour-long ceremony concluded when President Sadi Carnot made Dalou an officer in the Légion d'Honneur.[28] A week later *L'Illustration* ran a double-page spread showing the monument on one side and a portrait of Dalou on the other, explaining that Dalou had taken his place as first among contemporary sculptors: "We might even say that he is first among all French sculptors."[29]

Dalou's triumph made the show at the Georges Petit gallery even more difficult for Rodin. In 1888 he had made a last desperate effort to complete his portal for the Exposition Universelle. To stop working on the whole and ready the parts for a gallery exhibition did not represent an accomplishment comparable to that of placing a large work into the public domain. Rodin dreamed of receiving official blessing for a major state commission. Instead, he found himself sharing space with a painter in a commercial gallery where he had to dicker over percentages.[30] From our perspective, 1889 marks Rodin's ascendancy as a professional artist. For him, however, it was the year in which he began to relinquish the vision of a bronze portal bearing his name installed at the entrance of a national museum. In 1889, Rodin would have preferred to have been Dalou.

> Do something for this woman of genius (the word is not
> too strong) for whom I bear such love, and for her art.
> —Rodin to the critic Gabriel Mourey, May 1895

Having installed his own exhibition, Rodin let himself taste the pleasures of the Exposition Universelle. One summer's day in 1889 he strolled out of his studio at the Dépôt des Marbres in the direction of the Tour Eiffel. About ten minutes later he climbed into one of the big Roux elevators, made to hold a hundred people, and glided up to the Restaurant Russe on the first platform, from which one had the best view of Paris. There he met Léopold Hugo and Paul Foucher, Victor Hugo's nephews; and Camille Claudel. The next day, Léopold Hugo wrote to Rodin that his "charming and clever" twenty-four-year-old student had been "drawing my profile all the time you and I were talking." Rodin and Claudel had repaired the rupture in their relationship sometime in late 1887 and were now frequently and publicly in each other's company.

The Claudels remained, as ever, a family in conflict. Camille's father, Louis-Prosper, had changed jobs again in 1887 and was now working close to Paris in the registry office at Compiègne. However, he still came home only for the occasional weekend. The

96) The Tour Eiffel and the Exposition Universelle of 1889. Photo
R.M.N.

97) Camille Claudel. Photo by H. Cartier-Bresson. Paris, Cabinet
des Estampes.

most powerful axis of allegiance in the household was between the youngest and the
oldest of the three siblings, Paul and Camille. Each was aware of everything the other
did, and each suffered from the other's struggle to find an individual life. When
Camille's career as an artist flourished, Paul felt abandoned. On Christmas Eve in 1886,
he converted to Catholicism in the Cathedral of Notre-Dame and entered a period of
solitude—the "work of my conversion," he called it. Then it was Camille's turn to
experience loss.[1]

The other household alliance was between the two Louises—mother and daughter.
In 1888, at exactly the moment when young Louise made her plans to marry Ferdinand
de Massary, Camille decided to leave the family apartment on the boulevard de Port-

Royal and move into an atelier at 113 boulevard d'Italie (today the boulevard Auguste-Blanqui), near the southern edge of the city. Though not far from Port-Royal, it was a newer, less formed zone of the city, and it seemed a whole world away.[2] Rodin began paying the six-hundred-franc annual rent at number 113 on January 1, 1888.

Paul Claudel worked through his feelings of loss by writing *Une Mort prématurée,* a four-act play that he destroyed "because of his family" (à cause des siens). He later published the last act as *Fragment d'un drame.* It opens with a fourteen-line monologue spoken by a brother who is taking leave of his sister because of her impious deeds: "carnal sins, coarseness, betrayal with another. . . . Adieu! This is how we leave one another. I, never to come back, nor you! By what long, arduous, underground road will we pass? On what landmark will you be sitting when I find you again."[3]

Freedom from her family sparked a brilliant period in Camille Claudel's career. In the Salon that spring she placed a large sculpture of lovers based on the epic *Sakuntala* by the fifth-century Indian poet Kalidasa. In the story, an innocent virgin, Sakuntala, loses her heart to a stranger, who is also a king. When he leaves, she experiences sorrow for the

98) Camille Claudel, *Sakuntala.* Here seen in a 1905 marble version
called *Vertumne et Pomone.* Musée Rodin.

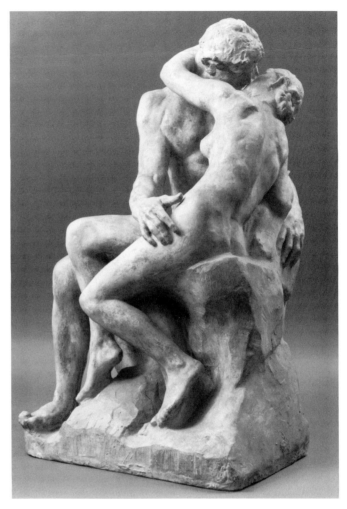

99) Rodin, *The Kiss*. c. 1884. Plaster. Musée Rodin.

first time. He is placed under a curse and no longer recognizes her. She brings up their son alone until the curse is broken. Claudel chose the lovers' reunion as the subject of her work: the king kneels before Sakuntala and plants a kiss upon her cheek as she bends languidly to receive him into her bosom. The group was a huge success, winning an honorable mention and favorable reviews. In *L'Art* Paul Leroi called it "the most extraordinary new work in the Salon," underscoring the "prodigious accomplishment that such a young woman could conceive and execute a group of such importance with so much success."[4]

Sakuntala reveals Claudel's indebtedness to Rodin. She was responding to his *Paolo and Francesca* (*The Kiss*), which had been shown at Georges Petit's gallery in 1887 and which the government commissioned in marble early in 1888. Claudel reached for a

similar poetry in depicting her lovers, also relying on a literary source, and describing her figures in a complex, richly modeled style equivalent to Rodin's. But she revealed originality as well in turning to a source with virtually no history in French art, a story in which the female played a more significant role than the male.[5] Claudel stayed closer to her source than Rodin ever did, and her narrative is powerful and fully realized. Although the torsion of the standing body, the forward pull of the upper part of the figure, and the dangling left arm are very similar to Rodin's Michelangelesque *Adam*,[6] the composition as a whole is more vertical, more four-sided, and more classical than Rodin's two-figure groups. Claudel had worked on Rodin's portal and on *The Burghers of Calais*. She certainly knew how to imitate his style, but in her first monumental work she proclaimed in no uncertain terms that she had her own way of making sculpture.

Before *Sakuntala,* Claudel's best works had been portraits. Like Rodin, she could evoke the language of a whole body in a head. Here, too, she showed originality in contrasting roughly modeled surfaces with smooth ones and drawing on the surface in a way that was quite dissimilar to Rodin's. Claudel was a talented draftswoman, able to pick up a piece of charcoal or a pastel crayon and capture the images of both friends and strangers to a remarkable degree.

In 1888 Claudel fashioned her lover's portrait. She sculpted Rodin's face in the clay much as he had sculpted hers: as he had augmented and unified his image of her by building up the volume of hair cascading down her back, she unified her mass of clay through the flowing beard in a symmetrical and frontal image. Claudel lets us feel the power of Rodin through his head alone. In future years she would not be pleased that, among all her works, this was the one most desired for exhibitions because it was a portrait of Rodin.[7]

To recover from the tense spring of 1889, Rodin needed a vacation, and it seems probable that he and Claudel went off together. François Captier stopped by Rodin's atelier on July 18, only to be told by the concierge that Rodin had left for Spain the previous day. Captier wrote to Rodin in "the fierce and picturesque land of Velasquez" to tell him how much he envied the "happy mortal able to pay for such an interesting trip." It may well have been Léontine Dewavrin who inspired the vacation. In the spring of 1887, after her trip to Spain, she wrote to tell Rodin how often she found herself reflecting: "Ah, if only M. Rodin were here, he would be so enthusiastic; he would be in ecstasy."

Rodin had traveled to a foreign country by himself only once—to Italy in 1876. The truth was, he was ill at ease in foreign places and had no facility for languages.[8] We would not expect to find him in Spain alone. No companion is mentioned in the correspondence; most of his friends, in fact, did not know where he was. "Where are you? I've been by to see you twice," Mirbeau wrote in September. Claudel's companionship would help to explain his silence. In the 1890s their trips would become more frequent, and out of respect for the Claudel family and for Rose Beuret, the lovers made an effort to keep them secret.

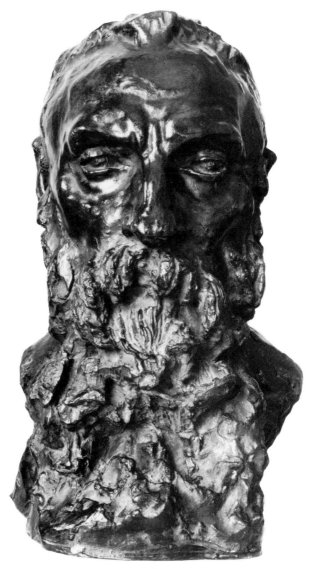

100) Camille Claudel, *Rodin*. 1888–89. Bronze. Musée Rodin.

Rodin was always reticent about his family. Some people did not know he had a wife; others who knew Beuret did not know they were not legally married; many did not know they had a son. One day Edmond de Goncourt asked Mirbeau, "What kind of creature is Rodin's wife?"

Oh! she's a little washerwoman without any capacity of being in communication with him and in total ignorance of what he does. . . . One day a friend was taking

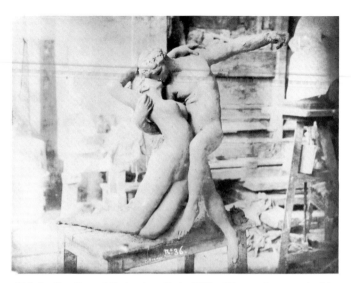

101) Rodin, *Eternal Springtime*. Early 1880s. Plaster photographed in
Rodin's studio by C. Bodmer. Albumen print. Musée Rodin.

him to Belgium. They went to his home so he could pack his bag. His wife was
out. He told neither the servant nor the concierge so they could let her know. He
was gone for three weeks, during which time she had no news of him.

"Does he have children?"

Yes, a son, a strange son with a queer eye and the head of a murderer who never
says a word and who passes all his time at military fortifications drawing the *backs of
soldiers,* backs which his father says sometimes display genius. . . . Actually, this
son is only seen at dinner hour, then he disappears.[9]

Although Rodin and Beuret were living together in the rue de Bourgogne in 1889,
there are very few references to Beuret in the correspondence of the period. Rodin was
clearly withdrawing from her, but he made no move to alter their situation and contin-
ued to take responsibility for her. He relied upon Dr. Vivier and his wife to invite
Beuret to their home in the country and to give her companionship when they could. In
early 1890 she was sick and convalescing with them in Châtelet-en-Brie. Rodin wrote
to say how happy he was that she was getting better. He would come for her on
Saturday: "I congratulate you. It's because of your energy and your love for me. Thank
you, you have made me happy." When Rodin wrote this letter, he was in Tours with
Claudel.

One of the people to whom Rodin apologized for having disappeared in 1889 was a
new friend, Edmond Bigand-Kaire. A retired officer of the merchant marine, collector,
and cofounder of the literary journal *La Plume,* Bigand lived in the Haute-Saône and

owned a vineyard in the south, in Bouches-du-Rhône, from which he sent Rodin frequent gifts of wine. Although we have no letters between Bigand and Rodin before 1889, they must have been fairly good friends by then, since Rodin gave Bigand a plaster cast of the group *Eternal Springtime*.[10] In the fall of 1889, Rodin introduced Bigand to Claudel, and they developed a semi-independent friendship. Later Rodin would convince Bigand to purchase a work by Claudel; for the moment, however, when he wrote, "You have been so kind to both my student and me and we are very grateful for all these nice little things," he was talking about the gift of wine.[11]

Another letter Rodin wrote shortly after his return from Spain was to Octave Maus in Brussels. Maus was the principal organizer of the Group of Twenty (Les XX), a society of avant-garde Belgian artists dedicated to fostering modern art in their country. Each year they invited a certain number of foreigners to exhibit in their annual show. Rodin had been there since the beginning in 1884, and by 1889 he was named a "Member of the Twenty." Therefore, he felt it was within his rights to put in a word for Claudel: "I wish you would invite my student, Mlle Camille Claudel, who has great talent and who has had a group in the Salon that made a sensation. If the rules will permit it, it would give me great pleasure."[12] Maus replied that the list was closed for the following year. Rodin's initiative on Claudel's behalf was characteristic, for in his eyes she was a woman of genius. Even in the periods when their personal relationship stretched to the breaking point—as it would in the nineties—he remained ready to use his influence to get her work into a show, to find her a patron, or to locate a critic who would adequately sing her praise.

Chapter 19
Monuments to Genius:
Bastien-Lepage, Claude Lorrain,
and *Victor Hugo*

Rodin's *Monument to Bastien-Lepage* was dedicated on September 30, 1889, five years after the painter's premature death in 1884. Many considered Jules Bastien-Lepage one of the glories of modern French painting. His *plein-air* approach was similar to that of the Impressionists, but differed in that he retained a commitment to figure and subject. Bastien and Rodin developed a close friendship in the early eighties. They agreed that it was important for an artist to take inspiration from nature. In his image of Bastien, Rodin sought to project the painter's strength and his intense pursuit of nature. Rodin placed the figure standing on uneven ground, leaning forward, a short cape covering his shoulders, bracing himself as if against the wind. In the crook of Bastien's left arm is a palette, while his right hand wields the brush in a broad, energetic swing. The painter has set off in the early morning light in search of his subject.[1]

Rodin looked forward to the dedication of the monument in Damvillers, Bastien's birthplace on the northeastern border of France. For the first time he would stand beside one of his own works and watch the cloth drop to reveal the dark and sober bronze figure against the sky. For the first time he would listen to the applause and hear the speeches celebrating a man whose image he had sculpted.

Unfortunately, it rained on September 30. The papers described it as a "penetrating, cold, and disheartening day." Nevertheless, Damvillers was decked in flags and bunting. At a banquet for one hundred in the town hall, Rodin was seated at the table of honor. At three in the afternoon, to the fanfare of the *Marseillaise,* the cloth was taken away. Gustave Larroumet, director of fine arts in the ministry of Edouard Lockroy and swiftly becoming a Rodin admirer, gave the principal address.[2] It was elegant and literary, focusing on the love of art and of landscape, and expressing the gratitude of France and Damvillers to people of many countries—England, America, Belgium, Holland, Norway, and Denmark—who had contributed money so that the monument might exist. The *Echo de Paris* reported that the crowd "without exaggeration could be described as 4,000 persons from every corner of the region," and that at half-past four they "dispersed, carrying away the profound emotions of the day."

It was a day that would have made Jean-Baptiste Rodin proud: finally the family name was assured of living for posterity. The success of the occasion reinforced Rodin's enthusiasm for the new challenges in his life. For one thing, while he was putting the finishing touches on *Bastien-Lepage* and getting ready for the show at Georges Petit's gallery, he won his first competition, for a monument to the landscape painter Claude

Lorrain in Nancy. Since his competitors were men of standing, sculptors like Barrias, Bartholdi, Falguière, Mercié, and Saint-Marceaux, it was not an insignificant victory.

According to Judith Cladel, Rodin conceived his idea for the *Monument to Claude Lorrain* one evening while he was returning home from an official function. He stopped at Jules Desbois' atelier: "Carried off in a fever of inventiveness, on the spot, without taking time to remove his coat and still wearing his top hat, Rodin amazed his collaborator, though he was well used to these magisterial displays, by improvising a 60-centimeter sketch that quivered with life on the edge of a turntable in the short span of forty-five minutes."[3] This sketch revealed what would remain the most original aspect of the monument: the figure and base were of equal importance, the latter including a pair of fiery stallions pawing the air and driven forward by Apollo. Rodin was very taken with this image and explained in a note that accompanied his competition entry: "My preoccupation in this project has been to personify, in the most tangible manner possible, the genius of the painter of light, by means of a composition in harmony with the Louis XV style of the capital of Lorraine." To make this evident, he used a well-known and much loved source: the beautiful eighteenth-century relief of Apollo riding the chariot of the sun by Robert Le Lorrain, which adorns the courtyard façade of the Hôtel de Rohan-Soubise in Paris. The figure he placed on this remarkable base was a variant of his *Bastien-Lepage,* admiring a sunrise: "The broad orange light bathes his face, intoxicates his heart, provokes his hand armed with a palette."[4]

On April 8, 1889, the maquettes for the monument to Claude were placed on view at Durand-Ruel. They came in all shapes and positions: standing, sitting, busts, some with allegories, most without, a few with reliefs. On one thing all the sculptors agreed: period dress, not nudity, was appropriate for the occasion.[5] The maquettes were numbered to conceal the artists' identities, yet some had signed their names in the clay, and Rodin had attached his description to his maquette. Further, Roger Marx was in constant communication with Rodin while he was developing his ideas for the monument, and Rodin was surely not the only artist whose studio had been visited by a jury member prior to the competition.

Rodin received six of the eleven votes. His maquette was the most challenging and the least traditional of the twelve works before the jury, so the vote must be seen as a testimony to Marx's extraordinary lobbying abilities. Since arriving in Paris from Nancy in 1883, Marx had worked his way up the ladder of the fine arts administration, becoming the principal inspector for all the departmental museums by 1889. Marx's friends, the jurors from Nancy, were Rodin's real backers. Besides Marx's vote, he received those of Emile Gallé, the illustrious glass and furniture maker, and of the retired French consul to Spain, Léon Mougenot, the major promoter of the monument. Mougenot frequently stopped at Rodin's atelier while he was planning his entry. The same was true of the painter François-Louis Français, who presided over the Paris committee for the monument. He wrote to Marx that he was "content, very content" with what Rodin was doing.[6] In his dedication address in 1892, Français said that

102) Rodin, maquette for the *Monument to Claude Lorrain*. 1884–89. Bronze. Musée Rodin.

Rodin's extraordinary idea of putting "the image to which Claude consecrated his life— that is, *light*—right on the pedestal" had won the competition for him.[7]

When Rodin returned to Paris from Damvillers, he had an even more important work than *Claude Lorrain* on his mind. He knew he was about to be awarded the commission for the *Monument to Victor Hugo* for the Panthéon. A few days before his departure for Damvillers, he wrote to Larroumet: "I am so happy about this magnificent commission that you have given." He told the director of fine arts that he believed he could have a sketch ready in about a month, but that he would need an additional studio at the Dépôt des Marbres, for his current studio was completely filled with sculptures for the door of the Musée des Arts Décoratifs.[8]

Rodin wanted the commission for the Hugo monument more than anything that had yet come to him. Larroumet had been instrumental in steering it his way, but another

administrator had played an even more crucial role: Edouard Lockroy, minister of public instruction in Charles Floquet's cabinet (April 1888–February 1889). Lockroy, writer and left-wing politician, having briefly studied in the studio of Gleyre, was something of an artist manqué. Married to Alice Hugo, Charles Hugo's widow, he was the stepfather of Victor Hugo's grandchildren. Rodin would have met him while working on Victor Hugo's portrait. Lockroy had the clarity of mind to recognize that the biggest problem for state-supported arts projects was the absence of continuity in government. Soon after he was appointed in April 1888, he reconstituted the Commission des Travaux d'Art, an advisory group to the ministry. He increased its size to forty and strengthened it by appointing highly placed people, including senators and deputies. A quarter of the members were well-known artists such as Dalou, Chapu, Guillaume, and Puvis de Chavannes. Such a committee, Lockroy believed, would ensure that commissioned works would not lose support when a minister was removed. Lockroy had in mind such projects as the Musée des Arts Décoratifs. The wisdom of his actions was rapidly proven. Lockroy signed a decree authorizing the sculptural decoration of the Panthéon on February 12, 1889. A week later, the Floquet government fell and Lockroy was out of a job.

Larroumet, a Lockroy appointee, retained his position and oversaw the plans for the Panthéon. Groups, statues, and bas reliefs would tell the story of the great periods and men of France, particularly the France that mattered most to this secular republic. Where the altar of Sainte-Geneviève had once stood would be a monument to the Revolution, which would be surrounded by images of the men who had prepared the way for 1789—Descartes, Voltaire, and Rousseau. On the four pillars supporting the dome, reliefs would tell the history of France before the Revolution. For the transepts, two special monuments were planned: one to Mirabeau, the other to Hugo. Statues of other illustrious men would stand in front of the numerous columns in the vast basilica.

Larroumet appointed a twelve-member subcommittee to deal with the specifics of the project. Initially, it included only two sculptors—Dalou and Jules Chaplain (also a friend of Rodin), but Larroumet later added Guillaume and Chapu. At their eighth meeting, on June 5, 1889, the new committee addressed the two principal questions facing it: Which commissions should they start with and who should get them? Larroumet read out a list of seventeen sculptors he thought suitable. Three of the four sculptors on the committee were included: Guillaume, Chapu, and Dalou. The rest were familiar names, among them the most reputable sculptors in Paris: Barrias, Falguière, Mercié, Dubois, Frémiet, Delaplanche, and Rodin.

The committee started with the monuments to Mirabeau and Hugo. Given the regime's vigorous anticlerical stance, this was not surprising. When Gabriel-Honoré de Mirabeau, leader of the Third Estate in 1789, had died in 1791, the church of Sainte-Geneviève had been secularized and renamed the "Panthéon" in order to to receive his body. In the course of the nineteenth century, two emperors (Napoléon I in 1806; Napoléon III in 1852) had returned the building to the Catholic church. In 1885, at the

time of Hugo's death, the leaders of the Third Republic had thought fit to declare Soufflot's masterpiece once again the Panthéon. After all, Hugo himself had said he would not be buried in a church.[9]

The members of the committee wanted the works to be "fairly low" so as not to obscure existing works at the ends of the transepts. More important, they did not want "banal" statues on pedestals. Larroumet proposed that men such as Mirabeau and Hugo would best be honored by sculptors presenting them in a "calm and tranquil manner." He liked the idea of allegories "such as eloquence crowning Mirabeau and poetry glorifying Victor Hugo."[10] On September 1 Jean-Antoine Injalbert was designated sculptor of the Mirabeau monument. He had won a Prix de Rome and frequently took medals in the annual Salons, but he had no notable monuments to his credit. Rodin was selected to do the Hugo monument. This was the news that awaited him when he returned from his holiday in Spain in early September.

The minutes of the committee are silent about the criteria they used in arriving at these decisions. Larroumet did point out, however, that the two sculptors were "entirely different in origin and in tendency." He had always thought it was the duty of the state to support many styles, and he wanted a variety of expression in government commissions.[11] Almost immediately, Larroumet announced that the committee could expect maquettes quite soon, as the artists had already started to work. He had gone over their projects with them and was apprised of Rodin's approach: "For his monument M. Rodin has chosen to show Victor Hugo in exile, the man who had the steadfastness to carry on an eighteen-year protest against the despotism that chased him from his own country. He believes that the great poet never again possessed the greatness of his genius quite as fully as he did during that period, for then he was able to unite his genius for political denunciation and the expression of profound human compassion. To convey this he has represented him sitting on the rock of Guernsey. Behind him, caught up in the spilling of a wave, are three muses—Youth, Maturity, and Old Age—and onto him they blow the hot breath of inspiration."[12]

In representing the poet in exile, Rodin harked back to his first image of Hugo—the man who wandered from Brussels to Jersey and finally settled on Guernsey, where he spent his exile during the Second Empire. This was the Hugo whom Rodin and Léon Fourquet had talked and written about in their youth, and it helps us to understand why the commission for this particular monument meant so much to Rodin. Larroumet's remarks also suggest that Rodin may have worked out his idea for the monument before he actually received the commission. Evidently, Rodin began discussing the project with Larroumet soon after the latter was appointed director of fine arts in 1888. During the week when Lockroy was getting ready to sign the decree calling for the Panthéon sculpture project, Larroumet wrote to Rodin: "Please don't accuse me of neglecting you. Even if it looks that way, I have never stopped thinking about our conversation. The project is very close to my heart, and if I let it sleep a little, it is out of necessity. Soon everything will be clear" (Feb. 4, 1889).

103) Rodin, first project for the *Monument to Victor Hugo*. 1889.
Plaster. Musée Rodin.

We immediately wonder where Dalou was in all this. He desperately wanted to create the monument to Hugo. It was Dalou who had been called by the family to take the death mask and Dalou who had fashioned the medallion of the Republic to carry in the procession that followed Hugo's remains to the Panthéon.[13] For the Salon of 1886, Dalou modeled two projects, one of which he called a "project for a Tomb for Victor Hugo to be Erected in the Panthéon." It showed Hugo on his deathbed beneath a triumphal arch, surrounded by figures from his works. The other project was an enlarged excerpt of the first, containing only the bier and corpse. Dalou called it "Memories of May 22, 1885: Victor Hugo on His Deathbed." Nothing came of either project. As a member of the committee for the Panthéon program, Dalou was in position to lobby for his own *Victor Hugo,* but there is no evidence that he did.

Traditionally, the Rodin-Dalou relationship, following the death of Hugo, has been portrayed as troubled. Judith Cladel said that Dalou kept the death mask a secret from Rodin and that it "profoundly wounded" Rodin. According to Cladel, Rodin did not confront Dalou directly, but "by way of his cool behavior Dalou came to understand that their affection was broken."[14] Letters in the Musée Rodin offer no evidence of this rupture, however. Dalou's name peppers the correspondence in the late 1880s; the two men were frequently together. In 1889, the year of the Hugo commission, Dalou sent New Year's greetings to Rodin and Rose Beuret, and in March Rodin passed along a greeting from Dalou to Léon Cladel. In July, after the opening at the Georges Petit gallery, Rodin fled Paris for a few days in the company of Dalou and Lhermitte. And once the Hugo commission was openly Rodin's, Dalou seemed more than ready to assist him. To Mme Ménard-Dorian, he wrote: "My friend A. Rodin, in order to complete the studies he has made of Victor Hugo, wishes to have a cast of my mask. Would you authorize me to give it to him? This would oblige him, as well as myself, and we both would be very grateful."[15]

In the 1890s, however, Rodin and Dalou fell out with each other. Mathias Morhardt ran into Dalou after a committee meeting at which Rodin's maquette was being examined: "'Just think of it!' he said to me . . . , 'he has put the ass of a muse under the poet's nose.'"[16] Edmond Bigand-Kaire always considered Dalou hostile to Rodin. When he heard that Rodin had been raised to the grade of officer in the Légion d'Honneur in 1892, apparently unaware that Dalou had received the honor three years earlier, he imagined that Dalou would "explode with jealousy." And when, a few years later, a campaign was opened to take the Balzac commission away from Rodin, Bigand wondered: "Who has excited these animals? Dalou has got to be behind this." In 1894, when Rodin organized a banquet in honor of Puvis de Chavannes and invited Dalou to be a member of the committee, Dalou turned him down. Something went wrong between these two, and it happened while Rodin was working on the Hugo monument, but nothing in the archives tells us what it was.

Victor Hugo was Rodin's second monumental commission from the Third Republic. Unlike the portal for the Musée des Arts Décoratifs, there was nothing ambiguous about the project and it was handsomely paid: Rodin was to receive seventy-five thousand francs, hardly comparable to the eight thousand francs originally appropri-

104) Jules Dalou, project for Victor Hugo's tomb. 1885–86. Plaster.
Paris, Musée du Petit Palais. Photo Giraudon.

ated for the doors. The most significant difference, however, was the context of this commission. Rodin was being asked to create a monument for a large, classically designed eighteenth-century space in which he would have to consider both the existing works and those to come. Sculptors trained in the Beaux-Arts tradition often worked in programs involving other artists, but Rodin had little experience in such collaboration. Only in Brussels had he worked with others on large programs.

When Rodin returned from Damvillers on October 1, he had his idea for the Hugo monument, but he did not have a maquette. Larroumet wrote anxiously on October 11 that it was important *he* be the first to have a "glimpse" of Rodin's sketch. For the next five months, except for a brief time working with Desbois on the monument to Claude, Rodin devoted himself almost exclusively to the Hugo sketch.

Rodin knew the members of the committee were expecting a maquette in the spring, and he had a plaster model ready for their studio visit in March. As he had initially proposed, Rodin placed the image of Hugo upon the rough terrain of Guernsey. Pensively, the poet rested his head against his right hand, while extending his left arm and opening his hand, as if his thoughts might pass out through his palm. Rodin enlarged the idea by including three muses with interlaced arms, floating behind the poet's head and shoulders—a motif he lifted from the left panel of his doors for the Musée des Arts Décoratifs. Two of the muses appear to breathe inspiration into his being. The third, lissome and beautiful, turns her back so that her buttocks, thighs, calves, and feet counterpoint Hugo's extended arm. Rodin clothed the figure and developed a rough drape across the legs, but in such a sketchy fashion that the members of the committee would have been unable to evaluate the way he would develop the dress.[17]

The committee had already been to Injalbert's studio when they visited Rodin's. Injalbert's six-figure maquette, with the orator Mirabeau actively declaiming and providing the focal point for the group, was well advanced. The committee retired to the Palais-Royal to discuss the sketches. Most members were particularly concerned about the groups' proportions in the vast space of the Panthéon. After considerable discussion, they came up with an unusual idea: each sculptor was asked to reproduce his maquette on a two-dimensional surface, like scenery flats. These cartoons would be erected in the Panthéon so that the committee could get a better idea of how the sculptures would actually look.

Larroumet wrote Rodin about the plan on March 31. The very same day, Rodin wrote to Marx: "I came home in the middle of the day attacked by a dangerous illness." Rodin must have instinctively felt that his commission was in jeopardy. He kept on working, though; he was reading Hugo's works again and again and examining all the visual and biographical material he could locate. He wrote to Hugo's former secretary, Henry d'Escamps: "Thank you for sharing the facsimile of Victor Hugo's letter with me; it made me very happy. . . . With respectful curiosity I have read your account of the great poet's death; it was indispensable for me to know this."

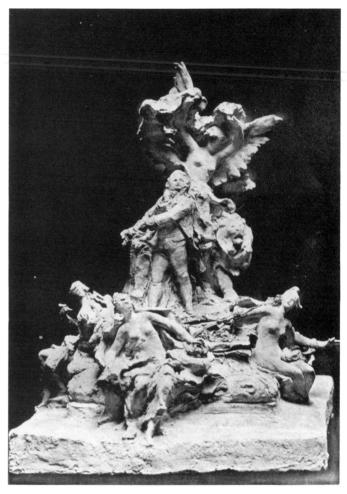

105) Jean-Antoine Injalbert, project for the *Monument to Mirabeau*.
Present location unknown.

On July 9, 1890, the committee members assembled in the Panthéon to look at the painted cartoons. They voted unanimously in favor of Injalbert's *Mirabeau* and against Rodin's *Victor Hugo*. Charles Yriarte, one of the critics on the committee, was designated to contact the sculptors. He wrote asking Rodin to meet him in the Panthéon, but before the meeting took place Rodin learned that the members were "almost unanimous in understanding that the projected monument to Victor Hugo lacks breadth and elevation" (*L'Intransigeant,* July 15, 1890).

Rodin's way of attempting to reveal the "genius" of Hugo was to search for a "truth" in gesture and physiognomy; through these he sought to create a psychological portrayal. Once he understood the nature of the search, he tried to establish the desired qualities in the clay into which he dug his hands. Rodin wanted to capture Hugo the

man; he was totally opposed to rendering him "larger than life" through rhetorical gestures, in the bombastic tradition of allegory. Rodin's work was thus difficult to accept for most members of the committee, who were accustomed to the conventional ways of conveying the "message." And they were surely right in thinking his work would not easily read in the Panthéon. Rodin's approach—complex, psychological, and intimate—was not at all suited to a monumental classical interior.

Following the great success of the exhibition at the Georges Petit gallery, the press frequently referred to Rodin as the "Michelangelo of the modern world." Therefore, the committee's negative vote was bound to become a major story. A writer for *La Justice,* Roger Berment, was one of many journalists who felt it was a mistake "to subordinate Rodin's work to the decorative ensemble as a whole, particularly to In-jalbert's work." If the committee wanted homogeneity, he wrote, they ought to turn the entire program over to Rodin. Berment excitedly rushed to Rodin's studio, where, to his shock and surprise, he found that "Michelangelo reborn" was a rather "modest, almost a timid" man. He quoted Rodin as saying: "First, I don't want to accuse anyone. I believe I've been working in a tough way, I've put everything I've got in this work and I believe I've succeeded. But what can I say, with these great men as my judges? They could be wrong or simply not see things as I do. And you know I'm not the first artist to suffer from these frustrations. I could cite the names of many more famous than myself who have had a bone to pick with the people who commissioned a work from them." Rodin informed Berment that he planned to start over on the sculpture. He would simply do the "grande machine" they wanted (July 19, 1890).

Thinking back only five years to Rodin's howling reaction to the criticism of his *Burghers of Calais* ("They are castrating my monument!") and to his brilliant rebuttal to the *Patriote de Calais,* we wonder at his subdued and yielding response to the Hugo rejection. Was this a failure of nerve? We would not expect it after his successes of the late eighties. A questioning was taking place in his mind—perhaps rightly, as the first maquette for the Hugo monument is not of the same quality as Rodin's early ideas for the *Burghers.* The composition is not as rich, the psychological moment as profound, nor the use of gesture as interesting. On some level, even though he had "put every-thing" he had into the work, he knew it was not his best.

Why was this monument so difficult for Rodin? Perhaps he was put off by the prestige of the Panthéon and the number and authority of people connected with the commission. He told Berment he considered his judges "si grands." Also, he had problems harmonizing his work with that of others. His whole way of creating had been based on uniqueness, even awkwardness when necessary, to realize a kind of uncanny directness. Perhaps the subject frightened him. It was a subject he knew deeply, one with which he identified. That did not make things easier. In the eighties he had been able to read Dante in order to prepare for his doors, and to read Froissart and Michelet when he was formulating the concept of his figures for the *Burghers.* It was his ability to let his curiosity rise with new experience that helped him develop new angles

on old subjects. But Hugo had been living under his skin for more than half his life. This commission was therefore different—and difficult.

Rejecting Rodin in 1890 was not the same, however, as rejecting him in 1885. He now had some of the most powerful voices in the press behind him; he could not simply be turned down. Arsène Alexandre wondered what the committee could have been thinking when they tried to make "this moving and eloquent work" conform to "Injalbert's *fla-fla décoratif*" (*Paris,* July 21, 1890). Geffroy described Rodin's sketch as only Geffroy was able to do, building upon the richness of the image before him. Of the muses, he wrote: "Never have whispers and cries explained inspiration in such a satisfying manner; it is grandiose and intimate at the same time. There is impatient desire, a fever in the way these three young bodies of infinite suppleness join together." Geffroy's wrote of "languid countenances," "breasts that lightly brush against the poet," in fact, a whole "atmosphere of seduction."[18] Mirbeau, tough-talking as ever, summoned up an image of a committee "all-powerful in their collective imbecility" and asked his readers to compare Rodin's *Hugo* to Michelangelo's Sistine Chapel ceiling. Even Julius II had not been so intractable—but then, Mirbeau added sarcastically, "he was only the Pope." Mirbeau found it a "revolting anomaly" that an artist like Rodin was being supervised by inferiors (*Le Figaro,* Aug. 10, 1890).

What was Larroumet to do now? He could not back away from the star, whom he himself had selected for the Panthéon project. Neither could he throw out the decision of the important committee, no matter what Mirbeau thought of them. Perhaps to gain time, he created a diversion: On July 18, he wrote asking Rodin to do a bust of Puvis de Chavannes for the museum of Amiens. Rodin admired Puvis more than any living artist, and he had already secured his agreement to pose, suggesting that the commission was Rodin's own idea.

Puvis posed through the month of August, which probably helped to take Rodin's mind off *Hugo.* In October, Larroumet suggested they meet and talk the situation over. Shortly thereafter, it was decided that Rodin would make *Hugo* exactly as he had envisioned it; when it was finished, it would go into one of the gardens of Paris. At the same time, he would start afresh on a monument for the Panthéon, one that would harmonize with the monument to Mirabeau as conceived by Injalbert.

Rodin, no doubt pleased with his victory, lost no time in getting to work on his new project. At the end of the year he invited Larroumet to look at what he had done. "Come as a friend, not as a representative of the ministry of art," he wrote. In his letter, Rodin described his new version of Hugo in contemporary dress, standing with his hand on his heart, as the "genius of the nineteenth century" reaches out to crown him. Iris, the cup bearer of the gods, descends from a cloud to assist in the coronation. "Below I made a powerful figure watching this apotheosis. It is the crowd that made the funeral so unforgettable. It is all of us, the vox populi," Rodin wrote (Dec. 28, 1890).[19] Rodin had capitulated: he had entered the world of allegory and operatic gesture.

By June Rodin had changed his idea: instead of "nous tous vox populi"—his expres-

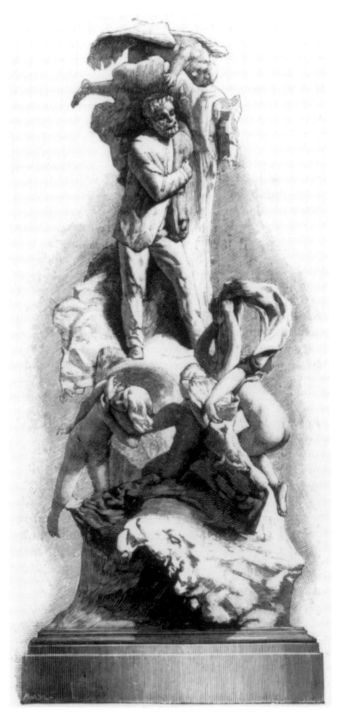

106) Rodin, "The Apotheosis of Victor Hugo." From *L'Illustration*, Dec. 26, 1891.

sion for the big figure at the bottom—he placed three entwined female figures, the "Voices of the Sea," at Hugo's feet. One suspects this change came out of the conference with Larroumet. The standing figure of Hugo dressed, with winged figures above and three figures below, was a perfect mate for Injalbert's "more successful" *Mirabeau*. This is the sketch the committee saw when they came to Rodin's studio in June 1891.

Rodin was so intensely engaged with the Hugo project in 1890 that he seemed almost to have forgotten his doors. Critics had not forgotten, however, and they frequently chided him for being unable to bring them to completion, disregarding the fact that they were intended for a museum that had not been built and a patron who no longer showed any interest in funding the bronze cast. Success bred envy, and criticizing Rodin for the unfinished *Gates of Hell* became a common way of expressing it. Edmond de Goncourt adopted a similar tone. He went to the opening of the Salon of 1890, in which Rodin had six works. When he got home, he decided that Rodin was "becoming too original, too superior, too *grand artiste*."[20]

Envy and critics aside, Rodin now began to attract an ever-wider circle of admirers and friends who felt he was necessary to them in one fashion or another. Among them was the celebrated journalist Séverine (pseudonym for Caroline Rémy). In her thirties, Séverine was not unlike Camille Claudel in that she was beautiful, independent, strong-minded, and most at ease when surrounded by men with whom she competed while never relinquishing the powers of feminine seduction. On February 25, 1891, she invited Rodin to lunch: "The menu will be detestable but the welcome warm." A political radical in the forefront of feminist and anarchist causes and unwaveringly dedicated to social justice, Séverine elicited a hundred-franc contribution from Rodin after he read an article she had written about a group of nuns who worked with sick children.[21] Requests for Rodin's intercession came from all sides. In 1892 Mme Joseph Van Rasbourgh wrote to Beuret, asking her to see if Rodin could help their son find work in Paris. Rodin would later become the godfather of the young Van Rasbourgh's daughter, Rosette.

In the spring of 1891, Alphonse Daudet, a prolific writer close to the Zola and Goncourt circles and friend of Rodin since the late 1880s, brought the young writer Jules Renard to 182 rue de l'Université. When Renard got home that night, he exclaimed, "God, give me the force to admire these things." Struck with wonder, he felt his "eyes burst open. Until now a sculpture would have interested me about as much as a turnip." Renard wondered if he would ever be able to write the way Rodin sculpted. He was amazed to hear Rodin "naively asking Daudet what he should call these astonishing creations he had made."[22] It did not add up: the strength of the work, the modesty of the man. Even as the power of Rodin's work could shock or frighten, as it evidently did Edmond de Goncourt, the majority of personal exchanges with Rodin indicate that there remained in him a quality of self-effacement. Almire Huguet, Rodin's old comrade in arms from the Franco-Prussian War, had such a reaction when he ran into Rodin in 1890 on the Pont de la Concorde. Returning to Geneva, he wrote

that he was pleased to see Rodin again and amazed to find him still "the indefatigable and modest worker" he had known so long ago.

Another younger artist who came to the rue de l'Université in the summer of 1891 was the composer Augusta Holmes. She camped on Rodin's doorstep and eventually persuaded him to do a medallion of her master, César Franck. In the fall the American painter John La Farge eagerly surveyed the wonders of Rodin's workshop.

In an uncharacteristic gesture, and with a strong push from Octave Mirbeau, Rodin took a moment in 1891 to think about purchasing a painting from Camille Pissarro. Mirbeau acted as go-between, writing to Rodin that when he had informed Pissarro of Rodin's desire, the painter had exclaimed: "Damnation! For a man like Rodin I don't have anything that would satisfy me. You understand that for Rodin it's necessary to have something perfect, something really great!"[23]

Rodin's cousin Hippolyte Coltat was still in the religious medal business. In 1890 he established an office in Lourdes. He wrote Rodin that he would feel less alone if he had a large photograph of the sculptor and a small one of his hand. Rodin was probably cool to this request, for he was not enthusiastic about religious medals. When he wrote to Zola in 1894 to congratulate him about his novel *Lourdes,* which the Catholic church had put on the Index of proscribed books, Rodin said that he found the "things you said about this industry of religious art . . . very useful. . . . It is all so silly."[24]

As many demands as friends, family, and fame placed on Rodin, the real pressure of the 1890s came from patrons. In June 1891, the Victor Hugo committee decided to ask Rodin to make a a second sketch for the Panthéon so they could check the size. His trompe l'oeil cartoon was ready by the end of the year. It was about twice as large as his first sketch, thus addressing the criticism about scale. The committee convened on December 17. Everyone was present, including Dalou. They thought they would like the sculpture better if it were more "in the round," like Injalbert's, and they wanted Rodin to make the silhouette clearer. Maybe he should enlarge the base so that it would be the same size as Injalbert's. They also felt the figure of the genius at the top crushed the rest of the composition.[25]

In short, the committee asked Rodin to follow the lead of an artist he considered vastly inferior. It was becoming harder and harder for Rodin to bring "The Apotheosis of Victor Hugo" to a happy conclusion.

Chapter 20
More Monuments to Genius: *Balzac,*
the Inauguration of *Claude Lorrain,*
and Baudelaire's Tomb

By 1892 Rodin was spending very little time on the monument to Victor Hugo. Sheer fatigue and exasperation could easily have provoked such a withdrawal, but there was another reason: Rodin had captured the commission for the other great literary monument of the nineties. The Société des Gens de Lettres had asked him to create a monument to Balzac, a founder and once a president of the organization.

The society had been founded during the July Monarchy at a time when French authors were becoming indignant about the condition of literary property. They wanted to control the rights to their own publications and to remove the profit from pirating books. George Sand, Alexandre Dumas, Victor Hugo, Théophile Gautier, and Honoré de Balzac were among the founders of the society, which subsequently protected and ordered the world of French letters with ever-growing authority.

This was as exciting a commission as the Hugo, but different. Hugo was august, Olympian, the established god of the Third Republic. There was a shared vision of who he was. Balzac, on the other hand, did not mean the same thing to various segments of French society. There was no generally accepted view of his significance or of his large literary output. Even his admirers disputed how he and his work should be seen.

For Emile Zola, Balzac was a particularly revered hero. In the seventies, as Zola fought to establish the legitimacy of the naturalist novel, he frequently invoked Balzac's name. According to Zola, Balzac was responsible for extricating modern French literature from the quagmire of artificiality and turning it to observation and reality. He lost no opportunity to identify the parallels between his *Rougon-Macquart* series and *La Comédie humaine.* As Balzac's life and work became the focus of scholarship in the seventies, the wealthy Belgian viscount Charles Spoelberch de Lovenjoul became the great Balzac specialist of the period. Zola, however, felt threatened by any suggestion that he was not the most significant spokesman for the Balzac movement. To stake his position, in 1880 he put forward the idea of a monument to Balzac.[1] Nothing came of his proposal, but the intention was now in the air, and in 1883, when the monument to Alexandre Dumas *père* was inaugurated, protests were heard from those who felt Dumas should not be honored before Balzac. The Dumas lobby suggested that Balzac was dated and unreadable. Gustave Geffroy answered them in an article in which he asserted that *La Comédie humaine,* based upon such a wide sweep of the passions of man and presenting such universal types, was not subject to changing fashion.[2]

Finally, in 1888, the Société des Gens de Lettres assumed responsibility for the project. Rodin was among those suggested to make the monument, but the commission went to Henri Chapu. Then Chapu fell ill. That Rodin was keeping careful watch over the situation is clear from a letter Geffroy wrote to him one week after the opening of the Monet-Rodin show: "Of course I want you to be the sculptor of the Balzac. I am sure you are the one who would know best how to conjure up the great name of the century and to register a beautiful summary of *La Comédie humaine* on a pedestal. We should just wait and be helpful to the project" (June 29, 1889). Geffroy's tone is almost conspiratorial. In April 1891, Chapu died, carried off during the flu epidemic, two weeks after Zola had been elected president of the Société des Gens de Lettres. Zola then simply handed the commission to Rodin, while contriving to make it look like a committee choice.

In 1891 Zola and Rodin were both fifty. We do not know when they met (it could have been anytime in the second half of the 1880s), but they had at least a dozen friends in common. The first record of their friendship is Zola's visit to Rodin's atelier in February 1889. Unfortunately, Zola was not feeling well and could not study the work as seriously he had hoped. Later, replying to a letter from Rodin, Zola wrote: "I'm completely well and hope to see you as soon as this terrible Parisian life will allow it."[3]

During the spring of 1891, when Zola and Rodin began discussing the Balzac commission, the writer had many things on his mind. He was worried about the bad reviews for his recent novel *L'Argent,* about the contest between Christians and Jews for domination of the Paris stock exchange. He had anxieties about the premiere on June 18 of the opera *Le Rêve,* his first venture as a librettist. Above all, he was concerned about the health of his mistress, Jeanne Rozerot, who was pregnant with their second child. Finally, he was worried about whether he would get a seat in the Académie Française.[4]

Amid all this activity, Zola still found time to organize the Balzac commission in Rodin's favor. This involved fighting back the candidacy of Marquet de Vasselot, a sculptor who had already done a bust of Balzac. As a historian of sculpture and a member of the Société des Gens de Lettres, Vasselot had significant support on the committee. But Zola considered Rodin the preeminent naturalist sculptor of the age and thus the right choice. Zola sent another member of the society, Gustave Toudouze, to inform Rodin that the commission was his even before the committee had met. That the award was no secret is clear from a letter the architect and critic Frantz Jourdain wrote to Zola: "It is certain that if you were not president of the Société des Gens de Lettres, Rodin would never have had this commission."[5]

Zola, who had defended Manet so brilliantly in the sixties and Cézanne and the Impressionists in the seventies, had become less active as an advocate of those artists. Manet was dead, Zola had had a falling-out with Cézanne, and in general he seemed to be losing interest in painting. In 1883 Zola confessed to Huysmans that the kind of artists he loved most were "those great, abundant creators who carry a whole world within them."[6] In 1889 Rodin fit this bill. Not only did he carry a "whole world" within

him, he did it in a way that was compatible with Zola's naturalist theories. No artist better supported Zola's claim that Balzac was the precursor of the naturalist school. Rodin quickly understood the personal nature of the commission; he felt graced that a writer of Zola's genius would take up his cause: "It's thanks to you, here I am the sculptor of Balzac and patronized by Zola! I feel surrounded in the most formidable fashion" (July 9, 1891). Zola asked Rodin to commit himself to completing the work May 1893. Rodin assured Zola on August 21 that he would work on nothing save the Balzac and that he would have a sketch ready in November.

Rodin, with three great French reputations assigned to his care—Hugo, Franck (he had agreed to do the medallion for the Franck monument in Montparnasse Cemetery), and Balzac—was now the man of the hour. In July 1891, any reporter who could get an appointment hastened to Rodin's atelier. A. B. de Farges, writing in *La France* (July 15, 1891), took an interesting tack when he decided to interview both the triumphant Rodin and Vasselot, who was perceived as having lost the Balzac commission. He asked the two men to explain their ideas of Balzac. Vasselot said he believed Balzac was unique in the history of letters because he had been able to see and to depict humanity as a whole. For Rodin, Balzac's greatness lay in his ability to see into the human heart, to make everything come alive with his striking reality. These comments were not necessarily contradictory, although Vasselot's humanity as a whole does seem to sit better in the "idealist" camp which opposed Zola's view of Balzac as a naturalist. Conversely, Rodin's comment about making everything come alive and his sense of striking reality were more closely allied to Zola's naturalism. In the nineties, however, the latter view was seen as being of the "left," and many were beginning to repudiate such an interpretation of Balzac.[7]

When Farges asked the two sculptors how they would depict Balzac's ideas in a monument, their answers could not have been more different. Vasselot said that the single word which meant the most to him was "simplicity." He considered it the primary condition for grandeur. "I would make a standing Balzac, dressed in the famous Dominican robe, open at the top so you could see his very male chest, all hairy." He intended to carve the figure in a blue-black Breton granite. The other image he had of Balzac was as a sphinx. He might put such a figure on top of the Tour Eiffel, so that it could survey the entire horizon, or maybe he would go to Egypt and replace the head of a famous sphinx with that of Balzac.

Rodin answered the question with characteristic humility. First of all, he had not had time to think about the monument, and he would not dream of suggesting anything until he had collected all the documents on Balzac. He intended to leave soon for Balzac's home in Tours, where he would conduct his research in the city library. He had already received a number of things from Balzac's great-nephew, M. Surville, from whom he was expecting to receive a plaster cast of Balzac's hand in the near future.[8] Beyond that, he would depend on Zola to direct his work, for he was "a man in the line of descent who truly knows Balzac."

Rodin said not a word about what his monument would look like; he spoke only about his research. His hope was that he would be able to penetrate the character of Balzac. His method of achieving this was similar to Zola's. In the 1880s, when Zola was writing about the hard life of the workers in the northwestern mining districts for *Germinal,* he descended into the mines himself and trudged through the soot-covered villages where the miners lived. He and Rodin shared a passion for the telling detail, and it helped reinforce their mutual respect and understanding.

As Rodin indicated in his interview, he believed the search for the truth about Balzac should begin in Touraine, the writer's birthplace. He would be looking for a stocky man to model for him, one of physical force, obese and thick-necked, the kind he knew from numerous prints. He asked a friend, Albert Pontremoli, to go to Brussels and discuss Balzac's physical type with Vicomte Spoelberch de Lovenjoul. Pontremoli reported that Spoelberch thought Rodin might as well skip Touraine, as neither of Balzac's parents was native to Tours (July 29, 1891). Rodin ignored the recommendation: the need to search for a specific physical type in Touraine was already too fixed in his mind. In August he disappeared into the byways of Touraine. Mostly he was working on physiognomy and head shapes. Desbois wrote to ask when he would be finished with all these "wild men" (Aug. 20, 1891). In September Rodin wrote Geffroy that he was still working on heads.[9] Geffroy, more sensitive than Rodin to the November deadline for the sketch, wrote back: "I don't want to bother your studies of Touraine heads, my dear Rodin, but don't lose your view of the whole." To get him back on track, Geffroy suggested that Rodin read Balzac's correspondence: "It's where you can find this magnificent and great man." The correspondence had only been published in 1876; the emotional honesty and evident warmth in the letters surprised many who thought of Balzac as a disreputable and difficult man.[10]

Rodin got in touch with the doyen of French portrait photography, Nadar. He was willing to provide prints of the illustrations he had used in a recent article entitled "Balzac et le daguerréotype."[11] The one that interested Rodin most was the only known daguerreotype of Balzac; it had been taken by Louis-Auguste Bisson in 1842.[12]

In early December Rodin was busy supervising the preparation of the Hugo monument mock-up in anticipation of the visit from the Panthéon committee. On December 18, the day after they met in his studio, Rodin received a letter from Zola: he would be by "tomorrow at 3 to see [Rodin's] sketch of Balzac," and the whole committee planned to come in a couple of weeks. The sketch they examined was described as a "standing Balzac, his arms crossed, head high, and dressed in his legendary monk's robe tied by a cord at the waist" (*Le Temps,* Jan. 11, 1892). The committee was enthusiastic; in fact, things could not have been better. The papers compared the committee of the Société des Gens de Lettres favorably to those of "other official commissions," lauding it for the statement made public at the time of its deliberation: "1) The maquette is eloquent and in the grand style of sculpture; 2) the sculptor will be allowed the freedom to finish the sculpture as he feels best, with no further formal examination or criticism deemed

107) Daguerreotype of Balzac. Bisson, 1842. Photographic copy by Nadar. Musée Rodin.

necessary."[13] The papers made it clear that the maquette was now established; all Rodin had to do was to enlarge it and the work would be done. The only problem was the right leg, and a few days after the committee's visit, Rodin wrote Zola that he had "arranged the leg, raised it and put it back; it is much better, so much so that I am happy." He asked Zola to send five thousand francs, pointing out that it was "the normal thing, after the sketch" (Jan. 15, 1892).[14]

Rodin's achievements in 1892 were considerable. Celebrity had negative aspects, however. Constant press coverage generated high expectations and enormous pressure. As a result, Rodin frequently canceled engagements. In March he excused himself from attending a banquet for Maurice Rollinat, telling Armand Dayot tht the "redoubling of the headaches and the pains in [his] stomach" were too severe.

In April, as the inauguration of *Claude Lorrain* drew near, Rodin was forced to turn his attention to that project. Desbois had supervised the completion of the work, frequently with the aid of Victor Peter. But Rodin was present for the crating, and on June 2 he accompanied the monument to Nancy for the unpacking and installation in the Pépinière Garden.

The inauguration of the *Monument to Claude Lorrain* on June 6, 1892, bore no resemblance to the unveiling of *Bastien-Lepage* three years earlier. What had happened in

Damvillers was a celebration of art and of two of its best modern practitioners: Bastien and Rodin. What happened in 1892 was an event of national significance. Nancy had absorbed large numbers of emigrants who had fled Metz and other towns when Germany took control of the Moselle. Nationalism was in the air and Sadi Carnot, president of the Republic, could feel it that morning when he visited the forestry school and the hospital, where he spoke with the workers about his administration and his hopes for bettering their conditions. The afternoon unveiling ceremony was the crowning event of a keenly political day. The major addresses were given by François-Louis Français, "venerable dean of contemporary landscape painters," and Léon Bourgeois, minister of public instruction. Bourgeois pointed out that even though Claude Lorrain was buried in Rome, only the people of Lorraine had had the good sense to raise a monument to his memory. The "soil of Lorraine" was the leitmotif of the day, ringing out to the accompaniment of military music as *la revanche*—the desire to reconquer the

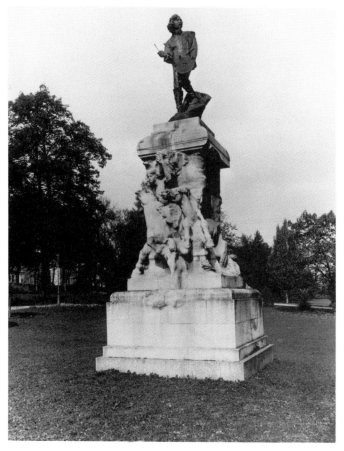

108) Rodin, *Monument to Claude Lorrain*. Inauguration on June 6,
1892. Pépinière Gardens, Nancy. Photograph by Bulloz.

lost provinces—swelled in the breasts of the vast audience. When the formal ceremonies ended, a cry went up: "Vive Rodin!" causing the president to turn to the sculptor and offer his compliments. Just at that moment, a courier arrived with a surprising message for Carnot: the Grand Duke Constantine, uncle and advisor to Czar Alexander III, was arriving by train to greet the president. The two spoke alone for a half an hour in the grand salon of the police department. This meeting, later recognized as the beginning of the Franco-Russian alliance, provided politically isolated Lorraine with a prominence it seldom enjoyed. All Lorraine took pride in this day.[15]

Once the music stopped and Rodin had taken the train back to Paris, the critics went to work: the figure of Apollo on the base was too important—it competed with the figure of the painter above; the horses of Apollo were not finished and their hindquarters were concealed in the base; Claude Lorrain's posture was inappropriate—

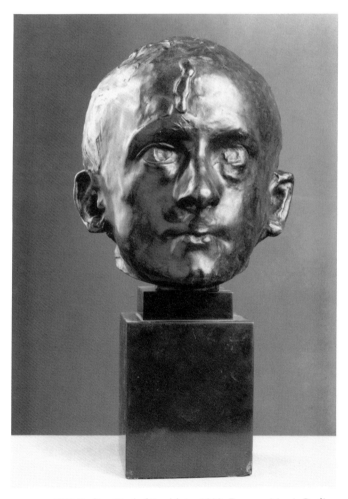

109) Rodin, *Head of Baudelaire*. 1892. Bronze. Musée Rodin.

110) Louis Malteste, model for Rodin's *Baudelaire*. Anonymous
photo in the Musée Rodin.

"melancholic," the critics called it. In sum: "Rodin wanted to break out of the mold of banal statues that look as though they were posing for their photograph. But he went too far."[16] Nevertheless, Rodin must have felt pride and a sense of purpose that day in the homeland of his mother, participating as an equal among men who moved history. These feelings can only have grown when he learned that he had been nominated for the grade of officer in the Légion d'Honneur. The day after the ceremony, one of the journals pointed out that "in spite of his eminent position," Rodin had been visibly moved; he stood before the assembled group in an "attitude of deference and respect."[17]

As if these commissions were not enough,[18] Rodin's interest was drawn to another project that was beginning to materialize: a monument for Baudelaire's tomb in the Montparnasse Cemetery. Rodin's friend Stéphane Mallarmé was on the committee, and he spoke to Rodin about it in August.[19] Next the symbolist poet Charles Morice wrote about the powerful affinities between Baudelaire and Rodin that made Rodin the

only choice: "a poignant nervousness [nervosité] and a kind of tragic rage in which there vibrates a sad echo of their own perversions; both men are subject to the most profound passion, one that is tenacious and unsparing."[20] Rodin was excited about the possibilities. "At first I thought about a medallion with satanic allegories, then about a bust with bas reliefs expressing the character of *Les Fleurs du mal*. . . . Of course, if we are rich enough, we can do a monumental group like Dalou's *Delacroix*."[21]

Again Nadar, who had known Baudelaire well, said he would put everything he had at Rodin's disposition. As with the Balzac, Rodin would require a living model to stand in for the poet whom he had never met, but who haunted so many of his dreams. In September he approached a draftsman named Louis Malteste, who he thought resembled Baudelaire in quite a remarkable way. Malteste was flattered to be asked, and from his head Rodin created one of the great portraits of his career. He described "the enormous forehead, swollen at the temples, dented, tormented, handsome nevertheless, the face described at length by [Léon] Cladel; the eyes have the look of disdain; the mouth is sarcastic, bitter in its sinuous line, but the swelling of the muscles, a little fat, announces his voluptuous appetites. In short, it is Baudelaire."[22]

As 1892 drew to a close, Rodin recognized that he had received the best commissions he might ever have imagined. He had been chosen to create the images of the three geniuses of modern French literature: Hugo, Balzac, and Baudelaire. Again his stomach ached; again he begged off from an engagement with Dayot. He promised he would go on a diet and told Dayot: "As for pretty women, listen, they don't come to see me any more because I have neglected the world for more than a year, and this will continue, because my work takes all my force" (Oct. 16, 1892).

The summer of 1892 also brought new contacts with Americans, especially Sarah Tyson Hallowell. It was her job to put together an exhibition of French art for the Chicago World's Columbian Exposition in 1893. She wanted four or five works from Rodin; he suggested instead a large retrospective of his work. We recognize once again Rodin's propensity to make unrealistic proposals. Only with *The Burghers of Calais* did he actually try to educate a group of commissioners to understand that "great sculpture takes time." It was more in his character to make ambitious proposals or promises, as he had made to the Société des Gens de Lettres, only to disappoint later on. He made no attempt to alter his time-consuming work habits, which demanded thorough investigation of every visual and written source he could lay his hands on. By December 1892, Rodin had only five months left to complete the monument to Balzac. The journals were already talking about a finished maquette at a time when he did not even have a clear idea of what form to give the monument. On December 6 Rodin received a curt note from the society's secretary informing him that they expected their work on the date promised. For Rodin, the difficult part of the nineties had begun.

knew his weakness, because he felt humble when he looked at nature and into the face of beauty. He expected others would come up with ideas, lessons from which he could learn. . . . But when one worked with him, his requirements were totally unreasonable. Nevertheless, the grandeur of the tasks he took on excused everything."[6] A well-known story in the atelier tells of Desbois showing Rodin a clay figure on which he had been working. Rodin called it "very good," and a pleased Desbois left for lunch thinking how he would "settle down and peacefully finish the work." When he returned to the atelier, however, he found the figure on the floor in pieces. Rodin had changed his mind.[7]

By the nineties, when Desbois was working on Rodin's *Claude Lorrain,* he was a highly respected master in his own right, showing works such as *Death and the Woodcutter* (Salon of 1890) and *Misery* (Salon of 1894). He was also engaged in carving his own marble *Leda* for the Musée du Luxembourg, a state commission of 1891.

When Rodin needed to send assistants to Nancy to make changes on the marble base after the inauguration of *Claude Lorrain,* he selected Victor Peter and Jean Escoula, who had been friends long before they went to work for Rodin. Peter, a student of Falguière, had a traditional Beaux-Arts background, while Escoula had apprenticed with his father in the Pyrenees before coming to Paris to work as a practitioner with Carpeaux in his last years. Peter and Escoula both received Salon medals during the eighties. Escoula even took a gold medal at the Exposition Universelle of 1889. He had carved Rodin's *Danaïde* and *Portrait of Madame Morla Vicuña.* For the latter, Rodin had paid him the backhanded compliment that it was not a "satisfactory reproduction of his model because it bears too much the impress of the character of the superior marble cutter who executed it."[8] Victor Peter's major effort for Rodin was the 1891 marble *Portrait of Puvis de Chavannes.*

The two assistants were both in Nancy when they heard Rodin had been named officer in the Légion d'Honneur. With obvious pride, they wrote their boss that the honor was the best response to the unjust attacks against his monument. Peter added: "Here, actually, there are more partisans than detractors" (July 21, 1892). In general, the letters of Peter and Escoula to Rodin show respect and affection. They kept him abreast of their own work, commented on Rodin's work, and gave information about the progress of the marbles they were carving for him. In the fall of 1891, Escoula wrote Rodin in Tours that he knew how busy Rodin was with the Balzac studies, that his own figure was coming very slowly—"always doing and redoing"—and that he was working on Rodin's *Danaïde* with great care. "When you come back, I'll do some more on [Rodin's] *The Sirens,* but at the moment I'm working on a singing shepherd [his own]. The head is going to be useful as a study" (Sept. 5, 1891). Here we find a total mixing of Escoula's work with what he was doing for Rodin. He took it for granted that Rodin would be interested in him not just as an assistant, but also as a sculptor.

Following the 1889 exhibition, Rodin hired more sculptors. One of the new men was François Pompon, a Burgundian who came to Paris in 1875 to attend the Petite Ecole,

where he discovered his vocation as an animal sculptor. To make a living, he relied on his abilities as a carver. Through the eighties he worked in ateliers all over Paris: in those of Carlier, Aubé, Jean Dampt, Antonin Mercié, Falguière, Saint-Marceaux, and Rodin's own practitioner, Baffier. For Pompon, Rodin was the greatest of the moderns and second only to Michelangelo as a sculptor. A young coworker from the studio, Ernest Nivet, remembered sitting spellbound one evening in the Pompon home listening to him "explain the form, composition, and feeling he perceived in a little terra cotta group which the *maître* had given him and which he kept moving in his hands to pick up the play of lights and shadows."[9]

Nivet was twenty when he came to Paris from Châteauroux with a scholarship to study at the Ecole des Beaux-Arts. Nivet heartily disliked the Ecole, however, so one of his Châteauroux patrons, Georges Lenseigne, arranged for an introduction to Rodin. In his usual way, Rodin said he did not take students, but if Nivet wished to join the atelier as a practitioner, he was welcome to work as the others did: an eleven-and-a-half-hour day for the daily wage of ten francs. Nivet showed up for work on December 17, 1891. That night he wrote M. Bourda, his old drawing teacher in Châteauroux, describing his general delight and his "enthusiasm in the presence of the big marble 'Kiss' and the 'Eve' and so many other groups that vibrate with passion and love."[10]

The honeymoon did not last. By January, Nivet found his new boss "not particularly accommodating. . . . He does not seem content with himself, or with the others."[11] In the summer, while Nivet was working on a marble version of *Eve,* he complained of being exhausted: "Paris disgusts and annoys me; I don't think I have ever disliked anything so much" (July 2, 1892). Besides, he was bored: "Ever since December, all I've done is carve, carve, carve. . . . I would like to do just one study for myself." Rodin suggested he take a few weeks off. He went home in the summer and again in the fall, writing Rodin in October that there was no point in returning since he would shortly be called up for the army. He was astonished when Rodin became angry because he had advanced Nivet pay for work that his assistant left unfinished. Nivet told Bourda he felt "imprisoned" by Rodin: "If you knew how one is pushed around here, pushed around there. You can have no idea, and most of the time one doesn't even know why one is being bawled out." He said that Camille Claudel, with whom he had become friendly, said he should stay and work for Rodin for years. But in his mind he would emerge from such an experience with "nothing" to show for it (Dec. 21, 1892).

A year later, out of the army, Nivet was again trying to figure out what to do. "What will become of me if I go back to working those long days for Rodin?" he wrote to Bourda. "But what else can I do? Do you think if I continue like that I can really learn something? No, anything but!" (April 1, 1894). Two weeks later, after thinking it through, he was ready to submit to his fate. "It gives me great honor," he wrote to Rodin, "to inform you that I am ready to engage myself to work under your orders, in your atelier for five consecutive years, with the goal of becoming completely your student." He wanted to set his own terms: two thousand francs a year as a beginning

Chapter 21
Ateliers and Assistants

The *Monument to Claude Lorrain* reflected Rodin's increased willingness to give major responsibilities to his assistants. He had relied upon assistants from the very first years of his career, but none had made as large a contribution as Jules Desbois did to *Claude Lorrain*. It was standard for the output of a nineteenth-century sculptor's atelier to be the joint production of a master and his assistants. This was how Rodin himself had learned his profession; as an old man he mused on the long hours he had put into the "*mise au point* [pointing] and the hewing of marble and stone." He regretted "having wasted so much time" as an apprentice.[1] But was it such a waste? After all, it taught Rodin how a big studio was run. In the 1890s, as the commissions began to roll in—not just public commissions, but numerous small, private ones—he took on more and more assistants.[2] By the end of the decade, he and Falguière had the most active sculpture studios in Paris, on a par with those of Carpeaux and Carrier-Belleuse in the Second Empire.

In 1892, in addition to the three studios Rodin occupied in the Dépôt des Marbres, he paid rent on 68 boulevard d'Italie, an unusually picturesque but badly deteriorating eighteenth-century property that he shared with Camille Claudel; another studio at 113 boulevard d'Italie; and a third at 17 rue du Faubourg-Saint-Jacques. He had given up the studio in the boulevard de Vaugirard late in 1890.[3]

The creative idea, the core of every sculpture that came from Rodin's studio, began as a clay form modeled in Rodin's own hand. Usually he tried the same idea out in several versions; only when he felt it was right did he have studio assistants make plaster casts. First they made a negative mold from the clay. From this a plaster figure, face, or group could be made. Rodin often had single figures broken into pieces and rearranged, though he usually kept at least one cast intact. When he considered the idea right, assistants established a metal armature—the interior structure that held a figure upright; then they packed on fresh clay before Rodin brought the work to its final form. Again a negative mold and a plaster positive were fashioned. The negative would be used by the foundry in making bronze casts, the positive by the carvers transferring the image into marble. Rodin did not fashion unique works; rather, he was chief of an atelier. The decisions and the governing imagination were his; he provided models and clear explanations of what he wanted to his assistants. On any given day in one of Rodin's studios, someone was roughing out a clay, while others were constructing an armature, using a machine to enlarge or reduce a clay or a plaster, sawing a block of marble, or using a pointing machine to transfer the plaster onto the marble block.

If a work was a commission, Rodin left the choice of material up to the client. When he asked the painter John Peter Russell what his choice would be for a portrait of his

wife, Russell wrote back that it should be cast, "because that would be the most exact reproduction of your creation. In short, what I want are all the nuances of your touch. I find that when the most perfect creases are copied into marble they lack the master's touch." Russell ordered this particular cast not in bronze, but in silver (Oct. 17, 1888).

As an artist, Russell understood how the cast restated in permanent material the artist's fingers on the clay surface. A number of Rodin's clients were less sensitive to this and preferred the traditional beauty of marble. During the 1880s most of Rodin's works were bronze casts. As his reputation grew and he received more commissions, this changed: the market dictated marble. All the orders that came out of the show at Georges Petit's gallery were for marbles. When Sarah Hallowell asked for works to show at the Columbian Exposition in Chicago, she and Rodin chose marbles. And when Charles Tyson Yerkes, the "Traction King" (responsible for Chicago's "Loop"), decided to buy some sculptures, he, too, wanted marbles. In the 1880s the French government had purchased two of Rodin's bronzes: *The Age of Bronze* and *Saint John the Baptist*. Now they were buying marbles: the *Portrait of Madame Morla Vicuña* (Salon of 1888) and the *Danaïde* (Salon of 1890). The state commissioned *The Kiss* in marble for twenty thousand francs in 1888, and both Victor Hugo monuments were planned in marble, as was the *Portrait of Puvis de Chavannes*.

Rodin was increasingly dependent on others to carve his marbles. Some of them were strong sculptors in their own right who had won Salon medals and were able to sell at respectable prices. But to be a good practitioner meant more than being an excellent carver; it meant learning the master's style. Frequently these men worked in their own studios, which in a sense enlarged the context and scope of Rodin's own atelier. Though they were responsible for the finished carving, practitioners depended on Rodin's constant intervention. A work done outside Rodin's atelier would be shipped back for him to give it the finishing touch.

Who were these men who worked for Rodin as he entered his years of fame and whose efforts made possible the tremendous explosion of his name? In 1898, when the critic Gabriel Mourey was preparing to write an article on a new project known as "The Tower of Labor," Rodin wanted to be sure that he spoke of Jean Baffier and Jules Desbois as "collaborators since the first moment." Desbois had, indeed, been there since the beginning; he and Rodin had both worked as practitioners in Legrain's studio in 1878. In an interview in 1933, Desbois said Rodin had sought him out and expressed a desire to get to know him.[4] Desbois grew to be the pillar of Rodin's atelier, and never more so than with the *Monument to Claude Lorrain*. Desbois confessed to Judith Cladel that "everything I know I learned from him," and he told Frederick Lawton that Rodin was his "way to Damascus." It was Rodin who taught him how to model all the surfaces of a statue simultaneously by continually walking around it.[5] After Rodin's death, Desbois spoke of him as "my spiritual father." He told an interviewer that most people did not understand that Rodin was restless and anxious, an extremely modest man but one who could be a tyrant when it came to the work. "If he was great, it was because he

salary, raised to four thousand francs in each of his fourth and fifth years (April 18, 1894). Rodin accepted. The two men suffered through a difficult year until the contract was annulled by mutual consent in May 1895. Nivet returned to Châteauroux.

Nivet had harsh things to say about working with Rodin, whom he found "tyrannical" and "stingy." Nivet felt exploited. He said Rodin just wanted him to make "Rodins" and would not let his creative potential grow. But Nivet clearly wanted not only a professor but a father-figure. He never seemed to grasp that he was in the employ of a man with real demands and exactingly high standards. Also, as Nivet took in the size of Rodin's operation and the number of commissions in progress, he considered Rodin to be much wealthier than he actually was. In the mid-nineties, Rodin still had little extra money, forcing him to make numerous economies in the studio.

Nevertheless, working in Rodin's studio was the great experience of Nivet's life. Forever after, back in Châteauroux, he could be heard to say: "Rodin says . . . Rodin does . . . Rodin thinks" He told about the long hours standing on his feet to cut the marble; about the awkwardness of being surrounded by foreigners, journalists, and politicians; about a whole world perpetually moving through the studio; and about the wild laughter that burst out among the workers when a lady would enter and Rodin had to shove a naked male model behind a block of marble—only to have his visitor immediately circle that particular block.[12]

In 1894 Escoula was offended when Rodin made an insensitive remark about the way a work looked. Escoula told him: "I'm not going to work on your marble anymore. . . . You are in complete ignorance of all the problems I've had working for you over the past seven years. . . . You say that I make a lot of mistakes. . . . Well, in this circumstance, that is totally unjust; the work is in no way damaged." He told Rodin he could find someone else to finish the group.[13]

Pompon, too, showed a flash of discontent. On July 10, 1893, he complained to Rodin that he was not happy with his "manner of payment." On July 12, having had no response, he made an appointment *en Prudhomme* (with a board of labor disputes). Evidently, this brought Rodin up short; he resolved the problem immediately, and Pompon, like Escoula, continued to work for him. These glimpses into the Rodin studio tell us that he was a hard and frequently insensitive taskmaster, but that, in the end, the quality of the work and of the man appear to have garnered loyalty from his associates.

Of all those who worked with Rodin during the eighties and early nineties, only Desbois was a real collaborator, not just an employee. In 1893 a second such figure appeared in the person of Emile Antoine Bourdelle, a man young enough to be Rodin's son. The death of their mutual friend Léon Cladel in July 1892 brought them together. Cladel's hometown, Montauban, turned to Bourdelle, also a native son, for a monument. Apparently, it was through the Cladel family and conversations about the monument that Bourdelle met Rodin. In the first letter that documents their acquaintance, Bourdelle says he and Rodin planned to exchange gifts of their own work.[14] Thus the

111) Emile Bourdelle, *Rodin at Work*. Drawing for a statue of Rodin.
Paris, Musée Bourdelle.

friendship began on terms of mutual respect, and Rodin must have been delighted when Bourdelle agreed to join his atelier. By September 1893 Bourdelle was carving in Rodin's studio. Thirty-two years old, he had trained at the Ecole des Beaux-Arts of Toulouse and worked briefly in Falguière's atelier at the Ecole des Beaux-Arts in Paris. He then worked with Dalou for several years before meeting Rodin. Rodin gave Dalou credit for saving Bourdelle from wasting precious time in preparing Prix de Rome competition pieces.[15] His training was solid and he had much to give Rodin, but the extent of his actual participation in the atelier is obscure. Some marbles are documented as being from Bourdelle's hand, but not many. Like Rodin, Bourdelle was primarily a modeler. The first documented assistance he gave to Rodin was in preparing *The Burghers of Calais* for the foundry in 1894 and 1895. He also worked on *Balzac,* but how much is unclear.[16]

During the latter half of the 1890s, poor health inhibited Bourdelle's work in sculpture, though not in painting and drawing. He did, however, have one major sculptural project of his own—a war memorial for the heroes of Montauban who had fallen in 1870–71. He had the maquette ready for the committee in 1896. When it became clear

that they were having difficulty arriving at a decision, Rodin addressed a letter of support to the president of the committee, Osmin Millenet. Bourdelle received the commission and the monument was inaugurated on the banks of the river Tarn in 1902. Rodin called it "one of the most momentous works created by a sculptor in our time."[17] Bourdelle was equally enthusiastic about Rodin, whom he thought of as *"le poète, moved, penetrated by a shudder of the gods. To him I owe more and better than I should ever be able to explain."*[18]

The first time we discover Bourdelle and Rodin truly working as collaborators in search of a common goal was in late 1899, when, with Desbois, they created the Institut Rodin. They were intent on teaching women as well as men in an environment where the corridors were not lined with plaster casts of ancient sculptures, and where there was an abundance of clay, light, and live models. Overnight the academy at 132 boulevard du Montparnasse had more than thirty students, many of them women and most of them foreign, young artists such as Clara Westhoff (the future Frau Rilke) from Germany. The school got good press, so when it closed in April 1900, there was considerable disappointment on the part of the young men and women who had signed up with the expectation of having their work corrected by the greatest master of modern times. Rodin had no time for teaching duties, but the Institut Rodin allowed him and his two most gifted assistants to give public voice to the idea they had been sharing for years: "The forms of life speak more profoundly than all the words one can utter."[19]

Chapter 22
The Passion of Camille Claudel

At the same time Rodin was struggling to avoid compromising his artistic integrity, enormously complex changes were taking place in his life with Camille Claudel. In the early 1890s, Claudel benefited from the special considerations he had promised her, especially introductions to his friends and help with commissions. Now their relationship seemed quite public. In a letter of 1892, Léon Gauchez, the editor of *L'Art* who had commissioned a marble bust from Claudel in the eighties, requested that Rodin convey his "respects to Mme Rodin and to Mlle Claudel." Rodin made sure that Claudel accompanied him on visits to the Bazires and the Mirbeaus. Unfortunately, by the time she met Bazire, he was dying of tuberculosis, so he was not able to write about her sculpture. Mirbeau, however, published an important review on Claudel's work in *Le Journal* in 1895. The Mirbeaus were delighted to make her acquaintance for several reasons, not least being their enthusiasm for her brother Paul Claudel's work.[1]

Rodin was proud of his ability to use his connections in the interests of his protégée and her family. In 1890, when twenty-one-year-old Paul decided on a career in the diplomatic corps, Rodin wrote to the minister of foreign affairs on his behalf, pointing out that the "young man comes from a good Republican family."[2] But Rodin was happiest when he could intervene for Camille herself. A mysterious incident occurred in the summer of 1891. Rodin had approached the fine arts inspector, Armand Dayot, to do something for her. The nature of his request is not mentioned in the correspondence, only that when Mme Claudel heard about it, she objected. Rodin wrote: "Don't mention the name of Mlle Claudel. I saw her mother this morning . . . she doesn't want this to get around" (July 4, 1891). The following year Rodin was back in touch with Dayot, who had come to Claudel's studio to look at her group *The Waltz*. He was considering a possible state purchase, but he objected to the "pungent emphasis on rendering the reality of the two sexes, so surprisingly sensual in expression that it appears to exaggerate the nudity."[3] Rodin asked him to reconsider: "She doesn't want to do drapery and she doesn't do drapery well" (March 21, 1892). He might have reminded Dayot that the state had had no such scruples when it commissioned *his* group *The Kiss,* in which both figures were similarly nude. Clearly, the state did not want nude figures from a *woman* artist.

That same spring, Claudel sent her beautiful bust of Rodin to the Salon. It was not well placed, so Rodin asked Antonin Proust to have it moved. He returned to the Salon in the middle of the day, only to discover that its new position was not right either: "I know the work is of me, that's not part of the question, but I feel that it is my duty to defend the interests of a young artist whose very real talent justly merits your ardent

solicitude." He suggested that the bust be returned to its original place (May 4, 1892). Rodin's own submission to the Salon of 1892 was the marble portrait of Puvis de Chavannes that the state had commissioned in 1890. One of the many journals that reviewed his work was the *Courrier de l'Aisne*, a newspaper published in the region where Claudel spent her youth. Rodin wrote ostensibly to thank them, but his real intention was to bring to their attention "Mlle Camille Claudel, from your own department, who is now enjoying a major success with her bust of me in the Salon. . . . I would be personally flattered if you could take her talent into account and mention her name, already so well known in Paris, in the *Courrier de l'Aisne*."[4] The bust Claudel showed in the Salon was in bronze, cast at Rodin's expense by Gruet, his own founder.

A further intervention on Rodin's part in 1892 was with his friend Edmond Bigand-Kaire. In May, Rodin received a letter from Bigand saying: "It's done. I just got a word from Mlle Claudel this instant." Bigand enclosed a copy of Claudel's letter, in which we learn that he had asked to purchase a work from Claudel. She replied that she was "very honored" that he wished "to give my old woman a place in your collection."[5] Bigand offered three hundred francs—"more than enough," Claudel said. The only problem was that she wanted to show the sculpture in an exhibition in June. If he did not want to wait, she would have another cast made. Bigand asked Rodin: "What should I respond?" As we read this letter, it becomes clear that Rodin was actually paying for the work. In fact, he was often instrumental in assuring a positive reception for Claudel's work, always taking care that she not find out it was his doing. When Bigand received the plaster cast in July, it had been broken. Unperturbed, he glued it back together and reported that "one sees nothing."

Given Rodin's pressing commitments in 1892—particularly, preparing *Claude Lorrain* for its inauguration and working intensely on the Balzac monument to meet the deadline—his attention to Claudel's needs in this period is a measure of his love. It seems likely that the only intimate letter we have from Claudel to Rodin dates from this period.[6] She wrote it when she was by herself at the Château d'Islette outside of Azay-le-Rideau in Touraine, which had become the lovers' special retreat. Rodin made it his home base for forays into the byways of Touraine in search of possible models for his *Balzac*. Claudel addressed the letter, as always, to "Monsieur Rodin": "With nothing else to do, I write you again. You can't imagine how beautiful the weather is at Islette. Today I ate in the middle room (the one that serves as a greenhouse), from which one sees the gardens on either side. Mme Courcelles has proposed that if it is agreeable for you, you can eat there from time to time, even all the time if you wish (actually, I think it would please her), and it's so beautiful there!"

Claudel wrote rapturously about her days in the countryside: "If you are very nice and keep your promise, we can have this paradise together. You can have any room you wish for your work. I think the old woman will be at our beck and call." She described the river where, with Rodin's "permission," she intended to go swimming often. "It would be awfully sweet if you would buy me a bathing suit, two-piece, dark blue with

white trim (get a medium) from the Louvre or the Bon Marché." She closed her letter: "I sleep nude in order to make myself think you are there, but when I wake it's not the same." She added a postscript: "And especially don't deceive me any more." Claudel was always jealous. Were there other women in Rodin's life besides herself and Rose Beuret? Or is this a sign of the paranoia that soon would grow so catastrophically? Although Rodin's "star-struck" feminine following was just beginning to come into view in 1892, there is no evidence that he was particularly responsive. It is more likely that, in this case, we are seeing a paranoid Claudel rather than a deceitful Rodin.

The interesting thing about Claudel's letters is the absence of a nineteenth-century bourgeois woman's "voice." Much has been made of Claudel's desire to regularize her relationship with Rodin through marriage as part of a bourgeois need consistent with her background. But from the little we know of her voice, here and in the earlier letter in which she expressed anger at Rodin's illness, we recognize it as her own. It was neither of her time nor of her class. She spoke to Rodin with astonishing directness and sharpness. She said what was on her mind, apparently unable to turn out a single soft, self-deprecating, idolizing phrase of the kind that appears over and over in the increasing volume of letters women wrote to Rodin as he rose to fame.

The flow of adulatory feminine correspondence began after the inauguration of *Claude Lorrain*. Among the first such correspondents was an old family acquaintance, perhaps a friend of Rodin's sister, Maria—a widow named Ernestine Zurniden Weiss who was the librarian at the Palais de Fontainebleau. She frequently invited Rodin to visit and spent much time worrying about his career, his health, and why he did not come to see her more often: "You are going to say I bore you with all these repetitious notes. You have to excuse a poor solitary woman, for whom happiness consists in showing affection for friends. . . . But you must tell me frankly if I'm boring you with all this" (December 1892).

This is the voice of the nineteenth-century woman: self-effacing, adoring, ready to serve. Camille Claudel's voice was different, but it was the voice Rodin loved. This is not surprising—after all, it was familiar. The girl-woman who asked Rodin in one letter to correct her muddle-headed French, and in another to buy her a bathing suit, was not so different from his adored sister, who had demanded that he talk to her parakeet and water her roses. This was part of the electricity of the Rodin-Claudel relationship: Claudel knew how to maintain a position of power as the older sister of a creative younger brother, and Rodin knew how to yield to a woman he admired and who was set on having her own way.

Zola's 1894 novel *Lourdes* must have reminded Rodin of Maria, who was fifteen years old when Bernadette Soubirous witnessed the miraculous appearance of the Blessed Virgin in a grotto near Lourdes. Zola tells the story of modern-day pilgrimages to the site in the remote foothills of the Pyrenees. In the voice of Abbé Pierre Froment, an idealistic young priest who has lost his faith, the skeptic Zola investigated the phenomena of the healing pilgrimages to Lourdes that were so popular during the Third

Republic. The Vatican quickly placed *Lourdes* on the Index of forbidden books. Rodin wrote Zola that he himself found it quite impartial; in fact, he believed it gave "radiance to these genuine saints, these girls who had nothing save their devotion, these divine creatures who revealed in all its falsehood *that sacrilegious thought that woman is inferior to man* [emphasis added]."[7] This is Rodin's first—though by no means last—"feminist" statement. His respect for women certainly was part of his admiration for Claudel and her work.

The high point of the affair between this dynamic and talented woman and the world's most celebrated sculptor occurred in 1892, in the dilapidated eighteenth-century château in the boulevard de l'Italie called the Folie Payen, where they shared a studio. Claudel's major work of that year was the pair of nude dancers that Dayot wanted her to drape. By the end of the year, she had agreed. By the time she showed the pair in the Salon of 1893, the legs of the female dancer were enclosed in a complicated pattern of flowing drapery, which did not, however, conceal the powerful suggestion of sexual vitality. When Jules Renard saw it in Claudel's studio in 1895, he said quite simply: "In this group of a waltzing couple, they seem to want to finish the dance so they can go to bed and make love."[8]

Rodin's principal concerns while he was closest to Claudel were his public commissions, but in 1892 and 1893 some private projects were also evolving in his studio. He continued to work on the portrait he had made of Claudel when she was first his assistant, the one that showed a bony, beautiful slip of a girl with high cheekbones and an intense gaze. He rephrased it by placing it on a block of wood and adding two unmatched hand fragments, one rising out of a thick scarflike drape and both touching her lips. The portrait suggests the hidden, the mysterious, the silence of private spaces, and it has been variously named "Convalescent," "Adieu," "Melancholy," and "Silence." It is frequently related to the lovers' ruptured relationship. Some have linked it to a supposed sickness or an aborted pregnancy of Claudel's, although no abortion has been convincingly documented.[9] Perhaps the work reflects Rodin's struggle in loving so much and yet never quite understanding the woman who was the object of his devotion.

In this same period, Rodin was fascinated with the theme of Orpheus. He created an *Orpheus* down on one knee, an imploring arm raised to heaven while the muse whispers in his ear.[10] In another image, *Orpheus and Eurydice,* we see Apollo's son at the moment when he is about to lose his wife to the underworld.[11] We can certainly understand Rodin's attraction to the tale of an artist whose beautiful music could move rocks, but who lost his love because he was unable to wait to see her face.

Early in 1893, Claudel had to face something she probably did not welcome. Her brother, Paul, took his first overseas post in the diplomatic corps. In March 1893 he was named vice consul in the French consulate in New York, surely a blow to his fiercely loyal sister. Meanwhile, brief notes between the lovers hinted that their affair was ending. A telegram in June from Claudel to Rodin: "My father came yesterday and I

went home to eat and sleep." She alluded to health problems. There are a couple of hastily scrawled notes: "Don't come. Let's avoid scenes." No dates; we cannot pin down a narrative to describe their final break-up. In 1894 Roger Marx told Edmond de Goncourt that on the day Claudel "broke off [the relationship] completely . . . Rodin arrived at [his] house, totally overwhelmed, weeping and explaining that he no long had any say over her."[12]

One possible source for enlarging this picture is Paul Claudel's writing. In 1892 he was living on the quai de Bourbon, Ile Saint-Louis. There he wrote the first version of *La Jeune fille Violaine*. Claudel told his biographer, Henri Guillemin, that into this play he put "something of the rapport I had with my two sisters; it is transposed, but that is the origin of it."[13] The drama is located in Villeneuve-sur-Fère en Tardenois, where the Claudel children were born. *Violaine* has always been considered Claudel's first Christian play, for he develops the forces of good and evil through the sisters Bibiane and Violaine. The drama circles around realities well known in the Claudel household: a father who leaves the family, sibling jealousy, and the complaint that one sister's destiny was achieved at the expense of the other's. There are aspects of Camille in both sisters: in Bibiane's aggressive and jealous nature, as well as in "spoiled," "dishonored" Violaine. In the last year of his life, Paul Claudel wrote a confessional letter to Guillemin about what he believed to be the "essential failures" in his own character: "violence, pride and an absence of sociability." He also pointed out that he shared these faults with Camille.[14]

None of these qualities made Rodin want to leave Camille Claudel. She left him. In October 1943, the day after her burial in the patients' plot at the Montdevergues Hospital in the Vaucluse, Paul made an entry in his diary: "My sister! What a tragic existence! When she was thirty years old and understood that Rodin would not marry her, everything in her world fell apart and reason could not hold."[15] It was important for Paul Claudel, the poet who transformed sexual fulfillment into religious experience, to believe that his sister had desired the normal satisfaction of marriage in spite of her revolt against bourgeois life and her willingness to become an older man's mistress. Perhaps she did want marriage, but her claim on Rodin was not voiced in those terms. Her letter of 1892 is playful and passionate, but the main message is in the postscript: "And especially don't deceive me anymore."

The deception that most angered Claudel was Rodin's life with Rose Beuret. Six drawings testify to her anguished fury once it was clear that Rodin did not intend to change the status quo. The drawings are in the Musée Rodin, indicating that Claudel actually gave them to Rodin. In one, a hairy, emaciated hag—a cruel caricature of Beuret—lies in bed with her man, tickling him in the armpits; in another, the hag has chained her mate, while she walks before him naked, guard-duty style, shouldering a broom. Claudel entitled the drawing "The Confinement System." Another, "Le Collage" (The gluing: *être à la colle* is the French expression for unmarried people living together), shows the couple pulling in opposite directions with their rear ends glued together. The subtitle is, "Ah! it's true! That does hold?" These Goyesque drawings

112) Camille Claudel, "The Confinement System." c. 1892. Pen and
brown ink with wash. Musée Rodin.

113) Camille Claudel, "Le Collage." c. 1892. Pen and brown ink
with wash. Musée Rodin.

reveal the violence of Camille's anger. Paul Claudel said it was central to her nature to
use mockery to tyrannize others.

When the tension in the affair came to a head, Auguste and Rose were living at 23 rue
des Grands-Augustins, near the Seine at the Pont Neuf.[16] Léon Cladel's widow, Julia,
and her daughters lived just around the corner in the rue Christine. Judith Cladel
remembered that when she walked by the ancient house where Rodin lived, she could
just perceive the face of a woman looking at her from behind the curtains.

Sometimes I ran into Rodin himself. He would excuse himself—of what I don't know—in a way that was vague, embarrassed, perhaps because he felt he could not receive me in his home. He said he didn't feel well, that he was suffering from neuralgia, he couldn't sleep. He was suddenly old; his pale complexion veined with dark patches, the redness in his eyes speaking of worry and anxiety. He no longer smiled, his features were tight and spoke of an unhealthy obsession. He alluded to serious worries, his shoulders straining in an automatic movement as if to throw off the burden, and I knew that he was going through one of the most tormented moments of his life.

One morning a moving cart stopped in front of the old house. Rodin himself supervised the loading of a few pieces of furniture and a great number of sculptures onto the cart. He said that for his wife's health, as well as his own, they were obliged to move to the country. He chose Bellevue and they moved into an apartment in a narrow little lane called the chemin Scribe.[17]

Cladel was surely witnessing the end of Rodin's affair with Camille Claudel. He had been negotiating to buy a house in Meudon for some time. The sale did not go through until 1895, and in the interim Rodin and Beuret lived in Bellevue. One possible explanation of the events is that when Rodin made plans to move to the country, it became clear to Claudel that he did not intend to abandon Beuret, and it was this that provoked their rupture.

At the end of 1893 Camille, now alone, wrote to Paul in New York. The letter was primarily about her work, which she said gave her "great pleasure." She described the submissions she was getting ready for the Salon de la Libre Esthétique in Brussels and included sketches for five new works.[18] She felt absolutely "yoked" to one in particular, a "group of three" into which she planned to put "a tree that leans in order to convey a sense of destiny." If she could finish it, she would put it in the next Salon. No one knew about this new work, so she insisted that Paul not show the sketches "*to anyone!*" These sketches were Camille's initial thoughts about the group that would become *L'Age mûr* (Maturity), an autobiographical work showing a man torn between a young woman and an old hag. Camille added that, "in order to take revenge, a mold maker destroyed a number of finished works in my atelier." This sentence is one of the early signs of the paranoia that would destroy Camille Claudel. Its appearance in 1893 may be connected to her two great losses: the loss of her brother to America and of her lover / mentor to his common-law wife. Her letter to Paul clearly reveals that, contrary to her assertion, distress was beginning to diminish the pleasure she took in work.

Rodin did not withdraw his support from Claudel even when their personal relationship changed. He continued to hold the lease on 113 boulevard d'Italie and presumably to pay the rent.[19] Not long after their rupture, Rodin approached Henry Roujon at the Ministère des Beaux-Arts to ask that the state give Claudel the marble she needed for her *Sakuntala*. Roujon wrote back: "I hardly need to tell you in what high esteem we hold the talent of Mlle Claudel and how seriously we take your request in her favor, but

the rule is that marble at the Dépôt des Marbres is uniquely for state commissions." When anyone spoke with Rodin about Claudel, he always said: "She is a great sculptor." Toward the end of September 1894, he wrote Gauchez: "You're being hard on me, but my consolation is that you are fair with my student, who is a great sculptor."[20]

Rodin thought up another scheme that would help bring Claudel's work into prominence. It may even have been partially for Claudel's benefit that he carried through with the idea of hosting a banquet in celebration of Puvis de Chavannes' seventieth birthday. In Puvis' honor, he stated that a work of sculpture would be donated to the Musée du Luxembourg. Rodin determined that the work would be Claudel's, and he started the subscription to purchase it with a contribution of a thousand francs.

The gesture toward Puvis was profoundly sincere. Rodin regarded him as the greatest living artist and felt a deep empathetic bond with Puvis as a man who had never attended the Ecole des Beaux-Arts and who had had as much difficulty as he himself had had in getting work into the Salons during his early years. Yet Rodin was ill at ease socially and did not normally propose such events. By April Victor Peter was working on a silver medallion taken from Rodin's bust of Puvis, which would be presented at the banquet. Next Rodin selected a committee composed mostly of younger artists and critics in his circle: Eugène Carrière, Octave Mirbeau, Ary Renan (Puvis' student), Gustave Geffroy, Georges Lecomte, Pol Neveux, Roger Marx, and Frantz Jourdain. Many years later, Mathias Morhardt recalled how Rodin had fussed over making sure that all constituencies were represented: the Société des Artistes Français, the Société Nationale des Beaux-Arts, the Société des Gens de Lettres, the Académie Française, the Institut, the modernists (Monet, Renoir, Signac, Gauguin, Zola, and Mallarmé), and professors from the Ecole des Beaux-Arts, especially Mercié, Bartholdi, and Falguière. At the same time, Rodin tried to avoid inviting too many people of any one stripe. He did not want to appear to be trying to placate the Société des Gens des Letters, with which he was now locked in battle because his *Balzac* was not finished. Nor would it do to have too many Academicians, since at the moment Puvis was a candidate for a seat in the Académie. But most of all, Rodin believed women should be included; he wrote to Morhardt that he would like to invite "Madame Adam, for example, and write to Mademoiselle d'Anethan, who is a student of Chavannes, to Mademoiselle Claudel, my student, and to Madame Madeleine Lemaire."[21] The committee did not follow through on his request. "We just didn't dare!" Morhardt wrote in 1935. "In this period, the move to include women in a banquet of such importance would have been almost revolutionary. It's not that they bothered us, that is certain, but all the same they could have jeopardized the sense of prestige and the solemnity of the occasion."[22]

The banquet was scheduled for January 16 at the Hôtel Continental. On the fifteenth came the startling news that the president of the Republic, Jean Casimir-Périer, had resigned. The reasons were not clear; many attributed the resignation to scandals and corruption, and particularly to the government's attempt to condemn to death an army captain by the name of Alfred Dreyfus, who had been degraded as a traitor ten days

earlier. In spite of the political crisis, the banquet took place as scheduled, with some six hundred luminaries from the worlds of art and politics in attendance. The two most important ministers were seated on either side of Puvis: Raymond Poincaré (finance) on his right and Georges Leygues (public instruction and fine arts) on his left. As president of the committee, Rodin gave the first toast. The manager of the Dépôt des Marbres had written a long speech for him, but at the last moment Geffroy had reduced it to a couple of sentences. In a voice filled with emotion, Rodin praised Puvis as "the greatest artist of our time."[23]

Although women were not invited to the banquet, a work by Camille Claudel was to be presented to the Luxembourg in Puvis' honor. The committee selected Claudel's *Clotho,* a figure of Fate as an old hag entangled in the web she has spun. When Claudel showed the plaster in the Salon of 1893, Mirbeau described it as "this ghastly *Fate.* Old,

114) Camille Claudel, *Clotho.* 1893. Selected as a work to be donated to the Musée du Luxembourg in honor of Puvis de Chavannes. Plaster. Musée Rodin.

emaciated, hideous flesh falling heavily like rags along her flanks, withered breasts falling like dead eyelids, scarred belly, long legs made for terrible journeys . . . she laughs into her mask of death."[24]

A few months after the banquet, Mirbeau had another idea for helping Claudel. He wrote that he was sure Rodin would like it (though without revealing what it was), but he thought they should get together and discuss it with Claudel. Rodin responded that he did not know if Claudel would come to Mirbeau's house on the same day he was there: "'It's two years since we have seen each other and since I have written her. Thus I know nothing.'" He said that though they did not see each other, Mlle Claudel was still considered his protégée, and that angered her. He considered her to be "a misunderstood artist" and "a victim of her own fierce artistic pride," but he truly believed in her ultimate success.[25]

Soon after, probably prompted by Rodin, Mirbeau wrote his greatest review of Claudel's work. He conceived of a dialogue with an imaginary person at the Salon. In front of a Claudel sculpture, he asked his companion: "Do you know that we are in the presence of something unique, a revolt against nature: a woman of genius? And no one knows who she is. . . . And the state is not on its knees in front of her to beg for chefs-d'oeuvres! Why? . . . It is clear that she is a genius. If she were a man, she would have great success. There is even a tradition in the family, as she is the sister of this fascinating Paul Claudel, in whom we have so much hope for the future. . . . *Eh bien!* This young woman works with a tenacity, a volition, a passion about which you can hardly have an idea . . . but she's got to live and she cannot live from her art. . . . Discouragement is crushing her. . . . She thinks of giving up her art." Mirbeau ended his article with a passionate plea to the ministry in favor of Claudel's work.[26] Rodin kept up the pressure; he wrote to another critic, Gabriel Mourey: "Please do something for this woman of genius (the word is not too strong) for whom I bear such love, and for her art."

Finally, results: an inspector of fine arts, Armand Silvestre, made an appointment to visit Claudel's studio in June 1895. He intended to give her a commission for a bust of Gaston d'Orléans. Instead, Claudel drew his attention to a work she wanted the state to purchase. Silvestre described it to the director of fine arts as a "very interesting composition for which the studies are quite advanced. It represents *l'âge mûr* [maturity] by showing a man who is attracted toward an old woman, while a young woman tries to hold him back. . . . The movement is very lyrical and the preoccupation with Rodin is clear [la préoccupation de Rodin manifeste]. The artist would much rather the state commission this work, which she intends to put into marble for five thousand francs. Without giving her any hope on this, I promised to submit her wish to you."[27] Things moved quickly; by the end of July, Poincaré had signed the commission to purchase *L'Age mûr*. In the margin of a letter prepared to send to possible recommenders for the commission, someone had penciled: "Do not write to M. Rodin. Strike the minutes."

The work to which the administrators committed themselves was a thinly veiled allegory of Claudel's view of the end of her relationship with Rodin. What irony that

this was the work the government commissioned as a result of Rodin's long labors to attract officials and critics to Claudel's cause. The fact that an effort was made to keep Rodin from knowing about the commission and that Silvestre chose to speak of Claudel's "preoccupation" with Rodin rather than of his influence on her, makes the story still more amazing.

In 1895 Claudel became friends with Ernest Nivet, Rodin's uncertain studio assistant. He introduced her to a patron, G. Lenseigne from Châteauroux. To Claudel's pleasure, they were able to work out a plan whereby the plaster of *Sakuntala,* which had been so well received in the Salon of 1888, would go to the museum in Châteauroux. In November it was installed in a place of honor, and Claudel went to Châteauroux for a celebration. It had been in the museum only a few days when an anonymous critic attacked: "a piece of gingerbread generously offered to the Musée de Châteauroux for the sum of three hundred francs . . . a sculptural accident . . . debauchery in plaster. . . . Is this how they make love after death? . . . And it is not even finished!"[28] Rodin mobilized his friends: Geffroy, Silvestre, Dayot, and Maurice Rollinat came forward to defend the work. Geffroy took up the cause in *Le Journal* (Dec. 15, 1895); his article elicited a note from Rodin praising Geffroy for bringing "your authority, your love of art, as well as your reserve and your courage" to Claudel's aid. If possible, he now respected Geffroy more than ever (Dec. 16).

As late as 1896, Rodin encouraged Claudel to take advantage of his connections with politicians and artists. He asked if she would like to meet Félix Faure, president of the Republic, when he visited the Salon in the spring of 1896. Claudel thanked him for the "kind invitation," but said she had not left her atelier in two months; besides, "I wouldn't have a thing to put on for such an occasion." Surely, wardrobe was not the issue. Claudel was unwilling to relinquish her anger or her unsociable ways; more and more they became her proudest possessions.

Dependency, however, had ceased on neither side. Claudel frequently needed Rodin to solve financial and bureaucratic problems. In a telegram of March 30, 1896, she told him she knew Léon Maillard was coming to his place the next day. Maillard, who was writing a book on Rodin, had asked to use two engravings after drawings she had made of Rodin, but she felt he was being difficult about payment and had told Maillard: "You [Rodin] would not be accommodating except if these drawings are published (please don't contradict me)."

Rodin's dependency arose from love. Sometime after May 1895—when he told Mirbeau he had not communicated with Claudel in two years—he was moved to write, explaining that he had caught a glimpse of Claudel at an art opening. It had felt like "consolation" to him. Rodin told her he was not well and thought just seeing her would bring him back to health. As in the old days, he lavished Claudel with praise and love, spoke of his own imperfection, and confessed that "in seeing you, I felt that fatality from which I could never escape."[29]

To the best of our knowledge, the last direct communication between Rodin and

Claudel took place at the end of 1897. *Balzac* occasioned an exchange of letters. When Rodin began the monument, the lovers had been at their closest. Now it was finished and in the studio of Henri Lebossé, the master craftsman who did enlarging for both Rodin and Claudel. Rodin wanted her to look at it and tell him what she thought. "I find it truly great, beautiful, better than all your sketches," she wrote. "I especially like the emphasis on the head and the way it contrasts with the drapery. It's just right, really thrilling. I also like the loose sleeves; they help to explain the heedless spirit of Balzac. (How did you do it—tear them?) So what I think is that you'd better expect a big success, especially with all your connoisseurs, who will not be able to find any comparison between this and the rest of the statues that now adorn the city of Paris."

Claudel's tribute to *Balzac* constitutes only about a fifth of a long letter. She told Rodin she wished to "take advantage of the occasion to speak to you a little about my own affairs." She complained that Mathias Morhardt was not an honest man and that his concern for her was disingenuous. Morhardt, the young Swiss critic and poet who had joined Rodin's entourage in the late eighties, became particularly close to him in 1894, when Morhardt took on the lion's share of organizing the banquet for Puvis de Chavannes. All the critics close to Rodin defended Claudel, but no one did more for her than Morhardt. He arranged for a commission from the *Mercure de France* for casts to be made of her bust of Rodin; he was writing a major review article on her work; he regularly wrote to Paul Claudel to keep him abreast of Camille's life; he even asked his wife to find Camille a doctor. As far as Claudel was concerned, however, the commission would cost her more money than she would earn. Nor did not she want Morhardt's article: "It is destined to bring anger and vengeance upon me, of which I have no need." Would Rodin intervene? Claudel did not believe in the Morhardts' good will: "They just pretend." As for Morhardt's wife: "You know perfectly well all these women have a black hatred of me, as they would like to see me return to my shell, and they will use any weapon. As soon as a generous man comes along to help me out of my quandary, a woman takes him in her arms and keeps him from acting. I run the strong risk of never harvesting the fruit of my labor, of just collapsing in the dark because of these calumnies and evil suspicions. All these things that I tell you, you must keep them secret." Claudel closed by telling Rodin that she had been sick for some time, which is why it had taken her so long to write.

Rodin answered on December 2.[30] Claudel's letter, he wrote, had "added to [his] suffering." He felt she was having "difficulties with life and with [her] imagination." His counsel was to *"remain faithful to your friends."* As far as he could see, Morhardt was one of her most devoted friends: "I suspect nothing wrong and I see no sign of cooling in your regard." Rodin sympathized with the crisis she was experiencing: "I am so sorry to see you this nervous and going in a direction that I, alas, know too well." He did not want to see her waste herself, for he knew she had the true "faculty for sculpture. You have a heroic perseverance. You are an honest man [un honnête homme]." Rodin thanked her for her kind words about *Balzac*—"It gives me a little confidence, and I

115) Camille Claudel, *L'Age mûr*. 1898. Bronze. Musée Rodin.

need your advice in the black hopelessness in which I have been left for dead." He had just had *Balzac* redone in a light cast, which he wanted to put into the courtyard to see how the light and air affected the work. He would love to have her by his side to look at it. Rodin then returned to Claudel's problems: "Forget your feminine nature that is capable of dispelling good will. Show your wonderful works—that is the path of reason. One is punished and one is rewarded. A genius like yours is rare." In the margin, Rodin made a sketch of Jacob struggling with the angel. He felt that this was Claudel's lot. It is clear that Rodin's love and generosity toward her remained intact, and that he understood to a remarkable degree the hell she was going through. His every effort was to make it more bearable.

When Claudel wrote Rodin her impressions of his *Balzac,* she was working on the three-figure group commissioned by the state. Rodin still did not know of its existence. On October 14, 1898, Claudel notified Henry Roujon that it was finished; he could send Armand Silvestre back to "inspect" it. Silvestre's third report was submitted on November 1. He described how Claudel had reworked the group to better represent "a man at the end of maturity swept away by age while extending a useless hand toward youth,

who, in vain, tries to follow." In the new version, the principal figure no longer touched the young woman, which "better explains the separation. [Claudel] has enveloped the figure of Age with flying draperies in order to better emphasize the rapidity of his movement. . . . The impression of Rodin is flagrant . . . but done with a great deal of sensitivity."[31] Silvestre was ostensibly speaking of stylistic issues, but, as before, his ambivalent choice of words implies that he clearly understood that Rodin was at the heart of the subject.

L'Age mûr was now securely identified as a state purchase. Evidently, Claudel was asked to bring a plaster cast of it to a warehouse of state-owned works, for there is a note from the minister to the curator of the Dépôt des Marbres informing him that "Mlle Claudel is authorized to keep the plaster at her own disposition, given that the definitive execution is in view."[32] Claudel's reluctance to let the group out of her studio is further evidence that she was trying to hide it from Rodin. In allowing her to keep the plaster, the state neglected to send the normal 2,500-franc purchase price. Claudel protested to Roujon: "If my request was supported by one of your friends, M. Rodin, for example, or M. Morhardt or someone else, you probably would not hesitate to pay me what you owe me. I shall restrain myself and simply point out that I have already advanced 2,000 francs on this group, and whether that pleases Rodin or Morhardt, I don't care; it's necessary that I get paid. I would like you to know that I am in no humor to be kept in suspense even by you."

The director of fine arts could hardly have been accustomed to such ungraceful requests. This one was effective, however; Claudel received her payment in January. By June 5, 1899, the paperwork allocating state funds for a bronze cast was finished. Then suddenly, three weeks later, the order was suppressed. It has always been assumed that Rodin was behind the cancellation; certainly Claudel never doubted he was. Rodin had finally seen the work in the spring 1899 exhibition of the Société Nationale des Beaux-Arts, where he was president of the sculpture section. He must have been displeased and probably wounded. It was not in his nature to use his influence negatively, but he may have done so in this case.[33]

The meaning was plain for anyone to see. Here is how Paul Claudel described the group: "The girl on her knees, this nude girl, is my sister! It is my sister imploring, humbly on her knees, this magnificent, proud woman represents herself in this way— imploring, humiliated, on her knees and naked! Everything is finished! This is the way it will be for all time, and she lets us look at it!"[34] Paul saw his sister as victim. He did not recognize the enormous anger expressed in an allegory in which Claudel consigns her lover to death's embrace.

Camille Claudel's 1897 letter to Rodin revealed another issue important to understanding this work. The motif of a man torn between two women was a central preoccupation in her own life. "As soon as a generous man comes along to help me out of my quandary, a woman takes him in her arms and keeps him from acting," she wrote. This was part of Claudel's oedipal struggle, growing up in a house in which the

father was eager to support his artist-daughter, while the mother was ever desirous of wrenching him away from their wayward offspring.

Claudel's *Clotho* was also in the Salon of 1899. She had put it into marble, and it was ready for the Puvis de Chavannes committee to present to the Musée du Luxembourg Maurice Guillemot's review of the Salon spoke to the way Claudel's *Clotho* resembled a work of Rodin's.[35] This, of course, made Claudel furious, and she shot off an angry letter: "My Clotho is an absolutely original work; . . . my works come from no place but myself, having rather too many than too few ideas. If M. Rodin accuses others of stealing his ideas, then you had better not publish his *Genius of War* in the same journal, because it is entirely copied from Rude."[36]

It turned out to be no easy task to get Claudel's *Clotho* into the Musée du Luxembourg. Rodin, Morhardt, Mirbeau, and Geffroy went to work on both the director of the museum, Léonce Bénédite, and the undersecretary for fine arts, Dujardin-Beaumetz. Six years later, just when they felt their efforts were coming to a successful conclusion, Claudel accused Rodin (who had stored the work in his studio) of stealing her sculpture.[37] Rodin then sent the marble to the Musée du Luxembourg, where it was not installed but where it was lost.

One description of Claudel at this time stands out. Henri Asselin, a friend of Claudel's founder, Eugène Blot, went to see her in her atelier on the quai de Bourbon, presumably in 1904: "She was forty, but looked fifty. There was such extreme negligence in the way she dressed, a total absence of any kind of stylishness. Her complexion was doughy, fading away in the precocious wrinkles and emphasized by her general state of physical decline. . . . However, there was not a trace of despondency in this woman, who was still active and charming." Claudel told Asselin that her shutters had been forced open by two of Rodin's Italian models: he had ordered them to kill her.[38]

Paul Claudel returned from China in the spring of 1905. He moved peripatetically around the country—Paris, Villeneuve, the Midi, Strasbourg. In July he took Camille for a vacation in Eaux-Chaudes, near Lourdes. (Did he hope to get her to the grotto?) In December the Claudels gathered for the opening of a show of thirteen of Camille's works in Blot's gallery. The next evening, she had a violent temper tantrum. Her family was shocked, uncomprehending: "The poor girl is sick and I don't think she can live much longer. If she were Christian, she would not have been so afflicted," wrote Paul.[39] In 1906 he left again for China, now in the company of a new wife. He returned with wife and son in 1909. When he reached Villeneuve and "the round table of the family with three generations" present, he found it "almost solemn." Camille was not there; she was in Paris. "Crazy Camille, wallpaper pulled off in long shreds, armchair broken and torn, horrible filthiness. She, enormous and dirty, incessantly speaking in a metallic monotone."[40] By this time, Camille was systematically destroying all the works she had made.

116) Camille Claudel with *Perseus and the Gorgon,* in her studio on
the Ile Saint-Louis, when she was in her late thirties.

Paul spent the next four years as French consul in Prague and Frankfurt, only return-
ing to Villeneuve in March 1913 in response to a telegram telling him that Louis-
Prosper Claudel was dying. No one informed Camille. On March 3, 1913, Claudel *père*
died and Paul, now head of the family, determined that his sister must be placed in
professional care. One week later, attendants entered Camille's studio and took her by
force to the asylum of Ville-Evrard.

In analyzing Claudel's paranoid derangement, modern psychiatrists have found that
she was obsessively focused on Rodin. She was convinced that her ambition bothered
him so much that he wanted to kill her. For Claudel, this was not a fantasy but a reality.

Doctors attending her in the asylum reported that she entertained a continual fear of being poisoned by "la bande à Rodin" (Rodin's gang).[41]

This obsession is critical to understanding the passion of Camille Claudel. She did want an exclusive relationship with Rodin, and she did idealize him and imagine what they could have been as a couple. But she also had personal ambitions, and she could imagine herself replacing him as France's preeminent sculptor. Bourdelle was torn in the same way between a terrible love and a terrible ambition to be the twentieth-century Rodin.[42] As Claudel lost her grip, she saw Rodin as the culprit and believed he had taken her ideas. Her life could not be far behind.

Like Bourdelle, Maillol, and Matisse, Camille Claudel was a child of the 1860s, ready to mature as a new torchbearer with the birth of the next century. As Marie-Victoire Nantet has pointed out, the reorientation of sculptural style in the hands of Matisse, Picasso, and Brancusi came into focus around 1905, the year Claudel's breakdown became evident. It was just then that she began destroying her works in a systematic way. Nantet compares Claudel with Modigliani, who also destroyed his sculpture. But he was getting rid of what he had done before he met Brancusi so that he could start over in a new style.[43] Claudel's destruction was motivated by psychosis, not stylistic innovation.

All the psychiatric studies of Claudel's illness begin by looking at her problematic family history, recognizing the escape she negotiated through her passion for sculpture. This put her into the middle of Rodin's life. As Rodin became first her mentor, then her lover, he became central to her identity. It does not matter that it was Claudel who ended the relationship. Their breakup was desperate and destabilizing, and her paranoia emerged only after she decided she could not continue the affair. But other factors contributed to Claudel's "failure" to become one of the pillars of modern sculpture. As a woman, she was automatically denied regular training in a school. She continually had to turn to others to pay her rent. She needed Rodin to intercede with workmen, state officials, and critics. Her sex even made her unacceptable to be invited to such occasions as the Puvis de Chavannes banquet. For Claudel in the early years of the new century, both past and present looked equally bleak.

As for Rodin, as psychologically sensitive as he was, for the rest of his life he would be baffled and saddened by his inability to lift Claudel up for the whole world to see what he saw—a "sculptor of genius."

Rodin had the commissions he most desired and his international reputation was grow-ing. Fortune's face turned away, however, in 1893, the year he lost Camille Claudel. Rodin's spirits were at their least steady at the very moment when clients began calling for the works they had ordered. Rodin must have looked back longingly to the eighties, when it was he who was pleading to have his work taken to the foundry and made ready for installation. Four clients now nipped at his heels: Omer Dewavrin, once again mayor of Calais, wanted his *Burghers* as soon as possible; Charles Yriarte, inspector of fine arts in charge of work at the Panthéon, was ready to see *Victor Hugo* put in place in the left transept; Armand Silvestre in the same capacity for the Luxembourg *Hugo* expected his monument to be coming along; and Zola was counting the months until he would see his *Balzac.* The last situation was the most emotionally charged. Never had Rodin had a client like the Société des Gens de Lettres; no one had ever been so exacting and hard to please. Further, its members were writers; when they wished to express their displeasure, they simply took to the printed page.

The date foreseen for the delivery of Rodin's *Balzac* was May 1, 1893. As far as Zola was concerned, the timing was perfect, for he had just completed *Le Docteur Pascal,* the twentieth and last volume of his *Rougon-Macquart* series. This and the monument would be the crowning glories of his presidency of the society. But Rodin's monument was not ready. In June, Edouard Montagne, a delegate from the society's monument com-mission, wrote sharply to Rodin that a large number of subscribers were beginning to complain about the postponement of the inauguration. Would Rodin "have the good-ness to indicate to me the day and the *place* where the commission can gather before your work in order to establish a date for delivering the model to a founder?" Rodin's response is missing, but it was widely quoted: he could not finish for at least another year.[1] When Rodin wrote Zola to thank him for his copy of *Le Docteur Pascal,* he added: "I assure you I work on nothing but *Balzac.*"[2]

Gustave Geffroy was quick to surmise that trouble was brewing. During a holiday on Guernsey with Rodin and Eugène Carrière, he sketched out an article tactfully attribut-ing Rodin's delay to his conscientiousness as an artist.[3] Knowing that the most impor-tant person to placate was Zola, Geffroy first called attention to the June banquet that Zola's publishers had given to celebrate his triumph. He likened it to the homage that Rodin now paid to Balzac: "I dreamed of Balzac on the day when, with such infinite justice on an island in the Bois de Boulogne, we celebrated the twenty-five-year achievement of Emile Zola." Geffroy reviewed Rodin's process over the past two years, his search for models in Touraine to find just the right corpulent body and a face that

would show the laughter in Balzac's eyes, lips, and mouth. He described the dozens of models: "I saw these masks in the sculptor's atelier when he came back from Touraine and I saw them again the other day. My astonishment only grows. . . . It is positively Balzac." Geffroy recounted Rodin's reading and rereading everything by and about Balzac. Rodin had made a thorough study of all the existing images of the great novelist, which led Geffroy to conclude that "the effigy of Balzac, that great observer of reality, could not have fallen into better hands than this ardent lover of nature, Rodin." Geffroy closed by analyzing the creative similarities between Rodin and Balzac. Both were grounded in reality, yet both found a wealth of material in myth and imagination. The match of two such visionaries was preordained by nature. It was best to leave Rodin alone to create the monument in his own time and way.

There is no doubt that Rodin was hard at work in 1893 and that he was regularly turning down engagements. As he moved away from portraiture and focused on the body, he began to correspond with Balzac's tailor for more realistic details. But he could not silence his distinguished clients. Throughout the summer and fall, the "chroniques artistiques" of various journals documented the widespread disappointment over the delay. The noted historian and lawyer Alfred Duguet, who led the opposition to Rodin's monument, continually expressed doubt that it would ever be finished. There were rumblings in the society that it had been a mistake to pay Rodin ten thousand francs.[4] In late October, trying desperately to appear in control, Rodin stated that the three sketches of his figure were "very far along, almost finished. But they did not satisfy me, so I destroyed them."[5] Rodin wanted people to understand that he and no one else was rejecting the work he had done.

Rodin badly needed visible signs of support beyond his own immediate circle. A measure of encouragement arrived in the form of a banquet. The literary magazine *La Plume* had been regularly hosting banquets in honor of major French writers. They decided to widen their scope by honoring artists and musicians as well. Rodin was their first choice. The date scheduled for his banquet, December 9, turned out to be inauspicious. That afternoon, an anarchist named Auguste Vaillant set off a bomb in the Chambre des Députés. No one was killed, but forty-seven people were injured. The crisis prevented a number of government officials from attending the banquet. Nevertheless, it took place. Soon after the guests took their places, a journalist approached the table of honor, where Rodin was sitting between Zola and Stéphane Mallarmé. The others at the table were Paul Verlaine, Georges Moreau (director of the *Revue encyclopédique*), Léon Deschamps (founder of *La Plume*), and Laurent Tailhade. The journalist asked how the distinguished group reacted to the attack that afternoon. Tailhade, himself an anarchist, responded with a widely quoted remark: "Qu'importe les victimes si le geste est beau?" (What matter the victims if the gesture is beautiful?). Vaillant's bomb convinced Frenchmen that the socialists' and anarchists' opposition to the current brand of Republican ideology and patriotism should be taken seriously.

We do not know what Rodin contributed to this conversation. In all likelihood, he

hung back. Except when art was at stake, he abstained from politics, and violence made him enormously uneasy. Besides, he might also have been worrying about the speech (written for him by Jean Marras) he was about to give. When things quieted down, Rodin rose to tell the assembled "Messieurs, grands ouvriers de la plume, poètes et prosateurs" that he was "simply a man who knows how to give form in an art dedicated to silence," and that he was not used to speaking in public. But they loved every moment of it, and he sat down to "vivas" and a "formidable" round of applause.[6]

At the end of 1893, Rodin's painter friend John Peter Russell invited him to his home on Belle Ile. Rodin declined, explaining, "I am tormented by my *Balzac*." The project for Baudelaire's tomb was stalled for lack of funding. Poor Dewavrin, who informed Rodin in September that a commission for the erection of a monument to Eustache de Saint-Pierre had been reconstituted, could hardly get an answer to his letters about readying the *Burghers* for casting and installation. By December Dewavrin was pleading with Rodin not to be "indifferent to your glory," to get going, and to "*answer my letter*." Rodin assured him that he had not lost the "feu sacré" (holy fire), it was just that he had so many things to do.

The Balzac and Hugo sketches still sat in his studio. When Rodin went on vacation in Guernsey, it was surely in hope of reopening channels of inspiration for the two Hugos he had put aside. In November he wrote to Yriarte that he was "working a great deal on the Victor Hugo." The "Apotheosis" for the Panthéon now included a figure of the poet standing on a rock of Guernsey, lost in thought, with a winged female figure (Iris) above his head and three Nereids thrashing in the waves below. Rodin said he hoped to begin carving the marble the next winter. Yriarte's report of December 11 recommended that Rodin be paid fourteen thousand francs, but it would be over a year before he received the money.[7]

Rodin was also back at work on the seated Hugo for the Jardin du Luxembourg. Silvestre saw the nude figure on January 6, 1894, and reported that Rodin had not yet "placed the drapery." The three muses above the head of the poet were no longer a tightly woven group of enlaced figures, but three separate female figures. Silvestre did not consider this feature really new; he found the sculpture "interesting," but essentially a reworking of the existing one. He thought five thousand francs would be an adequate interim payment.

The inspections over, Rodin put both Hugos aside. Dewavrin wanted his *Burghers,* but even more immediate were the demands of the Société des Gens de Lettres for their *Balzac*. Zola, whose term as president of the society had expired, wrote to his successor, Jean Aicard: "I leave you, dear friend, a question that threatens to be tumultuous. It is the statue of Balzac. Rodin . . . is late in delivering it in spite of continual reminders of his commitment. He does not finish and the committee is impatient. Try to locate a position for reconciliation. If not, watch out for squalls."[8]

The squalls were not long in coming. At the end of May 1894, a committee visited Rodin's studio. To their horror, they found nothing resembling the

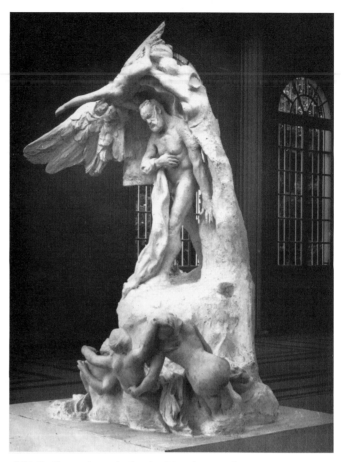

117) Rodin, nude study for the "Apotheosis of Victor Hugo." 1893.
Plaster. Musée Rodin.

118) Rodin, detail from the "Apotheosis of
Victor Hugo," showing the figure of Iris.
Musée Rodin.

maquette of Balzac in a monk's robe that had once pleased them so much; their monument had turned into a *naked* Balzac with a fat belly. Indecent! They drafted a report stating that Rodin's *Balzac* was a "shapeless, indescribable mass" and "artistically unsatisfactory."[9]

Did any of these men of letters realize that they were virtually re-enacting one of Balzac's most famous stories? In "Le Chef d'oeuvre inconnu" (The unknown masterpiece), set in seventeenth-century Paris, the main character, Frenhofer, the greatest painter of his age, has spent ten years trying to create the perfect image of a nude woman. Wrestling with nature, continually reworking the painting, he is drawn ever deeper into the complexity of the work, so that when the young painters Pourbus and Poussin come to look at it, all they see is "a confused mass of colors contained within a

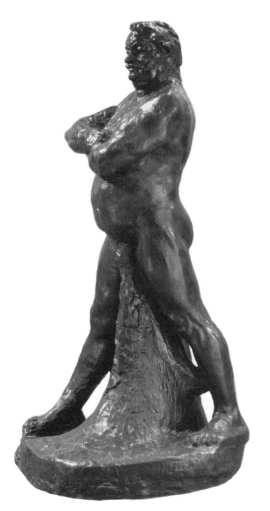

119) Rodin, *Study of the Nude Balzac.* 1894.
Bronze. Los Angeles County Museum of Art.
Gift of the B. Gerald Cantor Art Foundation.

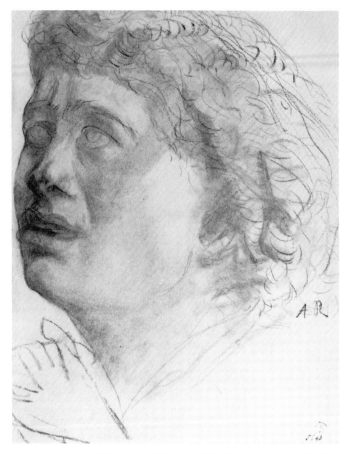

120) Rodin, *Séverine*. 1894. Charcoal. Musée Rodin.

multitude of bizarre lines." The masterpiece is destroyed. Balzac's story has been interpreted as censuring the evils of excessive literary revision. Was Rodin another Frenhofer?

To be sure, Rodin had his supporters among the members of the Société des Gens de Lettres. One was the enchanting Séverine, whose copper-colored curls, periwinkle eyes, and thick, sensuous lips Rodin portrayed that spring in a group of sublime charcoal sketches, as well as in some clay studies. "Others have made my features," she told Rodin, "you have made my soul."[10] Séverine's presence in Rodin's studio in 1894 means that she was thoroughly familiar with his *Balzac,* and she defended it from the committee's attack:

> Up close it was ugly, with skin looking as though it would peel off; the face was barely indicated—completely nude, what a horror! But the folded arms revealed the powerful pectoral muscles and the placement of the legs showed the act of walking. The conquering advance of the step was magnificently suggestive of the

idea of taking possession of the ground, while the feet looked as if they were attached to mother earth by roots. And the formless face full of holes, with a grin like a scar and a nose like a bird's beak, a cannibal-like jaw, a rugged forehead beneath a mass of hair like a clump of weeds, all produced an imperious sovereignty that was almost superhuman, so that a small shiver passed down my spine.

Séverine was touched by the timidity with which Rodin showed her his work: "It's my Balzac—well, at least it's one of the maquettes." When she said she found it very beautiful, he objected: "No, no! But it's not bad, in fact, fairly good in the movement. But it is the feeling, the intimate inner life of the man that I want to get—and that's a tough customer to find: the soul of Balzac."[11]

By the middle of the summer the strain had become almost unbearable for Rodin, so he left Paris. On August 1 he wrote Zola that poor health had forced him to go to the country and that had no intention of returning before October. Ten days later he sent the same message to Dewavrin, but he gave neither of them an address where he could be reached in the Auvergne and the Loire Valley. Séverine, however, did have his address at the Hôtel de la Gare in the picturesque town of Thiers, near Clermont-Ferrand. Rodin wrote to her that he was calming down, relaxing, getting his health back amid the "cats and dogs and asses and children . . . good people with ancient customs, the old town well preserved—how good all that is for me." He told Séverine he had decided to take his aching brain for a promenade, that it felt good no longer to be shouting at the top of his lungs.

In the peace and tranquility of the small Auvergne towns, Rodin reclaimed his balance, readying himself for the struggle ahead. He knew that when he returned the Société des Gens de Lettres would expect a completion date that he could not disregard. But he also knew he could set no such date, as he was still searching for Balzac's soul. How long it would take him to find that "tough customer," he had no idea.

At the committee meeting of October 12, 1894, Edmond Tarbé, former director of *Le Gaulois,* moved that Rodin be instructed to deliver his sculpture within twenty-four hours or to return the ten thousand francs he had received for the project. The essence of the quarrel between Rodin and the committee was time, but when the press got hold of the story, they framed the controversy in terms of what it meant to be an artist and what a relationship between artist and patron ought to be. Was the artist, like any reputable tradesman, someone who merely took an order and organized his work so as to deliver on time? Or was he a man in search of a greater truth, setting out to realize forms in which the artist, the buyer, and the world might recognize a new vision? Paradoxically, most members of the fifty-five-year-old organization, which had been founded to secure rights and privileges for writers, saw the artist as a producer who should deliver on time. But the majority of critics favored a larger latitude for the artist. Charles Morice asked: "What is all the fuss about? What's the peril? Are we living in a time of such universal worry about speed? Zola, who writes his big novels at the rate of six pages a day, can't seem to understand."[12] Jean de Nivelle (*Le Soleil,* Nov. 10) believed

that Rodin's hesitations were honorable, that he was searching to do something that went beyond banality: "Rodin has the right to correct his own sketches and to search for the best way to do the monument." Rodin's principal defenders were Geffroy and Clemenceau. On November 12, the day the vote was taken on whether to extend Rodin's time, Clemenceau published a major article in *La Justice* reminding the committee that "Balzac is not the property of the men of letters. He is a great French genius whom Paris must honor in the name of France." He added: "They tell us Rodin is late. Good! That means he's hard to please."

The committee voted to let Rodin take his time but not to pay him. The ten thousand francs he had received were to be returned and deposited in the Caisse des Dépôts et Consignation, where they would stay until he delivered the statue. Rodin accepted these conditions.

At this point things might have settled down. But on November 26, Jean Aicard and six other members of the committee resigned in protest. It was their understanding that Rodin had been paid for his sketches, and they believed he had been treated shabbily. Rodin was stunned by their gesture. "You have delighted and astonished me," he wrote to Aicard.[13]

The press no longer believed the disagreement was simply about deadlines. "The hidden side of this is much more complicated," *L'Eclair* suggested. The paper speculated that an unnamed sculptor with "influential friends on the committee of the *gens de lettres*" also wanted the commission, so that everything was being done to irritate Rodin and delay his delivery. Moreover, *L'Eclair* declared that "all this uproar serves to mask a manoeuvre against the eventual reelection of Zola as president of the Société des Gens de Lettres" (Nov. 27, 1894). Gustave Toudouze, a member of the committee, confirmed this theory when he told Goncourt that week that much of the hostility aimed at Rodin's *Balzac* was actually directed at Zola for his autocratic management of the monument commission.[14]

Throughout this period Zola was traveling in Italy. He seldom saw French papers and did not know what was happening until he reached Venice on December 8. He immediately wrote a superbly constructed letter to Rodin, in which he managed to exert the maximum pressure without qualifying his admiration for his chosen artist: "You know how much I admire you and how happy I was when such a great sculptor as yourself received the commission to glorify our greatest novelist, the father of us all. I beg you in the name of genius, in the name of French letters, do not make Balzac wait any longer. He is your god, as he is mine; spend your days, spend your nights, if necessary, that his image may reign in the midst of our immortal Paris. It all depends on you; it is you alone who are holding up the completion date. . . . Balzac waits."[15]

Members of the society were busy giving interviews for and against Rodin, which only increased the confusion in a badly shaken organization. The new president, Aurélien Scholl, lost no time in arranging a reconciliation with Rodin. Scholl was a man in his sixties who still bore the debonair aura of one of the Second Empire's great

121) Rodin, *Balzac in a Dominican Robe*. 1894.
Plaster. Musée Rodin.

boulevardiers. He and Rodin dined amiably on December 5 at the Restaurant Durand in the place de la Madeleine.[16] They put their understanding into contractual form, making clear that there would be no time constraints on Rodin and that he would return the ten thousand francs to be placed in an escrow account. The agreement stipulated that neither Rodin nor his heirs could touch the money until the statue was finished. Rodin had spoken so often of his ill health that the society felt they could take no chances. When Chapu died in 1891, his heirs claimed a part of Chapu's fee. Rodin wrote to Zola: "If I can pick up my work again in a true freedom of spirit, it is thanks to the intervention of Aurélien Scholl." He also gave credit to the members of the committee who had resigned.

On December 9 a reporter for *Le Matin* went to Rodin's studio. Although Rodin now knew that another sculptor was eager to claim the commission, he was in a "cheerful mood." He did, however, want to place his personal vision of the greatest novelist of the century on record: "There, in the middle of the place du Palais-Royal, I see Balzac dressed in his monk's robe, arms crossed, a simple pose, looking down at the passersby, the true actors of the *comédie humaine* he painted for us. I want a very simple architectural base with a single figure holding a mask in bas relief on it. Now you are going to ask me why I have not realized this conception already. First, because until August I had a

serious case of influenza, and second, because I cannot tolerate being pressed so hard on a date of completion." Rodin ended the interview by telling the reporter that he was sure the public knew how eager he was to give Paris the monument everyone wanted, but he needed to be free. Now that he had his liberty, he would use it.

By the end of 1894, Rodin had fought his way to an understanding with the most difficult patron of his life, even if it meant he had to invest personally in bringing the work to completion without his expected advance.

Chapter 24
Learning to Say:
"It Is Finished"

On November 30, 1894, when Rodin's struggle with the Société des Gens de Lettres was at its height, he signed a contract with the Argentinean government to create a monument to the country's first president, Domingo Faustino Sarmiento. He promised delivery in three and a half years, and they agreed to a sum of seventy-five thousand francs, the same amount he had been promised for the original Hugo monument commission.

The following week he signed the new agreement with the society that removed all time constraints, thus allowing him to turn to other work for the moment. The "Hugo inspectors" would soon be back. Charles Yriarte came early in January and found that virtually nothing had been done on the Panthéon "Apotheosis" since his visit a year earlier. Rodin must have pointed out that he had received no payment for the work he had done in 1892 and 1893, because Yriarte arranged for him to receive fourteen thousand francs.[1]

In contrast, when Armand Silvestre showed up the following week, he found that Rodin had made considerable progress on the Hugo monument for the Jardin du Luxembourg. His report was full of praise: the figure was "Olympian," recalling "the most beautiful conceptions of antiquity" and having a gesture of "incomparable grandeur."[2] His enthusiasm emboldened Rodin to ask for ten thousand francs (the amount he had just lost on the Balzac). Unlike Yriarte, Silvestre decided that withholding payment might be the best way of applying pressure. He considered the work ready and was eager for the marble to be carved, but he could see there was still something tentative about Rodin's attitude to the work. In fact, Rodin was considering further revisions.

The third commission remaining to be completed was *The Burghers of Calais*. For over a year Dewavrin had been pressing Rodin unrelentingly. Rodin consigned the final stages of work on the plaster model to Bourdelle. In January Bourdelle submitted bills for work he had done in the past year, attaching a note that said: "We can send the Burghers of Calais to the mold makers!"

Four months later, the bronze cast of the *Burghers* was bolted into place between the new post office (now the Hôtel de Ville) and the place Richelieu (now the Parc Saint-Pierre) on top of a five-foot pedestal designed by a local architect, which was then surrounded by a wrought iron grill. The installation did not please Rodin, who had wanted his *Burghers* on a lower pedestal, closer to the people.

The inauguration took place on June 3, 1895, with a full panoply of events: lectures about Eustache de Saint-Pierre and his companions, speeches, gymnastic competitions, exhibitions of lighter-than-air craft, bell ringings, cannon salvos, and a banquet. This was Calais, however, not Nancy, and the year was 1895, not 1892. President Carnot, who had saluted Rodin so warmly in Nancy, had been stabbed to death by an anarchist at an exhibition in Lyon the previous summer. In the new atmosphere of caution, it would have been unthinkable for President Félix Faure to come to Calais for the inauguration. Raymond Poincaré, the minister of public instruction and fine arts, would not come either. The new minister of colonies, Emile Chautemps, represented the government instead. Roger Marx, representing the absent minister of fine arts, gave the principal address, reminding the people of Calais that when they had hired Rodin, they knew they would not get "a dull representation or an equivocal allegory in that trivial convention."[3] Some found the monument not dignified enough, but they were in the minority. The sentiments that carried the day were expressed by Octave Mirbeau in *Le Journal* (June 2): the power, beauty, and originality of Rodin's *Burghers* were unequaled in any other modern monument. Although the article was quoted in newspapers all over France, this was anything but a day of national importance, as the inauguration of *Claude Lorrain* had been three years earlier. Rather, it was a personal triumph for Rodin, Dewavrin, and the people of Calais, whose distinguished history was celebrated in glowing terms.

We have no record of Rodin's reactions to the inauguration or of his feelings about seeing his monument in place. The records we do have for the summer of 1895 tell mostly of discouragement and depression. Edmond de Goncourt shared a train compartment with Rodin in July, when the two traveled home together after visiting the Mirbeaus: "I found him much changed and very melancholy, in a state of collapse and

122) Inauguration of *The Burghers of Calais,* June 3, 1895. Rodin in the front row of the dais to the far left. Photograph by M. Meys.

fatigue brought on by his work. He complains unhappily about the vexations inflicted on sculptors and painters by those who give them commissions. Instead of helping them, they make them lose time with constant appeals, solicitations, and demands for little errands. He wishes he had become an etcher."[4]

Early in 1896, Mirbeau told Goncourt that things had changed. Rodin had "triumphed over the physical and moral breakdown of recent years" and "started to work again."[5] There may have been a propagandistic side to this report, for everyone knew that anything Goncourt heard would end up in print. (Some people avoided him for this reason once he began publishing the *Journal* in 1887.) Mirbeau knew that it was important for people to believe Rodin was hard at work. Though Rodin had been the darling of the press for a decade, he could no longer take its adulation for granted. In 1896 his former supporter Félicien Champsaur published an article called "The Failure of Genius," in which he spoke of *The Gates of Hell* as a work that Rodin would "never finish, even more, which no longer exists, for the magnificent dream that gave it form has taken it back. And then there is the statue of Balzac that he can't seem to produce."[6]

There is much evidence that Rodin was not so free of his depression as Mirbeau would have had Goncourt think. Legros came to Paris in the spring of 1896; back in London, he wrote that he was worried and urged Rodin to send him good news soon: "It would give me so much pleasure to know that you have regained your tranquility, your spiritual equilibrium." He reminded Rodin that he was one of those people born to draw pleasure from work alone. Later in the year, Constantin Meunier wrote from Belgium that he hoped Rodin was no longer having his "terrible headaches." In December, as Eugène Carrière prepared to leave Paris for the winter, he wrote a long and reflective letter about Rodin's problems. He knew Rodin suffered more intensely than most people did and was afflicted with every sort of wound. "What can console you?" Carrière did not know, but he did believe that Rodin's suffering was not simply an empty loss. From these letters we glimpse Rodin's mourning of Camille Claudel as seen through the eyes of his friends, the loss that Rodin called the "fatality from which I could never escape."

In spite of Rodin's spiritual crisis, a great deal was going on in his studio in 1895 and 1896. There were preparations for a second big exhibition in Geneva, where his work would be shown with paintings by Puvis and Carrière; work on the enlargement of the monument to Sarmiento; and the carving of important marbles—*The Kiss* for the Musée du Luxembourg and *The Zephyrs* for Albert Kahn.[7] But Rodin was primarily preoccupied with bringing the Hugo and Balzac monuments to conclusion. By fits and starts, in depression, loneliness, and loss—and, occasionally, with the joy of creation— Rodin was struggling to resolve the central problem of his life: how to grasp individual genius and transform that understanding into a great modern monument.

A vivid picture of Rodin's thoughts in this period emerges from a correspondence with a new friend, Hélène Porgès Wahl. She was a young Parisian socialite, a neophyte painter and wife of Albert Wahl, chief engineer of the French navy. In December 1893

she invited Rodin to her home in Saint-Cloud. He declined but sent "admiration," "gratitude for the honor of the invitation," and a "little plaster." Since Claudel's disappearance from Rodin's life, he had been at loose ends. In his letters to Mme Wahl, he poured out his heart and exposed the part of himself that was most vulnerable and tentative.

After the inauguration of *The Burghers of Calais,* a period of anxiety and depression for Rodin, Wahl invited him to Saint Moritz. He was charmed that she would pay attention to "this sculptor, prisoner of Paris, enclosed in the vexations of illness." He was tempted, but "as victim of so many impulses that thwart me, I never know in advance what I'm going to do." In the end he went, and the two friends passed a day walking in the Engadina, a day that Wahl would never forget. Rodin arrived by way of Lake Como. From Menaggio, he wrote Wahl a letter that resounds with the pleasure of new sights and sounds. He talked about his own aging and his recognition that things other people had already had enough of, "I still want." He told her that he perceived himself to be a "rude man," that with the exception of his sculpture, he was still a stranger to beauty. He did not want to stay that way. He wanted to understand the spirit of those who had come before him, who had created beautiful things like the cathedrals and the great works of antiquity.

Rodin wrote Wahl regularly over the next couple of years, mostly from Meudon. Toward the end of 1895 he had purchased the Villa des Brillants and he and Rose Beuret had moved there from Bellevue. In his new home, Rodin delighted in being able to rise early in the morning and walk in the mist, sit under a tree, and write to a friend. Although he was living with Beuret, we know little of her during the 1890s. She is seldom mentioned in the correspondence of others, there is nothing from her own hand, and we have only seven brief letters written to her by Rodin during the entire decade, usually to let her know when he was returning to Paris. He had grown into a different person and led a different life than the one he had originally shared with Beuret in Montmartre and Brussels. We know from later comments that she was extremely jealous of his other life, and yet they still had one together, especially in their new country home. The inner dynamic of their shared life, however, has gone to the grave with them.

Like many other women, Wahl wanted Rodin in the most intense way. She felt alone—her husband never figures in her correspondence—and she focused on Rodin. She gave him too many invitations; she stopped by the atelier too often. When she pleaded for more of his time, he replied: "In you there is also an artist, and it is especially that side of you that should understand me." He sent her a couple of Italian models to pose for her; they were "heavy and oily," she said. "Work with any model you can get," was his response. "They are all beautiful."

Again and again in these letters, Rodin emphasized his self-imposed solitude in the interest of work. He spoke of himself as "a silent man." In the first letter Rodin wrote to Wahl refusing her dinner invitation, he made it clear: "I do not go out in the evening

because I must work and this is the only method at my disposition, to curtail everything in order to work." When she asked him to write longer letters, he said: "You know I'm not a clerk, and writing and speaking confuse me; my natural means are clay and pencil." When she sought reassurance about their friendship, he tried again to articulate who he was: "When I was young, I did not talk. For a long time I was too timid. With success I lost this prudence, which was a bad thing, because I was born not to speak, not to find stimulation in words."

In February 1896, Rodin referred directly to his suffering as a result of his break with Claudel: "I believe I'm coming out of my troubles because I am now working and sleeping, and I feel I am happy, or at least that I am going to be. I feel young again; my head is full of enthusiasm. The tyranny of passion appears to be passing. It's not that I love women less than before, but I love them differently. Finally, I can call you my divine sisters and admire you for the delicacy of form in which you have been made. In body and in heart, the Great Founder who made us all endowed you with a better patina than he did us."

Rodin's letters to Wahl provide a view into his psyche; he struggled to wrest himself free from his attachment to Claudel and to return to the present reality, which was completing the two most important sculpture commissions of his generation. *Hugo* for the Jardin du Luxembourg was in better shape than *Balzac*. In the fall of 1895, Rodin wrote to the ministry that the marble they were providing met with his approval, implying that the carving would soon begin.[8]

Balzac was another story. In April 1895 Zola was reelected president of the Société des Gens de Lettres. Once again he focused on Rodin. Unfortunately, it was just as Rodin was making the final push to ready *The Burghers of Calais* for the inauguration. Soon afterwards, he impulsively left for his vacation in Italy and Switzerland. As 1895 drew to a close and it was clear to Zola that the statue was not progressing, he asked Geffroy to talk to Rodin to see if he would consider giving up the commission. The society would let him have the ten thousand francs; they would then look for a "young, unknown sculptor" who would finish the monument by 1897 and agree to work for what remained in the budget.[9] We do not know if Rodin was insulted by the society's placing punctuality above artistic vision, but he refused to withdraw, and he did so—in the words of Mme Py—with a "moving stubbornness" (acharnement pathétique).[10] Rodin promised to deliver the statue by 1897 without fail.

Throughout January and February, headlines in the press continually posed the question: "Will Rodin finish *Balzac*?" Everyone was curious to see what would happen when Zola's term was over. At the end of March 1896, the society elected the critic Henry Houssaye as their new president. This had enormous significance because Rodin's competitor for the commission had been Marquet de Vasselot, and Arsène and Henry Houssaye had thought from the beginning that Vasselot was the right sculptor for the Balzac monument.[11]

Vasselot, like Rodin and Zola, was born in Paris in 1840. Like them, when young, he

was enthusiastic about the great artists and writers of modern France. As Rodin made a special cult of Hugo, his choice was Balzac. He began doing portraits of Balzac when he was in his twenties. In 1886 he offered one as a gift to the Société des Gens de Lettres. Vasselot was not only a sculptor but also wrote about sculpture, and thus he was able to become a member of the society in 1888 as an author. He soon joined another group, this one dedicated to spirituality and to the aesthetics of mystery: the Salon de la Rose + Croix, founded in 1892 by the poet and novelist Joséphin Péladan. Péladan too placed Balzac above all other French writers as "at least the equal of Homer, Dante, and Shakespeare."[12] So when Péladan discovered that there existed a sculptor who had "raised larger than life the Hercules of nineteenth-century letters," he knew beyond a doubt that Vasselot must have the commission.[13]

In 1893 Vasselot sent five works inspired by Balzac to the Salon de la Rose + Croix. The most important was a relief, *La Comédie humaine,* depicting 103 characters from Balzac's novels. It was shortly after these works were exhibited that the society made its first move to relieve Rodin of the commission. In 1895 Vasselot showed four works with a Balzacian theme, and his supporters openly initiated a press campaign with the goal of shifting the Balzac commission to Vasselot. The comte de Larmandie, a poet and officer in the Société des Gens de Lettres, called Vasselot's *Comédie humaine* "a unique work, thrilling, original, synthetic, and one I would like to bring to the attention of the minister of fine arts."[14] Péladan was even more direct: "Recently, there has been a bit of noise over the statue of Balzac ordered from M. Rodin, the sculptor of primates, the plastician of Borneo! M. Marquet de Vasselot has undertaken several projects for a statue of Balzac. . . . To prefer that of M. Rodin is not only unjust, it is absurd."[15]

In April 1896, just after the election of Houssaye, Vasselot showed his *Balzac-Sphinx* and published two articles explaining his use of the sphinx image for Balzac: the sphinx was the synthesis of force, power, intellectual prowess; its wings denoted the ability to take things beyond the highest mountains. Vasselot attached letters from people who believed that he, not Rodin, should be the sculptor of the Balzac monument. One was from Péladan: "If one day intelligence will have its temple at the door of *Lettres* [the Société des Gens de Lettres], they will put your Balzac-Sphinx to the left and a Dante-Sphinx to the right."[16]

Vasselot, Péladan, Larmandie, and their friends addressed the aesthetic issues, calling for a symbolic and visionary Balzac, not the pedestrian naturalist image that was sure to come from Rodin's hand. But their commitment to the political nature of the choice was even more insistent. The men of the Salon de la Rose + Croix viewed Balzac as "inspired, catholic, and monarchist,"[17] an image that harmonized with their own beliefs. Their principal bête noire was Zola, who had appropriated Balzac for the naturalist movement so successfully that it affected all writing about Balzac in the 1870s and 1880s. They now moved against the "excesses of naturalism" with outrage and moral indignation. They would save Balzac from Zola—and from Rodin.

Vasselot's objections to Rodin's figure were circulated in the press. He felt it should be "forbidden" to make a "grotesque Balzac." Everyone knew Balzac had had tiny legs that were further diminished by his overwhelming stomach. Why inflict the memory of this on the public? Would it not be better to take his magnificent head and put it on the noble body of a lion?[18]

In August it became known that fifteen subscribers had signed a petition demanding their money back if no statue was forthcoming within the year. Edouard Montagne, deputy of the society, denied the report. This made no difference; the story haunted the press.[19] Toward the end of the month, the Belgian poet Georges Rodenbach took up Rodin's cause. He pointed out that Parisians had waited a hundred years for a monument to Jean-Jacques Rousseau. Why was it that they needed Balzac right now? He speculated about the "series of tricks, summonses, and harassments." Surely these "intrigues were in the interests of giving [the commission] to another sculptor." Rodenbach feared that Rodin—with his "myopic vision and exalted philosophy"—did not see what was going on.[20]

Rodin's friends were perplexed. As usual, Octave Mirbeau sprang to his defense, describing Rodin as perhaps "the only genius of our time." Yet, "who are they proposing as the one to restore Balzac to us? M. Marquet de Vasselot! Such an idea seems totally improbable and slanderous."[21] Judith Cladel took a long view. She felt that the attacks on Rodin were the result of years of hostility on the part of academicians and conservative politicians. And Edmond Bigand-Kaire was convinced that Jules Dalou was at the bottom of the trouble.

The twentieth century affords a broader view of the circumstances that placed Rodin and his *Balzac* in such a precarious situation in 1896. France had a fairly stable moderate government under the leadership of Jules Méline. He was committed to continuing the existing social order and defended the interests of property against the left's proposals for taxation. But this led to a polarization between radicals and reactionaries. Further, the press, even though saddled with stricter laws against "anarchist propaganda" in the wake of the assassination of Carnot, was jittery and receptive to innuendo, rumor, and planted material. For instance, one big story in the fall of 1896 put the "spy" Alfred Dreyfus back on the front pages, when it became known that a "secret file" had been used to convict him in 1894. Rodin's troubles must be seen against this background of conflict in the nation as well as within the Société des Gens de Lettres, exacerbated by an overactive press. Tempers rose and passions of both participants and observers were propelled higher and higher.

Rodin had to fight as never before. He began giving interviews to counter the accusation that he would never finish *Balzac*. He claimed to have been totally preoccupied with the monument for the past two years. He talked about the large number of maquettes that he had made. But he emphasized that "the period of trial and error is over." A journalist explained: "M. Rodin finished a maquette about a month ago that gives him the satisfaction for which he has searched untiringly. Balzac will be repre-

123) Rodin, study of the dressing gown for
Balzac. 1897. Plaster. Photograph by Freuler.
Musée Rodin.

sented standing in an attitude that is strong and simple, with legs slightly apart and his arms crossed. He will be dressed in a long belted robe falling to his feet" (*Le Temps,* Aug. 19, 1896).

It seems quite likely that it was in response to the criticism of the summer of 1896 that Rodin began working with another model, one who was not as fat or grotesque as the men who had posed in previous years. He modeled him in a quiet academic studio pose, a sturdy figure—weight on the left leg, hands crossed—and, in a direct reference to Balzac's sexual potency, Rodin placed his erect penis in his left hand.[22] Morhardt came to Rodin's studio in 1897 and found six casts of this model in plaster and a big roll of cloth in the corner. Rodin began wrapping and draping each of the casts differently in search of the right look. "The cloth began to enlarge and amplify the form, so the final version had something imperious and grandiose about it."[23] Like the individual Burghers of Calais, Rodin designed Balzac's powerful body to interact with simple volumes of fabric, capturing light as sunlight and shadow moving across broad, ever-changing surfaces.

The head resulted from countless experiments based on the many visual documents and literary descriptions of Balzac's face that Rodin had so painstakingly acquired. In his earlier studies, working with models, Rodin favored a naturalistic approach. As the years passed, a more personal conception of the novelist took form in his head. He began to exaggerate the features, thicken the lips, deepen the eyes, add flesh to the jowls and mass to the neck. Rodin loved to quote Lamartine's description of Balzac: "He has the face of an element . . . he possessed so much soul that his heavy body seemed not to exist." This coincided with Rodin's own belief that to portray a man of intellect, one had to make the head the dominant force. A decade later, Rodin explained to Paul Gsell that in *Balzac* he had "wanted to show the very process of his breathing—Balzac, alone in his studio, hair in disorder, eyes lost in a dream, a genius who, in his little room, is able to reconstruct bit by bit the entire structure of his society and to expose life in all its tumultuousness for his contemporaries and for all generations to come."[24]

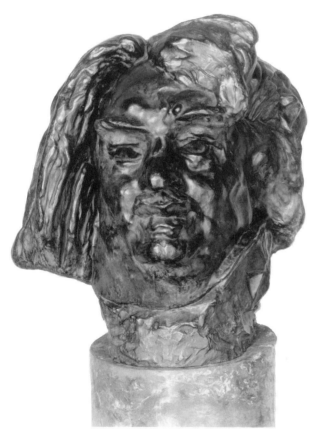

124) Rodin, *Head of Balzac*. 1897. Bronze. Philadelphia
Museum of Art.

125) Rodin, definitive study for the *Monument to Balzac*. 1897.
Plaster. Photograph by Druet.

This was the image Rodin readied for presentation to the members of the Société des Gens de Lettres in 1897. On April 5 it was announced at their general assembly that Rodin had finished his maquette. The inauguration was scheduled for the fall. Rodin sent the maquette to be enlarged at Henri Lebossé's studio, where Camille Claudel saw it for the first time and recognized it as "truly great, beautiful . . . just right, really thrilling."

Everything was ready. The architect Franz Jourdain, who was a member of the society, had designed the pedestal for the long-intended statue's installation in the place du Palais-Royal. But the society then did an odd thing: despite their claim of being in a rush, they voted not to have the statue cast in bronze at this time. Instead, they wished to have the plaster version shown at the Salon.[25] So, rather than going to the foundry, *Balzac* came back to the rue de l'Université. Rodin would have preferred to send *Balzac* directly to the foundry. Something in him knew this would be the safer route. But the following spring, when the plaster left his atelier for the exhibition, he felt a great absence. Reporters gathered around to see how he felt and to ask if he was satisfied with his work. Rodin tried to find words for what had been going through his mind all these years: "I searched, I dreamt, I meditated; I struggled so hard to find the way to give material form to my thoughts. I wanted so badly to make a work that was worthy of him who incarnated human expression. I don't know if I have really succeeded." He told the reporters it would be years before he knew. He added that he would have liked to keep the statue longer. If only he did not have to attend to normal life. But he could not escape to a cloister and live alone with his work, like a monk. "One has to pay attention to the demands of society; we cannot live just in our own ideal realm." After all, the monument was intended to give glory to Balzac in a public fashion, and Rodin knew that those who had commissioned it were justifiably eager to see it in a public place. "This is why I had to say: it is finished, just as I had to say it for the monument to Victor Hugo."[26]

It was not just his passion for perfection that kept Rodin from completing the Balzac and Hugo monuments. In the 1890s he had too much work, too many difficult patrons, and he suffered from a broken heart that made him depressed, sometimes even sick. Nevertheless, Rodin did complete his two great commissions. *Victor Hugo* and *Balzac* summed up his aspirations as a sculptor, completing the grandiose hymn to nineteenth-century male genius that he had begun in *The Gates of Hell* and *The Thinker*.

From his youth Rodin had placed himself at the feet of Victor Hugo. It was Hugo who led him to a personal credo of genius. From Baudelaire he learned about the suffering inherent in the sacred calling of the artist ("La Bénédiction"); he learned that being an artist entails terrible fears of boredom and infertility ("La Muse vénale") and that the artist can become enslaved in his pursuit of the unattainable ("La Beauté"). But, as Rosalyn Jamison has pointed out, Hugo's optimistic outlook was far more compatible than Baudelaire's pessimism with Rodin's own idealism.[1] Not that Hugo and Rodin did not understand the artist's search for identity as a tragic-heroic experience: both claimed the exiled Dante as their predecessor. Hugo, like Dante, placed himself outside his own society in order to judge it. In the preface to *Les Rayons et les ombres* (1840), he extolled the virtues of the "cults" of long ago, including Dante's "cult of thought." Hugo based his idea of the poet-thinker on Dante's powerful understanding of human intellect. This inspired Rodin's portrayal of his *Thinker* as a man pondering human destiny. Hugo believed there was a universal continuum of genius. Under his guidance, Rodin based his first conception of *The Thinker* partly on Dante. But he then moved to another image, one of self-identification in which he revealed the artist—the creator—as "the thinker."[2] For Rodin, the next step in the continuum was the image of Hugo himself.

Balzac, the other superior genius of modern French literature, then took his place beside Hugo. It is no accident that Rodin put more of himself into these two projects than into his *Bastien-Lepage* and *Claude Lorrain*. He—like most members of the Société des Gens de Lettres—thought of writers as weightier presences than artists in the history of human genius. In his monuments of the 1890s, Rodin envisioned writers as heroes, noble, spiritual, and sublime. At the same time as he was working, Richard Strauss, the most talked-about composer in Europe, was creating *Ein Heldenleben,* in which a modern artist was similarly cast as hero. Rodin grounded his work not only in philosophical and poetic ideas, but also in visual references. As *The Gates of Hell* had

drawn on Michelangelo's Sistine Chapel ceiling and the cathedrals of medieval France, Rodin's monuments to great men had sculptural sources—notably David d'Angers, Hugo's favorite sculptor.[3] David, we remember, was the sculptor to whom Rodin had turned when he created the image of the first great man he ever met, Father Eymard.

Like Hugo, the Republican David went into exile at the beginning of the Second Empire. Until that time, he had been *the* sculptor called upon to establish the image of *les grands hommes* on public squares in France. His series of great men constituted virtually a new mythology for the nineteenth century. As Jacques de Caso has said: "He attacked the problem of setting up these monuments with a willfulness that bordered on mania."[4] Rodin knew David's choices and solutions well: standing figures exhibiting significant gestures of authority and semireclining figures also exhibiting gestures of power.

The majority of David's monuments followed the established practice of Romantic sculptors: they were dressed in the clothing of their time. François Rude had been such a devotee of this practice that when he was working on his monument to Napoléon in the 1840s, he got in touch with Napoléon's valet to borrow the emperor's own clothing. David's ideal, however, was heroic nudity. He believed that, like the athletes of ancient times, great men had superior bodies. Even after having fashioned so many clothed figures, he was able to write: "I'm proud that I have been able to extricate myself from all the frippery of period clothing."[5] In this, David was Rodin's mentor. But both men hesitated in carrying out the ideal; a naked figure was simply too radical.

Rodin began work on *Victor Hugo* and *Balzac* just as he had begun his *Claude Lorrain:* by getting to know the subjects through existing images. For *Victor Hugo,* Rodin looked at Nadar's daguerreotypes and Charles Hugo's photographs of his father seated on the rocks of Guernsey.[6] What was important at this point was the body's seated position and the pondering, hand-to-head gesture seen in nearly half the contemporary photographs and prints made of Hugo.

With *Balzac* Rodin had an equally rich selection of visual sources: photographs, prints, paintings, and sculptures made when was Balzac alive.[7] Balzac took a characteristic pose—crossed arms over his ponderous girth—for the majority of the artists for whom he sat in the 1830s and 1840s. But the image that meant the most to Rodin was not a full-body portrayal but the famous bust of Balzac by David. In an 1888 interview on the subject of a Balzac monument, Rodin declared: "Whatever the sculptor who receives the commission does, he will not be able to neglect this bust. In fact, he will be obliged to copy it more or less exactly. Consequently, in my opinion, the very important question of Balzac's head is decided: it is David d'Angers' bust that will represent it."[8]

Once Rodin started working from life, however, the power of nature took over. By the time he finished his monuments, he would repudiate David's work as a model, telling a reporter: "David d'Angers was a great genius, to be sure, but he was an *idealist*; all his busts are alike, whether it is Balzac, Victor Hugo, Goethe, or Fréderick

Lemaître. . . . Therefore, I did not take inspiration from the bust of David d'Angers. I even wished to forget it."[9]

As with *The Burghers of Calais,* Rodin's first step after immersing himself in the sources was to fix the attitudes and gestures that had been established with clothed figures. Then he started working with nude models. Naturally, his patrons assumed the figures would be clothed again in the final stages. But with *Victor Hugo* (the monument intended for the Jardin du Luxembourg—the Panthéon "Apotheosis" was never finished), the usual progression from clothed sketch to nude studies to a finished monument with draperies was interrupted. In this case, Rodin never put the clothes back on.

Presumably, it was in the second half of 1893, after Rodin's trip to Guernsey, that he started working seriously with a model for the Hugo monument. The model is never named, but he was a middle-aged man with a powerful body. When Armand Silvestre came for his annual inspection in early 1894, he did not care for the muses but had no quarrel with the Hugo figure, remarking only that Rodin had "not yet placed the drapery." Yet the following year—by which time he knew that Rodin would never clothe the figure—Silvestre was truly enthusiastic, finding it "Olympian" and admiring the way it recalled "the most beautiful conceptions of antiquity."[10]

No modern sculptor had succeeded in placing a monumental nude statue of a well-known figure in a public space as the ancients had done. Previous attempts had all ended in failure. In the eighteenth century, Jean-Baptiste Pigalle had created a monumental Voltaire for the Société des Gens de Lettres (a learned society unrelated to the one that commissioned Rodin's *Balzac*). When the members beheld the realistic depiction of the philosopher's aging flesh, they rejected the monument. In 1810 Claude Dejoux chose to memorialize the hero of the Battle of Marengo, General Desaix, with a fourteen-foot-high nude figure in the place des Victoires. Before long, the authorities decided that it was in the public interest to cover the statue with a canvas and place it behind a fence. The most famous nude statue of all, Antonio Canova's *Napoléon as Mars,* which arrived in Paris in 1811, was similarly placed behind a curtain at the Louvre. In 1850, when Mathieu Meusnier created a blatant imitation of Canova's statue—by then long departed from France as war booty for Wellington's London house—for the place Vintimille, it was soon vandalized and had to be removed.[11] So it was a great achievement for Rodin to convince a government official that a nude rendition of a powerful older man's body would make a "sublime" monument to Hugo.

After Silvestre's inspection, Rodin made another change: the monument would have only two muses instead of three. One would stand directly behind the seated poet and the other would squat on a ledge above him. The standing muse, soft and round, sensuously moves in rhythmic counterpoise to the powerful, energetic body of the poet. The second muse lifts her long left arm in a strangely graceless fashion to open up a wide arc of space above Hugo's head, while pushing her grimacing face in the direction of his listening ear. The figures make visible the two poles of inspiration: the forces that lie buried within the artist and those that bear down upon him from outside.[12]

126) Rodin, *The Genius of Sculpture*. 1883. Brown ink and wash.
Los Angeles County Museum of Art. Lent by Mrs. Noah L.
Butkin.

127) Rodin, *The Sculptor and His Muse*. Early 1890s. Bronze. Fine Arts Museums of San Francisco. Gift of Alma de Bretteville Spreckles, 1941.34.2.

The female figure whispering into the creator's ear had haunted Rodin's imagination for years. It appears first in a drawing of 1883, in which a flying figure rushes to embrace the sculptor's "thinking parts"—his hand, shoulder, and head. The most extraordinary example of the theme is *The Sculptor and His Muse,* in which a seated sculptor is enveloped by the voluptuous pile of his muse's hair. When we look closer, the face of the sculptor turns out to be none other than that of *The Man with the Broken Nose.* In a paroxysm of contortion, the muse nuzzles the side of his jaw with her nose, while placing her right hand and left foot securely on his penis. *The Sculptor and His Muse*—so closely related to *Victor Hugo*—highlights another aspect of Rodin's concept of genius: that sexual impulse is at the very center of its energy. No one had believed that more thoroughly than Hugo, and it had not been lost on Rodin that women did not dare show up to dinners at the writer's home in gowns that were not décolleté. The sight of a breast or, in private, of a thigh—better still, of what Hugo called "la forêt"—was a constant source of inspiration for the poet.[13] Rodin made the idea explicit in his

128) Rodin, *Iris.* 1890–91. Originally intended for the *Monument to Victor Hugo*. Bronze. Washington, D.C., Hirshhorn Museum and Sculpture Garden, Smithsonian Institution. Gift of Joseph H. Hirshhorn, 1966. Photo by Lee Stalsworth.

maquette for the Panthéon *Hugo* when he splayed wide the legs of Iris, messenger of the Gods, to reveal her crotch, which he positioned directly over the poet's head. The orgiastic display of raw sexuality and mental energy added up to a metaphor of creation.[14]

Perhaps it was the radical nature of the Panthéon "Apotheosis" that kept it from ever being put before the public. But *Victor Hugo* for the Luxembourg was moving ahead nicely, and Rodin anticipated showing it in the Salon. The model arrived in Henri Lebossé's studio for enlarging late in 1895. Given the importance of the monument, Lebossé wanted to do the work himself, but bouts of rheumatism caused endless delays through the following year. On January 30, 1897, Lebossé wrote to Rodin: "I think I can bring it Tuesday or Wednesday, and I hope you'll be satisfied." Yet a few days later he apologized: "With all the good will in the world, I can't finish for tomorrow."

What Lebossé finally delivered was still incomplete; Rodin decided to put it in the Salon anyway. He called it a "study," lest anyone should think he considered it finished.

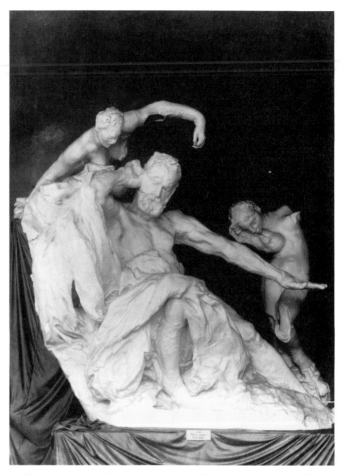

129) Rodin, model for the *Monument to Victor Hugo,* intended for the Jardin du Luxembourg, with the figures of the Tragic Muse and Meditation. 1895. Plaster.

Hugo's arms and the ledge for the crouching muse were held up by pieces of iron; the arms were attached to the poet's body by straps. The standing muse had no arms at all, and the crouching muse had a big hole in her arm exposing the interior structure. Rodin knew that the radical nature of the conception—Hugo as a nude figure—and the lack of finish would make it difficult for a Salon audience to accept. Nonetheless, *Victor Hugo* occupied the place of honor beneath the immense dome of the Palais des Beaux-Arts in the Champs-de-Mars. The exhibition of 1897 would be the last in Formigé's palace, one of the glories of the 1889 exposition: it was to be torn down to make room for the buildings of the Exposition Universelle of 1900.

Neither Félix Faure, the president of the Republic, nor Puvis de Chavannes, the president of the Société Nationale des Beaux-Arts, was present at the inauguration.

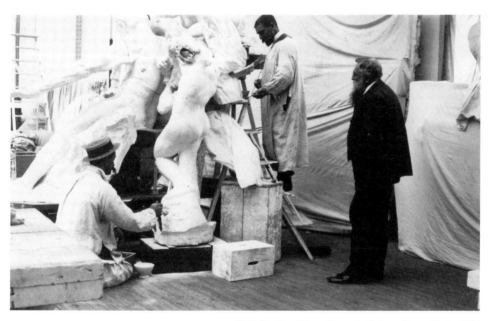

130) Rodin, *Victor Hugo,* in Lebossé's studio in 1896

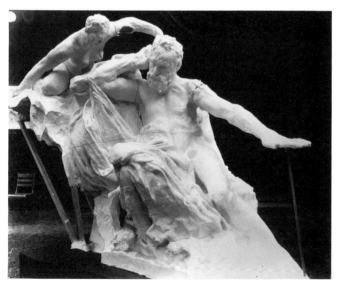

131) Rodin, *Victor Hugo,* in the Salon of 1897

Faure was in Russia to cement the Franco-Russian alliance and Puvis was too ill to attend. Thus it fell to Mme Faure to open the Salon. Four vice presidents of the society, including Rodin, escorted her through the exhibition. They stopped in front of *Victor Hugo*, which she very much admired.[15] This vote of confidence must have given Rodin a measure of hope as he lived through the anxieties of the evening. Twenty-four hours later, Rodin breathed again. The reviews were raves:

> The truly inspired work of sculpture whose privilege it will be to attract the crowds is *Victor Hugo* by Auguste Rodin, a marvelous group in plaster with an execution that affirms once again the incomparable control and integrity of the master. (*Petit Journal*, April 24, 1897)

> The man who has triumphed at the Salon of 1897 is Rodin. . . . The special manner in which he has conceived his immortal effigy of Victor Hugo with an aspect both titanesque and antique, a marvelous luminous modeling, the striking facture, so Michelangelesque—we have to search for words—this is something completely *à part*, it is outside of time, a splendid jewel of the human patrimony. "I have gravitated toward this all my life." This admission of the courageous artist . . . is the truth, for more than the famous *Doors*, more than *The Burghers of Calais*, more than *Saint John*, *Hugo* is the absolute measure of his art, it is his *Légende des siècles*. (*Gil Blas*, April 24, 1897)

The *Monde élégant* praised *Victor Hugo* as "le clou, le vrai clou" (the chief attraction) of the Salon—a truly "sublime work" (April 28, 1897). Of course, some critics had reservations. Georges Lafenestre, a conservative who never said a good word about Rodin's work, felt it was "premature" to express judgment about such a dismembered and incoherent maquette (*Revue des deux mondes*, July 1, 1897). In the *Jeune Belgique*, Ivan Gilkin questioned the propriety of depicting the "illustrious poet . . . nude on a rock. Surely not! Are we to see him as taking a bath?" (July 10). The Englishman M. H. Spielmann, a great admirer of French "dexterity" and elegant finish, worried that "the ordinary beholder" might think it a "memorial of a leprous group, in which not only quality of surface is ignored, but any sense of completeness is deliberately withheld" (*Magazine of Art*, October 1897). "L. C. E." of Nancy was equally unwilling to accept this "big, fat piece of plaster as a monument to Victor Hugo" (*Progrès de l'Est*, April 29, 1897). But these dissenters were conservatives, provincials, and foreigners. As far as the mainstream, avant-garde Parisian press was concerned, Rodin was the man of the hour. He *understood* Hugo and had given the French people an image that would stand for all time. His old friend Geffroy put it best: "*C'est le poète;* yet it is Hugo, the Victor Hugo whom we saw pass among us. Through the power of art, the man has been elevated to a type. At the same time, there is an extraordinary and absolute resemblance. . . . It is all there—Hugo, entrusted to the future, his life, his work are there among the rocks, the waves, haunted by those familiar muses."[16]

Rodin was ecstatic. For the first time in years, he could relax and enjoy success. After seeing *Victor Hugo,* Monet wrote that he was happy to witness Rodin's "triumph" and that he would not be satisfied until he could stand before the monument in the sculptor's presence. (They arranged a rendezvous for May 3.) When President Faure returned to France, Rodin escorted him to see the work. He had hoped that Turquet would be able to see it in his company as well, but his old patron was too sick. Rodin invited Ernestine Weiss, faithful correspondent from the Fontainebleau library, to be his guest for a viewing on June 2. In an expansive mood, he took her and her friends to lunch. "What a hole you must have put in your pocket!" she exclaimed in her thank-you note.

The exhibition remained open for almost three months, and the reviews continued to be good. Rodin kept bringing friends to see it. With *Balzac* now in Lebossé's hands, he was breathing more easily. "Le temps chez moi est magnifique," he wrote to Geffroy. It was not a weather report, but a comment about his new-found sense of well-being. Through the summer and fall, he enjoyed his friends and was open to new experiences. In July the millionaire banker Albert Kahn reserved spaces for the two of them on the Orient Express to go to Bayreuth for the Wagner festival. In September Rodin visited other wealthy patrons, the Fenailles, in Aveyron, where he had time to read and write. In a note to Hélène Wahl, Rodin mentioned reading Tolstoy's new and controversial tale "The Kreutzer Sonata," in which Tolstoy expressed horror at contemporary society's obsession with sex and the right of men to enjoy sexual pleasure without responsibility. Tolstoy rejected the idea that woman was "not man's equal in sexual intercourse." Nevertheless, he feared woman as a trap. One of his female characters says: "Ah, you want us to be merely objects of sensuality—all right, as objects of sensuality we will enslave you." Rodin believed Tolstoy's story bore reflection on his own life: "I am convinced that it's the truth and that Tolstoy is . . . a prophet who can best serve everyone when his ideas become popular—that is to say, in the course of time."[17]

December saw Rodin join the ever-growing number of enthusiasts for speed: he acquired a bicycle. In fact, he bought two "luxury machines" from M. C. Lelong of "La Metropole, Acatene-Velleda," in exchange for a bronze sculpture. Since Rodin was now getting twelve hundred francs for a bronze figure and a top-of-the-line bicycle sold for about five hundred francs, each man must have considered it a fair trade. In January Lelong visited Rodin in Meudon. The sculptor confessed that he had yet to master good cycling form, and Lelong suggested that he learn on an inexpensive rented model, since more than one of his machines had been destroyed in the hands of beginners. Riding a bicycle, as a character in Zola's *Paris* noted, required "a continuous apprenticeship of the will." In all likelihood, this was both Rodin's and Zola's experience.[18] By 1898 Renoir had already sworn off the contraptions, having fallen and broken his arm.

Not until November 1897, when Camille Claudel saw the figure in Lebossé's studio, was *Balzac* truly finished. But Lebossé was still not yet ready to release it. On March 17, 1898, Rodin finally informed Henry Houssaye, president of the Société des Gens de Lettres, that the sculpture "has been cleaned and is ready to go to the foundry. If you and

the committee want to see it in the Salon, it will have to be shown in plaster, which will delay things."[19] Word got out immediately: "This morning *Le Figaro* had news that is going to fill every art lover with joy. . . . The statue of Balzac is finished! And we are not speaking of a sphinx with a mustache, which in the eyes of M. Marquet de Vasselot is the correct personification of the genial author of *La Comédie humaine*. What we are talking about is *Balzac,* unique and without equal, for which we have waited so long . . . the definitive *Balzac* which will serve to represent the glory of the great novelist for posterity. . . . Friends of the artist have told us that *Balzac* will be *the* chef-d'oeuvre of modern sculpture."[20]

Rodin decided to pair *Balzac* with his marble enlargement of *The Kiss,* commissioned by the state in 1888. After ten years of work, it was now complete. At the end of April, the transporters came to load the the marble and the plaster onto carts that would carry

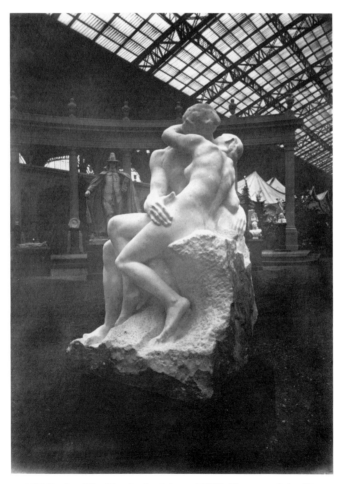

132) Rodin, *The Kiss,* in the Salon of 1898. Photograph by Druet.

them to the nearby Galeries des Machines in the Champs-de-Mars. Rodin watched *The Kiss* as it passed "in front of *Balzac,* which I had put in the courtyard so that I could see it against the sky. I was not dissatisfied with the vigor of my marble. As it went by, however, I had the sensation that it was a little flabby, that beside the other it was like the famous case of Michelangelo's torso being placed before the great works of antiquity. I knew in my heart that I was right and that I was alone against everyone."[21]

The Galerie des Machines, like the Tour Eiffel, had been built for the Exposition Universelle of 1889. It was the first time that the Société des Artistes Français and the newer Société Nationale des Beaux-Arts, to which Rodin belonged, had showed together. The Salon of 1898 contained more than seven thousand works, prompting Geffroy to wonder how any critic could be expected to walk by, let alone see, such an enormous production. He concluded that "one must confine oneself to the dominant works." Rodin's *Balzac* was the one work he believed would endure. He pointed out that Rodin had "penetrated and lived in the world of *La Comédie humaine,*" assimilating "its force and drawing from Balzac's own thoughts" in order to place the Hercules of modern letters, with all his longings and passion, in plain view.[22] In general, the press from the pre-opening session for critics was good. The reviewer for *Le Figaro* (April 30, 1898) exclaimed, "I want to cry out my admiration for *Balzac* of Rodin." That the statue would shock the public made him "laugh with joy, for it is in the nature of beautiful things and of new things to be like a slap in the face, upsetting the easy indolence of received ideas."

Shock it did. The immense white hulk stood in the central axis of the vast gallery, not far from *The Kiss.* "No one could talk of anything but Rodin's *Balzac.*" Jean Villemer of *Le Figaro* said that the luncheon was "*très gai,* even if unknown *bons bourgeois* grabbed all the places and many of the artists were obliged to eat elsewhere." By two o'clock the crowd was arriving. Four o'clock, high tide: "more than two thousand people in front of *Balzac* of Rodin." Villemer reproduced some of the remarks he heard: "Dreadful. . . . It's a madman. . . . It's Balzac at Charenton [the psychiatric hospital] and he's wearing his hospital gown. . . . No, it's Balzac being woken up by a creditor. . . . But it's a snowman! Look, it's melting! It already leans to one side: it's going to fall. . . . Balzac? I'd say a side of beef." Oscar Wilde, recently released from Reading Gaol, was in a minority when he recognized *Balzac* as superb: "The head is gorgeous, the dressing-gown is an entirely unshaped cone of white plaster. People howl with rage over it."[23]

Judith Cladel, in an article for the feminist review *La Fronde,* reflected on the passions that always surrounded the opening of a Salon. The crowd could be admiring, spiteful, jealous, or polite; it knew how to give the most loving looks or shoot the most malignant arrows. She juxtaposed the public's mercurial feelings to the steadfastness of Rodin. She had watched him enter the Salon in his bourgeois uniform, the redingote. There he was, "this small person, thick-set, whose countenance is half-hidden in his long beard. Combined with the shadow cast by his hat, it renders him mysterious and

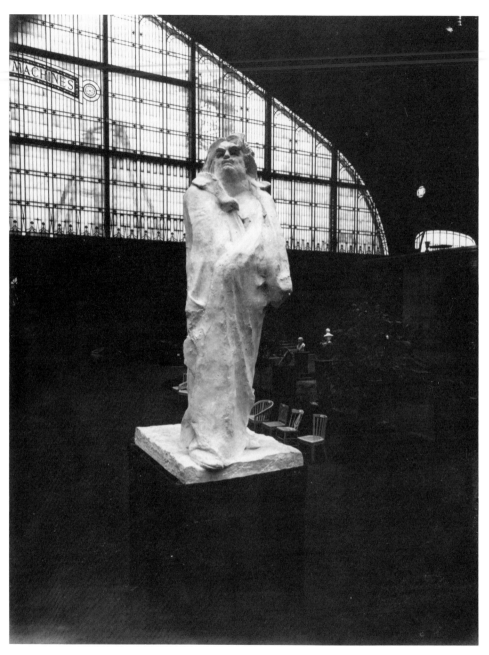

133) Rodin, *Balzac,* in the Salon of 1898

resistant to superficial questions." She described how he moved quietly through the crowd, shaking hands with friends, complimenting other artists on their work, listening, his face revealing affection and, sometimes, unexpected timidity. The climax of the article was Cladel's suggestion that both Rodin and *Balzac* were head and shoulders above everything else around them.[24]

The tide was against *Balzac,* however, and against Rodin. The next day Jean Rameau answered Cladel's article. With a delicious sneer, he told the readers of *Le Gaulois* that the "prophetess of Rodin has said, 'Don't touch Rodin!' Let's touch him all the same, wouldn't you say?" Rameau, a member of the Société des Gens de Lettres, felt the public was counting on the society to "prevent *Balzac* from stupefying passers-by in the place du Palais-Royal." He had another suggestion: "We should take this wonderful statue and place it upon a high pedestal so that all can see it from far and wide. It should be cast in indestructible bronze that will last into future centuries. Then they can know to what perilous degree of mental aberration we sank at the end of our century."[25]

Within days of the opening, the fight was in full swing. People vied with one another in vilifying the statue. *Ordure* (garbage) and *monstreuse* were favorite comments. Typifying the level of discourse was the taunt "a querulous concierge who has not yet shaved and is still in his bathrobe." Bernard Berenson wrote to Isabella Stewart Gardner about the "stupid monstrosity. Insofar as he has form at all, he looks like a polar bear standing on his hind legs."[26]

Everyone knew that Félix Faure had not stopped in front of *Balzac* when he visited the Salon. It was unclear, however, whether the president wanted to avoid being identified with the statue's supporters or whether he simply could not get to the statue because Rodin's opponents clustered around it to prevent him from seeing it. And there was plenty of speculation about which group (the Conseil Municipal, the Ministère de l'Instruction Publique, the Société des Gens de Lettres) would stop the statue from being erected as a public monument. Jules Claretie pronounced it "*the* polemic of the moment. Before long it will be necessary to be for or against Rodin, as it is necessary to be for or against Esterhazy."[27] (He was referring to the accusation against Major Esterhazy rather than Dreyfus, who was serving a life sentence on Devil's Island.)

On May 6, a writer for the *XIXe Siècle,* noting that the press was giddy with the pleasure of launching boorish attacks on Rodin and his statue, paid a sympathetic visit to see how the sculptor was weathering the storm. He found Rodin wildly fluctuating between humility and defiance: "I'm not infallible. Listen, I know that this monument has some defects. As far as I am concerned, I shall discover them later, since the execution is too recent to distinguish what's wrong." The reporter mentioned that a group of artists had blocked President Faure from looking at the statue. Rodin, his voice rising, said he now knew what Hugo and Carpeaux had suffered in order to found new schools. Toward the end of the interview, he became visibly angry: "Don't tell me that the Société des Gens de Lettres is going to ask the Conseil Municipal to stop the placement of my statue at Palais-Royal. I won't lower myself to discuss such a scheme.

They have never missed an opportunity to accuse me of taking too much time. The truth is that I make art for art's sake. . . . I reach my age proud of being as poor as I was when I began. I understand that in this way I am hardly a model for very many people."[28]

By now it was general knowledge that the Société des Gens de Lettres did not intend to accept *Balzac,* although the official vote of the society was not taken until May 9. The novelist Henri Lavedan crafted the final statement: "The Committee of the Société des Gens de Lettres regrets that it has the duty to protest against the sketch exhibited at the Salon by M. Rodin, in which it refuses to recognize the statue of Balzac." All fifteen members of the committee signed the letter sent to Rodin. By end of the day on May 11, reporters were swarming over the rue de l'Université to get Rodin's reaction. "What does this phrase mean: 'refuse to recognize'? What! This is five years of my life; I worked with all my force, with all my means, and this is Balzac as I wanted him, and the society that has commissioned me cannot wish for more!"[29]

It was only a matter of hours before Rodin's supporters responded. His lawyer, Maître P. A. Chéramy, wrote immediately that since the society was legally required to take the statue, he imagined that they were going to have a little "brush" in court. He awaited Rodin's instructions. Eugène Carrière wrote Mathias Morhardt: "Can we let pass such an outrage against an artist who has done such great honor to our country? Don't we have to protest against such ignorant people who have no conscience about the enormity of their act?"[30]

The next day Rodin published a response, moderating the anger expressed in his interview. He said that *Balzac,* like *Victor Hugo,* was his attempt to make a kind of sculpture that was not "photographic," and that, rejected or not, he considered it "the line of demarcation between commercial sculpture and the art of sculpture" in the great European tradition. Now he wanted nothing more than to have his peace and tranquility back. He felt too old to prolong the fight in defending his art.[31]

On Friday, May 13, Rodin's friends collected at the Dépôt des Marbres, which had become "the busiest spot in Paris," according to *Le Figaro.* Mirbeau and Geffroy were there, along with Carrière, Morhardt, Arsène Alexandre, and Charles Frémine. They composed a statement declaring that they regarded the views of the Société des Gens de Lettres as "without importance." They offered their sympathy to the artist, expressing their desire that the controversy would have a happy conclusion and their hope that a "noble and refined country like France" would not cease to be the object of respect in spite of this dreadful affair. The artists of Paris lined up to sign the statement: Toulouse-Lautrec, Signac, Monet, Maillol, and Bourdelle, together with the musicians d'Indy and Debussy, and the writers Rodenbach, Kahn, Catulle-Mendès, Valéry, France, Séverine, and dozens of others. The group opened a subscription, headed by Morhardt, to collect money to buy the monument so that it could be erected somewhere in Paris.

Donations soon began to pour in. Rodin's old student and friend Gustave Natorp immediately sent a thousand francs from London. Though Monet had not yet seen

Balzac (he did not get to the Salon until June 29), he contributed five hundred francs; Renoir and Besnard each gave a hundred francs; Legros, Meunier, Forain, and Desbois each gave fifty francs; Cézanne, forty francs; Raffaëlli, thirty; Sisley, five. The writers also subscribed, among them Mallarmé, France, Emile Verhaeren, André Gide, Camille Lemonnier, Léon Daudet, Paul Alexis, and Roger Marx. The cause became front-page news around the world, bringing contributions from foreigners: Alexander Harrison, an American painter living on Long Island, sent five hundred francs, while Prince George Karageorgevitch, who had met Rodin at the inauguration of *Bastien-Lepage* in 1889, sent twenty francs from Russia.

Dalou declined to give, telling Morhardt that he did not wish to be "drawn into this latest enthusiasm of blundering friends."[32] Another who would not contribute was the nationalist writer Charles Maurras (with Léon Daudet, cofounder of the *Action française*). He wrote Morhardt that he believed the actions of the Société des Gens de Lettres were absurd, but that he was not willing to be counted among Rodin's friends. Raymond Poincaré, ambitious Republican politician, twice minister of public instruction in the nineties, also declined, though he was friendly with Rodin, who had given him some drawings in 1897. Poincaré told Morhardt that though he held Rodin in high esteem, he could not take part in the subscription because "it could lead to misunderstandings."

We would expect the rush of support to have been a consolation for Rodin. It was not. He was more concerned with misunderstandings. As Poincaré had recognized, many of Rodin's supporters were involved in the "Affair," the intense debate, fueled by the press, about whether Captain Dreyfus was guilty of treason or whether he was rotting on Devil's Island because he had been framed in a heinous conspiracy within the army. In a sense, there had always been a link between *Balzac* and the fate of Dreyfus, for the simple reason that they came into view as problems at the same time—November 1894—and they were discussed in the same journals by the same writers, both under the rubric "L'Affaire." It did not matter that Zola and Rodin were no longer on good terms. Everyone knew Zola was responsible for Rodin getting the Balzac commission, and to pronounce the name Zola was to turn one's thoughts to the famous open letter he had written on January 13, 1898, to the president of the Republic. It began "J'accuse . . ." and indicted the army and the government for bringing about the condemnation of an innocent man.

Almost all Rodin's supporters were pro-Dreyfus and pro-Zola. Ernest Vaugnan, editor of *L'Aurore,* and Socialist leader Alexandre Millerand, a major figure in Dreyfus' defense, were strongly behind Rodin. So was the Socialist journalist Francis de Pressensé, who had been one of the first to join Dreyfus's cause; he gave five hundred francs for Rodin's *Balzac.* The association with Dreyfus worried Rodin. When Georges Clemenceau, political editor of *L'Aurore,* learned that Rodin took exception to so many Dreyfusards being on the list of his supporters, he asked that his own name be withdrawn.

Poincaré did not want his support for Rodin to give rise to implications about his position on Dreyfus. He had been a minister at the time of Dreyfus' conviction and had always kept silent about the Affair. In 1898 that silence weighed heavily on him; by the end of the year he would make a dramatic "confession" before the Chambre des Députés, but in May and June Poincaré was still guarding his neutrality, which is why he remained at a distance from the "Balzac Affair."

Before the national election on May 22, the topic of the Dreyfus Affair was so dangerous that no one dared mention it. But after the election people quickly turned their attention to *both* affairs. They speculated: Was there any relationship between the two? At this point Rodin began to pull back. On June 1, Lucien Descaves wrote an open letter to Rodin that appeared on the front page of *L'Aurore*. He explained his decision not to join Rodin's supporters: "It's in *your interests,*" he said. He ridiculed Rodin's fear of the "legendary Syndicate," a right-wing code word for an imagined Jewish plot to overthrow the government, for which Zola was the alleged tool. Descaves warned Rodin to think carefully about those who had been at his side and those who had not. If Rodin repudiated his supporters, Descaves would believe that it was "easier to have genius than to have character, and easier to be a great artist than to be a great man."

Worse than the rejection of his monument by the Société des Gens de Lettres, Rodin now found himself pushed to the center of the major political conflict of the Third Republic. He wanted no part of the hatred and strife of this strange period. All his life he had fled from conflict and overwrought emotions: he had left home when Maria died, quit France in the midst of the 1871 war, and fled to the country rather than answer Dewavrin's letters. It would have been unthinkable for Rodin to declare himself for or against Dreyfus, and he certainly did not want his monument to be a lightning rod in this explosive political situation.[33]

Rodin was not simply the captive of old fears, however. He believed that art should, as far as possible, be kept out of the reach of politics. The two were not entirely separable in France, but he wanted to be the creator of *Balzac* without having to take a position on the army, the Church, the monarchy, or the right or wrong of Zola's defense of Dreyfus. Rodin discussed the matter with Puvis de Chavannes, who remained the greatest living artist in his eyes. Puvis agreed totally with Rodin's belief in the "neutrality of art." He deplored "the passionate polemic taking place around your glorious name, for if the independence of the creative person is to remain whole and sacred, he must be seen as such by the public to whom he submits himself when he shows his work" (May 18, 1898). This was the kind of thinking that made sense to Rodin.

The mounting controversy not only compromised Rodin's ability to remain neutral, but threatened to ruin his good name. In all probability, it was immediately after Descaves' letter was published that Rodin decided to halt the *Balzac* subscription drive. Morhardt begged him not to do so. Rather than discuss the situation with the press, he urged Rodin to talk it over with trusted friends like Fenaille and Peytel: "If you give up

now, your enemies will win, and they will overcome you with a loud shout. On the contrary, if you give us *Balzac,* you will no longer have to struggle and worry." Morhardt could not understand Rodin at this point: "What is it that is making you suffer?" Refusing the subscription, he felt, was the most dangerous thing Rodin could do. He knew of Rodin's fears about the "subject of the Dreyfus Affair," but he didn't know what to do about it: "Would you like me to give back the donation of Francis de Pressensé? It would be cruel, but I'll do it."

Morhardt pleaded in vain; for Rodin the struggle was over. On June 9 he sent a letter thanking all his friends, informing them that he wished to remain *Balzac*'s sole possessor and that he intended to ask no indemnity from the Société des Gens de Lettres. Thirty papers published his letter on June 10. Judith Cladel went to see him that afternoon, finding a "sober and sad face, suffering as much from seeing such endless human stupidity as from the personal injuries. He announced that he had made a resolution, one he intended to keep: 'Like a woman, an artist has to preserve his honor.'"[34]

Rodin spent the rest of the month writing individual letters to all those who had subscribed to *Balzac*. Perhaps the most beautiful answer came from Anatole France:

> Your letter has touched me profoundly. . . . Your Balzac is not just Balzac: it is much more, which perhaps accounts for the astonishment it has caused. I have contemplated this powerful and magnificent figure for a long, long time, and I find here an art at once violent and tender, where I discover not so much the man as the genius. It is he who penetrated the roofs and the walls and who overheard every political and domestic secret. . . . Such a Balzac, this superhuman Balzac, has come forth from your prodigious hand, and one day he will be borne in triumph to one of the squares of Paris. And once established on its base, modern and powerful like the statue itself, it will look out at this city.

Though such responses may have been balm to Rodin's wounded spirits, the continuing abuse of him and of his work must have reinforced his decision. On July 1 the *Revue du monde catholique* warned its readers that they should not think of the "Rodin Affair" as a "simple news item. . . . No, it is quite a different matter, it is an admonition and a lesson. Art and literature have always explained the moral state of a people. Look at Zola, look at Rodin. Bad literature, bad sculpture. They and their companions want to destroy the *spirit* of *France*. Such an improbable thing can only be understood when one knows that Rodin and Zola—no more one than the other—are not of French origin! Both in effect have foreign blood in their veins, so it is natural that they do not think as we do." Xenophobia in France had reached such an excessive level that anyone with an Italian name (Zola's father was Venetian) or a name that sounded German was suspect. The journalist who wrote this article was ignorant of the etymology of "Rodin," which derives from *Hrodo* (meaning "gloire," or glory)—a medieval Christian name of Germanic origin, as were most French family names.[35]

On August 31, 1898, Lt. Col. Hubert Joseph Henry, who had forged the documents used to convict Dreyfus, committed suicide, adding ammunition to the fight to prove Dreyfus innocent. The following day, G. d'Azambuja wrote mockingly in *L'Univers et le monde* that "the innocence of Dreyfus is just another statue of Balzac."

In the meantime, the Société des Gens de Lettres had given the Balzac commission to Falguière. Although the academic sculptor was approaching seventy, he promised the monument would be ready for the Balzac centenary in 1899. Within months his maquette was ready for viewing. Critics stopped by to see the seated figure. Geffroy pointed out wryly that Falguière's *Balzac* seemed to be "worn out from remembering the *other* who had been so wonderful on his feet."[36]

Rodin's friends urged him to challenge the Falguière commission, but he chose not to. It is a tribute to those friends that they did not desert him as he abandoned the cause they were fighting in his name. Octave Mirbeau had been loyal as no one else throughout the ordeal. The Mirbeaus now lived in Carrières-sous-Poissy, west of Paris, and invited Rodin to spend time with them there toward the end of June. "Don't come on Monday because Zola will be here all day, and I know how disagreeable that would be for you," Mirbeau cautioned. Rodin accordingly waited until June 29 to go to Carrières. We can imagine how he and Mirbeau examined the events of the past month, discussing why *Victor Hugo* had been so "right" and *Balzac* so "wrong." Both men knew the latter was the better work, but probably they were still too close to take stock of the enormous gap between the organizations behind the two commissions: on the one hand, a group of bureaucrats with specifications, showing up for progress checks, complaining about details, asking for changes, and wearing Rodin down; on the other, a glamorous committee of men and women who promised Rodin total freedom and allowed him to engage in a real search for the essence of his portrayal. But the *Balzac* committee wanted a work of genius, *and* they wanted it on time. When denied, they had much to say about the matter, and they said it in the press. The ensuing quarrel would alternately anger Rodin and spur him to greater efforts, then depress him and totally close down his capacity to work.

No other work in Rodin's life emerged in such a charged emotional climate as *Balzac*. All elements conspired to make this true: patronage, press, subject, not to mention Camille Claudel and Rodin's overwhelming love for her at the time of the monument's inception. Claudel was always part of *Balzac*. Her praise of the finished monument, when she was briefly able to transcend her anger, is a powerful testimony to that fact.

A further dissimilarity between *Balzac* and *Hugo* is explained by Rodin's relationship to the two writers. He had idolized Hugo since his earliest days, had grown up with Hugo's work, and even had the privilege of sitting at the great man's table. He knew the time-worn face by heart. One senses that, as his reputation grew, Rodin frequently tried to emulate Hugo. Balzac, however, was a discovery of Rodin's mature years. Once he had the commission, Rodin stalked Balzac intensely. He read all the novels and plays; he read the biographies, collected the photographs. In that sense, Balzac was the

134) *Les Balzacs* (Rodin and Falguière). *Le Petit Illustré amusant,*
May 13, 1898.

easier of the two commissions, for Rodin's search took him totally outside of himself.
This helps to explain why *Balzac* was the more integrated, more successful work. It is
really Rodin's masterpiece.

Rodin's attitude toward the two authors mirrored the experience of most French
people. Hugo received the biggest funeral ever held in France; when Balzac died, the
only newspaper to carry more than a spare announcement was Hugo's *Evénement.* It
took a series of appreciative writers, led by Taine, Barbey d'Aurevilly, Baudelaire, and
Gautier, to bring Balzac to life as the grand figure of French fiction. But no one did
more for Balzac's appreciation than Zola. His insistence that Balzac was the father of the
naturalist novel provoked a countermovement in the 1880s, which placed Balzac in the
"classical tradition" of French letters. When Rodin was at work on his statue in the early
nineties, the two factions—one seeing the author as a socialist and a realist, the other as a
man of the "old order," a royalist, anti-Republican, and clerical—were engaged in a
heated public dispute.

This unresolved conflict was immediately apparent at the first event of the 1899 centenary of Balzac's birth, a production of his *Marcadet*. The play concerns two groups of people, hunters and ploughmen. Contemporaries interpreted the ploughmen as representing decent, honest Frenchmen, the hunters were foreigners and unscrupulous Jews. The right-wing papers loved it; by the time the play came to Tours, Balzac's birthplace, the anti-Semitic talk surrounding the production was so heated that the Socialist councilors of the city refused to allow it to be performed, voting that Tours not participate in the centenary celebration at all. The councilors themselves went out to take the bunting off the buildings of Tours.[37]

This was the climate into which Rodin introduced his image. When the crowds were confronted with a statue of such power—with its unusual simplicity, its radical asymmetry, its intense yet suppressed movement, its violently expressive face, and its strangely phallic form—they exploded. No wonder it was so easy for the critics (many of them members of the Société des Gens de Lettres) to whip the public into a frenzy of disapproval. Rodin was too wrapped up in the work, too obsessively fixed on his own goals, to see the trouble brewing. The success of *Victor Hugo* made him confident, and his aversion to political conflict made him naïve. So the intense controversy about his figure caught him off guard. His surprise was all the more painful because he believed so profoundly in his *Balzac:* "Nothing I have ever done satisfied me so much, and nothing else cost me so much, nor sums up so profoundly what I believe to be the secret law of my art."[38]

Historians have frequently suggested that the false accusations against Dreyfus exposed a preexisting rift in French society, a society that was ready to come apart. In the restless nineties—rife with nationalism, anti-Semitism, fear of foreigners, and the *esprit de coup d'état*—if Dreyfus had not existed, he, or someone like him, would have had to be invented. It is also universally believed that the Affair could not have arisen had not the press so eagerly fueled the bitterness.

The same theory can be applied to the "Balzac Affair." In the 1880s the artistic avant-garde accepted that naturalism offered the best escape from the rigid canons of the Ecole des Beaux-Arts. In the 1890s that was no longer true. Many found "mystery" to hold far more enchantment than naturalism, and they no longer cared whether they told the "truth" or addressed a large public. What is more, avant-garde artists had ceased to care whether there was a dominant style. These changes, along with a press hungry for sensation, made the climate right for a new fight of the type France knew so well. *Balzac* was only the latest in a series of controversies that included Hugo's *Hernani,* Baudelaire's *Fleurs du mal,* Wagner's *Tannhäuser,* Manet's *Olympia,* Carpeaux's *Dance,* and, only a few years before, the Impressionists' landscapes. *Balzac* was ripe for controversy because Rodin had stepped beyond his own naturalist credo to realize a singularly expressive form, a statue that, once mounted on its pedestal, was grander than life and poised to provide the last great aesthetic turmoil in the nineteenth century.

Theoretically, Rodin might have made other choices in 1898. Once it was clear that

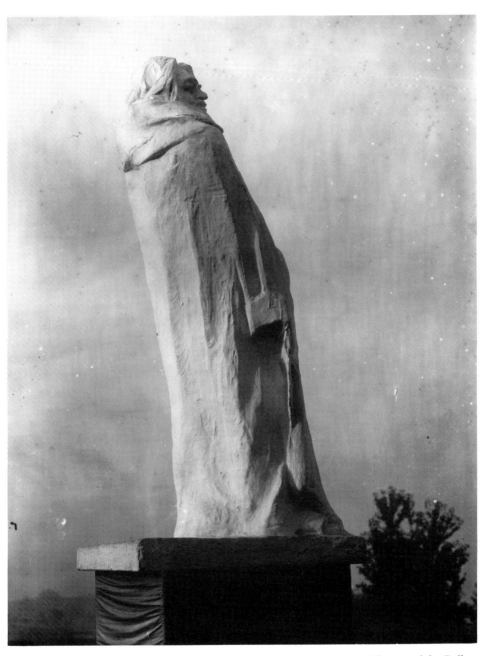

135) Rodin, *Balzac,* in Rodin's garden. Photograph by Bulloz.

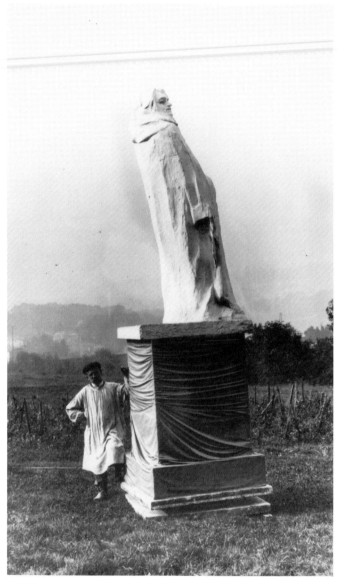

136) Rodin, *Balzac,* in Rodin's garden. Photograph by Bulloz.

Balzac had become an "affair," he could have fought for his work. But, in actuality, Rodin could not fight; there was hardly a controversial bone in his body. Camille Mauclair recognized this immediately: "Rodin prefers to withdraw his work without claiming its price or even discussing the matter. . . . Struggle is repugnant to his temperament." Mauclair was a great admirer of Rodin's "inflexible" will when he was engaged in the process of creating, but he had to admit that when it came to controversy, Rodin became both "timid and proud in his attitude."[39]

Rodin might have reflected on the struggles his predecessors had faced. He might have placed himself in their company and declared *Balzac* a triumph. When Monet wrote that he believed *Balzac* surpassed anything he could have imagined, Rodin told him that he knew he was receiving "broadsides parallel to those directed at you in the past."[40] But in Rodin's mind, to enter the company of Manet, Carpeaux, and Monet in this fashion would have been neither noble nor victorious. In a letter to Bigand, he called the affair "a defeat." And when Meunier wrote to say how anxious the artists of Belgium were to see *Balzac*, asking him to put it in the *Libre esthétique* exhibition the following February, Rodin replied: "*Balzac* has been a defeat for me and I do not dare run after another such defeat in Belgium."

The summer of 1898 was a watershed for Rodin, but not of the kind he had anticipated. The effort he put into the work, the dynamics of his exchanges with patrons, press, and public had been too great, and the resulting wounds of rejection too deep. Never again would he take on a new monumental project and successfully bring it to completion. *Balzac* was Rodin's best and last monument.

Chapter 26
Becoming an Entrepreneur

Carting *Balzac* back to his studio was an enormous disappointment for Rodin. Yet his letters of 1898 and 1899 say nothing about depression, as we might expect in the aftermath of the biggest rejection of his life. Somehow he maintained a keen sense of his special position as an artist. His integrity intact, Rodin returned to *The Gates of Hell*.

By late 1898 the government was building the Gare d'Orléans on the site of the old Cour des Comptes, where Rodin had imagined his *Gates* would be erected. The following year it was decided that the Musée des Arts Décoratifs would be installed in the Marsan Pavilion at the Louvre. Rodin's unfinished doors, which had already cost more than twenty-five thousand francs, had become, from the government's point of view, superfluous.

Nevertheless, the *Gates* were the bedrock of Rodin's creative life. His friend Joanny Peytel understood their stabilizing effect quite well; at the height of the storm over *Balzac,* he had come to see Rodin in his studio hoping to find him "in a peaceful frame of mind, working on the Gates of Hell, forgetting all criticism and praise." An outsider in the early days of the Third Republic, Rodin was now a solitary worker once again. Standing before his giant relief, covered with dust, with no home save his studio, he considered the future.

Despite the rejection of *Balzac,* Rodin still believed that a monument could be both modern and meaningful, that great men could be honored without using theatrical gestures, time-worn attributes, or men's clothing reproduced in bronze. Nevertheless, he stood by and watched his more successful contemporaries continue to produce in the traditional mode as the century of "statuemania" drew to a close. In the Salon of 1899, the public applauded the two most recent examples of these hackneyed types: Bartholdi's project for a monument to Lafayette and American independence, and Falguière's *Balzac.*

For the public, the greatest monument maker at the end of the 1800s was Dalou. The last year of the century saw the inauguration of his monuments to Charles Floquet (prime minister in 1888) and Jean-Charles Alphand (director of works for the city of Paris). But his sweetest moment came on November 19, 1899, when public employees, delegates from the provinces, and thousands of Parisian workers marched to the place de la Nation to see his *Triumph of the Republic* unveiled. Dalou's Republic wore her traditional Phrygian bonnet and long tunic, yet she was ever young and natural as she stepped across the globe mounted on a chariot led by Liberty and followed by Peace, Abundance, and Honest Labor. Rodin put aside their hard feelings and honored his oldest friend by attending the ceremony. We wonder if he felt out of place watching

137) Jules Dalou, *The Triumph of the Republic*. 1879–99. Bronze.
Paris, place de la Nation.

unionists marching under the red flag and singing the revolutionary "ça ira, ça ira, les bourgeois, on les pendra" (Everything is going to be okay; the bourgeois, let's string 'em up). The two men had no personal exchange, but Dalou knew Rodin had been there and later wrote that he was sorry he had "been unable to shake [Rodin's] hand on Sunday."

Dalou was the true sculptor of the Republic. He understood its issues, and he employed a vocabulary of sculpture that did not threaten convention as Rodin's did. For all his fame, Rodin was still odd man out. His only commissions at the close of the decade were personal and came to him in grief. In the last months of 1898, Rodin lost two close friends, Puvis de Chavannes and Georges Rodenbach. He was a pallbearer in both funerals and in 1899 agreed to design monuments to his departed friends.[1]

Rodin and Dalou were to compete once more, while Rodin was still struggling with his defeat (which makes his presence at the unveiling of *The Triumph of the Republic* all the more generous). Early in 1898, Armand Dayot was searching for a symbol for the Exposition Universelle of 1900 which would be as powerful as the Tour Eiffel had been in 1889. He discussed his idea for a "Monument to Labor," honoring all the modern

professions, crafts, and arts, with Rodin's former assistant, Jules Desbois. Convinced that the project was far too grand for any single sculptor, Desbois suggested Dayot approach all the important contemporary sculptors: "Rodin, Dalou, Falguière, Injalbert, Baffier, Meunier, Charpentier, Rivière, and also Mlle Claudel, who would symbolize so admirably the work of women."

Shortly after their conversation, a reporter for *L'Aurore,* Philippe Dubois, became intrigued with Dayot's idea and decided to interview the sculptors named by Desbois. He planned to meet with Dalou and Rodin on the same day, and stopped at Dalou's studio first. The sculptor offered him a chair and immediately launched into the subject: "So, you want to know if I shall collaborate in erecting the monument that has been dreamed up by M. Dayot? My answer is a categoric no." Dalou stressed that his refusal was in no way motivated by hostility toward Dayot; he himself had been thinking about such a monument for nine years, "not just since yesterday." Rather, he did not believe the collaborators would be able to work in harmony for long: "How can you bring together talents so diverse as those of Baffier and Falguière? This is going to be a Tower of Babel." (Dalou never mentioned Rodin's name.)

The interview was so negative that Dubois was relieved to depart for the rue de l'Université, where "morning and evening one is sure to find that tenacious worker whose very life portrays the idea of perpetual labor. . . . In his usual good-natured way, M. Rodin placed himself at my disposition, and I had the pleasure of ascertaining immediately that he is completely in favor of the Apotheosis of Work [Dayot's project]. 'It is grandiose! If it can be realized, as I hope it can, and I count on it, the monument will be the dominant monument of the century, the Tour Eiffel included, for, in spite of its height, the tower has no meaning.'"

Dubois told Rodin that Dalou did not think the collaboration would work, but Rodin reminded him of the Arc de Triomphe at the place de l'Etoile and how well such a collaboration had worked for Rude's generation. Had Rodin given any thought to the form the monument might take? Well, yes, actually he had, and he proceeded to describe his ideas: "From a distance [it] would have an imposing mass, elegant and slender, completely architectonic, like the Leaning Tower of Pisa, with the open arcades you see in cloisters. This mass would hold a column like the Column of Trajan, along which would wind a series of bas reliefs in a gracious disposition. Each would be a meter wide and separated from its neighbor by a figure in high relief or a caryatid symbolizing a profession or trade." Rodin thought a wide space should separate the column from the tower, something like the clock tower in Venice, the stairs of "which Napoléon is said to have ridden up on his horse." At the base of the monument he envisioned four open rooms, "like the ones you find in the British Museum where they show the famous Assyrian reliefs." There he could see reliefs dealing with work that takes place under the earth's surface, such as mining. The crown of the column might be an allegory suggesting triumph. Clearly, the project could employ the talents of at least twenty sculptors. Rodin became emotional as he talked, and all the while his hands

were working on a piece of clay. By the time the interview was over, a rough maquette had come into being before Dubois' eyes: "superb, formidable, resplendent in the rays of sun like those flooding the atelier."[2] There was do doubt in the journalist's mind that Rodin was the right man for the job.

The idea for a monument to labor was so much on Rodin's mind in the fall of 1898 that he went to Pisa to have a look at the Leaning Tower.[3] When he returned, he wrote to the critic Gabriel Mourey about possible collaborators on the project. The following fall, when Léon Maillard published the largest study yet to appear on Rodin, he reproduced a photograph of the maquette, speaking of the tower as the most "admirable conclusion of this existence devoted to reflection and work. It will be the audacious consummation of monumental statuary."[4] Consummation: we can almost hear Rodin's voice reflecting on how his work developed out of the great monuments of the past: Assyrian reliefs, Trajan's Column, the Leaning Tower of Pisa—even Napoléon riding his horse up the clock tower of Venice.

Was Rodin really becoming so conservative, even bombastic, as he approached sixty? Perhaps, and surely he was very intent on his place in history. So the monument to labor seemed important, and in spite of the unreality of the project. Rodin spent quite a bit of time thinking about it in 1898 and 1899. Before long, however, Dayot understood that the monument was not feasible for the 1900 exhibition, and after February 1899, discussion ceased.

Peytel had advised Rodin to go back to the *Gates* to recover his equilibrium after the *Balzac* debacle. Judith Cladel had a different idea to accomplish the same goal; she wanted Rodin to mount a large exhibition. Rodin's friend Edmond Picard of Brussels had turned his fashionable residence on the avenue de la Toison-d'or into the Maison d'Art, a new exhibition space for contemporary art. Rodin was high on the list of those whose work he wanted to exhibit, and Léon Cladel's daughter kept up steady encouragement in this direction.[5] Finally, sometime after his return from Italy, Rodin gave in: "You are right," he wrote to her. "And I'm going to send some fifty sculptures to Brussels, *Victor Hugo, Eve, The Burghers of Calais,* some drawings. For the young artists of Belgium this will be an occasion for study. And I want you to give a lecture."

Judith Cladel was twenty-six and had already made her debut as a playwright in 1895 with *Le Volant.* But this new activity—mounting Rodin's exhibition and lecturing on it at the various venues—brought fresh excitement to her life. As Baudelaire had initiated her father in the wonders of painting, so Rodin would initiate her in the mysteries of sculpture.[6]

The Brussels exhibition was scheduled for May. Rodin sent some sixty works—fifteen in large dimensions, along with a substantial number of drawings and photographs. Almost all the works were in plaster, but the catalogue included prices for bronze or marble versions. Since Rodin could no longer count on remunerative commissions for monuments, such orders were the best way of earning income from his work. Rodin supervised the installation himself. He envisioned an easy, open arrange-

138) Rodin, *Monument to Labor*. 1898–99. Plaster.
Photograph by Bulloz.

ment. "Symmetry," he said, "is for museum curators." Picard's son, William, was acting as director of the Maison d'Art and offered some suggestions, but Rodin firmly explained that he was the "maître" and would give the orders.

Crowds did not stream into the Maison d'Art. Nevertheless, each day brought a few more visitors and the press gave the show front-page coverage, reporting that the "elite" of Brussels was "vibrating with enthusiasm."[7] One reviewer said that Belgians were so used to trite and banal works in modern exhibitions that "it is a joy and a surprise to find a feeling for art at once so pure, complete, and elevated as it is in the Rodin exhibition. . . . 'Eve,' grandiose in her overwhelming anguish, the lifelike bust of Rochefort; the admirable figures of the Burghers of Calais . . . the Victor Hugo, so controversial two years ago, but of such grandeur of thought that it would be petty to discuss small details . . . the 'Thinker,' the figure that stands as the most complete synthesis of the master's genius."[8]

One of Cladel's favorite moments at the opening was when she watched Rodin escort Meunier through the show: "the creator of *Grisou* with his enormous shoulders deformed by hard work, exhibiting that beautiful Christlike face, a face much more roughly etched than the fine faunesque countenance of Rodin. The two chatted in low

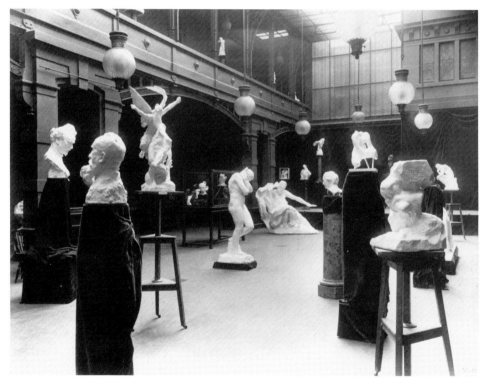

139) Rodin's 1899 exhibition in Brussels

voices, without gesturing, just walking, stopping, with the understanding of two powerful animals who have been joined in the same yoke for a long time."[9]

On May 12 Rodin's friend the poet-critic Charles Morice gave a lecture. Without mentioning a single work, he focused on the greatness of the *name* Rodin. Morice told his audience that they must think of Rodin as related to the Egyptians, Greeks, and Gothics. He also explained that Rodin's fundamental commitment to nature was the primary element in his work.[10]

Cladel's lecture was next. Critics were astonished at the unusual phenomenon of a woman giving a lecture, so they focused less on what she said than on how she looked.[11] They found her "enchanting" and "delicate." Her femininity was "admirable" and they particularly liked her azure-blue–flowered dress. Her words were "at once naïve and sure." Picard thought it an audacious performance, especially since "she did not read" her lecture. Although she gestured in a rather "masculine" manner, she did not imitate men, speaking simply from her heart about a man who was her friend. "She had no other preoccupation but to take us on a perfumed walk in the secret garden of his meditations and his dreams."[12]

When Rodin returned to Paris, he found a letter inviting him to bring the exhibition to the Kunstkring in Rotterdam. He turned the project over to his new disciple, Cladel, who promptly headed for Holland. There she worked with a circle of "simple and sincere" art amateurs who filled the entrance to the exhibition with plants and flowers, making it look "like a wedding." The president of the Kunstkring said that it was indeed "a marriage of the town of Rotterdam and great art." Cladel delighted in this new experience in a way that was reminiscent of Rodin's visits to Brussels in the 1870s: "Their taste is not spoiled here because there is almost no modern sculpture in Holland. They look for a long time, almost religiously, and say many things that are somewhat childish but never stupid."[13] Cladel worried about her ability to install the works, but the show was up and ready for the opening on Thursday, June 29. Cladel gave a lecture that evening. She told Rodin that it was going to take a "new form" and that she wished that he would come.

The Rotterdam exhibition was a huge critical success; for a country with minimal experience of modern sculpture, the enthusiasm was extraordinary. Critics recognized that Rodin had located life in every part of the human body; they thrilled at the naturalism of the fragments and the profound psychological character of the portraits. They were totally convinced by the portrayal of Hugo, and their only regret was that *Balzac* was not there.[14]

Next the show traveled to Amsterdam, where it was to be installed at the Cercle Arti et Amicitiae under the patronage of the queen and the queen mother. By this time Rodin was addressing Cladel as "my dear general," and she was determined that he should come. When she described the Rembrandts in the Rijksmuseum, he succumbed, even though Carrière assured him that the best Rembrandts were all in the Louvre. On Rodin's first morning in Amsterdam, Cladel wanted to show him the exhibition space,

but he insisted on visiting the Rembrandt House instead. From there they went to the Rijksmuseum, where Rodin became totally absorbed in Rembrandt's *Jewish Wedding, The Night Watch,* and *The Syndicates.* The last lit a fire in his brain, and he asked how old Rembrandt was when he painted it. Fifty-two, Claudel replied. "Of course," Rodin exclaimed, "this is not the work of youth. A young painter could never do that. Rembrandt was almost old. He had behind him that way of doing a complete study in detail; here he was free, he knew what to keep and what to sacrifice."

Cladel, following the drift of Rodin's thinking, asked if he saw parallels between Rembrandt's *Syndicates* and his own *Balzac.* Rodin turned back to the painting and, "visibly moved," responded: "It's true. I, too, was forced to stretch my art in order to reach the kind of simplification in which there is true grandeur. This is something one does not want to admit. Right now I feel more than ever how right I was. I'm so happy to have seen Rembrandt. It's as if he came back to say to me: 'You have not been wrong, you have done well!'"[15] Placing himself within the whole history of art was to become ever more important for Rodin as he approached sixty; he would make such references over and over again.

The painters on the committee of Arti et Amicitiae expected Rodin to visit their studios. Spend an afternoon looking at the work of modern Dutchmen when one could be in the presence of Rembrandt? Were they out of their minds? Instead, Rodin returned to the museum. Perhaps he would do a bust of Rembrandt. He began studying the men along the canals of Amsterdam, looking for faces that resembled the master's. Then, abruptly, Rodin took the train back to Paris, not even waiting for the opening of the exhibition. The local artists were not pleased. Guiltily, Rodin wrote to Cladel: "I think Amsterdam was not as successful as Rotterdam because I was there. (I confound everything when I come)" (Aug. 22, 1899).

Cladel supervised the dismounting of the Amsterdam exhibition and then took it to The Hague. From Paris, Rodin wrote that he was sure she would do better "without me bringing my anxieties to trouble you" (Oct. 18, 1899). Rodin's exhibition in Holland was a personal triumph for Cladel. A few years later, Gabrielle Réval described Cladel's journey to "Brussels and Holland with this caravan of statues following her as an Iris, messenger of the artist."[16] The success of the show and Cladel's position in making it happen set her on a course that would determine her entire life.

Rodin's first one-man show was all the more amazing in that it daringly included many new works, some of them fragments never seen outside of Rodin's studio. He even showed a full-scale cast of *The Burghers of Calais* cut at the waist and installed on a low base near the ground. Few sales resulted, though a small number of private collectors, mostly friends, bought bronzes and plasters. The Belgian government purchased a *Thinker* in bronze and a *Caryatid* in marble. Rotterdam bought the life-size *Eve* in plaster, a work that had never been exhibited before this show. Amsterdam bought nothing.

Back in Paris, Rodin again confronted the problem of presenting his most important work to the world. If the state would not have *The Gates of Hell* cast for a public

building, it was up to him to do it. He now had his eye on the Exposition Universelle of 1900. In 1893 he had approached the people in charge of fine arts for the Columbian Exposition in Chicago with the idea of a one-man show. They were not interested. Now, the biggest exhibition ever mounted was going to open on his doorstep in less than a year. The time was ripe.

Rodin had his eye on historic ground—the triangular plot on the south side of the avenue Montaigne in the place de l'Alma, where Courbet had shown in 1851 and Manet and Courbet in 1867. Rodin's idea of exhibiting *The Gates of Hell* to coincide with the Exposition Universelle bears a striking resemblance to Courbet's exhibition of *The Painter's Studio* in his one-man show. Both men put the whole of their creative lives out for the world to see in a context created by the artist alone.

Rodin first requested permission to use the land in March 1899.[17] After repeated applications and many reversals on the part of the Conseil Municipal, the project was finally approved on July 12. The result was predictable: a hue and cry from people who hated to see Rodin treated as a special artist, together with an outpouring of bravos from those who wished to celebrate his work as unique in modern times. A writer for *L'Illustration* put it this way: "When an artist proposes raising a chapel to his own glory, one can hardly expect the public not to jeer." He wondered why Rodin did not want to show with Dalou and Falguière in the big art exhibition that was being planned for the Exposition Universelle: "Is he unsure of himself, or is this an excess of vanity?"[18]

Not unexpectedly, Mirbeau complimented the men on the Conseil Municipal who had fought the "good fight." He then zeroed in on the enemy: the Institut, that collective of learned men in France's five academies who were "always there when needed to throw a barrier in the way or mud in the face of anyone with the criminal audaciousness to want to express thought freely and to lay the ground for a singular beauty." Watching trees being cut down and grassy plots on both the Left and the Right Banks being replaced with brick and stone to prepare for the exposition, Mirbeau lamented: "They have exiled the magnolias in order to raise shanties of cardboard and plaster . . . where they will sell fake oriental tapestries, false Persian rugs, and Turkish pipes made in Germany." Given these horrors, he believed the council had approved Rodin's show "to save their reputations." Mirbeau felt they knew how miserable the Exposition Universelle was going to be; the Rodin exhibition would be "the mantle that covers the nudity of Noah." The council acted out of *pudeur patriotique,* hoping to cover up their misdeeds.[19]

All through 1899 Rodin's studio teemed with activity. Receipts from paid bills leave no doubt about the intensity of the work. By the time the full-scale *Gates of Hell* was mounted, Rodin had spent 32,438.85 francs on labor. A chart from June gives the names of twenty specialists in plaster casting who worked on the plaster surface, dusty and damaged after a decade of neglect.[20] Many of the figures that had been used for making bronze casts now had to be recast in order to be returned to the composition. In reworking the two large panels, Rodin replaced the figured tomb reliefs with purely architectural tombs that anchor the bottom of each large relief panel. Over the tomb of

the left panel he placed a new figure, Fortune, and on the right a male and a female figure—Avarice and Lust—who hurtle down with cosmic force before the tomb.[21]

Among the least conspicuous additions of 1899 are two small reliefs inside the jamb panels on either side. At first glance they are barely noticeable. On the left is a seated female who pulls her legs tight to her chest and looks like an earlier figure that Rodin called Despair. But in contrast to Despair, who hides her face, this woman, apparently Eve, looks directly at us as she takes an apple from a crudely fashioned branch. On the right we see a male figure, also with knees bent, drawn in upon himself, hand to his head in a meditative pose, while a small female figure floats toward his right hand poised at his ear. It reminds us of *Victor Hugo,* but it is not a miniature image of the poet. Rather, it is a self-portrait.[22] The relief shows in no uncertain terms that in 1900 Rodin placed himself in the continuity of heroic thinkers after Dante and Hugo. His power as a heroic worker was equaled by that of woman in her various guises: rebellious, fallen

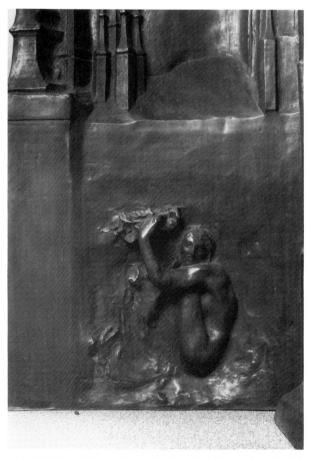

140) Rodin, inside panel of *The Gates of Hell,* showing Eve (?). 1899. Bronze. Stanford University.

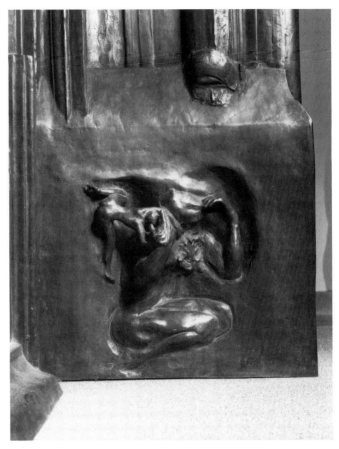

141) Rodin, inside panel of *The Gates of Hell,* showing Rodin's self-portrait. 1899. Bronze. Stanford University.

from grace, temptress, as well as the life-giving woman who inspires and saves. These were the central truths of Rodin's creation.

Sculpting was but one aspect of Rodin's daily concern in 1899. Once the Conseil Municipal had given its approval for the installation, the work to be done in less than a year was staggering: raising money, erecting a building, settling on a business plan. By August, Rodin was in conversation with three clients who happened to be bankers: Albert Kahn, Joanny Peytel, and Louis Dorizon. In the fall the four came to an agreement. Each banker would lend twenty thousand francs, while Rodin would put up fifteen thousand francs of his own. He would take 50 percent of the profit, the bankers would split 35 percent, and the remaining 15 percent would go to Eugène Druet, an amateur photographer who owned the café across the street from the site and would manage the exhibition. Profits would come from entrance tickets, sales of casts of works in the show, and orders for Druet's photographs of Rodin's work. These were to

be hung in a small gallery in the exhibition. Rodin entered these unknown waters with much trepidation. After reading the contract, he pounced on Peytel: what did the phrase "the sum of 75,000 will be divided into 75 equal and transferable shares" mean? Peytel quickly wrote back: "Calm down, *cher ami*. Neither Dorizon, nor Kahn, nor I is going to give away your shares—this is just a phrase of contingency" (Oct. 16, 1899).

Mirbeau was enraptured with the plan and promised Rodin his full support, even though his life was particularly complicated in 1899. After Zola had been convicted in a libel suit brought by the minister of war, his lawyers planned an appeal. When it became clear that this too would fail, Zola fled to London rather than spend a year in prison. Mirbeau now helped look after Mme Zola and gave a great deal of his time to keeping Zola abreast of what was happening in France. He wrote detailed letters about Lucie Dreyfus' petition to have the verdict against her husband reversed on the grounds that it was based on a secret communication to the judges. This secret disclosure was now a known fact, and the Cour de Cassation ruled that her petition be considered. The process leading to a new court martial was under way; France was once again consumed by the case. The country—or at least Paris—was split into two camps (some called them two nations): one consisting of intellectuals, antimilitarists, anticlericals, and people hospitable to Freemasons, Jews, and Protestants; the other of monarchists, anti-Semites, the military, the clergy, and the majority of practicing Catholics.

Most of Rodin's friends shared Zola's belief that France could not call herself an honorable nation until Dreyfus was found innocent. Mirbeau was particularly engaged in the struggle to exonerate Dreyfus, which makes the amount of time he gave Rodin's exhibition all the more impressive. He personally lobbied the minister of public instruction, and on July 12, 1899—the day the Conseil Municipal held their deliberations about granting permission for a building in the place de l'Alma—he published an open letter supporting the project.

Permission granted, Mirbeau wrote Rodin that he could "leave more content" for the second Dreyfus court martial in Rennes. "You cannot imagine how exasperating this affair is for me and how angry I feel about the everlasting baseness of man." In closing, he reaffirmed the solace he took in Rodin's friendship: "I might even say that it is the one thing in the world of which I am truly proud. It reassures me about myself. When I find a great *bonhomme* like you—the greatest of our time—loves me even a little, then it seems to me that I am not a complete beast."

The whole Western world was shocked when Dreyfus was condemned a second time. Séverine was in Rennes on September 9. As the judge read the verdict, she noticed that Mirbeau had tears in his eyes.[23]

Although many of Rodin's friends were profoundly committed to Dreyfus' cause, most permitted him his "neutrality." Mirbeau exhibited particular delicacy in this regard, for although he himself was totally preoccupied with the case, he wrote only one letter expressing his anguish; otherwise, he did not mention it to Rodin. Not everyone was so discreet. A new acquaintance, an artist by the name of Emilia Cimino,

wrote Rodin long letters about her reactions to the trial. She particularly admired the "traitor's" brother and wife: "I think these Jews know how to love better than we do." Cimino did not think many Christian women would have stuck by their men as Lucie Dreyfus did. She felt the Affair exposed France's entry into a period of decadence; she wondered how anyone could support the government as then constituted. "But you are totally detached from these questions as you sit there surrounded by your chef d'oeuvre. In fact, you are even able to benefit from the absence of all your friends and get some work done. I am so anxious to see that portal finished" (Aug. 31, 1899). For Cimino, the verdict in Rennes was a "bomb! I couldn't believe they would do a thing like that!" She hoped Rodin was not distracted by the turmoil, but immediately she caught herself. She was glad he was able to be so "detached," or at least that is what she said (Sept. 11, 1899).

Rodin was actually not so detached, but it was important for him to speak little of these things. If he had exhibited anti-Dreyfus feelings, he stood to loose the bulk of his support among the writers who had made his reputation. As noted above, the Norwegian painter Christian Krohg came away from meeting Rodin in the summer of 1898 convinced that he was a "glowing anti-Dreyfusard." In 1900, when a committee was formed to coordinate a series of events—lectures, publications, a banquet—to celebrate Rodin's retrospective exhibition, it became clear to Rodin that every member was an outspoken supporter of Dreyfus. He asked them to include some academicians (who just happened also to be members of the anti-Dreyfus Ligue des Patriotes). The committee refused and the celebration was canceled.[24]

Another sign of Rodin's anti-Dreyfus leanings might be seen in his exchange of works with the most outspoken of the anti-Dreyfusards among the artists, Degas. In July 1898, Rodin gave him a marble *Venus and Adonis* and received a pastel in return. Degas did not particularly like Rodin, so it would seem that their exchange, which exactly coincided with Zola's conviction, had more to do with politics than with friendship.[25] And, as everyone knew, Rodin could no longer even stand to be in same room with the man who had given him the Balzac commission.

The one person who had the courage to speak to Rodin directly about these highly charged matters was Cimino, whom Rodin had met in 1897. Of Neapolitan background, she was born in France when her parents were in exile. When still quite young, Emilia went to England on her own. She ended up working as governess to the children of George Howard, ninth earl of Carlisle. Lord Howard's home in Kensington was a famous center of contemporary art, particularly for the Pre-Raphaelite painters. After a few years in this heady environment, Cimino decided she was an artist. At age forty, she headed for Paris, her heart set on a career as a painter.[26] Through her English connections, Cimino managed to meet Rodin, and for the next ten years she cajoled him, used him, befriended him, and availed herself of every means at her disposal to become indispensable to him.[27] Cimino had two things to offer Rodin: admirable linguistic abilities—she was fluent in French, English, Spanish, Italian, and German—

and connections in England, the importance of which she greatly exaggerated. But in 1898 she was doing all she could to capture a truly grand commission for Rodin: the portrait of former Prime Minister William Gladstone. She did not succeed.

Cimino was not the only woman to enter Rodin's circle in this period. In the wake of the publicity surrounding the reception of the Hugo and Balzac monuments, a number of women began to think creatively about how to meet this fascinating artist. Rodin was quite open to these overtures. In the twentieth century he wrote to his American student, Malvina Hoffman, that he considered "the friendship of a woman to be as something willed by God, and after Him to be the strongest thing there is in the world."[28] His curiosity about women became ever more evident as he grew older, and the pleasure he took in their company appeared almost inexhaustible.

In the early nineties Rodin had developed friendships with Ernestine Weiss, Hélène Porgès, Sarah Hallowell, and Judith Cladel. The latest additions to his feminine entourage were somewhat more exotic. Cimino was one; another was Loie Fuller, who had come to Paris to dance at the Folies-Bergère in 1892. Her original movements and fantastic costumes (one of which she even patented) soon made her a major star at the Folies. In 1897 Roger Marx, one of Fuller's most avid fans, pressed Rodin to accompany him to the Folies to see her. Rodin declined, but by 1898 Fuller herself was plying him with invitations. Soon they would be the best of friends.

A third lady made her entrance in the late nineties: Sophie Postolska. Like Cimino, she was born of parents in exile. Her mother and grandmother, Emélie and Sophie Kuczewska, were forced to flee Poland because of Emélie's gunrunning in the Polish independence movement. They were soon joined by Ladislas Nicolas Postolska, a lieutenant in the Russian army who was in love with Emélie. Since Emélie was already married, the couple could not wed; nevertheless, they had two children: Sophie, born in 1868, and Casimira, born in 1870. The girls were sixteen and fourteen when the impoverished Emélie died of tuberculosis, by which time Postolska had long since disappeared. Thus, when Casimira met a rich and handsome widower, Louis Dorizon, it felt almost like a fairy tale.[29] It was Casimira who made the first overture to Rodin. The Dorizons had seen *The Dream* (*Le Rêve*) in the Salon of 1897, where they were carried away by its "charm and grace." They wanted to buy it. Kisia, as everyone called her—she signed her letters to Rodin "K Dorizon"—wrote to ask the price, and the Dorizons' friendship with Rodin developed out of this exchange.

Casimira's older sister, Sophie, was not so fortunate. She tried teaching but disliked it. Then she set her sights on becoming an artist. In the spring of 1897, when everyone in the Dorizon household was talking about *The Dream,* she decided to approach Rodin herself. She asked to model for him: "Your concierge says that you will interview models today. For me it would be an honor, an infinite joy, if you could use me for the least little sketch. At present I have posed for a sculptor only with my arms. Nevertheless, I would hope to be able to perform the model's profession intelligently. If I have taken this liberty to write you before presenting myself, it is because it would be too

painful for me to be seen by anyone but you. Could you receive me *alone,* either today, or on another day?"

It is not clear whether Sophie Postolska got the interview, but that summer she sent Rodin four telegrams—we might call them "mash notes"—and told him that she had begun to dream of him. In fact, she thought of him "too much." She always signed herself "toujours votre Sophie." By the end of the year she was writing every day: ". . . your eyes, a light voluptuous and fine *Chéri,* at the moment I am sad, for my forlorn heart has felt a grievous estrangement. . . . The warmth of your tenderness is so sweet Forgive my sadness" The refrain of the correspondence was the line "I suffer from your suffering" (Je souffre de ta souffrance).

In 1898 Postolska wrote Rodin at least sixty times, without once mentioning *Balzac.* On May 24—in the very week when Rodin was struggling to decide whether to let the subscription for *Balzac* proceed or to return the statue to his studio—she wrote: "Just a little note from your student, who is terribly tormented and works very hard. Your thoughts console me and give me courage. They are my biggest support. I always think about you when I finish my work, but sometimes I think it is only I who am thinking and that you are far from me, not just in terms of distance but in your thoughts. And that is really sad."

Frequently, Postolska saw Rodin in the company of Casimira and Louis Dorizon, which gave their relationship an air of respectability. Did the Dorizons understand the intense pursuit taking place under their noses? Sophie and Casimira traveled to Brussels to see Rodin's exhibition; Sophie asked Rodin to find ways for them to be "alone together." Her letters followed him to Holland. She hoped he was experiencing "rest, joy, and a sense of the past glories of that country." Even more, she hoped he was thinking about her. She said she was "proud" of him, but that she would have to work on herself to become resigned to his work. In the meantime, she was "waiting."

Rodin's answer to this letter was short, not quite a love letter: "Thank you, dear friend, for your letter. Its new direction about our friendship is very beautiful. You are a good person and a great artist. Spiritual force is also necessary to talent. Respectfully, *je vous embrasse.* Aug. Rodin."[30] Rodin was flattered by Postolska's attention, but he was naïve about her self-centered ego. She was enthralled to be in the company of such a famous man; at the same time, she found his career a tremendous inconvenience. In the hundreds of letters that Postolska wrote Rodin, she rarely mentioned a work or an exhibition. What she spoke of most often was her suffering. Cimino warned Rodin that Postolska was extremely ambitious and did not understand the "enormous benefit she has by living in your company" (July 24, 1899). Rodin, however, was smitten, and he responded to Postolska's dark, romantic longings for more than three years. Then, little by little, he slipped away.

The summer of 1899 is also memorable for one other reason: it was when Rodin may have quashed Camille Claudel's best hope of having a work cast in bronze at state expense (see chapter 22). It was her three-figure group *L'Age mûr,* with its naked man

walking into the waiting arms of death, while a young girl implores him not to go. It had just been shown in plaster in the spring Salon. It would hardly be surprising if Rodin did not want the state to commit funding to the work, which so clearly paraded his intimate life before the world.

Rodin was indeed approaching sixty, but death was not on his mind. Quite the opposite, as he turned toward the new century, he was flattered by the love of a woman half his age and experiencing his own virility in much the same way as the mature Hugo. Moreover, he was shepherding his greatest work to completion and preparing the largest exhibition of his career, on a scale no sculptor had dreamed of realizing before.

Claudel's situation, on the other hand, was painful in the extreme. Henry Asselin described her in a state of "extreme negligence" and said that, though only forty, she already "looked fifty." Claudel told him that someone, acting on Rodin's orders, had tried to pry open her shutters kill her.[31] The stark contrast between their lives in 1899 surely increased Claudel's suffering and, perhaps, inflamed her paranoid projections.

Chapter 27
Outsider's Victory

> Until Rodin came along, sculpture scarcely
> interested us at all.
> —Gustave Geffroy, *La Plume,* 1900

A month and a half into 1899, the anti-Dreyfusard president, Félix Faure, died. Republican groups immediately put forward the candidacy of the president of the Sénat, Emile Loubet. With support from radicals, and even from Socialists, he won the presidency. If Loubet had any doubts about the difficulties he faced, they were dispelled on February 23, the day of Faure's funeral, when the Ligue des Patriotes attempted a coup d'état. Months of governmental instability followed, and no semblance of order seemed possible until June, when Loubet asked René Waldeck-Rousseau to form a cabinet. A moderate of cool temperament, Waldeck-Rousseau was firmly set on reconciling France's conflicting factions. He began by selecting a cabinet of strong men; for the first time he even included a Socialist—Alexandre Millerand.

Positive signs about this government were in evidence on November 19, when citizens' groups, professional societies, and unions marched together to salute Dalou's *Triumph of the Republic.* The Republican celebration made one think that perhaps people were ready to forget the battles of the past few years. An editorial writer for *L'Illustration* commented in the final issue of the nineteenth century: "Let's hope 1900 will be more merciful, that under the auspices of the exposition, we shall be less unbearable for ourselves and for others." He made an appeal to public conscience; his message was to put bitterness away in order to receive the visitors who would soon be arriving.

Work on the Exposition Universelle had begun in an atmosphere of pessimism. Many Europeans had come to take it for granted that France was a declining power. Her defeats in foreign policy made her look more like the other "Latin" countries than like Germany and Great Britain. As governments became ever more mediocre, many questioned whether republicanism was really the right form of government for France. The government hoped the exhibition would help overcome the pessimism, but Parisians looked on with jaundiced eyes: "We cannot believe that the Exposition Universelle is going to open in two months; this, nevertheless, is the case. Hotel people are getting ready. As for the rest of us, we have more to lose than to gain from the fête in preparation, but we must resign ourselves and submit to it. Poor inhabitants of the City of Light, who will protect us from this exhibition?" (*L'Illustration,* Feb. 10, 1900).

Anti-exhibition spirit was everywhere. It was part of the malaise to believe that nothing good could come from a republican government. The closer the opening date,

the more acerbic the criticism against anyone who was participating in its creation. Two days before the opening, the president's secretary, Abel Combarieu, walked the route Loubet would take on April 14. He came home deeply discouraged: "What chaos, what congestion of scaffolding, cases, materials, filthiness of every sort! All this cannot be arranged, unpacked, and put in place in twenty-four hours."[1]

On April 14, under a grey sky, Loubet, a short man with a white goatee, entered the *salle des fêtes* to pronounce in his unmistakable southern accent: "The exposition is now open." After a stirring rendition of the *Marseillaise* from the Garde Républicaine, the dignitaries settled down to listen to the addresses. "Work" was the word of the day. Loubet saw the exhibition as an advance in the evolution of work in order to bring greater happiness to humanity. Millerand, who had primary responsibility for the exposition, spoke of work as "the Deliverer, . . . that which ennobles and consoles. . . . It is work that dissipates ignorance and vanquishes evil."

Certainly, nothing was needed more than work to get the exhibition off the ground. The press had a field day ridiculing the government about the spectacle of 150,000 people jostling through the entrances on opening day in order to see next to nothing. On April 21, London's *Saturday Review* felt that "the very vastness of the hoax to some extent saved the situation" and advised its readers to stay away from Paris for at least six more weeks. Not only had the exhibits not been installed, but the streets of Paris were "torn up by the new Metropolitan" and "half the picture galleries of the Louvre [were] being re-hung." The magazine called the exposition "ill-timed." On May 5, galleries were still unfurnished and the Electrical Palace was "awaiting its current." Further, the magazine reported, "the telescope that was to have brought the moon within a yard defies its masters and refuses at every séance to do its duty. Dust rises again and again; so that the Parisian must rub his eyes and use his handkerchief and gasp and weep." One thing did delight everyone, however: the *chemin roulant,* a raised sidewalk moving at three different speeds to carry visitors from Les Invalides, along the quai d'Orsay (past the back of Rodin's studio on the rue de l'Université) and up the avenue de la Bourdonnais beside the Champs-de-Mars. For some visitors, nothing was more exciting that this in the whole exhibition, for the moving sidewalk allowed a forbidden view into the interiors of Parisian dwellings.

The majority of the seventy-six thousand exhibitors were late, Rodin among them. He did most of the work for his show in March, April, and May. In March Rodin focused on his exhibition hall. It was designed by Alexandre Marcel and Louis Sortais, the latter being the cousin of one of Rodin's backers, Joanny Peytel. Peytel wrote Rodin on March 8 about getting together with the architects to discuss lighting and the problem of the weight the floor would have to bear. The final design for the small triangular plot was a building of sober classical grace, its single story ennobled by a strong entablature emphasizing its horizontal proportions, lit by tall, round-headed windows on all sides and approached through three portals pierced in the round entrance pavilion.

Eugène Druet, owner of the nearby Café du Yacht Club Français, was responsible for hiring the guards, getting information to the public, and overseeing sales and reproductions. In addition, he was to have a place for showing and selling his own photographs of Rodin's work. Rodin retained the right, however, to forbid the sale of any he thought not "sufficiently artistic." As tension mounted under weight of the enormous preparations, the two men quarreled. Fortunately, Mme Druet diplomatically patched up their disagreement, and the photograph gallery remained part of the plan.

Arsène Alexandre, critic for *L'Eclair* and *Le Figaro*, a supporter of Rodin's since the late 1880s, assumed responsibility for the catalogue. In March he was waiting for Rodin to classify the works so that he could organize the catalogue. For the photographs, he relied on Jean Limet, Rodin's best patina fashioner. Alexandre's job was complicated by the fact that until the last moment Rodin was sending out letters to friends asking to borrow back works. Two days before the opening, Maurice Fenaille wrote that his wife wanted him to show her portrait in marble, even if it was not finished. Rodin replied that it was too late: the plaster was already in.

The whole catalogue was an expression of the artistic friendship so fundamental to nineteenth-century artists' lives. Rodin took one of the many portraits Eugène Carrière had made of him—this one showing *The Toilette of Venus* rising out of his hands like a flame—to reproduce on the cover and the poster. The frontispiece was a photograph of Falguière's bust of Rodin, a choice probably made after Falguière's death on April 19. This was followed by four brief statements from Carrière, Laurens, Monet, and Besnard. Rodin carefully picked masters who were not only friends but who represented different trends of modern art—realism, impressionism, and symbolism—that accorded with his own taste. Sculptors were notably absent.

Rodin's final task was to draw up an invitation list for the opening: directors and critics from all the major journals, directors of schools, government officials, other politicians, artists, and friends. He asked his students Ottlie McLaren and Sarah Whitney to help him. Only at the last moment did Rodin learn that the minister of public instruction and fine arts, Georges Leygues, would actually open the exhibition.

Friday, June 1 "was a horrid wet afternoon but people came all the same," McLaren reported. She was impressed that the visitors obviously had not come to see one another, "as is generally the case at these functions, but they came to see his work & see it intelligently. It was nice to see the enthusiasm & dear old Rodin looked really happy & serene for the first time since I have known him."[2] B. Guinaudeau of *La Concorde,* who had never visited Rodin's atelier, wrote: "For the first time I have all of Rodin before my eyes . . . the power, the life, the passion, reaching the extreme limits of expressive intensity" (June 5, 1900).

Many foreigners were surprised by the amount of space available to Rodin; they did not understand that his work was not part of the official exhibition. An Englishman, Anthony Ludovici, who worked briefly as Rodin's secretary in 1906, remembered: "It was in 1900 that I first made the acquaintance of Rodin's works on a large scale. I

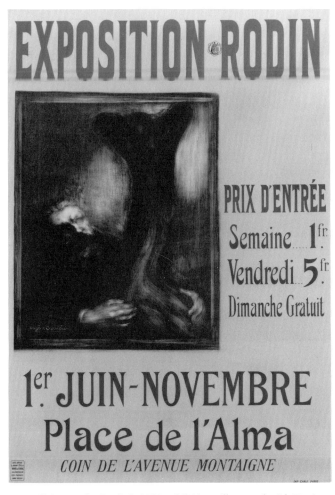

142) Poster for Rodin's 1900 exhibition, illustrated with Eugène
Carrière's portrait of Rodin holding his *Toilette of Venus*

happened to be in Paris for the Universal Exhibition, and I was among those who paid
their franc to be admitted into the special pavilion on the place de l'Alma. . . . Like
many others, I was struck by the fact that, in an Exhibition in which each big nation was
represented only by a comparatively small house of its own . . . a special place . . .
should have been provided for the works of one sculptor whom, though known to me
at the time, I did not believe to be important or popular enough to be worthy of this
official recognition."[3]

French people were divided in their opinions. One critic, Georges Casella, asked
whether his compatriots attended the exhibition "to laugh." Watching a group of men
standing outside the hall, he examined the disdainful pouts on their faces as they talked
about Rodin. They could see *Balzac* through the open door; one of them pointed to it.
Each loudly regaled the others with memories of the scandal. Hesitantly, the men put

down their canes and, with the air of knowing the whole thing was a hoax, passed through the curtain to discover "violent flashes of strained muscles, voluptuous force of hollowed loins, intertwining flesh melting into a kiss, painfully, inexpressibly, sadly, sweetly; here passion shrieks, trembles, is dumb; there Ugolino drags himself on bruised knees over the bodies of his dead children, looks at them with haggard eyes, a death-rattle at the bottom of his dry throat . . . ; a caryatid sinks under the weight of a stone, overcome by the force of the material and carried away by the great burden . . . ; the sad awakening of the Age of Bronze; pensive Victor Hugo, powerfully nude . . . haunted by a double chorus of voices. It is the madness of all passion advancing toward nothingness."

The astonished group continued to circulate past the *Burghers, Balzac,* and finally approached *The Gates of Hell,* on public view for the first time. Casella spoke of "the cry of desire coming forth from the mass of animated flesh, a flesh that was alive with sexual excitement." But the life before him seemed strangely impotent. More than one of the gentlemen wondered: Was this, then, the suffering of hell?

143) The Rodin pavilion in the place de l'Alma, 1900

The visitors picked up their canes and walked out into the sunlight. One stepped away from the group and bowed gravely to the museum. The rest watched him, laughed lightly, scoffed at the sculptor's name inscribed above them on the facade. Beyond, Balzac's disdainful face watched through the glass.[4]

The indignities of the pavilion were no laughing matter for a California critic: "The whole place seems to be held in a thinly lit, chill silence of horror, coldness, and terror emanating from the marbles that writhe and clutch in frozen poses of frenzy on every side. In the center, looking up, huge, weird, and terrible, is the statue of Balzac. This monstrous thing, ogre, devil, and deformity in one, stands facing the entrance like a gross epitome of all the forces that encircle it."[5]

Quantities of reviews were published through the summer. Again and again critics described how Rodin's works looked in the bright yellow hall, with its "penetrating light covering marbles and plasters to create an impression of freshness and repose" (*La Presse,* June 5). The large, airy space Rodin had conceived was widely seen as a break-through in the manner of presenting sculpture. Small rooms had been carved out by means of twelve-feet-high wall dividers. The first room on the right contained Druet photographs and Rodin drawings. One reviewer was particularly taken with the con-trast between Rodin's early drawings—those "mysterious and tragic evocations of shades and black masks in which eyes and mouths are no more than great luminous holes"—and his recent drawings, which he described as "pale watercolors in ocher . . . hastily drawn silhouettes after the living model, the effect being one of instantaneous-ness" (*Le Temps,* June 2).

The real crowds at the exhibition turned out on Sunday, when it was free. On other days it cost a franc and visitors were far fewer: hostile critics described it as the "désert Rodin." Rodin was available every day to greet, explain, and show his art, especially to curious foreigners. Twenty-one-year-old Helene von Hindenburg, who came from Berlin with her mother, later recalled that her first encounter with Rodin was at the exhibition: "He stood there with his long beard, his head bowed, silently contemplat-ing one of his statues. At first he did not approach us. Then the miracle occurred. A new world, filled with a light that appeared to emanate from his work, opened before my eyes. The vibrations of my feelings led him to me and we found speech, speech that was to last between us beyond death itself."[6]

Oscar Wilde, in the last year of his life, felt the salutary power of Rodin's work as keenly as Helene von Hindenburg. After touring the exhibition in Rodin's company, he wrote to Robert Ross (July 7) that he had seen Rodin's "dreams in marble." Wilde believed he had met the "greatest poet in France" and that Rodin had "completely outshone Victor Hugo."[7]

The following month Wilde's friend William Rothenstein, once a student of Legros and an acquaintance of Rodin's since 1897, wrote that he would attend the exhibition in August. He and his wife could not find a hotel room. Could they stay at Meudon? Albert Kahn was bringing the financier Okura from Japan at the end of June. Would

Rodin meet him and sign a catalogue? A young American photographer from Mil-waukee, Edward Steichen, came in the summer. Jelka Rosen, a painter of Danish descent, lived near Fontainebleau with the composer Frederick Delius. She appeared in the fall. She wrote to Rodin that she had been "enveloped in the intoxicating beauty of your works," that they had given her "the courage to go on struggling and searching" to find her own place as an artist.[8] Arnošt Hofbauer, a painter, and Miloš Jiránek, a writer, both from Prague, were amazed at Rodin's "affability and his inexhaustible kindness" at their meeting on October 28 and on subsequent occasions. The two men were gathering material for a Rodin article in the new Czech art review *Volné směry* and planning a major Rodin exhibition for Prague.[9]

The Germans were the most faithful visitors to Rodin's exhibition. Toward the end of the year, Rodin wrote to Bigand: "Not many Americans or English, but there were lots of Germans at my exhibition." One of them, young Paula Modersohn-Becker, wrote to her parents about the power she discovered in Rodin's approach to life: "That such human beings exist on earth makes living and striving worthwhile."[10] The highly respected sculptor of Leipzig, Max Klinger, came in November, just before the exhibition closed. Rodin was upset that he was not there on the day his German colleague arrived.[11] The art historian Paul Clemens brought his class from the Akademie der Künste in Düsseldorf. The philosopher Georg Simmel came from Berlin and Rudolf Kassner from Vienna. Rodin was working with his assistants when Kassner arrived. It gave the Austrian a chance to study "the greatest artistic genius of modern France." He watched the "master mason in Sunday clothes" giving instructions to his workers. He noticed the "wide mouth under the dense beard," a mouth betraying "extraordinary energy, the energy of a man of will, one who does not lack a sense of irony and one who is cognizant of what he has overcome."[12]

No German visitor was more welcome than Max Linde, an ophthalmologist from Lübeck. On October 17 the doctor wrote, "Sir: While I regret not having had the pleasure of meeting you last Friday at your exhibition . . . and of thanking you for the truly noble and wondrous feelings your powerful works inspire in me, I am taking the liberty of asking if it would be possible for you to let me have two sculptures, 'Eve' in marble and 'Man Awakening' in bronze for 12,000 francs."[13]

The next request was even better: a Danish brewer and collector, Carl Jacobsen of Copenhagen, wanted six works and was willing to spend seventy thousand francs for the lot. Then he ordered a bronze *Thinker* for four thousand francs. One of the works he wanted was the large *Kiss* in marble. This group, so widely acclaimed at the Salon of 1898, was now to be seen in the Decennial Exhibition in the Grand Palais. Jacobsen was not the only foreigner with his eye on it; an American connoisseur living in England, E. P. Warren, instructed Will Rothenstein to order a *Kiss* from Rodin. Only a week after Rodin received Jacobsen's letter, Rothenstein told Rodin his collector wanted him to start work as soon as possible on another large marble *Kiss*. Rodin could now pay off his debts with ease.

Rodin's exhibition of 165 sculptures, plus the completed *Gates of Hell* and a room full of drawings and photographs, was the single most impressive art event at the Exposition Universelle.[14] From the four corners of the earth, people trooped through the pie-shaped hall in the place de l'Alma to discover how one man had pushed back the accepted limits of sculptural form. They found sculptures that no longer depended on a simple or a visible harmony but rather on an interior psychological state, a state that could be "sublime or grotesque."[15] The overriding presence of sexuality escaped no one; many were offended by "such an audacious exhibition of marbles and bronzes that seem to have escaped from the private collection of the marquis de Sade."[16] But for every objection of this sort, a chorus of voices intoned the praises of the man who had replaced cold academic nudes with *la volupté, la passion*. "He is our paganism, our rebirth. . . . He has followed Pan into the marketplaces of our big cities; his greatness is having discovered eternal Venus in every woman."[17]

The most difficult thing for audiences to accept, however, was that nearly everything in the exhibition was unfinished, and that even the finished works looked unfinished. One reviewer wanted to ask Rodin if every time he rolled two balls of clay together, he called the result sculpture.[18] But another visitor felt the presentation was so natural that "you almost fail to notice they are fragments. It is as if they had to be this way!"[19] D. S. MacColl, writing for the *Saturday Review,* admired "the little clay projects in all stages of completion." He found the motifs utterly inevitable, yet "no one [had] thought of [them] before; for example, the woman enthroned and kissed under the soles of her feet in this superbly abject act of adoration!"[20] The fragments came from all periods of Rodin's career, many of them newly assembled for the show, such as the headless, armless torso of Saint John the Baptist of 1877. Rodin attached new legs to it, placed it high on a column, and called it *Saint John,* but it was later to become famous as *The Walking Man.* Another early fragment that gained self-sufficient status in the 1900 exhibition was a version of *Ugolino* fashioned during Rodin's early years in Brussels. At the entry, visitors were greeted by the nude and fragmented form of one of the Burghers of Calais.

The most impressive fragment of all, to be sure, was *The Gates of Hell,* shown for the first time outside Rodin's studio. Rodin had worked on it day and night, asking that electricity be installed at 182 rue de l'Université so he could finish.[21] Yet the work in the exhibition looked far from finished; it was a "weird object with some parts apparently finished and others indicated only by numbers scrawled in pencil on the white surface."[22] *Le Temps* (June 2) explained that Rodin had had to take off most of the three-dimensional figures because the color of the two plasters—the background and the figure groupings—did not match. We also know that he changed things in the course of the exhibition. For instance, the relief panels did not carry *The Three Shades* when it arrived, but the *Shades* show up in the photographs taken in the latter months of the show (as in the September 2 *New York Tribune*). There was a widely shared impression that the work would never be finished. If you disliked Rodin's work, as did the critic for

144) Interior shots in the Rodin pavilion. Published in the *Actualité
française,* Feb. 21, 1901.

L'Illustration, it was "better that it remain only a project." On the other hand, if you
loved the work, its present state allowed you to see new possibilities, to understand that
"limits are not limits, and the dream expands and relaxes endlessly like a river within its
crumbling banks."[23] Anatole France was one of those who had no problem with the
unfinished *Gates*: "Even in its present state—molded in plaster with its panels devoid of
the figures that are to be placed in high relief upon them—it is a work of profound
meaning and powerful expression. I know of nothing more moving."[24]

Another important aspect of the show's novelty was the loose and open arrangement
of the works, in stark contrast to the rigidity of the official sculpture exhibitions.
Kassner wrote that he had "the feeling of entering a workshop" in which individual
works did not draw attention to themselves. "Knowing one, we know all the others,
and to look at them for long is to get the feeling of looking at oneself." Kassner knew
that the titles of works did not count and that "nothing is more dispensable to this show
than the catalogue."[25] Others saw the exhibit as the "Musée Rodin." The work-
shop/museum combination suited Rodin perfectly, and he would fight to preserve it as
such—a fight he finally won in 1916, when the collection from the place de l'Alma
became the Musée Rodin.

On November 12, the day the Exposition Universelle closed, 369,535 people came to see it. Henry Adams wrote with emotion of the day when he would no longer be able to go down to the Champs-de-Mars and "sit by the hour over the great dynamos, watching them run . . . as smoothly as the planets, and asking them—with infinite courtesy—where in Hell they are going. They are marvelous. The Gods are not in it. Chiefly the Germans!"[26] It rained that day, but toward evening it stopped. At almost ten o'clock, people got out their watches: still three minutes; still two It's ten o'clock. "And then, as the cannon boomed, as red beacons were lighted on every stage of the Eiffel Tower, as a suffocating smoke filled the air, . . . a little bourgeois gentleman could be heard saying to his son: *regarde bien, Edouard . . . car c'est pour la dernière fois* [Look carefully, Edouard, it's for the last time]."[27]

Rodin did not want to close his show. So he went right on meeting visitors even after the exposition shut its doors. Edmond Picard gave a lecture in Rodin's exhibit as late as November 27. The press murmured that Rodin should be given permission to stay open indefinitely. But finally he accepted that his beautifully lit hall would have to come down; demolition work got under way the following spring.

Toward the end of the year Rodin reported to Bigand that he would recoup his expenses for the show; even more important, "In terms of moral outcome, [my exhibition] is truly beautiful."[28] What exactly was Rodin's sense of "moral outcome"? He understood very well that his show frequently was compared favorably to the Exposition Universelle. The critic Félicien Fagus wrote to him on his opening day: "The Musée Rodin is a necessary and conquering counterweight against the exhibition, that is, against our epoch. And it is you who are our example, our rehabilitation, our comfort." In the same vein, Picard published an article in July, pointing out: "What a strange contrast is the quiet authority of this Musée Rodin to the tormented spectacle of the Exposition Universelle, with its astonishingly bizarre monuments arranged, one might say, according to the caprice of a most restless and abnormal spirit. . . . Next to this you have this isolated and patient man who lives only to realize the miracles he believes in and which he proposes to offer to this same world."[29]

Rodin's sense of his moral victory was more complicated, however. First of all, he appreciated the enormous risk he had taken. No sculptor before him had ever mounted such a retrospective exhibition, so he felt triumphant in confronting the Academicians and stalwarts of the Ecole des Beaux-Arts who had brought so much pain into his life. He also felt he had won a moral victory over his recent enemies in the Société des Gens de Lettres. Moreover, he recognized that sculpture had never been what painting was in modern eyes. Painting had always been the favorite of the critics, the truly daring and interesting art in which the nineteenth-century artist made his mark. The public was aware that Rodin's retrospective occupied the same plot of ground where Courbet and Manet had exhibited their works at previous expositions. One journalist assured his readers that Rodin's exhibition could not "obtain the same success as . . . the exhibitions of Courbet and Manet and those of the Impressionists."[30]

Rodin's show provided younger artists a chance to look anew at sculpture. For the first time in a century, sculpture was open to experimentation. We see this in the work of two young French painters, Aristide Maillol and Henri Matisse. Maillol had begun experimenting with modeling in 1895, but he did not turn decisively to sculpture until 1900. Matisse, whose canvases were so sure and powerful in their coloristic achievement, created his first nude figure in clay in 1900: a male figure, about three feet high and clearly indebted to Rodin's *Walking Man,* one of the successes of the 1900 exhibition. So fixed was Matisse on the idea of Rodin's figure that he even sought out Rodin's old model, Pignatelli. Now known as Bevilaqua, he modeled for Matisse's *Serf.* Another artist influenced by Rodin's show was Charles Despiau. He had come to Paris in the nineties to attend the Ecole des Beaux-Arts, but only after 1900 did he find his

145) Rodin, *The Walking Man.* 1900. Plaster. Photograph by
Haweis and Coles.

146) Rodin, *The Gates of Hell*. 1880–1900. Plaster.

personal style; later, Despiau spoke of Rodin as the "spiritual father" who had made this possible.[31]

The response to Rodin's art among the foreign artists who poured into the French capital in the next decade is even more interesting. They came from all over: Picasso, Gonzalez, and Manolo arrived from Catalonia in 1900; during the next few years all three would experiment in a Rodinesque vein. A young Romanian peasant, Constantin Brancusi, walked across the continent in 1904 for the sake of Paris and the sense of what a sculptor could do there. He too fashioned portraits full of pathos, enlivened by light darting across roughly modeled surfaces clearly under the aegis of Rodin. Karl Albiker, Clara Westhoff, Bernard Hoetger, and Wilhelm Lehmbruck came from Germany, Elie Nadelman from Poland, Joseph Casky from Hungary, and Jacques Lipchitz from Lithuania. Hilda Flodin came from Finland and Carl Milles from Sweden. The Russians were eager for Paris and for Rodin; they included Zadkine, Archipenko, and Natalie de Golevsky. His work had the same draw for the Americans John Storrs, Malvina Hoffman, and Gutzon Borglum. Even the Japanese came to learn Rodin's lessons before the decade was through. When Ogiwara Morie saw the enlarged *Thinker* in 1904, he decided to give up painting and become a sculptor.

Rodin greeted the twentieth century as Canova had surveyed the advent of the nineteenth: with great confidence in the important lessons he had to teach the next generation. As Canova had given his followers line and the magnificence of marble, Rodin would teach the next generation about nature and the beauty of a personal touch in the yielding clay of the modeler's art.

Yet a quirk of history prevented Rodin from reliving Canova's triumph. The artists of the twentieth century had both a different sense of time and an altered understanding of the history of art and how to find a place within it. The ideas of a young French sculptor who worshiped Rodin, though he never met him, throw light on the situation. Henri Gaudier (Gaudier-Brzeska) created his first important statue, *Saint John,* in response to Rodin's. Soon, however, he destroyed it as "only a poor imitation of Rodin." In 1910 he explained his reasons to a German friend: "We shall never again see as great a sculptor as Rodin. . . . With *The Thinker* he attained the summit, and one cannot mount higher. Rodin remains for France what Michelangelo was for Florence. He will have imitators but never rivals. . . . But this is fatal, because such personalities bleed a nation to death; they leave no other alternative save imitation or veneration."[32] By 1910, a broad selection of the best young talents in modern art agreed.

Between 1877, when Rodin and Rose Beuret returned to France after seven years in Brussels, and 1896, when they moved to Meudon, they lived in six different apartments, five in Paris and one in Bellevue. None was really "home." When Truman Bartlett visited them in the rue de Bourgogne, he was astonished at the shabbiness of their quarters. He understood why Rodin never invited anyone there and why most of his collaborators did not know he had a wife. Rodin's social life took place in public and in other people's homes. It was rare that he took Beuret along.

The situation began to change in 1893, when Rodin's decade-long affair with Camille Claudel ended. We shall probably never be completely sure whether Rodin's decision to leave Paris was a consequence or a cause of the end of the affair, but surely the two events were related. By the summer of 1893, Rodin had found a house he thought of as home. It was called the Villa des Brillants and was situated on an isolated hill in Meudon, a village south of Paris. Three things recommended the house to Rodin: its former owner, a painter, had added an atelier to the side, the site was splendid, and there was good transportation from Paris by either boat or train.[1] The house was surrounded by a rich array of trees and bushes. Rodin had a passion for nature, which he had never before been able to indulge. He proudly wrote Helene von Hindenburg, "My hill

147) The Villa des Brillants in Meudon, c. 1893

flowers on every side" (April 23, 1905). From the edge of the terrace he could see the Seine meandering toward Rouen, the trains crossing the viaduct, the smokestacks of new factories in the valley below, and, in the great distance, the profile of Mont-Valérien.

The house itself was not grand—"an unpretentious little red brick villa" was how an American journalist described it.[2] "Definitely not beautiful," said Rainer Maria Rilke.[3] When Paula Modersohn-Becker saw it for the first time in 1903, she wrote her husband: "The building where he lives is small and confined and gives one the feeling that the act of living itself plays hardly any role for him."[4] But Rodin had never lived in anything so fine, and he loved his house in Meudon.

The nineteenth-century architect who designed the Villa des Brillants worked in a picturesque seventeenth-century revival style, emphasizing the high-pitched roof, dormers, chimneys, stone quoins at the corners, and stone chains framing the windows of the rez-de-chaussée and the upper floor. The atelier was the only large space; the rest, including the salon, the dining room, and the five bedrooms on the first and second floors, was modest. The kitchen was in the basement.

In September 1893 Rodin was negotiating to rent the house for 2,000 francs a year. This did not work out, and only in December 1895 did he sign a contract to purchase the villa for 27,300 francs. The house was not in good shape and Rodin and Beuret had little furniture, so they still did not live well or entertain. Few of Rodin's acquaintances visited Meudon before 1900.

Early in 1901 Rodin negotiated with his next-door neighbor, M. Dabermat, to buy the land between their houses. Dabermat wrote to Rodin that he was "not opposed to the construction of your pavilion from the exposition on the edge of the way that separates our properties" (Feb. 27). They agreed on a price of fifteen thousand francs; Rodin had the land registered in Rose's name. As demolition of the pavilion in the place de l'Alma got under way, Rodin engaged the architect Louis Sortais to reconstruct it in Meudon, at a cost of over forty thousand francs.

This building changed the whole character of Rodin's existence in Meudon. Even before the work was finished, Rodin was eager for friends to visit him in his paradise. He wrote to Camille Mauclair: "Couldn't you and Madame come for lunch in Meudon Val Meudon, avenue Paul Bert? I think I can be a little organized about my pavilion transported from Alma" (August 1901). An early visitor came away describing the "new musée Rodin in Meudon, its bright luminous colors, the way it dominates the valley of the Seine. From far away you can see the elegant arcades of the loggia that make up the facade. From down in the valley, where the river follows its peaceful course, . . . you look up and see this serene edifice, a temple of great art."[5]

Living in the midst of all his creations was deeply satisfying for Rodin. He seems to have felt more whole after joining his public and private spheres. When the pavilion was finally up and he could work there, Rodin moved his personal effects into the small atelier in the house, purchasing a huge, carved four-poster bed that still occupies the

148) The Villa des Brillants after the reconstruction of the Pavillon
de l'Alma in 1901

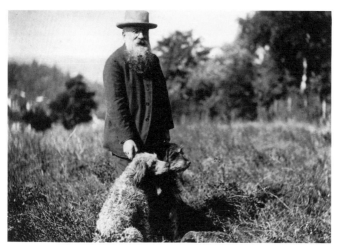

149) Rodin with his dogs in the garden at Meudon, 1904

pavilion today. It allowed him to sleep and work intermittently, and to slip out into the garden at dawn—a practice that gave him enormous pleasure: "At dawn, leaning on the balustrade in my garden, I think of the peace of our friendship," he wrote to von Hindenburg. The sounds of ducks and dogs, the sight of swans swimming in a basin that Rodin had constructed, enlivened the garden of the Villa des Brillants. It was there that he felt most himself.

Every year Rodin made improvements in Meudon. In 1904 he arranged for electricity to be installed (electric lighting had only become available in Meudon in 1903), work was done on the paneling, he had plumbing put in and the bricks repointed. In the same year he began enthusiastically buying antique sculptures, finally having a place to put them. In 1905 he invited Mme Mauclair to come see both his "new studies" and his "museum of antiquities" (Sept. 1). Under the arcade of the entrance, Rodin distributed Greek and Roman sculptures in a spirit that owed much to his recent visits to Italy. His own work now mingled with the ancient sculptures to which he responded with so much rapture.

In 1906, when Rodin heard that Louis de Bourbon-Conti's seventeenth-century château in near-by Issy-les-Moulineaux was to be pulled down (it had been burned in 1870), he offered twelve thousand francs for the best fragments, including the sculptured pediment, entablature, columns, ironwork, consoles, and keystones. He had the

150) Rodin in front of the facade of the Château of Issy-les-Moulineaux, after 1906. Photograph by Harlingue.

ensemble reassembled in his garden to further enhance the grandeur and make a museumlike setting of his home.[6]

Whatever grandness there was to the Villa des Brillants, however, lay in delights of the eye, not in the lifestyle of its occupants. When Rodin's new secretary, Anthony Ludovici, arrived from England in June 1906, he could hardly believe the lack of grace and comfort in the dining room: "But for a dozen white straight-backed chairs and a trestle table, the room was entirely bare; the walls, which were of a pale, even colour, stretched out on all sides with nothing but a picture by Falguière to relieve their reposeful monotony, and the floor was uncarpeted." Rodin noticed his new employee's astonishment: "You see, when I open the windows and the light and the landscape flood the room, it partakes of the pensive stillness of Nature. No obtrusive and artificial objects prevent it from harmonizing with the fields and hills about me." Warming to the subject, Rodin warned Ludovici not to expect to find English easy-chairs in his house. In fact, he did not approve of the "folded-up self-indulgence of English comfort which such articles of furniture encouraged." Nor did he "approve of half going to bed at all moments of the day."[7]

Few visitors to the Villa des Brillants can have overlooked the simplicity of the life lived within its confines. With Ludovici, Rodin felt defensive, so he took the offensive. He was also breaking a new employee into the idea that work—hard work—was to be

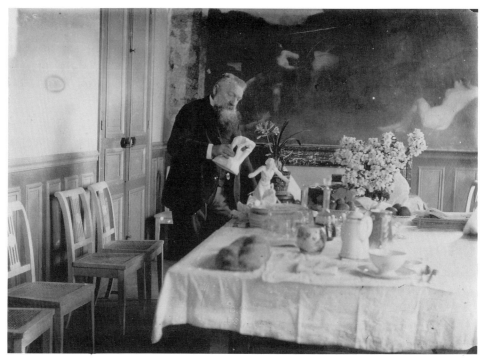

151) Rodin in his dining room at the Villa des Brillants, with painting by Falguière in the background

152) Rodin and Rose Beuret with their dogs in the garden of the
Villa des Brillants

the rule. But when Gustave Coquiot brought up the same issues, Rodin said more simply that he felt money had come to him too late to learn the ways of cultivating the pleasure of material things.[8]

Then there was the matter of Rose Beuret. She was now in public view. After 1900 everyone knew her. They gossiped about her. They talked about her terrible appearance and her menial position in the household. A characteristic story went like this:

> One day, when some friends were dining with Rodin, one of them said to him in confidence: "Monsieur, why don't you get rid of this terrible old woman who prowls about the place? What you need is a fresh young housekeeper who would make your life worth living."
>
> Rodin seemed to enjoy the joke immensely and often told afterward how discomfited his friend looked when the sculptor explained that the terrible old woman was none other than Mme. Rodin herself. And thus Mme. Rodin became known as the artists's wife—but she . . . never took part in any of the entertainments; always waited on the table; did the cooking and the housework, all as a matter of course.[9]

From all reports, it was Beuret's choice to perform the menial tasks of the household. In 1902 Rodin asked Emilia Cimino to find a servant. Cimino wrote that she had located a "good strong peasant" who she was sure would "take orders from her mistress." Cimino also thought this girl would work out because "your position as a great artist will not even exist for her. She will think of your works as insignificant plasters" (April 2).

During his six months at Meudon, Ludovici observed the constant stream of visitors and how they upset Beuret's wish for a "peaceful rural retreat." One day, when the

minister Georges Leygues was expected for lunch, Rodin caught a glimpse of Beuret in a crimson silk dress. Not wanting her to show up inappropriately dressed, yet not wanting to confront Beuret himself, he instructed his secretary to see that she changed into something more discreet.

The first time Rilke saw Beuret, in 1902, he described her as a woman with "gray curls, dark deep-set eyes, thin, unkempt, tired, and old, tormented by something."[10] At age fifty-eight, Beuret had much to be tormented about; she was isolated in a servant's position in her own house, which was now full of visitors who rarely came to see her and who often made her feel ill at ease. Her feelings were usually expressed through outbursts of anger. But there was no doubt about her importance in Rodin's life. As far as he was concerned, even though they were not legally married, she was always "Madame Rodin." When he wandered away, as he did more and more frequently after 1900, he would write her brief epistles of concern. From Düsseldorf in April 1904: "Stay in bed in the mornings." From Strasbourg in March 1907: "I worry about you and I'll come back to see you on Tuesday or Wednesday." But Beuret was never an equal, nor did they share quarters in the Villa des Brillants. She gave him no companionship in the parts of his life that mattered the most. For that, Rodin turned to other women, keeping Beuret in the position of a desexualized mother who tended his hearth and home. Perhaps Rodin's resistance to making a commitment to a normal family life was a form of loyalty to his beloved sister, Maria, the other child who also did not wish to define her life within a family structure.

Beuret's place in this problematic household seemed awkward to most outsiders. At times Rodin tried to explain her, but he never apologized for her. Once settled in Meudon, he tried to come to grips with the other deep problem in his life—the son he had never acknowledged. By the time Auguste Beuret was in his thirties, his army unit had been assigned to quarters near Saint-Ouen, just north of Paris. He was continually in bad health—at one point in 1898, he told his parents he could not come to see them because his rheumatism made it impossible to walk. He was never able to make ends meet, so Rodin seems to have struck a bargain with him: he would pay his son to do drawings. On December 31, 1900, Auguste sent a New Year's greeting to his parents, saying that he had seen the illustrated catalogue of Rodin's 1900 exhibition and that he was enclosing drawings he had made after the illustrations. In 1901 he told his father that he was reading Dante and making drawings based on the text. It is clear that Auguste was avidly interested in pleasing his father; nevertheless, when Rodin invited him to come and live in Meudon, Auguste turned him down. "My dear parents," he wrote, "I'm going to stay in Saint-Ouen, where I shall continue to work for you. I cannot get used to the chateau. I sent you yesterday's drawing, which is really not like I want it to be yet" (Nov. 21, 1901). From all reports, Auguste was awkward and ill at ease in company; we can understand why he was not anxious to join his parents in the Villa des Brillants.

Ludovici has left us a record of what he saw as a typical day in Rodin's life. By dawn Rodin was up and waiting for his hairdresser—someone came up from the village each

day. He expected his secretary right after breakfast. "Rodin never liked to spend more time over his correspondence than it took the barber to complete his hairdressing; consequently our first business interview of the day usually terminated with the little barber's 'Voilà, Monsieur, c'est fini.'" Rodin received guests in the studio in the morning. If there were unexpected visitors, and especially "ladies of either English or American nationality," Ludovici would go ahead of the group and cover the more indiscreet sculptures with cloths.

After a simple midday meal, Rodin took the train to the rue de l'Université, where he would either work with a model or receive more visitors. Ludovici noted that "the greater part of his time while I was with him was occupied by busts of wealthy or well-known people from all over the civilized world." Rodin was back in Meudon by six: "Now was the most critical hour of the day for me, for it was at this time that he signed the letters, and attended to all such questions as the payment of workmen and models, outstanding accounts and the moneys received from clients." In the evening Rodin would walk in the garden, alone or with his favorite dog, sitting, looking "across the valley of the Seine to Sèvres." Then he would meditate. Ludovici described the quickness with which he was once rebuffed when he tried to engage in small talk on such an occasion.[11] What Ludovici saw and described was the life of the sculptor/entrepreneur. In actuality, Rodin's life was more complicated than this tidy young secretary perceived, but many of his days did follow something like this rhythm once the struggle and uncertainty of his previous life had been settled.

Who were these visitors, what did they come to see, and, more pointedly, whom did they come to meet? At first, they were mainly German. Germans had dominated the exposition of 1900. Their exhibits stood out in size and grandeur, and they came in hordes, flooding the aisles and halls and bearing witness to the triumph of German ingenuity. In 1900 Rodin met the painters Carl Moll and Max Liebermann, the sculptors Max Klinger and Bernard Hoetger, the philosopher Georg Simmel, the ophthalmologist-collector Max Linde, and the diplomat-collector Count Harry Kessler, who introduced him to Sophie and Helene von Hindenburg.

Soon Rodin's English and Irish visitors outnumbered the Germans. By 1908 the writers Arthur Symons, George Moore, and George Bernard Shaw had been to Meudon. The Stephens girls, Vanessa and Virginia, were there as early as 1904.[12] There were wealthy leaders of society, such as Ernest Beckett (by 1905, Lord Grimthorpe); George Wyndham, the chief secretary for Ireland; Charles and Mary Hunter (who made their fortune in coal); the South African mining magnate Charles Davis and his wife; the duchess of Bedford; the duke and duchess of Somerset; Lord Howard de Walden; Lady Warwick (until 1898 the mistress of the prince of Wales); and Edward VII himself.

Constant talk of Rodin in the press gave prospective visitors a good idea of what to expect even before they laid eyes on the studio or the sculptor. They knew that he was a great *solitaire,* that he was not just a sculptor but a seer, a force of nature. "Nature is his mistress, his queen, his lover," Charles Morice wrote in 1900. He was considered as

much a poet as a sculptor, and specifically a poet of *la douleur* and *la passion*. By adopting sexuality as a guiding principle and infusing his sculpture with movement, he had managed to capture the very "life of the soul."[13]

In spite of his lionization in the press, visitors regularly used the word *simple* to describe Rodin's lifestyle. The Austrian writer Stefan Zweig, who met Rodin in 1905, remembered that during his day in Meudon he learned two important lessons about great men: that they are kind and that "nearly always they are the simplest in their manner of living. In the home of this man, whose fame was universal, and whose work was as familiar to men of our generation as an old friend, we ate as simply as at a plain farmer's; a good piece of meat, a few olives and copious fruit, and *vin du pays*."[14] The American photographer Gertrude Kasebier wrote that she had "learned most from simple people, from their primitive qualities and among these simple people are some of the greatest I have ever known. Rodin is one of them."[15]

Rodin's visitors also knew in advance what he would look like: they knew that he was unusually short and had "the great beard of a sapper" (l'immense barbe de sapeur). And he was vain about his beard, as we know from Ludovici's account of the daily trimmings, singeings, scentings, and brushings.

Among all the people who showed up in Meudon, however, two Germans counted the most: Helene von Hindenburg was Rodin's perfect soulmate, while Rainer Maria Rilke became his greatest disciple and, in a sense, a son—a successful son. These two encounters were rich and fulfilling for Rodin. They took place because of the energy and attention of two curious and imaginative young foreigners. *They* chose him. This is not surprising. What is surprising is that he was waiting to be chosen.

Sophie von Hindenburg, daughter of the German ambassador to Paris and wife of a Prussian general, met Rodin at his exhibition in 1900. Her twenty-three-year-old daughter, Helene, loved the show even more than her mother; in fact, she regarded it as "a miracle," one that had opened a "new world" before her eyes. Rodin responded by proposing a second visit, at which time he presented her with a flower from his garden and an invitation to Meudon.

The von Hindenburgs were from Berlin, but their spiritual home was Italy, where they had a villa on the Tuscan coast. In the fall of 1901, Rodin set out for Tuscany to purchase marble and wrote to the von Hindenburgs requesting "the pleasure of greeting you next week on my way to Saravezza-Carrara." He spent a week with them, walking by the sea and taking excursions to Lucca and Pisa in the company of Helene. "After our walks," she recalled, "we often sat in the white hall [of the villa] and I had to play for Rodin, or my mother sang arias by old Italian masters. . . . Sometimes he had a bit of paper in his hand and sketched while I played. More often the room was filled with the weight of his silence."[16] The week was a vast success, and Rodin returned a year later. These two visits remained in Rodin's mind as a magical memory, a rare time when he was able to share his love of art, music, the landscape, and to participate in a deep friendship: "I take away the seashore and those divine evenings as a new force, a new youth. I shall not lose it and I'll put it all into my poor sculpture" (Nov. 22, 1902).

By 1902 Rodin was completely dedicated to his correspondence with a woman thirty-eight years his junior, one whom Hugo von Hofmannsthal called "the most gracious and beautiful woman in all of Germany." As far as we know, Rodin never wrote another human being such touching letters. They reveal in a way that no other correspondence of his does the intensity of his need for a special person with whom he could share his inner life. Helene von Hindenburg's letters are also extremely sensitive—certainly written in better French than Rodin's—but they do not come near exhibiting the depth of feeling in Rodin's letters.

Von Hindenburg sent Rodin a poem commemorating their promenade to Castiglioncello. He wrote back that he would hold it like a "talisman" against "all these changes that lie in wait for us." He saw himself as "a bad captain of my life, and if I don't shipwreck, whom should I thank? I am looking at the little image that we bought together and this other card from Florence! Image of peace! That garden, those delicate arcades, soaring, all in a row like happy days." He added in a postscript: "I have no friends, I will perish alone; but I know God is closer to me in my art than in other people. I go on without fear because I have always understood that" (late 1902).

Rodin confided his feelings about aging to the young woman: "Everything must die, I'm resigned to it, but at my age, when I see so much delightful nature before my eyes, with all its charms and its seasons, I am astonished to be so old when I look in my mirror" (June 5, 1905). He wrote about God and women, two subjects of acute interest for him: "God is too great to send us direct inspiration; he takes precautions relative to our weakness and sends us earthly angels. . . . For an artist, a soft woman is his most powerful dispatch, she is holy, she rises up in our heart, in our genius, and in our force, she is a divine sower who sows love in our hearts in order that we can put it back a hundred times into our work" (November 1903).

In 1904 Helene von Hindenburg married a diplomat from Saxony, Count Alfred von Nostitz. The marriage did little to alter the intimate exchange between the two friends. When Rodin would pass through periods of fatigue and misgivings about himself, he continued to share his feelings with her. She offered him a quiet room in her new home; it would always be waiting for him. "But am I made to live in such a paradise?" he responded. "Yet I would wish it. But there is something wrong with me, I don't know how to get on with happiness" (May 11, 1906). This extremely depressing letter was written less than twenty-four hours after Rodin had dismissed Rilke as his secretary. He did not mention this incident, however.

In speaking about his pain, Rodin seldom described actual events; he preferred abstractions. When von Nostitz asked about his health, he wrote: "Life is a mosaic of black stones." Although he owned up to his unhappiness as being his own fault—"The bad things in my life come from me" and "These bad moments are the flower of the seeds that I have planted"—he gave few details about daily dilemmas. There was one theme, however, to which he often returned as a primary cause of his dejection: "*La volupté* [sensual pleasure] is too important in our time, and it is called *la douleur* [suffering]. It is true that suffering with the person you love is a kind of voluptuousness, as

Francesca da Rimini, the saint of love, has told us. Do you want more details? I feel that my life is over, I have conceived of a tower that is too tall in proportion to my force, and I tell you all this, *mon amie intellectuelle,* because you, like the Muses, have the gift of exaltation" (November 1906).

Rodin and von Nostitz remained friends until the First World War; after 1914 their letters ceased. He shared with her his fears, his longing for God and for a true love, his dark fits of loneliness, and his guilt. Rodin's words ring true and demonstrate how central suffering was to his life—suffering that increased rather than diminished once he had achieved fame.

Von Nostitz was a muse and a confidante for Rodin. She was also, like most of his younger friends, a disciple. He encouraged her music, her translations, her drawings, and taught her his creed that "nature" is the true guide. She always knew that "he wanted to be understood. He longed for pupils who would continue and develop his work. Quite often when talking with me, he admonished me to write down the things we had experienced together."[17]

No one came to Rodin wanting to write it all down as much as Rilke. Their first meeting, on September 1, 1902, was of enormous importance for both men, but only Rilke knew it at the time. For Rodin, it was just another encounter with a young foreigner, perhaps slightly more interesting than usual because Rilke had been commissioned to write a monograph on his work. Rodin had just conquered the German avant-garde with his successful showing in the 1901 Vienna Secession, Berlin Secession, and Dresden International Exhibition. Max Liebermann had hailed him as "the only contemporary genius among French artists."[18] The second-largest exhibition of Rodin's work ever mounted had taken place in Prague, Rilke's birthplace. The Bohemian Society of Manes gave Rodin a great banquet in Prague in May 1902, after which he went to Vienna and toured triumphantly through Bohemia and Hungary. These events were carefully covered in the German press.

It was not only Rodin's fame that brought Rilke to him. Rilke had recently married Clara Westhoff, the young German sculptress who had studied in Rodin's academy in 1900. Of even greater importance in his decision to meet and write about Rodin was his passionate desire to know a master, a figure who could fill his imagination with a kind of authority that his father, who now lived the monotonous life of a civil servant, no longer had for him. Rilke's travels placed great masters of the past before him; in Italy, Michelangelo became his luminous figure. In 1899 and again in 1900, in the company of Lou Andreas-Salomé, he went to Russia in the hope that it might become his true homeland, and that in the person of Leo Tolstoy he would find his master. He saw Tolstoy on both trips. In the summer of 1900 he and Andreas-Salomé, traveling with the Pasternaks, visited Tolstoy's country estate in Yasnaya Polyana. They came unannounced. They were not invited for lunch and it was unclear if Tolstoy would spend any time with them. He finally granted them a walk in the park, during which Rilke hesitantly admitted he was a poet, to which the aged patriarch responded by launching into a tirade against art.[19]

153) Clara Westhoff, wife of Rainer Maria Rilke

When Rilke prepared for his trip to Paris in the summer of 1902, his expectations were high. He arrived in August, waited a few days, and finally presented himself at 182 rue de l'Université. The two blue-eyed men sat opposite each other, Rilke observing every nuance of Rodin's look and behavior: the nose that rode out of his forehead "like a ship out of a harbor," his hands forever shaping or forming things in the air as he gestured, his laugh "embarrassed and at the same time joyful," like that of a child. "We spoke of many things—(as far as my queer language and his time permitted)." The meeting contrasted sharply with the visit to Tolstoy's home. Rodin "was extremely kind and gentle. I felt as if I had known him forever. . . . I like him very much."[20]

The next day Rilke went to Meudon, where he spent the better part of the day. Work on his book had begun. Rodin gave him the run of the place and did not bother him very much. Rilke—fresh out of Berlitz—was pained by the language barrier. He had brought his poems: "If only he could read them!" he wrote plaintively to Clara. At noon Rodin called him for lunch. Three other people were present—an old woman, a man with a red nose, and a young girl of about ten. No one was introduced. Suddenly, a fight broke out, the old woman "became quite nervous . . . and out of her mouth came a flood of hasty and violent words which didn't sound really malicious, not disagree-

154) Rilke, Beuret, and Rodin in Meudon. Photograph by Harlingue.

able, but as though they came from a deeply injured person whose nerves will snap." Rilke concluded that it was the strangest luncheon he had ever experienced. But he had made the grade. After lunch Madame, whom he now understood to be Mme Rodin, "spoke to me quite pleasantly" and he made arrangements to come the next day. He returned almost daily after that.

A week later Rilke wrote his new master a staggering letter in which he poured forth his desire to give himself up to the higher force he had found in Rodin. He knew Rodin might think it strange to get a letter from him—after all, they saw each other all the time—but when he was with Rodin, he felt the insufficiency of his French "like a sickness." So he preferred to sit in the solitude of his room and "prepare the words." He wrote some verses in French for Rodin. "Why do I write these lines? Not because I believe them to be good but out of my desire to draw near to you so that you can guide my hand. You are the only man in the world of such equilibrium and force that you can stand in harmony with your own work. . . . This work, like you yourself, has become the example for my life and my art. . . . It is not just to write a study that I have come to you, it is to ask you: how should I live? And you have responded: work" (Sept. 11, 1902).

Rodin was getting ready to go to Italy to visit the von Hindenburgs for the second time. He was gone for three weeks in October. In his absence, Rilke continued to work in Meudon. His wife, Clara, came to join him; by February, their friend Paula Modersohn-Becker was there too. She wrote to her husband that "ever since Rodin told the Rilkes, 'Travailler, toujours travailler' [Work, always work], they have been taking it literally; they never want to go to the country on Sundays." Hard work paid off; Rilke finished the book in early December. He dedicated it to Clara and had a copy in Rodin's hands before the first of April.

Rilke's *Rodin* is a hymn to genius that occupies a unique place in the Rodin bibliography. It speaks not just of Rodin; as Rilke explained to Andreas-Salomé, "it also speaks about me."[21] The two men shared many traits. Neither could stabilize a domestic life (Rilke's infant daughter, Ruth, was already farmed out to relatives, just as Auguste Beuret had been). Both were enormously active socially, but felt ill at ease with people most of the time. Though not conventionally religious, both were haunted by religious ideas and felt a link between religious exaltation, artistic creativity, and sensuality. They were both very dependent on women. And their common love of travel and new experience was part of an incessant search for some never-to-be-achieved possibility of "home." Rilke believed that great geniuses like Tolstoy and Rodin had allowed their lives to wither away "like some organ they no longer require." In the end, both men gave everything for their art. It was this commitment to the creative life that Rilke wanted to strengthen when he came to Rodin. As Leppmann says, he wanted Rodin "to cure him of his flightiness and his sterile waiting for inspiration."[22]

Rodin's response to Rilke's celebration of his genius was perfunctory: "Dear M. Rilke, Please receive my warmest thanks for the book that Mme Rilke has brought me"

(April 6, 1903). Not reading German, Rodin had no idea that he had just received the greatest panegyric ever written about his work.

For the next two years, the two men exchanged letters amiably. Rilke did most of the writing. It was a difficult period for the poet; he was in poor health, had little money, coped badly with family life. In the summer of 1905, on vacation with Andreas-Salomé in the Harz mountains, he was drifting. The actress Gertrud Eysoldt visited them and brought a letter from Rodin, who by this time had read a translation of Rilke's book. Rodin addressed his letter to "Mon bien cher ami Rainer Maria Rilke" and sent "all my affection, all my admiration for the man, for the writer who has influenced so many by his work and his talent." The letter put new life into Rilke, and he resolved to return to Paris.

Rodin invited him to stay at Meudon. When Rilke arrived in the middle of September, Rodin welcomed him as though he were a prodigal son. Rilke said the sculptor looked "like a big dog . . . recognizing me with exploring eyes, contented and quiet." Writing to Clara on the evening of his arrival, Rilke emphasized how good things seemed in Meudon: "Much more world has grown about him; he has built several little houses from the museum downward on the garden slope. And everything, houses, passages, and studios and gardens: everything is full of the most wonderful antiquities that associate with his dear things as with relatives." Rilke was particularly pleased with the new little pavilion that he was able to have for himself: "bedroom, workroom, dressing room, with enchanting things, full of dignity, and the main window with all the glories of the Sèvres valley" (Sept. 15). By the end of the week, Rilke wrote a friend: "At least for the moment I am happy." Rilke noticed how overcome Rodin was with obligations: "He is so alone and there are hundreds and hundreds of things that take up his time, and he never finds the right secretary to take care of the correspondence."[23] Rilke began giving Rodin two hours a day. It was not enough, so he went to work for Rodin in a serious way. Rodin paid him two hundred francs a month. Rilke described his duties to his friend Arthur Holitscher: "In French I write these detestable letters, but . . . also I meditate in the shadow of his great friendship, this wise and strong man who knows how to find joy."[24]

Rilke's letters to Clara give us the best descriptions we have of Rodin's family life. He placed himself in the middle of it, receiving the love that Rodin and Rose Beuret had not been able to give to Auguste Beuret. His letters of the fall and early winter of 1905 show that it was a rich time for both artists. Rose Beuret was frequently included in their excursions. "Just imagine, the last three mornings we got up very early at five-thirty, yesterday even at five o'clock, and went to Versailles." There Rodin showed Rilke everything, and they talked endlessly about his early life in Brussels, when he was "always on the move with Madame Rodin (who is a good, loyal person), in the woods, always wandering." While the two men were talking, Madame Rodin "picks flowers and brings them to us: autumn crocuses or leaves, or she draws our attention to pheasants, partridges, magpies (one day we had to go home earlier because she had

found a sick partridge that she took with her to care for)" (Sept. 20). They explored Paris—Notre-Dame and the Left Bank—walking "on to the blvd. du Montparnasse, which also for Rodin and Madame Rodin is full of memories of their very early days" (Dec. 2). They went to Chartres in the dead of winter, and Rodin explained to Rilke why the great cathedrals are always buffeted by terrible winds, "tourmentées de leur grandeur" (tormented by their grandeur). In November they celebrated Rodin's sixty-fifth birthday with a cake large enough to hold sixty-five candles. In December it was Rilke's thirty-first, and they had cakes from the shop "at the little pointed corner in the rue Racine."

On February 14, 1906, Rodin and Rilke lunched with the young Russian sculptor Prince Paul Troubetzkoy, whom Rilke had met in 1899 on his first trip to Moscow. After lunch, the three men walked in the Bois de Boulogne looking at the animals in the Jardin d'Acclimatation. These relaxed times, however, were coming to an end: "There is so much now for the Master to do." Rilke helped Rodin prepare his speech for the banquet preceding the opening of the International Society Exhibition in London. It was Rodin's second year as president of the organization. Rilke told Clara that "he has a lot of fruitful ideas, of which he wants to hand over all that is best. I must see to it that each idea is glad to stay beside the other, but I may add nothing." (Feb. 15, 1906).

In March, Rilke planned to return to Germany to lecture on Rodin. After giving talks in Elberfeld, Bremen, and Hamburg, he visited Clara in Worpswede. There he received the news of his father's death. The Rilkes immediately left for Prague, where Rilke learned that his mother, Phia Rilke, would not be joining them, as she was on vacation in the Tyrol. In a gesture betraying rather more feeling than Phia Rilke's behavior, Rodin telegrammed: "Do you have enough money?"

Tired and confused, Rilke arrived back in Meudon on the last day of March. Rodin was not only sick with a terrible grippe, he was overworked and nervous because in a few weeks his *Thinker* would be inaugurated in front of the Panthéon. Still, Rodin was immensely kind to Rilke. For his part, Rilke was beginning to think it was time to move on again, but he told Karl von der Heydt that he wanted to stay a while longer: "I cannot possibly leave Rodin now; that is . . . clear to me. My conscience would not be light enough for work of my own if I went away from him like that, unexpectedly. Especially as he has been sick all these weeks and still feels tired and low and has need of my support, insignificant as it is, more than ever" (Wednesday after Easter, 1906). As busy as Rodin was, he had agreed that Bernard and Charlotte Shaw might come in mid-April so that he could do Bernard Shaw's portrait. They started the sittings, but had to break off in the middle because of the inauguration of *The Thinker*. Rilke sat with the Shaws during the ceremony. He understood, probably better than most, exactly what the occasion meant to Rodin. It made him profoundly happy that there was "at last a place for a work of Rodin's in his home city."[25]

The ensuing weeks brought strain to the surface: Rodin was exhausted and Beuret in a foul humor. Then, suddenly, Rodin discovered that "*his* secretary" had been writing

letters to "*his* friends" (William Rothenstein and Heinrich von Thyssen-Bornemisza) with a familiarity that was totally unacceptable for an employee. He fired Rilke on the spot. Rilke wrote Clara as soon as it happened, but "only a short . . . letter, because I have a big task; . . . to pack up and move out of my little house into the old freedom with all its cares" (May 11, 1906). Rodin wrote the same day to Hélène von Nostitz that his "spirit [was] worn out from this incessant strife," but he did not say what the strife was about. The following day Rilke wrote to Rodin from a hotel in the rue Cassette. He was stunned; he had always understood that Rodin was inviting him to consider his friends as their "mutual friends. . . . Here I am, dismissed like a thieving servant, unexpectedly, from the little house where, before, your friendship had gently installed me. It was not to your secretary that you gave those familiar quarters I am profoundly hurt by this."

This episode reveals the complexity and anger beneath the surface of Rodin's immense charm. It makes us wonder about his kind and fatherly ways; perhaps they were not as "simple" as they seemed. It is an incident to which we shall return.

Chapter 29
The Favors of Edward's Court

In the summer of 1901, Camille Mauclair told Rodin he had written an article about "the psychological issues" in Rodin's work. To explain Rodin's sense of the mysteries of female sexuality, Mauclair focused on his "profound and violent sense of the voluptuous." Rodin was delighted, hoping the study would be read by the people of "Berlin, Dresden, in Germany in general, in Vienna, Budapest, and in Venice, where they begin to like our art, and in London and also in New York" (Aug. 21, 1901). He recognized that his international audience needed help in understanding certain aspects of his oeuvre, and none more than the British, who, after the Germans, were his most enthusiastic followers. We have already seen how keenly interested young artists in England and people like William Ernest Henley were in the early 1880s. Rodin's twentieth-century English partisans were of a different stripe, however; their ranks were dominated by wealth and title.

William Rothenstein was the transitional figure between the two groups. The twenty-five-year-old artist met Rodin in 1897 and saw him "through a prism of hero-worship." He was surprised, even embarrassed, when Rodin was so friendly, inviting him to "come and stay with him at Meudon."[1] One of a number of young artists who looked with envy at the Secessionist exhibitions in Germany, Rothenstein tried to encourage modern art in Great Britain by bringing in the work of foreign artists. He did it through a new organization called the International Society of Sculptors, Painters, and Gravers. In late 1897, the members chose James McNeill Whistler as their first president and designated Albert Ludovici (father of Anthony) to serve as their envoy to Paris, in charge of rounding up French artists for their first exhibition. Ludovici visited Rodin for the first time in March 1898, when Rodin could think of little else but *Balzac*. He was dismayed that Rodin offered him a female figure with her "legs apart" (Iris from the Hugo monument); Rodin called it his "flying angel." Ludovici returned with Whistler in tow, hoping to talk Rodin out of sending the work to the show. Rodin, however, was adamant. Privately, Whistler told Ludovici that they could "take it and stick it in some corner," but Ludovici worried that the figure could create such a scandal that it might close the entire exhibition.[2] Ludovici knew his prudish countrymen all too well; only a decade earlier, they had branded Zola's entire oeuvre obscene and taken all his books out of circulation. To its credit, the society would later continue to show Rodin in its annual exhibitions, even when his work made the members nervous.

Rothenstein participated in a second effort to get Rodin's work before British eyes. With a group of his friends—Alphonse Legros, John Tweed, John Singer Sargent, D. S. MacColl, and the wealthy collector Ernest Beckett—he initiated a subscription to buy a

work from Rodin for the South Kensington Museum (now the Victoria and Albert). Rodin felt honored and agreed to sell them a "beautiful bronze" for four thousand francs.[3] They decided on *Saint John,* and the *Saturday Review* supported the subscription campaign. In less than a year, more than enough money had been raised. Tweed wrote that he hoped Rodin would have "the goodness to accept the additional 2,500 francs" that had come in.

The transaction completed, Rodin's supporters planned a celebratory dinner at the Café Royal in London on May 15. Tweed to Rodin: "M. George Wyndham will preside, the French Ambassador will be there and my wife and I would like you to stay with us" (March 1902). Rodin at first declined, for his big exhibition in Prague would open on May 10. But Tweed begged him to delay his trip to Czechoslovakia "or the dinner [would] drop into the sea." So Rodin acquiesced.

The banquet at the Café Royal was Rodin's official entrance into English society. Two hundred men representing some of the most important ranks of British art and politics were invited. The chief secretary for Ireland, George Wyndham, who had visited Rodin in his studio in 1901, offered a toast and gave the first speech. He was followed by Paul Cambon, the French ambassador, and MacColl. Rodin mingled with the likes of Whistler, Henley, Sargent, and Alma-Tadema. The highlight of the evening, however, came when the students from the Slade and South Kensington art schools unharnessed the horses from Rodin's carriage and drew him "from the Café to the Club—Sargent on the box. Everyone, boys & all, were invited to supper, Wyndham again presiding & magnums of champagne were still flowing when I left." This was how Adrian Stokes described it to Rothenstein, who was in Berlin at the time. He was sure Rothenstein would have loved the speeches, and especially the way "Rodin read his dear little schoolboy effusion from half sheets of note paper pinned together & constantly lost his place."[4] Stokes's arch description illuminates Rodin's appeal to this sophisticated crowd. They liked his simplicity, but at the same time they found it amusing and frequently made fun of it. Rodin's German audience, by contrast, considered his "natural" artistic personality profound and moving. Rodin never quite understood how vast the difference was between his two major groups of admirers.

Rothenstein was instrumental in the second important acquisition of a Rodin sculpture in the British Isles. In the summer of 1900, he told Rodin that one of the most distinguished archeologists in the world wanted to buy one of his works. If this happened, he told Rodin, his piece would be the only modern sculpture in a truly fabulous collection of antiquities. The collector was offering twenty thousand francs for *The Kiss* in marble. Rothenstein finally revealed that his friend was Edward Perry Warren, an American from a distinguished Boston family who now resided in Sussex. Rodin said he would have to charge an additional five thousand francs for the purchase of the marble. The terms were worked out in a written contract that included the extraordinary stipulation: "The genital organ of the man is to be represented in its entirety." In the plaster version, this part of the male anatomy was left without detail. Such vagueness

would never do for a work bound for Lewes House, where the spirit of the day was a forthright depiction of manliness, as candid as that of the ancient Greeks.[5]

In 1903 Rothenstein took Rodin to Lewes House. The sculptor was enchanted with Warren's collection, since he himself was at a peak of excitement about purchasing Greek sculpture. One work in particular caught his eye: a head of Aphrodite. When he found he could not get it out of his mind, he wrote to both Warren and Warren's friend John Marshall to propose an exchange: the head for two Rodins—"I propose the figure with her legs spread (*Iris, Messenger of the Gods*) in bronze and a Danaïde in marble. Would these two works attract you, or is there another combination I could propose?" (Sept. 18, 1903). He also asked if Marshall, a distinguished expert in Greek art, would be his guide on a trip to Greece. Warren rejected the exchange, however. He knew *Aphrodite* was too special and he intended to give it to the Boston Museum of Fine Arts, for which he was the official scout.

By 1904 England could boast of only one Rodin in a public collection: *Saint John* in South Kensington. It was not much in comparison to the eighteen Rodins in the Albertinium in Dresden. The English were interested in Rodin as a representative of modern art, but neither aristocrats nor nouveaux riches seemed enthusiastic about purchasing his work. By contrast, the Danish brewer Carl Jacobsen owned ten Rodins by 1910, including full-scale casts of *The Burghers of Calais* and *Victor Hugo,* and a marble *Kiss* like the one Warren owned (except, of course, for the "genital organ"). Max Linde of Lübeck now owned eight Rodins, and Charles T. Yerkes, the Chicago "Traction King" who built the elevated "Loop," had already bought two marbles from Rodin by 1894. England had no such affluent collectors willing to take risks on Rodin.

After 1902, however, Rodin felt confident enough to suggest to Tweed that it was time for an official one-man show in London. Tweed talked it over with Lord Windsor, who expressed interest but wanted "the particulars in order to submit it to other members of the government" (Oct. 18, 1902). Nothing more was heard of the project. Again, the contrast with Germany is striking: in 1904 major exhibitions of Rodin's work were held in Düsseldorf, Dresden, Weimar, and Leipzig.

If the British were conservative with their pounds, they were forthcoming with hospitality. "The students at the Slade want to know if you will come back to London because they want very much to give you a supper," Tweed wrote in the summer of 1902. Despite his ambivalence about such public occasions, Rodin returned to London the following May. The students invited Albert Gilbert, Britain's most prominent sculptor, to preside at the dinner. A crowd of admirers pressed around Rodin, who looked to Gilbert "as though he wished himself elsewhere." After the speeches, Gilbert got the feeling "on the part of our guest and myself, that each was the other's victim." When dinner was announced, he offered Rodin his arm, only to hear his visitor murmur, "in suppliant tones, '*Ayez pitié de moi, je ne sais pas faire des discours*' [Have pity on me, I don't know how to give speeches]".[6]

A week later Rodin was the guest of Sir Edmund and Lady Davis. They had just

bought a group in marble called *Broken Illusion;* Rodin had promised to help place it in their vestibule (May 7, 1903). The painter Charles Ricketts was there and remarked on the contrast between Rodin's powerful appearance and his "small polite voice." He indicated that Rodin's eye was "a little *troublé*"; he suspected the sculptor "felt he was in for being bored, and was politely apathetic the whole evening."[7] Since Rodin neither spoke nor understood English—or any other foreign language, for that matter—such occasions were extremely difficult. Anthony Ludovici took pleasure in describing Rodin's mispronunciation of English names, such as "Ovardevaldant" (Lord Howard de Walden) and "Bernarre Chuv" (Bernard Shaw).

Nevertheless, Rodin put heart and soul into accommodating his British public. He was as carried away as the next Frenchman in his adulation of British aristocracy. It became even keener after Edward VII visited Paris in May 1903. A Belgian minister in Paris at the time observed, "Seldom has such a complete change of attitude been seen as that which has taken place in this country . . . towards England and her Sovereign."[8] In general, Westerners living in late Victorian and Edwardian times granted the "English gentleman" a much grander place than the ordinary man, saw that he moved with greater élan and betrayed a surer sense of doing things "the right way." Henry Adams agreed with Horace Walpole that next to English society, French society looked rather "thin," and that "hardly one country-house in France would be considered more than a second-rate house in England."[9] It was extraordinary for Rodin to wake up one day and find himself the toast of this race of gods and goddesses.

Whistler, who had done so much to forge artistic ties between London and Paris, died on July 17, 1903. Rodin, having been the toast of the town only a month before, was spontaneously nominated to succeed him as president of the International Society of Sculptors, Painters, and Gravers. Following his unanimous election, John Lavery, the society's vice president, and Albert Ludovici went to Meudon to "request him to honour us by accepting the Presidency of the Society." Rodin accepted in the same spirit, noting that it was "the first time a sculptor had been invited to be President of a distinguished Art society."[10]

The presidential banquet took place on January 9, 1904. Jacques-Emile Blanche traveled with Rodin to London. They were to meet at the Gare du Nord. Blanche knew Rodin would be punctual, even though "he wore no watch and appeared to live on another planet." He found Rodin waiting in the exceptionally cold weather, wearing "a fur-lined coat with an astrakhan collar. A white silk scarf entwined about his long fair hair that was going grey and his stream-like beard, enwrapped him up to the ears. His old ironed top-hat . . . seemed like a shoot growing from his highly polished boots that were just visible above his snow-shoes." The dining car was too warm, so Rodin took off his coat, revealing a frock coat that looked like a diplomat's, "blossoming with the rosette of a Commander of the Legion of Honor." Rodin told Blanche he had brought his "foreign orders . . . just in case I have to appear at Court," and that "when I go to London, which is an aristocrat's city, I dress as I do when I go to garden parties at the

155) Rodin in the New Gallery in London at the time of his installation as president of the International Society of Sculptors, Painters, and Gravers, Jan. 9, 1904. Photograph by the London Stereoscopic Company.

British Embassy."[11] The next week Charles Ricketts met Rodin in the home of Sir Edmund Davis. "Rodin . . . is like a child over his election to the presidency of the International,". he noted. "He thinks he holds England in his hand!!!"[12]

None of this socializing was easy for Rodin. Young Anthony Ludovici remembered the installation banquet, the first time he had laid eyes on the man who would soon be his employer: "I could not help wondering why, on that occasion, he sat so silently throughout the speeches. I remember he was asked to reply to the many kind things that were said about him, but all he did was to rise from his chair and bow three times in succession."[13]

Londoners were now eager to know the work of the new cultural lion. Neither *Saint John* in South Kensington nor the six works shown in the 1904 exhibition of the International Society satisfied them. The English were pleased to see the enlarged *Thinker* dominating the central court of the society's new headquarters on Regent Street. It was the first time Rodin had showed the new version of the central figure from *The Gates of Hell*.

156) Eve Fairfax

Rothenstein recalled in his memoirs that he began to see less of Rodin in this period: "Rodin had now become a European figure; going from capital to capital, receiving homage, sitting at banquets and, what was still more agreeable, selling his work to the great museums. It is perhaps as well that a good artist should have his measure of success early, for coming later, success may take too important a place in his life. It did in Rodin's; his head was a little turned, he played up to worshippers and became something of a social lion and, worst of all, he spent overmuch time as his own showman."[14]

Although the British were still not anxious to buy Rodin's daring groups and figures, they had their own way of responding to his work. The same kind of people who lined up to have their faces and figures painted by Sargent now arrived at Rodin's door. He did more portrait busts of English people in the twentieth century than of any other national group, including the French. George Moore captured the spirit of the enterprise in 1905, when he tried to get Lady Nancy Cunard to order a bust of herself: "Rodin is a man of sixty-five, so I would advise you to get the bust done this summer. When Rodin's hand begins to fail and his eye begins to see less clearly there will be no more sculpture. The opinion of every artist is that no sculpture has been done since antiquity that for beauty of execution can compare with Rodin's. . . . I would remind you that motor cars and hunters are passing things and drop into wreckage: but a bust outlasts Rome."[15]

The first Englishman in the twentieth century to commission a bust from Rodin was Ernest William Beckett, a Conservative member of Parliament and heir to a banking fortune and the Great Northern Railroad. He was a connoisseur, a gambler, and a great lover of women. His mistress in the early 1890s was Alice Keppel. By the beginning of

the twentieth century, Mrs. Keppel was the king's mistress and Beckett had moved on to the beautiful Eve Fairfax, whom he hoped to marry.[16] In February 1901, he asked Rodin to do a bust of her like the one he had seen of a young "French" woman (probably the portrait in the Musée du Luxembourg of Mme Vicuña, who was Chilean), with "the head, the throat and the tops of the shoulders . . . in a single piece of marble" (Feb. 29, 1901). Rodin quoted a price of twenty-two thousand francs.

Fairfax came to pose in the spring of 1901. "Rodin liked me very much," she said, not understanding that he liked every beautiful woman. When she returned home, she wrote Rodin that she hoped her bust would be "one of the most beautiful" he had ever made, adding, "With me as your model one will see what a marvelous man you are" (Sept. 17, 1901). At the end of the year, Beckett wrote that Fairfax was busy and could not return to Paris just then. He added: "I find I am not in shape to pay 22,000 for the bust. Could you do it for 10,000? If not I prefer to put it off until next year."

The sittings recommenced in 1903. Both Fairfax and Rodin took pleasure in their hours together. He complimented her on the "generous turn of her wit as well as her body"; he was touched by her "genuine greatness," which he discovered as he worked

157) Rodin, *Eve Fairfax*. 1903. Marble. Photograph by Bulloz.
Musée Rodin.

on her "beautiful and melancholy portrait." Once she had departed, it took Rodin two months to finish the portrait. He wrote that he needed time to let the work "germinate," and so that her "beauty and character might work upon [his] soul." He thanked Fairfax for helping him create a "masterpiece."

In 1904, Beckett canceled the commission, realizing that Fairfax would not marry him after all. Rodin, however, was far too enthusiastic to let it go, and he ordered the marble. It was not quite right. He asked Bourdelle to carve a second version, then a third and a fourth (*La Nature* in the collection of the Fine Arts Museums of San Francisco). In 1907 Rodin gave one of the marbles to Fairfax as a present, a "souvenir of your time in Paris" (May 27, 1907).

The next Englishman to approach Rodin for a portrait was George Wyndham. He had enjoyed a dramatic rise in Tory politics, becoming chief secretary for Ireland at age thirty-seven. He was socially prominent, immensely charming, handsome—Sarah Bernhardt thought him the handsomest man she had ever seen—and hunting and art were among his many passions. In 1903, Wyndham scored his most important political victory—passage of the Wyndham Land Purchase Act enabling more Irish to own their own land—and began to consider commissioning a bust from Rodin. In the spring of 1904, he spent a week in Paris and reported to his sister Pamela: "For Whitsuntide I go to Paris to be 'busted' by Rodin."[17] By May 24 he was installed in the Pavillon de Bellevue and spending "four or five solid hours a day" with Rodin. He would hold the pose for fifteen minutes at a time, and then he and Rodin would talk for ten: "We run over the whole Universe lightly but deeply." Wyndham recorded his impression of what Rodin said in French: "La beauté est partout; dans le corps humain, dans les arbres, les animaux, les collines, dans chaque partie du corps, aussi bien dans la vieillesse que dans la jeunesse. Tout est beau. . . . La femme, c'est la couronne de l'homme. La vie, l'énergie c'est tout" [Beauty is everywhere; in the human body, in trees, animals, hills, in every part of the body, in old age as well as youth. Everything is beautiful. . . . Woman is man's crown. Life, energy is everything]. He concluded that Rodin was "a very great man and the greatest Dear" (May 24, 1904).

By the end of the year, Wyndham had a plaster cast of his bust. Ecstatic, he examined it in the company of Hugh Lane, who was putting together the Municipal Gallery of Modern Art in Dublin and wanted to acquire some Rodins: "We both regard it as a chef d'oeuvre. It is so true and living that looking at the throat one expects to see the bust swallow. But it is more than that, a lot more. It is a Man at 40 years of age. No one has ever done that. We have masters who specialize in youth and in old age. But we do not have a work that is and always will be a portrait, the truth, the life of a Man in mid career, with his regrets, his worries, his force, his spirit, and his dash" (Dec. 25, 1904).

The bust is frontal, the chest naked and well developed, the features richly modeled. Though not vigorous in the manner of Rodin's portraits of the 1880s, the features accurately portray the extremely handsome man in a way that is both classical and modern. Not everyone thought the bust was so wonderful—George Moore told

Nancy Cunard, who was thinking of ordering a cast: "I cannot imagine a greater act of madness than to pay 280 for a bronze of Wyndham's bust. You will hate it when it has been in your house a month. . . . The Wyndham bust is one of Rodin's worst. . . . Better get your bust done, he told me he would do a bust of you for 500, and then I shall be able to have a bronze for 60, 80, or 100."[18] Since Moore was in love with Cunard, however, his judgment may have been warped by jealousy.

Among the guests at Ernest Beckett's home in 1902 when Rodin was there was Mary Hunter, one of London's most famous hostesses. Though close to fifty, she was still a beauty, as is evident in Sargent's portrait in the Tate Gallery (1898). She went to see Rodin in Paris, hoping to obtain a "special price" for a portrait, which she would "not mention to a soul." She could not come for sittings right away: "My husband has been chosen by Chamberlain's party to struggle here in Scarborough and I am forced to give dinners and receptions, etc." Although such things did interest her "a little," she said they were in no way as satisfying as "la vie artistique."[19]

It would be another year and a half before Hunter could find time for the project: "Enfin! I'm free next month. . . . Are you still in a good frame of mind about doing my bust? I assure you that I understand what an enormous compliment this is to me. I am very honored" (Sept. 27, 1904). Between November 14 and 20, Rodin did Hunter's

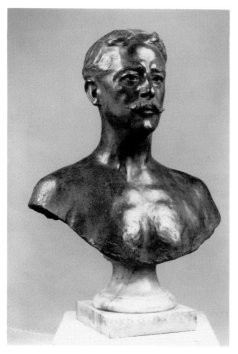

158) Rodin, *George Wyndham*. 1904. Bronze.
Musée Rodin.

portrait—not once but twice. She was full of admiration, preferring the second pose but finding them both superb. She thought she would get her husband to pay for one marble; somehow she herself would find twenty thousand francs, a "personal concession" for which she was "very touched," to pay for the other.[20] By this time Rodin had perfected his "manner" as a society portraitist. He told Hunter that he found her as a model to be a cross between Athena and Helena Fourment as seen by Rubens, and when he looked at her skin—well, it had the "whiteness of turbot as one sees it lying on the marble slabs of those amazing British fishmongers." Then Rodin kissed her hand, perhaps just "a little too greedily."[21]

When Hunter got home, she went into high gear. She hoped Rodin would do a portrait of their mutual friend Sargent. Scanning Rodin's social schedule for the period he would spend in London for the opening of the International Society's fifth annual exhibition, she said he could count on dining with "many beautiful English women." Her sister, the composer Dame Ethel Smyth, would sing songs from her new opera. Hunter promised to arrange for Rodin to dine with the prime minister, Arthur Balfour, in hopes that the meeting would lead to a commission for a portrait of the leader of the Conservative party. For the next six months, this was her pet project, but Balfour finally scotched it on August 7: "I am loath—very loath—to disappoint him; but I really do not see how I can manage to give him the time he requires *this* Autumn."[22] A general election was looming. Balfour could not have imagined that his party would suffer an overwhelming defeat, that even he would lose his seat in Parliament; he did know, however, that he had no time for portraiture.

Hunter's bust was shown at the International Society Exhibition in 1907. It was paired with another recent work, the bust of Thomas Evelyn, Eighth Baron Howard de Walden, a wealthy nobleman who had begun to collect Rodin's work, having just purchased a group, *Benedictions,* and a cast of *The Thinker.* Reviewers were not happy about either bust. *Howard de Walden* was "too Greek" for their taste, especially his naked chest, which made him look for all the world "like some Hermes . . . that rises half-god, half-symbol from the stone."[23] The sitters were satisfied, however, and that was what mattered.

One of Hunter's friends who was particularly taken with her bust was the countess of Warwick. During the nineties, she was regarded as the loveliest woman in England. That was certainly the opinion of her lover, the prince of Wales. Her period as royal mistress came to an end in 1898, along with her commitment to the Tory politics to which she had been born. Increasingly, she had become concerned with issues such as unemployment, low wages, and the lack of opportunities for women. In 1904 she became a Socialist. In the last week of 1904, she went to Paris, where she had lunch with Jean Jaurès and Georges Clemenceau. That week she wrote Rodin to ask if she and her husband could come and see his studio.

Margaret Blunden, Lady Warwick's biographer, says that "the first serious consequences of years of careless spending, expensive enthusiasms and extravagant gestures

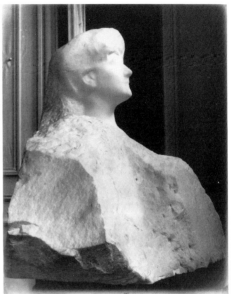

159) Rodin, *Mary Hunter*. 1904. Marble.
Musée Rodin.

160) Rodin, *Lady Warwick*. 1908. Marble.
Photograph by Druet. Musée Rodin.

began to overtake Lady Warwick" in 1907.[24] Nevertheless, in that year she wrote Rodin: "One day, if I am very virtuous [très sage], would you make my portrait?" By early 1908, when she began her sittings, she was deeply in debt, and in fact she would never be able to pay for her portrait. Rodin sent it to her anyway, and they continued to be friends for many years.

The behavior of the British aristocracy provided Rodin with a new view about how life could be lived. When, in a few years' time, he found himself in possession of a grand house and a duchess at his side, he probably thought he already knew something about this way of life.

One of Rodin's British sitters was anything but an aristocrat. Both George Bernard Shaw and his wife, Charlotte, loved Rodin's work. Shaw met Rodin in London, when he was installed as president of the International Society. At that time, Shaw sent his German translator, Siegfried Trebitsch, some photographs of himself, saying: "I am looking as like Rodin & Tolstoy in them as possible." Shaw had had a number of portraits made before. It was Charlotte's suggestion to commission one from Rodin, and there is no doubt that both Shaws were most interested in meeting him. When Rodin made his annual trip to London in 1906 for the opening of the International Society Exhibition, Charlotte extended her invitation. On March 1—only a few days after the great banquet at the Savoy at which Rodin had been presented to the king— Rodin was at the Shaw's home in Adelphi Terrace. Later that evening Shaw wrote to Trebitsch: "My wife insists on dragging me to Paris for twelve days at Easter so that Rodin may make a bust of me!!!!!"[25]

Shaw was sixteen years younger than Rodin, but already celebrated as a critic and a playwright. It seems he approached Rodin in a somewhat jocular and competitive spirit. Shaw to Trebitsch: "On Sunday I start for Paris—Hôtel Palais d'Orsay. Rodin has influenza, but he thinks he can at least make a beginning. I have the greatest doubt of the bust being ever finished" (April 13, 1906). Shaw attached to the letter his own drawing of a finished bust he had designed.

Not being in good health, Rodin asked the Shaws if they would mind coming to Meudon rather than working at the Dépôt des Marbres. They agreed and arrived on April 16. Shaw, full of anticipation, had taken his camera along. Discovering that Rodin had no objection to his taking pictures, he asked if he could invite his young American photographer friend, Alvin Langdon Coburn, to come in the future. Rodin agreed. Shaw wrote to Coburn the next day: "No photograph yet taken has touched him. . . . He is by a million chalks the biggest man you ever saw; all your other sitters are only fit to make gelatin to emulsify for his negative."[26] Shaw wrote to Sydney Cockerell, curator of the Fitzwilliam Museum and a protégé of William Morris: "I think I must try to get Rodin & you acquainted. He is extraordinarily like Morris in some ways—the same stature & figure. . . . You must add him to your collection of great men. He is perfectly simple and quite devilishly skilful at his work—not the smallest whiff of professionalism about him—cares about nothing but getting the thing accurate and making it live. It is my solemn opinion that he is the biggest thing at present going—or likely to be going for a long time—nobody in the running with him but Praxiteles & Michel Angelo, and both of them beaten in some points."[27]

It is clear that the two men were not on equal terms. Rodin knew nothing of Shaw's work, nor was Shaw able to display his brilliant conversation, for he was not fluent in French. "M. Shaw does not speak French well, but he expresses himself with such violence that he makes an impression," Rodin commented after listening to his model's anecdotes and stories.[28] The more they talked, the more certain Shaw became that Rodin knew "absolutely nothing about books."[29] He became ever more focused on trying to get Rodin to understand him in order to represent him as an "intellectual" and not "a savage, nor a pugilist, nor a gladiator."[30]

More often than not, Rilke was also in the studio watching Rodin fashion Shaw's face. He and Shaw had made the pilgrimage to Meudon in the same spirit; both believed Rodin and Tolstoy to be the reigning geniuses of their age. We do not know what Shaw thought of the German writer, but we know Rilke was dazzled by him. Within a few days he wrote to Shaw's German publisher, Samuel Fischer: "Rodin has begun the portrait of one of your most remarkable authors; it promises to be exceptionally good. Rarely has a likeness in the making had so much help from the subject of it as this bust of Bernard Shaw's. It is not only that he is excellent at standing (putting so much energy into standing still and giving himself so unconditionally to the sculptor's hands), but he so collects and concentrates himself in that part of the body which, in the bust, will have . . . to represent the whole Shaw, that his whole personality seems to become concen-

trated essence." Rilke desired to do something that never would have occurred to Rodin: to read Shaw's work. Could Fischer send some of his books? "I could write a short article about him."[31]

Rilke wrote to his wife about the process he was observing, knowing that, as a portraitist, she was bound to be interested. He described how Rodin took the measurements of Shaw's head with a large iron compass. Having marked the position of the eyebrows, nose, and mouth in the clay "with an incision such as children make in a snow-man," he began making "first four, then eight, then sixteen profiles, letting the model, who was standing quite close to him, turn every three minutes or so. . . . Yesterday, in the third sitting, he placed Shaw in a low child's chair (all of which caused this ironical and mocking spirit, who is, however, by no means an unsympathetic personality, exquisite pleasure) and sliced the head off the bust with a wire (Shaw, whom the bust already resembled very strikingly, watched this execution with indescribable delight) and then worked on the head as it lay before him."[32]

On April 21 they all took a break for the inauguration of *The Thinker* in front of the Panthéon. Rilke joined the Shaws, Sydney Cockerell, and Alvin Coburn, writing to Clara about the "congenial people" he was with for the ceremony, without mentioning their names.

When Shaw arose the following day, he asked Coburn to photograph him after his bath "nude in the pose of Le Penseur." He desired a photograph in which "the body was [his] body," in contrast to the bust, which portrayed "the face of [his] reputation."[33] It is difficult not to see this strange photograph in the same light as Shaw's sketch of a bust that he did not believe Rodin could finish: it is an idea with a competitive twist to it from a man who was ever focusing on his relationship to the reigning genius.

Shaw certainly convinced Rilke that he was not just another British model. Rilke wrote more or less the same thing to all his friends; to Elizabeth von der Heydt a few days after the installation at the Panthéon: "Shaw as a model surpasses description. He puts such energy into the business and has the power of getting his whole self, even to his legs and all the rest of him, into his bust, which will have to represent the whole Shaw."[34]

On May 8 Shaw sat for Rodin for the last time. Then he and Charlotte caught the four o'clock train for London. Two days later, Rodin fired Rilke. The week of the "geniuses"—three generations, three languages, three different art forms—along with the inauguration of *The Thinker* must have raised the level of tension beyond what Rodin could bear. He needed a great deal of support, and apparently he resented his protégé's losing his heart to a new hero. Rodin must have been not only jealous but angry, for Shaw had engaged—wittily, slyly, yet mercilessly—in a competition, in the week of all weeks when Rodin alone should have been the focus of everyone's attention. Rodin was a figure of international renown and expected to be treated as such. It was Rilke who paid the price for the mischievous Englishman's visit.

Rodin sent a bronze cast of Shaw's bust to England in October. Charlotte Shaw

wrote immediately that she was enormously pleased, even "startled" by its extraordinary resemblance to her husband. It was understood that there would also be a marble. Charlotte probably talked with Rodin about it when he came to England in the summer to receive an honorary doctorate from Oxford. She said her husband was less interested in the marble, for, unlike the bronze, it would not have been "worked by the hand of God" (Nov. 1, 1907). Rodin delivered it in time for the opening of the eighth International Society Exhibition in January 1908. The exhibition, which included his newly enlarged *Walking Man,* brought forth a classic Shavian sally. In his most ghastly French, Shaw described the room where Rodin's figure was "crushing the whole exhibition under its feet." He attached some drawings of a big foot about to crush his own surprised bust. "All the other marbles, plasters, and bronzes look like they have stopped short to the toot of an automobile horn. George Leygues huddles against the wall, protesting in vain that he too is a Rodin. One is afraid to look at Madame

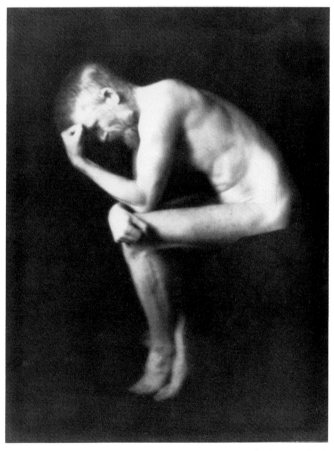

161) George Bernard Shaw in the pose of *The Thinker,* April 22, 1906. Photograph by A. L. Coburn.

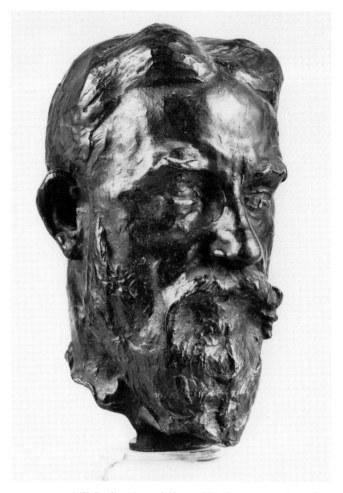

162) Rodin, *Bernard Shaw*. 1906. Bronze. Musée Rodin.

Goloubof and Madame Hunter because one does not want to turn one's back on the walker for fear of being crushed. . . . It's useless to stand beside the bust so that people can compare me to it: everyone's eyes look at nothing but the divine tramp. . . . I'm so downcast. Without these two satanic legs, I would be king of the exhibition with la Goloubof and la Hunter as my odalisques and Leygues as my valet."[35]

The Shaws' enthusiasm notwithstanding, Rodin's bust is not one of his great portraits; certainly it does not do justice to the wily Shavian wit or indicate that Rodin had grasped the subtlety of his character. In general, modern viewers have been unimpressed with Rodin's English portraits. But from Rodin's point of view, the venture into English portraiture was successful. He enjoyed the clients, they magnified his life, he was able to deliver on time, he was usually well paid, and the sitters were happy with their portraits.

In comparison to his earlier busts, Rodin's twentieth-century portraits reveal a new emphasis on symmetry. Whenever possible, he preferred nudity. Only when he had a model like Lady Warwick who was quite heavy did he resort to swathing his figure in uncut marble. His treatment of features was more generalized than in his prior work, an approach that felt more classical to Rodin. These busts came from his studio at the moment when he was energetically collecting antique sculptures, and they represent his wish to foster a style suited to the smart and worldly beings he now counted as friends, men and women who impressed him with their grace and who occupied a large proportion of his time in his later years.

Rodin surely hoped to receive the most exalted commission of all—a portrait of Edward VII—though there was never any concrete talk about it. He had been presented to the king in 1904, and in the spring of 1908 Edward came to Meudon. Rodin was enormously proud of this visit. Later in the year, a painter by the name of Noël Dorville put together an album of drawings of the people he considered the most important "promoters of the Entente Cordiale." Most were politicians, but he also wanted to include Rodin. Although Rodin was not sure that he deserved to be in such company, he nevertheless expressed pride in "the honors they have given me in England" and in "the fact that the king, who is the center and the pivot of our Europe, was *chez moi*." Dorville's notion that an artist could affect French-English relations may have struck Rodin as a confusion of the worlds of art and public affairs, but it suggests how unusual it was for a Frenchman who was not a political leader to have as many English friends as Rodin did.

The British gave Rodin his last important monument commission. Nothing could have seemed more logical than to approach the new president of the International Society of Sculptors, Painters, and Gravers to design a monument to Whistler, their former president. Rodin gave them a price—fifty thousand francs (more than twice the amount the Société des Gens de Lettres would have paid for *Balzac*)—and a site was selected: the Chelsea Embankment near the Whistler house. The American artist Joseph Pennell (Whistler's biographer) took the lead. Ernest Beckett (now Lord Grimthorpe) and George Wyndham were both on the monument committee.[36] They suggested a "Winged Victory symbolizing Whistler's triumph—the triumph of Art over the Enemies." There is, in fact, a drawing in the Musée Rodin that shows a Victory holding a garlanded medallion with a head in profile, on which Rodin wrote "génie de Whistler."[37] Although winged figures were part of Rodin's vocabulary, he was not really interested in this idea.

One reason Rodin did not follow up on the committee's suggestion was that he was already at work on a figure that he wished to turn into the central image for the monument. It was based on his work with another British woman, the Welsh painter Gwen John. She visited Rodin's studio for the first time in 1904, when she was twenty-seven and making her living as an artist's model. One of his new assistants, Hilda Flodin, a Finnish sculptor, had introduced them. Rodin must have had John in mind

when he told Albert Ludovici that he preferred Englishwomen as models because "no women have such fine legs as the well-built English girl.".

John knew a great deal about Rodin when she met him, having been a student at the Slade School, where he was seen as a hero. She and her brother, the painter Augustus John, showed at the Carfax Gallery, which handled Rodin's work as well. John, a strange and unusually stubborn woman, had a slender body and tiny hands and feet that appeared fragile. Her face, a perfect oval, was delicate and pale, and "her soft Pembrokeshire voice, much to her irritation, [was] almost inaudible."[38] She began to model for Rodin, to translate for him (presumably letters—he was without a secretary for a period in the summer of 1904), and to sleep with him. John fell passionately in love with Rodin. In one of the earliest of the almost one thousand letters she wrote to him between 1904 and 1914, she emphasized what they had in common ("I loved Greek statues long before I met you") and she conjured up the life they would have together: "I know that one day we shall go to Rome together you and me. When that time comes make no objections. And you will not be cold in the nights because I shall warm you." Though her dreams of their adventures were in full swing, she knew "perfectly well that first you want to finish the Muse."[39] To a friend she wrote: "I am at Rodin's nearly every day now—he has begun a statue. . . . Rodin says I am too thin for his statue & that I don't eat enough."[40]

This was the "Muse" that was under way. John had even briefly been a Whistler student, so her modeling from the Whistler figure seemed appropriate. We do not know when Rodin melded the muse and the monument; a likely guess is that it was in the fall of 1905. A public subscription was opened in the summer of 1906, and by the end of the year the committee was expecting photographs. None was forthcoming. Early in 1908 it was rumored that Rodin would show the Whistler monument in the Salon. Now the committee definitely wanted a photograph, especially since they had just informed Rodin that all the funds had been raised. The committee did not yet know that upon visiting the Salon they would find their "triumphal Victory transformed into a Venus climbing the mountain of fame, though, in a letter, Rodin described it as a Muse who would hold—she had as yet no arms—or have placed near her, a medallion portrait of Whistler."[41]

What Rodin showed was an over-life-size figure of enormous power with the left leg raised high and the knee pivoting to the left in a compelling and awkward pose. (John prided herself on being able to hold difficult poses for a long time.) The muse, an uneasy figure, gives a powerful impression of John's striking oval face pressing forward on a long columnar neck. Although the English committee was dismayed, the statue got tremendous reviews. Critics especially liked the back: "sublime, Rembrantesque" (Louis Vauxcelles in *Gil Blas*); "In the back of this *Muse* one perceives trembling flesh that has a modern beauty equivalent to the most beautiful art of antiquity" (Lucien Chantal in the *Action française*); and "The back is one of the most astonishing things I have seen in a long time" (J. L. Blanche in the *Grande Revue*).[42]

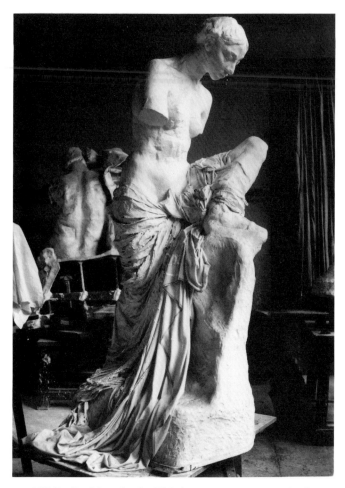

163) Rodin, Muse for the Whistler monument. 1905–08. Plaster.
Photograph by Bulloz. Paris, Musée d'Orsay.

Though the work was successful in Paris, its development as a monument was not assured, for reasons reminiscent of *Balzac*. Early in 1909 Rodin telegrammed to London, "The Whistler monument is the constant worry of all my days,"[43] and the following year he explained to a reporter from the *Morning Post* how "impossible it is for me to fix a time for the completion of a work of art" (Feb. 15, 1910). Rodin's ideas for the Whistler monument were good, he had enthusiastic patrons, and the money was there. But he was now seventy and a certain fire was gone. Rodin was frequently distracted by being a public figure. More important, he was consumed by the idea that he had not yet found a real personal life. As Whistler's friend and biographer Joseph Pennell said later: "The failure was Rodin's."[44]

164) Rodin, Muse for the Whistler monument. 1905–08. Plaster.
Photograph by Bulloz. Musée d'Orsay.

At the close of the nineteenth century, Octave Mirbeau was rushing to finish an article on Rodin for an American publication. Unsure that he would meet the deadline, he wrote to Rodin that he would "be completely broken-hearted" if he missed "this occasion to tell those fat, greedy American merchants everything on [his] mind about the greatest artist of the century."[1] Although Rodin may have shared some of Mirbeau's prejudice, by and large he believed Americans had a real love for art. He expected them to be receptive to his work, and with good reason, for most of his contacts with Americans had been positive.

The first American to visit 182 rue de l'Université was William C. Brownell, a young New York writer who lived in Paris for three years in the early 1880s. In the fall of 1884, he headed home with sheaves of notes and observations about French life, character, and art. These notes became *French Traits—An Essay in Comparative Criticism,* a staple for Americans who wanted to learn about French culture. Brownell interviewed Rodin, borrowed photographs, and promised to send his article when it appeared. Years later—in the winter of 1889—Rodin received a letter from Brownell, apologizing for the delay and informing Rodin that his article was about to appear in the *Century Magazine.* The illustrations were being engraved, but, Brownell wrote, "we are rapacious and we want more photographs." Actually, what the publishers wanted was *different* photographs, since the ones Rodin had given Brownell could not be reproduced in America: "In matters of art our public is not only stupid, it is stupidly squeamish," he explained, referring to the prudish streak in the American public which Rodin would run up against again and again.

In 1887 two American sculptors, a father and son, came to see Rodin. Twenty-two-year-old Paul Bartlett had taken a studio around the corner from Rodin's atelier in the rue de Vaugirard. His talent was promising; he had already shown in the Paris Salon. Through Paul, Rodin met his father, a sculptor of less talent than his son, but a gifted critic and teacher. (He was a professor at the Massachusetts Institute of Technology.) Toward the end of 1887, Truman Bartlett began studying Rodin's work and conducting interviews with him. He took copious notes and wrote a series of ten articles that came out two years later in the Boston publication *American Architect and Building News.*[2] When this series appeared, it was the longest, most detailed, most accurate discussion of Rodin's work in any language. Bartlett's plain style and straightforward factual reporting provides considerably more information about Rodin's early career than the entire mass of adjectival French criticism of the 1880s. Bartlett traced the

chronology of Rodin's works, interviewed his friends, and read his clipping file. He was intent on figuring out why this talented man had met with so much adversity. The no-nonsense directness of Americans attracted Rodin; it echoed his own desire to keep things simple. The part of Rodin that disliked putting on airs and stayed aloof from the imbroglios of French society came into its own when he was with his American friends.

Rodin's best American friend in the nineteenth century was an energetic mid-westerner by the name of Sarah Tyson Hallowell. A true zealot of contemporary French art, she had been mounting art exhibitions in Chicago since the 1870s.[3] By 1890 she had exhibited Degas, Pissarro, and Monet in her shows alongside Whistler and Sargent. More often than not, Chicagoans saw the paintings as "blotches of ill-assorted colors," but the shows prepared Hallowell for the biggest undertaking of her life: the Loan Collection of Foreign Masterpieces Owned in the United States, which was to be the major art event of the 1893 Columbian Exposition in Chicago. Hallowell worked closely with Mrs. Potter Palmer, the chair of the Board of Lady Managers for the exposition. By 1891 both women were in Europe, Hallowell scouting for works, Palmer moving from capital to capital to convince various governments that they should support the Board of Lady Managers of the Woman's Building. From Paris Hallowell wrote to Palmer of her ambition "to make that gallery of French pictures owned in America surpass what is sent from here."[4] The French were planning their own art exhibition for Chicago, and Hallowell was determined to show American (that is, her own) taste as more up-to-date and well informed than official French taste. Palmer cooperated enthusiastically, acquiring most of her collection of impressionist paintings in 1891 and 1892.

Hallowell was primarily interested in painting, but she knew she had to have Rodin in her exhibition. In the letter quoted above, she wrote: "I so hope you will conclude to order the Rodin marble. In all America, there is nothing of sculpture to equal this work of his which it would be so fine for you to own with your other great works of art in the way of pictures." The Palmers met Rodin in 1892 in the home of Paul Durand-Ruel, at whose gallery they had made many of their purchases. Durand-Ruel had invited Rodin to dine with the Americans: "I know you don't like to go out in the evenings but your presence is important; I believe it will useful for our common interest" (May 3, 1892). Rodin had a particular project in mind—a group of Orpheus and Eurydice, which he hoped Mrs. Palmer would order. She, however, showed no interest.[5]

Later that summer Hallowell brought a second potential buyer to Rodin: the Chicago millionaire Charles T. Yerkes. But, like the Palmers, he found Rodin's sculpture too avant-garde for his taste in 1892.

Rodin was pleased by Hallowell's efforts on his behalf. Eager for his work to be seen in America, he suggested a one-man show at the exposition, but Hallowell explained, regretfully, that the rules prevented it: "Even for the greatest artist which is Rodin, *bien entendu*—it is impossible." She had another idea, however: she could show his sculptures in her collection of French works owned by Americans. Of course, there was the

problem that no one in America owned a Rodin.[6] But Hallowell saw a way around it: "Could you give me four or five works? I shall inscribe them in the catalogue as being in the collection of an American whose name I shall make up. I think this is legitimate because it is monstrous that so far there is not a single work of yours in our country!" (Nov. 15, 1892).

Rodin loaned Hallowell three works for her exhibition: *Cupid and Psyche,* which portrayed two nude figures wrapped in each other's arms and lying on a bed of marble; *Sphinx,* a nude female figure kneeling and stretching luxuriously so that her breasts rise up toward the viewer; and *Andromeda,* a nude bent double and hugging a mass of marble beneath her body. Few visitors saw them, however, for one week after the Columbian Exposition opened they were removed from the public exhibit hall. The committee in charge decided the Rodins were too risqué and determined that anyone who wished to see them would have to apply for special permission. As the *Chicago Herald* pointed out: "If such works were placed in the open of the sculpture corridors they would have been brutally defaced" (Oct. 1, 1893). For the second time, Rodin was confronted with American puritanism.

Most visitors to Chicago saw only Rodin's two works in the official French exhibition: a single *Burgher of Calais* and the *Bust of Dalou.* The sequestration of the Rodins in the Loan Exhibition drew attention to his work in the press. Thus Rodin entered the American consciousness with a special flavor attached to his name. Yerkes, stimulated by the flavor of forbidden fruit, ordered two large marbles, *Cupid and Psyche* and *Orpheus and Eurydice,* for his Michigan Avenue mansion. Also, the young sculptor Lorado Taft was completely won over. Although he had studied at the Ecole des Beaux-Arts in the early eighties, in all probability he had not even been aware of Rodin's existence at that time. As a result of the Chicago exposition, he began writing about Rodin's work and two years later traveled to Calais for the installation of *The Burghers of Calais:* "Many will recall that strange, grim figure which rose so impressive in the south court of the art palace, the rugged man who clutched a gigantic key in his enormous hands, whose feet were big and ugly beyond description. . . . You may not like him, this stern old Sieur Eustache de St. Pierre . . . but you cannot fail to respect him" (*Chicago Record,* July 8, 1895).

In 1900 Taft presented himself at 182 rue de l'Université. The condition of Rodin's atelier shocked him: "Our studios in the Fine Arts building are palaces compared with these." Taft looked at the dirty towel, a bar of soap, and a tin washbasin: "I thought of our towel-supply companies and a clean towel every day, and a great wave of remorse swept over me as I realized how unworthy I was to have these luxuries while the greatest sculptor in the world lives in such simplicity."

Taft had arrived on Rodin's established reception day and there was a great crowd: "I sought in each face the features that I had known so long through portraits, in painting and sculpture. At last I recognized him. There was no doubt that the gentle-looking little man in gray, he of the strange, retreating brow and sandy beard, was the famous sculptor himself. I forgot for the moment whether it was Rodin or Michael Angelo that

165) Rodin, *Orpheus and Eurydice*. 1893. Marble. Purchased from
Rodin by Charles T. Yerkes in 1894. New York, Metropolitan
Museum of Art. Gift of Thomas F. Ryan, 1910.

I had come to see." He summoned his courage and introduced himself. He even showed
Rodin photographs of his own work. He wanted to know if Rodin thought the motif he
was working on was too complex. He hung on every word of advice: "But, no, if you
make a good sculpture it doesn't matter; good sculpture will carry a certain amount of
subject." Taft reflected how different this point of view was from the way Americans
thought about sculpture: "We have to have the subject . . . and then it is hit or miss in
regard to the 'good sculpture.'" (*Chicago Record,* June 16, 1900).

Hallowell had told Rodin that if he lent his work, she would sell it. But the Great
Depression of 1893 intervened, and only Yerkes bought work from Rodin. Rodin was
not greatly perturbed; he came away from the Columbian Exposition more confident
than ever that America would be one of his great successes. In 1894 he told a reporter for

Le Matin that "the Americans have an ardor to learn about everything that is happening in the Old World and to take what is most profitable for the benefit of the New. There is no doubt that the Yankees are worth more than we give them credit for. It's not just for their dollars, which glitter before the eyes of our impoverished noblemen; it's for their sense of curiosity and their intelligence that we should appreciate them" (Dec. 10). By that time, the American Art Association had purchased several works that were shown in a gallery in New York in the spring of 1895. A Boston gallery followed suit in 1895 and 1896 with shows that included small groups of Rodin works.

Another result of the Chicago exhibition was Henry Adams's acquaintance with Rodin. Almost certainly Adams saw the "forbidden" works in Chicago in 1893. Two years later he was in Paris, intent on purchasing a Rodin bronze. He considered the plan daring because "they are mostly so sensually suggestive that I shall have to lock them up when any girls are about, which is awkward." Adams had a hard time getting an appointment to see Rodin, but finally, at the end of September, he wrote that he had "passed an hour with Rodin in his studio looking at his marbles." As Adams had suspected, they were "too too utter and decadent," but he loved them. "Why can we decadents never take the comfort and satisfaction of our decadence?" he mused. "Surely the meanest life on earth is that of an age that has not a standard left in any form of morality or art, except the British sovereign. I prefer Rodin's decadent sensualities, but I must not have them."[7]

Adams articulated the dilemma Americans felt about Rodin better than anyone else— but he never solved it. He purchased Rodin's works only for friends and family, never for himself. From the 1900 exhibition, he bought for his niece, Louisa Hooper, a nude figure bending in a dancerlike pose with a swatch of drapery billowing over her shoulder. Rodin called it *Psyche Carrying Her Lamp,* but he placed no real significance in the title. Adams did not understand this at all. As Taft pointed out, subjects meant everything to Americans. Adams wrote to his niece about the figure, which he called "Fishy," explaining that he had picked it out for her because "Fishy" was "cool and calm and appears to be minding her business. Is it not characteristic that the idiot Cupid would not let her see his bank-account? He kept her in the dark. You can see by her attitude and expression that she knew he was a fool, and she another, for loving him, but that she had to run the machine, for he was utterly incompetent."[8] Adams did not appreciate Rodin's loose, intuitive sense of subjects in which one meaning was easily shed for another. Literary man that he was, Adams needed to interpret, clarify, and fix the meaning for himself.

Psyche was Adams's first Rodin purchase. Two years later he and Elizabeth Sherman Cameron, wife of Sen. Don Cameron of Pennsylvania, helped the very proper Bostonian Henry Lee Higginson purchase a Rodin. Lizzie Cameron had seen the 1900 exhibition in Rodin's company and quickly became a Rodin enthusiast. After she ordered an *Eve,* she and Rodin had lengthy discussions about patina, price, and date of delivery over numerous lunches and teas.[9] Adams, who cared deeply for Lizzie Cameron,

observed their flirtation with annoyance. "Michael [as he called Rodin, short for Michelangelo] has a pronounced feebleness for handsome women," he wrote to Louisa Hooper.

Nevertheless, Adams enlisted Lizzie Cameron in the negotiations for the Higginson purchase. Perhaps he thought he would get a better price. Rodin, for his part, simply thought Mrs. Cameron a beautiful woman with whom he enjoyed visiting. He did not know there was someone—Adams—in the background expecting a well-documented, businesslike negotiation. Adams wanted everything signed, sealed, billed, and delivered before Mrs. Cameron left Paris in July 1902. As her departure approached, Rodin was assaulted with a flurry of crisp letters. He quickly located a "misplaced" list and brought the prices down to the level he usually offered only to friends. Adams, exultant when the deal was concluded, described the entire negotiation to Higginson, whose money purchased the first substantial group of Rodin's sculptures for an American collection. It consisted of two marbles and three bronzes.[10]

> My dear and learned Friend
>
> To you, who have dealt with artists all your life, there is no need to explain what artists are. Our friend Rodin is an artist. I am an irritable cuss. Yet, guided by the genial influence of your character, I've not quarreled with him. . . . He is not in the least dishonest; he is only a peasant of genius; grasping; distrustful of himself socially; susceptible to flattery, especially to that of beautiful or fashionable women; and just now much elated by his personal triumphs in London and Prague. He is perfectly buzzy about his contracts; keeps no books or memoranda; forgets all he says, and has not the least idea of doing what is promised.
>
> When I arrived here in May, he was still cavorting about Europe, flattered as he had never been before, and quite oblivious to work. It was not till June that I could get at him, and then I surrounded myself with a sworn band of pretty women— Helen Hay, Mrs. Alan Johnson, Mrs. Cameron—and marched them all in on him with orders galore. When he sent his memoranda of prices, I was startled to find that he had doubled them, and said nothing about delivering the objects ordered a year ago. Thereupon Mrs. Cameron sailed in and asked him flatly what it meant.[11]

Rodin, more concerned with pleasing his exotic patrons than with making money, immediately tried to organize the transaction in a way to please his American clients. The following day Adams wrote Higginson, describing with mordant wit how Rodin had personally delivered a bronze: "He appeared at half past five . . . with a man lugging the heavy Alcestis." Adams speculated that this gesture reflected "some clumsy French notion of politeness . . . for he wasted a couple of hours on a stupid errand which any sculptor in America would have sent an Irishman on."[12]

Clearly, Rodin rankled Adams, who thought of himself as an elderly gentleman at the stage of life when he entertains his nieces. Rodin, two years his junior, still had a charged sensual life. Besides, Adams was in love with Mrs. Cameron. The spectacle of

this vigorous—and lower-class—sculptor charming his beloved Lizzie only reinforced Adams's puritanical rigidity.[13] In 1908 Adams wrote to Lizzie Cameron from Paris after paying a visit to Marie van Vorst in the company of Edith Wharton. He described "old Rodin making old eyes at the fair Marie, as at others whom we remember. Old Rodin is rather disgusting."[14] While he disdained the sculptor, Adams loved the sculpture. Thanks to him, the Boston Museum of Fine Arts had the first real collection of Rodins in America. By 1903 both Higginson and Hooper had lent their sculpture to the museum, and before Rodin died the collection included ten of his works.[15]

More congenial than the Adams connection were Rodin's encounters with American artists who were making their way to his studio. He took pleasure in the friendship of the great modern dancers Loie Fuller and Isadora Duncan. The latter admired Rodin greatly and was frequently included in events at which he was the principal attraction. Fuller became a closer, though not always easy, friend. Their meeting came about through her friendship with the Roger Marx family and the proximity of her "Museum of Dance" to Rodin's exhibition in the place de l'Alma in 1900.

Fuller was an extravagant woman. Raised in Chicago, successful on the New York vaudeville stage, she reached her ultimate success at the Folies-Bergère. Her dances, featuring veils, light, and color, were seen as a unique contribution to the Art Nouveau movement. Moreover, she was the stage sensation of the 1890s. Fuller's entrepreneurial cast of mind was clear as she patented costumes, the wands she used to move her garments, and the colored lighting in her shows. Ever alert to new inventions, when her friends Pierre and Marie Curie discovered radium, she thought of using it in her act, and was only dissuaded by their suggestion that it could be dangerous.

For Fuller, the opportunity to know the most gifted sculptor in the world was not to be lost. She set out to do what no one else had done: to organize an American exhibition of Rodin's work. She arranged it at the New York National Arts Club on West 34th Street in May 1903, where it was presented as "Miss Fuller's Collection." It is not clear how many works she exhibited, although her list included nineteen. She and Rodin originally planned that she should take only plasters to New York, making a price list available so that people could order bronze and marble versions. In the end, however, the show did include some marbles and bronzes. It gave New Yorkers their first glimpse of Rodin's major works: the *Bust of Victor Hugo, Head of Balzac, Adam, Eve, Torso of Saint John, The Hand of God,* and *The Thinker* were all there. A reviewer for the *New York Times* said that the show affected him in much the same way as Wagner's music: it "seizes one and carries one along despite all protests; it excites and disquiets one. But it makes one think and in the end compels one, however reluctantly, to acknowledge its power" (May 9, 1903).

The show lasted only one week. Why it was so short we do not know, but Fuller hoped that some of the works might remain in America. To that end, she worked out an arrangement with the Metropolitan Museum of Art and proudly wired to Rodin that

"our national museum" wanted some of his works for a year. "Should I accept?" she inquired. To her astonishment, he replied: "Send everything back immediately."

Rodin did not understand Fuller's role in these negotiations, and he was prey to doubts planted by Emilia Cimino, who was also in New York in the spring of 1903. Cimino, always drawn to conspiracy theories and jealous of other women in Rodin's life, had interpreted Fuller's intentions negatively. She suggested to Rodin that Fuller had not been giving him the facts about the financial arrangements and that she was motivated by personal gain. Fuller's failure to be candid with Rodin about her probable intention to take some sort of commission cost her his trust. This is not directly addressed in their correspondence; Fuller's reply to Rodin's retraction of his work was a lament: "All my efforts for nothing" (July 1, 1903).

Prior to the Fuller show, New Yorkers had seen even less of Rodin's work than Londoners, who at least had the *whole* figure of *Saint John the Baptist,* whereas the Metropolitan Museum had only the head. That Rodin was now a personality of international note is illustrated by the coverage in the *New York Times* of his nomination to the rank of commander in the Légion d'Honneur. The journalist who wrote the story closed his article with a call for Rodin's work to become better known in the United States: "The exhibition at the Arts Club last Spring was suggestive of what might be done by some impresario who could afford to bring over an extensive series of Rodin's sculpture; but what impresario would court the deficit inevitable to such an undertaking?" (July 26, 1903).

Indeed, men and women of money were not the prime movers in the effort to make Rodin better known in America, though their aid would repeatedly be sought. One of the viewers of Fuller's New York show was a young photographer who already knew Rodin personally: Edward Steichen. He wrote Rodin that the show was so well received that Rodin himself "would be surprised." He hoped that soon "we can have many of your beautiful creations in this country." Steichen had just finished doing Pierpont Morgan's portrait and told Rodin that "the man of millions was very friendly toward me," implying that something good might come of this connection. A few years later Fuller tried to provoke Morgan's interest in *The Tower of Labor.* Neither had any luck; Morgan's eye was fixed on the treasures of the past and he was indifferent to modern art.

It was Steichen himself who organized Rodin's next New York show. He had loved Rodin's sculpture since the day he saw a reproduction of *Balzac* in a Milwaukee newspaper. He made the pilgrimage to Paris in 1900 and got up his courage to approach Rodin personally with the intention of showing his work to the great man. Steichen wrote to Alfred Stieglitz that the first time Rodin went through his portfolio, he "took *my hand in his silence* "[16] Their meeting resulted in the Steichen portraits of Rodin, surely among the best ever made. Steichen published one of them, showing Rodin face to face with his own *Victor Hugo,* in *Camera Work* (1903). Sidney Allen described it as

166) Edward Steichen, *Rodin*. Published in *Camera Work* in 1903.
Library of Congress.

one of the masterpieces of photography: "It is a whole man's life condensed into a simple silhouette, but a silhouette of somber splendor, powerful and personal." Allen found this single print so rich and complete that he believed it had won for photography the distinction of being a true art form: "The battle is won!"[17]

Steichen became one of Rodin's most prominent promoters in America. After the establishment of the Photo-Secession Gallery at 291 Fifth Avenue, he and Stieglitz were determined that the first show *not* devoted to photography would be a Rodin drawing show.[18] Their hopes materialized in January 1908, when New York was presented with fifty-eight of Rodin's twentieth-century drawings of female nudes. The drawings depicted the female body with a candor totally new to Americans: "As one looks at these amazing records of unabashed observations of an artist who is also a man, one marvels that this little gallery has not long since been raided by the blind folly that guards our morals," wrote J. N. Laurik in the *New York Times*. However, Rodin's spontaneous observations of such unconventional poses struck one reviewer as not sufficiently artistic: "Stripped of all 'art' atmosphere they stand as drawings of nude women in attitudes that may interest the artist who drew them but which are not for public exhibition." The drawings did not derive from any circumscribed or received notions of beauty. But for artists such as the Mexican Marius de Zayas, who also showed at 291 in 1908, they were a breakthrough. He called the Rodin drawing exhibition the most important art event in America before the Armory Show in 1913: "Steichen must have seen in them all the elements needed to stir up things in New York. . . . The Rodin drawing exhibition started the ball rolling towards real modern art. Whether or not it was premeditated, this exhibition was a good beginning, an excellent 'apéritif' for what New York had to swallow subsequently."[19]

In many ways, American reactions to Rodin and his work paralleled those of the British. The majority of wealthy patrons were mostly interested in portraits, leaving it to artists and connoisseurs like Hallowell to do the early work of bringing Rodin's art before the public as something of consequence.

Rodin's American portraits were not very satisfying for him. The first wealthy patron of whom he did a bust was Mrs. Potter Palmer. She was an unwilling subject; if it had not been for Hallowell, the bust surely never would have been completed. Following her husband's death in 1902, Mrs. Palmer spent more and more time in Europe. By 1904 she owned a house in the rue Fabert, not far from the rue de l'Université. She began her sittings with Rodin there, and over the next two years she made more appointments with him than she kept. Every time she did not show up, Hallowell picked up the pieces: "Mme. Palmer promised to come to Paris a long time ago but now she won't come until the London season is finished. She has not forgotten her bust and remains proud to think that finally she will possess a great work of yours. . . . It's her first *season* in London and from her point of view she must not miss the ten great events because it is now that she is establishing her position."[20]

At the end of the month, Mrs. Palmer herself wrote that she was about to miss

another sitting: "Since it's for the drapery perhaps my secretary could come and pose" (July 25, 1904). In 1906 Rodin tried to bring the project to closure; he finished the plaster and hired a practitioner to carve the marble. The bust was ready in October 1907, but Mrs. Palmer did not pick it up. Again Hallowell tried to make things right: "Before I left Paris I saw Mrs. Palmer on the subject of the bust. She would still like to have it, supposing that you would have the generosity (in my opinion this is not a matter of generosity) to finish the work when *she* has time. She promised me that she would come to see you in January. She told me that *Edward and his friends* didn't like it very much, to which I responded: *so much the better, because every enlightened person knows what the court of England likes.*"[21] Though Mrs. Palmer told Hallowell that the king's opinions did not influence her, she neither collected nor paid for the bust, which is still in the collection of the Musée Rodin.

As Rodin was finishing his portrait of Mrs. Palmer, he was approached to do the bust of another rich American, Joseph Pulitzer. In early 1907, Pulitzer, who had made the New York *World* into the most influential newspaper in America, retired to his villa on the Côte d'Azur outside of Menton. The well-known reformer and fighter for the underdog arrived in France blind and ill, his stomach tormenting him, constantly suffering from headaches and feeling that he might die at any moment. He was traveling with a huge entourage of staff and secretaries, one of whom, Stephen MacKenna, knew Rodin quite well.[22] It was MacKenna who negotiated with Rodin to make a bust of Pulitzer. They agreed that Rodin would make a bronze and a marble version, which was his standard arrangement, and that his fee would be thirty-five thousand francs. (Rodin was charging British clients twenty to twenty-five thousand francs for the same work.) MacKenna asked about prices for some of Rodin's other sculptures; Pulitzer's son had already purchased a bronze *Thinker.* Rodin mentioned thirty-two thousand francs for *Orpheus and Eurydice,* more than twice what he had charged Yerkes for the same group in 1893. MacKenna accepted his terms for the bust, but did not purchase the other works.

Rodin came to Menton in late March 1907. Pulitzer was not yet sixty, but he seemed older than Rodin. The meeting quickly turned into a contest of wills. Rodin asked Pulitzer, as he asked every male sitter, to take off his shirt. Pulitzer refused. Rodin, saying he could not model a bust without understanding the way the neck developed from the chest, prepared to return to Paris. Pulitzer relented, but ordered everyone except one assistant to stay away; he wanted no one to see his naked shoulders and chest.[23] He then told Rodin to show him as a sighted person, to which Rodin replied: "What I see in your face I will show, and not what you see."[24] Although Pulitzer spoke excellent French, throughout the sittings he remained silent. Back in Paris, Rodin immediately commissioned one of his best practitioners, Victor Peter, to begin work on the marble, instructing him to lose no time. Clearly, he was taking no chance that Pulitzer would die before he could deliver the bust.

In 1908 and 1909, Rodin was negotiating commissions for portraits of two more self-

167) Rodin, *Joseph Pulitzer.* 1907. Bronze. Musée Rodin.

made American millionaires: Thomas Fortune Ryan and Edward Henry Harriman. Ryan had started life as a penniless Irish orphan. By 1900 he owned the Metropolitan Street Railway Company of New York, controlling virtually every streetcar line in the city. Pulitzer's *World* was constantly trying to expose his watering of Metropolitan stock. He astonished the financial world of New York by acquiring the controlling share of the Equitable Life Assurance Society. Harriman had also tried to buy a majority interest in Equitable, and when he lost out, he declared Ryan unfit to control the company. From that day, Ryan was his enemy.[25]

Harriman was a rail man too; in fact, he controlled fully a third of American railroad companies. He totally rehabilitated the Union Pacific. He, too, had frequently been under investigation for watering stock and establishing monopolies. By 1909, when he probably met Rodin, his health was disintegrating and he had come to Europe in hopes

168) Edward Henry Harriman and
Mary Harriman on board ship in 1909

of finding a cure. His daughter Mary definitely saw Rodin during that visit, and when her father died in the fall of 1909, she commissioned Rodin to make his bust from photographs and a death mask. Rodin usually turned down such commissions, but he accepted this one, probably because a vast fortune stood behind it and he thought it part of the process of getting Americans to know his work.

Rodin finished the busts of the two New York rail barons in 1910. He shipped them together and they were exhibited side by side at the Metropolitan Museum, as if the subjects had been the best of friends. Rodin had a good relationship with Ryan, even though Ryan spoke no French. Ryan loved sculpture and had built an important collection, which he had installed in his garden at 858 Fifth Avenue. He purchased two works from Rodin, a bust of Napoléon and *Pygmalion and Galatea*. He gave the latter to the Metropolitan. When it went on exhibit, the *New York Sun* said: "The new marble has been added to the sparse representation of the great French sculptor's work at the Metropolitan" (April 9, 1910). The reporter described the sculptor Pygmalion pressing his lips against the belly of his own creation, Galatea, who had been miraculously brought to life by the goddess Aphrodite: "It might be Rodin himself evoking the image of his ideal." This was the first of Rodin's distinctly sensual images to enter a public collection in America.

Despite these commissions, Rodin's relationships with monied Americans did not result in the kind of rapport he had with his English portrait sitters. For one thing, he did not visit them; he had no context for their lives. A second obstacle was Rodin's relative disinterest in money as such; in dealing with Americans, he frequently had to

take into account their mystique of wealth. He quoted high prices to the American millionaires, understanding intuitively that they purchased art partly to show they had money. Samuel P. Colt, president of the National India Rubber Company, for example, printed the amount of his capital and surplus on his letterhead. In 1906 he sent Rodin a check for twenty-five thousand francs as a down payment for "a statue of a girl or a muse," apparently having no idea what he would get. He assured Rodin (in English, although most Americans wrote to Rodin in French) that he knew "the Statue will be all that I could desire" (Oct. 20).

Even in their gaucheness, though, Rodin did not dislike his American clients—especially American women, for whom he had nothing but praise. In early 1904 he was hurrying to finish his bust of Kate Simpson of New York for the Salon. A critic came to his studio to discuss his entries and asked what Rodin thought of American women. "Almost invariably there is intelligence in the faces of the women of this nation," Rodin replied. "But there is furthermore, kindness of heart evidenced in the countenance of this model. That is what I shall attempt to express and it is a difficult task."[26] Simpson was Rodin's greatest American patron. She was the daughter of a banker, George Seney, a benefactor of the Metropolitan Museum who had taught her that collecting art could be one of the great joys of living. In 1889 she married a successful corporate lawyer, John Woodruff Simpson. He, too, was a great lover of art. In 1897, the year in which Jean, their only child, was born, the Simpsons moved to 926 Fifth Avenue. By the beginning of the new century, the Simpsons had a regular rhythm of travel: they

169) The Simpsons and Rodin at Versailles. Photograph
by Ouida Grant.

spent June at the Simpson family home in East Craftsbury, Vermont; then they would leave for the British Isles; by August they were usually in Paris; in September they visited various sites in France; and by the end of October, they were back on Fifth Avenue.[27] By 1901 this annual ritual included a visit with Rodin.[28] The pattern and the visits did not end until the onset of World War I.

The second time the Simpsons met Rodin, in 1902, they commissioned him to do a bust of Kate. Thanks to Jean Simpson's governess, Ouida Grant, we have a photographic record of Rodin at work on Kate Simpson's bust. Mrs. Simpson stands, stripped down to her camisole, as Rodin works in the clay or scrapes on plaster. He caught the beauty of her round and regular face, steady gaze, restrained smile, and a puff of curly hair tossed up on the crown of her head and falling down on her forehead. The bust was sufficiently finished for a plaster cast to be shown in the fall at Samuel Bing's Galerie de l'Art Nouveau, the fashionable new gallery of fine and applied art in the rue de Provence. The following spring there was an exchange of letters; Mrs. Simpson managed to be both affectionate and formal with Rodin: "The friendship you have expressed for my husband and myself is so pleasing to us. . . . I know that my bust will reveal dignified and serious thoughts. In your heart I find both loftiness and tranquility" (April 3, 1903). Kate Simpson looked forward to her visit with Rodin each

170) Rodin at work on Kate Simpson's bust in 1902. Photograph by Ouida Grant.

year, and the family came to think of him as one of the important people in their lives. Grant's photographs show us the Simpsons in Rodin's studio, with Rose Beuret, with Rodin at Versailles, and on a visit to Calais to see the *Burghers*. The bust was carved in 1903. The Simpsons came to Paris in the spring of 1904 to see it in the Salon. It was a great success. Most agreed that Rodin had shown a special sensitivity to Mrs. Simpson's features, delicately suggesting the subtlety of her emotions, while not neglecting fashionable, up-to-date details and a robust sense of design: "a perfect gem," according to the *New York Tribune* (April 17).

In the summer of 1903, the Simpsons began building their Rodin collection. Rodin helped them with frequent gifts. By 1909 Kate wrote to Rodin that "people come to see your beautiful works almost every day." Kate lobbied vigorously to get friends, family, and especially the Metropolitan to buy Rodins. After the drawing show at 291 in 1908, she wrote: "My sister, Mrs. Robinson [wife of the vice president of the museum] bought two of the drawings, *La Serpentine* and *The Walking Man*." When Mrs. Simpson donated her collection to the National Gallery of Art in Washington in 1942, she owned twenty-eight Rodin sculptures, eight drawings, and three prints.

Another milestone in Rodin's conquest of America took place at the Louisiana Purchase Exposition in St. Louis in 1904, where he showed his enlarged *Thinker*. Irene Sargent explained to readers of the *Craftsman* that a figure like *The Thinker* was capable of acting "as a public servant of great value" because it addressed such problems as oppression, and that Rodin was "smitten by the 'world-pain.'" She believed Americans could learn much from Rodin. "It is too much to expect that a second Rodin will arise

171) Rodin, *Mrs. John W. Simpson*. 1902–03. Marble.
© 1993 Washington, D.C., National Gallery
of Art. Gift of Mrs. John W. Simpson.

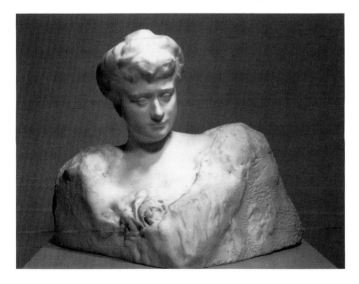

among us in our own time, but his works should be explained to the people, and his influence propagated, so that his point of view of work may be gained by both sculptors and people. By this means, there might be created a public art which would instruct and refine."[29]

When the exposition closed, the French government donated the plaster *Thinker* to the Metropolitan Museum. This gesture, in combination with Kate Simpson's constant urging, moved the museum to consider buying some Rodins. The acquisition plan gained impetus when America's leading sculptor, Daniel Chester French, was named head of the museum committee. Charged with locating and investing in modern sculpture, French, who in 1900 had found *Balzac* to be "simply a clod" with "nothing to it," was now ready to take on Rodin.[30] In 1908, E. P. Warren's friend John Marshall, who frequently worked as an agent for the Metropolitan, went to visit Rodin. On January 8, Marshall sent a list of twenty-four sculptures he had seen in Rodin's studio, together with prices and photographs. He was particularly taken with a plaster model of a triton and nereid, which he thought "might easily pass for some superb Hellenistic monument."[31] He said the committee could have everything on the list for $26,000 (140,000 francs).

There was one man in New York who was both willing and able to provide this sum: Thomas Fortune Ryan. When he gave his *Pygmalion and Galatea* to the Metropolitan in 1910, the idea of forming a Rodin collection at the museum began to take root in his mind. In January 1910 he had purchased the two Yerkes marbles, *Orpheus and Eurydice* and *Cupid and Psyche,* at auction, and in the spring he put $25,000 on deposit so that the Metropolitan could purchase the works selected by Marshall. Paul Gsell wrote an article in which he pointed out that Ryan aimed to provide a teacher for America's youth; he hoped his gift would help create a "school of Rodin" and that young artists in the New World would be able to learn "sincerity, the love of nature and a respect for the tradition of antiquity."[32]

Marshall, who lived in Rome, wrote to Rodin that he, French, and the vice director of the museum, Edward Robinson, wished to meet in Rodin's studio in the summer. After the meeting on July 18, 1910, Robinson sent to New York the names of the sixteen sculptures they had selected for the Metropolitan. In addition, Rodin would donate a selection of small plasters, as well as a bronze cast of Ryan's bust.[33]

At that very moment, Ryan was on his way to Europe. Curiously, he heard the good news neither from the museum staff, nor from Rodin. Instead, he learned it from another American who played a role in the establishment of the Rodin Gallery at the Metropolitan. Claire Coudert de Choiseul wrote to Ryan: "After a few days of deliberation Robinson and French decided *that there is to be* a room at the Met dedicated entirely to Rodin's works." She added that "under the influence" of Ryan's "great donation," the committee had been "forced to do it!"

The "Duchesse de Choiseul," as she was known, was an American who had married into the old and celebrated Choiseul family. Her husband had met Rodin first, in 1904.

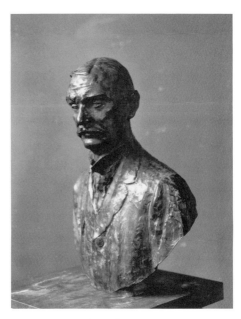

172) Rodin, *Thomas Fortune Ryan*. 1909.
Bronze. Photograph by Bulloz. Musée Rodin.

By 1907 Mme Choiseul had decided that he would be the centerpiece of her life. She accomplished her goal: we can safely say that between 1909 and the summer of 1912, Choiseul was the most important person in Rodin's life.

Choiseul, who had a healthy ego, was more than ready to take full credit for the Rodin Gallery at the Metropolitan, and she had little difficulty in finding reporters willing to write the story as she told it. When Herman Bernstein, special correspondent for the *New York Times,* who had already interviewed Tolstoy and Shaw, arrived in Paris in April 1911 with the assignment to interview distinguished men, he called on Rodin at the rue de l'Université and was greeted by Choiseul. Bernstein had heard that "Rodin's Muse" was an American. When he asked her about this, she replied: "Yes, I am proud to be both—the Muse of the greatest sculptor in the world and a daughter of the greatest country in the world. . . . I am also proud that I persuaded an American millionaire, Thomas F. Ryan, to do something really worthwhile for his country." She explained that she and Rodin were particularly enthusiastic about the collection because they knew how much it would help in the education of young American artists: "Here in Europe we have dried fruit, while in America we have vigorous, young talents. . . . America could be greater than Greece and Rome ever were; we have enough millionaires there—now we want artists. By bringing such works as those of Rodin or other great artists the young American artists could have the best examples of Europe's greatest works amidst their own surroundings."[34]

Choiseul also seems to have impressed the French art historian and critic Louis Gillet. Writing in *France-Amérique,* he credited her with arranging the Metropolitan purchase, saying that she had "graciously devoted herself to the master's glory" in a way that could only be compared to Victoria Colonna, Michelangelo's muse (April 1911). Choiseul did handle the bulk of the correspondence dealing with the Metropolitan purchase, and she did introduce Ryan to Rodin. But the efforts of Kate Simpson, bolstered by the enthusiasm of John Marshall and the willingness of Daniel Chester French to focus his committee on Rodin's work, were far more important in preparing the leaders of the Metropolitan to take this bold step.

The sculptures started to arrive in New York in September 1910. A gallery was selected: it would be the north corridor, just off the main hall. For more than a year the crates kept arriving. Finally, on November 7, 1911, Robinson wrote to Rodin: "The last have been received in the Museum. And what marvels!"

The Rodin Gallery opened with forty sculptures on May 3, 1912; his drawings and watercolors lined the walls. The newspapers greeted the occasion with words like "notable" and "splendid," but the reviews were restrained. An unsigned article in the *Sun* (May 12) focused on Rodin as a "penetrating psychologist" in his portraits and lauded him as an artist who could create "lyric beauty" like the Greeks and reveal the "tragedy of life" in *Adam* and *Eve.* But reviewers found this group of works extremely difficult to sum up.

Gillet, who had been teaching the history of art in Montreal for a year, felt he had a pretty good idea of American taste. He was curious to know "what effect all this paganism" would have in New York. "What will these people, for whom flesh by tradition, more or less, has always represented sin, think of this splendid sensuality? What would their Pilgrim Fathers say?" Gillet wondered whether the enormous recent influx of people who had nothing to do with the Anglo-Saxon tradition had changed the social and political climate enough for Americans to accept Rodin's art. "Are we watching the birth of a world more cordial, more bold, more gay, with less rigid temperament and a taste that is less protestant?"[35]

Americans certainly had not lost their puritanism in the early twentieth century, but the Rodin Gallery at the Metropolitan proves that a transformation was taking place. By 1912, taste in the cultured centers of East Coast urban America was not what it had been in 1900. For artists and connoisseurs, Rodin's work offered a new beauty and naturalism that Americans were eager to absorb. This was even truer after the shock of the 1913 Armory Show, where people were riveted by the "horrors" of abstract art. Rodin brought modernism to Americans in a much more acceptable form. When avant-garde Europeans began to turn their back on his work in the 1920s, American interest in Rodin did not diminish. In fact, ever since the opening of the Metropolitan Gallery, Americans have been unmatched in their enthusiasm for Rodin. The first commissions for bronze casts of *The Gates of Hell* were from the United States. Of the

eighteen bronze casts of the enlarged *Thinker,* over half are in the United States. And America has its own Rodin Museum, in Philadelphia.[36]

Rodin provided Americans with a way of looking at sculpture as an art form, not simply as a way of praising famous men in the form of public monuments. Further, he opened up a new naturalist vision and an expression of sensuality, a lesson badly needed to free sculpture from academicism. We must count Rodin among the major figures in bringing American art and taste out of its provincial foundations, and give him due credit for seeing beyond the callousness of rich Americans to the art hunger of the American people.

We have watched the growth of Rodin's reputation in foreign countries, especially in the English-speaking world and in Germany. In 1902 the German philosopher Georg Simmel compared Rodin and Nietzsche for offering the world positive alternatives to traditional European cultural values.[1] In France, Rodin's contributions to modern art did not garner the same kind of respect. Rodin was very sensitive to his countrymen's hesitancy, which made him feel persecuted and ill-treated. When he did not remove his pavilion at the place de l'Alma in a timely fashion in 1900, the Conseil Municipal of Paris threatened to put his work in the street. He complained to the press: "I have the impression that the authorities are animated by a certain ill-humor. . . . As you know the official world connected with the Ministry of Fine Arts treats me . . . as an outlaw."[2]

Then there were the indignities he suffered during the Hugo centennial. Rodin was putting the finishing touches on his marble *Victor Hugo Monument* for the Salon of 1901, where it had the place of honor in the middle of the rotunda of the Grand Palais. Critics spoke of its inauguration the following year, though Maurice Tourneaux of the *Gazette des beaux-arts* remarked ominously that he hoped no "obstacle [would] intervene" to impede the unveiling.[3] His caution was well placed, for once again Rodin was shut out. Paris celebrated Hugo's birthday with the inauguration of Ernest Barrias' monument in the place Victor-Hugo on February 26, 1902. Camille Mauclair spoke of the "hideous and gigantic monument" that disfigured the great circular place on the Right Bank (it was destroyed in 1942).[4] The festivities climaxed on March 8 with a parade of children, who placed flowers on yet another new Hugo monument, this one by Georges Barreau, in the place des Vosges. Rodin had to be content with his personal observance—an over-life-size bust of Hugo in the Salon. He put it on a tall column, and, as in the previous year, his sculpture stood alone in the place of honor in the center of the rotunda of the Grand Palais.

Another notable event of 1902 was the inauguration of the monument to Baudelaire in the Cemetery of Montparnasse, the work of the young symbolist sculptor José de Charmoy. Even more important, however, the *Balzac Monument* was finally unveiled. Following Falguière's death in April 1900, Laurent Marqueste had been hired to finish it. The year ended with yet another round of articles about the history of the monument, rehashing the old attacks on Rodin's work. Hugo-Balzac-Baudelaire: only a decade earlier Rodin, still young at fifty, had basked in his position as the sculptor commissioned to create the image of these geniuses. Now he felt he had lost on all three counts.

September 1902 brought the tragic news of Zola's death: asphyxiated as the result of a stopped-up chimney in his home upon returning from the summer in the country. Zola and Rodin had had a falling out, but in the mind of the public they were still connected. When the commission for a monument to Zola went to Constantin Meunier, it appeared as yet another rebuff for Rodin. Monet was quick to note it: "I am profoundly sorry that Rodin will not be entrusted with the Zola monument, since this concerns a question of art, the homage of a great sculptor to a great man, and in such cases the question of politics should not arise."[5] It is no wonder that Rodin was so appreciative of the applause he received in London, Cologne, Dresden, Prague, Moravia, and Vienna in 1902.

Rodin returned from his travels to face an open and personal attack in *L'Art,* the very journal that had done so much to help him weather the slanders of the 1870s. France's most eminent scientist-politician, Marcelin Berthelot, a friend of Rodin's since the mid-1890s, had publicly expressed admiration for Rodin's work. This prompted J.-A. Carl to write: "Once again I am confirmed in the idea that it is thanks to people who know nothing of art that this artist enjoys such a big reputation." Carl condemned Rodin as an arrogant "would-be great man" supported by a pack of "courtesans" from the press.[6] Paul Leroi, once Rodin's supporter and still the editor of *L'Art,* kept up the attack in his review of the Salon of 1903. He noted that Rodin was "prudently absent" after the "complete fiasco of . . . his group of three vulgar dock hands, which he ineptly baptized *Shades . . .* and his mediocre bust of Victor Hugo" in the Salon of 1902. Rodin was the most "cunning trickster on record" and had "played with the state and its precious taxpayers as no artist before [had] ever attempted." Leroi focused on the thirty-year-old commission for the unfinished doors, which continued to provide the artist with "an abundant source of revenue, thanks to the exploitation of many fragments endlessly reproduced for sale to credulous Americans." Finally, he pointed out that Rodin did not carve his own marbles, because he only knew "how to model in clay and wax."[7]

Soon after this vitriolic article appeared, Rodin was honored as a commander of the Légion d'Honneur. This was the last straw for Leroi; he called for a public investigation of state monies received by Rodin and proceeded to list every last franc the state had put in Rodin's pocket. He cited the prices of every sculpture the state had purchased from Rodin over the years, as if they constituted some kind of violation of citizens' rights. Leroi held Rodin liable for 65,700 francs, the sum of what he had received for the doors and the two Hugo monuments. Was the state making an effort to get its money back? Nothing of the kind: "After having acquiesced to the numerous commissions that he has not finished, it named him commander of the Légion d'Honneur. We find this scandal just a little too hard to take!"[8] The attack on Rodin in the pages of *L'Art* echoed the objections raised to *Balzac.* Once again, it was clear that his opponents were mostly conservatives whose motivations were as much political as artistic. When George Wyndham came to Paris in 1904 to have Rodin model his bust, he was not impressed by

the cream of French aristocracy who feted him: "They are children," he reported to his sister, Pamela, "arrested in intelligence and so narrow that you couldn't put a knife into them even if you wanted to. They hate us (as a nation; love us as friends), hate Jews, Americans, the Government, Rodin." Wyndham lunched with the duchesse de Luynes, who told him bluntly, "Nous détestons Rodin."[9]

By 1900, Rodin was internationally renowned as a genius and was at last in a position to manage his own sales, being one of the few avant-garde artists who did not rely on the new gallery system. Nonetheless, he was haunted by the fact that his audience in France was limited, and he had no work on public view in Paris except in the Musée du Luxembourg. One had to go all the way to Calais or to Nancy to see one of his public monuments. Yet Rodin remained a profoundly French sculptor and would not be satisfied until a work by him took its place in the streets of Paris.

A modest opportunity arose in 1904, when a committee was put together to erect a monument to the late playwright Henri Becque. Rodin had modeled a bust of Becque in 1883, and when the memorial began to be discussed, he indicated he was interested in the commission. The committee asked for a sketch, but in such a way as to make Rodin wary. Mirbeau, a member of the committee, wrote to Rodin that he himself found the request strange. He felt that if they had been dealing with Barrias, they would not have asked for anything. Mirbeau wrote to the committee's chairman, the playwright Victorien Sardou: "It's as if someone commissioned a play from you and then said, 'Before you start, we need to know the scenario.'" Furthermore, added Mirbeau, "Rodin is very touchy and he is right. For, as you know, the administration has given him a bad time, so now he has become stubborn."[10]

Toward the end of 1903, the writer Albert Thiébault-Sisson tried to make sense of these conflicting views of Rodin in France. He looked carefully at his admirers, a group, for whom Rodin was the center of a cult and who were ready to embrace whatever came out of his studio. Some of these devoted followers assembled in late June 1903 to celebrate Rodin's elevation in the Légion d'Honneur. Led by Bourdelle, Rodin's assistants and students rented a restaurant at Vélizy in the woods of Chaville near Versailles. They brought along a sculpture—Rodin's headless study for *Saint John the Baptist* (*The Walking Man*)—to serve as an emblem of their maître. They placed it on a tall column, as it had been seen in the 1900 exhibition. Fifty people gathered around it and had their picture taken with Rodin and Rose Beuret in the center. At table, the toasts were long and splendid. Rodin's protégé Jean Baffier spoke first. He described his admiration for Rodin's courage in having followed the long and arduous path to fame. He felt that the guests were not simply saluting Rodin, but French sculpture in general. When his turn came, Bourdelle looked at Rodin and declared the feast "a communion, in the sacrament of art . . . prepared by your sons." His eyes rested on the the sculpture: "Is it the torso of Saint John? Is it the torso of Bacchus? Is it the torso of the prudent Ulysses? Is it the torso of Theseus? Perhaps. What difference does the name make? It is indestructible flesh made through your spirit; it is an indefatigable torso born of your knowing, it is the human torso, it is sublime life, it is art."

173) Celebration in Rodin's honor at Vélizy, June 1903.
Photograph by Limet.

Bourdelle continued speaking for a long time. Finally, raising his glass, he delivered a stirring peroration: "I drink to you, Rodin, father of passion and of tears! I drink to you who have come back from Hell! I drink to you, father of fauns! To you, father of the panting *Age of Bronze!* To you, father of the Olympian *Hugo!* To you, father of the prodigious *Balzac!* I drink to your prophetic soul, to your great genius!"[11] Bourdelle then picked up his violin and the Danish painter Fritz Thaulow took out his cello. As they played, Isadora Duncan—whom Judith Cladel described as "still timid, but with the charm of youth"—flung off her shoes and dress and danced barefoot in her petticoat: moving, swaying, rushing like a "falling leaf in a high gale . . . finally to drop at Rodin's feet in an unforgettable pose of childish abandonment."[12]

It was a big day for Judith Cladel too; her book *Auguste Rodin, pris sur la vie* had just appeared. An intimate account of Cladel's personal discovery of Rodin and his art, the story is told through the device of an invented friend, "Claire," whom Cladel introduces to Rodin.[13] The three of them go on outings—visits to the Louvre, walks in the woods of Saint Cloud, boat trips up the Seine—during which Rodin explains his philosophy of art and life. The notes Cladel made on these excursions constitute the core of her book. She was assembling Rodin's "thoughts and doctrine of art" with the particular goal of giving new hope to young artists. Rodin felt people were losing their grasp of "the beautiful" and needed a guide to help them regain their vision—a new religion, a "man of genius" to explain its tenets.[14]

Camille Mauclair, even more than Cladel, was responsible for establishing a "cult of Rodin" at this time. We do not know if he and his wife were at the luncheon party in Vélizy. Probably not, for Mauclair was frequently sick in 1903 and 1904, and they spent much of their time in the Alpes-Maritimes. But his articles on Rodin were coming out

in rapid succession—three in 1903 alone—and Mauclair was hard at work on a major book. Although he wrote brilliantly on many artists in the early twentieth century, it was Rodin who set his imagination on fire. "The most extraordinary figure of an artist I ever knew was Rodin," he recalled in his memoirs.[15] Mauclair's special contribution was to place Rodin's work in the context of the whole history of sculpture. For him, Rodin was related to "Puget, Goujon, the sculptors of the Middle Ages of Greece, and the rules for decoration established on the Lion Gate of Mycenae." Rodin stood apart from other contemporary French sculptors in reacting "against the false tradition of degenerate Italianism" that had "poisoned French taste from the time of the School of Fontainebleau to the Ateliers Julian."[16]

Many found Mauclair's uncritical attitude toward Rodin and his work extravagant. Thiébault-Sisson objected that it was as if "genius makes no mistakes." He perceived many mistakes in Rodin's work, especially in the "affectations" of *Victor Hugo* and *Balzac.* But he believed the work Rodin planned to send to St. Louis for the Louisiana Purchase Exposition in 1904 revealed a new aspect of his art. Rodin had taken *The Thinker,* created many years earlier for *The Gates of Hell,* and given it colossal proportions. In doing this, Thiébault-Sisson wrote, he had "happily modified" the sculpture

174) Rodin and Judith Cladel in the garden of the Villa des Brillants

and "corrected details in a way that makes it an entirely new work," one that would "be a rude awakening for those who believe that only the unfinished is a mark of genius."[17] Thiébault-Sisson considered the enlarged *Thinker* the most important work in Rodin's studio. He praised Rodin's decision to rethink earlier sculptures by finishing and enlarging them so that they might be placed in totally new situations. This idea led to some of Rodin's most famous sculptural images, such as *The Hand of God, Iris, The Walking Man,* and *The Call to Arms.*

It was normal for nineteenth-century sculptors to use small models as the basis for large monuments. When the final form was established, they would then have reductions made that could be sold in an edition. Sculptors such as Barye, Frémiet, and Carpeaux had successful commercial experience with this practice. An enlargement was a different matter, and far less common. Rodin first attempted one in 1888, when the state commissioned the marble *Kiss* to be made from the small version he had showed in 1887. His energies were really set in motion, however, when he started working with the *réducteur* Henri Lebossé. Lebossé had the necessary equipment to reduce or enlarge sculpture. Rodin was mostly interested in enlargements. In the process of working together on *Victor Hugo* and *Balzac,* Lebossé and Rodin became an excellent team. As they embarked on *The Thinker,* Lebossé wrote: "I want to be your perfect collaborator" (Jan. 24, 1903) and noted that he had to "pay attention and to start over many times in order to preserve the character of your modeling" (March 1, 1903). Lebossé put so much of himself into *The Thinker* that when, in the end, he did not receive public recognition for his role, he was extremely disappointed.[18]

By the summer of 1903, Rodin was impatient to see what Lebossé was doing with *The Thinker,* but Lebossé kept putting him off. A few days before the celebration in Vélizy, Lebossé wrote: "The more I work on your art, the more I see its importance; on a large scale it takes much time to obtain the beauty of your modeling." Lebossé's machine had parallel turntables on which a small model and a large hunk of clay sat side by side. By means of a stylus attached to a sharp knife, a technician made a succession of tracings in the clay that reproduced the original model's profiles.[19] By August, Lebossé was working from 6 a.m. to midnight: "Tomorrow Guioché will help me detach the first leg from the machine; it will be two weeks before the second is ready. I want time to make the second leg as good as the first." Lebossé was rushing to get the plaster ready for the foundry so that the large *Thinker* could be exhibited in bronze in the Salon of 1904. Thiébault-Sisson lauded Rodin for choosing the foundry the "young and audacious" A. A. Hébrard. Although Rodin usually had his works sand-cast, for this project he hired specialists in the elegant lost-wax process, which took additional time and cost more money.[20]

The first bronze cast of the enlarged *Thinker* was in the Salon, placed alone in the center of the rotunda, now considered Rodin's special preserve. As expected, it attracted more attention than anything else, to the annoyance of the critic Gabriel Boissy, who felt "forced" to stand in front of it. He even felt "forced" to praise it, because

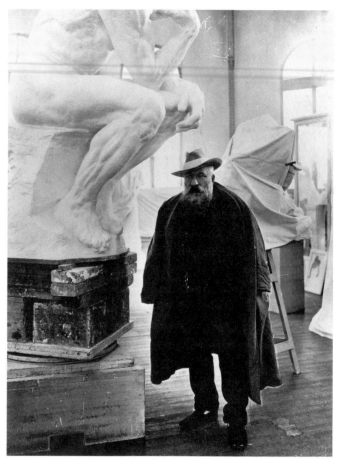

175) Rodin in his studio in Meudon, with the enlarged *Thinker*.
Photograph by World's Graphic Press.

anyone who "does not admire this angry orangutan is assessed as unintelligent."
Boissy, however, was impervious to such pressures. Instead, he wrote three columns
about the "enormous brute, the gorilla, the Caliban, obstinately stupid all the while he
is chewing his cud." He predicted that in thirty years no one would be able to compre-
hend why the public had been so infatuated with Rodin, who had "scoffed at beauty and
suggested replacing it with the sculptural dogma of the brute."[21] Others, however, saw
The Thinker as the new Adam, a modern father of us all; as the new Hercules thinking
with every muscle in his body; or as the modern peasant-philosopher. *The Thinker*'s
richness was—and remains—its ability to absorb a multitude of ideas about the nature
of man and his place in society. Rodin's friend, the critic Gabriel Mourey, put it another
way: "C'est simplement un homme de tous les temps" (It is simply a man for all time).[22]

Mourey was editor of a small review called the *Arts de la vie*. Before the Salon closed
at the end of June 1904, he had launched a campaign to put Rodin's *Thinker* into the

streets of Paris. Gustave Geffroy, treasurer for the committee Mourey put together, warned that if they did not succeed, the figure would simply end up in England or America, which were "so much more hospitable to Rodin's work than Paris." He noted disparagingly: "Even if we are not an artistic people, and even if we are overly anxious to submit to the formulas of conventional art, it is probable that a subscription under-taken by all our journals would succeed." Geffroy praised Mourey for entering the arena on Rodin's behalf. He was quite sure that the major Paris journals would never have done such a thing, since they were "run by captains of industry who think about nothing except business or by politicians who have no time for such matters."[23]

Rodin's close friends Besnard and Carrière were happy to serve as honorary presi-dents of the committee. By June 5,833 francs had been collected. Mirbeau, a member of the committee, was disappointed that the fund had not reached 30,000 francs. He blamed the "wealthy nationalists who formerly insulted Rodin and now applaud him, but do nothing to support him with their money."[24] Some of Rodin's friends gave as little as two francs (Despiau), others as much as two hundred (Monet and Mirbeau), five hundred (Picard), and even two thousand francs (Maurice Fenaille and Baron Vitta). Paul Leroi published the names of sixty-eight sculptors who had donated money. He challenged them to prove that his judgment that the "*soi-disant Thinker . . .* mechan-ically enlarged with such clumsy vulgarity" was not just a "corpulent figure fit to embellish a gymnasium for boxing." He placed five hundred francs in the hands of the mayor of the Ninth Arrondissement, to be collected by any of the artists he had named if they could prove him wrong.[25]

Rodin worked closely with Mourey and Geffroy. As in 1900, when a committee had been appointed to make a public celebration in his honor, he wanted the group to be balanced in terms of its political coloration. This did not go unnoticed: a journalist for *La Liberté* called him "an artisan of national reconciliation" for winning the support of sworn enemies such as Joseph Reinach, a deputy from Basses-Alpes and one of Dreyfus' staunchest supporters, and Henri Rochefort, the ultranationalist author of many anti-Dreyfus articles (June 1, 1904).

Everyone wanted to know where *The Thinker* would go. J. R. A. Fleury of the *Revue de l'art pour tous* reported talk of putting it near the Opéra or in front of the Eglise de la Trinité. Instead of these neighborhoods, noted for their "luxury and ugliness," he cast his vote for the Luxembourg or Tuileries gardens.[26] Rodin himself wanted it to face "the Panthéon at the end of the rue Soufflot, at the traffic circle . . . [near where he had] passed his youth."[27] Sentiment was not the only reason Rodin favored the Panthéon site: it would also help make amends for the shabby treatment he had received over the Victor Hugo commission. With this placement, he would finally make his mark within the precinct of the building that embodied the idea of French genius. The plan did not come to fruition, but a better one took its place: *The Thinker* would be placed in front of the Panthéon, behind the iron grill at the bottom of the steps leading to the entrance.

On November 26 Rodin was in Leipzig for the inauguration of an exhibition that

included a second bronze cast of *The Thinker* (already purchased by Dr. Linde of Lübeck). Two days later he was back in Paris to supervise the placing of a patinated plaster cast in front of the Panthéon. "We were afraid that the statue would look small, crushed by the gigantic façade," wrote Geffroy, but "to tell the truth it looked like it had been there since the Panthéon itself."[28]

Adequate funds were collected and the state rapidly accepted the gift. Rodin wrote to Mourey that he was full of joy ("le placement du Panthéon me comble de joie"); he wished to publish a letter of thanks to everyone who had had anything to do with the success of the project. Geffroy subtly interpreted the statue as a suitable symbol of the Panthéon's modern secular status: "It will be as a funerary sphinx before the necropolis where the nation offers final rest to those it wishes to honor." The statue was fitting because it was an "enigma" that proposed both "dream and action. So let us dream and let us act! This is a formula for life."[29]

176) *The Thinker* in front of the Panthéon. Photograph by Lucien Napoleon Brunswig.

Early in the morning on January 16, 1905, a man scaled the fence in front of the plaster *Thinker* with a hatchet in hand and hacked the statue to bits. An approaching policeman heard the vandal cry: "I avenge myself—I come to avenge myself!" When the man was taken to the police station, he explained that he knew the statue was making fun of him, a poor man with only cabbages to eat. The Thinker's gesture— shoving a big fist into his mouth—seemed to mimic the way the man ate.[30] Bourdelle wrote to comfort Rodin: "The accident with the Thinker is stupid. We can only feel sorry for the poor devil" (Jan. 16, 1905).

Something even more upsetting happened two days later: Emile Combes resigned as prime minister, and with him Joseph Chaumié, minister of public instruction and fine arts, whose favor Rodin had been intensely courting over the past year and whom he had successfully enlisted in the ranks of supporters for *The Thinker.*

Rodin had watched the plans to build a Musée des Arts Décoratifs disappear as a result of ever-changing governments, and he knew what it meant to have a different set of bureaucrats inspecting his Victor Hugo project every year, only to have it end in deadlock. The change in the political configuration, at the moment when he was so close to realizing his dream, altered his joyful mood of November. In early February, he wrote to Helene von Nostitz that he felt burdened by "unnecessary hardships."

That month Leroi published a description of the shake-up. He was sorry to see Chaumié depart, because he had taken with him one of the truly decent people in the administration: Henry Marcel, who had been in charge of the fine arts office. In Leroi's eyes, Marcel's one weakness was his inability to extricate himself from the intrigues of his superiors: "Thus he was not able to throw out this ridiculous and shameful piece of quackery organized in favor of the pseudo-*Thinker,* detestable, machine-made rubber, misfired *Dante,* commissioned from M. Rodin thirty years ago, this ostentation made for export, one that offends everything that French art stands for in the sight of true artists."[31]

The new undersecretary of fine arts was the painter-politician Henri-Charles-Etienne Dujardin-Beaumetz. The announcement of his appointment was met with broad support, and in his first public statements he alluded to a "renaissance in the making," declaring that he intended to support all tendencies of modern French art. To make the activities of the state with regard to the arts more public, he promised to announce every state commission in the *Journal officiel.* He intended to hold annual exhibitions of every work commissioned or acquired by the state. He was fully aware how sensitive and political his position was, and he felt that as ancient Romans had believed in their right to "bread and games," modern Frenchmen should assert their right to "bread and art."[32]

Four days after Dujardin-Beaumetz's policy statement was published, he headed for 182 rue de l'Université.[33] He wanted to invite Rodin to serve on the Conseil Supérieur des Beaux-Arts, replacing Barrias, who had just died. Bourdelle was astonished: "How

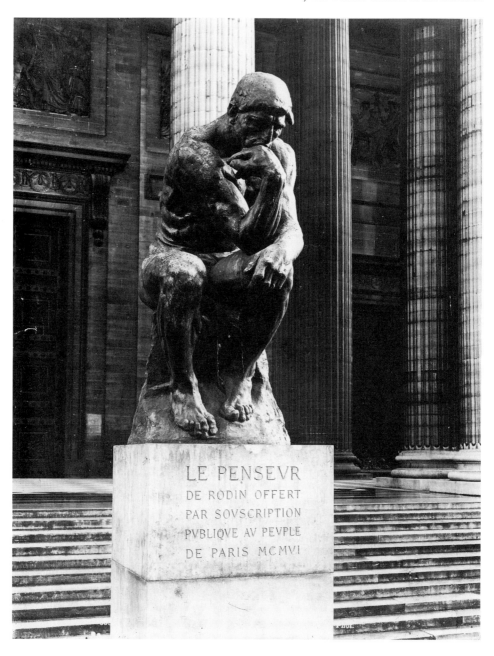

LE PENSEVR
DE RODIN OFFERT
PAR SOVSCRIPTION
PVBLIQVE AV PEVPLE
DE PARIS MCMVI

178) Dujardin-Beaumetz reading his speech at the inauguration of
The Thinker at the Panthéon, April 21, 1906. Photograph by Hutin.

the times have changed; one would have expected it to be Puech!" (Feb. 14, 1905). This sign of official support should have made Rodin feel secure about *The Thinker*. But he did not, and events proved him right. Although the statue itself was approved, the architect of the Panthéon rejected the pedestal. (Approval had to come from both the architect and the Ministère des Beaux-Arts.) A discouraged Rodin wrote to Geffroy: "As it was with my early work, we have fallen in the grip of the Institut [de France]. It is the end of everything" (June 26, 1905). Months later, Rilke, in his capacity as Rodin's secretary, wrote to Dujardin-Beaumetz to request his intervention. This worked and Rodin wrote Geffroy: "We are free to move ahead with the execution now" (December 1905).[34]

The Thinker would be inaugurated a week after Easter. Rodin went to church on Easter Sunday at Saint Gervais. The following day the Shaws arrived from London. A reporter who interviewed Rodin in Meudon that week asked about the figure's "social significance." Rodin's reply was different than it would have been a few years earlier; he referred to "the diverse ways of thinking among workers and the problem of the unemployed in this country."[35] This was a radical change from *The Thinker* as "le poète," through whose feverish brain tumbled a myriad of creative thoughts.

On Saturday afternoon, April 21, 1906, under a cloudy sky, a crowd gathered to listen to Mourey and Dujardin-Beaumetz speak about *The Thinker,* now sitting high on a white stone cube inscribed: "The Thinker of Rodin is offered by public subscription to the People of Paris." The undersecretary called it one of the finest works of modern art he knew and spoke of the inauguration as a victory for independent art. Rodin was a "man of the people" and, like the Thinker, he had "a common soul." He was the "worker." Then Dujardin-Beaumetz indicated the pediment above their heads, the great composition by David d'Angers on the facade of the Panthéon, with its allegory of France handing out laurel wreaths to the great men of the nineteenth century. For Dujardin-Beaumetz, Rodin's monument expressed the French people's zest for the gifts of their geniuses. "Rodin has completed the work begun by David d'Angers," he declared. The day would not have been complete without a reference to Victor Hugo. The ideas expressed by Dujardin-Beaumetz—that *The Thinker* was both "athlete" and "arduous worker" in the cause of "social progress"—were indebted to Hugo's social philosophy. When the speeches were over, Mme Segond-Weber of the Comédie Française, draped *à l'antique,* stepped from behind the columns to declaim Hugo's *Stella:* "This is the angel of liberty, this is the giant of light."

It was the most important public day in Rodin's life. He had raised up a monument in the heart of Paris; he was vindicated. Geffroy pointed out that although Paris had many statues, "it's rare to find a beautiful statue. . . . The majority of our statues have no significance as art, as thought, or as life." He suggested this was because they came from sculptors of the Institut who had "nothing to say." He could not resist mentioning the sorest point of all: the city had preferred Falguière's Balzac over Rodin's masterpiece. Now at last Rodin, who was "treated like a master in Berlin and in London," had "taken possession of a few paving-stones in Paris."[36]

The transformation of *The Thinker* reflected the social agenda of the early twentieth century, when thousands of workers were on strike every year, supported by many thousands more. Some of the writers in Rodin's camp, especially Mourey and Dayot, understood that this wider dimension of his work could have important ramifications. When the Carnegie Foundation announced a competition for a monument to be erected in The Hague before the opening of the 1907 peace conference, they implored Rodin to dust off his sketch for *The Tower of Labor.* They understood that it did not exactly coincide with the subject, but they believed that it did respond to the spirit of nations coming together in search of lasting peace. Rodin thought so too: "There will have to be a united Europe; its various countries must come together, if they are to continue to live and flourish," he said in submitting his work.[37]

The idea took hold, but not in Holland; instead, the colossal monument would be in France. Writers such as Paul Adam and Gustave Kahn, both enthusiastic backers of labor and eager supporters of Rodin, joined the "cause." Adam felt strongly: "It is the worker who gives the nation its life; industry can only develop with his unceasing

collaboration." According to Adam, the country was wrong not to have raised a monument to the men responsible for the great "pacific" victories won by workers. Rodin had just what they needed; why didn't France get on with it? Adam had already spoken with Dujardin-Beaumetz. The minister was not opposed as long as there was sufficient capital. Rodin estimated the cost at four or five million francs.[38]

This kind of talk put fear into the hearts of Rodin's opponents. A week before the inauguration of *The Thinker,* an editorial writer for *L'Illustration* (which did not mention the inauguration itself) responded on a hysterical note to the new proposal: "If M. Dayot wins his cause, we will be condemned, for the rest of our lives, to look at another work of M. Rodin, even if it turns out to be totally obnoxious. To fight against such monuments, it is necessary that people rise up, that revolution break out, that blood flow in the streets."[39]

The unlikely plan went ahead. Rodin engaged Paul Nénot as architect and Dayot set about to establish a committee. He persuaded Léon Bourgeois, former prime minister and twice France's chief delegate to the Hague Peace Conference, to serve as president. Albert Nobel, nephew of the discoverer of dynamite and now active in the search for peace, wrote from Biarritz in April 1907 that he would be happy to serve. At the end of the year, the Belgian critic Camille Lemonnier wrote: "Centuries will throb under Rodin's hand; I must lend myself to this project." He began the work of forming a Belgian committee.

Thus Rodin was launched on the biggest project of his life. The tower would be 130 meters high, about half the height of the Tour Eiffel. Rodin felt that "the higher and more formidable the tower, the better it will serve the end I propose."[40] Visitors would enter the crypt of the miners and the divers through *The Gates of Hell.* Then they would climb the stairs to ground level, passing statues of Night and Day, masons, carpenters, forgers, woodworkers, potters, and so on, on their way up and up. Finally, they would reach the realm of artists and intellectuals beneath the crowning group of two winged Benedictions. Where would this monument be located? No one quite knew. Perhaps in the suburbs, "toward which Paris creeps each day."[41] Pros and cons were hashed out in the press over the next couple of years. But by 1910 there was silence on the matter, and we hear no more about the "first monument of a new age." It had been more a media dream than anything else. Rodin joined in the fantasy but never engaged seriously in a real effort to create this grotesque monument.

There was one unfinished commission, however, that Rodin had to see through. Once *The Thinker* had found its home, he returned to the troublesome Hugo monument. The main figure was ready in marble, but Rodin had so much difficulty harmonizing the figure of Hugo with the muses that he abandoned the muses altogether. It was not an easy decision, nor did he take it with much conviction; it did allow him, however, to resume work on the monument.[42] In 1908 the plan was again altered, since *Victor Hugo* was no longer intended for the Jardin du Luxembourg, but for the gardens

of the Palais-Royal. Dujardin-Beaumetz had picked the new site, which he could see from his office in the palace. He was even thinking about populating the entire garden with "great men in bronze and marble."[43]

Throughout the spring and summer of 1909, Rodin supervised the preparation of the site. The grounds of the Palais-Royal pleased him very much; his thoughts were frequently quoted in the press: "This foliage, these trees, the harmonious architecture in such fine French taste will provide a wonderful frame. Do you see the two trees that will stand on either side of the monument? Do they not look as if they had been whipped about by a great wind?" The press loved these statements and responded with considerable irreverence. A writer for the *Dépêche de l'Est* twittered: "This lyrical enthusiasm has filled us with admiration and confusion. *Vite,* let's go have a look at these romantic trees." The report came back: "two trees, dark and sad, like a couple of old civil servants, between which the rock of Guernsey looks like a grounded boat supporting the elegant statue that sleeps beneath the tarpaulin." The writer called the Palais-Royal a "grave for a romantic lion," saluting "the imagination of the artist" who, in the presence of all these "boutiques and the smell of fried food, is able to see tormented trees beaten by a great wind. Ah, the wondrous youth of genius."[44]

By 1909, when *Victor Hugo* was unveiled, the notion of modern art had changed profoundly in France. Even the conservative *Illustration,* heretofore one of Rodin's major foes, not only covered its inauguration but praised the monument for combining symbolic intent with realistic handling so as to bring Hugo the Olympian to life in all his force and being.[45]

The changes in avant-garde art were particularly in evidence at the new Salon d'Automne, where artists showed paintings with colors, shapes, and surfaces completely independent of nature; the press called them Fauves, or "Wild Beasts." Another group of artists, known as Cubists, revamped the spatial concepts that had guided Western painting since the Renaissance. They recognized beauty in the objects of non-European peoples, especially Africans, which few other Westerners perceived. Not surprisingly, they saw no value whatsoever in repeating the significant themes of the past, such as Victor Hugo in exile. In February 1909, as Rodin was working on his base for *Victor Hugo,* a young Italian poet named F. T. Marinetti published the "Manifesto of Futurism" in *Le Figaro,* in which he proclaimed a "racing automobile" more beautiful than the *Victory of Samothrace.* By 1909, the cultured world that collected art in Paris and read the journals had moved away from notions of public grandeur, individual pathos, and the importance of naturalism—the very qualities that were the bedrock of Rodin's creation. Rodin felt his identity as a Frenchman with urgency; he fervently wanted to participate in the great events of his time and country. As a nationalist, he had always wanted his work to stand as a monument to French genius, which had made the long list of rejections and attacks all the more painful.

One further undertaking sheds light on Rodin's persona in the twentieth century. Having assembled a team of workers to prepare his casts and transfer his groups into

179) Inauguration of the *Monument to Victor Hugo* in the garden of the Palais-Royal, Sept. 30, 1909. Claire de Choiseul stands to the far right.

marble, and enjoying his new-found financial security, Rodin could afford to devote part of his energies to collecting. He bought ancient Greek, Roman, Egyptian, and Oriental art, medieval sculpture and objects, as well as contemporary works by friends such as Monet, Carrière, Besnard, and Blanche. Greek and Roman sculpture was his special passion: by 1907, he owned more than three hundred pieces. Otto Grautoff called it "one of the richest and most beautiful private collections in Europe."[46] Anatole France, also a collector of antiquities, accused Rodin of spoiling the market for ordinary amateurs.[47] When Rodin died, his collection was valued at four million francs.

Rodin's friends—such as Dayot (founder of *L'Art et les artistes*), Mourey (editor of the *Arts de la vie*), Bénédite (on the editorial board of *Art et décoration*), and Marx (editor of the *Gazette des beaux-arts*)—provided a context for these activities. Their publications reflected the new culture of art history, in which old and new art joined for mutual enhancement on glossy paper with splendid photographs, sometimes even in color. They supported Rodin's work wholeheartedly, frequently quoting his ideas about art. The critic Paul Gsell observed that many of his contemporaries believed one should not ask artists about their work, but this was not the case with Rodin: "No matter what one says, there are still artists who know how to talk about art."[48]

It was but a short step for Rodin to enter the world of criticism under his own name; in 1904, just as his workmen were finishing *The Thinker,* he was preparing to present

himself as a "thinker." He set down his thoughts about the lessons of antiquity in an article about the *Aphrodite of Chios,* the Greek sculpture in the Warren collection that he had tried to acquire in a trade for some of his own works (see chapter 19). Since Rodin could not own the ravishing head, he would possess it through his panegyric in print: "All my life I shall remember the impression she made on me the first time I saw her. She entered my life as a gift of the gods." In the simplest language, Rodin stated that he believed such marbles by the Greeks were divine messengers put within our reach to teach us our duty, which is how to celebrate life.[49]

In 1904 Rodin began giving interviews about medieval cathedrals. He credited Hugo with helping him learn to love the Gothic monuments and recalled Hugo's role in saving the Tour Saint-Jacques from demolition. Compared to English and German cathedrals, he believed the French had "greater sculptural expression. . . . In this respect, they are second to nothing outside antique Greek architecture."[50] This was a central theme in Rodin's thinking for the rest of his life. When he joined with others to protest the modern restoration of the Parthenon in Athens, he called it the "heaven" (le ciel) of the South, as the cathedrals of France were the "heaven of the North." Together, they formed a "synopsis of nature."[51] Rodin was, in effect, restating a commonplace of art history. In his mind, the Greek-Gothic route took primacy over the Roman-Renaissance axis, thus ensuring the ascendancy of France over Italy in the history of Western art. Rodin's love of French sculpture and his fervent nationalism intensified over the next few years as he enlarged upon these ideas.[52]

In 1907, in addition to revising his *Victor Hugo* and talking with journalists about *The Tower of Labor,* Rodin was engaged in a third project: he was beginning to pull together drawings and notes he had been making since the 1870s about the cathedrals of France. Hoping to focus his ideas, he initiated an exchange of letters with Bourdelle. Writing from the Cathedral of Le Mans in September 1907, he spoke of going to the four corners of France to seek counsel about "immortal beauty, [which] varies only in its intonation, being ever faithful to the same principle: the unadorned modeling [le modelé nu] of the planes." Bourdelle wrote back that he had always considered Rodin a relative of the great early artists of France, so it was easy for him to assist Rodin's pilgrimage to the basilicas of France and to appreciate the intensity with which Rodin was scrutinizing the great ancient forms.[53]

Rodin engaged the critic-poet Charles Morice to help put his stacks of drawings and word-sketches in permanent form. Starting in 1908, the two men began working on a book, not always easily, but with enormous intensity: "Dear Rodin, Don't be so impatient, I'm giving every free moment I have to our book. I cannot tell you the joy I find in this work," Morice wrote (July 24, 1908).[54] Rodin took the book forward "like a prophet conducting his people to the promised land." When it was published in 1914, Emile Mâle, the pioneering historian of medieval art, greeted it with open arms: "When a man who has created masterpieces tells us that the cathedrals are sublime and should

be contemplated through tears of joy, we can take him at his word. Do we ask reasons of a prophet or seer? We simply listen and feel our hearts burning in our breast."[55]

The Rodin who looked to the past was in harmony with French officialdom. He laid down his tools in order to consider the place of his own work and the great sweep of history before him. He was the "Thinker." As he had once been the young and slender "Vanquished One," stretching upward, filling the air with his cries in pursuit of an ideal self, then the "Thinker" in the midst of his own creation, meditating on man's transgressions, now he was the ponderous giant guarding the great men of France. This was the official face of Rodin in the twentieth century.

Rodin's powerful rendition of that anonymous giant, *The Thinker,* is probably the world's best-known sculpture. It became his official persona. But what if Rodin had allowed the more original examples of his twentieth-century creation—his drawings— to stand for his old-age style? We might place him more comfortably into the literature of twentieth-century art, for it is the drawings that relate most pertinently to the initiatives of younger avant-garde artists at the beginning of the twentieth century, as was understood so well by the artists who saw them at Steichen's 291 gallery in 1908 (see chapter 30).

In the early 1880s, drawing was central to Rodin's search for the themes of his great doors. In the 1890s, however, he engaged in drawing for its own sake. Rodin told Bourdelle that the drawings were the "result" of his sculpture, that they came after his intense searches in three-dimensional form.[1] Frequently, they went beyond his sculpture in totally synthesizing a single idea.

Rodin's twentieth-century drawings also depended much more than his sculptures on female models. In the nineteenth century, Rodin's most important models had been the men who posed for *The Age of Bronze, Saint John, The Thinker, Adam, The Burghers of Calais, Victor Hugo,* and *Balzac.* In the twentieth century, Rodin moved unreservedly to drawing dozens of women models. From his files we know their names—Yvonne Odero, Julia Benson, Dourga le Hindu, Renée Couchet, Nora Falk, Juliette Toulmonde, Marguerite de Fontenay, Carmen Damedoz, Suzie Langlois, Fenella Lovell— and, of course, Gwen John. Rodin was willing to rescue them from disaster, lend them money, or stand up for them in court.[2] The working conditions in his studio were considered among the best in Paris. One model, identified only as Thérèsa, tells us that Rodin, who preferred "vigorous, muscular models with salient whipcord sinews," was "always good hearted," paid "generously," and gave them "biscuits and coffee or wine."[3]

In the twentieth century Rodin could afford to keep a number of models on hand, just as Monet could afford to hire a team of gardeners at Giverny. It was not just a similar attainment of wealth which makes this comparison apt. Rodin's models were analogous to Monet's lily ponds and poplars—they were his nature, his leaves, his shimmering movements of watery surface. They held unfathomable secrets. He studied them from every viewpoint, hoping for that fleeting appearance of a special confidence for his pencil alone. William Rothenstein watched: "Rodin was always drawing; he would walk restlessly round the model, making loose outline drawings in pencil, sometimes adding a light coloured wash. And how he praised her forms! caressing them with his

eyes, and sometimes, too, with his hand, and drawing my attention to their beauties."
Jules Desbois described how, as a working session came to an end, Rodin approached a
model who was still lying on her back on the table and "delicately kissed the young
woman on her stomach—a gesture of adoration for Nature who had just yielded up all
her joys to him." He was grateful for the opportunity to encounter the visual wonders
of life and movement, saying: "I will not say that woman is like a landscape . . . but the
comparison is almost right."[4]

We would not say of Rodin, however, as Cézanne said of Monet: "He is just an eye,
but, God, what an eye!" In these drawings, Rodin was not simply celebrating the
wonder of the visual encounter with the feminine body. Every description of his studio
practices, either by Rodin himself or by a contemporary critic, makes it clear that when
he began to work with a new model, he always discovered a thought he had never had
before. He would look at a model's legs and suddenly recognize something "utterly
primeval, the way people were in prehistoric times. . . . Look at those slim legs, look at
those clever feet. With these she could have climbed and lived in trees."[5]

More than anything else, however, Rodin was consumed with a desire to understand
the nature of sexuality as a physical reality. The spontaneity of drawing and his constant
envelopment in a world of female bodies provided him with the means to carry out the
search. Camille Mauclair, in preparing his 1905 critical biography for an English audi-
ence, felt it necessary to devote a few words to this "delicate point." He knew people
were shocked by Rodin's recent drawings, which had been done "for himself alone, in
the privacy of his studio." He explained that the drawings represented Rodin's way of
searching for nature "beneath the original animality," and that through them Rodin
wanted to understand "feminine sexuality, its movements, and impulses . . . because
therein woman is psychologically revealed." Rodin was searching for everything that
"exalts, maddens, contorts and fevers the human body," and only "mediocre minds"
would see anything low in such an important study.[6]

In the mid-1890s, Rodin initiated a new drawing style, characterized by summarily
handled volumes and sketchy outlines. Perhaps he started to experiment with this kind
of hurried sketching while he watched his models on their breaks.[7] The public had no
awareness of the new style until the publication of *Les Dessins d'Auguste Rodin* (the
Album Fenaille) in 1897.[8] In a special 1900 issue of *La Plume* devoted to Rodin, Arthur
Symons gave a totally new view of his art: "The principle of Rodin's work is sex, sex
which is so conscious of itself that it finds a desperate energy to attain the impossible."
Symons liked Rodin's sculpture, but he found the drawings staggering: "bodies vio-
lently agitated either by the memory of, or the waiting for, sensual pleasure. . . . She
turns on herself in a hundred attitudes, but always on the central pivot of her sex which
accentuates itself with a fantastic and terrifying monotony, like an obsession." Symons
pointed out that Rodin had gone beyond anything Degas had ever done to fashion *la
femme animale;* he had discovered *la femme idole.*[9]

One day, as the critic Gustave Coquiot watched Rodin at work in the studio, it

occurred to him that the models were probably the only people to whom Rodin felt close. With them Rodin was able to acknowledge the enthusiasm and joy he found in their presence. "He would say: 'Don't hurry in taking off your clothes,' . . . and with greediness he watched."[10]

The number of drawings resulting from Rodin's greediness is enormous. The Musée Rodin owns more than seven thousand; there are probably another thousand or so in other collections. Over 80 percent are late drawings of female figures. Looking through the Musée Rodin's four-volume catalogue raisonné, we are amazed at how many drawings show models rolling up on their shoulders, waving their hips and legs in the air, or lying on the floor with legs spread wide, positions that allowed Rodin to focus on the female genitalia.[11] Frequently, Rodin asked his models to masturbate or invited the women in twos and threes to interlock their bodies and touch each other with loving caresses.[12] He found that young, athletic girls were best able to perform the kind of modeling he wanted. Somehow he was able to create an atmosphere of comfort and appreciation that allowed the models to participate in his visual experiments with relative ease, one suspects even with pleasure.

Presumably, most of Rodin's models were lower-class; however, he did not limit himself to professional models. In 1905, when working on Countess Anna de Noailles' portrait, Rodin asked her to model for some figure studies. The countess described his efforts to make her comfortable during their sessions. One day, after stoking the

180) Rodin, *Woman on Her Back*. Pencil. Musée Rodin.

181) Rodin, *Anna de Noailles*. 1905–06. Terra
cotta. Musée Rodin.

furnace, he suddenly fell "on his knees before me. He took my feet in his hand; well, it
seemed totally natural. Then he said to me: 'I have never really seen you before because I
never see when I don't look.'" Next Rodin showed her some drawings. How could one
imagine drawing such things? she wondered. One drawing especially repelled her:
"How could a woman be so shameless as to take her melancholy pleasure in front of this
old artist?" Later she heard Rodin mutter, "What a beautiful drawing I could make of
you." Rodin told her that what he found fascinating in her face was the combination of
sensuality and contemplation. De Noailles thought of Rodin as "intelligent, and he
understands everything intelligent that one says; he creates an order with a sureness and
no fumbling." But she left his studio worn out "from the way he looks at me, the way
he imagines me nude; from the necessity of fighting for my dignity before this hunter's
gaze."[13]

 We cannot imagine parallel scenes taking place in Camille Claudel's studio. If, in her
search to lay hold of the natural world and the delights of movement and light, she had
asked a male model to roll over, throw his hips in the air, and masturbate, her father
surely would have withdrawn his support, and she would have found herself confined
to an asylum years earlier.

In assessing this vast and important production of Rodin's later life, a line must be drawn between exploitation of female models and ability to celebrate the erotic as a life force. Rodin was far from being the only artist obsessed with images of women in this period. Carol Duncan writes about the "vogue for virility in early twentieth-century art"; Munch, Kirchner, Matisse, and Picasso all felt the need to assert their "sexual will." When we look at Matisse's *Joy of Life* (1906) or Picasso's *Demoiselles d'Avignon* (1907), we immediately think about the relationship between the models and the artist: "The assertion of that presence—the assertion of the artist's sexual domination—is in large part what these paintings are about," writes Duncan.[14]

Rodin was fond of showing his erotic drawings to select visitors in his atelier. Anatole France found them obsessional and repetitious: "In his drawings Rodin represents little more than women showing their And his monotonous audacity is just a little tiring."[15] France's remark must have been born of a momentary eruption of prudishness, for the drawings are so fresh and various that it is hard to believe anyone could find them monotonous. After Rodin died, the erotic drawings were seldom on view until interest in his work revived in the 1960s.[16] Two Frenchmen, the writer Philippe Sollers and the sculptor Alain Kirili, played a role in the second wave of discovery.[17] Both had seen exhibitions in which the erotic drawings were intermixed with other drawings; Kirili said they had seemed "like accidents." But taken as a whole—hundreds and hundreds of them—this "bacchanalia on paper" was "an unequaled breakthrough in the representation of the human body." The drawings riveted both men. They tried to imagine who the women were and how Rodin got them to do what they did. "Who was this old faun who asked women to desire each other, to take off their clothes, to offer themselves to each other, to touch each other, to slide into each other's bodies in front of him?" Sollers emphasizes that the drawings were not the work of a "sexual maniac" but have a metaphysical dimension. He sees their subject as being the nature of liberty in human experience.

Another recent critic to study Rodin's twentieth-century drawings is Catherine Lampert (who has worked as an artist's model herself—for Frank Auerbach). She tried to imagine Rodin's state of mind as he followed "the action of the model with no limit to what might be considered to be in the domain of 'art'." She calls these drawings "Rodin's aphrodisiac. . . . What the aging Rodin is desperate to discover but cannot, as he realizes, is to 'know' what it feels like from the other side. What sensations female languor, lust, Lesbian pleasings, manual stimulation and finally ecstasy are comprised of." Lampert sees him as "an addict using his charismatic power over women," as well as his "money which pays for the models." Nevertheless, Lampert considers Rodin "the first sculptor to want to make women's sexuality important." This, she suggests, is why this part of Rodin's oeuvre is more than simply the work of a celebrated old man demonstrating his power over women.[18]

Rilke had the same insight and felt delight when it dawned upon him that Rodin gave equal attention to the passions of men and the passions of women in *The Gates of Hell*.

Rodin's woman is "no longer the forced or unwilling animal. Like man, she is awake and filled with longing, it is as though the two made common cause to find their souls."[19]

The person who best articulated this view was the feminist writer Aurel (pseudonym for Aurélie Besset-Mortier), who met Rodin after 1904. Although she found him "too far gone, even a little over the hill" (trop fait, un peu défait), she regretted that their friendship was Platonic ("une amitié bien pensante") and that "between him and me there was just gracefulness." When he died, Aurel reflected how grateful she was to have lived in the same time as Rodin. In his memory, she wrote *Rodin devant la femme* (Rodin in the presence of woman). It is a love poem to Rodin, the artist who saw woman in her strength, not in her weakness. The book opens with the highest accolade:

> If there is any art in the world that has ceased to be unisexual, that calls upon human sensibility, that is women's as well as men's, if there is an art drenched with feminine force, one that draws an extra keenness from that, that has a violence, a spur, an art that is the male child of woman, it's Rodin's. . . . Our mothers told us, "Men like weakness!" But this man prefers force. . . . In Rodin's presence, a woman dares to be free and to give up pretending. She ceases playing at being prey, the sweet plaything that costs dearly and yields up smiles for Monsieur. She can embrace her grandeur and her autocracy. She looks grand in her nobility by which humanity mounts to its true nature. She becomes an animal.

Aurel was convinced that only a woman could explain Rodin's art. She liked to recall his words to her: "I owe everything to women; they move ahead as great masterpieces." When a journalist asked Rodin what he thought of the women's suffrage movement, he said he applauded them for wanting to "have men understand and appreciate their value." He did not think men understood women. Man had been "weakened in the course of his work of research and eager quest for money, while women have in the meantime become superior to men in their love."[20]

Knowing Rodin's art helped Aurel to be more comfortable in her woman's body. How should we characterize Rodin's erotic drawings: as a healthy exaltation of woman's physical reality, or a man's egregious domination of the female body? Aurel would have said they were the former and assured us that Rodin had made the world a better place for women. But what of the other women whose relationship with Rodin was not simply a matter of "gracefulness"?

From his teens to his late forties, four women dominated Rodin's life: his mother; his sister, Maria; Rose Beuret; and Camille Claudel. All of his other most intimate friends were men. He himself said he was not comfortable with women. Descriptions about his manner in the company of women vary greatly. The poet and woman-about-town Lucie Delarue-Mardrus recalled him standing silent and "looking at his feet" in her presence. "And then suddenly, without speaking to anyone in particular, he would say something immense about sculpture or architecture."[21] Rodin started sending her

affectionate letters "full of spelling mistakes." More often than not, however, Rodin's curiosity about women was perceived as a kind of sexual advance. Once he dined with four beautiful young women at the Monets' home. Rodin looked at them so intensely that "one by one, each of the four felt obliged to leave the table."[22] Henry Adams accused Rodin of "making eyes at Marie." And surely Anna de Noailles' experience at her modeling session was anything but unique.

At the other extreme from Delarue-Mardrus were the gossips who described Rodin as an incorrigible lothario: "The whole of Paris was talking about the not very savory details of his erotic adventures."[23] Many years after the dancer Ruth St. Denis posed for him, she remembered the difficulty of getting her blouse back on, for Rodin was kissing her "arm from wrist to shoulder, murmuring endearments. He started to embrace me, and I became very frightened."[24] Gladys Deacon, the duke of Marlborough's second American wife, met Rodin in the Montesquiou circle. She claimed that he "precipitated himself on every woman he met. You know . . . hands all over you!"[25]

Was Rodin lusty, shy, or both? To answer this question, we must examine the women who occupied a place in his sentimental life and the relationships he had with them.

During the last twenty-five years of his life, when Rodin was celebrated in the press as a genius, he attracted an exceptionally diverse group of women. Ernestine Zurniden Weiss, a widow and a librarian at the Palais de Fontainebleau, first wrote to him on June 20, 1892. Weiss wanted Rodin to do a bust of her brother. Of course, she would pay, but she hoped he would give her a "prix d'ami." She would come to see him. Better yet, he could come to see her. She enclosed a train schedule. It took her two months to achieve her goal: lunch in Fontainebleau, tête-à-tête. There ensued a barrage of letters containing invitations, signs of concern for Rodin's health and state of mind—"Why are you so morose and droopy?"—offers to help find commissions, clippings of articles about American millionaires. The widow Weiss, who was a year older than Rodin, was pressing her case for a special relationship during the period when he was involved with Camille Claudel, and he paid little attention to her pursuit. By the end of the year she felt she had to speak her mind: she wanted him to know how much she loved "men of talent, men of genius!" Further, he should understand she was alone: "I have no father, mother, brother, husband, and I have no children. And, with my nature, how could I remain alone!" Weiss's invitation was clear enough. Rodin sent a little note promising to visit, but he did not come. This lopsided relationship continued until 1906, Rodin putting in just enough effort to keep it alive. After he paid a surprise visit to Fontainebleau in 1901, Weiss wrote: "I thought you had forgotten me; it was awful to think you were indifferent."

Rodin's friendship with Hélène Porgès Wahl (see chapter 24) was not unlike his involvement with Ernestine Weiss: Wahl full of desire, Rodin keeping his distance, never quite able to deny her completely. Thus she hung on a thread of hope, extending

invitations to Switzerland, to the theater, to dinner with the Poincarés. Many times in the twentieth century Rodin neglected to keep a rendezvous with Wahl. She wanted him do her bust and accused him of passing her over in favor of Americans. But little as he encouraged her, she remained faithful. A few months before Rodin's death, she wrote to Léonce Bénédite, curator of the Musée Rodin, imploring him to arrange for her to see Rodin one last time. Her wish was not fulfilled.

Part of the dynamic of these women in their pursuit of Rodin was the special mystique that surrounded the "genius" around 1900. It was the ultimate aphrodisiac, especially for women with a certain standing in society who had more time and cleverness than they knew how to use. The grayest and dustiest academician could count on women paying him court. How much more magnetic Rodin must have been—this famous sculptor who believed in the bond between sexuality and creativity and who expressed his belief daily as he worked with the models in his studio. This extraordinary fantasy about being loved by a genius was entertained in all echelons of Parisian society—and not only women were susceptible. When Rodin's friend Robert de Montesquiou became attached to Gabriele d'Annunzio, he said: "I experienced the heady intoxication of believing myself to be tenderly loved by a man of genius," and he remained "religiously attached for a period of one year."[26]

Rodin's first lover following the end of his affair with Claudel was Sophie Postolska. When they met in 1897, she was twenty-eight and an aspiring artist. Aware of her physical voluptuousness, yet projecting an air of innocence, she wrote him asking for a modeling position. She set just one condition: she would disrobe for him alone. Within weeks, Postolska was signing herself "toujours votre Sophie" and Rodin had become her "grande joie voluptueuse." At times, as during the 1900 Exposition Universelle, Rodin was unable to give her the attention she wanted. Then she would assert herself: "If you don't come on Sunday, that will be the end!" (Sept. 26, 1900). And he would come.

In the wake of his international triumph, Rodin tried to extricate himself from this intense affair. In May 1901, Postolska wrote: "How difficult it will be for me to do what you want, to be more moderate in my desire for you." Here is Rodin's answer to Postolska's daily reports of "solitude, souffrance, et suprême volupté," sent to her in the south of France in 1902:

> I order you to enjoy the beautiful weather. . . . If you obey, you will make me happy. . . . As an artist you have not even spoken of the little plasters you are supposed to be working on. . . . You don't have a grip on yourself, which is bad for you and for me. I am here in Paris weighed down by a thousand things in this difficult life that I lead. And you, with little to do that is really serious, carry on in tears and in anger as if you were a child. I am not going to come, I am terribly tired, please make sure that when you return I find my woman in a good mood and not trying to inhibit my freedom. I live as best I can. At my age I don't need any grief, and you should cheer me up and take care of me in whatever way you can.

182) Postcard bearing the photograph of Sophie Postolska

The patronizing tone betrays Rodin's waning interest in the relationship. The letter is signed "to my true love who must *obey* me and if this be the case, a delicious kiss."[27]

Of course, Rodin had no history of loving women who obeyed him. Postolska, watching him being feted and invited in every direction, concluded that he no longer had much feeling for her. She was particularly jealous of foreign women and hated his trips abroad: "You leave me with my heart on fire, bursting with pain, without any desire to console me or to help restore some kind of calm to ease my suffering." Darkly, she said there was nothing left save sinking into oblivion, "into the beautiful and voluptuous earth which now attracts my wretched body." Rodin replied that he could do nothing, that she should stop arguing and be obedient: then "you will be saved."[28]

The lovers' quarrel was much discussed in Rodin's studio. Bourdelle declared that "Mlle Postolska does you great honor" (Aug. 24, 1903), but Emilia Cimino, who had been around Rodin's studio through exactly the same period as Postolska, considered the affair a big mistake: "You sought my presence four or five years ago in order to conceal the beginning of the relationship with the woman you took as Claudel's replacement." Cimino accused Rodin of taking revenge against Claudel for abandoning him. She pleaded with him to stop: "This is not the way the really great grow old, giants like the Gladstones, the Victor Hugos, and what I had dreamed for you!!" Cimino predicted that if Rodin did not get rid of Postolska, *Victor Hugo* would never be inaugurated and there would be much trouble in the studio: "*Mon maître chéri,* I implore you that in the coming winter you take up your work and direct it yourself. . . . Remember—she is not *la Pensée* [the title of Rodin's most celebrated head, portraying Claudel's face]—she is *le Corps,* which is the earth, and she will kill the artist." In the same series of letters, Cimino said she was well aware that there was no longer anything between Rodin and Claudel, and perhaps his "lusting after the young Jewess" was

simply the amusement of a man in his last years. "A man like yourself who works with his brain cannot at sixty-three years of age take up an earthy life again. . . . This girl will *never* be a sculptor. She is lascivious, ambitious, and lazy."[29]

On March 16, 1904, Postolska took a large dose of *sublimé corrosif* (a mercury chloride) in an unsuccessful suicide attempt. When she recovered, she moved to Austria. Rodin sent a bronze figure of a Burgher of Calais for her new home, and arranged for one of her studies to be exhibited at the Salon d'Automne in 1907. A few years later, Postolska moved to Cracow. She continued to write letters to Rodin, describing the "ancient tombs of the kings, the many souvenirs of early days, the sixty Catholic churches," and all that she could find of interest in this "vast sepulcher of Poland" (Nov. 20, 1909). She stopped making sculpture and turned to music: "Can I play for you one

183) Emilia Cimino with Rodin

day?" When war broke out, Postolska moved to Lausanne; she could not afford to pay the shipping charges for her Burgher. Would Rodin send money? He did. After Rodin's death, Postolska wrote to the mayor of Meudon in the vain hope of recovering her letters.[30]

At the turn of the century, Rodin's intimate life was focused on Postolska. Their affair, however, was only a small part of his life; he was arranging exhibitions and establishing his reputation as one of the arbiters of culture in the Western world. Postolska's pleasure in the affair was limited by her jealousy, which would have been even worse had she known how much there was to be jealous about. A whole new group of young women flooded into Rodin's life in the wake of the 1900 exhibition.

One was an Isabelle Perronnet, mistress and model of Rodin's friend and rival Alexandre Falguière. Perronnet wrote Rodin for the first time the day after Falguière's funeral (April 23, 1900). She explained that she had not gone to the funeral; what would people have thought? Alone, she went to the cemetery to lay flowers and to weep for "my dear departed one." Now she needed a job. Could Rodin help? Perronnet wrote Rodin many letters in 1901, as she searched for a new position. He suggested she learn to type and take dictation. He also began spending Wednesday nights with her when he could. These visits were thrilling for Perronnet: "It was only a little while ago that you left, and everything in this house speaks of you—the chair where you were seated, the fire where you warmed yourself. . . . Thank you for having deigned to come. How many people would envy me if they knew. I want to put my arms around your neck and kiss you. See you Wednesday." By the end of the year Perronnet had a job: "I am really happy, and to whom do I owe this happiness? To you, *cher Monsieur*. I will never forget your goodness."

That their close friendship was brief did not stop Perronnet from asking Rodin to give her a sculpture after it was over: "I know I'm being audacious, but I would be so proud to have a work of Rodin to put beside my Falguière" (Aug. 18, 1902). There is no evidence that Rodin fulfilled her wish, but he sent her a typewriter. Sometimes he hired her for secretarial jobs, and often he sent money. As late as 1916, she wrote: "My mother died. Could you send me what you can?"

Cimino did not have an affair with Rodin, but she was a tough-talking modern woman who knew how to open him up for frank exchanges about his personal life. He told Cimino that he felt an enormous irony in being "too old to enjoy women," who nevertheless chased him at every turn. In his youth, when he would have relished being pursued, "they did not choose me." Of course, Rodin was not being quite candid, as he did enjoy the attention of all these women, though his pleasure was not without its edge of ambivalence.

In the early twentieth century, an array of women were hoping for a rendez-vous or a meaningful exchange of letters with Rodin; in addition to Postolska and Perronnet, there was Ernestine Zurniden Weiss, Hélène Porgès Wahl, Helena von Hindenburg, Eve Fairfax, Kate Simpson, and Elizabeth Cameron. There was also Jelka Rosen, a

German who married Frederick Delius in 1903. The story is familiar: it started with a visit to Rodin's exhibition in 1900. Because of it she took the "risk" of inviting him to visit her at home in Grez-sur-Loing, a small town near the forest of Fontainebleau. By March 1901, each wrote of the pleasure received from the other's letters. Rodin called Rosen "mon amie," keeping her letter in his portfolio so that he could "read it frequently. You have shared your spirit with me with such generosity and it gives me much joy. Yes, I will come and see you." For Rosen, Rodin's visit was a dream come true, a "holy and splendid thing." Writing to her "dearest *maître*," she expressed gratitude that "you came into my life, that you have given me your art, your guidance, your words that are sacred for me" (July 4, 1901).[31]

These affectionate letters and Rodin's visit to Grez-sur-Loing coincided with his affairs with Postolska and Perronnet. There was no hint of an affair with Rosen, however, nor with any of the other upper-class women on the list. Rodin kept his relationships with women of prestige and money confined to friendly flirtations. With the others, he liked the feeling of being needed, not just admired.

In the early twentieth century, Rodin received a letter from a young woman called Minna Schrader-de Nygot. "Monsieur Rodin," she wrote, "You do not know me, consequently you have no reason to be interested in me." She explained that she was nineteen, had no parents and no work: "Thus I am reduced to prostitution, or I could kill myself." Not interested in the former, too young for the latter—"I haven't struggled sufficiently"—she was looking for work. Though she had never posed, she wanted to become Rodin's model. The idea had come to her in the Musée du Luxembourg, when she realized that only Rodin's work moved her. She planned to come to his atelier: "Of course . . . I am put together in a manner that is more or less digestible. The chest is even quite nice." Rodin did help Schrader-de Nygot in some fashion, though she never really became a member of his circle.[32] He probably received many such letters, and it must have been well known in the studios of Paris that Rodin was a particularly soft touch.

Perhaps the most ambiguous relationship in Rodin's life in the early twentieth century was with Judith Cladel. By 1900 she was hard at work on her first version of his biography. To be in closer proximity to the man she now called "maître et ami," she moved to Saint-Cloud. She had first looked for housing in Meudon but found nothing suitable. Saint-Cloud, however, was close enough so that Rodin could drop by her tiny house for a meal or a walk in the forest. The question is frequently asked: Did they share their lives more intimately? Some members of the Cladel family believe they did.[33] Certainly, the letters Cladel wrote to Rodin while she was working on her book are deeply affectionate. They also betray sadness that the relationship was not closer, and a sense of loss for something that never quite existed. There is also anger over not being taken seriously enough—as a person and as a woman. Cladel longed to be "immortalized in the fragile human flesh that I am." She cried: "Why not me instead of a model?" But she was not the young animal beauty that so attracted Rodin, and there are

no real indications that their relationship was ever physical. The beauty of Cladel's love was that it was for both the artist and the work. This was in marked contrast to the majority of the women in Rodin's life. When Cladel visited the Salon of 1904 and saw *The Thinker* in isolated splendor in the rotunda of the Grand Palais, she wrote to Rodin: "I didn't expect to feel such emotion. It was like discovering a temple you had never seen before in a hidden part of the landscape. Its beauty is *terrible*. . . . When I saw you, I didn't know what to say, but I wanted to show you my emotion by taking you in both my arms in front of everyone."

184) Postcard bearing the photograph of Judith Cladel in a kimono

In greatest contrast to the complex relationship between Rodin and Cladel is Rodin's friendship with the artist and model Gwen John. Whereas Rodin had virtually no interest in Cladel's face or form, he was riveted by John's physical presence. John entered Rodin's life in 1904 with a display of innocence and honesty that soon turned into an obsession. Her first letter (in terrible French) reveals the mixed strains of pride, pleasure, and pain that marked this strange love affair and friendship, which were to last more than a decade:

> *Cher Monsieur,* I did not know what to do this afternoon because you did not come to the studio. I want to come here at least one day a week. You said I could come until I was an old woman, but then I will be an artist, but if you were to tell me you were finished with me, it would be too difficult and I am afraid of boring you when you see me because I am not very amusing."

Another letter, probably also of 1904, reads: "Don't forget me, *Mon Maître,* in the times when I am not with you, think of me sometimes when you are working with the beautiful educated women. I, too, see more beauty than I can describe in your statues, which I love as well as Nature in the way that you love her."[34]

John fell so hastily and deeply in love with Rodin that she lost interest in everything she had known before him—England, her family, even painting. She told him that he had become her master and her god, that she wished nothing in life but to serve him. She felt that in his arms she performed acts of worship. She speculated about the different situations of men and women on this earth, concluding that women are probably happier than men, for "men have only God to adore, and he is so distant, so silent." The hundreds of letters she wrote to Rodin record how, under his tutelage, John came alive as a sexual being. She rejoiced in the experience of his "thumb" thrusting into her "affair." And even when her "poor little affair" was worn out, it wanted more. When he cautioned her that too much lovemaking turned people into brute animals, she wrote to a friend: "As far as I'm concerned, if he doesn't come for two weeks, I become stupid as a stone."[35] But she promised she would try not to think about *l'amour* for five days.

Their affair was probably at its height in 1905 and 1906, when Rodin was working on the *Muse* (see chapter 29) and overseeing the installation of *The Thinker.* He was extremely solicitous of John, worrying about her health and eating habits, encouraging her to dress more stylishly and to take better care of her body. He was concerned about her financial resources; when she lacked money, he provided for her. In June 1906 Rodin wrote: "You must change rooms from this one, which is too humid and has no sun. Give notice and have Mlle O'Donnell [an Irish sculptor who worked for Rodin] help you look."[36] It seemed to Rodin that John did not read enough, so he lent her books from his library. And he insisted she draw. As Rodin had told Wahl and Postolska, being a real artist is a matter of working every day, so he demanded she bring him one work each time she came to the studio. Rodin even sold some of John's drawings.

185) Gwen John, *Self-Portrait with a Letter*. c. 1905–08. Watercolor.
Musée Rodin.

One reason it is difficult to know how long this affair lasted is the lively fantasy of John's mind; for her, the affair lived on long after it ceased being real for Rodin. She imagined that when the *Muse* was finished, they would go to Rome. She fussed endlessly over such details as what she would wear (a red dress). She assured Rodin that he would never have to think again about practical things—"I'd do all that"—and that he would no longer have headaches. "We will not return the key to the concierge, and when one day we want to return, all will be as we left it." In the same letter John explained why she was so happy: "Everyone I have ever known before you has wanted to change me. . . . But you have said that you do not want me to be different than I am."

Because John put so little emphasis on her work, Rodin may not have known how great her talent was. Although she had been painting for a decade when she met him,

she stopped in order to make room for love. But by 1907 John was painting again. Both her paintings and drawings were powerfully affected by the experience of Rodin. She wrote: "I'm going to try to draw more in the way that you have suggested, *mon Maître.*" Under Rodin's influence she simplified her technique and learned to work more rapidly, taking the contours from the model's profile and reinforcing them with broadly applied washes. The majority of drawings were of her cat, though some were of a friend or the table in her room. These small watercolors have a quiet tonal beauty and mysteriously reflect the restricted world in which John chose to live and paint.

In 1908 it was clear to John that Rodin was coming to see her much less frequently. She decided to change her approach, writing to her friend Ursula Tyrwhitt:

> I have been very stupid in never scolding him enough. I see now that I should have done so much more. . . . I scold him therefore now, but what I say runs off him like water off a duck's back. I have been inspired to write things, to make them more serious & found it answered only too well—he came like a poor punished child & then I had remorse. In my letters I said dreadful things—I said "if you met a dying dog you would still be too *bousculé par le monde,*" too "bothered by everybody" to pay attention. . . . I said other things, & called him "*Impoli*;" that is a dreadful thing to say to him. I adore him & so it is dreadful to be angry with him—I see that I must be so, though. [37]

By 1910 John was hanging around the railroad station to watch the trains arrive after lunch when Rodin habitually came into the city. Sometimes she would go to Meudon and look over the wall of his garden to try to see his coat or his hat. She now needed a note from Rodin in order to get by the concierge at 182 rue de l'Université. Rodin and she remained in contact for the rest of his life. John never relinquished her obsessive letter writing, while Rodin would send only the briefest occasional reply. His role in her life was to encourage her to work, and he was ever ready with money, which she seldom accepted.

Although John modeled for Rodin's beautiful Whistler *Muse,* she was not really his muse. If anyone was Rodin's muse, it was Helene von Hindenburg-Nostitz. Rodin said so himself one day as he wrote of his struggle to understand the relationship between suffering and voluptuousness: "I tell you all this, *mon amie intellectuelle,* because you, like the Muses, have the gift of exaltation."

Rodin never had another friend like von Hindenburg-Nostitz. They were not lovers; she was usually chaperoned by her mother or her husband when she was with Rodin. But Rodin and von Hindenburg-Nostitz lived together on the heights—the heights of art, music, poetry, the sea, the mountains. Rodin never spoke with more respect to any human being. He honored her thus from the very start; in the first letter he wrote her, he thanked von Hindenburg-Nostitz for praising his work by saying that if his sculptures were beautiful, they were more so because she had looked at them: "If they whispered of life, now they speak" (July 6, 1901).

Helene von Hindenburg was an unusually beautiful and cultivated woman. Her talents included all the arts, and in each she was an impassioned amateur. In spite of the nearly forty-year age difference, their relationship was the closest Rodin ever came to befriending a woman in the spirit of equality. In fact, there had been nothing like this in Rodin's life since he and Léon Fourquet had spent long hours writing to each other about all they held dear. Before her marriage, as von Hindenburg roamed through Italy, she sent Rodin her impressions of special moments—Michelangelo's Sistine Chapel ceiling, the paintings of Perugino and Simone Martini, the dome of Saint Peter's, the landscape in the countryside of saints Francis and Clare. She translated Michelangelo's sonnets for Rodin and taught him about Beethoven, whose music became emblematic of their spiritual kinship. Even when they were not together, von Hindenburg would write: "I played Beethoven tonight for you with *force!*" (January 1903). She thanked Rodin for showing her "the way" and for saving her from marrying an artist "whose sentiments were false in all respects and who brought bitterness into my life. . . . It was your art and your understanding of my most intimate feelings that lifted me up" (March 3, 1903). Not so, protested Rodin; it was he who had "profited from [her] mysterious wisdom, [her] perfect justice, astonishing attributes in one so young" (April 22, 1903). When he showed his drawings in Berlin and feared the public would not understand, he turned to von Hindenburg for the truth: "I beg you, give me your impressions and your criticism" (Feb. 2, 1904).

Between 1901 and 1914, Rodin wrote von Hindenburg-Nostitz sixty-nine letters filled with otherwise unknowable information about his inner life.[38] On a more limited scale, Léontine Dewavrin had once been such a correspondent. Rodin tried to initiate a friendship of spoken confidences with Hélène Porgès Wahl, but she proved too superficial and pursued him too avidly to be "safe" for this kind of relationship. So it fell to this young German, "inspired by a pure heart," a woman of "heroic simplicity," whose very being was "animated by poets and thinkers," to fill the important role of confidante to Rodin.

The first few years of their friendship were marked by mutual admiration founded on a shared taste. Following Helene's marriage to Alfred von Nostitz in 1904, a change began to take place: Rodin's letters contained more frequent references to what was wrong in his life. He did not shift his tone without considerable thought. When Helene von Hindenburg-Nostitz had finished setting up housekeeping in Dresden, she wrote that she wanted Rodin's photograph for the piano and extended an invitation for him to visit. In the first draft of his reply, Rodin said that the "delicious perfume of your letter" had chased "away the odor of my life filled with useless toil." When he came to writing the actual letter, however, he censored the sad parts and spoke only of his gladness about her new life (Feb. 4, 1905).

By 1906 Rodin was too needful of speaking the truth to dissemble any longer. After the inauguration of *The Thinker,* his spirit was worn out and he confessed that "something is missing in me." By the fall of that year, he could find no way to escape from the

"mosaic of black stones" that constituted his life, and he blamed his unhappiness on the exaggerated presence of voluptuous pleasure in contemporary life. Rodin's draft of his New Year's letter in 1907 spoke of living with memories and with his work, but of having almost no new ideas. In the finished letter, once again he put his blackest thoughts aside and turned instead to von Hindenburg-Nostitz's report of her experience reading Balzac. Rodin's identification with his subject is apparent. Balzac, he wrote, "should have had a woman to take care of him and to love him. But men like him do not have such pleasant things. Their constant preoccupation with their art keeps them from being gracious and neat and even makes them unpolished in spite of their intelligence" (January 1907). This telling letter gives us a glimpse of Rodin's angst: his lifelong focus on work had denied him a true companion.

Things were not much better when Rodin answered von Hindenburg-Nostitz's Christmas letter of 1907: "I know less and less how to put things right, and I am overburdened on every side, without the force to enjoy the power which I have acquired but not learned to regulate." In the spring, von Hindenburg-Nostitz was waiting for her second child; Rodin wrote reflectively about the contrast between her well-deserved happiness and his own life, one that was burdened as clearly as the *Caryatid* he had fashioned so long before.

In the fall of 1908, Rodin informed von Hindenburg-Nostitz that he was living alone in La Goulette, a little property he had taken over in Meudon and in which Helene and her husband had been his guests in 1907: "I'm alone in the big room; I receive no one." Helene promptly sent him a photograph of herself and her son to keep him company. Rodin responded that the image was a "masterpiece of woman and child such as they have always been." Von Hindenburg-Nostitz was Rodin's ideal; her being was imbued with such salutary powers that the photograph acquired the force of a perfect Renaissance madonna.

Rodin's three-year depression reached its nadir in the summer of 1909, when he was installing *Victor Hugo* in the Palais-Royal. "My noble and great friend," he wrote to von Hindenburg-Nostitz, "What a disappointing life I lead. If I were a vain man, it would please me. But I have an aversion to it because pure friendship, which I value so highly, does not dwell in a house overrun with clients, if I may say so. Many people do not know the profound happiness of spirits that understand each other; a multitude of vanities impedes everything, especially the meaning of things. In this century we have taken the wrong path, and men who were once intelligent have become shopkeepers." Clearly, Rodin believed it was he who had become the shopkeeper. Again he complained that he was "always worn out by a senseless life" and "totally out of touch with my energy" (July 11, 1909).

Then the complaints stopped. In 1910 Rodin's letters to von Hindenburg-Nostitz took on a new tone: "The beautiful vase of my life has been filled with the most noble, the most brilliant, the most proud, the most virginal flower" (Dec. 3). In the spring of 1911, he described more fully the ways in which his life had become "a blessing." He

186) Helene von Hindenburg-Nostitz with her son in 1907.
Photograph by Louis Held.

was filled with gratitude for being able to respond to what had come to pass: "Not in bitterness, like Faust, of whom you have read to me, but overcome with happiness, I draw near to the tenderness of life, the masterpiece of existence which I have admired, though not being able to give this admiration to the world. . . . Now I, too, am happy."

At the age of seventy, Rodin was in love.

Chapter 33
A New "Wife" and a
Home in the City

Claire Coudert de Choiseul was just over forty when she met Rodin. She came from a prominent New York family of French descent; in 1891, through her marriage, she became a French citizen. Her Bonapartist grandfather, Charles Coudert, had come to America in 1824 to escape arrest. He was a minor participant in the Carbonari conspiracy to place Napoléon's son, the king of Rome, on the throne of France. In New York, Coudert founded an academy to which other exiles could send their sons to receive lessons in French. He never made much money, but his home was patrician in atmosphere and alive with a sensitivity to art and literature, interests that always played a large part in the lives of the members of the Coudert family.

The next generation of Couderts were lawyers, and they made money. Charles Coudert's sons formed their own partnership, Coudert Brothers, in 1855. By the 1880s all three brothers owned brownstones off Fifth Avenue, as well as homes in the country.

Claire was the daughter of the second brother, Charles, Jr. Her mother was Marie Guion, of French Huguenot descent. Perhaps because it was a mixed marriage—Catholic and Protestant—Marie remained slightly aloof from the Coudert clan. Having suffered as a part of the poor branch of a rich family, she was much taken with the glamour of European royalty.

Marie Guion Coudert was ambitious for her six daughters, and she succeeded most stunningly with the eldest. For Claire she found a bon fide French aristocrat: Charles-Auguste de Choiseul-Beaupré, who could trace his ancestors to the Middle Ages. The newspapers usually mentioned a forebear from whom he was not in direct line of descent, the famous duc de Choiseul who had directed France's foreign policy in the eighteenth century. There were distinguished Choiseul-Beauprés—bishops and military men, even an ambassador to Turkey—but they did not make such good copy.

The wedding took place in Saint Patrick's Cathedral on March 12, 1891; it was a classic version of the familiar nineteenth-century exchange of American dollars for a European title.[1] Charles Coudert, Jr., agreed to transfer a sizable amount of property to the groom and his mother. He also promised to send the couple a substantial allowance. The bride's family was one of the most prominent Catholic families in America, her uncle, Frederic René Coudert, was a trustee of Saint Patrick's, and so the wedding received a papal blessing. The number of guests reportedly was between fifteen hundred and two thousand, all from the top echelon of society.

The *New York Times* described Charles-Auguste as being "of medium size and very handsome." It reported that the twenty-nine-year-old nobleman had a residence in

Paris and a château in northern France, and that he gave his bride the "Choiseul diamonds."[2] There were several mistakes in the report, however, one of them being the groom's age: Charles-Auguste was only twenty-three, four years younger than Claire. Claire's teenage cousin, Renee, wrote to her mother, who did not attend the wedding, that the "Marquis wept. Had little weeps to himself. Sniffles." Claire, on the other hand, "looked *very* solemn and dignified."[3]

Shortly after the wedding, Frederic René Coudert sent his wife, Elizabeth, a clipping from a gossip column that speculated about where "the new Marquise de Choiseul" might "land her unmarried sisters." The journalist pointed out that "her own French descent will not be in her favor with the *ancienne noblesse* in France, where they will naturally more readily forgive a marquis of the bluest blood for marrying a real American than for wedding in a French family of humble origin."[4] It was true that Claire Coudert would bear the brunt of prejudice in France, where she would be considered a woman who had bought her title. Yet, viewed more closely, the comparison between the two families does not really favor Charles-Auguste. The marquis de Choiseul-Beaupré had come into his title in 1889, just before he met Claire. His family also had a transatlantic cast to it, for his father, Marie-Joseph-Gabriel-Xavier de Choiseul, had served as French consul in Charleston, South Carolina, from 1832 to 1860. There he had met and married Cecile Howard, an American heiress. After moving to France in 1860, they had two children, a daughter in 1861 and Charles-Auguste in 1868.

Charles-Auguste grew up more under the tutelage of an older unmarried cousin, Charles de la Belinaye, than under the guidance of his elderly and unreliable father. Boix-le-Houx, the residence referred to by the *Times* as the marquis' château in northern France, actually belonged to the Belinaye family, and it might better have been described as a modest manor house. Charles-Auguste inherited little money from his father, whom the family regarded as a black sheep; what he did inherit came from his mother. And, like his father, Charles-Auguste gambled this away, running up huge debts.[5]

The newly married Choiseuls had two local residences: an apartment in the rue Bayard on the Right Bank, not far from the place de l'Alma, and a residence in Versailles. By the end of the century, it was becoming difficult to maintain this lifestyle, because they were in deep financial trouble. Charles Coudert had died in 1897, never regaining the great wealth he had enjoyed before the recession of 1893. His children contested the estate with their mother and, although they won, its value was not as great as they had hoped. A cousin wrote to Claire's aunt Elizabeth: "I agree with you that Claire's situation is the most deplorable of all. There seems to be an impression in that family that their father had left more money than I hear he has."[6]

This Franco-American household was perennially short of money for its lavish lifestyle. It is not certain whether there were any Choiseul children, but by the time the Choiseuls met Rodin, they clearly had none.[7] It was the marquis, not the marquise, who first made Rodin's acquaintance. In 1904 he sent Rodin two brief notes mentioning

a bust by the seventeenth-century sculptor Antoine Coysevox and asking that Rodin's secretary write a letter about it. It seems probable that the marquis de Choiseul owned a Coysevox—not an unlikely object for him to have inherited—that he needed to sell. It was well known that Rodin was one of the leading private sculpture collectors in Paris. Whom better to contact?

The next dated correspondence bearing the Choiseul name is in a woman's hand. On March 15, 1907, the marquise de Choiseul wrote to Rodin in Menton, where he was working on Joseph Pulitzer's bust:

Mon Amour adoré,

I am profoundly sad, I think endlessly about the distance that separates me from everything I love, from you, my adored one, my idol. Only your letters console me. How much, *cher amour,* do you relieve my pain by writing often. On Sunday I shall go to the post office to see if there is a note from you. Tell me that you love me. I live only for you.

This instant I received your telegram. At least I know you have arrived! Tell me what you are doing—do you like Menton?—and everything! Now the horrible moment when I left you on Wednesday vanishes. But life stops! I am living in an abyss, a nightmare, and only two days have passed since you left me and there are yet many hours of suffering that remain until I see you! I love you! All my life, all my body calls to you. To live by your side as your wife with my head on your adored heart, to hear you say in that adorable voice that I am "your little wife." I want to live forevermore like that! I shall cover you with kisses. . . . If you could see how I suffer to know that you are so far away. I try to be patient, but oh! the long, sleepless nights, the anguish-filled days. . . . Do write me a dear, good letter.

Ta petite femme

In spite of the fact that both she and Rodin had spouses, by March 1907 Claire de Choiseul was calling herself his "little wife." She wrote him every day they were not together, frequently sending her letters to Meudon. She was not interested in hiding their situation from anyone, least of all Rose Beuret. She gave Rodin advice on matters large and small, even his mealtimes: "It was past two when you started eating yesterday. I'm convinced it is very bad for you to wait so late." Like Maria Rodin and Camille Claudel, Choiseul had a natural willfulness and the ability to exercise her considerable powers over Rodin. But he was hesitant. For one thing, he was concerned about the marquise's drinking habits. She reassured him: "I never touch *eau de vie,* nor this horrible American drink, *le Whisky.*" She had an "absolute horror of women who are victims of these vices—morphine, drink, and the others. *Non, Dieu merci.* I am not the slave of any addiction, and when you know me better, when you have lived intimately with me, you will be able to judge for yourself" (March 31, 1907).

In September, Rodin visited Boix-le-Houx for a couple of weeks. Charles-Auguste

de Choiseul sent Rodin a postcard there, saying he hoped Rodin found his host's country residence to his liking. The visit must have disturbed Rodin, for after he left, Claire wrote: "You say that I live too fast a life! that you cannot follow me." She sought to reassure him that this was not the case. By late fall, the marquis was alarmed. He sent Rodin a telegram asking him to stop encouraging his wife's daily visits to his studio. We know Rodin was unsure about what he was doing from his Christmas letter to Helene von Hindenburg-Nostitz, in which he confessed that he knew "less and less how to put things right, and I am overburdened on every side."

Judith Cladel remembered the first time she saw the marquise de Choiseul. It would have been in 1909 or 1910. Cladel had stopped by Rodin's studio, having not seen him for a long time. She walked with him to the boat he would take to Meudon, as she had done so often over the years. Just as they were leaving the studio, she noticed a tiny woman "under a large hat . . . who, though dressed with sober elegance, jeopardized this look with excessive makeup on her faded features." The woman followed, "modestly walking behind us; then, to my enormous surprise, she got aboard the *Hirondelle* with Rodin."[8]

The advent of Choiseul in Rodin's life infuriated Gwen John; she railed at "this woman who makes you forget everything. And she is malicious and without intelligence." We cannot begin to imagine how the affair affected Rose Beuret. If she tried to see it as just another of Rodin's passing infidelities, the illusion was shattered on July 1, 1908, when she received a letter from the marquis de Choiseul. "Madame," he wrote, "It is unendurable that you tolerate the state of things which I can no longer abide. I refer to the constant presence of my wife . . . in the atelier of M. Rodin." The marquis told Beuret that his wife had accepted gifts from Rodin with alacrity, and that he had left her because he did not approve of what was going on. He then sent Rodin a seemingly candid letter composed of a series of not-quite-related thoughts. The marquis was "out of his mind about this affair" and assumed that "Madame Rodin" would "probably want a separation." He knew Rodin had a "great deal of influence" over the marquise. All he wanted was "a calm life," and he would do whatever he had to do to get it. In spite of these letters, it does not appear that Charles-Auguste left Claire de Choiseul.

It was this situation that drove Rodin to spend two months alone in La Goulette—the "solitude cure" he had described to Helene von Hindenburg-Nostitz. In late November 1908, Claire wrote him there: "I am so tried by your silence. Twice today I went to the rue de l'Université and to the château—alas, no one. How are you? How can you leave me with no word. I *beg* you to send me a word tomorrow morning."

Claire de Choiseul was not the only woman worrying about Rodin's whereabouts. John was also trying desperately to see him. On December 9 Rodin wrote John that he suspected she was "pinched" and that he was sending money. He said he was still sick and did not want her to come: "It is necessary that the old man think and live only in the world of ideas. I am like a broken vase: if someone touches me, I'll fall to pieces."

The next day a letter arrived from Claire de Choiseul's maid: "Madame is in a terrible

state—not eating. If she could see you, things might be better." Rodin relented and the lovers spent Christmas of 1908 in Dijon. Charles-Auguste de Choiseul passed his own holiday in the Alpes Maritimes, from where he addressed Rodin's Christmas card to "General Delivery, Dijon," in care of the marquise. On New Year's Eve, Rodin sent Beuret a two word telegram alerting her to his impending return "Friday evening."

Rodin's relationship to the Choiseuls took a new turn in 1909. Claire's youngest sister, Grace, the only unmarried Coudert daughter, died of tuberculosis in Versailles on June 5. The official announcement was sent in the names of the four men of the family: Charles Dupont Coudert; two brothers-in-law, Frank Glaenzer and William Garrison; and the marquis de Choiseul. In accordance with French law, which made it impossible for married women to own property separately, the beneficiary of Grace's will was the marquis. Two days after the funeral, Claire wrote to Rodin that Charles-Auguste would have to go to America to straighten out the legal matters, but he did not have the money to make the trip. Could Rodin advance him a thousand francs? By return post, Rodin sent fifteen hundred.

On the announcement of Grace Coudert's death, Charles-Auguste's name read the "Marquis de Choiseul." By the end of the year, and perhaps as a result of the inheritance, he was listed in the social register (*Tout Paris*) as the "Duc de Choiseul." The new title had no legal basis; he simply changed it on his own initiative.[9]

As much as Rodin supported this strange couple, he was not relaxed about the situation. A few weeks after Grace Coudert died, he wrote Helene von Hindenburg-Nostitz about the "multitude of vanities" in his disappointing life. He had taken the "wrong path" and his life seemed "senseless" and not in keeping with the energy he was able to expend. But Claire—now the "duchesse" de Choiseul—was very much part of this life. We see her in the official pictures of the *Hugo* unveiling in the fall of 1909. Toward the end of the year, Rodin stopped complaining. It appears that the little American woman with her big French title was indeed able to be for Rodin what he had wished for Balzac: "a woman to take care of him and to love him."

Something fortuitous had happened to make the Rodin-Choiseul affair more possible than it might otherwise have been. Rodin found a distinguished—albeit rundown—residence in town: the Hôtel Biron. Actually, it was Clara Westhoff Rilke who discovered that there were spaces for artists in this magnificent eighteenth-century residence. The 1904 Law of the Separation had resulted in the state confiscating the hôtel from the Dames du Sacré Coeur. Since the departure of the last nun in 1907, the château had been rented *"bourgeoisement,* if one can use such a term," to an odd assortment of artists.[10] Matisse had established a teaching studio there by 1908; the café singer Jeanne Bloch was there, as well as the Rumanian actor De Max. The young poet Jean Cocteau was most impressed with the garden of the hôtel: "It was hard to imagine that Paris lived, walked, rode, and worked around such a pool of silence."[11] Isadora Duncan took a long gallery against the garden wall, which she used for dance rehearsals. Clara Rilke rented her room on the main floor in May 1909. When she returned to Germany in August, her

husband took over the space. He wrote to Rodin the day he moved in: "You've got to see this beautiful building and the room where I live since this morning. The three windows face an abandoned garden, where one can see wild rabbits jumping through trellises as though in an ancient tapestry."

Rodin came on September 2, and the two men made up from the brutal rupture of 1906. "Rodin really did come . . . he spoke from his heart without complaint, objectively," Rilke wrote to his wife. He had resolved to "be as good to him as I always was," though he understood Clara did not share his feelings of forgiveness. Rilke believed that "the best thing that could now happen would be for him to need people only a thousandth part as much as we once needed him." He described their conversation as deep and free-ranging; Rilke began to feel he finally understood Rodin's fate, which was connected to "his nationality."

> I spoke to him of Northern people, of women who do not want to hold men fast, of possibilities of loving without deception: he listens and listens and cannot believe there is such a thing, and still wants to experience it. To him it seems a calamity that the woman should be the obstacle, the snare, the man-trap on those roads which are loneliest and severest. At the same time he thinks that the sensual must so expand and change as to be equally strong and sweet and seductive in every spot, in everything. So that each thing shall transcend the sexual and with the whole abundance of its sensuality pass over into the spiritual, with which alone one can lie with God.[12]

In an aside, Rilke pointed out to Clara: "As you can see Madame Rodin was not present!" The two men argued into the late afternoon, until, Rilke said, they reached a "stalemate." The conversation gives us a glimpse into Rodin's mind and why he had retreated to La Goulette in 1908.

187) The Hôtel Biron in the early twentieth century

In October, Rodin rented four rooms on the main floor of the Hôtel Biron for fifty-nine hundred francs a year. He moved in some furniture, brought over sculptures from the Dépôt des Marbres, and overnight became what *L'Illustration* called the château's "most notorious tenant." Rodin purchased six Louis-Philippe chairs and bought the duchesse de Choiseul a phonograph.[13] Though neither lived in the Hôtel Biron full-time, she was now referring to it as "our enchanted abode." Rilke has left an exquisite description of Rodin and Choiseul in their early months at 77 rue de Varenne: "He now has a gramophone. The Marquise winds it up and the thing wheezes round. I was apprehensive when I found myself invited to hear it. But it was marvelous; they have bought records of some old Gregorian chants which nobody likes and which, apart from the dealer, nobody possesses but the Pope. But when a castrato's voice intoned a

188) Rainer Maria Rilke at his desk in the Hôtel Biron

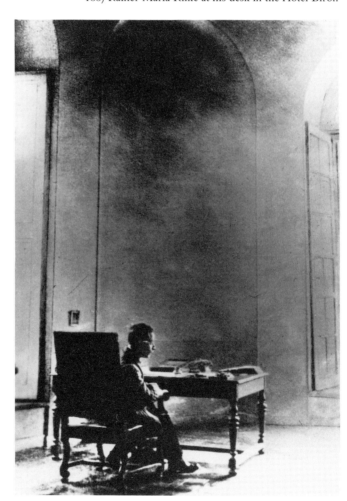

requiem of the 13th or 14th century, wailing forth like the wind from a crack in the world, then you forgot all the fatuity of the instrument, all the stupid mechanical noises."[14]

Rilke described Rodin in these moments as "quite quiet, quite closed, as though facing a great storm. He could hardly breathe with listening and only snatched a little air when the force of the voice abated for a few bars." Rilke found the experience exhausting: "Afterwards you felt, physically, as you do after heavy work." Then he had a tremendous insight: "Now it transpired why the Marquise is there: to lead Rodin slowly down from the great heights beside some merry watercourse. Perhaps Rodin really does need this now, some one to climb down with him, carefully and a little childishly, from the high peaks he was always straying among. Formerly he used to remain up there, and God knows how or where and in what pitchy blackness he finally made his way back again."

Rilke listened as Choiseul put on stupider and "stupider records, so that in the end we came to a caterwauling music-hall waltz." Rodin's phonograph was famous. Most of his guests at the Hôtel Biron in late 1909 and 1910 were invited to listen to it. Marcelle Martin, who worked intermittently as a secretary for Rodin, was frequently asked to wind it up as Rodin lay listening to church music, Choiseul's hand in his. Then they would pass to folk dances from Auvergne; Choiseul would drape herself in a black shawl and begin to dance across the room.[15]

Rilke was profoundly disappointed. He told Count Harry Kessler that Rodin was behaving just like "any old Frenchman" in his weakness for women. He saw the real reason for this terrible change in the man he so admired as fear of death. "Death," Rilke said to Kessler, "he has never before thought about death! I assumed that he had made peace with these thoughts some thirty years earlier, but now they grab him for the first time, now that he is old and no longer has the strength to cope with them."[16]

An even more immediate cloud than death hung over Rodin's life: since the summer of 1909, a "For Sale" sign had been attached to the great door at 77 rue de Varenne. The five hectares within its walls were to be broken into forty-five lots. The price was 5,191,000 francs and the sale was set for the December 18.[17]

Rodin contacted a deputy, Paul Escudier, with a proposition: he was willing to give all his sculpture—"plaster, marble, bronze, stone, and my drawings, as well as my collection of antiquities"—to the state. In return, he wanted "the state to keep the Hôtel Biron as a Rodin museum," allowing him to "reside there for the rest of [his] life." In the end, it was a senator, Gaudin de Villaine, who intervened to postpone the sale, although there was no talk of taking Rodin up on his offer.

Rodin and Choiseul welcomed 1910 with a little more assurance that they might remain at the Hôtel Biron. The duc de Choiseul had left the Right Bank for an apartment in the avenue Silvestre-de-Sacy, in the shadow of the Tour Eiffel. Presumably, Claire shuttled back and forth between the two residences. The duke had now accepted the situation, probably because Rodin was helping him financially, we assume to cover

189) Claire de Choiseul with Rodin at the Hôtel Biron

his gambling debts. In 1910 he gave Rodin ten thousand francs' worth of receipts. Yet Rodin did not feel he was being taken advantage of. We know from his letters to Helene von Hindenburg-Nostitz in 1911 that he felt his life had become a "blessing" and that he was "overcome with happiness."

By 1911 Paris had become the center of Rodin's existence. He kept in touch with Beuret through secretaries and the briefest of notes. A typical one read: "My dear Rose, In spite of my desire to see you yesterday, I had so little time with Monsieur Hanotaux [the journalist-politician Gabriel Hanotaux] that it was impossible to escape even for an instant. Take care of yourself. I embrace you, I'll see you soon" (April 7, 1911).

The number of American visitors to the Hôtel Biron increased. Claire de Choiseul now handled all Rodin's English correspondence. When E. H. Harriman died in the summer of 1910, she helped to arrange for his daughter and widow to inspect the bust.

She also sold them *Echo and Pan* for thirty-five thousand francs. Before Rodin met Choiseul, he was selling similar groups for twenty-five thousand francs.

Choiseul took special care with her letters to Thomas Fortune Ryan, who had contributed twenty-five thousand dollars for a Rodin collection at the Metropolitan Museum. When Edward Robinson and Daniel Chester French came in the summer of 1910, she was their hostess. French was accompanied by his wife and daughter. Mrs. French had fond memories of their lunch at that "wonderful palace." She was astonished at Rodin's "simplicity," for "he seemed quite as pleased at our liking his work as if our criticism had been really valuable."[18] As soon as they left, Choiseul sent a letter to Ryan: "After a few days of deliberation Robinson and French decided *that there is to be* a room at the Met dedicated entirely to Rodin's works. So you see you have gained the cause. . . . Under the influence of your great donation things have turned out all right" (July 24).

Choiseul knew the Simpsons, the Whitneys, and the Vanderbilts, and she entertained them all at the Hôtel Biron. In the fall of 1910, she wrote to Lilly Barney (née Whitney): "Mrs. Simpson told Mr Rodin that you had asked if the master would do the portrait *bust of Mr Whitney* your brother after the death mask of Mr Whitney and if so what would be the time it would take and also the price." She estimated it would take a year and a half, and that a marble and two bronzes would cost sixty thousand francs. In 1909 Rodin had charged the duc de Rohan seventeen thousand francs for the same thing. Even Pulitzer's bill was only thirty-five thousand francs. Choiseul saw no reason why Rodin should not make as much money as possible.

When Rodin was briefly away in 1911, Choiseul wrote him that she had talked to the minister of finance, sold a group to Mrs. Whitney, seen the American ambassador on his behalf, and installed drawings on the first floor of the Hôtel Biron. In short, she was a demon of energy. She was also good company. In 1911, when Rodin was working on his manuscript for *Les Cathédrales de France,* she accompanied him to the cathedrals. For Rodin, it all added up to unexpected happiness so late in life.

Rodin's friends tried to adjust. Monet sent "hommages" to Mme de Choiseul; the Mirbeaus invited her to visit them, as did Robert de Montesquiou. Hanotaux found lunch with her "unforgettable." Loie Fuller got in trouble when she failed to address her correctly; Fuller immediately wrote a particularly saccharine (and surely insincere) letter of apology: "Duchess is very easy for me, but Duchess 'so and so' isn't. I am sure to get the wrong one when I mean the other, but I have my own name for you and you must be good and let me call you by it. Yes?" The name Fuller had chosen was "Lady Flower."

The most annoying change for Rodin's friends was that they now needed a note to get by the concierge at the Hôtel Biron, and could no longer simply drop in to see their old friend. Gertrude Vanderbilt Whitney, then an aspiring sculptor in Paris, met Rodin in 1911. She remembered "the duchess" as being in "absolute control," and described how

Choiseul would stop visitors and inform them: "No use disturbing him since I am here. I handle everything. I am Rodin!"[19]

To celebrate Rodin's seventieth birthday in 1910, a small ceremony was scheduled for 4 p.m. in front of *The Thinker* at the Panthéon. Magnificent bouquets of chrysanthemums, roses, and baskets of violets were placed all around the statue. Dujardin-Beaumetz brought Rodin in his automobile. Arsène Alexandre described the simple ceremony in *Le Figaro,* giving a list of people who attended: Nénot, Fouquières, Goyet, Dayot, Niederhaüsern, Despiau, and "especially the duke and duchess de Choiseul. As mistress of ceremonies, the duchess was the heart and soul of this elegant and charming occasion" (Nov. 15).

Alexandre was surely conscious that his mention of the birthday celebration constituted a public announcement of the turn of events in Rodin's life. Yet evidently, with the exception of Despiau, none of Rodin's close friends was present. What a contrast to the birthday seven years earlier when they had gathered in the woods of Vélizy. Some of Rodin's most important friendships did not survive his relationship with Claire de Choiseul. After 1912, we find many fewer exchanges between Rodin and Geffroy, Mirbeau, Mauclair, Bourdelle, and Monet. Rilke remained Rodin's friend, but was badly shaken: "I have gone through so much bewilderment, experiences like finding Rodin, in his seventieth year, simply gone to the bad, as though all his unending work had never been."[20]

The person in Rodin's entourage with whom the duchess had the most complicated relationship was Judith Cladel. At first Choiseul was friendly, even suggesting an American lecture tour for Cladel and arranging a reception in her honor at the Hôtel Biron. The duchess invited a number of distinguished Americans who could facilitate the venture.

At the time, Cladel's major effort was promoting the establishment of a Musée Rodin at the Hôtel Biron. She had been thinking about it ever since Rodin's exhibition in Belgium and Holland, and it may well have been Cladel who had first put the idea of the museum in Rodin's head. By 1911 she was systematically lobbying politicians such as Aristide Briand, Paul Doumer, Georges Clemenceau, Léon Bourgeois, and Raymond Poincaré. She prepared a petition to be published in *Le Matin* and lined up dozens of important backers. Cladel assumed that she and the duchess were working together. She drew a different conclusion when she learned from an editor at *Le Matin* that a certain "lady named de Ch . . . had written to request the editors suspend publication of the petition, or, at least, delete my name."[21] After that, Cladel had few illusions about her relationship to Rodin's duchess, and she no longer planned to leave on an American lecture tour.

In October 1911 the government decided to keep the Hôtel Biron. Several schemes were put forward for its potential use: as offices for the secretary of fine arts or for the mayor of the Seventh Arrondissement, or as a mansion where visiting dignitaries could

stay in Paris. The state ordered everyone, including Rodin, to vacate the building. Not until the end of July 1912 did the Conseil des Ministres allow Rodin to remain as the sole tenant.

Though Rodin's studio was busy turning out casts and pointing up marbles, he himself made few sculptures during the Choiseul years. In the summer of 1910, an important German client, August Thyssen, wrote to ask for a bust. Rodin answered that he was "too busy"; besides, his "prices for this sort of work" had "really gone up." J. J. Tourvay wrote from London asking for photographs of the Whistler monument. There were none, for the monument was not finished, nor would Rodin make any promises about when it might be done. [22]

Probably the works closest to Rodin's heart in these years were his portraits of Choiseul. As he had made his earlier portrayals of Beuret and Claudel, Rodin now fashioned unique portraits of Choiseul. Three of them show an aspect of human expression hitherto absent from Rodin's work: laughter. Rodin put what most charmed him about his mistress into permanent form: her dumpling cheeks, her teeth clicking be-

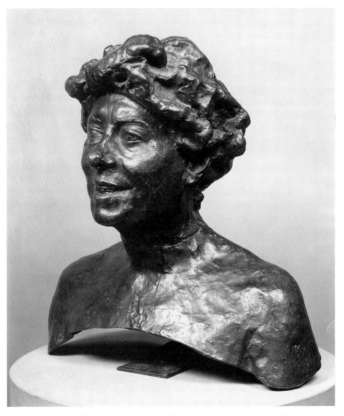

190) Rodin, *Claire de Choiseul*. 1911. Bronze. London, Victoria and
Albert Museum.

191) Rodin, *Claire de Choiseul*. 1911. Marble. Photograph by Druet.
Musée Rodin.

tween open lips, and a mop of curls forming an aureole around her face. Choiseul's busts are images of delight. They are also odd and unlike Rodin's other work, a fact that cannot fail to impress us when we see the marble version in the company of many of his *grandes dames* at the Musée Rodin. When Herman Bernstein of the *New York Times* visited Rodin's studio in the spring of 1911, Choiseul herself pulled the cloth off her unfinished portrait: "The master really regards this bust as his masterpiece." Bernstein agreed that it was a "wonderful work representing laughter."[23]

Rodin continued to show in international exhibitions. In the winter of 1911, he looked forward to participating in a show in Rome to celebrate the fiftieth anniversary of the Italian Republic. He sent a large bronze cast of *The Walking Man,* which, as a small figure, had made such a hit in 1900. After the show it was proposed for the Palazzo

Farnese, Michelangelo's palace, recently purchased by the French government as its embassy. Four loyal patrons—Maurice Fenaille, Joanny Peytel, Victor de Goloubeff, and Léon Grunbaum—came forward to purchase the work and present it to the government. Rodin decided he ought to be there to supervise the installation, which occasioned a winter holiday for him and Choiseul. Their hosts in Rome would be John and Mary Marshall, whom Rodin had met through E. P. Warren. The Marshalls sent Warren a detailed description of the lovers' fortnight in Rome, the only account that exists to give a real sense of the inner dynamics of this relationship.[24] There was hesitation on both sides about the impending visit: the Marshalls had heard what the wags of Paris were saying about the duchess, and Choiseul feared being placed in a situation where she might not be accepted. Rodin told her: "Marshall is my friend. . . . Treat him and his wife as such, and they will recognize what you are."

The Marshalls had planned to put Rodin up with them and Choiseul in the Hasler, but Rodin "wouldn't allow it; he must stay with her." John Marshall feared the hotel was not good enough for Choiseul: "She seems accustomed to luxury." He described her as "small, very thin, and evidently once a beauty." Marshall immediately noticed her strange eating habits; on the very first night, she "suddenly got up, rushed to the W.C. and vomited." But they could not keep enough food on the table for her: "She eats every hour of the day, and is always hungry. But not a bit can she retain." This description supports the frequent characterization of the duchesse de Choiseul as bulimic.

What Marshall liked best about Choiseul was her skill in conversation. She was a "fascinating talker" and told one story after the next. Having been to Rome before, she had an array of stories about the Pope and cardinals. She also drew good laughs with her "weekends at the château" stories. Marshall believed she could out-talk Anatole France. When the stories got too raunchy, Rodin would pull in a bit, but mostly "over these Balzacian things he laughs like a cow." After a week of this entertainment, however, Marshall began to find it wearing thin: "She is much too sure of herself, too much wrapped up in herself—she is the heroine of all her tales—she doesn't like other people talking when she is at table. She is in fact a very bright, but somewhat commonplace, Parisian lady, with a title which she values very, *very* highly, very proud of her husband—whom Rodin, by the way, once spoke disparagingly of, when she was not near—as amusing as a monkey, full of deviltry, with no manners, except what her husband has taught her. The one thing which makes her great is this absolute devotion to the helpless old man." Marshall could not emphasize the last point too strongly. Rodin was "a big baby with her." She helped "him to dress and undress, for, as you know, he cannot do it himself."

After Choiseul settled down, she was quite frank with her new friends, telling Mary Marshall how she got "hold of" Rodin. She felt that Madame Rodin, who was not really his wife, was "one of his main enemies." Choiseul considered Beuret to be simply "a servant and model to whom Rodin was intensely faithful" and not adequate to be his companion. She bragged about her own contributions to Rodin's life, pointing out that

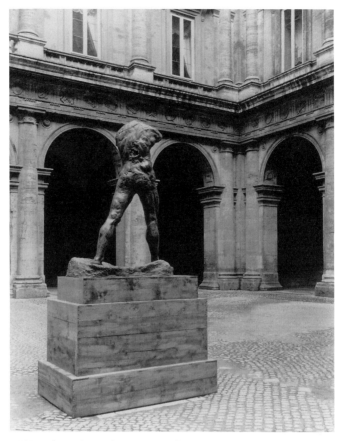

192) Rodin, *The Walking Man,* in the courtyard of the Farnese Palace
in Rome. Photograph by Faraglia.

before she took control of things, he never "made more than 12,000 dollars a year."
Now he made $80,000.

Choiseul told Mary Marshall that she had managed to persuade the French govern-
ment to grant Rodin the Hôtel Biron for life. She had paid three journalists to write
about the proposed sale of the château and elicited so many protests that the govern-
ment had caved in and Rodin was now secure.

Marshall was touched by the way Rodin always said "we" rather than "I,." as in "'We'
are going to put the *Homme Marchant* up in the Palazzo Farnese." The issue of where *The
Walking Man* was to be placed was becoming a problem. The obvious site was the
middle of the courtyard, but Ambassador Barrère felt it would create a circulation
problem for automobiles. Rodin would have been satisfied with another position, but,
Marshall said, "she *will* have it there, and nowhere else, and Rodin is as clay in her
hands."

Rodin and Choiseul's Roman holiday ended with a reception on the Campidoglio.

City officials lit the piazza, including the museums and the Palazzo Senatorio, especially for Rodin: "Plants all over the place, a very fine buffet and God knows what else." John Marshall felt out of place, but he noticed that "Rodin stands flattery very well and he got a lot of it." Then it was off to the train station, where people had gathered to see them off. "He left calling me John (which he can't for the life of him pronounce, and cannot write however often he tries: the 'h' is always in the wrong place)." In parting, Rodin told Marshall that the situation with the Hôtel Biron was extremely insecure. He was anxious to return to see "the man, I forget his name, who has the ultimate decision of the matter." The man whose name Marshall could not remember was Raymond Poincaré, Rodin's old friend and admirer. While Rodin and Choiseul were in Italy, he had become premier of France.

Rodin's spring schedule in 1912 was filled with problems about the installation of *The Walking Man*. Letters flew back and forth between Paris and Rome. The ambassador did not want it in the courtyard. Finally, in March, his wife, probably suspecting where the decision-making power resided, wrote to ask Choiseul to "intercede with Rodin to give up the idea of this placement," explaining that it would cause problems with drainage in the center of the court as well as with traffic. There was always the danger that "a car could run right into the pedestal." But the statue was installed in the courtyard and remained in Rome until 1923, when the state removed it to the museum in Lyon.

Dujardin-Beaumetz had decided there should be a cast of *The Burghers of Calais* in the Panthéon. In the end, only one Burgher, Jean d'Aire, was placed there. The group as a whole fared better in England, where the National Art Collections Fund had purchased it with the intention of placing it in a central position in London. Rodin was pushing Lebossé to hurry on an enlargement of *La Défense,* which he was donating to the "National Movement in Favor of Military Aeronautics."[25] Rodin was extremely interested in the new possibilities of flight; by 1913 he had taken his first airplane ride.[26]

In March, Hanotaux wrote to find out how things were going with Poincaré. He was about to leave for America as head of a delegation to participate in the three hundredth anniversary of the discovery of Lake Champlain. They were taking a bust by Rodin—an old portrait of Camille Claudel now transformed into *La France*—to be placed as a monument at the tip of the lake. Charles-Auguste de Choiseul was also a member of the delegation, which stayed on for the inauguration of the Rodin Gallery at the Metropolitan Museum on May 2, 1912. Claire de Choiseul felt no remorse at not being present; she had had a quarrel with the museum officials and told the Marshalls that "the New York Museum has behaved contemptibly." As far as she was concerned, "it is finished. Not another thing shall they have."[27]

At the end of May, Rodin and Choiseul anticipated a treat: the Ballets Russes would be returning to Paris for Sergei Diaghilev's fifth Parisian season. His star, Vaslav Nijinsky, was to dance his own ballet set to Debussy's *L'Après-midi d'un faune.* The premiere attracted a sophisticated audience. Rodin's box was close to the stage, afford

ing a good view of the twelve-minute performance in which Nijinsky—wearing skin-fitting tights painted with animal spots, a tiny tail, and little horns that curled—pursued nymphs who danced barefoot and wore nothing beneath their colorful pleated tunics. As the last nymph danced off stage, she dropped a scarf. The Faun bent down, retrieved it, and then, in ecstasy, threw himself upon the gauze, his body awakening in sexual paroxysm. The audience was stunned. When it recovered, the applause exploded—mixed with the unmistakable sound of boos.

Nijinsky's ballet was a smashing success. The next morning, on May 30, it received fabulous reviews. The praise was not universal, however. Gaston Calmette, editor/owner of *Le Figaro,* substituted his own review for that of his theater critic's. On the front page, under the headline "Un Faux Pas," he charged that "no decent public could ever accept such animal realism . . . as those vile movements of erotic bestiality and gestures of heavy shamelessness."

The Russians were devastated by the attack. By the middle of the day, the embassy was involved. There were speculations that the verbal volley was inspired by Calmette's opposition to Poincaré's efforts to strengthen the Franco-Russian alliance. It became known that the prefect of police would stop the next performance. Diaghilev felt the appropriate counterattack would be to find some respected elder statesmen of French art to defend the ballet. The next morning, again on the front page of *Le Figaro,* Parisians found a brief letter from Diaghilev: "*Monsieur le Directeur,* I cannot defend in a few lines the result of years of work. . . . It seems simpler to offer to the public the opinion of the greatest artist of our epoch, M. Auguste Rodin, as well as that of another great master, Odilon Redon, who was the intimate friend and confidant of Stéphane Mallarmé." (Debussy's inspiration came from Mallarmé's *L'Après-midi d'un faune.*) This was followed by letters from each artist. Redon focused on how much Mallarmé would have appreciated the ballet had he lived to see it. Rodin's letter was not so diplomatic; it went right to the heart of the matter: "Nothing could be more soul-stirring than the movement at the close of the act, . . . when he throws himself down on the discarded veil to kiss it with all the pent-up force of passionate *volupté.*"

Following Diaghilev's, Redon's, and Rodin's statements—published "in the spirit of fairness"—Calmette re-entered the ring of contention, this time with his sights on Rodin instead of the Ballets Russes: "I admire Rodin deeply as one of our most illustrious and able sculptors, but I must decline to accept his judgment on the question of theatrical morality. I feel it necessary to recall that, in defiance of common propriety, he now exhibits in the former chapel of Sacré Coeur, as well as in the former rooms of the exiled nuns, a series of objectionable drawings and cynical sketches, which with great brutality depict the same kind of immodest gestures as those of the faun who was justly booed yesterday at the [Théâtre du] Châtelet."

We can only imagine what Rodin felt as he surveyed the damage done to his own cause by his defense of Nijinsky. Calmette was now more indignant about Rodin's use of property once owned by the nuns of the Sacré Coeur than he was about the Ballets

Russes. He continued: "It is inconceivable that the state—that is, the French taxpayers—has paid 5,000,000 francs for the Hôtel Biron, simply to house our richest sculptor. This is the real scandal, and it is the business of the government to put a stop to it." Calmette had always been against the Hôtel Biron becoming a Musée Rodin. The lengths to which he would go to get his way were revealed in 1914, when he tried to bribe a former employee at the hôtel to "tell all" about Rodin's personal life.[28]

The controversy ignited overnight. On Wednesday night Rodin went to the theater; on Friday morning he opened his paper to find the call for his expulsion from the Hôtel Biron, just when he thought the government was about to give him lifetime possession. The press was off and running: along with *Le Figaro, L'Intransigeant* and *Le Temps* lined up against him. Jean-Louis Forain captured the moment with a caricature showing Rodin with his models: a girl sprawls on her back across a bed while another clutches her dress and shoes to her bare breast and asks: "*Maître,* where do I put my togs?" Rodin's reply is: "Next door in the chapel."[29]

Rodin's defenders stepped into the fray—*Gil Blas, Comoedia, La France* backed him all the way.[30] G. de Pawlowski pointed out (*Comoedia,* June 2) that Rodin paid rent at the Hôtel Biron, that he was not the only tenant. In *La France,* Remy de Gourmont said: "They insinuate that Rodin's atelier costs us 250,000 francs. As for myself, I find it not too much if we realize we are accommodating Michelangelo" (June 4). In *Gil Blas,* Pierre Mortier used the incident to resurrect the campaign of 1911 for a Musée Rodin. Most of Rodin's old supporters came forward to sign the new petition: Mirbeau, Monet, Hanotaux, Marie Cazin, Anatole France, and many others.[31]

The statement that got Rodin in trouble—so beautifully written, and in less than twenty-four hours—was, in fact, not written by Rodin. It was the work of an experienced critic, Roger Marx. He had sent it to Rodin with a note: "Here are the lines in which I have tried to sum up your thoughts on Nijinsky. . . . I shall come by to get your response . . . between four and five." When Rodin was attacked, he, Marx, and the duchesse de Choiseul considered issuing a joint statement that the article was really Marx's work. But Bunau-Varilla, the director of *Le Matin,* did not want any retraction, so Rodin let the matter drop.[32]

The scandal amounted to a new round of publicity for Rodin. Letters started pouring into the ministry in favor of a Musée Rodin. One of the bureaucrats, however, told Cladel that it would be in Rodin's best interests if these efforts ceased. She went to the Hôtel Biron to pass along the information and found a very anxious Rodin alone in his atelier. He told her that she should not get mixed up in the matter, that she was just "complicating everything." Clearly, in the competition to be Rodin's most effective helper in solidifying his claim to the hôtel, the duchess had won. Cladel described herself as "dumbfounded I said nothing, except that I would leave in his care the work into which I had put so much during the last three years. . . . Would I like 'to say good-bye to Madame,' he asked. I declined. With that, a satanic smile came over his features, one which I so disliked.[33]

Some idea of the extent to which Rodin's friends had been alienated by the Choiseul liaison can be obtained from a letter of July 1, 1912, to Rodin from his faithful friend Edmond Bigand-Kaire. To make sure Rodin received it, he sent three copies: one to Meudon, one to the rue de l'Université, and one to the rue de Varenne. Bigand said he was leaving Paris and did not expect to return for a long time. Before his departure, he felt it necessary to speak to Rodin alone: "I have serious things to say to you . . . that, given my old affection for you, I can no longer restrain. It is not just the reputation, the present and the future glory of the great artist that is in jeopardy. It is more than that: it is his talent, his honor, perhaps even his life. While I live, I shall oppose with all my force, even in spite of you, anyone who is your enemy, be they French or *foreign*." He closed by saying that *tout Paris* was anxious about this matter.

The subject of their impending conversation must have been all too clear to Rodin, but he could hardly have dreamt of the seriousness of Bigand's accusations and what his recommendations would be. Bigand told Rodin that people felt he was being robbed by Choiseul; the graveness of the matter demanded police intervention. He had already spoken with Lépine, the prefect, who would be expecting Rodin on the evening of July 5 to discuss it.

The incident that brought matters to a head had taken place on June 13: a box of Rodin's drawings disappeared. Choiseul blamed Marcelle Martin, the secretary who had worked for Rodin on occasion since 1909, mostly transcribing notes on the cathedrals. It was Choiseul who had introduced Martin to Rodin. When Martin understood that she was under suspicion, she wrote asking Choiseul for protection, since Madame would know she could not do such a thing (June 13, 1912). Soon she understood that, far from being a potential protector, Choiseul was her accuser. She had even been threatening to have Martin arrested. Martin then started to write Rodin: "You who have always loved the truth, you at least must understand why I put so much energy into seeking justice for myself." That was on July 12. Ten days went by without a response from Rodin, and the duchess was still coolly refusing to acknowledge Martin's request for a rendezvous. Martin informed Rodin that "all of Paris knows about this crude conduct." She also demanded back pay that she felt Rodin owed her. On July 31 Martin was packing to leave and wrote one last, imploring letter: "Rodin will not be Rodin anymore if he refuses to render justice to one who has been slandered. I beg you to see me tomorrow in Meudon." Rodin yielded. Martin described the interview in a book she wrote a few years after Rodin's death. It is a strange mélange of error, half-truth, and untruth, but probably this scene bears some resemblance to what happened: "I told Rodin the truth about her and gave him proofs. Poor Rodin! He cried over his love like a fifteen-year-old schoolboy. We were in the big studio at Meudon. He sank back against the 'Ugolin' statue shaking with sobs. 'I am a fool, an unhappy wretch,' he moaned. I did not spare him, but made him see how ridiculous he was."[34]

Although Martin and Bigand never tell us exactly what they said, it is clear that their combined efforts undermined Claire de Choiseul's position in Rodin's life. Rodin's

liaison with his American duchess was over. J.-F. Limet (Rodin's *patineur*) was given the assignment of retrieving Choiseul's key to the Hôtel Biron. Rodin immediately left for Brussels, without facing his lover to tell her of his decision.[35] He went to Malines and, after a brief return to Paris, left again, this time for Lille. As before in his life, he was unwilling or unable to explain himself.

Choiseul fled to Brittany, where her husband's old guardian, the comte de la Belinaye, offered solace. He cabled Rodin in Brussels: "Claire very anxious. Does not understand silence. Send news immediately." He followed this with a long letter describing Choiseul's suffering: "The day before yesterday, she was suddenly taken by a nervous crisis and fainted on the carpet in the salon."

In early September, Choiseul and Rodin talked. Afterwards she wrote: "I have finally seen you again after so much agony. Oh, that I could die now.

Oh *ami adoré,* you who taught me the beauty of life. I have ceased to live. My heart is broken—the hour of deliverance does not frighten me. My suffering is beyond my strength" (Sept. 12, 1912).

Rodin agreed to support Choiseul with monthly payments of a thousand francs. He would send the checks to the comte de la Belinaye, who would see that she received the money. Nevertheless, the count thought Rodin "cruel," complaining: "*Nothing, nothing, nothing* can justify it. If you could only see her, I cannot believe you would not take pity on her" (Oct. 15).

Naturally, the lovers' separation was newsworthy. On the front page of the *New York Times,* under the headline "Rodin and Duchess Quarrel," it was reported that "Paris society people . . . are talking of nothing but the quarrel alleged to have taken place between . . . Rodin and a well-known Franco-American Duchess." The *Times* said that no one knew what had happened, but that Rodin's admirers welcomed the rupture because the duchess "had exercised too great influence over the master, made him live at the rate of $40,000 a year, imposed her opinion on the sale prices . . . and generally monopolized the sculptor's affairs" (Sept. 16). The *Cri de Paris* reported that Rodin's atelier, "delivered of its Cerberus, has reopened its doors to friends of the most beautiful modeler of torsos in our time" (Dec. 8).

Friends wrote letters of support, expressing their general satisfaction at the turn of events. Kate Simpson said that she had felt for some time there was far "too much distraction" in Rodin's life: "Basically, your nature is simple and strong; you are a world unto yourself with your thoughts and your work" (Oct. 16, 1912). Helene von Hindenburg-Nostitz received the news in November through Count Kessler. She wanted Rodin to know that she would willingly share his suffering with her "loyal affection," and that the "vast world around" him would not let him "suffer too long" (Nov. 4, 1912).

Rilke was in Venice when the break came. After returning to Paris the following February, he wrote: "The awful Mme de Ch . . . is no longer there, unfortunately the end came owing to a wretched trifle, I would have wished it to have had a more inward

cause and to be more convincing and real for him."[36] Rilke wanted Rodin to remain what he had been for the younger artist: a great man. He did not care for the revelation that his idol had clay feet. If Rodin was going to err, at least he could have experienced real illumination about how he had strayed from the truth. Rilke considered the reason for the breakup—the theft of some drawings—to be a "wretched trifle."[37]

Cladel's account of these events was rather more serious: "Seconded by two friends, powerful magnates of the press, and in the presence of a notary, Madame de Choiseul got him to sign a contract whereby she and her husband would inherit the rights of reproduction for the works he intended to leave to the state."[38] This accusation is not borne out in the correspondence, nor is it supported by any one else. Nevertheless, when Rodin broke with Choiseul, the future ownership of his work must have been on his mind. It was clear that Choiseul's proprietary sense toward the Hôtel Biron and the concept of a Musée Rodin were at odds. As everything was coming to a head, in late July, Rodin wrote Helene von Hindenburg-Nostitz: "My life is confused by the thought that I want to give a museum to my country, which stands implacably against me. But at the same time there is something singular and magnificent, for the great men of the state are for me. There is this great faith, this great desire that I have to do it; will I have the force? I hope so!" In the last week of July, the Conseil des Ministres decided in favor of Rodin; they gave him exclusive use of the hôtel as long as he lived, paving the way for the future museum.[39]

Only Bigand knew what Rodin suffered in separating from Choiseul, and he had to strengthen his friend's resolve over and over again. He suggested people with whom Rodin could consult in Paris: "You need rest, I mean rest of the spirit." He told Rodin to "stop talking about this subject. Moreover, it's the last time I'm going to talk about it, because I don't want to lose your friendship." Rodin should work, walk in the woods, make new friends. That was in January. But in March he was still haunted by one of the images Rodin gave of himself in a letter: "I am like a man who walks in a woods overcome by darkness."

The breakup with Claire de Choiseul cost Rodin a great deal. He surely loved her. He shared his life her in a way that he had done with no other woman. Together they were able to participate in the events of Parisian life as Rodin had never done before. They were the best of traveling companions. She decorated his house, thought about his clothes, told him stories. She made him laugh, and she made him feel loved.

Between August 1912 and April 1916, Choiseul wrote Rodin eighty-three notes and letters. She seems never to have stopped loving him, and she needed to tell him so. By 1914 she was reduced to following his life in the newspapers. During the war she worked as a nurse and received the *medaille d'or* for her work in the Fougères hospital. Her last letter to Rodin, dated April 5, 1916, congratulates him that the plans to turn the Hôtel Biron into a Musée Rodin had finally been settled.

Cladel tells an anecdote about the last year of Rodin's life. His attention and memory had begun to slip after he suffered a stroke. Rose Beuret was sitting with him, and he

turned to ask: "Where is my wife?" She answered: "Here I am. Aren't I your wife?" "Yes, but my wife in Paris—has she any money?" Cladel concluded: "He must have meant his former pupil, whom he had never forgotten." Her suggestion that Rodin, as he approached death, could not forget his love for Camille Claudel has been repeated in dozens of books. But Cladel might have suspected that Choiseul, not Claudel, was the object of Rodin's wandering mind. Nor is it surprising that Cladel might have taken this small revenge against her rival impresaria.[40]

Chapter 34
Reckonings

I'm tired and I've lost the sense of balance—
I'm not as experienced in life as I am in sculpture.
—Rodin to Gabriel Hanotaux, October 1913

For the second time, Rodin had to fight his way back to a semblance of life after a disastrous love affair. At seventy-one it was more difficult than at fifty-two to relocate himself in his work and to rebuild broken bridges with friends and family. Nor could he count on his health; in February 1913, Rodin told Alfred Roll that he was too sick to see him, and in the spring he wrote to his American student Malvina Hoffman about his terrible flu. It became so severe that winter that journals on both sides of the Atlantic were reporting on his condition. Kate Simpson wrote: "Grieved to hear you are in bed again. Get well and go south" (Feb. 6, 1914). Rodin canceled a planned visit with Bigand-Kaire that winter; at the last minute he wrote that he and Beuret would have to travel directly to Menton because he had injured his arm and leg and was "dead tired from the air and the stiffness" (Feb. 24).

Though thriving economically, France was in the grips of a virulent neo-nationalism, exalting patriotic glory and martial adventure. The biggest public debate of 1913 was whether to increase obligatory military service from two to three years. It took place in the early months of the presidency of Rodin's admirer Raymond Poincaré. His election in January 1913 was seen as a victory of the right over the left.

Rodin cared little about these political questions. He might have discussed them with Georges Clemenceau, whose bust he had begun in 1911, but he had the uncomfortable feeling that the former prime minister was somehow "scoffing" at him. Nevertheless, Rodin put a great deal of effort into numerous studies, and by 1913 friends were calling his bust of Clemenceau one of the best portraits he had ever done.[1] Rodin planned to show it at the Salon of 1913, but Clemenceau thought it made him look old and would not give his permission.[2] He complained to his sister-in-law, Berta Szeps, that posing for Rodin was exhausting: "He has already modeled me in three different versions and they are all wrong . . . he who is capable of making the most beautiful of Roman portraits, but me . . . he's made me into an old grouser."[3] On March 13, Rodin wrote Clemenceau that he had "been working on the bust" and awaited his "presence to do the shoulders and the retouching. I am at your disposal, though I should stay at home a few more days, having caught last winter's flu again." Although Clemenceau came to sit again and Rodin did make changes, Clemenceau would not relent. But then, Clemenceau generally disliked his portraits, even the painting by Manet: "There is not a single [good] portrait of me, they are all bad."[4]

Initially, Rodin had been happy to get the Clemenceau commission. He thought the subject was worthy of him: "We are of equal strength in our different lines." But when he was actually working on the bust, especially in his exhausted state of 1912 and 1913, he felt unhappy: "Clemenceau supplies all the talk . . . I don't attempt to argue with him. . . . His sneering expression worried, almost paralyzed me. When the first stage was finished he spoke to me as if I had been an apprentice! 'That's not me: it's a Japanese you've made, Rodin; I won't have it!'"[5] It is a pity that Clemenceau never allowed Rodin to exhibit the portrait showing the fiery old Socialist-turned-nationalist just as he was re-emerging as a national leader.

Not having *Clemenceau* for the Salon of 1913, Rodin exhibited a new marble of his portrait of Puvis de Chavannes. He also decided to mount a small show in the outer hall of the Faculté de Médecine to coincide with the International Congress of Physical Education. He paid a student, Eugène Lagare, to install some twenty marbles and

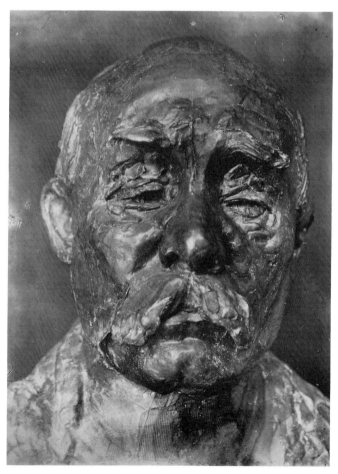

193) Rodin, *Clemenceau*. 1911–13. Bronze. Photograph by Choumoff. Musée Rodin.

bronzes, along with drawings and antique works from his own collection. Rodin had borrowed tapestries from Gobelins, allowing him to spend time with Geffroy, who was now director of Gobelins and whom he had barely seen in recent years. But people were not interested in his show. He wrote Geffroy: "My exhibition is very beautiful and the tapestries are magnificent, but it will all pass like a flash of lightning, with no one seeing it" (March 19, 1913).

We sense Rodin groping for direction, and none too successfully. On top of his health problems and professional endeavors, he realized he had to give serious thought to Rose Beuret. One day he thanked Judith Cladel for her loyalty to Beuret. He called Beuret a "flower of the field," confessing that he knew how much he had wounded her.[6] In August, Rodin spent a week with the Hanotaux, friends with whom he and Claire de Choiseul had often stayed as a couple. He must have felt his changed status with particular sharpness as he wrote to Beuret: "I send you this letter as a reflection made upon thinking about the magnificence of God's gift when he placed you next to me. Put this in your generous heart. I shall return Thursday. *Ton ami,* Auguste Rodin" (Aug. 24, 1913).

Another problem Rodin could not avoid was their son, Auguste Beuret. After being discharged from the army, Auguste had remained in Saint-Ouen with his companion Eugénie Doré—known as Nini—a junk and used-clothes dealer. Auguste was in the reserve and continued to receive a small stipend from the government, but he was frequently ill and constantly had to ask his parents for money. Rodin did send money, but he seldom answered his son's letters, which caused Auguste enormous pain. Auguste's letters disclose a person of considerable simplicity who worshipped his father. He wanted a relationship with Rodin much more intensely than he wanted any kind of exchange with Rose Beuret.[7] He followed Rodin's activities through the newspapers: "I

194) Rose Beuret in the garden of the Villa des Brillants

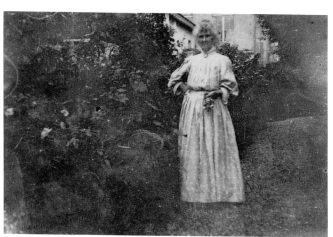

see you will go to Prague to exhibit"—"I saw in the newspaper that you were in London and that you will give your Saint John to the Museum of South Kensington"—"I learned in the paper that you were named commander in the Légion d'Honneur, a recompense that is well deserved"—"I read in the paper that you were at the banquet for Paul Adam at the Hôtel Continental."

The other constant in Auguste Beuret's letters are references to his drawings and engravings. Through this work he created a bond with his father, and when he did apply himself as an artist, Rodin was particularly inclined to send him money. The drawings are now in the Musée Rodin. There are scenes of life in the streets—figures sitting and walking or men on horseback—but the greatest number are nude figures, usually men, whom Auguste called *damnés* and who are in some sense oppressed or falling. Some show considerable skill, and a few have even been attributed to Rodin. Sometimes Auguste asked his father for assignments; on one such occasion, he wrote: "I want to work alone with only you as my judge."

Auguste's confusion about his identity is painfully apparent in his letters. He would frequently address his father as "Monsieur Rodin, Statuaire, Commandeur de la Légion d'Honneur," and then hardly know how to sign his own name. Sometimes it was "your son, Auguste," or "Eugène," or "Auguste-Eugène," or sometimes "A. E." One undated letter opens with a familiar complaint ("I have written you so many times with no response") but continues with a request that we have not heard before: "I am asking you something that I must know and which may be painful for you to respond to—yes or no, will you recognize me? This would be advantageous for me, and knowing it will

195) Auguste Beuret, *Portrait of Rodin, Sculptor, by Beuret*. Musée Rodin.

help me decide my future. If you are not going to recognize me, then simply say it and everything will be set between us and I will no longer have anything to count on from you." In the postscript, Auguste wrote: "Do this for me even if the response is negative." We do not have Rodin's reply, but his life pattern had long since been set: Rodin gave his name only to his work.

In 1913 Auguste's requests for money and reports of illness became more urgent. Sometime in the first half of 1914, Rodin decided to invite his son—now forty-eight— to live in Meudon. He sent Auguste's cousin, Emile Beuret, to Saint-Ouen to explain what he had in mind. At first Auguste said he would do as his father wished. Then he changed his mind. "Dear Parents," he wrote, "You have proposed I leave home. I can't do it because I'm all right where I am. I know I promised, but I have reflected and I just want to carry on my drawing work where I am. I've been in society with my woman for twenty years now; that's the reason I can't leave. I told that to M. Edmond [sic]."[8] Rodin was not in the mood to take no for an answer, however. He sent Emile Beuret back again, the latter making it clear that he was not happy to perform this "thankless and delicate task." Finally, a solution was worked out that was acceptable to the younger couple. They would come to Meudon and live in the house that Rodin was providing for them under the names of "M. and Mme Menier." Auguste would be identified and paid as an engraver in Rodin's employ. He would also work as a guard at the Villa des Brillants. They would move on August 15. Emile Beuret told Rodin that Auguste was "happy that he can do this for your peace of mind and to honor you" (July 28, 1914).

Though Rodin had turned his attention to his family, Choiseul could never have been far from his mind. In 1913 she wrote him almost every day: "Your memory accompanies me everywhere in this solitude. I want to be like Mary Magdalene on my knees before you. I shall be faithful unto death" (June 1913). Rodin would answer her letters for a time and then lapse into silence, at which point she, like Auguste Beuret, would have to follow his movements through the press.

Another shadow from Rodin's past fell on him in March 1913. He learned that Camille Claudel had been forcibly taken from her studio on the Ile Saint-Louis and committed to an insane asylum; she would remain there for thirty years, until her death in 1943. Rodin tried to visit her but could not gain admittance. Through the intervention of Mathias Morhardt and Philippe Berthelot, he found a way to send her money in the summer of 1914. More important, he promised to try to set aside a room for her work at the Hôtel Biron. This had been Morhardt's idea; in June 1914 Rodin wrote that he was not yet sure how things would work out, but if they did, Claudel would "have a place."[9]

Rodin coped with these burdens partly by seeking comfort in women friends. For the moment, there were two. Both spoke English but otherwise were as dissimilar as two women could be. Malvina Hoffman was an American in her twenties when she met Rodin in the summer of 1910. She was determined to become his pupil. Once allowed

196) Auguste Beuret at about fifty years of age

to come to his studio, she followed his every suggestion: drawing from the old masters in the Louvre, working from memory, practicing "patience in the little things." Hoffman seemed to fit right in, and during her time in Paris in 1910 and 1911 she got to know both the duchesse de Choiseul at the Hôtel Biron and Rose Beuret in Meudon. When Rodin took her to Meudon, he cautioned her about Beuret, describing her as a woman of a "violent nature, jealous, suspicious, but able to discriminate between falsehood and truth, like the primitives, and possessed of the power of eternal devotion. . . . You will be good friends, I know, but remember what I have said."[10]

After the duchess was gone, Rodin took consolation from his correspondence with this earnest young artist. Although his letters to Hoffman are not as intense as his correspondence with Helene von Hindenburg-Nostitz, they similarly suggest a search for higher truth through shared understanding of art. Rodin wrote Hoffman that "the

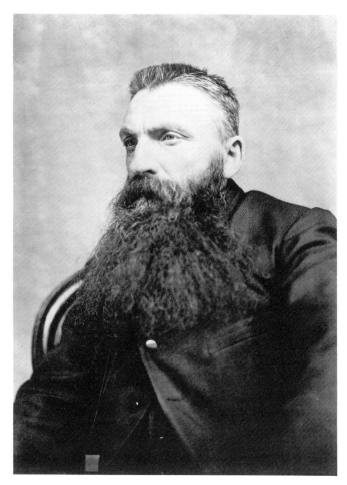

197) Rodin at about fifty years of age. Photograph by Braun.

friendship of a woman is something willed by God; after him, it is the strongest thing in the world." He loved to praise Hoffman's courage, her talent, and her profound force. He asked her to recount the daily events of her life for him: "You were sick. You must tell me all the details that I might participate in your pain."[11] He lamented the "prickly complications that come into view toward the end of a life." Nevertheless, he remained a mentor ever ready with advice: "Be more moderate in your work as in everything" (Sept. 27, 1913).

While Rodin found this innocent exchange a healthy distraction, he also allowed himself to be drawn into a friendship with one of the most world-weary women alive: Victoria Sackville. Violet Trefusis, a friend of Lady Sackville's daughter Vita, described the mother when she and Rodin were becoming friends as being "like new wine in an old bottle. She was a woman of c. 50. In her too fleshy face, classical features sought to

escape from the encroaching fat. An admirable mouth, of a pure and cruel design, held good. It was obvious she had been beautiful. Her voluminous, ambiguous body was upholstered, rather than dressed. . . . Shopping lists were pinned to her bosom."[12]

Lady Sackville adored portraits of herself, having commissioned them from such artists as Helleu, Sargent, and Carolus-Durand. She became interested in Rodin as early as 1906, but never quite had the time—or perhaps the money for a portrait. In the summer of 1913, she could easily afford one, having just come into an immense fortune left to her by a "soul" friend, Sir John Scott.[13] As one biographer put it, she "needed more in her life than being decorator to a self-centered military hero [her recent companion, Lord Kitchener] and Lionel's [her husband's] unpaid housekeeper."[14] Rodin became the "more."

198) Malvina Hoffman in her New York studio in 1913

Rodin renewed his friendship with Lady Sackville at the end of May, when he came to London to oversee the installation of *The Burghers of Calais*. On May 28 Rodin motored around London with Lionel Earle, secretary of the Office of Works, to look at five or six possible sites for the monument.[15] He was very much on show in London, the *Daily Mail* reporting that "in spite of his white beard and advancing years, the great sculptor has never grown old . . . [his] faculty for enjoyment remains fresh and keen." On May 29 Rodin met Lady Sackville and Mary Hunter for lunch at the Ritz. They both invited him to their country estates. Lady Sackville loved to show off Knole, her estate in Kent. The evening of Rodin's lunch, she wrote in her dairy: "He seems to move in a dream, never hurries; he is not absent-minded, but he is dreamy and very quiet, and likes everything arranged for him."[16] They discussed the proposed portrait. A few days later she took him to a Louis XIV costume ball at Albert Hall and "looked after him as if he was my father." At Hunter's estate, Rodin met Henry James, who wrote to Edith Wharton that "I banqueted at one of [Mary Hunter's] tremendous three-table affairs— in honor of the singularly ingrate (as he strikes me) Rodin."[17]

By June 9, Rodin was back in Paris and sent the terms for the portrait to Lady Sackville: "But first I have to tell you how much I want to please you (as well as *la grande demoiselle* [Vita]). Such a marvelous château, such a marvelous lady of the manor, such sympathy which I only merit because of my work—it has all enchanted me and dictates that I write you that the bust you have asked for will cost 30,000 francs. That will be for both a bronze and a marble." Observing that he hardly ever made busts any more, Rodin said that Lady Sackville could criticize his work as she wished and he would gladly "redo it at [his] own expense." He suggested that her presence in Paris would be welcome, for she had the right qualities to "help arrange things in the transformation of my museum."[18] Are we not hearing something about a life that lacks a duchess?

Lady Sackville and Vita summered in Italy. In September they returned via Paris, where Lady Sackville expected to discuss plans for the sittings with Rodin. But she was too worn out from shopping. Vita went alone to the Hôtel Biron. Writing to Harold Nicolson, who was to become her husband in a fortnight, she described what waiting for Rodin was like: "Do you know how suggestive a person's room can be, before they come? It was rather dark, and there were huge roughly-hewn lumps of marble, and a chisel left on a chair where he had put it down, and nothing else—and the suggestive-ness of it grew on me more and more as I waited, and then he came in, very gentle and vague, and rather a commonplace little French bourgeois with long boots and the légion d'honneur in his buttonhole—rather an unreal little fat man, like a skit on the Académiciens in a funny paper." Vita found Rodin's entrance a "come-down," but this impression changed the moment he began to talk about his work. Vita was fascinated by the contrast between the ordinariness of the man and the grandeur of the artist within him.[19]

Lady Sackville wrote to Rodin in late October that she wanted to be "done" with her "boa around my neck and the end held in my hand," for "at my age, being almost a

199) Rodin, *Victoria Sackville-West*. 1913.
Marble. Photograph by Braun. Musée Rodin.

grandmother, one loses a bit of line in the neck." She warned Rodin that he was going to have to be indulgent and flatter her. She stayed in Paris for two weeks in November, devoting all her time to modeling for Rodin. She could not understand why he was always so "kind and patient" with people who interrupted him. She was constantly amazed at the number of things he did not know, such as who Darwin was. Then there was the strange way he insisted on having the greengrocer put on white gloves in the afternoon to serve them tea and cakes. The entire experience was exotic for Lady Sackville. For Rodin, it was the last occasion on which he would study and fashion the image of one of the grandes dames who had graced his studio over the past decade and a half, beginning with Maurice Fenaille's wife in 1898.

As the days went by, they became more frank. Lady Sackville complained of her loneliness since Vita's marriage. Rodin took her to Meudon, where she met Rose Beuret. Lady Sackville noticed that Beuret and Rodin did not talk much to each other, while "with me he never stops!" She found Meudon a "curious agglomeration of grandeur and of great discomfort. . . . They generally have some soup and a glass of milk." Rodin told her he now needed to sleep in Beuret's room because her asthma was so extreme that someone had to help her in the middle of the night when she coughed. He complained that his life was "dull" and begged Lady Sackville to meet them on the Riviera in the spring.

Rodin and Beuret were in the south of France by the end of February 1914. Lady Sackville, arriving a week later, was shocked to find them in a "3-room villa, very dark

and tiny." She did secretarial work for Rodin, because "he muddles his letters" and "does not know how to draw cheques. How has he managed until now?" She came across one very surprising letter about the possibility of Rodin doing a portrait of Kaiser Wilhelm II. As far as anyone knew, the German leader despised Rodin's art.[20] But in late 1913 and early 1914, both the French and the German governments were trying to repair their damaged relations in the wake of the Agadir crisis of 1911, when the two countries had come to blows in Morocco. Perhaps the portrait was a cultural straw in the wind. In any event, Rodin was far too much a nationalist to take on such a project. He told Lady Sackville that he would certainly refuse to do the portrait of an "enemy of France."

Lady Sackville went to lunch with Rodin and Beuret at Renoir's in Cagnes, then departed for a holiday in Italy. Luxuriating in her new friendship with yet another powerful man in her long string of admirers, she demanded that Rodin have a letter waiting for her at each stop of her complicated itinerary. In June, she passed through in Paris on her way home. She found Rodin in low spirits: he told her that "old Rose was unbearable now, and he wanted to leave her. . . . He was most depressed."[21] Depression was a large element in Rodin's life in 1913 and 1914. It probably explains why he barely participated in one of most important events of his life: the creation of a Musée Rodin in the Hôtel Biron.

With the departure of the duchesse de Choiseul, Cladel came back into Rodin's life, faithful and hard-working as ever. In the spring of 1913, a committee was established to make a final investigation of the possibility of accepting Rodin's donation and creating a museum at state expense. Cladel followed its every move, as she would also do with the architect's report later in the year. She saw to it that a dossier was prepared for Prime Minister Louis Barthou. When his government fell in December 1913, she watched carefully to see who would be the next person with the power to accede to her wishes. In February 1914 she went to see the new minister of education, René Viviani, who promised to take the proposal to the Conseil de Ministres. Cladel reported her activities to Rodin, but he was far more attentive to Lady Sackville's bust and to arranging his imminent trip to the south of France than he was to the plans for the museum.

A week after Cladel informed Rodin about her visit to the minister, she was stunned to receive a curt note from him saying that she no longer had his authorization to photograph at the rue de Varenne. She was in the final phase of work on the English edition of her book on Rodin, and new photographs were critical. Why Rodin treated Cladel as he did remains an unanswered question. No one had done more for his career. Cladel had organized the important early exhibitions in Belgium and Holland, had written well-received articles and books about his work, and had steadfastly pursued the establishment of the Musée Rodin. For this she received no money and little thanks.[22] Rodin did allow her to keep the originals of some of the drawings with which she illustrated one of her books. He also gave her a small bronze figure and he promised her a marble *Pygmalion and Galatea*. In the end, however, he sold it to the Metropolitan

Museum. Worst of all, Rodin borrowed sculptures he had given to Cladel's father for an exhibition, then failed to return them.

In addition to these past discourtesies, Rodin was now barring Cladel from taking photographs for a book intended to enhance his reputation. She complained to Marcelle Martin, who suggested she discuss her concerns with the one man Martin believed to be a truly disinterested friend of Rodin's—Bigand. On March 14, 1914, Cladel wrote her first letter to Bigand. It was the start of a very real friendship. From that date forward, the two were in constant contact about the man Cladel frequently referred to as "our bizarre friend."

In her very first letter, Cladel exposed her aching heart. She began at the beginning: Rodin, young, timid, and poor, coming ever so humbly to the home of the great Léon Cladel, the latter full of encouragement for the younger artist's gifts. Cladel described how the Belgian exhibition was her idea; she told Bigand about the lectures she had given and the books she had written. Everything had been wonderful until the arrival of the duchess, who, with lies and stories, had systematically separated Rodin from his true friends. Cladel was convinced that Choiseul could see how inconvenient a Musée Rodin in the Hôtel Biron would be for her.

The problem with Cladel's rendition of events to Bigand is that she suppressed the fact that there had been flare-ups between her and Rodin even before the duchess arrived. Rodin had long known how to ignore and neglect Cladel, to wound her with his characteristic vagueness and his habit of forgetting appointments. She had been particularly hurt by his coolness in the spring and summer of 1906, the same period when Rodin broke with Rilke. Cladel's reaction ranged from sensitive coaxing to weary acceptance: "I suppose your silence is your habitual indifference toward me" (August 1906). Nevertheless, she knew how to be angry as few others in Rodin's life. Beuret, of course, was frequently angry. Claudel had been furious during much of the time she was with Rodin. But there were differences: one was a wife and a dependent; the other a lover and a student. Cladel's work was Rodin's reputation, the core of his life, his ego. Somehow this got to Rodin, made him suspicious and uneasy, and made him take note when people—especially the duchess—said unpleasant things about Cladel. Martin told an extraordinary story about an article Cladel wrote on Rodin "practically at his dictation. He thought it very good, but the next morning changed his mind and sent one of his molders to the Préfecture de Police to ask how to suppress the issue of the paper which published it. . . . The article was in print and I brought back a copy to Rodin; the managing editor came too, with Mlle. Cladel. But Rodin would not give way. The next day, however, I read the article over again to him, without any mention of what had happened the day before, and he thought it very good."[23]

Rodin's inability to differentiate between true and false friends caused Cladel enormous anxiety. Her fears only intensified his aloofness. She was less and less sure whom she could trust. Having Bigand as a confidant became enormously important to her. It remains a puzzle, however, why Cladel, so active in Rodin's defense, so endlessly busy

in his regard, so high-minded about it all, was kept at a distance and regarded with a coolness unique in Rodin's life.

In her letter to Bigand, Cladel finally came to the present. Two more "good-for-nothing women" had arrived to plague the lives of those dedicated to the museum: the young, beautiful model Juliette Husted and her mother, Mme Bourdeau. Husted wrote Rodin many letters in 1913 and 1914, mostly from London, where she lived with her English husband. The letters are flagrantly manipulative, embellished with the coyest of formulas, and her signature was always preceded by a phrase such as "votre petite amie qui toute sa vie, se dévoue à votre vie" (your little friend who all her life is devoted to your life). Such language was totally foreign to Cladel, but it did not seem to displease Rodin. He gave Mme Bourdeau a position at the Hôtel Biron and permission to live there. Martin learned that mother and daughter were seen talking with the mold makers, and she felt that unauthorized casts could not be far behind. Journalists began hanging around the hôtel; the concierge heard Mme Bourdeau making plans to hide photographers in the bushes so that they could take compromising shots of Rodin walking arm in arm with Husted on one of her frequent visits to her mother. "And," Cladel reported, "Mme Martin heard the daughter tell Rodin that I was intriguing against him."

The next item in Cladel's long lament had to do with herself and the kindness of "Léon Bourgeois, who . . . out of concern for me and with discretion toward Rodin, assured me of some kind of small place in the museum." Rodin heard about this discussion between Cladel and the powerful senator, then between ministerial posts, who had apparently once been on intimate terms with Cladel. He did not like it at all.[24] Cladel told Bigand that the next time she saw Rodin, he was "aggressive and ill-tempered to me . . . he said I was *indiscreet!*" Cladel raged as she told Rodin "that only intriguers and adventuresses could count on his consideration." The next thing she knew, she had been barred from taking photographs at the Hôtel Biron.

Cladel asked Bigand to "excuse this too long letter," but she had a big subject to discuss: "*There is a will made out in favor of the duchess.* Rodin told me so himself last year, asking me to inform the secretary of finance that such a paper does exist."

Bigand's intervention on Cladel's behalf worked, at least in a limited way. She was thrilled to receive word from Rodin and acknowledged his note with a "very sincere, affectionate long letter." He didn't answer. Again silence descended. "Don't get depressed," she wrote to Rodin, "neurasthenia is a sickness for people who are rich in money, not in spirit. You know what I call you—the Croesus of Beauty—which seems to me to be just the right expression." Still no word. Two weeks later, on June 26, Cladel wrote: "I've been hearing that your museum is being put off because of your depression and the state of your health."

Others noted Rodin's depression as well. Berta Szeps remembered a day in late May when an official reception was ending and she sat with Rodin looking into the gardens of the Hôtel Biron. It was the "kind of occasion that the master hated. . . . It may have

been because of some deep inner anger stirred up by this that he opened his heart to me, and began his account. Slowly and quietly, he told me the story of his life, listing every persecution, every injustice, every meanness, every idiocy, every lie, every ignominy, every crime against his work that had left its scar on the lineaments of his spirit."[25]

Cladel wrote to Rodin on July 3: "You must not have received my letter of last Sunday inviting you to have lunch with M. Bourgeois in order to talk about the museum. We have to do it *now* or *never!* There is a counterproject to establish a sanitarium for children in the Hôtel Biron, and it seems to be a popular idea, especially since it was launched by the Socialists. You can't waste time. Dalimier [undersecretary of state for fine arts] has good intentions toward you. Poincaré approves."

Shortly afterward, Rodin received a letter from Cladel's sister, Esther Rolin Cladel, in Brussels. On a recent trip to Paris, she had found her sister "suffering physically and morally. Her strong and magnificent confidence is shaken, almost broken at the roots, and that has been done by you, M. Rodin." Esther Cladel implored him to see Judith and to remember that they were "the daughters of one of your oldest friends."

In July 1914 Rodin saw neither Léon Bourgeois nor Judith Cladel. When these letters arrived, he was in London opening an exhibition, about which Cladel knew nothing. Countess Greffuhle had arranged it in Grosvenor House, the home of the duke of Westminster. As Cladel fretted in Paris about getting her old friend interested in establishing his own museum, Rodin was carrying on in London with the duchess of Rutland, Lady Cunard, Prince Troubetzkoy, Queen Alexandra, Empress Marie of Russia, and Princess Victoria.[26]

Rodin, in his usual way, needed a buffer against so many grandes dames. Fortunately, Hoffman was there: "In July, 1914, I was in Surrey recuperating from a serious illness when I received three telegrams from Rodin asking me to supervise the installation of his exhibition at the Duke of Westminster's in London. . . . There were several very opinionated ladies who felt it their duty or privilege to object to the manner in which I was placing the marbles. On the morning of the day of the official opening, when the Queen and her ladies of the court were to be present, Rodin suddenly appeared with the Countess Greffuhle from Paris and asked if everything was in readiness. Luckily it was."

Graceful as ever in the company of a young woman he admired, Rodin ordered a hansom cab so that he and Hoffman might drive to the Leicester Gallery and look at an exhibition in which *her* bronzes were included.[27] Fifteen years earlier, Cladel had walked the streets of Amsterdam in the same spirit of accomplishment, gratitude, and wonder that must have filled Hoffman that day. As for Countess Greffuhle, she proclaimed the exhibition a triumph and happily accepted the title Rodin had bestowed upon her: "Ambassadress of the Occult." But at Knole, Lady Sackville was out of sorts—Rodin's new aristocratic admirer had not thought to invite her to the opening.

About a week before Rodin's departure from Paris, Clemenceau had remarked to an American journalist: "My readers scoff at talk of war but wait and see. Paris is gay,

elegant, luxurious. . . . We are having the races at Auteuil, and next Sunday the Grand Prix at Longchamps. These are major interests for the public. Paris is now the important place for unimportant things."[28] Then, on June 28, as Rodin, unwell, tried to find the strength to go to London, a Serbian nationalist assassinated the Austrian archduke Franz Ferdinand and his wife in Sarajevo. The scale of the crisis precipitated by the assassination would not be clear for one more month.

Rodin returned to Paris and was busier than ever. Cladel, wounded, withdrew from the museum project, and the curator of the Musée du Luxembourg, Léonce Bénédite, came to the fore. Bénédite would work his own channel of influence through the soon-to-be powerful minister of commerce, Etienne Clémentel. Also in July, the San Francisco contingent arrived. Loie Fuller had her new patroness, the sugar heiress Alma de Bretteville Spreckles, in tow. They hoped for a big Rodin presence at the San Francisco exposition that was being planned for 1915 to celebrate the completion of the Panama Canal. Hoffman came to Paris and installed herself in the Hôtel Biron to organize Rodin's drawings. Claire de Choiseul, thinking that Hoffman might help her see Rodin again, complained to her about "this stupid estrangement brought about by his enemies." But for them, she wrote, they would still be "in possession of what we had and what he himself wanted."[29]

Rodin went back to London for the closing of the exhibition, then took Beuret to Le Châtelet-en-Brie for a few days' rest with the Viviers. Emile Beuret wrote to Rodin: "I don't want you to think I'm giving you advice, but it might be expedient if you made some provision at the bank; given the way things are going, when one thinks about the situation in Paris, that could become a problem, and I must tell you that in case of mobilization, I will have to leave immediately" (July 28, 1914).

They returned to Paris on August 1. Jean Jaurès, the great Socialist leader who had been so active in the peace movement, had just been assassinated. That evening handbills went up around Paris: mobilization was declared. Emile Beuret left the next day.

On August 3 Rodin wrote to an unidentified person who had asked him to give a talk in London. He declined the invitation, saying that he was flattered but did not "have the habit of speaking in public." Further, the time was not right. A "terrible moment" had come to Europe as a punishment, "with one side appearing as martyrs and the other as executioners, but all are wretched; the martyrs have more chance because their position is more glorious and more fertile, but all the people of Europe must render an account for this time, which is only interested in materialism. The equilibrium is broken and our lives will only recover when the state of the soul is no longer in exile." Rodin particularly lamented the way Europeans treat their culture and their great works: "That which we call barbarous has finally come."

**I am like a moon that shines on an immense,
unknown sea where ships never pass.
—Rodin to Aurel, late in the artist's life**

Early in the morning on September 4, 1914, Gwen John took the train to Meudon and walked to the Villa des Brillants. Although she feared Rose Beuret, one of Rodin's workers, Eugène Guioché, had told her that Rodin had something for her. "I walked down your little avenue," she wrote Rodin a few days later, "to find a man behind the grill who was taking care of a horse. He said you had left for the country. I said you'd probably be back in a day because you wrote me to come. He said maybe, but that you didn't say so."

Disappointed, John started back for Paris, but she was so sad that she simply sat down beside the road. "Suddenly, I saw an automobile packed high with baggage coming toward me at top speed. I thought it was you and I ran to the avenue to be there when you arrived. The automobile was coming so fast I thought you saw me. It passed by." John went home, had a bite to eat, and went to the rue de Varenne. "The concierge said you had gone to London. I said you'd be back in the evening because you wrote that I should come. . . . She said she was afraid the Germans would come and eat us." John then caught a train back to Meudon: "It took a long time because it kept stopping. Everything is troubled these days." Finally, John found Guioché; Rodin had left a hundred-franc note for her. She thanked Rodin for the money but told him, as usual, that she had plenty. "Even if there is a siege, I have enough." John asked Guioché for Rodin's address. He did not know where Rodin was, nor when he intended to return. Mme Guioché, an Englishwoman who wanted to speak English in these terrible days, walked John to the train station. She confessed how frightened she was that a bomb would fall on her house: "I told her not to fear—the enemy would prefer the great monuments of Paris."

Scores of letters in the Musée Rodin provide bits of evidence about the fears and confusion in the first days of the war. They show that people in France believed the Germans capable of doing anything—even of destroying the great monuments of Paris. John's letter also indicates the abruptness of Rodin's decision to leave for England and his hasty, last-minute attempts to help the people he cared about.

The German army launched its attack on France by way of Belgium. Rather than mount a defense, the French generals focused on the more sentimental task of freeing Alsace, so in the initial days of the war the two armies did not meet head on. But by the

third week in August, the entire frontier on both fronts, Flanders and Alsace, was one long line of battles, in which the French experienced a disastrous sequence of defeats. Photographs of the dead and the destroyed villages began to appear in the journals—hundreds of corpses and horses lying by the roadsides of Belgium and France. On August 24 a million Germans marched through the northern provinces toward Paris. A week later the French army was placing charges under the Seine and Marne bridges. Memories of 1870 abounded. The generals told the politicians to leave Paris as the Germans leafleted the city: "There is nothing you can do but surrender."

Early in August, Judith Cladel had informed Rodin that the prime minister's wife, Mme Viviani, wanted to establish a children's center in the garden of the Hôtel Biron, as well as a field hospital in the chapel. She was worried about the security of Rodin's works. Although he indicated his willingness to participate in the war effort, he was very agitated and wrote as much to Mme Viviani, expressing hope that she would not be offended by his intense desire to protect his sculpture.

In spite of German propaganda, the mood in France was for confidently taking the offensive and going straight for the enemy. Almost everyone thought it would be a short war. Not Rodin, however. He wrote to the dealer Bernheim Jeune that the war would be long, and he wanted his works to remain in London. Marcelle Martin has described the dark side of Rodin and his "incomprehensible fear in the presence of any kind of suffering."[1] Cladel said that his negative view about the war effort was hard on her family: "We admired him less when he voiced his doubts as to a victory for France and the valor of our generals. A mystical faith . . . enabled us to believe in her eventual triumph, and it was painful to have this faith undermined."[2]

Rodin was now more than ever determined that his son should come to Meudon. Though the move was planned, it had not yet taken place, so he sent Martin to Saint-Ouen, warning her that it would not be easy, for Auguste was "a proud, blundering fellow, an artist, very touchy. Go and find him, tell him to come just as he is; bring him back with you. He need not bring anything; he'll find everything he needs here. Tell him—that may persuade him—that I will arrange an exhibition of his work." When Martin found Auguste Beuret, she was amazed at how much he resembled his mother; he had "Rodin's mouth, however, and Rodin's gestures, and much of his expression." He was extremely polite but seemed to be "dreading something, and this made him awkward and timid."[3] Auguste did come to Meudon, where he and his companion, Nini, remained in a small house at the Villa des Brillants for the rest of his parents' lives.

Sometime in 1914, Rodin's son imagined projects for a "Monument to a Dead Soldier." One of the drawings is inscribed: "A work in honor of the great master Rodin, who has put his autograph on this drawing." Rodin signed his name, adding the words "très beau" (very fine). The drawing for the monument depicts a theme not unrelated to Auguste Beuret's life: we see a weeping bearded man attached to a great classical monument; clinging to his legs is a small child.

Cladel wrote to Bigand-Kaire that Rodin was in bad shape. Martin agreed, mention-

200) Auguste Beuret and his wife, Nini, in front of Rodin's *Kiss*

ing that he was "a lover of money, but at the same time improvident, and found himself on August 3, 1914, absolutely without money." He was constantly in a temper and had her going in several directions at the same time, asking: "Why haven't you reminded me that I've got to go to the Ministry of Beaux-Arts!" to which she responded, "I didn't know you had to go there, *Maître.*" Rodin complained: "How do you expect me to know what I've got to do? Whether I'm to stay here or to go away? If I'm in any danger, the Minister will tell me. I don't belong to myself; I belong to the State, and it's their business to protect me. I'm their only great artist, and I've given them all my works."[4]

In fact, the person with whom Rodin had the appointment was Cladel. She was working with a newly established group, the Société Fraternelle de Secours aux Artistes, founded to help artists in wartime. In talking about protecting the works at the Hôtel Biron, Cladel mentioned she was taking her mother to London. In no time at all she had committed herself to taking Rodin and Beuret as well. She assumed he would stay with one of his many friends: "To my enormous surprise, his anger toward me had disappeared. Instead of staying in London, he wanted to accompany us to the provinces and stay in a little family pension where two of my sisters were staying, in the village of Cheltenham. We lived there for five weeks, all together on the best of terms. Rodin again became confidential with me and affectionate. He asked me to take care of those small chores—correspondence and changing money."[5] It was Cladel's mother who pointed out to Rodin that he was behaving very differently than he had over the past couple of years: "He brushed this aside, saying he had been the victim of an outburst of gossip and *des histoires de concierge.*"[6]

The worst moment of the exile for all of them came in the third week of September, when the Germans bombarded Reims. At first, Cladel said, Rodin refused to believe it,

201) Auguste Beuret, *Project for a Monument to Dead Soldiers*.
c. 1914–15. Musée Rodin

"but when the second edition of the *Daily Mail* published an immense reproduction of the cathedral, the horror was confirmed. . . . He turned pale as if he was dying, and for two days, white and mute from sorrow, he himself seemed to have turned into one of the statues of the mutilated cathedral."[7]

The destruction at Reims made Rodin extremely receptive to a letter from the young writer Romain Rolland: "Dear *grand* Rodin, Will you associate your name with us in a protest we are initiating against the ravagers of Malines and Louvain? We are sending out a call to the major representatives of art and thought in the world to begin common action against the barbarism of this war and against the destruction of monuments and works that are the patrimony of the entire civilized world." Rodin was eager to add his name to Rolland's list. In his reply, he once again leveled his anger at all of Europe. "From this time forward, one will say 'the fall of Reims' as one says 'the fall of Constantinople,' and that's where history will start. . . . I want you to say that I was one of the last to have seen and studied this résumé of the history of France."[8]

Until September 5, everything had gone badly for the French. Then they launched the counterattack that became known as the Battle of the Marne. That day also saw the famous mobilization of the Parisian taxicabs. The cabs lined up six hundred strong, full of soldiers, to rush troops to the front, where the French arduously achieved an incomplete victory that at least forced a German retreat.

On October 9, Cladel thought it was safe to return to Paris. Rodin and Beuret did not go with her; as Rodin wrote to one of his English friends, Gladys Deacon: "The Germans can always come back, and that upsets me very much." He visited various friends in England, among them Mary Hunter at her country house in Epping Forest, which Henry James considered the "most beautiful and vast of old Jacobean houses." James, who was there at the time, sent Edith Wharton an exceptionally cruel description of "Rodin and his never-before-beheld and apparently most sordid and *inavouable* little wife, an incubus proceeding from an antediluvian error, and yet apparently less displeasing to the observer in general than the dreadful great man himself."[9] Otherwise, Rodin was well received, especially after he presented the large group of sculptures that had been exhibited at Grosvenor House to the English nation as a gift honoring the unified effort of England and France to stop the German menace.

Rodin's other English project, *The Burghers of Calais,* was also ready for unveiling. But Sir Isidore Spielmann, honorary secretary of the National Art Collections Fund, postponed the ceremony: "The group represents the 'Surrender of Calais' and this would be regarded as a singularly inappropriate moment to draw attention to the event, while the German armies are making desperate attempts to reach Calais and again compel its surrender!" He thought an unveiling at that moment would be a terrible "faux pas."[10] Rodin was deeply disappointed.

By November Rodin knew he did not want to spend the winter in England. He thought of going to Rome, but asked Deacon: "Is Italy going to remain neutral? Is this prudent?" On November 12 he sent a telegram to Martin: "Come this evening to the

Hôtel Terminus Saint Lazare 8 p.m." He and Beuret would not stop even a night in Meudon. Martin's description of the encounter at the hotel is quite comical; she found Rodin "sitting in his underclothes . . . drinking chocolate and studying English. . . . He announced he was going to Italy to do a bust of the Pope." She asked if the Pope had commissioned him to do one. "No. It is through Jean de Bonnefon and Cardinal Vanutelli's sister that I am able to have sittings arranged."[11]

Rodin wanted to make a portrait of Benedict XV; he also wanted to stay clear of the war, preferably in a warm place. He wrote to Hugo Ojetti, the Italian minister of public instruction, to ask for a place where he could work: "If I had a beautiful room in an old palace, I would be very content—something simple for myself and my old wife, who is sick with asthma."

Although Rodin wanted Italy to remain neutral so that he could spend the winter there, he certainly did not think neutrality a good thing. Soon after he arrived, he wrote to the Spanish painter Ignacio Zuloaga that neutral countries, such as Spain, should not remain spectators: "It would be magnanimous if Spain, along with America and Italy, would reproach this barbarianism that terrifies us. Several years of war will put to ruin the ordering of twenty centuries." He encouraged Zuloaga to collect names of celebrities who might influence Spain to enter the war. He said he would do the same in Rome; he particularly had his eye on the American ambassador.

It would take Rodin almost four months to get near the Pope. In the interim, he settled down to running his Parisian affairs at a distance. He relied on Guioché in Meudon and a secretary, G. Barthelemy, at the Hôtel Biron. Problems with servants abounded: The chauffeur had wrecked Rodin's automobile. Barthelemy was particularly concerned about keeping receptacles filled with water at the hôtel in case a zeppelin left its "carte de visite," as he called the German bombs. And there was an ongoing effort to continue the production of sculpture.

Loie Fuller came to Rome at this time with the goal of helping Rodin focus on his part in the retrospective of modern French art in the 1915 Panama Pacific International Exposition in San Francisco, which was scheduled to open in June. Rodin wrote to friends in America to borrow works. The Museum of Fine Arts in Boston and Kate Simpson turned him down. Even for Rodin, Simpson would not lend her portrait: "My bust is the most precious thing I own and I cannot risk it." In the meantime, Fuller returned to Paris to select new works by Rodin. It was understood that her wealthy friend Alma Spreckels would buy most of them once the exhibition was over.[12] Fuller, in cooperation with Armand Dayot, selected drawings for an album to be sold in San Francisco as part of the effort to raise money to help wounded French soldiers.

Dayot was also working with Cladel to advance the cause of the Musée Rodin. In March he published an extensively illustrated article in *L'Illustration*. In spite of the war, he did not want any momentum to be lost. He knew there was anti-Rodin grumbling in the corridors of power, so he urged Rodin to return to Paris. He telegrammed to Rome: "I beg you . . . for a thousand reasons and more than anything else for France, for the

202) Rodin and Rose Beuret in Rome in the winter of 1914–15.
Photograph by John Marshall.

glory of your country. . . . France has need of all her force and especially of Rodin—do not prolong your absence any longer." That Dayot couched his request in patriotic rather than personal terms rattled Rodin in the worst way. He sent back a long letter defending himself: "I gave England a collection in the name of France. . . . I collaborated on a book to be offered to King Albert [of Belgium], and even though my drawing got there too late, it will appear in the second edition. . . . When I arrived here, Besnard said it was a good thing because there are so many Germans in Italy and Germany is not calling them back. . . . Italian artists are going to protest against the destruction of monuments and I'm hoping it will continue in America."

By means of this sad litany, Rodin hoped to convince Dayot that he was "more useful" in Italy. In the postscript, he mentioned two more considerations: "Monsieur Henri de Rothschild has asked me to patronize his committee [a committee for the 'secret and anonymous' aid for artists, both French and foreign] . . . and I gave a big bronze for the Vestiary of the Wounded." He concluded: "I think for my age I'm working hard" (Jan. 25, 1915). But the implied criticism of his patriotism rankled; two days later he wrote again: "I've proved myself enough that no one has the right to suspect me. I don't understand the reasons for any talk, unless it's my enemies, but my friends have to respect what I'm doing. I've begun something, it's not much, but I want to finish it."

Rodin's desire to do the portrait of the Pope intensified as the months went by. For him it was part of the war effort, as were his acceptance of a commission to do a statue of Senator Zebulon Baird Vance of North Carolina for the rotunda of the United States Capitol and his energetic pursuit of the opportunity to do a portrait of King Albert of Belgium.[13] Rodin's commitment to these portraits, as well as his San Francisco show and his London donation, were his way of keeping the greatness of French genius before the eyes of the world. The view that artists had a crucial role to play in the war effort as shapers of thought was widely held in France. When Matisse considered how many artists—friends like Derain and Braque—were serving in the army, he experienced the noncombatant's crisis. He asked Marcel Sembat, the minister of public works: "How might we serve the country?" To which Sembat wrote back: "By continuing, as you do, to paint well."[14]

A reporter from the *Washington Times* came to Rodin's studio in the Palazzo Colonna to listen to his views on the barbarism of the war. Rodin considered it yet one more manifestation of "an age which sends men in slavery into the bowels of the earth in the midst of danger to work in coal mines for a pittance in order to enrich others, which keeps little children working in factories, which crushes everything beautiful out of life before the juggernaut—commercialism" (Jan. 11, 1915).

By late February, Beuret's health had deteriorated significantly and Rodin took her back to Paris. On March 1, John Marshall wrote that the Holy Father would be at his disposition after Easter. Pointing out that peace in Italy was not assured, the Marshalls urged Rodin to return as quickly as possible, because it was not going to be easy to

organize the sitting: "Bring clay and any equipment you need" (March 22, 1915). Rodin left Beuret in the care of Dr. Vivier in Châtelet-en-Brie and headed for his anticipated encounter with the Vicar of Christ. Weighed down by worries, Rodin hoped he could make a difference by talking with the Pope:, his naïveté about politics and people in power had in no way diminished with age

Giacomo Della Chiesa, archbishop of Bologna, had mounted the Chair of Saint Peter one month after war broke out. His opposition to the war was couched in theological terms: one should pray for the end of war but resist telling God *how* to do it. As Vicar of Jesus Christ, Benedict XV felt obliged to extend equal charity to all combatants. Rodin had few warnings about just how difficult it would be to meet and sculpt this man, called the "child pope" because of his short stature, who was an aristocrat down to his fingertips. On top of the Pope's badly built body was a large head; his eyes stared in a fixed, piercing fashion and stood out sharply in his pallid, emaciated face.

Rodin had one hour with the Pope on the day of their first meeting. On the second, they had barely begun when a cardinal interrupted with important business. The Holy Father told Rodin to return another day. Someone asked Rodin how things were going. He said the bust was progressing well, adding with bravado: "We talked about the war and I told the Pope the truth about it."[15] Rodin told the young Croatian sculptor Ivan Mestrovic, who was in Rome, that the Pope was unwilling to sit in the way necessary for him to make a serious portrait.[16] The cellist Livio Boni, a friend of Rodin's,

203) Pope Benedict XV. Photograph by Felici.

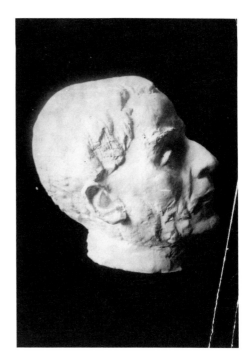

204) Rodin, *Benedict XV.* 1914. Plaster.
Musée Rodin.

accompanied him to all three sittings, probably to act as interpreter. Boni described how dissatisfied the Pope was with the work of the first day. Rodin himself disliked the results of the second day. On the third, when Rodin asked the Pope to change his pose, Benedict XV refused and Rodin reluctantly abandoned the project. "*Le maître* had tears in his eyes as we came down the staircase of the Vatican; I had to support him with my arm," said Boni.[17]

The previous month, March 1916, Rodin's old friend Albert Besnard, now director of the Villa Medici, had been granted four sittings for his own portrait of Benedict XV. He was familiar with the difficulties, and he now helped Rodin collect his unfinished work from the pontifical apartments; he, too, said that the papal bust had been enormously important in Rodin's mind.[18] Besnard introduced Rodin to Boni de Castellane, who had come to Rome to have his marriage annulled. The two men traveled back to Paris together, Boni carrying Rodin's bust of the Pope in his arms "like a holy relic."[19] Rodin suffered deeply from his failure to create a papal portrait, and in subsequent conversations spoke about the Pope in very negative terms. But then, by the end of 1915, most French people were calling Benedict XV "le pape Boche" (the German pope).

As far as the portrait goes, it is certainly not a failure. Its form is powerful and it is singularly successful in emphasizing Benedict's penetrating gaze. Rodin himself regarded it as a good "resemblance," but in no way a "masterpiece."[20]

Just how bitter and disappointed Rodin was becomes clear in his recollections of the Roman trip, which he shared with Cladel. The experience had reinforced his conviction that the destruction of Europe was the result of the decadence of modern life. He feared for Rome: "People do not see how beautiful the Appian Way is and that it will soon disappear." He had met younger artists in Rome, but "it is not their work that makes Rome. . . . Rome is Bernini The Church is ignorant and so is the Pope."[21]

The historian Jean-Jacques Becker described Paris in 1915 as in the grips of "the banality of war." People were more concerned with the high cost of living than with news from the front. Their major anxiety was the diminished coal supply.[22] Such was the Paris to which Rodin returned in May. Martin described him as "tired; the war overawed him, aroused his fears. As a result, he had no inclination to work." She said that he would just show up at the Hôtel Biron for an occasional appointment.[23] Rodin may have complained to Malvina Hoffman about the general rise in prices, for in May she deposited twenty-five hundred francs in the Hayes Bank to be at his disposal in case of emergency.

Rodin was viewed as a public figure in France and was therefore expected to be a presence in the war effort. When Dayot planned an issue of *L'Art et les artistes* on the war's destruction of French art, he felt Rodin had to be one of the participants. Rodin prepared for Dayot a series of scattered notes about the Europe he saw, a Europe composed of martyrs and executioners. For him, King Albert and the Belgians were as noble as Saint George. He thought things would be right only when the human spirit became as "simple as the sun, as calm and as fertile as that heavenly body that envelopes all." In the end, he refrained from publishing the document, considering it the wrong note to strike when France was fighting. Besides, he wrote, "I don't want it to furnish a pretext to not put central heating into my Hôtel Biron" (July 17, 1915).

Soon after his return from Rome, Rodin met Cladel by chance. They had not seen each other since the previous October in England, and Cladel was hurt that, after all she had done, he had not sent her so much as a postcard. Rodin was cool, but nevertheless invited her to stop by the rue de Varenne. When she arrived, he was still distant and spoke dejectedly about the prospects for the museum. Cladel said frankly that if he had not put his "confidence in intriguers and exploiters," it "would have been finished long ago." Suddenly Rodin turned on her, accusing Cladel of being interested in the museum only as a way of creating employment for herself.

This provoked an angry response from Cladel's mother. After all Cladel had done to further Rodin's career and reputation, she wrote, "you have the nerve to tell her in the most discourteous way and the most brutal tone that she is interested in serving her own interests [elle veut faire des affaires]. That's how you show your thanks as you are on the verge of having your museum. She asks you for a little secretarial job *after the war,* a situation with less recompense than that of a guard and in which she would continue to

serve your glory, not just because you are Rodin, but because you are a *French* artist, and everything that has to do with the intellectual value of our country is dear to her! Nor did you think one instant about her and that she might need a situation." Mme Cladel told Rodin that she had made copies of her letter and was prepared to show it to their mutual friends. She also issued a closing threat: if she ever again heard that Rodin had uttered the phrase "Judith voulait faire des affaires," she would send her brother to settle the matter with him (July 5, 1915).

Two days later, Cladel wrote to Bigand that she had seen Rodin "for the last time." Since the two men were friends, she would refrain from telling him what had happened.

As she wrote this, Cladel did not know that another woman was actively seeking to take over the leading role in planning Rodin's life and museum. She was Jeanne Bardey, a painter, printmaker, and sculptor of some talent from Lyon. Rodin had known her since 1909, when he had admired her work in the Salon des Indépendants. Like Sophie Postolska and Gwen John, she soon could think of little save Rodin and the benefit she believed she would gain by coming under his close tutelage. Though "a debutante in the world of art," Bardey was certain she understood Rodin from the moment they met. By the end of 1909 she was "drawing like a madwoman," sometimes producing eighty drawings a week in a style that clearly resembled Rodin's recent work. She would whisk them off to the Hôtel Biron, where Rodin expressed considerable admiration for them. That year Bardey stayed in Paris for Christmas, depriving herself of her husband's and her daughter's company, only to find Rodin leaving town for the holiday in the company of Madame de Choiseul. Ultimately, Choiseul kept Bardey from developing a closer relationship with Rodin, but Rodin and Bardey never lost touch with each other. In 1912 Bardey helped arrange an important exhibition of 279 prints and drawings by Rodin in the new Lyon library.[24]

From late 1913 through the first year of the war, there was little contact between Rodin and Bardey. In the summer of 1915, after the death of her husband, Bardey moved quickly to reestablish their friendship. She was frequently in the company of her twenty-one-year-old daughter, Henriette, who was also studying to become an artist. Bardey often signed her letters "Your two devoted students, Henriette and me." In the fall Bardey was searching for an apartment and an atelier in Paris. By November 18, 1915, mother and daughter were happily installed at 31 rue Campagne-Première. Bardey told Rodin of a second atelier-apartment combination in the same building. Wouldn't he like to take a look at it? One of the attractions of the Bardeys' new residence was heat. Neither Biron nor Brillants had this comfort, which was very hard on Rodin and Beuret. Bardey made it clear that "everything we have is yours," mentioning her properties in Lyon, Mornant, and Paris (Dec. 30, 1915). Rodin did not take the apartment, but he frequently spent time that winter in the rue Campagne-Première, where the three artists passed their hours modeling: Bardey fashioned Rodin's portrait, while he created one of Henriette.

On March 10, 1916, Rodin fell; he seems to have had a light stroke. This intensified

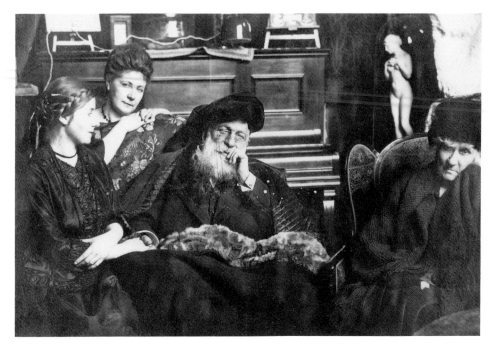

205) Jeanne and Henriette Bardey (left) with Rodin and Rose Beuret
in 1916

Bardey's concern for her mentor, and she wrote him daily as he recovered in Meudon:
"The more I know you, the more I understand you, and the more I feel that my only
reason for existing is to consecrate my entire life to you" (March 14). "Forty-eight
hours without seeing you seems very long to me. If you have anything that I can do for
you, do not hesitate to entrust it to me. I want to be your slave" (March 15). Henriette
wrote too, addressing her letters to "my dear little papa Rodin."

One of the other active contacts in Rodin's life in this period was the powerful
minister Etienne Clémentel, who directed France's economy throughout the war.
Rodin had been hard at work on his bust over the past ten months.[25] The stroke made it
clear to Clémentel that there was no time to lose in organizing the legal work on
Rodin's donation to France. Within a matter of weeks, a draft of an act of donation was
drawn up and signed in Meudon on April 1, 1916, in the presence of Clémentel,
Valentino (representing the Ministère des Beaux-Arts), and Anatole de Monzie, the
lawyer and deputy who had helped prepare the deed. The document included a number
of safeguards for Rodin: at the Hôtel Biron—thenceforth to be called the Musée
Rodin—he was to be in charge of personnel. He would have the right to use the
building until the end of his life, and the state would install heat. All reproduction rights
to his art would remain with Rodin during his lifetime. It was his responsibility to
arrange and pay for transportation of his work to the hôtel. If Parliament did not vote to
accept the donation within six months, all would be returned to Rodin or to his heirs. In

April 1916, however, Rodin declared himself a "célibataire" (bachelor) and refused to name his heirs.[26]

Bardey made arrangements to take Rodin and Beuret to Lyon, where he could be seen by her own trusted doctor. When they returned, Rodin felt better and put many of his affairs in Bardey's capable hands. She saw that his automobile was repaired, picked up his prescriptions, worked with photographs, even oversaw the progress of work at the Hôtel Biron. In the words of Hubert Thiolier: "With a wife in Paris and a wife in Meudon, the old artist found an equilibrium which he had so long been missing."[27]

On July 10 Rodin fell down the stairs at Meudon. He had suffered another stroke, one which Bardey recognized as serious. She also understood that, although the donation had been drawn up, there remained to be settled the matter of a will and the heirs whom Rodin had refused to name a few months earlier. On July 12 she contacted his lawyer, Maître Paul Thérêt, and invited him to come to Meudon to prepare a will. The document Rodin signed read simply: "I appoint Marie-Rose Beuret and Jeanne Bardey as my joint residuary legatees, with accretion to the survivor. I revoke all previous wills."[28] Loie Fuller was present at the execution of the will, presumably because Beuret, who had to sign it, felt close to her. Bardey had only met the American dancer the previous month, but they had immediately become "as sisters." Moreover, Bardey suggested to her other mentor, the painter François Guiguet—to whom she had long given a confidential view of her friendship with Rodin—that he visit Meudon: "He would so much like to shake the hand of a friend! I count on you" (July 13, 1916).[29]

The following week Rodin agreed to sell Fuller a large *Balzac* for two thousand francs, along with the right to have it cast in bronze. He had always been protective of *Balzac* and had turned down other offers of purchase. Presumably, Fuller had Bardey's help in this important acquisition. The sale, however, was never consummated.

The first person outside the intimate circle at the Villa des Brillants to know about the new will was Martin. Auguste Beuret and Nini had informed her that "there's trickery going on in there and no mistake!" as Martin put it in her book.[30] Martin lost no time conveying this news to Cladel, who was still out of touch with Rodin. On July 25, Cladel wrote Bigand about the "sharks from Lyon," whom she considered even more skillful intriguers than the duchesse de Choiseul, if that were possible. Her first impulse had been to go to Clémentel or Joanny Peytel, but she was afraid they might say, "*Et voilà*, here's another one." Cladel elaborated on her dilemma in her book: "Had I been a man, the situation would have presented no difficulties, but a single woman is an object of suspicion in this conventional France of ours, even when she is sincere and disinterested."[31]

In the end, Cladel asked Bigand for a letter of introduction to Peytel. He was "full of bourgeois prudence such as we often find in these old men; he wanted to avoid unpleasant things, insisting that 'Rodin simply needs rest.'"[32] Then she went to Clémentel, who was "very reserved" but listened, and in the end "thanked me warmly."[33] Clémentel placed a telephone call to the Ministère des Beaux-Arts to tell Dalimier that "the

disappearance of works of art destined for the state would seriously injure the reputation of his administration."[34] Arrangements were quickly made for national museum guards to be placed on duty at the Hôtel Biron, so that Bardey no longer had the right to walk through the door of the domain that she had overseen for the past year. Cladel reported to Bigand that "the lady from Lyon" was so out of sorts that "she went to Meudon, saying she would make a beautiful museum here, demanding an example of every work and nothing less!"

On August 4, Cladel and Martin went to Meudon in the company of Clémentel, Dalimier, Valentino, and Léonce Bénédite, director of the Musée du Luxembourg. In Clémentel's words, they were going to save Rodin's works from "these robbers." That very day, Bardey simply left. She went first to her property in Mornant near Lyon and then to Florence. Thiolier, her champion, has described what took place on August 4 as a "véritable coup d'état." He sees Bardey's departure as "wise and discreet," for "she did not have the treacherous cleverness of Cladel nor the self-interested tenacity of Martin. Honors left her cold, money as well. She could only think of her work and of Rodin."[35]

Martin was then installed in an annex of the villa; before long, Cladel rented a house on the hill opposite Rodin's property. It is not clear how lucid Rodin was at this point. Like many stroke victims, he intermittently lost control of his faculties from the summer of 1916 until his death in November 1917. During this period, Rodin's life and affairs were managed by others, notably Martin and Cladel. Each individual had a vision of what she or he might gain by being at Rodin's side. There was not a single disinterested party to care for his needs.

On September 13, 1916, Rodin's bequest to the state was formally executed. A select group gathered at the Villa des Brillants to witness the signing of the papers: Clémentel and Dalimier represented the state, as did the mathematician-politician Paul Painlevé. Cladel and Martin sat with Rodin and Beuret. The deed of gift included "all works of art, without exception, contained in M. Rodin's different studios, whether his own work or of other origin; all his writings, manuscripts or printed works, published or not, with full rights in them."[36]

The following day the debate on the acceptance of the gift opened in the Chambre des Députés. Opposition came primarily from the far left and far right, but only the deputies on the right were interested in debating the question. Their objections fell into three categories: that the terms of the donation set a bad precedent; that the state already had too many museums to maintain; and that a vote for Rodin was a vote against the Catholic orders, for many still associated the Hôtel Biron with the Convent of the Sacré Coeur. Jules Delahaye, deputy from Maine-et-Loire, rose to speak against the motion that would "create a precedent without equal in the ancient or modern history of French art. If we are going to give historical palaces to all the artists who are somewhat talked about, the residences of a thousand congregations will not be sufficient." To support his views, Delahaye started to read an article by the right-wing journalist Urbain Gohier, which sent the left into convulsions: "We will not listen to the prose of Jaurès' assassin!"

Although Gohier had had nothing to do with the assassination of Jaurès, he had frequently attacked him in the press. To a man, the Socialists rose, fists in the air, and left the chamber. One suspects they did not wish to vote. In general, the Socialists did not favor spending funds on art in such difficult times. But, after all, Rodin was a kind of revolutionary, and the left did not want to go on record with a strong vote against him.

When order was restored, Anatole de Monzie took the floor to speak about the three-million-franc valuation on Rodin's sculpture, arguing that such a magnificent gift should be gratefully accepted. Three hundred and seventy-nine deputies agreed with him; only fifty-six did not. A measure was introduced to create an account of 10,818 francs for maintenance of the museum. This, too, passed.[37] A journalist covering the debate for the *Archives Israelites* was pleased that "all our Israelite representatives voted in favor"; it was in total harmony with the "profound and sincere traditions of liberalism" for which his journal stood.[38]

The Sénat debate was not scheduled until November, which gave the conservative forces time to gather their strength. "Does Rodin merit the Hôtel Biron?" demanded the headline for Jean Dorsenne's article in *Paris-Midi* (Oct. 23, 1916). He had interviewed Rodin, who reportedly referred to the artists of the Institut as "all those old retrograde revivalists; in a hundred years they will still find me too audacious."[39] Dorsenne quoted the history painter Luc-Olivier Merson, one of the most "retrograde" artists, as calling Rodin's art "vulgar, tending toward the pornographic."

When the Sénat session opened on November 9, people looked forward to a "great debate." The press dubbed Rodin's opponents "disciples of Paul Bourget, the notorious Royalist and Catholic." One after another the senators stood up to speak of Rodin the "decadent," Rodin the "immoral," Rodin the "subversive." Paul Soudy called him "the accursed one, outside the law, carrying on a satanic and disastrous revolution."[40] As the right droned on, the majority of senators grew impatient. Clemenceau was seen walking in the corridors. Finally, Eugène Lintilhac rose to speak for the "honor of the Republic" and his hope that it would remain "secular and Athenian [laïque et athénienne]". A vote was taken: 203 in favor and 22 against, Senator Maurice Barrès, literary giant, nationalist to the core, was among the twenty-two.[41]

Before the debate, Bénédite, worrying about the outcome, talked the issue over with the president of the Sénat, Antonin Dubost. One of Dubost's objections, he discovered, was that Rodin was not married, although a usufructuary clause in favor of Rose Beuret was part of the agreement; Dubost considered this a bad precedent.[42] The idea of a marriage began to take hold. Cladel strongly favored it, and she felt Clémentel and Peytel supported it. Once the debate on the donation was concluded, however, she noticed the men beginning to lose interest. Cladel believed that they had held out hope to Beuret and that withdrawing this quasipromise would make her feel personally disgraced. She wrote to Bénédite that, in her opinion, the men had "played out a comedy in order to gain our end, which is that of the state, to be sure, but nevertheless"[43]

Auguste Rodin and Rose Beuret were married on Monday morning, January 29, 1917. To Cladel goes the major share of the credit for this strange event. Bénédite had now been officially appointed as Rodin's agent (*mandataire*). He was not in favor of the marriage, but in this instance Cladel's will prevailed. She took Rodin to purchase a ring; he had no money, so she lent him twenty-five francs.[44] She chased down birth certificates, got a letter from Rodin's doctor in order to obtain permission to hold the wedding at home, and wrote out the invitations. Although Rodin scarcely knew his Coltat and Cheffer cousins, they had made a sudden appearance in the last days of his life; so they too were invited. Cladel informed Bénédite that she would bring everything from Paris—"You wouldn't be able to find three cups or six glasses in the villa." Nor was there heat. Fortunately, in December Martin had married, and her new husband, M. Tirel, found a way to improvise with mold-making stoves from the studio. Auguste Beuret was full of anticipation, for he had the mistaken idea that the marriage would make him legitimate.

The mayor of Meudon performed the ceremony. Dalimier could hardly believe that the Villa des Brillants had been made respectable, and during the ceremony he leaned over to Cladel to say, "I'm going to name you directress of the Odéon." But Cladel had her mind on Rodin, fearing he would neglect to respond at the right moment. In a whisper, she prompted, "Yes, Your Honor." He dutifully repeated the words after her.[45]

After the ceremony, the newlyweds were packed off to bed; there was no fuel left and the villa was cold. Two weeks later Rose came down with bronchitis, which turned into pneumonia. By the time Cladel arrived at the Villa des Brillants, Rose Rodin was dead.

206) The wedding of Auguste Rodin and Rose Beuret, Jan. 29, 1917. Photograph by Choumoff.

"Poor Rose was badly used," Cladel wrote to Bigand. Renouncing her role as the arbiter of the marriage, she told him: "I saw her end coming for months; and then this marriage *in extremis,* wasn't it a terrible deception?" It had become evident to Cladel that she could not trust Bénédite. As the time for the wedding approached, Rose asked Cladel to be one of her two witnesses, along with Countess Greffuhle's secretary, Miss O'Connor, who had frequently helped Rodin and Rose. Bénédite peremptorily substituted himself and the man from whom Rodin had purchased his automobile.[46]

Bénédite, a man in his fifties—that is, almost fifteen years older than Cladel—had come up through the system. He started in law, then attended the Ecole des Hautes Etudes, following which he helped organize the annual Salons in the Champs-Elysées. This was followed by a stretch at the Musée de Versailles before he became director of the Musée du Luxembourg. Rodin had many works in the Luxembourg and the two men had been in frequent contact since the early nineties. Their letters are cool and businesslike; there is no evidence of any personal relationship. Nor is there any evidence that Bénédite was much of an admirer of Rodin's sculpture. Around 1912 the tone of the letters changes; Bénédite seems to have made more of an effort to please Rodin. In 1913 he asked his brother, Georges Bénédite, the curator of Egyptian art at the Louvre, to appraise Rodin's Egyptian collection. But by 1914 he was on the bandwagon, engaging in the fight "to break down the last resistance" to the Rodin museum, as he wrote Rodin that June. When it was clear that Rodin could no longer do the day-to-day thinking about his works, the state selected Bénédite to act as his representative. On November 12, 1916, Rodin wrote to an unknown party: "M. Léonce Bénédite, curator of the Musée du Luxembourg, is my representative with total authority to administer my artistic patrimony."

The correspondence suggests that Cladel tried to get along with Bénédite; she performed menial secretarial tasks for him, as well as endless errands to Meudon and the ministry. She even spied on the ever-present female population of Meudon at Bénédite's request. She addressed him as "cher Patron." At one point, Cladel complained that the physical circumstances of Meudon were too difficult for Rodin and that Bénédite was withholding the necessary funds to take care of his basic comforts, but she softened her criticism by acknowledging "how hard [Bénédite was] working." Cladel felt she was being eased out, but it would have been unthinkable for her to abandon Rodin. Also, she badly wanted to work in the Musée Rodin. The only person Cladel trusted was Bigand; in April 1917 she wrote him how much she wished he were close at hand: "Rodin needs a devoted friend with more authority than mine. I am only a woman and feminism is not sufficiently part of our ways to permit the least frivolous among us to be listened to profitably—what is needed is a strong mind, because there is some kind of deranged sorcery taking place in a certain measure among those who are busy in the affairs of Auguste Rodin."

Part of the sorcery was a new will prepared on April 25, 1917, under Bénédite's direction. He got Rodin to sign a piece of paper in the presence of his Coltat and Cheffer

cousins which confirmed Bénédite's position as future organizer of the Musée Rodin. Martin-Tirel said that "from that day Rodin was shut up at Meudon with three women [as guards], who sat ceaselessly up to five o'clock in the evening with scarcely a word spoken between them."[47]

Cladel was horrified by how cold the house was and by Rodin's frequent boredom: "*Le Maître* is isolated, in spite of the invasion of relatives," she wrote to Bigand, "isolated because there is no one with his habits of mind with whom he can speak." Then, under Bénédite's orders, workers started to pack up Meudon to move Rodin's works to the Hôtel Biron. It was profoundly upsetting for Rodin. Cladel wrote: "Sometimes, weary of his seclusion, he would leave for Paris and the museum. If his guards weren't paying attention, he would just go by himself. They would catch up with him on the road. At other times he wanted to see again his father's house in the faubourg Saint-Jacques. . . . It was decided that he could emerge from exile every other Sunday. We would go and get him and pass some time together."[48]

By the summer of 1917, France was growing tired of the useless slaughter of the war. Mutinies had broken out in the army, there were political scandals and a campaign against the alliance with Great Britain, and, in the fall, for the second time in less than a year, the government fell. Rodin's supporter Paul Painlevé became prime minister; Cladel hoped he would appoint a council to look after Rodin and his fledgling museum. The most immediate worry was fuel. Rodin's physician, Dr. Chauvet, said he would not survive the winter in an unheated villa. Cladel suggested he be moved to the Hôtel Biron; Bénédite said it was impossible. He also said it would be "très dangereux" to have Rodin around because he had "his ideas." Evidently, Bénédite did not want Rodin interfering with his own plans for installing the museum.[49] It was proposed that he be moved to the south of France, but Chauvet said he would not survive the trip. "Dr. Chauvet then demanded a furnished flat; anywhere in Paris, he said, would do, provided Rodin could be kept warm and the third attack of congestion, which the doctor foresaw, staved off. This too was found impossible, and the third attack came."[50]

That was early November, just before Rodin's seventy-seventh birthday. Martin-Tirel remembered that a few days later, on November 15, Bénédite came to Meudon in the company of Eugène Rudier, the head of Rodin's foundry, and the lawyer Thérêt for the purpose of adding a codicil to Rodin's will. There were a few details that were not fully described in the existing will: Rodin's personal souvenirs, his portraits, and his decorations would go to the Musée Rodin; furniture and personal effects to his cousin, Mlle Coltat; and his watch to his son. "Furthermore, he [Rodin] entrusted 'anew,' and exclusively, to his friend M. Bénédite the task of sorting and publishing his writings and correspondence. He 'thanked him once more' for all his disinterested devotion and put forward his name to the ministry to be curator, in succession to himself, of the Musée Rodin. Finally, he appointed M. Bénédite executor of his will."[51]

When the signing was over, Dr. Chauvet arrived; he stated that Rodin was in no condition to do any kind of business. After examining him, he went home and wrote

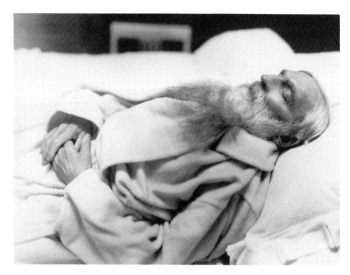

207) Rodin on his deathbed, Nov. 17, 1917. Photograph
by Choumoff.

Clémentel that his patient was dying of congestion of the lungs and that he took no
responsibility, for his advice had been consistently disregarded.[52]

The following day Judith Cladel and Henriette Coltat were sitting by his bed when,
"suddenly . . . Rodin's voice rose strong and clear, nuanced with a mocking compas-
sion: 'And they said that Puvis de Chavannes was not beautiful!'" They were his last
words; late on November 16 Rodin went into a coma.[53] Coltat and Cladel conferred
about how to dress him. Cladel suggested a long white robe that he sometimes wore in
the studio. She leaned over, kissed the burning forehead, and left. Rodin died at 4 a.m.
on November 17.

Cladel said many people came to see Rodin stretched out in his white robe: "One
might have thought him a penitent emperor who had put on a monk's habit." She
mentioned only four by name: Dr. Vivier, the sculptor Albert Bartholomé, the writer
Aurel, and the duchesse de Choiseul, "who laid a bouquet of violets upon the sleeping
hands of the man to whose life she brought so much trouble."[54] After looking at
Rodin's body, Aurel wrote down her feelings: "It was no longer Rodin, river of joy,
force of nature, demon of work; no longer the man of impudent nymphs—yet it was
he. It was also a sadness in which one could read the hard beginnings which never
finished, those things that made him say: 'I am like a moon that shines on an immense,
unknown sea where ships never pass.'" She looked on the man whom she called "the
confessor of the Sun" and understood that "we must make his funeral as he wished it—
one of profound national outpouring. . . . Let us come together around the master of
French suppleness, that spirit that is so opposed to German stiffness which now grinds

down the earth and the blood of this stirring and divine France of which Rodin has preserved the mark."[55]

Excelsior reported that "it is most likely that the state will hold a national funeral for Rodin. In this case, his body would be brought to Paris, where the official ceremony would take place, and then be taken back to Meudon" (Nov. 18, 1917). *Action* added: "In order to show in a dignified fashion the enormousness of the loss suffered by the entire country through the death of the sculptor Auguste Rodin, the government will, most probably, reach an agreement today with the executors of the deceased—MM. Clémentel, Peytel, and Bénédite—concerning his funeral. Like all our great men who have been true 'national' glories, the creator of *The Thinker* will have a 'national' funeral" (Nov. 19).

208) Rodin's tomb, November 1917

Rodin did not have a national funeral, however. On the day he sank into a coma, the headlines read: "M. Clemenceau agrees to form a cabinet." Painlevé's cabinet had fallen on November 13, and President Poincaré finally turned to Clemenceau, the man who renounced the idea of a negotiated peace. Clemenceau would now devote himself wholeheartedly to the prosecution of war. Evidently, a national funeral was out of the question while Clemenceau was choosing his cabinet and calling on all French people to join him in a supreme effort of will. But he was very sensitive to Rodin's death. A young Swiss architect, Le Corbusier, recently arrived in Paris, wrote a friend on November 18: "Rodin is dead. Starting today, the *Homme enchaîné* [Clemenceau's journal] is called the *Homme libre*. In the midst of the great hope everyone has since Clemenceau is nominated, the first article in the *Homme libre* is on Rodin. Clemenceau had the greatness at this moment to devote [space] to Rodin."[56]

The funeral was held in the garden in Meudon; Cladel noticed "a touch of winter in the air." Bénédite organized the speakers: Lafferre, the new minister of public instruction; Charles-Marie Widor, a musician, spoke for the Institut; Bartholomé represented the Société Nationale (it would have been Alfred Roll, but he was sick); Frantz Jourdain, as president of the Salon d'Automne, made some remarks; and Besnard reminisced about Rodin's recent visits to the Villa Medici. Clémentel spoke as a personal friend. He was scheduled to give the final adieu. But his voice was not the last. Aurel had asked Bénédite for a place on the program, and he had denied her request. Throughout the ceremony, as she listened to one dry male voice after the other, some the voices of men who had barely known Rodin, she fumed. At the last moment she pressed herself upon Séverine, the feminist writer whose portrait Rodin had made in the nineties. In the name of women, would not Séverine give the final eulogy? "She advanced to the middle of the steps and spoke, simply at first, and then, little by little, her oratory became more vibrant and warm. In her passionate voice she uttered words rapidly, tenderly, and movingly, words that everyone longed to hear."[57]

The next day a journalist reported that of all the speakers, only Séverine had shown sympathy for Rodin's mutilated youth, comparing it in the most superb fashion to the famous fragments for which he would ever be reproached by "serious" people.[58]

After seven years of steeping myself in the long and vivid life of August Rodin, I searched for one word that might encapsulate it for me. The word I find that fits best is "lonely." Rodin lost his only surviving sibling—and his dearest friend—when he was still young; he suffered the loneliness of an artist whose real master was of another century and another country and whose work he could study only on the briefest voyage; he was lonely within his family, as in significant ways he could not connect with his parents, his wife, or his son; as an artist he made his first masterpiece in semi-isolation in a foreign country, and he received his most significant commission almost as a fluke. Rodin took hold of his life through work, the actual day-by-day intensity of physical labor and of a personal vision of how nature—the contour of bodies, the light and color of a surface, the textures of roughness and smoothness, the angle of a plane, the volume of a shape—could be captured in clay, only to be rethought again and again in order to express in bronze and marble the psychological reality of human experience. His life is a story much larger than human loneliness. Yet even in his art, his attempt to communicate his vision to others, he suffered the loneliness of neglect, misunderstanding, and outright rejection.

Rodin's life was most whole, most centered in the mid-1880s when, after years of not attaining real recognition, he was certain that his doors would frame the entrance of an important new museum. During this same period, he was fashioning the great figures of *The Burghers of Calais*. The *Burghers* worked particularly well, as Rodin mediated among the idea of the monument, the models with whom he worked, the friends who helped, and the patrons whom he convinced that the unusualness of his monument was worth their effort and patience.

Rodin's great work of the 1890s had a completely different fate. Rodin knew how good his *Balzac* was (and posterity bore him out), but its commissioners, the members of the Société des Gens de Lettres, were not prepared for its originality. When the statue's setting became Rodin's own garden, he considered it a "defeat." It is fair to say that Rodin never recovered from the setbacks he encountered with *Balzac*. Work in the old way ceased to be the center of his life. He became more entrepreneurial, more social, and he yielded to the fame that gathered around him. Fame made him lonelier still; he came to feel that he was as a moon shining "on an immense, unknown sea where ships never pass."

One of the most astonishing aspects of Rodin's post-*Balzac* life was his focus on women. Once, when he and William Rothenstein were walking in the garden at Meudon, Rodin remarked: "People say I think too much about women." Rothenstein was on the verge of a conventional "But how absurd!" when Rodin asked, "And yet, what is there more important to think about?"[1] It is clear that the thousands of

twentieth-century drawings inspired by Rodin's female models occupy a more search-
ing, more creative and original place in his oeuvre than the enlargements of *The Thinker*
and the effort he put into getting *Victor Hugo* installed in the Palais-Royal. And his
studies of women artists—Claudel, Séverine, the Japanese dancer Hanako—have a
unique and strong niche among his portraits.

Rodin was not just interested in women; he respected them. He said it in word and
deed over and over again. To Aurel he declared, "I owe everything to women; they
move ahead as great masterpieces"; with Zola, Rodin talked about "that sacrilegious
thought that woman is inferior to man"; and to Malvina Hoffman he wrote that "the
friendship of a woman is something willed by God; after him, it is the strongest thing in
the world." The women responded in kind, not just to Rodin's magnetism—which
was real enough—but to his respect. In a particularly touching letter, Gwen John
acknowledged that "everyone I have ever known before you has wanted to change
me. . . . But you have said that you do not want me to be different than I am." Aurel
expressed the same sentiment in other words: "In Rodin's presence, a woman dares to
be free and to give up pretending."

In a slightly different vein is Jeanne Bardey's belief that "God has deigned to mold for
me a tiny piece of the clay from which He fashioned you" (letter of Dec. 21, 1915). This
raises another point: Rodin wanted women to succeed. When Hélène Wahl invited him
to dinner too often, he spoke firmly: "In you there is also an artist, and it is especially
that side of you that should understand me." The combination of these impulses made
women feel their potential in a very special way, helping them to realize that they could
do things of which they had not dared dream, either as artists or as impresarias of a great
artist. The competition that Rodin inspired in the last decade of his life—among John,
Cimino, Fuller, Postolska, Choiseul, Cladel, Martin, Bardey—was not simply a mat-
ter of sexual or paternal attraction; it was more deeply about power. Each of these
women was coming to grips with her own power, actual or potential, whether artistic,
sexual, managerial, or some combination of these. But Rodin had little sense of his own
power and what he was setting loose in others. Nor was he a good judge of character, so
what we see by digging deep into the correspondence is at times a dark and unhappy
story. It is quite clear that the attention of so many women did not alleviate Rodin's
loneliness.

The triumph of Rodin's life was and will remain his work. In the winter of 1916–17,
as Rodin sat in his cold house, sometimes knowing where he was and whom he was
with, sometimes not, a young poet and critic was putting together notes on contempo-
rary painting and sculpture. André Salmon called his essay on sculpture "Under the
Gates of Hell." Salmon, a major advocate of the new style of cubism, had many doubts
about the sculpture of the previous generation. Yet he wrote: "Despite everything,
Rodin remains the giant, the titan of his century, the master of the young sculpture, and
the procession of sculptors who enter into this career by passing under *The Gates of Hell*
is not yet over. . . . This great artist studied so much, learned so much, and perhaps in

vain. He only had to produce. Once in a while the world yields up an inspired one. It may be a prophet, a pope, a soldier, a poet, an artist."[2]

This is who Rodin wanted to be as his life was ending—the inspired one, the French genius who lived as a beacon for young artists around the world. Yet Salmon had his doubts as to where Rodin's work would lead for others. He saw that his influence was able to paralyze younger artists and that not one of them understood his "fragment." As Salmon so astutely recognized, in creating the fragment, only Rodin has had "the grace to venture without risk."

Notes

Preface

1. Claude Keisch, "Rodin im Wilhelminischen Deutschland: Seine Anhänger und Gegner in Leipzig und Berlin," *Forschungen und Berichte der Staatliche Museen zu Berlin* 28 (1990).
2. Hubert Thiolier, *Jeanne Bardey et Rodin,* Lyon, 1990.
3. Frederic V. Grunfeld, *Rodin: A Biography,* New York, 1987, x.

Chapter 1
A Parisian Family in 1860

1 This is how Rodin described his work to Léon Fourquet in a letter of Dec. 30, 1858.
2. One of the pleasures of writing this book has been making use of the great French archival collections. Starting in the early nineteenth century, the Observatoire de Paris began recording the weather in Paris every hour. See U.-J. Verrier, *Annales de l'Observatoire Impérial de Paris,* vol. 16 (1860). Schedules for nineteenth-century public conveyances are found at the Bibliothèque de la Ville de Paris.
3. This letter from Rodin to his mother is in the archives of the Musée Rodin in Paris, as are over 80 percent of the letters quoted here. Henceforth, letters preserved in the Musée Rodin will not be cited in the endnotes.
4. Judith Cladel gives Marie Cheffer Rodin's age at the time of Rodin's birth as 34, which would put her birth date in 1806. *Rodin: Sa Vie glorieuse, sa vie inconnue,* Paris, 1936, 68. This has been accepted as the standard date in most books on Rodin. Frederic Grunfeld's recent biography states that she was born on May 20, 1807, in the town of Landroff. *Rodin: A Biography,* New York, 1987, 7. On Marie Cheffer's birth certificate in the Archives Départementales de la Moselle in Metz, her birth date is listed as "quatorze nivôse l'an six de la République française, dix heures du matin," and the place is Gorze.
5. In the course of a systematic search for all Rodin births, marriages, and deaths in the archives of the Préfecture du Département de la Seine, I discovered the *acte de décès* (death certificate) for Anna Olympie Rodin in 1848: "agée de quatre ans, née à Paris, fille de Jean Baptiste Rodin et de Marie Scheffer [sic]." To my knowledge Rodin never mentioned the existence of his younger sister to anyone.
6. Rodin's height is recorded in the "Liste de Tirage du Cinquième Arrondissement de Paris, pour la Classe de 1860." Archives de la Seine. More than half the men inducted into the French army at this time were taller than he was.
7. In the first volume of Rodin correspondence, another photograph, from the fashionable firm of Thiébault, was identified as "Madame Rodin." Although the woman bears a family resemblance to Maria and Rodin, it cannot be Marie Cheffer Rodin. The woman in the photograph is clearly under forty years of age and the Thiébault firm had its beginnings in the 1850s, when Mme Rodin was over fifty.
8. Rodin had corresponded with a school friend, D. Holen, in 1854. His correspondence with Léon Fourquet began in 1858. In both cases, however, we have only their side of the correspondence, not Rodin's. All the early Rodin letters we know are in the Musée Rodin and have been published by Alain Beausire and Hélène Pinet in vol. 1 of *Correspondance de Rodin,* Paris, 1985.
9. My thanks to Mlle Hélène Puech for inviting me into her apartment and describing the layout of the Rodins' rooms before they were renovated, when they would have still been in the nineteenth-century arrangement.

10. In 1861 Paris had 1,696,141 residents. See Louis Chevalier, *La Formation de la population parisienne au XIXe siècle,* Paris, 1950, p. 45. There were only 129,000 low-rent housing units costing between 250 and 500 francs a year. This means that there was a serious housing shortage and that the Rodins were quite fortunate in the housing they had. Françoise Marnata, *Les Loyers des bourgeois de Paris, 1860–1958,* Paris, 1961, 14.

11. Jean-Baptiste Rodin's birth certificate in the Archives Départementales in Rouen states that he was born on the "trentième jour du mois de Pluviôse an onze [Feb. 19, 1803]."

12. Alain Plessis, *The Rise and Fall of the Second Empire, 1852–1871,* trans. Jonathan Mandelbaum, Cambridge, 1985, 125.

13. According to documents in the Jean-Baptiste Rodin dossier in the Musée Rodin, he was earning 500 francs a year when he joined the police department as an office boy in the 1820s.

14. Some of his most notable students, besides Rodin, were Dalou, Lhermitte, Guillaume, the Régameys, Cazin, Legros, Fantin-Latour, Aubé, Whistler, and Roty. See the preface written by L.-D. Luard for Lecoq de Boisbaudran, *L'Education de la mémoire pittoresque et la formation de l'artiste,* Paris, 1913.

15. Horace Lecoq de Boisbaudran, *Sommaire d'une méthode pour l'enseignement du dessin et de la peinture,* Paris, 1876, 74.

16. Archives Nationales, Paris AJ53 158.

17. H.-C.-E. Dujardin-Beaumetz, *Entretiens avec Rodin,* Paris, 1913. Translated by Anne McGarrell in Albert E. Elsen, ed., *Auguste Rodin: Readings on His Life and Work,* Englewood Cliffs, N.J., 1965, 100. In his remarks to Dujardin-Beaumetz, Rodin remembered himself as being sixteen when he first saw Carpeaux, but Carpeaux was no longer at the Petite Ecole in 1856. The *Almanach impérial* gives his dates as *répétiteur* as 1851 to 1854. See Jacques de Caso, "Rodin's Mastbaum Album," *Master Drawings* 10 (Summer 1972): 160.

18. See Kirk Varnedoe on Rodin's early drawings in Albert E. Elsen, ed., *Rodin Rediscovered,* Washington, D.C., National Gallery of Art, 1981, 157–60. Varnedoe redated drawings previously considered in relationship to *The Gates of Hell* in the 1880s and placed them in the 1850s, suggesting that Rodin's very personal vision began long before the late 1870s, as the traditional view would have it.

19. Of four such letters in the archives of the Musée Rodin, only this one is dated: Feb. 4, 1859. The letters powerfully refute the long-standing notion that Rodin's father was opposed to his career as a sculptor, an idea made popular by Judith Cladel and restated in the most recent biography of Rodin: Grunfeld, *Rodin,* 30.

20. Marcelle Tirel, *The Last Years of Rodin,* trans. R. Francis, New York, 1925, 81.

21. Adolphe Etienne wrote Rodin in October 1860 to say he could no longer participate in their group atelier. Letter in the Musée Rodin.

22. A draft of Maria's letter is preserved in the Musée Rodin. When Maria was composing a formal or special letter, she always wrote a draft.

Chapter 2
Maria's Vow

1. Archives de la Seine, DR1 131, Classe de 1860, Liste de Tirage.

2. Albert Kahn, a banker and one of Rodin's patrons, took him to Bayreuth in July 1897. One of Rodin's secretaries said in a 1934 interview that Rodin hated opera and had a particular aversion to Wagner. Meunier reported that when Rodin returned from Bayreuth, he said: "It was terrible. I listened to the first act of Parsifal. It was like a badly played Mass. I left after the first act." *Aujourd'hui,* March 18, 1934.

3. In 1898 the press was even more xenophobic than it was in 1861. The *Revue du monde catholique* suggested that when Rodin put his *Balzac* on exhibition, he was out to "break the spirit of France." Why would he want to do such a thing? The journalist answered his own question: because Rodin was

"not of French origin," apparently a suggestion he felt was possible because the origin of the name "Rodin" is Germanic. *Revue du monde catholique,* July 1, 1898.

4. Judith Cladel stated that Maria was in love with her brother's friend, the painter Barnouvin. He did portraits of both the young Rodins in this period. Cladel believed that Maria suffered so profoundly when Barnouvin fell in love with someone else that she entered the convent. Cladel, *Rodin: Sa Vie glorieuse, sa vie inconnue,* Paris, 1936, 83–84. There is no evidence in Maria's letters to suggest that she was in love with anyone in the early 1860s, and there is much evidence demonstrating her considerable interest in the religious life.

5. No one has ever indicated what community Maria Rodin joined. When I found an emblem embossed on the stationary used by Maria's superior with the words "Saint-Enfant-Jésus," I went through the convents in the Paris telephone book and discovered the Community of Saint-Enfant-Jésus. I am grateful to Mother Jeanne d'Arc, the present archivist of the community, for showing me through the residence and for helping me to locate the documentation of Maria's participation in the order.

6. R. P. Henri de Grèzes, *Histoire de l'institut des écoles charitables du Saint-Enfant-Jésus dit de Saint-Maur,* Paris, 1894. Rodin carefully kept Maria's notebooks from her school days. They can be found in the archives of the Musée Rodin.

7. Claude Langlois, *Guide des sources de l'histoire des congrégations féminines françaises de vie active,* Paris, 1975. In 1861 there was a "recensement spécial des communautés religieuses." See pp. 227–37. Also see J. Michael Thayer, *Sexual Liberation and Religion in Nineteenth-Century Europe,* London, 1977, 96.

8. This passage from one of Bishop Pie's pastoral letters has been quoted in Thomas Albert Kselman, *Miracles and Prophecies in Nineteenth-Century France,* New Brunswick, N.J., 1983, 89–90.

9. During the Franco-Prussian War, smallpox took the lives of 23,000 Frenchmen, while only 278 Germans died of the disease.

10. This is documented in a letter the Butins wrote toward the end of December. They sent not only condolences for Maria's death but sympathy for the Rodins' second loss, saying they were "sorry that your son is also in a convent and that you are now alone."

Chapter 3
Brother Auguste

1 Rev. Martin Dempsey, *Champion of the Blessed Sacrament: Saint Peter Julian Eymard,* New York, 1963, 119.

2. Father Eymard, *La Sainte Eucharistie, la présence réelle,* Rome, 1950, 1: 89–90.

3. Father Jules Gayroud wrote to Rodin on May 21, 1895, from a parish in the diocese of Rouen, recalling the time they had known each other in 1863 in the community of Father Eymard: "C'est là que je vous ai connu ainsi que votre pieuse et sainte mère."

4. Information from the interviews Bartlett carried on with Rodin in the winter of 1887–88. These interviews were published in 1889 in ten parts. They are Rodin's earliest published remembrances of a substantial nature. Truman H. Bartlett, "Auguste Rodin, Sculptor," *American Architect and Building News,* Jan. 19, 1889: 28.

5. "Je regrette le Fr. Augustin assurément, il y a là une tentation de famille." Letter from Father Eymard to Father Chanuet, May 30, 1863. E. Tenaillon, ed., *Recueil des écrits du V. P. P.-J. Eymard: Lettres,* Rome and Paris, 1899–1902, 1: 269. This letter came to my attention through the aid of a note written by Sister Laura St.-Jean, general counsellor of the Servants of the Blessed Sacrament in Rome. I thank Ornella Francisci-Osti for providing me with the note.

6. Father Gayraud, the curé of Malleville-lès-Grès, wrote to Rodin on May 21, 1895: "You came back often; it was then that I really got to know you."

7. "Vous pouvez m'envoyer votre lettre par ce brave frère Augustin—c'est un pauvre cadeau qu'il vous a

fait là." Tenaillon, *Recueil*, 2: 247. The word *par* in the published letters has caused confusion. Sister Laura St.-Jean went back to the original letter and found that it was not *par* but *pour*—i.e., the letter was *for* Brother Augustin. Evidently, Father Eymard continued to address Rodin as "frère Augustin" even after he had left the community.

8. Mother Marguerite Guillot, "Journal," 2: 247. This manuscript is in the possession of the Servants of the Blessed Sacrament in Rome.

Chapter 4
Independent Man

1. Archives de la Seine, Cadastre, DP4 1862, carton 939.
2. Issued on March 15, 1864. Musée Rodin archives.
3. Frederick Lawton, *The Life and Work of Auguste Rodin*, London, 1906, 172.
4. Truman H. Bartlett, "Auguste Rodin, Sculptor," *American Architect and Building News*, June 19, 1889: 29.
5. The photograph must have been taken before June 1864, since Fourquet returned to Marseille in June. We know the location of the photograph from a letter Fourquet wrote in 1911 to thank Rodin for sending it to him. It was at the time when Rodin supported Fourquet's candidacy for the Légion d'Honneur.
6. Rodin replied in kind and modeled Aubry's portrait. Nothing is known of this work, but it is mentioned by Bartlett in his notes for his articles, though not in the published version. The notes are in the Houghton Library at Harvard University. Anne McCauley found Aubry's bankruptcy papers in the Archives de la Seine. They establish that he was born in 1811, making him considerably older than Rodin.
7. See Colin Eisler, "Charles Aubry," *Connaissance des arts*, September 1983: 46–53, and Anne McCauley, "Photographs for Industry: The Career of Charles Aubry," *J. Paul Getty Museum Journal* 14 (1986): 158.
8. Théophile Thoré, *Salons de T. Thoré (1844–48)*, preface by W. Bürger, Paris, 1868. Quoted in Luc-Benoist, *La Sculpture romantique*, Paris, 1928, 30–31.
9. *Artiste*, Aug. 1, 1863. Elizabeth Gilmore Holt translated the passage from Castagnary. See Holt, *The Art of All Nations, 1850–1873*, New York, 1981, 424.
10. Henri Lemaitre, ed., *Curiosités esthétiques: L'Art romantique et autres oeuvres critiques de Baudelaire*, Paris, 1962, 187–91.
11. Bartlett, "Rodin," Jan. 26, 1889: 44.
12. Ibid., June 1, 1889: 262.
13. Ibid., Jan. 19, 1889: 28.
14. Rodin shared these ideas, specifically linking them to *The Man with the Broken Nose*, with a young artist by the name of Yourlévitch who lived in the Hôtel Biron when Rodin took rooms there in 1909. Irénée Mauget published them in an article titled "Souvenirs sur Rodin et l'Hôtel Biron" in *Comoedia*, Aug. 10, 192? (clipping in Musée Rodin with last digit in date cut off).
15. All books on Rodin say he submitted *The Man with the Broken Nose* to the Salon of 1864. In the archives of the Musée Rodin, however, we find the receipt from the Salon of 1865. It was registered as submission no. 9197. Rodin told Bartlett that it took him eighteen months to complete the work. This too argues for completion in 1865, not 1864.
16. H.-C.-E. Dujardin-Beaumetz, *Entretiens avec Rodin*, Paris, 1913. Translated by Ann McGarrell in Albert E. Elsen, ed., *Auguste Rodin: Readings on His Life and Work*, Englewood Cliffs, N.J., 1965, 148.
17. Paul de Saint-Victor, *Presse*, May 28, 1865.
18. Bartlett, "Rodin," Jan. 19, 1889: 29.
19. Lawton, *Rodin*, 172.

20. Bartlett, "Rodin," Jan. 19, 1889: 28.
21. Elsen, *Rodin: Readings*, 148–50.
22. Verified in the Archives de la Haute-Marne in Chaumont.
23. Marcelle Tirel, *The Last Years of Rodin*, New York, 1925, 21. Marcelle Martin married M. Tirel in December 1916, but during most of the time she worked for Rodin and was friendly with Rose, she was Mme Martin, so that is how I shall refer to her.
24. Remark made to Victoria Sackville-West. Lady Sackville recorded the conversation in her journal, which is owned by her descendants at Sissinghurst Castle. Quoted in Frederic V. Grunfeld, *Rodin: A Biography*, New York, 1987, 44.
25. Judith Cladel, *Rodin: Sa Vie glorieuse, sa vie inconnue*, Paris, 1936, 86.
26. Archives de la Ville de Paris.
27. *Statistique des familles* (1906 and 1939). See Theodore Zelden, *France, 1848–1845: Ambition and Love*, Oxford, 1979, 315.
28. *Soixante Ans dans les ateliers des artistes; Dubosc modèle*, Paris, 1900. Also see Jacques Lethève, *Daily Life of French Artists in the Nineteenth Century*, New York, 1972, 185.
29. Translated in Jack Lindsay, *Gustave Courbet: His Life and Art*, New York, 1973, 90.
30. Tirel, *Last Years*, 130–31.
31. Cladel, *Rodin*, 127.
32. Judith Cladel, too, had to struggle with the difficult question created by Rodin's relationship to Rose and Auguste Beuret. In her chapter on the young Rodin, she asked: "Quelle fut la pensée secrète de Rodin en ne reconnaissant pas l'enfant, en ne régularisant pas sa situation conjugale, si ce n'est aux derniers jours de son existence?" Not being able to answer the question, she went on to wonder if he was waiting for better times, if he was just careless, or if he preferred a docile mistress to a wife. She finally fell back on "ceux qui l'ont bien connu à ce moment," who said that "absorbé par sa difficultueuse carrière, ce sont tout simplement des choses auxquelles il ne pensait pas." *Rodin*, 87.

Chapter 5
A Sculptor's Assistant

1. June Hargrove, *The Life and Work of Albert Carrier-Belleuse*, New York, 1977, 236. This is a note attached to a report about the sale of Carrier's work at the Hôtel Drouot on Dec. 23, 1874. Hargrove found it in the Bibliothèque de la Ville de Paris.
2. Ibid., 181.
3. Truman H. Bartlett, "Auguste Rodin, Sculptor," *American Architect and Building News*, Jan. 26, 1889: 44.
4. Both these quotations are among Bartlett's hand-written research notes in Houghton Library, Harvard University.
5. Frederick Lawton, *The Life and Work of Auguste Rodin*, London, 1906, 30.
6. Edmond and Jules de Goncourt, *Journal: Mémoires de la vie littéraire*, Monaco, 1956, 2: 347–48.
7. Bartlett, "Rodin," Jan. 26, 1889: 44.
8. Ibid.
9. Charles Blanc, *Les Artistes de mon temps*, Paris, 1876, 448.
10. Patricia Mainardi, *Art and Politics of the Second Empire*, New Haven and London, 1987, 135.
11. Letter of Feb. 18, 1867, to Alfred Bruyas. Quoted in ibid., 138.
12. Unpublished letter in the collection of Mme Gaveau. Quoted by André Maurois, *The Life of Victor Hugo*, trans. Gerard Hopkins, New York, 1985, 374.
13. Blanc, *Artistes*, 418.

14. H.-C.-E. Dujardin-Beaumetz, *Entretiens avec Rodin*, Paris, 1913. Translated by Ann McGarrell in Albert E. Elsen, ed., *Auguste Rodin: Readings on His Life and Work*, Englewood Cliffs, N.J., 1965, 180.

15. Arthur Duparc, "La Danse, par Carpeaux," *Correspondant*, Sept. 10, 1869: 951–52. Georges Lafenestre, "Les sculptures décoratives," *Moniteur universel*. C. A. de Salelles, *Le Groupe de la Danse de Mr. Carpeaux jugé au point de vue de la morale*, Paris, 1869, 9. Quoted in Anne Middleton Wagner, *Jean-Baptiste Carpeaux*, New Haven, 1986, 237, 238.

16. E. Zola, "Une Allégorie," first published in *Cloche*, April 22, 1870. *Oeuvres complètes*, 13: 277–78. See Wagner, *Carpeaux*, 243.

17. Dujardin-Beaumetz in Elsen, *Rodin*, 180.

18. Between May 4 and Aug. 8, l870, twenty-two French sculptors and stone cutters registered with the Brussels police. The police records of 1870 contain no evidence that Rodin came to Brussels, but since he did not intend to stay, he probably did not register with them. Archives de la Ville de Bruxelles, Travaux Publics: 30.153.

19. This important letter in the archives of the Musée Rodin establishes for the first time that Rodin went to Brussels before the war.

20. Archives de la Seine, Série R, Affaires Militaires.

21. Bartlett interview notes, Houghton Library, Harvard.

22. Judith Cladel, *Rodin: Sa Vie glorieuse, sa vie inconnue*, Paris, 1936, 93.

23. Goncourt, *Journal*, 9: 158.

24. Cladel, *Rodin*, 94.

25. Bartlett notes, Houghton Library, Harvard.

Chapter 6
Brussels and a Partnership

1. Hippolyte Taine, "Notes de voyage en Belgique et en Hollande," *Revue de Paris*, June 15, 1895: 673ff. Taine traveled in the Low Countries in the 1850s and 1860s.

2. June Hargrove, *The Life and Work of Alfred Carrier-Belleuse*, New York, 1977, 160.

3. Judith Cladel, *Rodin: Sa Vie glorieuse, sa vie inconnue*, Paris, 1936, 96.

4. Truman Bartlett and Judith Cladel offer slightly different versions of the story. Bartlett said Rodin put some sculptures in a shop window on the same street where Carrier showed. "Auguste Rodin, Sculptor," *American Architect and Building News*, Jan. 26, 1889: 45. Cladel said Rodin sold a figure to a bronze manufacturer who worked for Carrier. *Rodin*, 96.

5. Marcelle Tirel, *The Last Years of Rodin*, New York, 1925, 53.

6. Rodin's letter of Nov. 22, 1871, is in the collection of the prince de Ligne, Beloeil, Belgium.

7. Hargrove, *Carrier-Belleuse*, 160.

8. Archives de la Ville, Brussels.

9. The cast maker Eugene Mascré's bill, dated Dec. 23, 1872, for work he had installed in the "Palais du Roi" is in the archives of the Musée Rodin. Baronne Van Ypersele showed me through the palace and informed me that it was the throne room sculpture that was completed in 1872.

10. Judith Cladel and Rodin were together in Brussels in 1899. Rodin took Cladel to see the works he had done in the city. She said that there were "une dizaine de cariatides qui ornaient des maisons construites en ce temps sur le boulevard Anspach." She mentioned in particular "trois de ces figures, hautes de plus de deux mètres," for which Rodin received 750 francs. Cladel, *Rodin*, 104–05.

11. The drawing is dated June 27, 1872. Archives de la Ville, Brussels. I am grateful to Léon Zylbergeld and Mlle Soligné for locating it for me.

12. Amédée Blanche was the proprietor of 65 boulevard Anspach in 1929, when the modernization of Brussels brought the building down. He saw to it that two sets of plaster casts were taken from Rodin's

figures, one for the Musée Rodin in Paris and the other for the museum in Brussels. Georges Grappe, *Catalogue du Musée Rodin,* vol. 1, *Hôtel Biron,* Paris, 1944, no. 28. The stone figures, called the "Caryatids of Saint Gilles," are also in the Musée Rodin. Ibid., no. 27.

13. Cécile Goldscheider, "Rodin en Belgique," *Médecine de France* 90 (1958): 20.

14. Camille Lemonnier, "Le Nouveau Conservatoire de Musique de Bruxelles," *Art universel,* Nov. 18, 1874: 291.

15. Archives de la Ville, Bruxelles, Travaux Publics 10295. This document says that the firm of Van Rasbourgh–Rodin had permission to erect a scaffolding along the sidewalk in front of the Palais des Académies for a period of ten days in March 1874, which is when they must have installed the works.

16. There were many prototypes for Rodin's conventional treatment of the allegories of Art and Science. Probably the most recent ancestor that Rodin would have known was François Bonvin's 1863 painting *Attributes of Sculpture,* in which he surrounded the *Belvedere Torso* with a mallet, chisels, a compass, and many books.

Chapter 7
Outside the Partnership

1. Truman H. Bartlett, "Auguste Rodin, Sculptor," *American Architect and Building News,* Jan. 26, 1889: 45.

2. Jean Rousseau, "Le Salon de Bruxelles," *Echo du parlement,* Nov. 23, 1875.

3. Bartlett interview notes, Houghton Library, Harvard University.

4. Alain Beausire, *Quand Rodin exposait,* Paris, 1988, 54–65.

5. Jean Rousseau, *Echo du parlement,* Nov. 20, 1874, and Nov. 23, 1875.

6. *Art universel,* Nov. 10, 1875.

7. Beausire, *Quand Rodin exposait,* 61–64.

8. The catalogue gives the names of the works: *The Renaissance, Loving Thoughts, The Rose, Alsatian Woman, Spring, Autumn, Large Grapes, Field Flowers.* There are no photographs of the works, nor do we have any idea what happened to them, except that they would have been shipped back to Rodin in Belgium.

9. The portrait in the Musée Rodin has always been identified as a portrait of Rodin's mother, although it looks nothing like photographs of Marie Cheffer Rodin and closely resembles Rodin's portraits of Rose Beuret, especially the terra cotta *Alsacienne* in the Musée Rodin (Georges Grappe, *Catalogue du Musée Rodin,* vol. 1, *Hôtel Biron,* Paris, 1944, no. 16).

10. Mario Meunier, "Rodin, dans son art et dans sa vie," *Le Marges,* April 15, 1914: 247–51. Quoted in Frederic Grunfeld, *Rodin: A Biography,* New York, 1987, 81.

11. Judith Cladel to Edmond Bigand-Kaire, Aug. 15, 1916.

12. Bartlett interview notes, Houghton Library, Harvard.

Chapter 8
Michelangelo

1. Louis Alvin, *Souvenir du IVe centenaire de Michelange,* Brussels, 1875. My thanks to Eva Heidelberg at the Bibliothèque Royale in Brussels for locating this publication.

2. Truman H. Bartlett, "Auguste Rodin, Sculptor," *American Architect and Building News,* Jan. 26, 1889: 45.

3. Ibid., Feb. 9, 1889: 65. Someone sent Rodin a letter on June 27, 1875—unfortunately the name of the sender has been cut off—which ends, "Et vous allez-vous toujours en Italie?" This allows us to know that Rodin was thinking about a trip to Italy as early as spring 1875.

4. Three letters in the archives of the Musée Rodin establish Rodin's presence in Brussels during the first six weeks of 1876. The last of the three is from N. Manoy, a decorator who was selling busts for Rodin. Manoy wrote on Feb. 7 to say he would drop by in the next few days.

5. J. Kirk T. Varnedoe is the scholar who has studied Rodin's early drawings most closely. See particularly "Rodin's Drawings, 1854–1880," in Ernest-Gerhard Guüse, ed., *Auguste Rodin Drawings and Watercolors*, New York, 1984.

6. Bartlett, "Rodin," Feb. 9, 1889: 65.

7. Emile Ollivier, *Une Visite à la Chapelle des Médicis*, Paris, 1872.

8. See, for example, Charles Calemard de Lafayette, *Dante, Michel-Ange, Machiavel*, Paris, 1852.

9. Michelet's journal from the voyage of 1830 has been published by Théodora Scharten as *Les Voyages et séjours de Michelet en Italie*, Paris, 1934; the quotation is on p. 218. The Italian deputy David Levi wrote a book that also gives insight into this notion of Michelangelo as a guide for modern republicans. It was translated into French by Edouard Petit as *Michel-Ange: L'Homme, l'artiste, le citoyen*, Paris, 1884.

10. An 1857 letter to his parents. Quoted in Anne Wagner, *Jean-Baptiste Carpeaux*, New Haven, 1986, 136.

11. The friend was Bruno Chérier and the remark is found in Léon Riotor, *Carpeaux*, Paris, 1927, 39.

12. See the discussion of the "Neo-Renaissance" in sculpture in Bo Wennberg, *French and Scandinavian Sculpture in the Nineteenth Century*, Stockholm, 1978.

13. Bartlett, "Rodin," Feb. 9, 1889: 65.

14. Helen Zimmern, "Auguste Rodin Loquitur," *Critic*, December 1902.

15. Letter published in the *Grande Revue*, November 1929: 6.

16. Judith Cladel, *Rodin: Sa Vie glorieuse, sa vie inconnue*, Paris, 1936, 113.

17. Auguste Rodin, *Art: Conversations with Paul Gsell*, trans. Jacques de Caso and Patricia S. Sanders, Berkeley, Calif., 1984, 92 (originally published in 1911). John E. Gedo, writing about the psychology of genius, discusses men with extraordinary gifts who come from ordinary families in which no one can understand their exceptional talent. He observes that they usually have a fragile sense of self-worth and need to go outside of the family to find an ideal model capable of setting them on the track of their true creative powers. He describes Freud's discovery of Goethe's writings in these terms. Rodin's discovery of Michelangelo was very similar to the cases described by Gedo. John E. Gedo, "The Psychology of Genius Revisited," *Portraits of the Artist*, Hillsdale, N.J., 1989.

Chapter 9
The Vanquished One

1. Duparc, "Le Salon de 1872," *Correspondant*, June 10, 1872: 951.

2. Bartlett interview notes, Houghton Library, Harvard University. When Bartlett asked Rodin if he had worked from life when he was in Belgium, Rodin responded, "Very little."

3. Truman H. Bartlett, "Auguste Rodin, Sculptor," *American Architect and Building News*, Jan. 26, 1889: 45.

4. *Gand artistique*, 1922. Quoted in Robert Descharnes and Jean-François Chabrun, *Auguste Rodin*, Lausanne, 1967, 49.

5. Bartlett, "Rodin," Feb. 9, 1889: 65.

6. He told this to Gustave Coquiot. See *Rodin à l'Hôtel Biron et à Meudon*, Paris, 1917, 100.

7. See Albert E. Elsen, *In Rodin's Studio: A Photographic Record of Sculpture in the Making*, Ithaca, 1980, 12 and figs. 2–5.

8. Bartlett, "Rodin," Feb. 9, 1889: 65.

9. Ibid., 101. Elsen has identified the figure as one in the Musée Rodin annex in Meudon. *In Rodin's Studio*, 158–59.

10. Bartlett interview notes, Houghton Library, Harvard.

11. Letter to Rodin dated Dec. 28, 1876.

12. "Chronique de la ville," *Etoile belge,* Jan. 29, 1877. Rarely was there any art news in this daily column.

13. *Etoile belge,* Feb. 3, 1877.

14. Bartlett, "Rodin," June 15, 1889: 285.

Chapter 10
The Paris Salon

1. As far as we know, Rodin went on working in the atelier on the rue Sans-Souci even after his partnership with Joseph Van Rasbourgh was dissolved. Nor did the two men's friendship come to an end. They remained close until Van Rasbourgh's death in 1902. Rodin helped establish two of his sons in Paris and was godfather to one of his grandchildren.

2. "Dix-huit mois! car, disait-il à ses jeunes collaborateurs de l'atelier Van Rasbourgh, 'il ne faut pas se hâter . . . Il suffit qu'un artiste fasse une seule statue pour établir sa réputation.'" Judith Cladel, *Rodin: Sa Vie glorieuse, sa vie inconnue,* Paris, 1936, 115.

3. See my essay "Rodin and the Salons of the Seventies," in Albert E. Elsen, ed., *Rodin Rediscovered,* Washington, D.C., National Gallery of Art, 1981.

4. E. Stranham, *The Chef-d'Oeuvres d'Art of the International Exhibition,* Philadelphia, 1878, 21.

5. Emile Burnouf, "L'Age du Bronze et les origines de la métallurgie," *Revue des deux mondes,* June 15, 1877: 752–82.

6. I emphasize Rodin's wording because most books say he must have written to Eugène Guillaume, the president of the sculpture section of the Salon, but the letter is clearly addressed to the president of the whole exhibition, which was Chennevières' position.

7. Georges Rivière, "L'Exposition," *Impressioniste,* April 6, 1877: 4. Quoted in Richard R. Brettell, "The 'First' Exhibition of Impressionist Painters," *The New Painting,* Fine Arts Museum of San Francisco, 1986, 201.

8. Bartlett interview notes, Houghton Library, Harvard.

9. Bartlett, "Rodin," May 25, 1889: 250.

10. Documentation of Rodin's work for Carrier in 1877 solves the dating problem of the *Vase des Titans,* which is signed by Carrier but is so clearly in Rodin's style that it has long been attributed to him. On stylistic grounds, Albert Alhadeff dated it 1875, after Rodin's Italian trip. Albert Alhadeff, "Michelangelo and the Early Rodin," *Art Bulletin* 45 (1963): 363. Janson agreed, but asked how Rodin could have signed the name of a man for whom he did not work. H. W. Janson, "Rodin and Carrier-Belleuse: The Vase des Titans," *Art Bulletin* 50 (1968): 278–81. I previously dated it 1879, because I knew Rodin started a new period of work with Carrier in that year. *The Romantics to Rodin: French Nineteenth-Century Sculpture from North American Collections,* Los Angeles County Art Museum, 1980, 333. The documentary proof of Rodin's 1877 employment now gives the work a plausible date.

11. Bartlett, "Rodin," March 2, 1889: 99.

12. See Albert Alhadeff, "An Infinity of Grotesque Heads: Rodin, Legrain, and a Problem in Attribution," in Elsen, *Rodin Rediscovered.*

13. Bartlett interview notes, Houghton Library, Harvard.

14. Eugène Véron, *Le Salon de 1878,* Paris, 1879, 813–14.

15. Bartlett, "Rodin," March 2, 1889: 100.

16. H.-C.-E. Dujardin-Beaumetz, "Rodin's Reflections on Art." In Albert Elsen, ed., *Auguste Rodin: Readings on His Life and Work,* Englewood Cliffs, N.J., 1965, 165–66.

17. Pignatelli made his reputation with this pose once Rodin's statue became famous. He was on the roster of models available for work at the Ecole des Beaux-Arts. Standard procedure for this kind of employment was a set of photographs of the model from the front and back and assuming an action pose.

Pignatelli's advertising pose was that of *Saint John*. These photographs were discovered in the photo archive of the Ecole des Beaux-Arts by Mme Catherine Mathon and Mme Hélène Pinet. I thank them for showing them to me. Albert Elsen has pointed out that Matisse used Pignatelli to model for his *Serf* in 1900. Albert E. Elsen, *The Sculpture of Henri Matisse,* New York, 1972, 28.

18. Eugène Véron, *Dictionnaire Véron, Le Salon de 1879,* Paris, 1879, 270.

19. "Les artistes, sentant leurs forces, se montraient plus absolus, plus tyranniques, et quand vint l'exposition universelle de 1878, pris comme en un étau, entre leurs exigences hautaines, sournoisement excitées et secondées par les madrés politiques qui cherchaient de ce côté fortune de ministres ou de sous-secrétaires d'Etat, . . . je perdis patience, et passai les guides à de plus endurants. M. Turquet, après le court interrègne de M. Guillaume, avait recueilli l'héritage." Philippe de Chennevières, "Les Expositions annuelles et la Société des Artistes Français," *L'Artiste,* 1887. Reprinted in *Souvenirs d'un directeur des beaux-arts,* Paris, 1979, 4: 98.

20. Emile Bergerat, *Souvenirs d'un enfant de Paris,* Paris, 1912, 3: 249.

21. A series of pamphlets called "Les Hommes d'aujourd'hui" was published around 1880. I located the one on Turquet at the Bibliothèque de la Ville de Paris (Actualité, série 30).

22. Archives Nationales. The committee included state inspectors Roger Ballu and Henri d'Escamps and writers Charles Yriarte and Paul de Saint-Victor. Bartlett, in his notes in the Houghton Library at Harvard, observed that Saint-Victor was considered even "more brilliant than [Théophile] Gautier."

23. Archives Nationales, Inv. L. 907. A copy of the letter is in the Musée Rodin.

24. There are two versions of the visit to Rodin's studio. Bartlett says that Turquet "requested a number of the best-known sculptors in Paris to examine the statue." "Rodin," March 2, 1889: 100. Judith Cladel gives credit to the sculptor Alfred Boucher, who had met Rodin after his return from Brussels. Boucher told her he was convinced that the first committee was wrong and went to discuss it with his teacher, Paul Dubois, who then assembled the other sculptors. Cladel, *Rodin,* 120. Bartlett's account is much closer in time to the event, and I believe it is the correct one.

25. Chennevières published the story of the "Expositions annuelles" in *L'Artiste* in the spring of 1887. It is reprinted in *Souvenirs d'un directeur des beaux-arts.*

26. "L'airain, c'était lui, Rodin, c'était son âme!" Antoine Bourdelle, *La Sculpture et Rodin,* Paris, 1978, 20.

27. Bartlett, "Rodin," May 25, 1889: 250.

Chapter 11
The Republic Needs Monuments

1. *Réveil,* Dec. 12, 1870. Quoted in Maurice Agulhon, *Marianne into Battle: Republican Imagery and Symbolism in France, 1789–1880,* Cambridge, 1981, 138–39.

2. Remarks of Castagnary at a meeting of March 14, 1878. Quoted in ibid., 174.

3. John Hunisak, *The Sculptor Jules Dalou,* New York, 1977, 208. Hunisak points out that the vote to open the competition was taken on March 18, the anniversary of the foundation of the Commune.

4. Albert Elsen has pointed out that there is sketch in the Musée Rodin in Meudon of a powerful seated female figure suckling a child, very similar to Daumier's *Republic* prepared for the 1848 competition. Rodin's is a seated figure, so it could never have fulfilled the dictates of the 1879 competition, but because of its similarity to the Daumier, Elsen believes Rodin probably made it with the 1879 competition competition in mind. Albert Elsen, "Recent Rodin Discoveries," *La Scultura nel XIX secolo,* ed. H. W. Janson, Acts of the XXIV International Congress of Art History, Bologna, 1979, 217.

5. Eugène Véron, *Art* 19 (1879): 134–35.

6. An isolated sketch of this brutal, caricaturelike face was recognized by Albert Elsen in the storage rooms of the Musée Rodin in Meudon in 1979. It was exhibited for the first time in 1981 at the National Gallery in Washington, D.C. See the catalogue *Rodin Rediscovered,* ed. Elsen, E129, fig. 6.3.

7. See Denis Lavalle, "Le Monument de la Défense et la statuaire du XIXe siècle," and Véronique Magol-Malhache, "Le Symbolique du drapeau," in Georges Weill, ed., *La Perspective de la Défense dans l'art et l'histoire*, Paris, 1983.
8. The relationship is even more visible today, with the new district of La Défense taking its name from the monument and the history of the site. The monument is still there, moved slightly from its original position and sitting in the colossal project like a bauble.
9. *Petit Moniteur universel*, Dec. 17, 1879.
10. Agulhon, *Marianne into Battle*, 187.
11. Truman H. Bartlett interview notes, Houghton Library, Harvard University.
12. There were ten men on the commission, the most well known being Jules-Antoine Castagnary, Joseph Liouville, and Viollet-le-Duc. Anne Pingeot, "La Statuaire du nouvel hôtel de ville," *Centenaire de la reconstruction de l'hôtel de ville de Paris*, Paris, 1982, 59.
13. Archives de la Seine, Cote 10624/72/1, liasse 165.

Chapter 12
Why Was Rodin Commissioned to Make the Doors?

1. These comments are found on small scraps of paper in the Paul Bartlett papers in the Library of Congress.
2. Truman H. Bartlett, "Auguste Rodin, Sculptor," *American Architect and Building News*, May 11, 1889: 223.
3. Serge Basset, "La Porte de l'Enfer," *Journal de Liège*, March 24, 1900.
4. The committee to search for a site was established on April 24, 1880. Its members searched the "four corners of Paris from the Bois de Boulogne . . . to the ruins of the former Palais du Conseil d'Etat (the Cour des Comptes)." Chennevières, *Souvenirs d'un directeur des beaux-arts*, Paris, 1979, 2: 79. The land where the Cour des Comptes stood only became the preferred site when the Committee for the Musée des Arts Décoratifs fused with the Union Centrale in 1882. Antonin Proust, *L'Art décoratif et le musée national du quai d'Orsay*, Paris, 1887, 187.
5. Proust, *Art décoratif*, 187.
6. This point has been skillfully developed by Debora Leah Silverman, *Art Nouveau in Fin-de-Siècle France: Politics, Psychology, and Style*, Berkeley, Calif., 1991, 111–16.
7. *Art* 6 (1876): 210.
8. "Rapport à M. le Ministre de l'Instruction publique et des Beaux-Arts," found in a dossier of the Ministre des Travaux Publics at the Archives Nationales.
9. The original article was published in *Le Temps* and was quoted in *L'Art* 6 (1876): 210.
10. Archives of the Manufacture de Sèvres. Dossier marked "Affaires diverses prises à l'essai par M. Carrier-Belleuse."
11. Meeting of July 1, 1879. "Extrait du registre des procès-verbaux des conférences de la Manufacture Nationale de Sèvres," in Roger Marx, *Auguste Rodin céramiste*, Paris, 1907, 45.
12. Marx, *Rodin*, 30–31.
13. Anne Pingeot, *"L'Age mûr" de Camille Claudel*, Paris, 1988, 56. She gives the specific dates when Rodin worked at Sèvres, based on Tamara Préaud's research in the Sèvres archives.
14. Letter of resignation dated March 17, 1883. Dossier of M. Haquette in the archives of Sèvres.
15. Georges Grappe dated the portrait of Maurice Haquette in 1883, though he gave no reason for his dating. All subsequent authors have used his date, but clearly we must now place it in 1880. Maurice Haquette's "document" has been published in Alain Beausire, *Quand Rodin exposait*, Paris, 1988, 369.
16. Turquet's report was published in *L'Art* 3 (1880): 25–26.
17. Bartlett says that Dargenty spoke of the door in *L'Art* in 1880, but Dargenty was not writing for the

journal in 1880. I have gone through *L'Art* in 1880 from August on, page by page. There is not one mention of the commission.

18. Bartlett, "Rodin," May 11, 1889: 223.

19. See Bartlett: "The sculptor selected as a starting point for his design his favorite work in literature, Dante's Inferno, adding to it any fancy of his own that seemed connected with the subject." This sentence, found in the Paul Bartlett papers in the Library of Congress, is a little more direct than Bartlett's published account of the commission.

Chapter 13
Silence and Creativity, 1880–81

1. Letter of Oct. 20, 1880. Archives Nationales, Dossier F.2109.

2. The manuscript in Rodin's hand is in the Bibliothèque de l'Institut de France, filed with the correspondence of Gaston Schéfer, who was the curator at the Bibliothèque de l'Arsenal. In an accompanying letter, Rodin wrote, "Here are a few notes, but I have more ideas than this." At some later point Ludovic Baschet, founder of the *Revue illustrée,* wrote to Rodin, "I have not yet received the manuscript of your biography from M. Schéfer, but I promise to sent you the proofs before it is published, have no worry about that." As far as I know, the piece was never published.

3. Emile Bergerat, *Souvenirs d'un enfant de Paris,* vol. 3, Paris, 1911–12, 250–51. Osbach could not have said "*The Gates of Hell,*" since that title was never used before 1883 and was not common until 1885.

4. Thurat thought the Musée des Arts Décoratifs would be at Trocadéro, which was indeed one of the primary contenders for the site. Since the Cour des Comptes site was chosen on April 24, 1882, Thurat must have written the article before then.

5. Rodin read the cheap Rivarol translation used by most ordinary Frenchmen and by schoolchildren. He told Bartlett: "Other translations have been recommended to me as better than his, more learned, but I have never looked at them." Truman H. Bartlett, "Auguste Rodin, Sculptor," *American Architect and Building News,* May 11, 1889: 223.

6. Judith Cladel, "La Jeunesse de Rodin," *Revue universelle,* May 1, 1935: 320.

7. These works are illustrated in my article "Rodin and the Paris Salon" in Albert E. Elsen, ed., *Rodin Rediscovered,* Washington, D.C., National Gallery of Art, 1981.

8. Eugène Véron, *Art* 17 (1879): 294.

9. The best discussion of how Rodin worked on his door is "The Architectural Genesis of 'The Gates of Hell,'" chap. 2 of Albert E. Elsen's *"The Gates of Hell" by Auguste Rodin,* Stanford, Calif., 1985.

10. Bartlett, "Rodin," May 11, 1889: 223.

11. Serge Basset, "La Porte de l'Enfer," *Matin,* March 19, 1900.

12. Extract from a letter Rodin addressed to Marcel Adam. It was published in *Gil Blas,* July 7, 1904.

13. Catherine Lampert, *Rodin: Sculpture and Drawings,* London, 1986, 50.

14. The best discussion of *The Thinker* as a spiritual portrait of Rodin is found in Albert E. Elsen, *Rodin's "Thinker" and the Dilemmas of Modern Public Sculpture,* New Haven, 1985.

15. See Rosalyn Frankel Jamison's dissertation "Rodin and Hugo: The Nineteenth-Century Theme of Genius in *The Gates* and Related Works," Stanford University, 1986. I am grateful to her for giving me a copy of this wonderful work, from which I received so much information and inspiration.

16. M. Gaïda, "Le Salon," *Courrier du soir,* July 3, 1881.

17. See my essay "Religious Sculpture in Post-Christian France" in Peter Fusco and H. W. Janson, eds., *The Romantics to Rodin,* Los Angeles County Art Museum, 1980.

18. Letter in the Archives Nationales.

19. Letter in the Kleinmann Collection. There is a copy in the Musée Rodin.

Chapter 14
Genius in a Man's Face

1. Gustave Coquiot, *Rodin à l'Hôtel Biron et à Meudon,* Paris, 1917, 109.

2. Bastien-Lepage's letter is undated, but it was probably written in April 1882, for he speaks of seeing Rodin soon "au vernissage," and there is a letter from Rodin of June 17, 1882 (in the collection of Claude Ménard de Chardon), in which he speaks of the marble he is making for Bastien-Lepage.

3. The Carrier-Belleuse dossier at the Musée Rodin is mysteriously empty, so our knowledge of their relationship is not as clear as one would hope.

4. Truman H. Bartlett, "Auguste Rodin, Sculptor," *American Architect and Building News,* June 15, 1889: 284.

5. From a press clipping in the Musée Rodin archives written by Emile Soldi. The reference to the journal has been cut off, but it may have been the *Nouvelle Revue,* for which Soldi was a critic. The Musée Rodin owns a letter from Rodin to Soldi, written on June 20, 1882, thanking him "for the attention that you have drawn to my busts."

6. Paul Leroi, "Salon de 1882," *Art* 4 (1882): 188. Quoted in Ruth Butler, *Rodin in Perspective,* Englewood Cliffs, N.J., 1980, 37.

7. As a former Communard and an exile, Hugo welcomed Bazire when he returned to France. His stock really rose with the Hugo crowd, however, when he spearheaded the organization of a public celebration of Hugo's 79th birthday in 1881. Almost 100,000 admirers from all over France passed by Hugo's house in the avenue Eylau (soon after renamed the avenue Victor-Hugo).

8. This letter, in Bazire's handwriting, is in the Bazire file of the archives of the Musée Rodin.

9. Such a dinner is described by Bazire in "August Rodin," *Art et critique* 1 (July 6, 1889).

10. Emile Bergerat, "Souvenirs contemporains," *Annales politiques et littéraires,* June 16, 1895: 371.

11. H.-C.-E. Dujardin-Beaumetz, "Rodin's Reflections on Art." Translated by Ann McGarrell in Albert E. Elsen, ed., *Auguste Rodin: Readings on His Life and Work,* Englewood Cliffs, N.J., 1965, 170.

12. Maurice Barrès, *Mes Cahiers,* Paris, 1931, 4: 126.

13. Léon Daudet, *Fantômes et vivantes: Souvenirs des milieux littéraires, politiques, artistiques et médicaux de 1880–1905,* Paris, 1920, 89.

14. Truman H. Bartlett interview notes, Houghton Library, Harvard University. Neither account is included in Bartlett's *American Architect and Building News* articles. In an undated letter to Rodin about visiting Hugo, Bazire asked: "Will you be bringing Dalou along?"

15. Louis de Fourcaud, "Le Salon de 1884," *Gazette des beaux-arts* 30, 2d period: 63.

Chapter 15
The Women in Rodin's Life

1. Jules Michelet, *La Femme,* Paris, 1860, 104. By 1889 this book had gone into 17 editions.

2. Bartlett interview notes, Houghton Library, Harvard University.

3. The first letter Rodin received from Boucher in Italy, dated Sept. 12, 1882, was from Florence. The majority of books give 1883 as the year Rodin met Camille Claudel, but they surely met in the fall of 1882.

4. See Charlotte Yeldham, *Women Artists in Nineteenth-Century France and England,* New York and London, 1984.

5. I would like to thank Mme Anne Rivière for her help with these facts. In the roster of the Salon of 1883, I only counted 88 women, but Mme Rivière pointed out that a number of women showed under masculine pseudonyms. She is presently preparing a book on French women sculptors in the nineteenth century.

6. Carpeaux's daughter, Louise, became a student of Rodin's. We do not know the years, however. Their

correspondence in the Musée Rodin dates from 1896–97, when she was asking Rodin to stand up for her at her wedding. She always signed her letters "your respectful student."

7. Alice Greene, "The Girl Student in Paris," *Magazine of Art* 6 (1883): 286–87.

8. Jessie Lipscomb's grandson, Robert E. M. Elborne, has Jessie's pass that allowed her to study in these collections.

9. Hélène Pinet located their names in the "Registre des Personnes Venues Etudier dans le Cabinet d'Anatomie du Musée d'Histoire Naturelle" in the Archives Nationales (AJ/15/145).

10. Most writers have wrongly assumed that the romance was a couple of years in the making. In the letter quoted here, Rodin speaks of working on his bust of Dalou, which means he wrote it in 1883, probably in the fall. This letter, along with four others Rodin wrote to Claudel, turned up in August 1988 in the home of Mme Cécile Goldscheider, after her death. Until that time it was thought that no such letters still existed. They have been removed to the archives of the Musée Rodin and were published by Reine Marie Paris and Arnaud de La Chapelle, *L'Oeuvre sculptée de Camille Claudel*, Paris, 1990.

11. All Rodin's letters to Jessie Lipscomb are owned by Jessie Lipscomb's grandson, Robert E. M. Elborne. I am grateful to him for letting me see them before they were published by Paris in *L'Oeuvre de Camille Claudel*.

12. Paul Claudel, *Cahiers*, vol. 1, Paris, 1959, 113.

13. This is a rare instance in which we have Rodin's letters but not the answers. There are many Jessie Lipscomb letters in the Musée Rodin archive, but none from 1886.

14. Judith Cladel gives 1885 as the date in *Rodin: Sa Vie glorieuse, sa vie inconnue*, Paris, 1936, 150. A check in the records of the Tirage au Sort in the Archives de la Seine reveals the date as 1886 and documents that Auguste Beuret was living at 71 rue de Bourgogne when he left to join the army.

15. Rodin had given Mirbeau a cast of his *Femme accroupie* (Crouching woman) the previous fall.

16. Pierre Michel and Jean-François Nivet, eds., *Correspondance avec Auguste Rodin*, Tusson, Charente, 1988, 56.

17. H.-C.-E. Dujardin-Beaumetz, "Rodin's Reflections on Art." Translated by Ann McGarrell in Albert E. Elsen, ed., *Auguste Rodin: Readings on His Life and Work*, Englewood Cliffs, N.J., 1965, 164.

18. Adèle became pregnant when Rodin was working with her on *Eve* in the early 1880s. When Anna became pregnant in the nineties, she was treated so badly by her lover, a young artist, that she threw acid in his face. Rodin went to court to testify as a character witness on her behalf. "Chronique des Tribunaux: Les Amours d'un peintre," *Echo de Paris*, March 1, 1897.

19. Truman H. Bartlett, "Auguste Rodin, Sculptor," *American Architect and Building News*, June 1, 1889: 262.

20. Catherine Lampert, *Rodin: Sculpture and Drawings*, London, 1986, 61.

21. Identifications made by Alain Beausire, *Quand Rodin exposait*, Paris, 1988, 82.

22. G. Dargenty (pseudonym of Arthur Auguste Mallebay du Cluseau d'Echérac), *Courrier de l'art* 1886: 316.

23. Gustave Geffroy, *Justice*, July 11, 1886.

24. Emile Michelet, "Critique d'art," *Jeune France*, July 1886, 772.

25. Armand Silvestre, *Correspondance belge*, June 31, 1886. This was reproduced by G. Dargenty in the *Courrier de l'art*, July 1, 1886, and it is translated in Ruth Butler, *Rodin in Perspective*, Englewood Cliffs, N.J., 1980, 58–60.

26. "She . . . posed for a number of works by Rodin and probably for many of the figures on *The Gates of Hell* that are no longer identifiable." John Tancock, *The Sculpture of Auguste Rodin*, Philadelphia, 1976, 589.

27. Catherine Lampert believes that "*Meditation* is the piece most descriptive of Camille's specific vulnerability and sensuality," and that *The Martyr* is "not necessarily a portrait of Camille, but the convulsive state expresses Rodin's mistress's self-destructiveness and doom." *Rodin*, 96. Jacques Cassar

believed that "elle a inspiré la *Danaïde, Fugit Amor, Paolo et Francesca, L'Emprise.*" *Dossier Camille Claudel,* Paris, 1987, 75.

28. Charles Baudelaire, "Beauty" from *Les Fleurs du mal,* in *Baudelaire, Rimbaud, Verlaine,* ed. Joseph M. Bernstein, trans. Arthur Symons, New York, 1947, 24.

29. The work is called *The Minotaur* or *Faun and Nymph* and is dated before 1886 by Grappe, *Catalogue du Musée Rodin,* vol. 1, *Hôtel Biron,* Paris, 1944, 56–57. It was particularly loved by writers: Goncourt, Mirbeau, Catulle Mendès, and, perhaps, Stéphane Mallarmé all owned casts. See Jacques de Caso and Patricia B. Sanders, *Rodin's Sculpture,* San Francisco, 1977, 107–08.

30. Paul Claudel, Preface to *Camille Claudel,* Paris, Musée Rodin, 1951.

31. This letter in the Musée Rodin is not dated, but I believe it fits well here.

32. William Rothenstein, *Men and Memories,* New York, 1932, 2: 169.

33. This is the second of the five documents found in the possession of Mme Goldscheider at the time of her death. It is in the Musée Rodin and I have translated it in its entirety.

Chapter 16
The Burghers of Calais, 1884–89

1. There has been much discussion about the number and meaning of the monuments in nineteenth-century France. Maurice Agulhon's "La Statuomanie et l'histoire," *Ethnologie française* 1978: 145–72, is a key article which opened the whole discussion. See also Chantal Martinet, "Le Monument public de 1850 à 1914," *De Carpeaux à Matisse: La Sculpture française de 1850 à 1914 dans les musées et les collections publiques du Nord de la France,* Lille, 1982; and June Hargrove's chapter on the Third Republic in *The Statues of Paris: An Open-Air Pantheon,* Antwerp, 1989.

2. Published in the *Journal de Calais,* Sept. 27, 1884. Reproduced in *Auguste Rodin: Le Monument des Bourgeois de Calais,* catalogue of an exhibition held at the Musée Rodin in 1977, 30.

3. Letter in the Municipal Archives in Calais. Reproduced in the Musée Rodin catalogue, 31.

4. Letter dated Nov. 3, 1884. Rodin's letters to Mayor Dewavrin are preserved in the Municipal Archives in Calais and reproduced in the Musée Rodin catalogue.

5. E. Lormier of Calais, a competitor for the monument, complained about Rodin's low bid. He did not think Rodin was being candid: "A work as serious as that of M. Rodin will cost at least 80,000 or 100,000 francs." Musée Rodin catalogue, 46.

6. Musée Rodin catalogue, 47. In alluding to "the spirit of defaming reputations," the council joined a debate begun by Voltaire in the eighteenth century. He believed that Edward III had never intended to behead the burghers of Calais. A scholar sent to London to investigate found that Eustache de Saint-Pierre had accepted favors from the British, calling his patriotism into question. During the July Monarchy, Eustache's patriotism was again debated, but this time he emerged as a patriot. The controversy resurfaced in the newspapers in 1884. See Mary Jo McNamara, *Rodin's "Burghers of Calais,"* New York, 1977, 9–13.

7. The entire article is reproduced and translated in McNamara, *Rodin's "Burghers of Calais,"* 71.

8. This manuscript is lost, but it was once in the archives of the Musée Rodin. It was published by L. Bénédite in *Rodin,* Paris, 1923, 31–33, and it is reproduced in the Musée Rodin catalogue, 116–17.

9. Rodin's letter was published in *Le Patriote* on Aug. 19, 1885. Reproduced in the Musée Rodin catalogue.

10. Edmond and Jules de Goncourt, *Journal,* Monaco, 1956, 14: 115.

11. In the Claudel and the Lipscomb families, an oral tradition holds that the young women worked on the figures' extremities, but Rodin told Dewavrin more than once that he did all the work himself.

12. Except for Eustache de Saint-Pierre, no names were assigned to the figures in the nineteenth century. In the 1920s Georges Grappe, curator of the Musée Rodin, worked out the names that we now use. *Catalogue du Musée Rodin,* Paris, 1931, 85.

13. Léontine Dewavrin's letter is lost, but its content is clear from Rodin's reply on Jan. 20.

14. R. Cameron, *Annales*, September–October 1970, part 1, p. 421.

15. Alain Beausire and Hélène Pinet, eds., *Correspondance de Rodin*, vol. 1, Paris, 1985, letters 84 and 85. Nothing came of this initiative.

16. Molin-Neuf, "Notes sur le Salon," *Centenaire de 1789* 3, no. 117 (June 20, 1886). Judith Cladel: "In 1886 he received the commission for a Monument to Victor Hugo destined for the Panthéon." *Rodin: Sa Vie glorieuse, sa vie inconnue*, Paris, 1936, 172–73. Frederick Lawton: "The project for a statue from Rodin's chisel was informally made within a year or two after Victor Hugo died." *The Life and Work of Auguste Rodin*, London, 1906, 258. This is all summarized and made clear by Jane Mayo Roos in her Ph.D. dissertation "Rodin, Hugo, and the Panthéon: Art and Politics in the Third Republic," Columbia University, 1981, 36–37.

17. Rodin's letter is in the Beinecke Rare Book and Manuscript Library, Yale University. It was written in answer to a letter of February 1887 from Stevenson.

18. Mirbeau's first important review of Rodin's work was a lengthy assessment of the portal, which Mirbeau considered potentially "the principal work of the century." *France*, Feb. 18, 1885. Reproduced in Ruth Butler, *Rodin in Perspective*, Englewood Cliffs, N.J., 1980, 45–48. See Joy Newton, "Octave Mirbeau and Auguste Rodin, with Extracts from Unpublished Correspondence," *Laurels* 58, no. 1 (Spring 1987).

19. The letter is addressed to Paul Hervieu and is in the collection of the Fondation Custodia in Paris. Pierre Michel and Jean-François Nivet, eds., *Correspondance avec Auguste Rodin*, Tusson, Charente, 1988, 68.

20. Edmond and Jules de Goncourt, *Journal*, 16: 102.

21. Gustave Geffroy, *Claude Monet: Sa Vie, son oeuvre*, Paris, 1924, 25–26.

22. Bartlett interview notes, Houghton Library, Harvard University. The note is dated Dec. 4, 1887.

23. A few years later Rodin was instrumental in helping Geffroy to be named to the Légion d'Honneur. Edmond de Goncourt did not receive the invitation to Rodin's Jan. 24 banquet, so a second banquet was held for Rodin alone, with Goncourt presiding, on Feb. 17, 1888.

24. Written in 1853, the poem was not published until 1883, when it appeared in the "série complémentaire" of *La Légende des siècles*. It was published in serial form in *Le Rappel*, September 1883. See Patricia Ward, *The Medievalism of Victor Hugo*, University Park, Pa., 1975.

25. Félix Jeantet, "Exposition des oeuvres de Rodin," *Blanc et noir*, June 1889. Translated in Butler, *Rodin in Perspective*, 74.

Chapter 17
How the Doors of the Musée des Arts Décoratifs Became *The Gates of Hell*

1. Antonin Proust, "L'Union Centrale des Arts Décoratifs: Ses Origines—son programme," *L'Art sous la République*, Paris, 1892, 183–276.

2. Debra Leah Silverman, *Art Nouveau in Fin-de-Siècle France: Politics, Psychology, and Style*, Berkeley, Calif., 1991, 119.

3. Rodin had received three installments so far: 2,700 francs in October 1880, 3,000 in January 1883, and 4,000 in November 1883. For a summary of the payments from 1880 to 1911, see John L. Tancock, *The Sculpture of Auguste Rodin*, Philadelphia, 1976, 104. Tancock published the two documents in the Archives Nationales in which the accounts of the commission are listed.

4. Dalou's letter is in the *Gates of Hell* file at the Archives Nationales. It must have been published in one of the Paris journals, because it was picked up by the Philadelphia *Evening Telegraph*, surely the first mention of the portal by an American journal.

5. Albert E. Elsen, *"The Gates of Hell" by Auguste Rodin*, Stanford, Calif., 1985, 64.

6. The *Gates of Hell* file, Archives Nationales. There are 32 letters in this file, dated between 1880 and 1904.

7. The whereabouts of this letter are unknown, but it was published in the *Mercure de France* 132 (1919): 377.

8. Rodin's letters to Gauchez are in the Austrian State Archives in Vienna. There are copies in the Musée Rodin.

9. Antonin Proust, *L'Art décoratif et le musée national du quai d'Orsay,* Paris, 1887, 249.

10. There was another round of negotiations in 1889. They came to nothing. Probably the final death knell to the Musée des Arts Décoratifs was struck in February 1890, when Proust resigned as president of the Union Centrale. He was succeeded by Georges Berger. A final agreement was worked out between the government and the union by the end of the century, placing the museum in the Marsan Pavilion of the Louvre, where it remains.

11. Jean-Marie Mayeur and Madeleine Rebérioux, *The Third Republic from Its Origins to the Great War, 1871–1914,* trans. J. R. Foster, Cambridge, 1987, 123. See also François Caron, *La France des patriotes,* Paris, 1985, 275–84.

12. *France,* Feb. 18, 1885. A translation of the article by John Anzalone is reproduced in Ruth Butler, *Rodin in Perspective,* Englewood Cliffs, N.J., 1980, 45–48.

13. I have not seen this letter, but I have read it in an old sales catalogue at the Musée Rodin. Its location is unknown.

14. After Champsaur wrote the article, he was bold enough to ask Rodin to give him the group *Femmes damnées.* He signed his letter to Rodin "Your trumpet." Rodin obliged, as he did a few months later, when Champsaur asked to have the "man who raises a woman to his lips" (*Je suis belle*).

15. Claudie Judrin conjectures that it was *Young Mother in a Grotto,* because it was cast in 1888 and because it was in Monet's collection. "De la main à la main," *Claude Monet–Auguste Rodin: Centenaire de l'exposition de 1889,* Paris, 1989, 37.

16. This undated letter was published in a sales catalogue of the Librairie de l'Abbaye, 1986. All the letters that have to do with the Monet-Rodin show were published in the Musée Rodin catalogue *Claude Monet–Auguste Rodin.*

17. Letter of March 3, 1889. Sales catalogue, Librairie de l'Echiquier, Paris, December 1982. Reproduced in *Claude Monet–Auguste Rodin,* 210. It is not clear to whom Monet addressed the letter.

18. Paul Hayes Tucker, *Monet in the '90s,* New Haven, 1989, 52.

19. Edmond and Jules de Goncourt, *Journal,* Monaco, 1956, 16: 94.

20. Letter to Georges Petit dated June 21, 1889. Paris, Librairie de l'Abbaye, 1963, bulletin 28, 65. Reproduced in *Claude Monet–Auguste Rodin,* 215.

21. The number and identification of the paintings were established for the 1989 exhibition at the Musée Rodin.

22. Gustave Geffroy, *Monet: Sa Vie, son oeuvre,* Paris, 1924, 214–15.

23. See Tucker, *Monet in the '90s,* 53.

24. Joseph Reinach, "Proverbe en action," *République française,* May 16, 1889. Quoted in Brenda Nelms, *The Third Republic and the Centennial of 1789,* New York, 1987, 6.

25. Replies to France's invitation trickled in through the spring and summer of 1887. Austria-Hungary, Germany, Great Britain, Italy, and Russia all declined. Most of the lesser European states followed their lead, saying the exhibition was too expensive. On the other hand, the emerging nations of America and Asia were eager to come. See Nelms, *Third Republic,* 50–51.

26. A generous sampling of reviews has been published in *Claude Monet–Auguste Rodin.*

27. Félix Jeantet in the *Blanc et noir,* June 1889. Reproduced in *Claude Monet–Auguste Rodin,* 232–33.

28. See Nelms, *Third Republic,* chap. 3, "The Decade of Discussion: Monuments," and chap. 4, "1889: The Year of the Centennial." See also John Hunisak, "Dalou's *Triumph of the Republic:* A Study of Private and Public Meaning," in H. W. Janson, ed., *La Scultura nel XIX secolo,* Acts of the Fourteenth Congress of Art History, Bologna, 1979, 169–75.

29. *Illustration*, Sept. 28, 1889: 260.

30. Petit was able to sell four marbles as a direct result of the exhibition: a bust entitled *Bellona, Springtime, The Wave,* and *Christian Martyr.* Together they yielded 20,000 francs, of which Rodin received half in 1,000-franc monthly installments starting on Nov. 1. The details are described in a letter Petit sent to Rodin on Oct. 9, 1889. *Claude Monet–Auguste Rodin,* 215. The standard price for a Rodin marble in this period was 3,000–4,000 francs. Monet, with no need to pay assistants or to purchase marble, commanded considerably higher prices for his canvases. In 1890 he received 9,000 francs for one of his Creuse paintings, although most of his works sold for less.

Chapter 18
In the Company of a "Woman of Genius"

1. Discussed by Bernard Howells in "Postface: Sur la Trace de Camille Claudel dans l'oeuvre de son frère," in Reine Marie Paris, *Camille Claudel, 1864–1943,* Paris, 1984, 314–16.

2. Several calling cards in the archive at the Musée Rodin are engraved "Mademoiselle Camille Claudel, Statuaire, Boulevard d'Italie, 113, Paris."

3. Howells, "Postface," 316. Howells points out that this passage turned up again in *Partage de midi* (1906).

4. *Art,* May 16, 1888.

5. Kalidasa was much loved in late eighteenth-century England and Germany. Goethe said of *Sakuntala:* "When I first became aware of this unfathomable work, it excited such an enthusiasm in me and attracted me so much that I have never stopped studying it." Mayadhara Mansinha, *Kalidasa and Shakespeare,* New Delhi, 1969, 5. Interest in Kalidasa came later to France, the first major translation of his work in French being realized during the Second Empire. Two operas based on the story of *Sakuntala* were produced in German in the 1880s, one by Felix von Weingartner in Vienna (1884), another by P. Scharwenka in Berlin (1885). Claudel may have been aware of these new works.

6. Pointed out by Catherine Lampert, *Rodin: Sculpture and Drawings,* London, 1986, 92.

7. Claudel's portrait was cast in a bronze edition in 1892 and from that time on it was highly sought after. See the discussion in Bruno Gaudichon, *Camille Claudel,* Paris, Musée Rodin, 1984, 37–40. For the catalogue of the first Camille Claudel show at the Musée Rodin in 1951, Paul Claudel wrote about this portrait: "This is not some vague mishmash [tapototripotage], but what is stirring is a true architectural realization of the human animal, the animation of bones that makes the flesh function, that awakens a face. He is here with his own look. But it was not just his face that made sense for her."

8. Emilia Ciminio observed Rodin in Italy on a trip in the twentieth century. She said that if he was on a tramcar and someone spoke to him in Italian, he ignored them. If they persisted, he just got off.

9. Edmond and Jules de Goncourt, *Journal,* Monaco, 1956, 16: 102.

10. Gérard Fabre, "Biographie de E. Bigand-Kaire," *A Notre Ami Bigand, Rodin, Redon, Moreau . . . ,* Martiques, Musée Ziem, June 13–Sept. 6, 1992.

11. Letter 140 (undated) in Alain Beausire and Hélène Pinet, eds., *Correspondance de Rodin,* vol. 1, Paris, 1985, 107–08. Most of Bigand's and Rodin's letters are undated, but this is from the period 1889–92.

12. Archives de l'Art Contemporain en Belgique, inv. 5349. Cited by M. Hanotelle, *Paris/Bruxelles: Relations des sculpteurs français et belges à la fin du XIXe siècle,* Paris, 1982, 96.

Chapter 19
Monuments to Genius

1. In Rodin's words to Frederick Lawton, the statue shows "Bastien-Lepage starting in the morning through the dewy grass in search of landscapes. With his trained eye he espies around him the effects of light or the groups of peasants." *The Life and Work of Auguste Rodin,* London, 1906, 78.

2. He wrote to Rodin on July 23, 1889: "Recently I returned to your exhibition for the third time; each time it is with a more profound impression and more lively admiration."

3. Judith Cladel, *Rodin: Sa Vie glorieuse, sa vie inconnue*, Paris, 1936, 168. Véronique Wiesinger, who has written a thesis on Desbois (University of Paris, VIe, 1983), accepts Cladel's story as approximating truth, even though it has a flaw in that Cladel said Rodin went to Desbois' atelier on the rue de Plantes. Desbois did not move to this studio until 1894. Wiesinger has published a photograph (*La Sculpture française au XIXe siècle*, Paris, 1986, fig. 126) of Rodin's quick sketch, which is in the Musée Rodin. Wiesinger dates it "between 1883 and 1889," but the incident probably took place in 1886, when the plan for the restricted competition was made public and by which time Desbois was working for Rodin.

4. Lawton, *Rodin*, 142.

5. Véronique Wiesinger has described and illustrated the maquettes and discussed the composition of the jury in "Le Concours pour le monument à Claude Gellée dit Le Lorrain érigé à Nancy," *Sculpture française*, 218–23.

6. Cladel, *Rodin*, 169. Cladel gives no date for the letter.

7. M. Français, *Discours prononcé à l'inauguration du monument élévé à la mémoire de Claude Gellée dit le Lorrain à Nancy*, Paris, 1892. Quoted in John Tancock, *The Sculpture of Auguste Rodin*, Philadelphia, 1976, 409, n. 5.

8. Letter in the Archives Nationales, F21 4264. Quoted in Jane Mayo Roos, "Rodin, Hugo, and the Panthéon: Art and Politics in the Third Republic," Ph.D. diss., Columbia University, 1981. My understanding of Rodin's work on the Hugo monument is deeply indebted to Roos, doubly so as she lent me her personal copy of her dissertation. Roos has published the crux of her findings in an article by the same title in the *Art Bulletin* 67 (December 1986). See also Anne Pingeot, "Le Décor sculpté du Panthéon sous le Second Empire et la IIIe République," *Le Panthéon: Symbole des révolutions*, Paris, 1989, 259–304.

9. Roos, "Rodin, Hugo, and the Panthéon," 106.

10. Meeting of June 12, 1889. Quoted in ibid., 62. The minutes of the meetings are in the Archives Nationales.

11. See Nicholas Green, "'All the Flowers of the Field': The State, Liberalism and Art in France under the Early Third Republic," *Oxford Art Journal* 10 (Nov. 1, 1987): 71–84.

12. *Courrier de l'art*, Sept. 27, 1889: 305–07.

13. Maurice Dreyfous, *Dalou: Sa Vie et son oeuvre*, Paris, 1903, 214.

14. Cladel, *Rodin*, 37.

15. This letter is in a private collection. Quoted in Hunisak, *The Sculptor Jules Dalou: Studies in his Style and Imagery*, New York, 1977, 269.

16. Mathias Morhardt, "La Bataille du Balzac," *Mercure de France*, Dec. 15, 1934: 465.

17. We know several early Rodin sketches for the Panthéon monument. That this particular sketch was the one the subcommittee viewed has only become clear since Jane Roos's meticulous analysis of the material. "Rodin, Hugo, and the Panthéon," 71–84.

18. *Justice*, July 22, 1890. The day after the article was published, Geffroy wrote to Rodin that he should not worry about the monument because the committee's decision was clearly "excessive." He pointed out that Rodin had been too conciliatory. This letter, as well as the reviews cited above, are reproduced in Roos, "Rodin, Hugo, and the Panthéon," 88–97. Also on July 23, Edmond de Goncourt noted: "Rodin recognizes that he gave in too easily and that he should have listened to Bracquemont and to Goncourt, and then he would not have been such a coward." *Journal*, Monaco, 1956, 3: 1214.

19. Archives Nationales, F21 2189. Quoted in Roos, "Rodin, Hugo, and the Panthéon," 113. The sketch Rodin described is no longer extant.

20. Goncourt, *Journal*, 17: 50.

21. Séverine, "Les Petits Poitrinaires," *Figaro,* April 17, 1892.

22. *Journal de Jules Renard,* Paris, 1965, 84–85 (entry for March 8, 1891).

23. Mirbeau explained Pissarro's reaction in a letter of Nov. 20, 1891. A few days later, Pissarro wrote to Rodin that he had selected a work, "a setting sun with haze over the prairie—I hesitated, I have so little confidence in my judgment. If it's not what you want, tell me truthfully." Rodin purchased *Un Soleil couchant avec une brume épaisse s'élévant des prairies* for 500 francs.

24. Rodin's letters to Zola are in the Cabinet des Manuscrits of the Bibliothèque Nationale.

25. Roos, "Rodin, Hugo, and the Panthéon," 116–18.

<div align="right">

Chapter 20
More Monuments to Genius

</div>

1. Article in *Le Figaro,* Dec. 6, 1880. See David Bellos, *Balzac Criticism in France, 1850–1900: The Making of a Reputation,* Oxford, 1976, 149–50.

2. *Justice,* June 25, 1883. Cited in ibid., 153.

3. Letter of Feb. 14, 1889. There are 11 letters from Rodin to Zola in the Bibliothèque Nationale (dated 1891–96) and 8 letters from Zola to Rodin in the Musée Rodin (dated 1889–98). The correspondence has been published by Joy Newton and Monique Fol in *Cahiers naturalistes* 59 (1985). These authors have also published "Zola et Rodin" in *Cahiers naturalistes* 51 (1977).

4. Zola lost the election to the academy, and Pierre Loti won. The information in this section comes primarily from Alan Schom, *A Biography of Emile Zola,* New York, 1987.

5. Letter of July 8, 1891. Quoted in Newton and Fol, "Zola et Rodin," 178.

6. Letter of May 1, 1883. Quoted in Newton and Fol, "L'Esthétique de Zola et de Rodin, 'le Zola de la sculpture,'" *Cahiers naturalistes* 53 (1979): 75.

7. My cryptic sentences reduce many pages of David Bellos's chapter "Fin-de-Siècle Criticism" in *Balzac Criticism in France.* Bellos surveys the opposition to Zola on the part of men such as Marcel Barrière, who believed in Balzac's "idealism," and Ferdinand Brunetière, who praised Balzac's ability to give "general psychological meaning" to life in a way that was absent from the naturalist novel.

8. Laure Surville, Balzac's sister, had published a life of Balzac in 1865 based on his correspondence. It was generally recognized as the most authoritative work.

9. Sept. 6, 1891. This letter is in the Institut Néerlandais in Paris. It has been published by Alain Beausire and Hélène Pinet in *Archives de l'art français* 29 (1988): 192–93.

10. Bellos, *Balzac Criticism in France,* 143–44.

11. *Paris-photographe,* April 1891.

12. On Dec. 24, 1891, Rodin acknowledged receipt of the prints, thanking Nadar for having sent them. Rodin's letters to Nadar are in the Bibliothèque Nationale. See Joy Newton, "Rodin and Nadar," *Laurels* 52, no. 3 (1981–82): 168.

13. "Deux monuments: Balzac et Victor Hugo, par Auguste Rodin," *Eclair,* Jan. 20, 1892.

14. Bibliothèque Nationale. Published in Newton and Fol, "Esthétique."

15. The following articles tell this story: "L'Inauguration de la statue de Claude Lorrain" in *Le Temps,* June 8, 1892; articles in the *Petite Républicaine,* June 8, 1892, and the *Journal de Granville,* June 11, 1892; and "Le Monument de Claude Lorrain," *Art français,* June 18, 1892.

16. *Dépêche Lorraine,* June 12, 1892.

17. *Eclair,* June 7, 1892.

18. On Aug. 14, 1892, Omer Dewavrin wrote Rodin that he had been reelected mayor of Calais. Rodin congratulated him by return mail and said he counted on inaugurating their monument in the coming year.

19. See *Gil Blas,* Aug. 14, 1892.

20. Charles Morice, "Le Monument de Baudelaire," *Journal des artistes,* Sept. 5, 1892: 261–62.

21. René Malliet, "Chez le sculpteur Rodin," *Rappel,* Oct. 14, 1892.

22. An 1892 article in the Musée Rodin clipping file, from which the exact date and journal name have been cut off.

Chapter 21
Ateliers and Assistants

1. H.-C.-E. Dujardin-Beaumetz, *Entretiens avec Rodin,* Paris, 1913, 81.

2. Daniel Rosenfeld, who has done the major work on Rodin's marbles, has identified eighty individuals who worked on Rodin's marble sculptures in the course of his career. "Rodin's Carved Sculpture," preliminary draft of a dissertation for Stanford University, 149.

3. Francis Spar, working with the many receipts in the archives of the Musée Rodin, has carefully drawn up a list of the addresses at which Rodin lived and worked through his life.

4. Philippe Diolé, *Beaux-Arts,* Nov. 10, 1933.

5. Judith Cladel, *Rodin: Sa Vie Glorieuse, sa vie inconnue,* Paris, 1936, 92. Frederick Lawton, *The Life and Work of Auguste Rodin,* London, 1906, 64.

6. From the Diolé interview in *Beaux-Arts.*

7. The story is told in a letter written on Dec. 21, 1892, by another assistant in Rodin's atelier, Ernest Nivet. See Bertrand Tillier, *Ernest Nivet, sculpteur: Des Fenêtres ouvertes sur la vie,* Châteauroux, 1987.

8. Truman H. Bartlett, "Auguste Rodin, Sculptor, *American Architect and Building News,* May 25, 1889: 250.

9. Département de l'Indre, "'François Pompon,' Hommage par E. Nivet," May 21, 1933, 196.

10. Nivet's letters to Bourda have been published in Tillier, *Ernest Nivet,* 46. See also Georges Lubin's catalogue for the Nivet exhibition in the Musée Bertrand, Châteauroux, 1972.

11. Jan. 5, 1892. The letters of Nivet to Bourda are in the Musée Bertrand in Châteauroux. Selections can be found in Tillier, *Ernest Nivet.*

12. Ibid., 60.

13. Escoula's letter is undated, but the work to which he refers is probably *Cupid and Psyche* for Charles Tyson Yerkes in Chicago, which was finished in the first half of 1894.

14. Letter from Bourdelle to Mme Michelet in August 1893. My thanks to Penelope Curtis, who has made this and other letters in the archives of the Musée Bourdelle available to me. She discovered them in the process of work on her dissertation, "E. A. Bourdelle and Monumental Sculpture," for the Courtauld Institute, University of London, 1989.

15. Rodin made this remark in an interview published in 1909 in *Volné Směry* at the time of a Bourdelle exhibition in Prague. It was reprinted as "L'Opinion de Rodin" in Raymond Cogniat, ed., *Hommage à Bourdelle,* Paris, 1961, 18.

16. After Rodin's death, Bourdelle constantly implied that he had played a considerable role in creating *Balzac.* Some authors have even given him primary credit for the work. Since the step-by-step struggle of Rodin's realization is so well documented, Bourdelle's claim does not seem legitimate.

17. Cogniat, *Hommage à Bourdelle,* 20.

18. Letter of Dec. 4, 1898, to an anonymous correspondent in the collection of the Fondation Custodia, Institut Néerlandais de Paris. It has been published by Penelope Curtis in *Archives de l'art français* 29 (1988): 180.

19. This was Rodin's standard phrase when he spoke about the work of the school. It was much quoted in the press.

1. There is a Mirbeau letter to Marcel Schwob in the Musée Rodin from March 6, 1892, in which he mentions that he is turning again to *Tête d'or:* "I've read it three times."

2. Jan. 6, 1890. Bibliothèque Nationale. Quoted in Gérald Antoine, *Paul Claudel, ou L'Enfer du génie,* Paris, 1988, 81.

3. Archives Nationales, F21 4299. See Bruno Gaudichon, *Camille Claudel,* Paris, 1984, 50.

4. May 19, 1892. This letter is in the collection of G. Alphandery and is reproduced in Jacques Cassar, *Dossier Camille Claudel,* Paris, 1987, 91–92.

5. Reine Marie Paris believes this work was *La Vielle Hélène. L'Oeuvre sculptée de Camille Claudel,* Paris, 1990, 253.

6. The Musée Rodin has only three dated letters from Claudel to Rodin, one from 1893 and two from 1896. In addition, there are eight undated letters, of which this is one. Reine Marie Paris dated it 1892 in *Camille Claudel, 1864–1943,* Paris, 1984, 46. She changed this to 1887 in *L'Oeuvre sculptée de Camille Claudel,* 251, published in collaboration with Arnaud de La Chapelle. Perhaps she followed the lead of Frederic Grunfeld, who dated it 1887 in *Rodin: A Biography* (New York, 1987, 224). Jacques Cassar (*Dossier,* 98) placed it in the summer of 1893, and Pierre Daix assigned the date of June 25, 1892 (*Rodin,* Paris, 1988, 107). The letter, however, is definitely undated.

7. Bibliothèque Nationale, N.A.F. 24523, f. 328. The letter has been published by Newton and Fol, *Cahiers naturalistes* 59 (1985): 98.

8. *Journal de Jules Renard,* Paris, 1960, 272 (entry of March 19, 1895).

9. When Judith Cladel confronted Rodin with the frequently repeated gossip that he and Camille Claudel had had children, he denied it. *Rodin: Sa Vie glorieuse, sa vie inconnue,* Paris, 1936, 228. In 1976 Jacques Cassar corresponded with Romain Rolland's widow, who said that Paul Claudel had once discussed his sister with her. He told her that Camille had been pregnant by Rodin and had had an abortion. Cassar, *Dossier,* 100. I, like Cassar, feel this does not constitute real information and that Camille's pregnancy or pregnancies remain conjecture.

10. See Georges Grappe, *Catalogue du Musée Rodin,* vol. 1, Paris, 1944, no. 261, 89.

11. The marble, now in the Metropolitan Museum of Art, was finished in 1893 and sold to Charles T. Yerkes of Chicago in 1894.

12. Edmond and Jules de Goncourt, *Journal,* Monaco, 1956, 20: 58.

13. Antoine, *Paul Claudel,* 421.

14. Ibid., 84.

15. Paul Claudel, *Journal, 1904–1932,* Paris, 1968, 463 (entry for Oct. 23, 1943).

16. They had moved there from the rue de Bourgogne in late 1890. There is a letter from Geffroy written on Nov. 19, 1890, which was sent to the rue de Bourgogne and forwarded to the rue des Grands-Augustins.

17. Cladel, *Rodin,* 42–43.

18. Letter in the Fonds Claudel in the Bibliothèque Nationale. Published in Paris, *Camille Claudel,* 68–75.

19. Claudel used this studio until 1896, when she moved to 63 rue de Tureen, near the place des Vosges.

20. Gauchez dossier in the Austrian State Archives, Vienna.

21. Rodin's letters to Morhardt about the banquet are in the Museum of Geneva. Charles Goerg has published a note on them, "Quelques Lettres de Rodin," *Revue du Musée de Genève* 23 (March 1962): 5–7.

22. Mathias Morhardt, "Le Banquet Puvis de Chavannes," *Mercure de France,* Aug. 1, 1935.

23. A description of the banquet appeared in the *Journal des débats,* June 17, 1895.

24. Mirbeau's 1893 article is reproduced in Cassar, *Dossier,* 401–03.

25. Letter reproduced in Cassar, *Dossier,* 117, and in Michel and Nivet, eds., *Correspondance avec Auguste Rodin,* Tusson, Charente, 1988, 143.

26. Gustave Mirbeau, "Ça et là," *Journal*, May 12, 1895. Reproduced in Cassar, *Dossier*, 114–16.

27. Archives Nationales, F21 2162, July 3, 1895. The first person to read, analyze, and publish the material in the archives concerning the commission of *L'Age mûr* was Anne Pingeot in the *Revue du Louvre* 4 (October 1982). Her article was published when the Musée d'Orsay acquired the second version of *L'Age mûr* from the Tissier family.

28. Letter from a "Bourgeois Grincheux" published in the *Tribune publique*. Reproduced in Cassar, *Dossier*, 126–27.

29. This undated letter, which begins "Ma souveraine amie" and ends "Votre Rodin comblé et heureux de votre bienveillance," is another of the letters discovered in Mme Goldscheider's house.

30. A copy of Rodin's letter was found recently in the Musée Rodin among the papers of René Chéruy, who was Rodin's secretary in the twentieth century.

31. Archives Nationales, F21 2162.

32. Ibid.

33. *L'Age mûr* remained in Claudel's studio on the Ile Saint-Louis until 1902, when a private collector, Louis Tissier, commissioned a bronze cast. This was made by Thiebaut Frères and exhibited in the Salon of 1903. It is now in the Musée d'Orsay.

34. Paul Claudel, Preface to *Camille Claudel*, Paris, Musée Rodin, 1951, 10.

35. Maurice Guillemot, "Boîtes aux lettres," *Europe artiste*, May 28, 1899.

36. This undated letter was sold at a Drouot auction on Jan. 30, 1980, and has been published by Gaudichon, *Camille Claudel*, Paris, 1984, 53.

37. Claudel's letter to Rodin is lost, but Rodin referred to it in a letter to Morhardt. On July 5, 1905, Morhardt replied that Claudel's accusation that Rodin had "stolen" her marble was "wild." This letter is among the Claudel papers in the Bibliothèque Nationale.

38. Asselin described this meeting in a series of radio broadcasts in 1956 entitled "La Vie douloureuse de Camille Claudel." The transcripts are published in Cassar, *Dossier*, 441–52.

39. Letter of Nov. 15, 1905, to G. Frizeau. Reproduced in Cassar, *Dossier*, 202.

40. Claudel, *Journal*, 103 (entry for Sept. 5, 1909).

41. François Lhermitte and Jean-François Allilaire, "Camille Claudel, malade mentale," in Paris, *Claudel*, 168–71. Both authors are members of the staff of the hospital of Salpêtrière. A thesis has also been written on Claudel's psychiatric history: Brigitte Fabre, "Mademoiselle Camille Claudel, statuaire: Trente Ans de sculpture, trente ans d'internement," University of Paris, V.

42. By 1915 Bourdelle was capable of bragging about his works as exemplary because one was not forced to look at that "Rodinian butcher's meat in marble and bronze." Remark found in a letter quoted in Penelope Curtis, "E. A. Bourdelle and Monumental Sculpture," thesis, Courtauld Institute, University of London, 1989, 175. After Rodin's death, Bourdelle made many extravagant claims about his own importance in realizing *Balzac, The Burghers of Calais,* and the *Sarmiento Monument*. See Bourdelle's letter to Charles Léger of Feb. 26, 1927, published in the *Art vivant*, Oct. 15, 1929.

43. Marie-Victoire Nantet, "Camille Claudel: Un désastre 'fin-de-siècle,'" *Commentaire* 42 (Summer 1988): 542.

Chapter 23
The Société des Gens de Lettres

1. See the *Petit Républicain*, June 27, 1893, and *Le Journal*, June 29, 1893.

2. Letter of July 15, 1893, in the Bibliothèque Nationale. Published by Joy Newton and Monique Fol in *Cahiers naturalistes* 59 (1985): 196.

3. Gustave Geffroy, "L'Imaginaire," *Figaro*, Aug. 29, 1893.

4. "Le Statue de Balzac et l'affaire Balzac-Rodin," in Geneviève Py, ed., *Ephéméride de la Société des Gens de*

Lettres de France, Paris, 1988. This short essay tells the story from the point of view of the society, based on its archives.

5. *Echo de Paris,* Oct. 23, 1893, and *Petite Presse,* Oct. 28, 1893.

6. "Onzième Banquet de La Plume," *Plume* 1893: 540.

7. Archives Nationales, F21 4404. Report quoted in Roos, "Rodin, Hugo, and the Panthéon: Art and Politics in the Third Republic," Ph.D. diss., Columbia University, 1981, 120.

8. Albert Cim, *Le Dîner des Gens de Lettres: Souvenirs littéraires,* Paris, 1903, 91–92.

9. Quoted in Robert Descharnes and Jean-François Chabrun, *Auguste Rodin,* Lausanne, 1967, 169.

10. Letter of Aug. 30, 1894. Published in Claudie Judrin, *Rodin et les écrivains de son temps,* Paris, 1976, 128, where it is dated "30 avril 1894." Since it is an answer to an August letter from Rodin, the "April" must be an erroneous transcription of Séverine's nearly illegible handwriting.

11. "Les Dix Mille Francs de Rodin," *Journal,* Nov. 27, 1894. Reproduced in John Tancock, *The Sculpture of Auguste Rodin,* Philadelphia, 1976, 448.

12. "Le Conflit Rodin-Balzac," *Soir,* Nov. 9, 1894.

13. Letter of Nov. 26, 1894. Located in the archives of the Musée Jean Aicard. Published in Alain Beausire and Hélène Pinet, eds., *Correspondance de Rodin,* vol. 1, Paris, 1985, 147.

14. Edmond and Jules de Goncourt, *Journal,* Monaco, 1956, 20: 155.

15. Letter in the Bibliothèque Nationale. Published by Newton and Fol, *Cahiers naturalistes,* 198–99. Zola sent copies of the letter to all the major journals, most of which published it between Dec. 12 and 15.

16. Reported in *Le Temps,* Dec. 6, 1894.

Chapter 24
Learning to Say: "It Is Finished"

1. Roos, "Rodin, Hugo, and the Panthéon: Art and Politics in the Third Republic," Ph.D. diss., Columbia University, 1981, 121.

2. Report by Armand Silvestre, Jan. 15, 1895. Archives Nationales, F21 4264. Quoted in ibid., 140.

3. *Petit Journal* (Calais), June 4, 1895.

4. Edmond and Jules de Goncourt, *Journal,* Monaco, 1956, 21: 79.

5. Ibid., Feb. 4, 1896.

6. Félicien Champsaur, "Un Raté de génie," *Gil Blas,* Sept. 30, 1896. Reproduced in part in Ruth Butler, *Rodin in Perspective,* Englewood Cliffs, N.J., 1980, 85–87.

7. Kahn paid Rodin 6,000 francs for *The Zephyrs* in May 1896.

8. Letter in Archives Nationales, F21 4223.

9. Henry Lapauze, "Rodin abandonnerait-il Balzac?" *Gaulois,* Jan. 26, 1896.

10. Geneviève Py, "La Statue de Balzac et l'affaire Balzac-Rodin," in *Ephéméride de la Société des Gens de Lettres de France,* Paris, 1988, 626.

11. Jacques de Caso, "Rodin and the Cult of Balzac," *Burlington Magazine* 106 (1964): 280. De Caso describes how, as early as 1883, Vasselot had appointed himself the man who should immortalize Balzac, and notes that he pursued this end "with almost psychopathic insistence."

12. Joséphin Péladan, "Jules Barbey d'Aurevilly et son oeuvre critique," *Artiste,* July 1885: 31–36. Arsène Houssaye was editor of *Artiste,* which frequently published Péladan's articles.

13. Joséphin Péladan, *La Décadence esthétique (Hiérophanie),* vol. 19, *Le Salon de Joséphin Péladan (Neuvième année): Salon National et Salon Jullian,* Paris, 1890, 55–56. Quoted in Robert Pincus-Witten, *Occult Symbolism in France: Joséphin Péladan and the Salons de la Rose + Croix,* New York, 1976, 76.

14. *Notes de psychologie contemporaine: L'Entr'acte idéal: Histoire de la Rose + Croix,* Paris, 1903, 140. Quoted in Pincus-Witten, *Occult Symbolism,* 155.

15. Joséphin Péladan, "Quatrième Salon de la Rose + Croix," *Bulletin Mensuel de la Rose + Croix du Temple*

et du Graal, troisième année, série ésotérique, no. 2 (May 1895): 40–41. Quoted in Pincus-Witten, *Occult Symbolism,* 155.

16. "Libres critiques. A propos du monument de Balzac," *Nouvelle Revue internationale: Matinées espagnoles,* Paris and Madrid, June 1 and July 15, 1896. Discussed in De Caso, "Rodin and the Cult of Balzac," 283.

17. De Caso, *Burlington Magazine,* 283.

18. "Lettres, Sciences et Arts," *Journal des débats,* June 15, 1896.

19. "Pêle-mêle actualité: La Statue de Balzac," *Soir,* Aug. 19, 1896.

20. *Figaro,* Aug. 25, 1896. Rodin wrote Rodenbach to thank him for his support. Letter in the Musée de la Littérature, Bibliothèque Royale, Brussels.

21. *Journal,* Aug. 30, 1896.

22. Albert E. Elsen was the first to notice this. *Auguste Rodin: Readings on His Life and Work,* New York, 1965, 101.

23. Mathias Morhardt, "La Bataille du Balzac," *Mercure de France,* Dec. 15, 1934: 467. Athena Tacha Spear has suggested there were as many as sixteen casts of the second naked Balzac with plaster-stiffened fabric over them. *Rodin Sculpture,* Cleveland Museum of Art, 1967.

24. Paul Gsell, "Chez Rodin," *L'Art et les artistes* 4 (February 1907): 410–11.

25. Py, "Statue," 627. That it was the Société's choice to place the *Balzac* in the Salon is an extremely important point. This was never clear before Mme Py wrote her essay. My interpretation is that the Salon showing was another tactic on the part of the opponents of Rodin's work.

26. Interview in *L'Eclair,* April 10, 1898.

Chapter 25
Victory and Defeat

1. Rosalyn Frankel Jamison, "Rodin and Hugo: The Nineteenth-Century Theme of Genius in *The Gates* and Related Works," Ph.D. diss., Stanford University, 1986, 19–20. Again I wish to state my debt to Jamison's dissertation in helping me to understand Rodin's reading of the poets.

2. Ibid., 27 and 332–33.

3. In *Les Rayons et les ombres,* Hugo compared the two colossi of sculpture, Michelangelo and David, in the line: "Michel-Ange avait Rome et David a Paris." One of Hugo's reasons for not wanting Rodin to do his portrait in 1883 was that he believed no one could come near the two busts of him that David had fashioned in 1837 and 1842. They were seen as the ultimate idealist rendition of Hugo's face. See Marcel Adam, "Victor Hugo et Auguste Rodin," *Figaro,* Supplement, Dec. 28, 1907.

4. Jacques de Caso, *David d'Angers: L'Avenir de la mémoire,* Paris, 1988, 75.

5. Ibid., 104.

6. Another possible prototype is a full-length seated sculpture of Victor Hugo by F. L. Bogino (Salon of 1884). This dull and heavy portrait is, with the exception of the position of the left hand (Bogino's closed, Rodin's open), in exactly the same position as the figure of Rodin's first maquette. The statue has disappeared, but a photograph is in the Musée Victor Hugo. Reproduced in *La Gloire de Victor Hugo,* Paris, Grand Palais, October 1985–January 1986, 70.

7. Works illustrating this point can be found in Albert Elsen, Stephen McGough, and Steven Wander, *Rodin and Balzac,* Beverly Hills, Calif., 1973.

8. "Au Jour le jour: La Statue de Balzac," *Temps,* Sept. 12, 1888.

9. Gabriel Ferry, "La Statue de Balzac," *Monde moderne* 10 (1899).

10. Report by Armand Silvestre, Jan. 15, 1895. Archives Nationales, F21 4264. Quoted in Roos, "Rodin, Hugo, and the Panthéon: Art and Politics in the Third Republic," Ph.D. diss., Columbia University, 1981, 140.

11. These statues are discussed in June Hargrove, *The Statues of Paris: An Open-Air Pantheon,* Antwerp, 1989.

12. Rodin reused figures created for *The Gates of Hell*. See Georges Grappe, *Catalogue du Musée Rodin*, vol. 1, Paris, 1944, nos. 127 and 129. Roos points out that the conventional names of these figures—Interior Voice and Tragic Muse—appeared for the first time in a report written by Eugène Morand on Feb. 9, 1904. Archives Nationales, F21 4338. "Rodin, Hugo, and the Panthéon," 148.

13. Jean Savant, who has written six books on Hugo and sexuality, was kind enough to discuss this material with me. These are basically his words.

14. Photographs that make this clear are almost impossible to find. The best source of images to understand the unfinished Panthéon "Apotheosis" are in Jane Roos's article "Rodin's Monument to Victor Hugo," *Art Bulletin* 68 (December 1986): 655. It was Roos who first made it clear that the highly sexualized Iris is the figure on the top of the monument Rodin planned for the Panthéon. No one had put the two together before.

15. *Courrier national*, April 24, 1897.

16. Gustave Geffroy, "Le Victor Hugo de Rodin," *Journal*, April 23, 1897. As soon as Rodin read this review, he invited Geffroy to lunch so that he could thank him in person (letter of April 29, quoted in auction catalogue no. 250, Librairie de l'Abbaye). Geffroy couldn't come but told Rodin that he, too, was very content with what he had written (letter of May 1).

17. "The Kreutzer Sonata" is a critique of modern marriage, a subject that must have been on Rodin's mind in 1897. That fall he was an official witness at the weddings of Louise Carpeaux and Alice Van Rasbourgh.

18. Emile Zola, *Paris*, Paris, 1898, 418. Paul Morand shows a photograph of Zola with his bicycle in his book *1900 A.D.*, Paris, 1931, 40.

19. Letter in the Bibliothèque Doucet, Paris.

20. Maurice Demaison in *Débat*, March 20, 1898.

21. Judith Cladel, *Auguste Rodin: L'Oeuvre et l'homme*, Brussels, 1908, 53.

22. Gustave Geffroy, "Le Salon de 1898," *Journal*, April 30, 1898.

23. Rupert Hart-Davis, ed., *The Letters of Oscar Wilde*, London, 1962, 732.

24. Judith Cladel, "Ceux que j'ai vus," *Fronde*, May 2, 1898.

25. Jean Rameau, "La Victoire de M. Rodin," *Gaulois*, May 3, 1898.

26. Letter of June 28, 1898. Rollin Van N. Hadley, ed., *The Letters of Bernard Berenson and Isabella Stewart Gardner, 1887–1924*, Boston, 1987, 142.

27. *Temps*, May 5, 1898.

28. "La Statue de Balzac: Une Visite à Auguste Rodin," *XIXe Siècle*, May 6, 1898.

29. Adolphe Possien, "Le 'Balzac' de Rodin: La Réponse de l'artiste à la Société des Gens de Lettres," *Jour*, May 12, 1898.

30. Letter of May 11. Quoted in Mathias Morhardt, "La Bataille du Balzac," *Mercure de France*, Dec. 15, 1934: 471.

31. *Journal*, May 12, 1898.

32. Mathias Morhardt, "La Bataille du Balzac," *Mercure de France*, Dec. 15, 1934: 475. John Hunisak has speculated that Dalou may have been so acid because he was bitter that Rodin's *Hugo* had gotten all the attention in the Salon of 1897, when Dalou himself had presented a major bronze group, *Silenus*.

33. The general attitude about Rodin's politics is that he was at heart an anti-Dreyfusard, but that he went to considerable lengths to keep this from becoming public knowledge. Frederic Grunfeld found a fascinating statement in an unpublished manuscript by the Norwegian painter Christian Krohg. After a visit to Rodin in 1898, Krohg wrote: "Rodin is a glowing anti-Dreyfusard and anti-Semite, a fact that is difficult to understand when one talks with him about other subjects, on which he has approximately the same views as the Dreyfusards." Oslo University Library. Quoted in Frederic Grunfeld, *Rodin: A Biography*, New York, 1987, 383.

34. Judith Cladel, *Rodin: Sa Vie glorieuse, sa vie inconnue*, Paris, 1936, 218.

35. My thanks to Stani and Gillie Faure for looking this up in Albert Dauzat, *Dictionnaire étymologique des noms de famille et prénoms de France*, Paris, 1951.

36. Gustave Geffroy, "L'Art d'aujourd'hui," *Journal*, Nov. 20, 1898.

37. Bellos, *Balzac Criticism in France, 1850–1900: The Making of a Reputation*, Oxford, 1976, 149–85.

38. Camille Mauclair, *Revue des revues*, June 15, 1898: 592.

39. Camille Mauclair, *August Rodin: The Man—His Ideas—His Works*, trans. Clementina Black, London, 1905, 44.

40. July 7, 1898. Published in Cladel, *Rodin* (1936), 219–20.

Chapter 26
Becoming an Entrepreneur

1. Rodin received the commission for Puvis' monument from the Société Nationale des Beaux-Arts in the spring of 1899. In 1902 he showed the committee plans that included a bust after his earlier bust of Puvis, to be placed on a stele, and a muse figure called the Spirit of Eternal Repose. He intended to finish the monument by 1904, but never did.

 For the Rodenbach monument, Rodin made a portrait medallion, intending to present it as a gift. It was to be inserted into a small pyramid and erected in Bruges on the banks of Lac d'Amour near the Béguinage, about which Rodenbach had written some of his most famous verse. An objection was raised by the Flemish members of the city council, who did not think Rodenbach merited public honor in Bruges, since he did not write in Flemish. The monument was, therefore, never installed.

2. Philippe Dubois, "L'Apothéose du travail," *Aurore*, April 1, 1898.

3. Letter to Rose Beuret from Pisa, Oct. 31, 1898.

4. Léon Maillard, *Auguste Rodin, Statuaire*, Paris, 1899, 76.

5. Rodin met Picard in the 1880s in Léon Cladel's home. Judith Cladel had the idea for this show as early as 1896, as is clear from her letters.

6. Judith Cladel, *Rodin: Sa Vie glorieuse, sa vie inconnue*, Paris, 1936, 47.

7. Ibid., 50.

8. Ergaste, "L'Exposition Rodin," *Petit bleu* (Brussels), May 9, 1899.

9. Ibid., 51.

10. The lecture was published in two parts in *Art moderne* (May 14 and 21, 1899).

11. The Cladel lecture was considered of particular interest for a Brussels audience. The *Indépendance belge*, which did not review the exhibition, reported that "Mlle Judith Cladel gave a lecture on 'The Work of Auguste Rodin' at the Maison d'Art, where fifteen years ago she was a guest with her father in the period when Edmond Picard was making it into a collector's palace" (May 15, 1899).

12. Edmond Picard, "Mlle Judith Cladel: Conférence sur Auguste Rodin à la Maison d'Art," *Plume* 1899: 381. Camille Lemonnier also reviewed the lecture for *Art moderne*, May 14, 1899: 167.

13. Judith Cladel, *Auguste Rodin, pris sur la vie*, Paris, 1903. In this volume, Cladel published two letters from Amsterdam written to a friend she called "Claire" (pp. 61ff.).

14. *Nieuwe Rotterdamsche Courant*, July 1, 1899: 1, and *Het Vaderland* (The Hague), July 9 and 10, 1899: 3. My thanks to Nancy Stieber for helping me find so many reviews of the Rodin exhibitions in the Royal Library in The Hague and for translating them for me. Prof. Stieber, who is very familiar with Dutch newspapers in this period, tells me that the extensive coverage of the show on the first page of so many journals and the enthusiastic language employed by the critics were most unusual for an art exhibition in Holland at the end of the nineteenth century.

15. Cladel, *Rodin* (1936), 58.

16. Gabrielle Réval, "Mlle Judith Cladel," *Femina*, April 1, 1906.

17. The chronology of the documents for Rodin's exhibition have been published in Alain Beausire, *Quand Rodin exposait*, Paris, 1988, 160–64.

18. *Illustration* 2 (July 15, 1899): 34.

19. Octave Mirbeau, "L'Apothéose," *Journal,* July 16, 1899. Reproduced in Michel and Nivet, eds., *Correspondance avec Auguste Rodin,* Tusson, Charente, 1988, 248–51.

20. See "The Last Campaign, 1899–1900" in Albert E. Elsen, *"The Gates of Hell" by Auguste Rodin,* Stanford, Calif., 1985, 133–41.

21. Elsen describes some of these changes, but aspects of his description are not quite accurate because he published his book before the photographs taken by Jessie Lipscomb in 1887 came to light.

22. Albert Alhadeff first identified this relief as a self-portrait: "Rodin: A Self-Portrait in *The Gates of Hell,"* *Art Bulletin* 48 (1966): 393–95. He placed it in the early 1880s period of work. Elsen places it in 1899–1900 and sees it as a signature piece included at the time of the completion. Elsen, *"The Gates of Hell,"* 138. I agree with Elsen.

23. Joy Newton, "Octave Mirbeau and Auguste Rodin, with Extracts from Unpublished Correspondence," *Laurels* 58, no. 1 (Spring 1987): 54. Séverine published a description of the trial in the *Cahiers d'aujourd'hui* 9 (1923): 107.

24. The *République française* described the situation in an article entitled "Les Scrupules de M. Rodin" (June 22, 1900). The editors congratulated Rodin for not allowing himself to be "enrolled in the army of *dreyfusisme.*"

25. The young British painter William Rothenstein remembered seeing Degas in the late 1890s: "I was all eyes and ears at the rue Victor-Massé and my friends too were eager to hear me repeat Degas' latest *mot.* Truth to tell, I heard more of admiration than of abuse." Degas told Rothenstein how much he liked Forain and Lautrec, but to "my great surprise, he greatly disliked Rodin, who, in our eyes was one of the Olympians." Rothenstein, *Men and Memories,* New York, 1931, 1: 106.

26. Most of my information comes from an article in the Italian journal *Omnibus,* Nov. 27, 1937. It was made available to me by Campbell Cimino, Emilia's grandson, who is presently working on a family history. Mr. Cimino is particularly intrigued by colorful Emilia, whose "name was taboo in our home when I was a child." Letter to the author, Sept. 24, 1987.

27. There are 147 letters from Cimino in the Musée Rodin. She was a most expressive correspondent and her letters are rich in details about Rodin's life. Her last letter is dated Aug. 2, 1907. It was mailed in Constantinople.

28. Letter of Dec. 27, 1913, to Malvina Hoffman. Archives, Getty Center for the History of Art and Humanities, Santa Monica.

29. Information on the Postolska family from Marc Toledano, *La Polonaise de Rodin,* Paris, 1986. Jean Dorizon, son of Casimira and Louis Dorizon, found Sophie Postolska's papers after her death in 1942. He put them away in a drawer, where his son François discovered them in 1970. In 1985 he and his wife asked Toledano to write a book based on these notes.

30. Both letters published in Toledano, *Polonaise,* 258–59.

31. From a radio talk given by Henry Asselin in 1956: "La Vie douloureuse de Camille Claudel sculpteur." Reproduced in Cassar, *Dossier Camille Claudel,* Paris, 1987, 442.

Chapter 27
Outsider's Victory

1. Abel Combarieu, *Sept ans à l'Elysée avec le Président Emile Loubet,* Paris, 1932.

2. Quote from Frederic Grunfeld, *Rodin: A Biography,* New York, 1987, 409. Grunfeld consulted the McLaren papers in the National Library, Edinburgh.

3. Anthony M. Ludovici, *Personal Reminiscences of Auguste Rodin,* Philadelphia, 1926, 33.

4. The above description is based on Georges Casella, "L'Exposition Rodin." It was written on June 27, 1900, and published in *L'Effort* sometime in July.

5. Geraldine Bonner, *Argonaut* (San Francisco), December 1900.

6. Helene von Nostitz, *Rodin in Gespräche und Briefe,* Dresden, 1927. English translation by H. L. Ripperger, New York, 1931.

7. Wilde's original letter has disappeared. Rupert Hart-Davis translated it from *Letzte Briefe* (1925). Hart-Davis, ed., *The Letters of Oscar Wilde,* New York, 1962, 831.

8. Letter of Oct. 27, 1900. The correspondence between Jelka Rosen Delius and Rodin was published by Lionel Carley in *Nottingham French Studies* 9 (May–October 1970).

9. Anna Masarykova, "Rodin in Prague," in Claude Kiesch, ed., *August Rodin: Plastik, Zeichnungen, Graphik,* Berlin, 1979.

10. Letter of ca. June 8, 1900. Günter Busch and Liselotte von Reinken, eds., *Paula Modersohn-Becker: The Letters and Journals,* trans. Arthur S. Wensinger and Carole Clew Hoey, New York, 1983, 192.

11. Letter from Rodin to Klinger, Nov. 18, 1900. Archives in Naumberg.

12. Rudolf Kassner, *Motive Essays,* Berlin, 1906. Sabina Quitslund has translated the section reproduced in Ruth Butler, *Rodin in Perspective,* Englewood Cliffs, N.J., 1980, 101–05.

13. The Linde-Rodin correspondence has been published by J. Patrice Marandel in two parts in the *Bulletin of the Detroit Institute of Arts* 62–63 (1987–88). Linde's letters are in the Musée Rodin, Rodin's in the archives of the city of Lübeck. Between 1900 and 1905, Linde bought eight works from Rodin.

14. There has been much disagreement about when and if the *Gates* were completed. Albert Elsen has discussed this question in depth and convincingly demonstrated that what Rodin showed in 1900 was a completed work. See chap. 8 of *"The Gates of Hell" by Auguste Rodin,* Stanford, Calif., 1985.

15. *Patriote de l'Ouest,* July 27, 1900.

16. "Chronique de Paris," *Illustration,* June 30, 1900: 406.

17. Gustave Geffroy, "L'Exposition Rodin," *Echo de la semaine,* June 10, 1900.

18. Marcel Nicolle, "L'Exposition Rodin, *Journal de Rouen,* July 16, 1900.

19. Kassner, *Motive Essays.* Reproduced in Butler, *Rodin in Perspective,* 101.

20. D. S. MacColl, *Saturday Review,* Sept. 29, 1900: 393.

21. See Alain Beausire, *Quand Rodin exposait,* Paris, 1988, 185.

22. *New York Tribune,* Supplement, Sept. 2, 1900. The graphite numbers can still be seen on the plaster cast in the Musée Rodin in Meudon.

23. MacColl, *Saturday Review,* 393.

24. Anatole France, "La Porte de l'Enfer," *Figaro,* June 7, 1900. Reproduced in Butler, *Rodin in Perspective,* 105.

25. Butler, *Rodin in Perspective,* 102.

26. Letter to John Hay, Nov. 7, 1900. *The Letters of Henry Adams, 1899–1905,* vol. 5, Cambridge, Mass., 1988, 169.

27. *Saturday Review,* Nov. 17, 1900: 613.

28. On the evidence of other letters in the Musée Rodin, Alain Beausire dates this letter between Dec. 11, 1900, and March 8, 1901. See *Correspondance de Rodin,* vol. 2, Paris, 1986, 41.

29. Edmond Picard, *Echo de Paris,* July 19, 1900. Reproduced in Butler, *Rodin in Perspective,* 101.

30. "Cri de Paris," *Illustration,* June 30, 1900: 406.

31. Interview in *Beaux-Arts,* Nov. 10, 1933.

32. The letter was written on Jan. 1, 1910, to Dr. Uhlemayer of Nuremberg. Quoted in Roger Secrétain, *Un Sculpteur "maudit": Gaudier-Brzeska, 1891–1915,* Paris, 1979, 34.

Chapter 28
The Home of the Sculptor

1. Des Moulineaux, a railroad line from the Pont de l'Alma to Issy, Bellevue, and Bas-Meudon, opened in 1889. In 1901 a new line provided service on an electric train from the Gare des Invalides to Versailles, with a stop at Meudon Val Fleury. This first electric train in Europe provided almost door-to-door service from Rodin's studio to his home. See *L'Illustration,* June 1, 1901.
2. Dexter Marshall, "Rodin's Home at Meudon, Near Paris." This is an article of 1906 in the Bartlett papers in the Library of Congress. The name of the newspaper has been clipped off.
3. Wolfgang Leppmann, *Rilke: A Life,* trans. Russell M. Stockman, New York, 1984, 168.
4. Günter Busch and Liselotte von Reinken, eds., *Paula Modersohn-Becker: The Letters and Journals,* trans. Arthur S. Wensinger and Carole Clew Hoey, New York, 1983, 304.
5. Quoted in Alain Beausire, *Quand Rodin exposait,* Paris, 1988, 206.
6. L. Vaillat, writing in 1933, was appalled at the spectacle of an artist "de cette valeur donnant ainsi l'exemple de cette déplorable manie de l'elginisme." *Temps,* March 8, 1933.
7. Anthony M. Ludovici, *Personal Reminiscences of Auguste Rodin,* Philadelphia, 1926, 49–50.
8. Gustave Coquiot, *Rodin à l'Hôtel Biron et à Meudon,* Paris, 1917, 97.
9. This comes from the American article "Rodin's Home at Meudon, Near Paris," which I found in the Bartlett papers in the Library of Congress, but the same story is told in many other places almost word for word.
10. From Rilke's correspondence. Quoted in Leppmann, *Rilke,* 170.
11. Ludovici, *Personal Reminiscences,* 39.
12. Frances Spalding, *Vanessa Bell,* New Haven, 1983, 42.
13. Charles Morice, "Rodin," *Rodin et son oeuvre,* special issue of *La Plume* 1900: 31.
14. Stefan Zweig, *The World of Yesterday,* New York, 1943, 147.
15. *Craftsman* 12 (April 1907): 88.
16. Helene von Nostitz, *Dialogues with Rodin,* trans. H. L. Ripperger, New York, 1931, 32, 33.
17. Ibid., 16.
18. He made his remark to Helene von Hindenburg in 1902. Claude Keisch, *Auguste Rodin: Plastik, Zeichnungen, Graphik,* Berlin, Staatliche Museum, 1979, 26.
19. Donald Prater, *A Ringing Glass: The Life of Rainer Maria Rilke,* New York, 1986, 63.
20. Letter to Clara Westhoff, Sept. 2, 1902. *The Letters of Rainer Maria Rilke, 1892–1910,* trans. Jane Bannard Greene and M. D. Herter Norton, New York, 1945, 77–78. Unless otherwise stated, all quotations from Rilke's letters come from this book.
21. Letter of Aug. 1, 1903. Correspondence between Rilke and Andreas-Salomé, Paris.
22. Leppmann, *Rilke,* 170, 171.
23. Letter to Ellen Key, Sept. 20, 1905. Quoted (in French) in Charles Dédéyan, *Rilke et la France,* vol. 1, Paris, 1961, 124.
24. Letter of Dec. 13, 1905. Ibid., 136.
25. Letter to Gerhart Haupmann, April 19, 1906. The letter is in the Staatsbibliothek in Berlin and is quoted in Prater, *Ringing Glass,* 132.

Chapter 29
The Favors of Edward's Court

1. William Rothenstein, *Men and Memories,* New York, 1931, 1: 320.
2. Joy Newton and Margaret F. MacDonald, "Whistler, Rodin, and the 'International,'" *Gazette des beaux-arts* 103 (1984): 120.

3. Letter of Oct. 31, 1900, from Rodin to Rothenstein. Houghton Library, Harvard University.

4. William Rothenstein, *Men and Memories,* New York, 1932, 2: 18.

5. Osbert Burdett and E. H. Goddard, *Edward Perry Warren: The Biography of a Connoisseur,* London, 1941, chap. 13, "Rodin and *Le Baiser.*"

6. Isabel McAllister, *Alfred Gilbert,* London, 1929, 143.

7. Charles Ricketts, *Self-Portrait,* London, 1939, 97.

8. Sir Sidney Lee, *King Edward VII,* London, 1924, 2: 241.

9. Letter to Charles Milnes Gaskell, written in Paris on May 23, 1907. *The Letters of Henry Adams,* vol. 6, Cambridge, Mass., 1988, 68.

10. Albert Ludovici, *An Artist's Life in London and Paris,* London, 1926, 145.

11. Jacques-Emile Blanche, *Portraits of a Lifetime,* London, 1938, 113–14.

12. Ricketts, *Self-Portrait,* 101.

13. Anthony Ludovici, *Personal Reminiscences of Auguste Rodin,* Philadelphia, 1926, 36

14. Rothenstein, *Men and Memories,* 2: 46.

15. George Moore, *Letters to Lady Cunard, 1895–1933,* London, 1957, 39.

16. In 1904 George Moore wrote about staying at Beckett's home in Leeds: "Miss Fairfax was there, a very beautiful and interesting girl. I wonder if she loves Ernest and if he will marry her." Ibid., 34.

17. Letter of May 1, 1904. J. W. Mackail and Guy Wyndham, eds., *Life and Letters of George Wyndham,* vol. 2, London, 1925, 479.

18. Moore, *Letters to Lady Cunard,* 49.

19. Letter of Feb. 23, 1903. Mary Hunter's husband, Charles, a coal magnate from Northumbria, was the kind of successful businessman whose work informed Joseph Chamberlain's concept of imperialism.

20. The normal cost of a bust from Rodin in the early twentieth century was between 22,000 and 25,000 francs.

21. Hunter described the sitting to Jacques-Emile Blanche. *Portraits of a Lifetime,* 123.

22. The letter is in the Musée Rodin. Hunter sent it on to Rodin.

23. *Daily Telegraph,* Jan. 11, 1907.

24. Margaret Blunden, *The Countess of Warwick,* London, 1967, 195.

25. Samuel A. Weiss, ed., *Bernard Shaw's Letters to Siegfried Trebitsch,* Stanford, Calif., 1986, 95.

26. George Bernard Shaw, *Collected Letters, 1898–1910,* ed. Dan H. Laurence, New York, 1972, 617.

27. Letter of April 20, 1906. Shaw, *Collected Letters,* 618.

28. Robert Boothby, *I Fight to Live,* London, 1947, 102.

29. Michel Holroyd, *Bernard Shaw,* vol. 2, New York, 1989, 183.

30. Shaw wrote a detailed account of his sitting with Rodin to the sculptor Jacob Epstein. Hesketh Pearson, *Bernard Shaw: His Life and Personality,* London, 1942, 299.

31. A copy of this letter, as well as a translation, are among the Shaw Papers in the British Library, Add. Mss. 50548.

32. Letter of April 19, 1906. Copy in the Shaw Papers, British Library.

33. Holroyd, *Shaw,* 2: 183–84.

34. Letter of April 26, 1906. Copy in the Shaw Papers, British Library.

35. Letter of Jan. 26, 1908 in the Musée Rodin. Published in Shaw, *Collected Letters,* 754–55.

36. E. R. Pennell and J. Pennell, *The Whistler Journal,* Philadelphia, 1921, 307.

37. Illustrated and described in Joy Newton and Margaret MacDonald, "Rodin: The Whistler Monument," *Gazette des beaux-arts,* December 1978: 222.

38. My sense of Gwen John comes from Michael Holroyd, *Augustus John: A Biography,* vol. 1, London, 1974, 17.

39. This letter was dated "Saturday, 6 P.M." John seldom gave more precise dates in her letters to Rodin. An archivist who formerly worked at the Musée Rodin went through the letters and took the years off

the envelopes, wrote them down on as many letters as there were envelopes for, and then threw the envelopes away! So the years are as close as we can get for dates.

40. Undated letter to Ursula Tyrwhitt. Cecily Langdale, *Gwen John,* New Haven and London, 1987, 31.
41. Pennell and Pennell, *Whistler Journal,* 311.
42. See Alain Beausire, *Quand Rodin exposait,* Paris, 1988, 298.
43. Pennell and Pennell, *Whistler Journal,* 311.
44. Ibid., 48.

Chapter 30
Teaching Americans about Sculpture

1. Michel and Nivet date this letter in late October 1899. *Correspondance avec Auguste Rodin,* Tusson, Charente, 1988, 190.
2. The articles appeared Jan. 19–June 15, 1889. Bartlett remarked that he published them in an architectural magazine "because no one else would take them." However, *American Architect and Building News* had a very large circulation.
3. John D. Kysela, "Sarah Hallowell Brings 'Modern Art' to the Midwest," *Art Quarterly* 27 (1964): 150–67.
4. Letter of July 9, 1891. Art Institute of Chicago. My thanks to Susan Glover Godlewski for making this letter available to me.
5. Rodin wrote Durand-Ruel in June that he was waiting for a response to his proposal from Chicago. Archives Durand-Ruel. Published in Barbier, *Marbres de Rodin,* Paris, 1987, 54.
6. There was one Rodin in an American collection, but Hallowell probably did not know about it. In 1888 George A. Lucas, a Baltimorean who resided in Paris, bought the *Bust of Saint John the Baptist* and sent it to Samuel P. Avery in New York. Avery donated it to the Metropolitan Museum of Art in 1893. See Ruth Butler, "Rodin and His American Collectors," *The Documented Image: Festschrift in Honor of Elizabeth Gilmore Holt,* Syracuse, N.Y., 1987, 89.
7. Letter of Aug. 30, 1895, to Elizabeth Cameron. *The Letters of Henry Adams,* Cambridge, Mass., 1988, 4: 313.
8. Letter of April 24, 1901. *Letters of Henry Adams,* 5: 241–42.
9. Rodin's letters to Elizabeth Cameron are in the National Gallery of Art in Washington, D.C.
10. *Ceres* and *Flight of Love* in marble; *Brother and Sister, Vulcan Creating Pandora,* and *The Death of Alcestis* in bronze. All of these works except *Flight of Love* are still in the Boston Museum of Fine Arts.
11. Letter of July 12, 1902. *Letters of Henry Adams,* 5: 390–91.
12. Ibid., 5: 393.
13. See Arline Boucher Tehan, *Henry Adams in Love: the Pursuit of Elizabeth Sherman Cameron,* New York, 1983, 193.
14. Letter of May 24, 1908. *Letters of Henry Adams,* 6: 146.
15. The Museum of Fine Arts continues to treat its Rodin collection with an ambivalence worthy of Adams: to this day, the handsome marbles and bronzes spend more time in storage than in the museum galleries.
16. Steichen's letters to Stieglitz are in the Beinecke Rare Book and Manuscript Library at Yale University.
17. Sidney Allen, "A Visit to Steichen's Studio," *Camera Work,* January 1903: 23.
18. Actually, the first show in 291 not devoted to photography was of the drawings and watercolors of Pamela Coleman Smith. This happened because it took so long to assemble the Rodin show. See William Innes Homer, *Alfred Stieglitz and the American Avant-Garde,* Boston, 1977, 57–58.
19. Quoted in Marius de Zayas, "How, When, and Why Modern Art Came to New York," *Arts Magazine* 54 (April 1980): 98. W. B. McCormick, *Press,* quoted in ibid.

20. Letter of July 14. No year is indicated, but it is surely 1904.

21. Letter of Nov. 5, no year indicated. Presumably, it was after Edward VII visited Rodin's studio in 1908.

22. In July 1901, MacKenna published an article entitled "In Rodin's Studio—The Personality and Doc-trine of a Revolutionary Sculptor" in the *Criterion*. In it he said, "For some months I have been a constant frequenter of these most informal receptions [Rodin's Saturdays] and have had long and familiar talks with the artist." (Sometime in the 1890s, Rodin initiated the practice of receiving infor-mally at 182 rue de l'Université on Saturday afternoons.)

23. W. A. Swanbert, *Pulitzer,* New York, 1967, 338.

24. Frank Harris, *Vanity Fair,* April 17, 1907.

25. George Dennan, *E. H. Harriman: A Biography,* New York, 1922, 413.

26. Jean Schopfer and Claude Anet, "Rodin." Translated by Irene Sargent in the *Craftsman,* March 1904: 532.

27. We know about the Simpson travels from a series of photographic albums put together by Ouida Grant. She documented the Simpsons' family life between 1901 and 1914. I owe thanks to Morris and Mary Anthony Rowell of East Craftsbury, Vt., for allowing me to examine the Simpson archives following Jean Simpson's death in 1980. These documents were sold at Sotheby's on Dec. 10, 1982, and I do not know where they are at present.

28. The Simpson archives contained a Steichen photograph of Rodin's *Victor Hugo* signed by both Steichen and Rodin and dated 1901. I interpret this as evidence that the Simpsons, Steichen, and Rodin were together in 1901.

29. Irene Sargent, "A Second Lesson of Sculpture: The Art Considered as a Public Servant," *Craftsman* 7 (1904–05): 123–24.

30. D. C. French, travel notebook, Europe 1900, box 38, French Family Papers, Library of Congress.

31. Clare Vincent, "Rodin at the Metropolitan Museum of Art," *Metropolitan Museum of Art Bulletin,* Spring 1981: 28.

32. Paul Gsell, "Un Triomphe pour l'art français aux Etats-Unis," *Journal,* Sept. 5, 1910.

33. Archives, Metropolitan Museum of Art, New York.

34. Herman Bernstein, "American Sculpture Is Still French, Says Rodin," *New York Times,* July 9, 1911. The subhead reads: "But it has a great future if it escapes commercialism—How his 'Muse,' an American Duchesse, persuaded T. F. Ryan to establish the Rodin Gallery here."

35. Louis Gillet, *France-Amérique,* April 1911: 235.

36. Jules Mastbaum of Philadelphia commissioned the first two bronze casts of *The Gates of Hell.* They were executed by Eugène Rudier in 1928, one for the Rodin Museum in Philadelphia, which opened in 1929, the other for the Musée Rodin in Paris. The most recent cast, commissioned by B. G. Cantor in 1977, is at Stanford University.

Chapter 31
Rodin's Reputation in France

1. Georg Simmel, "Rodins Plastik und die Geistesrichtung der Gegenwart," *Zeitgeist* (Berlin), Sept. 29, 1902.

2. *New York Herald* (Paris edition), Feb. 23, 1901.

3. *Gazette des beaux-arts,* August 1901: 116.

4. Camille Mauclair, *Auguste Rodin: The Man—His Ideas—His Works,* London, 1905, 20.

5. Letter of January 1903 quoted in Gustave Geffroy, *Claude Monet: Sa Vie, son oeuvre,* Paris, 1980, 358.

6. J.-A Carl, "Nos Sculpteurs," *Art* 62 (1903): 122–23.

7. Paul Leroi, "Treizième Exposition de la Société des Beaux-Arts," ibid., 232.

8. Paul Leroi, "Comtes éloquents! M. Rodin . . . doit à la Direction des Beaux-Arts," ibid., 289–90.

9. Letter of May 24, 1904. J. W. Mackail and Guy Wyndham, eds., *Life and Letters of George Wyndham*, vol. 2, London, 1925, 480.

10. Michel and Nivet, eds., *Correspondance avec Auguste Rodin,* Tusson, Charente, 1988, letters 144 and 145. Rodin's monument to Becque was inaugurated in the place Prosper-Goubeaux on June 1, 1908.

11. The three major toasts by Baffier, Bourdelle, and Lucien Schnegg were published in *La Plume,* July 1903.

12. Frederic Grunfeld, *Rodin: A Biography,* New York, 1987, 461. Grunfeld is quoting from Lady Kennet, *Self-Portrait of an Artist,* London, 1949, 40.

13. I have assumed that Cladel created Claire in order to talk of her time alone with Rodin without making it too privileged and personal. On the other hand, the descriptions of Claire are so vivid that at times I am not sure whether she is fact or fiction.

14. Judith Cladel, *Auguste Rodin, pris sur la vie,* Paris, 1903, 99–100.

15. Camille Mauclair, *Servitude et grandeur littéraires,* Paris, 1922, 176–78. Quoted in Joy Newton, "Camille Mauclair and Auguste Rodin," *Nottingham French Studies* 30, no. 1 (1990): 40.

16. Camille Mauclair, "Auguste Rodin: Son Oeuvre, son milieu, son influence," *Revue universelle,* Aug. 17, 1901. Translated by John Anzalone and reproduced in Ruth Butler, *Rodin in Perspective,* Englewood Cliffs, N.J., 1980, 108–12.

17. Thiébault-Sisson, "Le Penseur de Rodin," *Temps,* Dec. 2, 1903.

18. Gustave Coquiot, *Le Vrai Rodin,* Paris, 1917, 127.

19. See Albert E. Elsen, *Rodin's "Thinker" and the Dilemmas of Modern Public Sculpture,* New Haven, 1986, 76–78, and "Rodin's 'Perfect Collaborator,' Henri Lebossé" in Elsen, ed., *Rodin Rediscovered,* Washington, D.C., 1981, 248–59.

20. Louis Vauxcelles described the casting of *The Thinker* in detail. It took Hébrard six weeks to complete the work. "La Fonte à cire perdue," *Art et décoration* 1905: 189.

21. Gabriel Boissy, *Chronique des livres,* April 25, 1904.

22. *Arts de la vie* 5 (May 1904).

23. Gustave Geffroy, "Le Penseur de Rodin au Panthéon," *Revue bleue,* Dec. 17, 1904: 775

24. Letter from the end of June 1904. Michel and Nivet, *Correspondance,* 222.

25. Paul Leroi, "La Société Nationale des Beaux-Arts," *Art,* June 1904: 307–09.

26. "Le Penseur," *Revue de l'art pour tous,* July 1904.

27. Marcel Adam, "Le Penseur," *Gil Blas,* July 7, 1904.

28. Geffroy, "Penseur," 776.

29. Ibid.

30. *Journal,* Jan. 17, 1905.

31. Paul Leroi, "Le Sous-secrétaire d'état des beaux-arts," *Art* 64 (February 1905): 51. Rodin mentioned Marcel in several letters in November and December, without indicating that Marcel had evinced any animosity toward his statue.

32. *Matin,* Feb. 6, 1905.

33. On Feb. 9, 1905, Rodin wrote to Robert de Montesquiou that he would not be able to keep their date: "The undersecretary can only come tomorrow." Letter in the Montesquiou papers in the Bibliothèque Nationale.

34. Letter listed and quoted in the 1980 auction catalogue of the Librairie de l'Abbaye, p. 248. Present whereabouts unknown.

35. "'Le Penseur' de Rodin," *Patrie,* April 22, 1906. Everyone in France was thinking about the workers the spring of 1906 after the mining disaster at Courrières (Pas-de-Calais) in March, when 1,200 workers lost their lives. The tragedy was followed by a series of strikes. A lampoon of *The Thinker* in *Gil Blas* labeled Rodin's figure a "robust 'escapee' from Courrières" who wears no clothes save "his miner's helmet." April 22, 1906.

36. Gustave Geffroy, "Le 'Penseur' de Rodin," *Aurore,* April 22, 1906.

37. Lawton, *The Life and Work of Auguste Rodin,* London, 1906, 271.

38. "Chez M. Paul Adam," *Patrie,* April 7, 1906. On April 2, Adam had published an article in *Le Journal* about the individuals trapped underground for almost three weeks in the mining disaster at Courrières. If they had been soldiers, "would we not have raised a monument to them?" he asked. Kahn used the same argument in *Le Siècle* on April 17.

39. Nozière, "Cri de Paris," *Illustration,* April 14, 1906.

40. *Bâtiment,* April 30, 1908.

41. Ricciotto Canudo, "Notre Colonne Trajane: La 'Tour du Travail' de Rodin," *Censure,* Aug. 3, 1907. Translated in Butler, *Rodin in Perspective,* 121–25.

42. Rodin probably made the decision to eliminate the muses in late 1906. A government decree of Dec. 26 speaks of the monument as consisting of the seated poet and cuts Rodin's fee by 10,000 francs. Judith Cladel took credit for talking Rodin into abandoning the muses. *Rodin: Sa Vie glorieuse, sa vie inconnue,* Paris, 1936, 178.

43. Roos, "Rodin, Hugo, and the Panthéon: Art and Politics in the Third Republic," Ph.D. diss., Columbia University, 1981, 157–58.

44. "Le 'Victor Hugo' de Rodin," *Dépêche de l'Est,* May 29, 1909.

45. "Le Victor Hugo de Rodin," *Illustration,* Oct. 9, 1909.

46. Otto Grautoff, "Aus Gesprächen mit Rodin," *Jugend* 47 (1907). The keeper of Greek and Roman antiquities at the Louvre, however, writing in the 1940s, was less enthusiastic about the quality of Rodin's collection. N. Plaoutine and J. Roger, *Corpus Vasorum Antiquorum, Musée National Rodin,* Paris, 1945.

47. Paul Gsell, "Propos d'Auguste Rodin sur l'art et les artistes," *Revue,* Nov. 1, 1907.

48. Ibid.

49. Auguste Rodin, "La Tête Warren," *Musée* 1 (1904): 15–18.

50. Auguste Rodin, "Gothic in the Cathedrals of France," *North American Review* 180, no. 2 (February 1905): 219–29. The interview took place in 1904 and was translated by Frederick Lawton, an English expatriate living in Paris. Lawton wrote to Rodin for the first time on Jan. 17, 1904, briefly became his secretary in March 1905, and published his book *The Life and Work of Auguste Rodin* in 1906.

51. Auguste Rodin, "Le Parthénon et les cathédrales," *Musée* 2 (1905): 66–68.

52. Although Rodin gave much time to thinking about and collecting the art of the past, he showed little interest in contemporary art. He supported the new Salon d'Automne and even acted as its honorary president in 1906 (along with Renoir), but he had difficulty with a great deal of the art shown there. Paul Gsell asked him what he thought about the great Cézanne retrospective of 1907: "Hearing this name, Rodin shrugged his shoulders. Very softly, in an apologetic tone, he said, 'That one, I don't understand him at all.'" Gsell, "Propos d'Auguste Rodin," 99. Rodin had little use for the cubists; he called twentieth-century art "stereotyped" and longed for a second Renaissance, but by 1910 he had lost hope and proclaimed, "Art is dead." Rodin, *Art: Conversations with Paul Gsell,* trans. Jacques de Caso and Patricia S. Sanders, Berkeley, Calif., 1984, 4.

53. Rodin wrote on Sept. 5; Bourdelle replied on Sept. 6. Both letters are published in Antoine Bourdelle, *La Sculpture et Rodin,* Paris, 1978, 185–88.

54. Letter quoted in Paul Delsemme, *Un Théoricien du symbolisme: Charles Morice,* Paris, 1958, 100.

55. Emile Mâle, "Rodin interprète des cathédrales de France," *Gazette des beaux-arts,* May 1914: 372–78. See Butler, *Rodin in Perspective,* 153.

1. Judith Cladel, *Rodin: Sa Vie glorieuse, sa vie inconnue*, Paris, 1936, 352.

2. Rodin had long worked with a pair of Italian models, the Abbruzzesi sisters. Anne, the younger of the two, became pregnant by a young painter, a student of the Ecole des Beaux-Arts named Gorguet. When he denied paternity, she attacked him physically and he brought charges against her in criminal court. Rodin was a character witness in her favor. *Temps*, Feb. 28, 1897.

3. "Life of an Artist's Model in Paris: A Transcript from the Experiences of One Who Poses for Painters and Sculptors," *New York Tribune*, Jan. 25, 1903. Unsigned article based on Marie Laparcerie's psychological investigation of women models in Paris.

4. William Rothenstein, *Men and Memories*, New York, 1931, 1: 321. Cladel, *Rodin*, 266. Rodin, *Art: Conversations with Paul Gsell*, trans. Jacques de Caso and Patricia S. Sanders, Berkeley, Calif., 1984, 49.

5. Georg Brandes, "Bei Auguste Rodin," *Kunstwelt*, May 1913: 504. Quoted in Frederic Grunfeld, *Rodin: A Biography*, New York, 1987, 515.

6. Camille Mauclair, *Auguste Rodin: The Man—His Ideas—His Works*, London, 1905, 97–98.

7. Gustave Coquiot, "Ses Dessins en couleurs," *Maîtres artistes* 1903: 288.

8. Maurice Fenaille, industrialist, collector, and friend of Rodin since the late 1880s, paid for the limited edition (125 copies) of 129 plates, with a preface by Octave Mirbeau.

9. Arthur Symons, "Les Dessins de Rodin," *Plume* 1900: 382–83.

10. Gustave Coquiot, *Le Vrai Rodin*, Paris, 1913, 162.

11. Claudie Judrin, *Inventaires des dessins de Rodin*, 4 vols., Paris, 1983–92.

12. Lesbian love was an established theme in the nineteenth century, treated by artists such as Courbet in painting and Baudelaire in poetry. Traditionally, male and female models did not pose in the nude at the same time. When Marie Laparcerie interviewed models in Paris at the beginning of the century, she asked a woman who was married to a male model if she and her husband ever posed together. The woman replied that they would do so only if they were draped, "because, as you know, men and women never pose together if they are nude." "Is it forbidden?" asked Laparcerie. "I don't know if it is forbidden, but it is never done. . . . Women can pose with other women in the nude, but male models and women models only work together if they are dressed." Laparcerie, "Les Modèles à l'Académie," *Presse*, Jan. 19, 1903. This statement makes us wonder whether such groups as *The Kiss* and *The Eternal Idol* were assembled from separate figures.

13. Account contained in the memoirs of Maurice Barrès, who was Anna de Noailles' lover. The countess must have come home and gone through the whole encounter in detail. Barrès, *Mes Cahiers*, Paris, 1963, 263–65.

14. Carol Duncan, "Virility and Domination in Early Twentieth-Century Vanguard Painting," *Artforum*, December 1973.

15. Paul Gsell, *The Opinions of Anatole France*, New York, 1922, 179.

16. The major early exhibitions of Rodin's drawings were in Brussels and the Netherlands in 1899, at the place de l'Alma in 1900, in Prague in 1902, in Düsseldorf in 1904, Bernheim Jeune in Paris (303 drawings) in 1907, and at the Devambez Gallery in Paris (148 drawings) and the 291 gallery in New York (58 drawings), both in 1908. Modern scholarship on the drawings began in the 1960s with the work of Elisabeth Chase Geissbuhler on the architectural drawings and J. Kirk T. Varnedoe on the general chronology. Claudie Judrin, curator at the Musée Rodin, began preparing the catalogue raisonné in 1974. The last of the four volumes appeared in 1992.

17. Philippe Sollers and Alain Kirili, *Rodin: Dessins érotiques*, Paris, 1987. Kirk Varnedoe brought them to Kirili's attention in 1977 when he was doing research on his article on Rodin's drawings for the catalogue of *Rodin Rediscovered*.

18. Catherine Lampert, *Rodin: Sculpture and Drawings,* London, 1986, 162–75.

19. Rainer Maria Rilke, *Rodin and Other Prose Pieces,* trans. G. Craig Houston, London, 1986, 22.

20. Interview with Herman Bernstein of the *New York Times* in May 1912. Bernstein published it in his book *Celebrities of Our Time,* New York, 1924, 135.

21. Lucie Delarue-Mardrus, *Mes Mémoires,* Paris, 1938, 162.

22. Mirbeau's description to Edmond de Goncourt. *Journal,* Monaco, 1956, 16: 102.

23. Georg Simmel, *Brücke und Tür,* Stuttgart, 1957, 198. Quoted in Grunfeld, *Rodin,* 513.

24. Ruth St. Denis, *An Unfinished Life,* New York, 1939, 86.

25. Hugo Vickers, *Gladys, Duchess of Marlborough,* London, 1979, 132.

26. Quoted in Philippe Jullian, *Prince of Aesthetes: Count Robert de Montesquiou, 1855–1921,* New York, 1965, 218.

27. Toledano, *La Polonaise de Rodin,* Paris, 1986, 279–80.

28. Ibid., 288.

29. These extracts are taken from three long letters. One was written on Oct. 15, another on Oct. 17, 1903; the third is undated, but clearly written within a week of the others. Cimino, with all her extremes, was nevertheless one of the few in Rodin's entourage who said exactly what was on her mind, so her letters are extremely valuable. When she wrote (or spoke) to Rodin like this, she knew she was risking a rupture in the friendship, so at the same time she would plead with him to sell her some work at a good price "in memory of 5 years of devotion." There was a serious cooling of their relationship, and in 1904 Cimino moved to Rome. In 1905 Rodin gave her a single bronze *Burgher of Calais,* just as he had given one to Postolska.

30. Toledano, *Polonaise,* 292.

31. The Delius-Rodin correspondence has been published by Lionel Carley. "Jelka Rosen Delius: The Correspondence, 1900–1914," *Nottingham French Review* 9, nos. 1 and 2 (May and October).

32. My thanks to François Cizek in the archive of the Musée Rodin for bringing the Schrader-de Nygot letter to my attention.

33. Dominique Rolin, daughter of Judith Cladel's younger sister Esther, shared with me her family's view on this point. They believed that Judith did have an affair with Rodin. Mme Rolin knew her aunt well, but out of respect for her discretion she did not question her directly. Interview, June 20, 1991.

34. The Musée Rodin has over 900 letters from John to Rodin. None of them is dated. Alain Beausire has grouped them by address. Between 1904 and 1906, John lived on the boulevard Edgar-Quinet. In February 1906 she moved to the rue St. Placide, in 1907 to 87 rue du Cherche-Midi, and in 1909 to 6 rue de l'Ouest.

35. Susan Chitty, *Gwen John,* New York, 1987, 90.

36. Quoted in Cecily Langdale, *Gwen John,* New Haven and London, 1987. There are approximately 60 letters from Rodin to John, many of them simply reminders for appointments, in the National Library of Wales in Aberystwyth.

37. Letter in the National Library of Wales. Quoted in Grunfeld, *Rodin,* 482–83.

38. Helene von Hindenburg-Nostitz knew these letters were a rich gift and used them as the basis for two books: *Dialogues with Rodin,* New York, 1931, and *Briefe an zwei deutsche Frauen,* Berlin, 1936. The Musée Rodin purchased the 97 von Hindenburg-Nostitz letters, Rodin's epistles to both mother and daughter, in 1960.

Chapter 33
A New "Wife" and a Home in the City

1. Virginia Veenswijk, in her history of Coudert Brothers, has pointed out that "over 500 such marriages were contracted in the 35 years following 1874, when Jenny Jerome set the fashion by wedding Lord

Randolph Churchill." Veenswijk will soon publish her work, and I wish to thank her for making her manuscript available and for providing me with copies of letters written by members of the Coudert family. This section is strongly indebted to her work.

2. *New York Times,* March 13, 1891.

3. This letter is owned by Ferdinand Coudert of Key West, Fla. I am grateful for his permission to quote from the copy provided by Veenswijk.

4. The letter in the possession of Ferdinand Coudert is dated Aug. 27, 1891. The date and title of the publication have been cut off the clipping.

5. This information was conveyed to me by Marc de Montalembert, who is the grandson of Charles-Auguste de Choiseul-Beaupré's sister.

6. Letter of Aug. 20, 1897, owned by Ferdinand Coudert.

7. When Claire de Choiseul and Rodin visited John and Mary Marshall in Rome in 1912, she told them that she had lost three children: "She had one child, a boy, who lived for two years. There was a second. When she was expecting her third baby, something went wrong; the Caesarean operation was performed and the child was cut piecemeal out of her body. Peritonitis set in. She lived; but from that day to this she had never been able to eat at any table save her own." John Marshall's letter to E. P. Warren, Jan. 24, 1912. Osbert Burdett and E. H. Goddard, *Edward Perry Warren,* London, 1941, 266. There is no trace of these children. No one in the Montalembert family ever heard any mention of the Choiseul couple having had children, nor have I found any records of them in the municipal archives of Versailles or at Notre Dame de Versailles, the family church.

8. Judith Cladel, *Rodin: Sa Vie glorieuse, sa vie inconnue,* Paris, 1936, 267.

9. Marc de Montalembert confirmed for me that Charles-Auguste had no right to the title of duke.

10. "Une Beauté de Paris à sauver," *Illustration,* June 19, 1909.

11. Jean Cocteau, *Portrait-souvenirs,* Paris, 1935, 179–86.

12. *Selected Letters of Rainer Maria Rilke, 1902–1926,* trans. R. F. C. Hull, London, 1947, 170–71.

13. Rodin bought the phonograph for 400 francs from the Compagnie Française du Gramophone. The bill is dated Sept. 20, 1909.

14. Rilke's letter of Nov. 3, 1909, to Clara Rilke. *Selected Letters,* 173–74.

15. Marcelle Tirel, *The Last Years of Rodin,* New York, 1925, 30.

16. Count Harry Kessler, diary entry for Oct. 12, 1909. "Aus Unbekannten Tagebüchern," *Jahrbuch der Schiller Gesellschaft* 31 (1987): 33. I am grateful to Catherine Krahmer for bringing this source to my attention.

17. "Une Beauté de Paris à sauver."

18. Mrs. Daniel Chester French, *Memories of a Sculptor's Wife,* Boston, 1928, 203.

19. B. H. Friedman, *Gertrude Vanderbilt Whitney,* New York, 1978, 288.

20. Letter to Lou Andreas-Salomé, Dec. 21, 1911. *Selected Letters of Rilke,* 185.

21. Cladel, *Rodin,* 272–73.

22. Letter of Sept. 20, 1910, in the Archives, Getty Center for the History of Art and Humanities, Santa Monica.

23. Herman Bernstein, "American Sculpture Is Still French, Says Rodin," *New York Times,* July 9, 1911.

24. There are four long letters, dated Jan. 24 and 31 and Feb. 5 and 6, 1912. Burdett and Goddard, *Edward Perry Warren,* 263–74.

25. Article in *Gil Blas,* March 16, 1912.

26. *Homme libre,* May 7, 1913.

27. Burdett and Goddard, *Edward Perry Warren,* 267.

28. The employee was Mme Bourdeau, whose daughter, Juliette Husted, modeled for Rodin in 1912 and 1913. Juliette talked Rodin into giving her mother a job at the Hôtel Biron that lasted about a year. In March 1914, Mme Bourdeau wrote to her daughter that the "Directeur du figareau on me venu me

trouver en me promettant une forte somme d'argent pour que je disse au figareau tous la vie privé de M. Rodin" (The director of *Le Figaro* came to me and promised a lot of money if I would tell *Le Figaro* about M. Rodin's private life). The point soon became moot because on March 16, 1914, the wife of the former prime minister, Joseph Caillaux, a radical who had been the object of a *Figaro* smear campaign, took matters into her own hands and shot Calmette dead.

29. *Figaro*, June 3, 1912.

30. Other articles defending Rodin appeared in *Le Radical* (June 1, 1912), the *Vie parisienne* (June 8, 1912), and the *Petite République* (June 1, 1912). All the information has been beautifully assembled by Joy Newton in "Rodin and Nijinsky," *Gazette des beaux-arts*, September 1989.

31. The other furor over indecency in Paris in 1912 was occasioned by Jacob Epstein's tomb for Oscar Wilde, assembled in Père Lachaise cemetery during July and August. The French government wanted to stop it from being unveiled because the angel-demon figure had an exposed penis. A protest was mounted and Epstein made a direct appeal to Rodin to be among his supporters. He could not understand it when Rodin would not even examine the photographs he had sent. Jacob Epstein, *An Autobiography*, London, 1955, 53. Obviously, he had not kept abreast of all Rodin had suffered in defense of another foreigner's penis.

32. Newton, "Rodin and Nijinsky," 101–04.

33. Cladel, *Rodin*, 285.

34. Marcelle Martin remarried and wrote the book under her new name: Marcelle Tirel, *Rodin intime, ou l'Envers d'une gloire,* preface by A. Beuret, Paris, 1923, 22.

35. Another story that circulated in Paris was written down by Limet's daughter and placed in the Limet dossier in the Musée Rodin archives. She said the duchess tried to poison Rodin by putting arsenic in a dish of beans. Rodin didn't want them and gave them to someone else at the table, who then got sick. An analysis revealed the poison.

36. Letter to Marie Taxis, March 21, 1913. *The Letters of Rainer Maria Rilke and Princesse Marie von Thurn und Taxis,* trans. Nora Wydenbruck, New York, 1958, 93.

37. It has never been made clear whether Claire de Choiseul stole the drawings or not.

38. Cladel, *Rodin*, 286.

39. *Paris-Journal*, Aug. 22, 1912.

40. Hubert Thiolier, who has written on Jeanne Bardey, another important woman in the waning years of Rodin's life, whom we shall meet in the final chapter, agrees with me that this anecdote was not about Claudel. Rather than Claire de Choiseul, however, he believes Rodin's "femme de Paris" was Bardey. *Jeanne Bardey et Rodin,* Lyon, 1990, 225. Of course, neither Thiolier nor I really knows what took place in Rodin's damaged brain in 1916.

Chapter 34
Reckonings

1. *Matin*, April 13, 1913.

2. Mme de Noailles shared this with a reporter from the *Vie Parisienne*, Feb. 22, 1913.

3. Berta (Szeps) Zukerlandl, *Clemenceau tel que je l'ai connu,* Paris, 1939, 200.

4. Interview with René Godard, September 1929. Quoted in *Georges Clemenceau, 1841–1929: Exposition du cinquantenaire,* Paris, 1919, 95. Many of the portraits are illustrated in this catalogue of the exhibition held at the Petit Palais.

5. Marcelle Tirel, *The Last Years of Rodin,* New York, 1925, 77–78.

6. This information is found in a series of letters from Cladel to Bigand, of which there are copies in the Musée Rodin.

7. When Anthony Ludovici was living in Meudon in 1906, Rose Beuret talked to him about Auguste

Beuret, who called at Meudon "about once a month." Ludovici was surprised that Rose showed so little tenderness in his regard. Ludovici, *Personal Reminiscences of Auguste Rodin,* Philadelphia, 1926, 114.

8. Letter of July 21, 1914. Rose's brother was Edmond Beuret. His son was Emile; it was Emile who was working for Rodin in 1914 and there is no doubt that it was Emile who went to Saint-Ouen. Auguste Beuret has mixed up the names in his letter.

9. A room devoted to Claudel's work was established in the Musée Rodin after the 1983 exhibition "Camille Claudel."

10. Malvina Hoffman, *Heads and Tales,* New York, 1936, 44.

11. Letter of March 30, 1913. Most of Rodin's letters to Malvina Hoffman, as well as many from her to Rodin, are in the Getty Center for the History of Art and Humanities, Santa Monica. I am grateful to Jo Anne Paradise and Stephen Z. Nonack for making a microfilm of this correspondence available to me.

12. Philippe Jullian and John Phillips, *The Other Woman: A Life of Violet Trefusis,* Boston, 1976, 23.

13. Scott left Lady Sackville £150,000 in cash and the contents of his Paris house, valued at £350,000. Lady Sackville was in such a hurry to get her money that she sold the collection (which was the Paris half of the Wallace Collection) to the Paris dealer Seligmann for only £270,000.

14. Susan Mary Alsop, *Lady Sackville: A Biography,* New York, 1983, 186.

15. All the information on the history of the purchase and the locating of a site for the monument have been assembled by Susan Beattie, *"The Burghers of Calais" in London,* London, 1986.

16. Lady Sackville's diary is at Sissinghurst Castle and is owned by Nigel Nicolson. The passage is quoted in Benedict Nicolson, "Rodin and Lady Sackville," *Burlington Magazine* 112 (January–June 1970): 43. Vita Sackville-West married Harold Nicolson. Nigel and Benedict Nicolson are their sons.

17. Lyall H. Powers, ed., *Henry James and Edith Wharton: Letters, 1900–1915,* New York, 1990, 313.

18. A typed copy of this letter is in the Musée Rodin. The location of the original is unknown to me.

19. James Lees-Milne, *Harold Nicolson: A Biography,* vol. 1 (1886–1929), London, 1980, 64–65.

20. See Claude Keisch, "Rodin im Wilhelminischen Deutschland: Seine Anhänger und Gegner in Leipzig und Berlin," *Forschungen und Berichte der Staatliche Museen zu Berlin* 28 (1990): 285–86.

21. The information in the last three paragraphs comes from Lady Sackville's diary and has been quoted by Benedict Nicolson, "Rodin and Lady Sackville," and by Frederic Grunfeld, *Rodin: A Biography,* New York, 1987, 615–18.

22. The Musée Rodin archives contains a letter (dated March 9, 1906) from one Emile Lerou of the Comédie Française, reproaching Rodin for giving no recompense to Cladel for working on his exhibitions.

23. Tirel, *Last Years,* 111–12. Tirel says the article was "Rodin et la statuaire moderne" for *La Vie,* September 1910. This is not correct: the article was actually entitled "L'Enseignement d'art de Rodin," and it appeared in *La Vie* on Nov. 23, 1912. The article thus appeared during the troubled months just after the departure of the duchess.

24. In an interview of June 1991, Cladel's niece, Dominique Rolin told me that her aunt had had an affair with Bourgeois. It would have taken place in the late nineteenth century.

25. Berta Szeps, *My Life and History,* trans. John Sommerfield, London, 1938, 141–42.

26. Joy Newton and Monique Fol, *Romance Notes* 19 (1979): 313–20.

27. Hoffman, *Heads and Tales,* 46.

28. Wythe Williams, *The Tiger of France: Conversations with Clemenceau,* New York, 1949, 114.

29. Letter in the Archives, Getty Center for the History of Art and Humanities, Santa Monica.

Chapter 35
The Gift

1 Marcelle Tirel, *The Last Years of Rodin*, New York, 1925, 53.

2. Judith Cladel, *Rodin: Sa Vie glorieuse, sa vie inconnue*, Paris, 1936, 14.

3. Tirel, *Last Years*, 123–26.

4. Ibid., 133.

5. This account is found in the Fonds Cladel in the Musée Rodin. It is a long document (some 60 pages) that Cladel labeled "Quelques précisions biographiques: notes sur mes relations d'amitié avec Rodin."

6. Cladel, letter to Bigand dated Dec. 9, 1914.

7. Cladel, *Rodin*, 19.

8. Rolland's letter is dated Sept. 17, 1914. The Musée Rodin has a draft of Rodin's letter written on stationary from the Richelieu Hotel in London, where he was staying on Sept. 23.

9. Letter of Oct. 14, 1914. Lyall H. Powers, ed., *Henry James and Edith Wharton: Letters, 1900–1915*, New York, 1990.

10. Beattie, *"The Burghers of Calais" in London*, London, 1986, 12.

11. Tirel, *Last Years*, 137–38.

12. When the Panama Pacific International Exposition closed, Mrs. Spreckels purchased *The Thinker, The Age of Bronze, The Prodigal Son, The Siren of the Sea, Henir Rochefort*, and *Youth and Old Age*. These works formed the nucleus of the large Rodin collection sponsored by Mrs. Spreckels for the Palace of the Legion of Honor in San Francisco.

13. The contract for the portrait of Sen. Vance was signed on March 6, 1915; nothing ever came of it, however. The statue that now stands in Statuary Hall in the Capitol is by Gutzon Borglum of Mt. Rushmore fame. Rodin very much wanted the King Albert commission, as we know from his letters to Emile Verhaeren, who was helping him get it. To Verhaeren he wrote: "Attache grande importance à ce travail." The letters are in the Musée de la Littérature in Brussels.

14. Quoted in Raymond Escholier, *Matisse ce vivant*, Paris, 1956, 112. The quotation came to my attention in Kenneth E. Silver's beautiful book *Esprit de Corps: The Art of the Parisian Avant-Garde and the First World War, 1914–1925*, Princeton, 1989. In chap. 2, "The Rewards of War," Silver discusses at length the artists' patriotic response to the war.

15. Cladel, *Rodin*, 309.

16. Ivan Mestrovic, "Quelques souvenirs sur Rodin," *Annales de l'Institut Français de Zagreb* 1 (April–June 1937). Quoted in Frederic Grunfeld, *Rodin: A Biography*, New York, 1987, 628.

17. From an article in the *Journal des débats*, Dec. 16, 1917. Clipping in the Musée Rodin, from which both author and title have been cut off.

18. Albert Besnard, *Sous le ciel de Rome*, Paris, 1925, 238.

19. Boni de Castellane, *L'Art d'être pauvre*, Paris, 1926, 216.

20. Olga Signorelli Resnevic, *Il Ritratto di Benedetto XV di Auguste Rodin*, Staderinik Pomezia, 1981.

21. Cladel, *Rodin*, 317.

22. Jean-Jacques Becker, *The Great War and the French People*, trans. Arnold Pomerans, New York, 1986. Becker worked with the regular reports on the morale of the people assembled by the Paris police.

23. Tirel, *Last Years*, 145.

24. An account of Rodin's relationship with Bardey is given in Hubert Thiolier, *Jeanne Bardey et Rodin*, Lyon, 1990. Many of their letters are reproduced in this book.

25. For a description of Rodin's bust of Clémentel, see Albert E. Elsen, *All the Masks Fall Off*, Memphis, Brooks Museum of Art, 1988.

26. This is nicely summarized by Thiolier, *Bardey et Rodin*, 183.

27. Ibid., 193.

28. Cladel gives a detailed description of the discovery of this will. It had been torn into bits, then pasted together by Martin and eventually taken by Léonce Bénédite, director of the Musée du Luxembourg. *Rodin*, 360–61.

29. Bardey's letters to Guiguet are quoted in Thiolier, *Bardey et Rodin*, 199.

30. Tirel, *Last Years*, 150.

31. Cladel, *Rodin*, 327.

32. Ibid., 330.

33. Fonds Cladel, Musée Rodin Archives.

34. Cladel, *Rodin*, 331.

35. Thiolier, *Bardey et Rodin*, 210 and 225. Thiolier firmly believes that Bardey was ready to become the curator of the Musée Rodin and that it was Rodin's intention to designate her as such. He also quotes a note that Grunfeld saw in the Cladel archives in Bloomington, Indiana. In it, Cladel says Fuller told her that Bardey intended to marry Rodin once Beuret was dead.

36. Cladel, *Rodin*, 357.

37. This material is covered in *Le Gaulois* and in the *Libre Parole*, Sept. 15, 1916.

38. Emile Cahen, "Pendant et après la guerre," *Archives Israelites*, Sept. 21, 1916.

39. A week after the article appeared, Marcelle Tirel wrote a letter (Oct. 29, 1916) under Rodin's name to Secretary Dalimier saying that everything in the interview had been "imagined by the author." But, of course, that is exactly what Rodin thought. By the fall of 1916, Rodin was hardly making the decisions about his life, however. Surely the letter was an attempt at diplomacy on the part of Cladel or Bénédite.

40. Paul Soudy, "Au Sénat," *Paris-Midi*, Nov. 10, 1916.

41. Gustave Geffroy, "Décision pour Rodin," *Dépêche*, Nov. 28, 1916.

42. Cladel, *Rodin*, 370.

43. Undated letter from Cladel to Bénédite in the Musée Rodin.

44. Cladel, *Rodin*, 374.

45. Ibid., 387.

46. Ibid., 381.

47. Tirel, *Last Years*, 216.

48. Cladel, *Rodin*, 399.

49. Ibid., 399.

50. Tirel, *Last Years*, 217.

51. Ibid., 219.

52. Ibid., 221.

53. Cladel, *Rodin*, 413.

54. Ibid., 414, 416.

55. Aurel, *Pays*, Nov. 22, 1917.

56. Letter in the Swiss National Library in Bern in the Ritter Nachlass. I wish to thank Francesco Passanti, who brought this letter to my attention.

57. Cladel, *Rodin*, 421–22.

58. L. V., "Aux Obsèques de Rodin," *Pays*, Nov. 25, 1917.

Afterword

1. William Rothenstein, *Men and Memories*, New York, 1931, 1: 320.

2. André Salmon, *La Jeune Sculpture française*, Paris, 1919, 30–33.

Bibliography

The bulk of the research for this book took place in the archive of the Musée Rodin. It was Rodin's lifelong habit to keep his correspondence. The earliest letter to Rodin in the archive came from a schoolmate in 1854. There are dossiers of letters from over two thousand individuals, as well as many other kinds of documents, such as Maria Rodin's school notebooks and the employment records of Jean-Baptiste Rodin. The archivists of the Musée Rodin have classified a wealth of published materials that would be difficult to locate elsewhere, particularly newspaper reviews. Rodin subscribed to the major clipping services of his day, which enabled him to receive articles about himself and his work from Parisian, provincial, and foreign publications.

Work on births, deaths, marriages, baptisms, residences, and military records was done in the departmental archives of the Seine in Paris, of the Moselle in Metz, of the Oise in Beauvais, of the Haute-Marne in Chaumont, and of the Seine-Maritime in Rouen, as well as in the parish registers of Gorze and Paris.

Outside of the Musée Rodin, I read Rodin's letters in the Bibliothèque Nationale, the Bibliothèque Doucet, and the Institut Néerlandais in Paris; the Musée de la Littérature in the Bibliothèque Royale in Brussels; the British Museum in London; the Metropolitan Museum of Art and the Public Library in New York; the National Gallery of Art and the Library of Congress in Washington, D.C.; and the Getty Center for the History of Art and Humanities in Santa Monica, California. Other archival materials are found in the Musée d'Orsay in Paris, the Chicago Art Institute, Houghton Library of Harvard University, the Beinecke Rare Book and Manuscript Library of Yale University, and the Museum of Modern Art in New York.

Writings by Rodin

"La Tête Warren." *Musée* 1, no. 6 (November–December 1904): 298–301.
"Le Parthénon et les cathédrales." *Musée* 2, no. 1 (January–February 1905): 66–68.
"The Gothic in the Cathedrals and Churches of France." Trans. Frederick Lawton. *North American Review* 180, no. 2 (February 1905).
Les Cathédrales de France. Paris, 1950.

Published Letters

Adams, Henry. *The Letters of Henry Adams*. 6 vols. Ed. J. C. Levenson et al. Cambridge, Mass., 1982–88.
Busch, Günter, and Liselotte von Reinken, eds. *Paula Modersohn-Becker: The Letters and Journals*. Trans. Arthur S. Wensinger and Carole Clew Hoey. New York, 1983.
Delius, Jelka Rosen. "Jelka Rosen Delius: The Correspondence: 1900–1914." Ed. Lionel Carley. *Nottingham French Review* 9, nos. 1–2 (May and October 1970).
Mirbeau, Octave. *Correspondance avec Auguste Rodin*. Ed. Pierre Michel and Jean-François Nivet. Tusson, Charente, 1988.
Powers, Lyall H., ed. *Henry James and Edith Wharton: Letters, 1900–1915*. New York, 1990.
Rilke, Rainer Maria. *The Letters of Rainer Maria Rilke, 1892–1910*. Trans. Jane Bannard Greene and M. D. Herter Norton. New York, 1945.
——. *The Letters of Rainer Maria Rilke and Princesse Marie von Thurn und Taxis*. Trans. Nora Wydenbruck. New York, 1958.

Rodin, Auguste. *Briefe an zwei deutsche Frauen*. Ed. Helene von Nostitz; introduction by Rudolf Alexander Schröder. Berlin, 1936.

——. *Correspondance de Rodin*. Vol. 1, 1860–99. Ed. Alain Beausire and Hélène Pinet. Paris, 1985.

——. *Correspondance de Rodin*. Vol. 2, 1900–1907. Ed. Alain Beausire and Florence Cadouot. Paris, 1986.

——. *Correspondance de Rodin*. Vol. 3, 1908–12. Ed. Alain Beausire and Florence Cadouot. Paris, 1987.

——. *Correspondance de Rodin*. Vol. 4, 1913–17. Ed. Alain Beausire, Florence Cadouot, and Frédérique Vincent. Paris, 1992.

——. "Dix-huit lettres de Rodin." Collection of the Fondation Custodia, Institut Néerlandais de Paris. Ed. Alain Beausire and Hélène Pinet. *Archives de l'art français* 19 (1988): 189–98.

——. "Quelques lettres de Rodin." Ed. Charles Goerg. *Revue du Musée de Genève* 23 (March 1962).

Rodin, Auguste, and Max Linde. "Correspondence between Auguste Rodin and Max Linde." Ed. and trans. J. Patrice Marandel. Part 1, 1900–1901. *Bulletin of the Detroit Institute of Art* 62, no. 4 (1987): 38–52. Part 2, 1902–1905. Ibid., vol. 63, nos. 3 and 4 (1988): 34–55.

Rodin, Auguste, and Ignacio Zuloaga. *Etude critique de la correspondance de Zuloaga et Rodin de 1903 à 1917*. Ed. Ghislaine Plessier; preface by Bernard Dorival. Paris, 1983.

Catalogues of Permanent Collections

Berlin, Staatliche Museen. *Auguste Rodin: Plastik, Zeichnungen, Graphik*, by Claude Keisch. 1979.

Cleveland Museum of Art. *Rodin in the Cleveland Museum of Art*, by Athena Tacha Spear. 1967.

Copenhagen, Ny Carlsberg Glyptotek. *Rodin: La Collection du brasseur Carl Jacobsen à la Glyptothèque— et oeuvres apparentées*, by Anne-Birgitte Fonsmark. 1988.

London, Victoria and Albert Museum. *Rodin Sculptures*, by Jennifer Hawkins. 1975.

New York, Metropolitan Museum of Art. "Rodin at the Metropolitan Museum of Art," by Clare Vincent. *Metropolitan Museum of Art Bulletin*, Spring 1981.

Paris, Musée Rodin. *Catalogue du Musée Rodin*. Vol. 1, *Hôtel Biron*, by Georges Grappe. 1944.

——. *Inventaire des dessins*, by Claudie Judrin. 6 vols. 1984–92.

——. *Marbres de Rodin: Collection du musée*, by Nicole Barbier. 1987.

Philadelphia, Rodin Museum. *The Sculpture of Auguste Rodin*, by John Tancock. 1976.

San Francisco, California Palace of the Legion of Honor. *Rodin's Sculpture: A Critical Study of the Spreckels Collection*, by Jacques de Caso and Patricia B. Sanders. 1977.

Exhibition Catalogues (by date)

Exposition Monet-Rodin. Introduction by Gustave Geffroy. Paris: Galerie Georges Petit, June–August 1889.

Exposition Rodin. Prefaces by E. Carrière, J.-P. Laurens, C. Monet, A. Besnard; introduction by A. Alexandre. Paris, 1900.

Exposition Rodin. Preface by Stanislaw Sucharda. Prague: Pavillon Manès, Kinsky Garden, May–August 1902.

Camille Claudel. Preface by Paul Claudel. Paris: Musée Rodin, 1951.

Rodin, by Albert Elsen. New York: Museum of Modern Art, 1963.

The Drawings of Rodin. Preface by Albert Elsen; introduction by J. Kirk T. Varnedoe. Washington: National Gallery of Art, November 1971–January 1972. New York: Solomon R. Guggenheim Museum, March–May 1972.

Rodin and Balzac. Introduction by Albert Elsen, with Stephen C. McGough and Steven H. Wander. Stanford: Stanford University, Spring 1973.

Rodin et les écrivains de son temps. Introduction by Claudie Judrin. Paris: Musée Rodin, June–October 1976.

Auguste Rodin: Le Monument des Bourgeois de Calais. Essays by Claudie Judrin, Monique Laurent, and Dominique Viéville. Calais: Musée des Beaux-Arts, December 1977–March 1978. Paris: Musée Rodin, April–September 1978.

Romantics to Rodin: French Nineteenth-Century Sculpture from North American Collections. Ed. Peter Fusco and H. W. Janson. Los Angeles County Museum of Art, March–May 1980. Minneapolis Institute of Arts, June–September 1980. Detroit Institute of Arts, October–January 1981. Boston Museum of Fine Arts, February–April 1981.

Rodin Rediscovered. Ed. Albert E. Elsen. Washington: National Gallery of Art, June 1981–May 1982.

De Carpeaux à Matisse. Prefaces by Noël Josephe, Hubert Landais, and Monique Laurent. Introduction by Dominique Viéville. Calais: Musée des Beaux-Arts, March–June 1982. Lille: Musée des Beaux-Arts, June–August 1982. Saint-Waast d'Arras: Musée des Beaux-Arts, September–November 1982. Boulogne-sur-Mer: Musée des Beaux-Arts et d'Archéologie, December 1982–April 1983.

Camille Claudel. Preface by Monique Laurent; introduction by Bruno Gaudichon. Paris: Musée Rodin, February–June 1984. Poitiers: Musée Sainte-Croix, June–September 1984.

Auguste Rodin: Zeichnungen und Aquarelle, by Ernst-Gerhard Güse. Münster: Westfälisches Landesmuseum für Kunst und Kulturgeschichte, November 1984–July 1985.

La Gloire de Victor Hugo. Introduction by Pierre Georgel. Paris: Grand Palais, October 1985–January 1986.

Rodin: The B. Gerald Cantor Collection, by Joan Vita Miller and Gary Marotta. New York: Metropolitan Museum of Art, April–June 1986.

La Sculpture française au XIXe siècle. Introduction by Anne Pingeot. Paris: Grand Palais, April–July 1986.

Rodin: Sculpture and Drawings, by Catherine Lampert. London: Hayward Gallery, November 1986–January 1987.

"L'Age mûr" de Camille Claudel. Introduction by Anne Pingeot. Paris: Musée d'Orsay, September 1988–January 1989.

Claude Monet–Auguste Rodin: Centenaire de l'exposition de 1889. Paris: Musée Rodin, November 1989–January 1990.

Le Corps en morceau. Introduction by Anne Pingeot. Paris: Musée d'Orsay, February–June 1990.

Rodin et ses modèles, by Hélène Pinet. Paris: Musée Rodin, April–June 1990.

Rodin, Genius Rodin, by Rainer Crone and Siegfried Salzmann. Bremen: Kunsthalle, November 1991–January 1992. Düsseldorf, January–March 1992.

A Notre ami Bigand, Rodin, Redon, Moreau . . . , by Sophie Blass-Fabiani, Gérard Fabre, and Christiane Sinning-Hass. Martigues: Musée Ziem, June–September 1992.

Studies and Related Material

Adam, Marcel. "Le Penseur." *Gil Blas,* July 7, 1904.

——. "Victor Hugo et Auguste Rodin." *Figaro,* Supplement, Dec. 28, 1907.

Agulhon, Maurice. *Marianne into Battle: Republican Imagery and Symbolism in France, 1789–1880.* Trans. Janet Lloyd. Cambridge, 1981.

Alhadeff, Albert. "Rodin: A Self-Portrait in *The Gates of Hell.*" *Art Bulletin* 48 (1966): 393–95.

Aurel. *Rodin devant la femme: Fragments inédits de Rodin; sa technique par lui-même.* Paris, 1919.

Bartlett, Truman H. "Auguste Rodin, Sculptor." *American Architect and Building News,* Jan. 19–June 15, 1889.

Basset, Serge. "La Porte de l'Enfer." *Journal de Liège,* March 24, 1900.

Bazire, Edmond. "Auguste Rodin." *Art et Critique* 1 (July 6, 1889).

Beattie, Susan. *"The Burghers of Calais" in London*. London, 1986.

Beausire, Alain. *Quand Rodin exposait*. Paris, 1988.

Becker, Jean-Jacques. *The Great War and the French People*, Trans. Arnold Pomerans. New York, 1986.

Bellos, David. *Balzac Criticism in France, 1850–1900: The Making of a Reputation*. Oxford, 1976.

Bénédite, Léonce. *Rodin*. Paris, 1923.

Bergerat, Emile. "Souvenirs contemporains." *Annales politiques et littéraires* 16 (June 1895).

——. *Souvenirs d'un enfant de Paris*. 2 vols. Paris, 1911–12.

Bernstein, Herman. *Celebrities of Our Time*. New York, 1924.

Blanc, Charles. *Les Artistes de mon temps*. Paris, 1876.

Blanche, Jacques-Emile. *Portraits of a Lifetime*. New York, 1938.

Boime, Albert. "The Salon des Refusés and the Evolution of Modern Art." *Art Quarterly* Winter 1969: 411–28.

——. "The Teaching Reforms of 1893 and the Origins of Modernism in France." *Art Quarterly* Autumn 1977: 1–39.

Bourdelle, Antoine. *La Sculpture et Rodin*. Paris, 1978.

Bredin, Jean-Denis. *The Affair: The Case of Alfred Dreyfus*. Trans. Jeffrey Mehlman. New York, 1986.

Burdett, O., and E. H. Goddard, *Edward Perry Warren: The Biography of a Connoisseur*. London, 1941.

Butler, Ruth. *Rodin in Perspective*. Englewood Cliffs, N.J., 1980.

——. "Rodin and His American Collectors." In Gabriel P. Weisberg and Laurinda S. Dixon, eds. *The Documented Image: Festschrift in Honor of Elizabeth Gilmore Holt*. New York, 1987.

Canudo, Ricciotto. "Notre Colonne Trajane: La 'Tour du Travail' de Rodin." *Censure*, Aug. 3, 1907.

Caron, François. *La France des patriotes*. Paris, 1985.

Caso, Jacques de. "Rodin and the Cult of Balzac." *Burlington Magazine* 106 (1964).

——. "Rodin's Mastbaum Album." *Master Drawings* 10, no. 2 (Summer 1972).

Cassar, Jacques. *Dossier Camille Claudel*. Paris, 1987.

Champsaur, Félicien. "Celui qui revient de l'Enfer: Auguste Rodin." *Figaro*, Supplement, Jan. 16, 1886.

——. "Un Raté de génie." *Gil Blas*, Sept. 30, 1896.

Chennevières, Philippe de. *Souvenirs d'un directeur des beaux-arts*. Paris, 1979.

Chevalier, Louis. *La Formation de la population parisienne au XIXe siècle*. Paris, 1950.

Cladel, Judith. *Auguste Rodin: L'Oeuvre et l'homme*. Brussels, 1908.

——. *Auguste Rodin, pris sur la vie*. Paris, 1903.

——. "Ceux que j'ai vus." *Fronde*, May 2, 1898.

——. "L'Enseignement d'art de Rodin." *Vie*, Nov. 23, 1912.

——. "La Jeunesse de Rodin." *Revue universelle*, May 1, 1935.

——. *Rodin: Sa Vie glorieuse, sa vie inconnue*. Paris: Bernard Grasset, 1936.

Claudel, Paul. *Cahiers*. Vol. 1. Paris, 1959.

——. *Journal*. 2 vols. Paris, 1968–69.

Coquiot, Gustave. *Rodin à l'Hôtel Biron et à Meudon*. Paris, 1917.

——. *Le Vrai Rodin*. Paris, 1913.

Curtis, Penelope. "The Sculpture of Antoine Bourdelle." Ph.D. diss., Courtauld Institute, n.d.

Daudet, Léon. *Fantômes et vivants: Souvenirs des milieux littéraires, politiques, artistiques et médicaux de 1880–1905*. Paris, 1920.

Dédéyan, Charles. *Rilke et la France*. 2 vols. Paris, 1961–63.

Delarue-Mardrus, Lucie. *Mes Mémoires*. Paris, 1938.

Delsemme, Paul. *Un Théoricien du symbolisme: Charles Morice*. Paris, 1958.

Descharnes, Robert, and Jean-François Chabrun. *Auguste Rodin*. Lausanne, 1967.

Dubois, Phillip. "L'Apothéose du travail." *Aurore*, April 1, 1898.

Dujardin-Beaumetz, Henri-Charles-Etienne. *Entretiens avec Rodin*. Paris, 1913. Trans. in Elsen, *Auguste Rodin: Readings*.

Duncan, Carol. "Virility and Domination in Early Twentieth-Century Vanguard Painting." *Artforum*, December 1973.

Elsen, Albert E. *All the Masks Fall Off*. Memphis: Brooks Museum of Art, 1988.

——. *In Rodin's Studio*. Ithaca, N.Y., 1980.

——. *"The Gates of Hell" by Auguste Rodin*. Stanford, Calif., 1985.

——. *Rodin's "Thinker" and the Dilemmas of Modern Public Sculpture*. New Haven and London, 1985.

Elsen, Albert E., ed. *Auguste Rodin: Readings on His Life and Work*. Englewood Cliffs, N.J., 1965.

Fabre, Brigitte. "Mademoiselle Camille Claudel, statuaire: Trente Ans de sculpture, trente ans d'internement." Diss., University of Paris, V, n.d.

Ferry, Gabriel. "La Statue de Balzac." *Monde moderne* 10 (1899).

France, Anatole. "La Porte de l'Enfer." *Figaro*, June 7, 1900.

French, Mrs. Daniel Chester. *Memories of a Sculptor's Wife*. Boston, 1928.

Gedo, John E. *Portraits of the Artist*. Hillsdale, N.J., 1989.

Geffroy, Gustave. "L'Art d'aujourd'hui." *Journal*, Nov. 20, 1898.

——. *Claude Monet: Sa Vie, son oeuvre*. Paris, 1924.

——. "Décision pour Rodin." *Dépêche*, Nov. 28, 1916.

——. "L'Exposition Rodin." *Echo de la semaine*, June 10, 1900.

——. "L'Imaginaire." *Figaro*, Aug. 29, 1893.

——. "Le 'Penseur' de Rodin." *Aurore*, April 22, 1906.

——. "Le Penseur de Rodin au Panthéon." *Revue bleue*, Dec. 17, 1904.

——. "Le Victor Hugo de Rodin." *Journal*, April 23, 1897.

Goldscheider, Cécile. "Rodin en Belgique." *Médecine de France* 90 (1950).

Goncourt, Edmond de, and Jules de Goncourt. *Journal: Mémoires de la vie littéraire*. Monaco, 1956.

Grautoff, Otto. "Aus Gesprächen mit Rodin." *Jugend* 47 (1907).

Green, Alice. "The Girl Student in Paris." *Magazine of Art* 6 (1883).

Green, Nicholas. "'All the Flowers of the Field': The State, Liberalism, and Art in France under the Early Third Republic." *Oxford Art Journal* 10 (Nov. 1, 1897).

Grunfeld, Frederic V. *Rodin: A Biography*. New York, 1987.

Gsell, Paul. *L'Art: Entretiens réunis par Paul Gsell*. Paris, 1911. Trans. Jacques de Caso and Patricia B. Sanders as *Art: Conversations with Paul Gsell*. Berkeley, Calif., 1984.

——. "Chez Rodin." *L'Art et les artistes* 4, no. 23 (February 1907).

——. "Propos d'Auguste Rodin sur l'art et les artistes." *Revue*, November 1907.

——. "Un Triomphe pour l'art français aux Etats-unis." *Journal*, Sept. 5, 1910.

Hanotelle, Micheline. *Paris/Bruxelles: Relations des sculpteurs français et belges à la fin du XIXe siècle*. Paris, 1982.

Hare, Marion. "The Portraiture of Auguste Rodin." Ph.D. diss., Stanford University, 1984.

Hargrove, June. *The Life and Work of Albert Carrier-Belleuse*. New York, 1977.

——. *The Statues of Paris: An Open-Air Pantheon*. Antwerp, 1989.

Hoffman, Malvina. *Heads and Tails*. New York, 1936.

Holroyd, Michel. *Augustus John: A Biography*. Vol. 1. London, 1974.

——. *Bernard Shaw*. Vol. 2. New York, 1989.

Hunisak, John M. *The Sculptor Jules Dalou: Studies in His Style and Imagery*. New York, 1977.

Jamison, Rosalyn Frankel. "Rodin and Hugo: The Nineteenth-Century Theme of Genius in the Gates and Related Works." Ph.D. diss., Stanford University, 1986.

Janson, H. W. "Rodin and Carrier-Belleuse: The Vase des Titans." *Art Bulletin* 50 (1968).

Jay, Robert Allen. "Art and Nationalism in France, 1870–1914." Ph.D. diss., University of Minnesota, 1979.

Jeantet, Félix. "Exposition des oeuvres de Rodin." *Blanc et noir,* June 1889.

Kassner, Rudolf. *Motive Essays.* Berlin, 1906.

Keisch, Claude. "Rodin im Wilhelminischen Deutschland: Seine Anhänger und Gegner in Leipzig und Berlin." *Forschungen und Berichte der Staatliche Museen zu Berlin* 28 (1990).

Kysela, John D. "Sarah Hallowell Brings 'Modern Art' to the Midwest." *Art Quarterly* 27 (1964).

Langdale, Cecily. *Gwen John.* New Haven and London, 1987.

Langlois, Claude. "Les Effectifs des congrégations féminines au XIXe siècle: De L'Enquête statistique à l'histoire quantitative." *Revue d'histoire de l'église de France* 60 (January 1974): 39–64.

Laparcerie, Marie. "Life of an Artist's Model in Paris: A Transcript from the Experiences of One Who Poses for Painters and Sculptors." *New York Tribune,* Jan. 25, 1903.

———. "Les Modèles à l'Académie." *Presse,* Jan. 19, 1903.

Lapauze, Henry. "Rodin abandonnerait-il Balzac?" *Gaulois,* Jan. 26, 1896.

Lavalle, Denis. "Le Monument de la Défense et la statuaire du XIXe siècle." In Georges Weil, ed. *La perspective de la Défense dans l'art et l'histoire.* Nanterre, 1983.

Lawton, Frederick. *The Life and Work of Auguste Rodin.* London, 1906.

Lecoq de Boisbaudran, Horace. *Lettres à un jeune professeur: Sommaire d'une méthode pour enseignement du dessin et de la peinture.* Paris, 1876.

Lemonnier, Camille. "Le Nouveau Conservatoire de Musique de Bruxelles." *Art universel,* Nov. 18, 1874.

Leppman, Wolfgang. *Rilke: A Life.* Trans. Russell M. Stockman. New York, 1984.

Leroi, Paul. "Comtes éloquents! M. Rodin . . . doit à la Direction des Beaux-Arts." *Art* 62 (1903): 289–90.

———. "La Société Nationale des Beaux-Arts." *Art,* June 1904.

———. "Le Sous-secrétaire d'état des beaux-arts." *Art,* February 1905.

Levi, David. *Michel-Ange: L'Homme, l'artiste, le citoyen.* Trans. Edouard Petit. Paris, 1884.

Lindsay, Jack. *Gustave Courbet: His Life and Art.* New York, 1973.

Ludovici, Anthony M. *Personal Reminiscences of Auguste Rodin.* Philadelphia, 1926.

McCauley, Anne. "Photographs for Industry: The Career of Charles Aubry." *J. Paul Getty Museum Journal* 14 (1986).

Mackail, J. W., and Guy Wyndham, eds. *Life and Letters of George Wyndham.* Vol. 2. London, 1925.

MacKenna, Stephen. "In Rodin's Studio—The Personality and Doctrine of a Revolutionary Sculptor." *Criterion,* July 1901.

McNamara, Mary Jo. *Rodin's "Burghers of Calais."* New York, 1977.

Maillard, Léon. *Auguste Rodin, statuaire.* Paris, 1899.

Mainardi, Patricia. *Art and Politics of the Second Empire.* New Haven and London, 1987.

Mâle, Emile. "Rodin interprète des cathédrales de France." *Gazette des beaux-arts,* May 1914.

Marnata, Françoise. *Les Loyers des bourgeois de Paris, 1860–1958.* Paris, 1961.

Marx, Roger. *Auguste Rodin, céramiste.* Paris, 1907.

Mauclair, Camille. "Auguste Rodin: Son Oeuvre, son milieu, son influence." *Revue universelle,* Aug. 17, 1901.

———. *Auguste Rodin: The Man—His Ideas—His Works.* Trans. Clementina Black. London, 1905.

———. "The Decorative Sculpture of August Rodin." *International Quarterly* 3 (February 1901).

———. "Un Don du génie." *Petit Niçois,* April 12, 1916.

Mayeur, J. M., and Rebérioux, Madeleine. *The Third Republic from Its Origins to the Great War, 1871–1914.* Trans. J. R. Foster. Cambridge, 1987.

Mestrovic, Ivan. "Quelques souvenirs sur Rodin." *Annales de l'Institut Français de Zagreb* 1 (June 1937).

Meunier, Mario. "Rodin, dans son art et dans sa vie." *Marges*, April 15, 1914.

Michelet, Jules. *La Femme*. Paris, 1860.

Mirbeau, Octave. "L'Apothéose." *Journal*, July 16, 1899.

———. "Auguste Rodin." *France*, Feb. 18, 1885.

———. "Auguste Rodin." *Echo de Paris*, June 25, 1889.

———. "Auguste Rodin." *Journal*, June 4, 1895.

———. "Auguste Rodin." *Plume*, June 1, 1900.

Morand, Paul. *1900 A.D.* Paris, 1931.

Morhardt, Mathias. "Le Banquet Puvis de Chavannes." *Mercure de France*, Aug. 1, 1935.

———. "La Bataille du Balzac." *Mercure de France*, Dec. 15, 1934.

Morice, Charles. "Le Monument de Baudelaire." *Journal des artistes*, Sept. 5, 1892.

Nadar, Félix. "Balzac et le daguerréotype." *Paris-photographe*, April 1891.

Nantet, Marie-Victoire. "Camille Claudel: Un Désastre 'fin-de-siècle.'" *Commentaire* 42 (Summer 1988).

Nelms, Brenda. *The Third Republic and the Centennial of 1789*. New York, 1987.

Newton, Joy. "Octave Mirbeau and Auguste Rodin, with Extracts from Unpublished Correspondence." *Laurels* 58 (Spring 1987).

———. "Portrait of an Art Critic: Gustave Geffroy, with Extracts from His Unpublished Letters to Rodin." *Laurels* 59 (Winter 1988–89).

———. "Rodin and Goncourt." *American Society of the Legion of Honor Magazine* 50 (1979).

———. "Rodin and Nadar." *Laurels* 52 (Winter 1981–82).

———. "Rodin and Nijinsky." *Gazette des beaux-arts* 108 (September 1989).

Newton, Joy, and Monique Fol. "Zola and Rodin." *Cahiers naturalistes* 59 (1985).

Newton, Joy, and Margaret F. MacDonald. "Whistler, Rodin, and the 'International.'" *Gazette des beaux-arts* 103 (1984).

Nicolle, Marcel. "L'Exposition Rodin." *Journal de Rouen*, July 16, 1900.

Nicolson, Benedict. "Rodin and Lady Sackville." *Burlington Magazine* 112 (January–June 1970).

Nivet, E. "François Pompon." *Département de l'Indre*, May 21, 1933.

Nostitz, Helene von. *Dialogues with Rodin*. Trans. H. L. Ripperger. New York, 1931.

———. *Rodin in Gespräche und Briefe*. Dresden, 1927.

Ollivier, Emile. *Une Visit à la Chapelle des Médicis*. Paris, 1872.

Paris, Reine-Marie, ed. *Camille Claudel, 1864–1943*. Paris, 1984.

Paris, Reine-Marie, and Arnaud de La Chapelle. *L'Oeuvre sculptée de Camille Claudel*. Paris, 1990.

Pearson, Hesketh. *Bernard Shaw: His Life and Personality*. London, 1942.

Pennell, E. R., and J. Pennell. *The Whistler Journal*. Philadelphia, 1921.

Phayer, J. Michael. *Sexual Liberation and Religion in Nineteenth-Century Europe*. London, 1977.

Picard, Edmond. "Mlle Judith Cladel: Conférence sur Auguste Rodin à la Maison d'Art." *Plume*, 1899.

Pincus-Witten, Robert. *Occult Symbolism in France: Joseph Péladan and the Salon de la Rose + Croix*. New York, 1976.

Pinet, Hélène. *Rodin, sculpteur, et les photographes de son temps*. Paris, 1985.

Pingeot, Anne. "Le Chef d'oeuvre de Camille Claudel: L'Age mûr." *Revue du Louvre* 4 (October 1982).

———. "Le Décor sculpté du Panthéon sous le Second Empire et la IIIe République." In *Le Panthéon: Symbole des revolutions*. Paris, 1989.

———. "La Statuaire du nouvel Hôtel de Ville." In *Centenaire de la reconstruction de l'Hôtel de Ville de Paris*. Paris, 1982.

Plessis, Alain. *The Rise and Fall of the Second Empire, 1852–1871*. Trans. Jonathan Mandelbaum. Cambridge, 1985.

Possien, Adolphe. "Le 'Balzac' de Rodin: La Réponse de l'artiste à la Société des Gens de Lettres." *Jour*, May 12, 1898.

Prater, Donald. *A Ringing Glass: The Life of Rainer Maria Rilke.* New York, 1986.

Proust, Antonin. *L'Art décoratif et le musée national du quai d'Orsay.* Paris, 1887.

———. "L'Union Centrale des Arts Décoratifs: Ses Origines—son programme." In *L'Art sous la République.* Paris, 1892.

Py, Geneviève, ed. "Le Statue de Balzac et l'affaire Balzac-Rodin." *Éphéméride de la Société des Gens de Lettres de France de 1888 à 1987.* Paris, 1988.

Rameau, Jean. "La Victoire de M. Rodin." *Gaulois,* May 3, 1898.

Réval, Gabrielle. "Mlle Judith Cladel." *Femina,* April 1, 1906.

Rilke, Rainer Maria. *Auguste Rodin.* Berlin, 1903.

———. *Rodin and Other Prose Pieces.* Trans. G. Craig Houston. London, 1986.

Riotor, Léon. *Carpeaux.* Paris, 1927.

Rivière, Anne. *L'Interdite: Camille Claudel, 1884–1943.* Paris, 1983.

Roos, Jane. "Rodin, Hugo, and the Panthéon: Art and Politics in the Third Republic." Ph.D. diss., Columbia University, 1981.

———. " Rodin's *Monument to Victor Hugo*: Art and Politics in the Third Republic." *Art Bulletin* 68, no. 4 (December 1986): 632–56.

Rosenfeld, Daniel. "Rodin's Carved Sculpture." Ph.D. diss., Stanford University, n.d.

Rothenstein, William. *Men and Memories: Recollections of William Rothenstein, 1872–1900.* 2 vols. New York, 1931–32.

Salmon, André. *La Jeune Sculpture française.* Paris: Société des Trente, 1919.

Schom, Alan. *Emile Zola: A Biography.* New York, 1987.

Secrétain, Roger. *Un Sculpteur "maudit": Gaudier-Brzeska, 1891–1915.* Paris, 1979.

Silver, Kenneth E. *Esprit de Corps: The Art of the Parisian Avante-Garde and the First World War, 1914–1925.* Princeton, N.J., 1989.

Silverman, Debora Leah. *Art Nouveau in Fin-de-Siècle France: Politics, Psychology, and Style.* Berkeley, Calif., 1991.

Simmel, Georg. *Brücke und Tür.* Stuttgart, 1957.

Sollers, Philippe, and Alain Kirili. *Rodin: Dessins érotiques.* Paris, 1987.

Symons, Arthur. "Les Dessins de Rodin." *Plume,* special number, May 15–Aug. 1, 1900.

Taubman, Mary. *Gwen John: The Artist and Her Work.* Ithaca, N.Y., 1986.

Thiébault-Sisson, Albert. "Le Penseur de Rodin." *Temps,* Dec. 2, 1903.

Thiolier, Hubert. *Jeanne Bardey et Rodin.* Lyon, 1990.

Tillier, Bertrand. *Ernest Nivet, sculpteur: Des Fenêtres ouvertes sur la vie.* Châteauroux, 1987.

Tirel, Marcelle. *The Last Years of Rodin.* Trans. R. Francis; preface by Judith Cladel. New York, 1925.

———. *Rodin intime, ou l'Envers d'une gloire.* Preface by A. Beuret. Paris, 1923.

Toledano, Marc. *La Polonaise de Rodin.* Paris, 1986.

Wagner, Anne Middleton. *Jean-Baptiste Carpeaux.* New Haven and London, 1986.

Ward, Patricia. *The Medievalism of Victor Hugo.* University Park, Pa., 1975.

Wennberg, Bo. *French and Scandinavian Sculpture in the Nineteenth Century.* Uppsala, 1978.

Yeldham, Charlotte. *Women Artists in Nineteenth-Century France and England.* New York, 1984.

Zayas, Marius de. "How, When, and Why Modern Art Came to New York." *Arts Magazine* 54 (April 1980).

Zweig, Stefan. *The World of Yesterday.* New York, 1943.

Index

Illustration Credits

Archivi Alinari: 53

Bibliothèque Marguerite Durand: 116
Bibliothèque Nationale, Paris: 20, 21, 61b, 61c, 91, 97, 151
Bulloz: 33, 50, 135, 138

Caisse Nationale de Monuments Historiques et des Sites: 17, 62, 103
Centre National d'Art et de Culture Georges Pompidou: 196
Jean-Loup Charmet: 89

Documentation Photographique de la Réunion des Musées Nationaux: 15, 52, 64, 96

Ecole Nationale Supérieure des Beaux-Arts: 42, 44
Albert Elsen: 37, 48

Fine Arts Museums of San Francisco: 127
Fogg Art Museum: 61a

Giraudon/Paris: 34, 104
Giraudon/Art Resource: 54, 77, 137

Hirshhorn Museum and Sculpture Garden: 128

Institut Royal du Patrimoine Artistique: 23, 25, 26, 27, 29

Bruno Jarret par ADAGP: 67, 84, 86, 88, 99

Library of Congress: 130, 166
Mrs. George Liddle: 176
Los Angeles County Museum of Art: 80, 119, 126

Metropolitan Museum of Art: 165
Musée des Beaux-Arts, Rouen: 7
Musée d'Orsay: 14, 39, 81, 105
Musée Rodin: 1, 2, 12, 13, 16, 28, 30, 43, 45, 51, 56, 60, 63, 65, 66, 69, 70, 78, 82, 90, 92, 94, 95, 101, 107, 108, 110, 121, 122, 123, 131, 148, 152, 153, 156, 157, 159, 160, 163, 167, 172, 173, 177, 178, 182, 186, 188, 191, 192, 193, 194, 197, 199, 201, 203, 204, 206, 208
©Musée Rodin: 142, 175
Musée Rodin/contretypes Bruno Jarret: 9, 35, 36, 57, 73, 79, 83, 93, 129, 132, 136, 143, 146, 147, 149, 150, 161, 179, 184, 200, 202, 205, 207
Musée Rodin/contretypes Jean-Claude Marlaud: 74, 75, 125, 139, 144, 155, 164
©Musée Rodin and ©Bruno Jarret par ADAGP: 3, 6, 18, 31, 32, 58, 72, 85, 100, 102, 109, 112, 113, 114, 115, 134, 158, 162, 180
©Musée Rodin and ©Adam Rzepka: 5, 98
Museum of Fine Arts, Boston: 71

National Gallery of Art, Washington: 171

Reine-Marie Paris: 76
Philadelphia Museum of Art: 124
Ivor Protheroe: 4

Roget-Viollet: 22, 46, 154, 174
Jane Roos: 118

Bill Schaefer, courtesy of B. G. Cantor: 140, 141
Dorothy L. Steven: 183

Victoria and Albert Museum: 190

DATE			